A SHORT HISTORY OF THE ITALIAN RENAISSANCE

A SHORT HISTORY OF THE ITALIAN RENAISSANCE

KENNETH R. BARTLETT

 UNIVERSITY OF TORONTO PRESS

Library and Archives Canada Cataloguing in Publication

Bartlett, Kenneth R., 1948–
A short history of the Italian Renaissance / Kenneth R. Bartlett.
Includes bibliographical references and index. Issued also in electronic format. ISBN 978-1-4426-0014-0
1. Renaissance—Italy. 2. Italy—Civilization—1268–1559. I. Title.

DG445.B37 2013 945'.05 C2012-908032-2

We welcome comments and suggestions regarding any aspect of our publications—please feel free to contact us at news@utphighereducation.com or visit our Internet site at www.utppublishing.com.

North America
5201 Dufferin Street
North York, Ontario, Canada, M3H 5T8

2250 Military Road
Tonawanda, New York, USA, 14150

orders phone: 1–800–565–9523
orders fax: 1–800–221–9985
orders e-mail: utpbooks@utpress.utoronto.ca

UK, Ireland, and continental Europe
NBN International
Estover Road, Plymouth, PL6 7PY, UK
orders phone: 44 (0) 1752 202301
orders fax: 44 (0) 1752 202333
orders e-mail: enquiries@nbninternational.com

Every effort has been made to contact copyright holders; in the event of an error or omission, please notify the publisher.

The University of Toronto Press acknowledges the financial support for its publishing activities of the Government of Canada through the Canada Book Fund.

Printed in Canada

For the thousands of students I have had the joy of teaching

CONTENTS

List of Figures • x
List of Maps and Table • xiii
List of Genealogies • xiii
Acknowledgements • xiv
A Note to the Reader • xv
A Timeline of the Italian Renaissance • xvii
Popes following the Great Schism • xxi

Chapter One: Defining the Renaissance • 1
 Jacob Burckhardt • 6
 Burckhardt's Legacy • 9

Chapter Two: Before the Renaissance • 17
 The Memory of Rome and the Problem of Sovereignty • 21
 The Rise of Communes and Long-Distance Trade • 25
 Dante and the Late-Medieval Italian World • 27
 Dante's Works • 30

Chapter Three: Social Continuities • 35
 Marriage and the Family • 36
 The Renaissance Italian House • 43
 The Lives of the Less Privileged • 46
 The Role of Religion and the Church • 47

Chapter Four: Petrarch • 55
 Petrarch's Life and Career • 55
 Petrarch and Early Humanism • 61

Chapter Five: Humanism • 69
 The Circle of Salutati • 72
 Humanism and Women • 76
 Humanism and Education • 80
 The Humanist Curriculum • 82
 The Great Humanist Educators • 86
 The University of Padua • 87

Chapter Six: The Republic of Florence • 93
 Florence: Government and Economy • 93
 The Florentine Republic • 98
 The Rise of the Medici • 107

Chapter Seven: Rome and the Papacy • 113
 The Babylonian Captivity • 113
 The Return to Rome and the Great Schism • 115
 The Renaissance Comes to Rome • 117
 The Borgia Papacy • 122
 Julius II: *Papa Terribile* • 124
 Grandeur, Reaction, Catastrophe, and Renewal • 130

Chapter Eight: The Maritime States: Pisa, Genoa, and Venice • 137
 The Alliance of Pisa and Genoa • 137
 Pisa after Meloria • 138
 Genoa after Meloria • 141
 The Creation of Venice • 143
 Venice in the Renaissance • 145
 The Expansion of the Venetian Empire • 149
 The Myth of Venice • 151
 Humanism in Venice • 156
 Christians and Turks: The Struggle for the Mediterranean • 159
 The Voyages of Discovery • 164

Chapter Nine: The Principalities • 169
 Il Regno: The Kingdom of Naples • 171
 Milan • 175
 Mantua • 186
 Ferrara • 192
 Urbino • 198

Chapter Ten: Renaissance Neo-Platonism • 209
 The Transition to a Courtly Society • 209
 The Platonic Tradition • 211
 Platonic Love and the Platonic Academy • 213
 The Circle of Lorenzo the Magnificent • 217

Chapter Eleven: The Age of Crisis • 225
 The Age of the Peace of Lodi, 1453–94 • 225
 The Rise of Savonarola • 230
 The Expulsion of the Medici and the Theocracy of Savonarola, 1494–98 • 232
 Italy after 1494 • 240

Chapter Twelve: Medici Popes and Princes • 247
 The Medici Popes • 247
 The Medici Principate • 255

Chapter Thirteen: The Counsel of Experience in Challenging Times • 265
 Niccolò Machiavelli: *The Prince* • 265
 The *Discourses on Livy* • 273
 Francesco Guicciardini • 276

Chapter Fourteen: Art and Architecture • 285
 Renaissance Art and Sculpture • 286
 Painting in Venice • 298
 The High Renaissance • 303
 Architecture • 307
 The Decorative Arts • 312

Chapter Fifteen: The End of the Renaissance in Italy • 319
 Florence • 320
 Venice • 325
 Rome • 330

 Conclusion • 336
 Bibliography • 339
 Sources • 345
 Index • 348

FIGURES

2.1 Rome, Vatican, Apostolic Palace Sala dell'Incendio. Workshop of Raphael: *Coronation of Charlemagne* (Detail, 1516–17) • 23

2.2 Florence, Cathedral. Domenico di Michelino (1417–91): *The Divine Comedy of Dante Illuminates Florence* • 29

3.1 Florence, Galleria dell'Accademia. Giovanni di Ser Giovanni Scheggia (Lo Scheggia, 1406–86): *Adimari Wedding Cassone* • 38

3.2 Florence, Santa Maria Novella, Tornabuoni Chapel. Domenico Ghirlandaio and Workshop: *The Birth of John the Baptist* • 40

3.3 New York, Metropolitan Museum of Art. Giovanni di Ser Giovanni Scheggia (Lo Scheggia, 1406–86): *The Birthing Tray for Lorenzo de' Medici, 1449* • 42

3.4 Florence, Palazzo Davanzati Exterior • 43

3.5 Florence, Palazzo Davanzati Bedroom • 44

4.1 Minneapolis, Minneapolis Institute of Art. Giorgio Vasari (1511–74): *Six Tuscan Poets* (1544) • 56

4.2 Petrarch's Villa at Arquà Petrarca • 59

5.1 Florence, Santa Croce. Bernardo Rossellino (1409–64): *The Tomb of Leonardo Bruni*, c. 1448 • 75

5.2 Poznan, Poland, Muzeum Narodowe. Sofonisba Anguissola (c. 1532–1625): *Portrait of the Artist's Sisters Playing Chess* (1555) • 79

5.3 Padua, University of Padua, The Great Hall (*Aula Magna*) • 88

5.4 Padua, University of Padua. Anatomy Theatre of Fabrizio Acquapendente (1537–1619) • 89

6.1 The Florentine Florin • 95

6.2 Florence, the Palace of the Wool Guild • 96

6.3 San Gimignano • 102

6.4 Florence, Palazzo della Signoria (Palazzo Vecchio) • 104

7.1 Rome, Vatican Apostolic Palace, *Sala Regia*. Giorgio Vasari (1511–74): *The Return of Pope Gregory XI to Rome* • 116

7.2 Rome, Palazzo Venezia • 119

7.3 Rome, Vatican, Apostolic Palace, Stanza della Segnatura. Raphael Sanzio (1483–1520): *The School of Athens* (1510–11) • 126

7.4 Rome, Vatican, Apostolic Palace, *Stanza della Segnatura*. Raphael Sanzio (1483–1520): *The Disputation over the Holy Sacrament* (1509–10) • 128

7.5 Naples, Museo Nazionale di Capodimonte. Titian (Tiziano Vecellio, d. 1576): *Paul III and His Grandsons* (1546) • 132

8.1 Pisa, *Campo dei Miracoli* (Field of Miracles) • 139

8.2 Venice, Palazzo Ducale (*Doge's Palace*). Francesco Guardi (1712–93): *After His Election, the Doge Thanks the Grand Council in the Grand Council Hall of the Doge's Palace in Venice, Italy* • 146

8.3 Venice, Palazzo Ducale. *Bocca del leone* • 147

8.4 Venice, Palazzo Ducale • 148

8.5 Venice, Accademia. Gentile Bellini (c. 1429–1507): *Procession in the Piazza San Marco* (1496) • 152

8.6 Venice, San Giorgio Maggiore • 158

8.7 Venice, *Fondamenta dei Mori* • 160

8.8 Istanbul, Topkapi Museum. Copy of Gentile Bellini (c. 1429–1507): *Portrait of the Ottoman Sultan, Mohammed, the Conqueror of Istanbul* (1480) • 161

8.9 Museo Correr, Venice. Venetian School: *Battle of Lepanto, 1571* • 162

9.1 Naples, *Castello Nuovo* • 172

9.2 Pavia, *The Certosa* • 178

9.3 Milan, Brera. Anonymous (Master of the Pala Sforzesca): *The Sforza Altarpiece* • 185

9.4 Mantua, Ducal Palace, *Camera degli Sposi* (*Camera Picta*). Andrea Mantegna (c. 1431–1506): *Family of Lodovico Gonzaga* (1474) • 187

9.5 Mantua, Palazzo Tè. Giulio Romano (c. 1499–1546): *Amor and Psyche* • 189

9.6 Ferrara, Palazzo Schifanoia. Francesco del Cossa (c. 1430–c. 1477, with perhaps Ercole Roberti): *April, the Sign of Taurus and the Triumph of Venus* (1469–70) • 196

9.7 Urbino, the Castle of Federigo da Montefeltro • 200

9.8 Urbino, Galleria Nazionale delle Marche. Pedro Berruguete (c. 1450–1504) or Justus van Ghent (c. 1410–c. 1480): *Federigo and His Son, Guidobaldo* • 201

9.9 Paris, Louvre. Raphael Sanzio (1483–1520): *Portrait of Baldassare Castiglione* • 204

10.1 Florence, Uffizi. Sandro Botticelli (c. 1445–1510): *Primavera* (*Spring*) (c. 1482) • 215

10.2 Bourg-en-Bresse, France, Musée de Brou. Luigi Mussini (1813–88): *Lorenzo il magnifico and the Platonic Academy (Célébration néo-platonicienne à la cour de Laurent de Médicis)* (1851) • 216

10.3 Florence: The Villa at Careggi • 218

10.4 Florence, Santa Maria Novella, Tornabuoni Chapel. Domenico Ghirlandaio (1449–94): *The Platonic Academy, 1485–90* • 220

11.1 Florence, Museo di San Marco. Fra Bartolomeo (1472–1517): *Girolamo Savonarola* (c. 1498) • 231

11.2 Florence, Uffizi. Francesco Granacci (1469–1543): *The Entry of Charles VIII of France and His Army into Florence on 17 November 1494* (1518) • 233

11.3 Florence, Museo di San Marco. Anonymous: *The Burning of Savonarola, 23 May 1498* • 239

12.1 Florence, Palazzo della Signoria (Palazzo Vecchio), *Sala di Clemente VII*. Giorgio Vasari (1511–74): *The Siege of Florence, 1529–30* (1558) • 252

12.2 Florence, Uffizi, Tribuna. Agnolo Bronzino (1503–72): *Eleonora of Toledo* (1544) • 257

12.3 Florence, Museo di Firenze com'era (The Museum of Florence "as it used to be"). Giusto Utens (d. 1609): *Palazzo Pitti, with the Boboli Gardens and Belvedere Fortress* (1599) • 260

14.1 Padua, Scrovegni (Arena) Chapel. Giotto (1280–1337): *The Lamentation* (1305) • 287

14.2 Siena, Palazzo Pubblico, Hall of the Nine. Ambrogio Lorenzetti (c. 1290–1348): *Image of Good Government* (1338–39) • 288

14.3 Florence, Santa Maria Novella. Masaccio (1401–28): *The Trinity* (1425) • 291

14.4 Milan, Brera Museum. Piero della Francesca (1415–92): *The Montefeltro (or Brera) Altarpiece* (1474) • 292

14.5 Florence, Uffizi. Sandro Botticelli (1445–1510): *The Uffizi Adoration of the Magi* (c. 1475) • 294

14.6 Florence, Uffizi. Sandro Botticelli (1445–1510): *Pallas and the Centaur* (1482–83) • 296

14.7 Padua. Donatello (c. 1386–1466): *Gattamelata* (1450) • 297

14.8 Venice. Andrea Verrocchio (c. 1435–88): *Bartolommeo Colleoni* • 297

14.9 Venice, Accademia. Vittore Carpaccio (c. 1465–c. 1525): *Miracle of the True Cross* (1494) • 299

14.10 Rome, Museo Borghese. Titian (c. 1488–1576): *Sacred and Profane Love* (c. 1514) • 300

14.11 Windsor, Royal Library. Leonardo da Vinci (1452–1519): Notebooks (c. 1510), Anatomical Drawing • 302

14.12 Rome, Vatican Apostolic Palace, Sistine Chapel (1508–12). Michelangelo Buonarroti (1475–1564) • 304

14.13 Florence, Church of San Lorenzo, New Sacristy (1520–33). Michelangelo Buonarroti (1475–1564) • 305

14.14 Rome, Vatican Apostolic Palace, Room of Heliodorus (1511–14). Raphael Sanzio (1483–1520) • 306

14.15 Florence, Church of Santa Croce, Pazzi Chapel (1430–46). Filippo Brunelleschi (1377–1446) • 308

14.16 Rimini, Tempio Malatestiano (c. 1460). Leon Battista Alberti (1404–72) • 310

14.17 Rome, Forum boarium, Temple of Vesta (more probably Hercules) (first century BC) • 311

14.18 Rome, Tempietto, San Pietro in Montorio (1502). Donato Bramante (1444–1514) • 311

14.19 London, British Museum. Pope Julius II Medal. Cristoforo Foppa Caradosso (1445–1527) • 312

14.20 Florence, Cathedral Baptistery (San Giovanni). Lorenzo Ghiberti (1378–1455): *The Entry into Jerusalem* (1404–24) • 313

14.21 Florence, Cathedral Baptistery (San Giovanni). Lorenzo Ghiberti (1378–1455): *The Sacrifice of Isaac* (1425–52) • 313

14.22 Vienna, Kunsthistorisches Museum. Benvenuto Cellini (1500–71): Salt Cellar (*Saliera*) (1543) • 314

15.1 Florence, Bargello. Donatello (c. 1386–1466): *David* (c. 1430) • 322

15.2 Florence, Bargello. Andrea del Verrocchio (c. 1435–88): *David* (c. 1475) • 322

15.3 Florence, Accademia. Michelangelo Buonarotti (1475–1564): *David* (1504) • 322

15.4 Rome, Pantheon (second century AD) • 327

15.5 Vicenza, Villa Rotonda (Capra) (1567–80). Andrea Palladio (1508–80) • 327

15.6 Vicenza, Teatro Olimpico (1580–85). Andrea Palladio (1508–80) • 329

15.7 Rome, Basilica of St Peter • 332

MAPS

2.1 The Geography of Italy • 18

8.1 Venice and the *Terraferma*, including Dalmatia • 150

9.1 The Major States of the Peninsula (c. 1494) • 170

9.2 Lombardy, including the Duchies of Milan and Mantua • 176

9.3 Emilia-Romagna, including Ferrara • 193

9.4 The Urban Plan of Ferrara • 197

9.5 Le Marche, including Urbino • 199

11.1 States Participating in the Peace of Lodi, 1454 • 228

TABLE

6.1 The Guilds of Florence • 101

GENEALOGIES

9.1 Naples: The House of Aragon • 173

9.2 Milan: The House of Visconti • 177

9.3 Milan: The House of Sforza • 182

9.4 Mantua: The House of Gonzaga • 190

9.5 Ferrara: The House of Este • 194

9.6 Montefeltro Counts and Dukes of Urbino • 203

12.1 The Medici • 250

ACKNOWLEDGEMENTS

THERE ARE A GREAT many people who have contributed to this book and who greatly deserve to be recognized. First, I must acknowledge the thousands of students whom I have taught at the University of Toronto over the past thirty years in the Victoria College Renaissance Studies Program, the Department of History, and the Summer Abroad Program in Siena, Italy. Their enthusiasm, interest, and fascination with the Italian Renaissance have continued to fuel my energy in both teaching and research and sustained an appreciation for Italy and the Renaissance that began when I was an undergraduate. It is to my students, therefore, that this book is dedicated.

I also wish to recognize the contributions of the great many scholars whose work is synthesized in this book. Their deep knowledge and compelling ideas have nourished me as a scholar and teacher and provided the evidence that allowed this book to be written. I apologize for any oversimplification or misunderstanding that may have occurred; any error that this book contains is mine alone.

My editor at the University of Toronto Press, Natalie Fingerhut, has been a constant source of encouragement and insight and indeed was the reason this book exists, as she convinced me some years ago to consider writing a comprehensive text on the Italian Renaissance. This collaboration has also resulted in the migration of my earlier source-book, *The Civilization of the Italian Renaissance*, to the University of Toronto Press as a complement to this text, producing what I hope is a fruitful union of primary sources and narrative history. Also at the Press, Anna Del Col has designed an elegant and attractive cover, and Zack Taylor produced clear and effective maps. Martin Boyne, the copyeditor on this book as well as on my earlier text, proved again to be an assiduous and creative reader, bringing much greater clarity and consistency to my work. My graduate student, Kristina Francescutti, worked long and hard reducing my earlier drafts, many handwritten notes, scribbles, and marginalia into a coherent and organized manuscript. Without her technical skill and patient keyboarding, this project would have taken much longer. To all of these talented colleagues, I and this book owe a great deal.

Finally, as always, my greatest debt is to my wife, Gillian, who read my many drafts and helped impose order on my often centrifugal thoughts. She also undertook the complex task of securing the permissions for the illustrations and indeed took some of the photographs herself. Her contribution to this book has been profound and offers even more evidence of how our shared life's work continues to prosper.

A NOTE TO THE READER

IT HAS BEEN MY pleasure to have taught courses on the Italian Renaissance for more than thirty years. My students have always been an inspiration, and the material continually intrigues, astounds, and delights me. This book is the result of those years in the classroom. My approach to the subject has always been the interdisciplinary, "mosaic" structure that introduces Italy as a complex laboratory of ideas and practices in all areas of human experience. It is this interpenetration of perspectives that has enlivened discussions and introduced students to the rich intensity of Renaissance life. The readings assigned in my courses have largely been primary sources so that students might see the past through the eyes of those who were alive in Italy between about 1350 and 1550. All classes and occupations, all regions and perspectives are discussed as a means to understand how complex were both the explosion of art and culture and the experimentation in social, political, and economic systems.

I want my students to see the Italian Renaissance on its own terms, rather than reading the scholarly debates of the present back into our narrative of the past. Consequently, there will be times in this book when inclusive language is consciously not employed—such as in discussion of the political structures of Florence or Venice or the hierarchy of the Roman Church—because to do so would be anachronistic. Equally, I have refused to hold the past accountable for the concerns of the present. Italians of the Renaissance had their own issues and obsessions; they were not ours, but they were valid and consuming nonetheless. Although we have knowledge of how things turned out, we should not apply this privileged information when assessing the decisions, fears, and ambitions of those who confronted their challenges as best they could.

Jacob Burckhardt's great book of 1860, *The Civilization of the Renaissance in Italy*, provides a general framework for certain parts of my book. This is not because his is the defining text in the field but because he helped design how the Renaissance is still studied: an interdisciplinary, dynamic period in which it is counterproductive to separate out elements for undergraduate study in an almost scholastic manner. The distinctions and sub-distinctions of "The Poor," "Women," "The Church," and so on were not part of the Renaissance Italian worldview. Theirs was a very integrated perspective in which many things contributed to a relatively coherent understanding of their own times. Consequently, I will follow the same model, as my intention is to have students see the past through the experience of Italians who served as witnesses to contemporary events. The past is indeed a different country and one whose history was formed by different ideas and forces. To understand them we must accept that observation; otherwise, we will always be describing the past with the vocabulary of the present.

It is also my expectation that this book will be both useful in courses outside my own discipline and of interest to general readers who want to know more about this most engaging historical moment. My intention has been to construct a book with wide appeal that would attract any reader curious about the Italian Renaissance. The book

is very heavily illustrated, as many readers today need and desire a visual component that elucidates ideas through painting, sculpture, or architecture. All the images have detailed captions so that they can serve as an entry point into the material of the chapter or as informative in themselves. In my many years as a scholar and teacher of the Italian Renaissance, I have come to recognize the signal importance of images as instruments for sparking interest and breaking into the minds of generations long past, far from the experience of our own time.

My hope, then, is that everyone who reads this book will discover or rediscover the excitement of the Italian Renaissance and see how much that period has bequeathed to the present. In celebrating what the eye sees, the Renaissance has shown us how to interpret our world as well; my sincere desire is that the past will come alive once more through knowledge and imagination so that the Italian Renaissance can continue to animate our appreciation of the human condition.

Kenneth Bartlett
Toronto

A TIMELINE OF THE ITALIAN RENAISSANCE

YEAR	EVENT
800	Charlemagne crowned as the first Holy Roman Emperor
1016	Pisa and Genoa together drive the Saracens from Sardinia
1052	Genoa organized as a self-governing commune
1077	Pisa given authority over Corsica
1095	Preaching of the First Crusade by Pope Urban II at Clermont
1137	Pisa shatters its maritime rival, Amalfi
1167	Siena establishes an independent communal government of nobles
1190	Death of Frederick II Barbarossa, under whom division between Guelf and Ghibelline was crystallized
1195	Pisa officially organized as a free, self-governing commune
1204	Europeans in the Fourth Crusade establish the Latin empire at Constantinople
1241	Pisa defeats the Genoese fleet
1260	The Sienese defeat Florence at the Battle of Montaperti
1264	Obizzo d'Este seizes control of Ferrara
1266	Charles of Anjou establishes the French Angevin dynasty in Naples
1282	The Sicilian Vespers: Sicily revolts against the crown of Naples and attaches itself to the royal house of Aragon
1284	Genoa conclusively defeats Pisa at Meloria
1287	Siena institutes a communal government called *The Nine*
1293	Florentine Ordinances of Justice promulgated
1297	Closing of the Great Council in Venice (*Serrata*)
1298	Genoa, under Admiral Doria, defeats the Venetians at sea at Curzola
1309	Pope Clement V takes up residence in Avignon: Beginning of the Babylonian Captivity
1311	The Peace of Constance, a treaty between the Holy Roman Emperor and the Lombard cities
1311	The Visconti establish hereditary control of Milan as *signori*
1315	Council of Ten established in Venice
1327	Emperor Louis IV captures Pisa

YEAR	EVENT
1328	Luigi Gonzaga seizes control of Mantua
1339	Simon Boccanegra elected as first doge of Genoa
1343	Walter of Brienne expelled from Florence; the Monte is established
1345	Bankruptcy of Bardi and Peruzzi banks
1348	The Black Death appears in Italy, killing huge portions of the population
1355	Beheading of Venetian Doge Marin Falier for treason
1355	Fall of *The Nine* in Siena
1371	Revolt of the Sienese woolworkers
1377	The Papacy returns to Rome from Avignon
1378	The Great Schism begins
1378	Ciompi revolt in Florence
1380–81	War of Chioggia: Venice defeats Genoa and begins a policy of expansion onto the mainland.
1382	Joanna I of Anjou dies without heir, resulting in competing French and papal interests in the throne of Naples
1385	Giangaleazzo Visconti consolidates power in Milan
1402	Giangaleazzo Visconti, Duke of Milan, dies, removing the threat to Florence for control of all north-central Italy
1405	Venice conquers Padua
1406	Florence conquers Pisa
1408	Creation of the Bank of St. George in Genoa
1409	Council of Pisa
1412	Galeazzo Maria Visconti murdered
1414	Council of Constance: Pope Martin V elected to end the Great Schism
1420	Martin V officially returns to Rome
1425	*Monte delle doti* (state dower fund) established in Florence
1434	Cosimo de'Medici returns from exile to take control of Florence
1442	Naples falls to an Aragonese siege under Alfonso, King of Aragon and Sicily
1444	Federigo da Montefeltro becomes Duke of Urbino
1447	Francesco Sforza assumes control in Milan
1453	Fall of Constantinople to the Turks

YEAR	EVENT
1454	The Peace of Lodi
1455	Formation of the Italian League by Francesco Sforza and Cosimo de'Medici
1474	Ercole I of Ferrara marries Eleonora of Aragon, daughter of Alfonso the Magnanimous
1475	Fall of Genoese outpost of Caffa to the Turks
1478	Pazzi Conspiracy: Death of Giuliano de'Medici
1479	Dynastic union of Spain under Ferdinand of Aragon and Isabella of Castile
1480	Turks capture the Italian city of Otranto, holding it for a year
1488	Guidobaldo da Montefeltro of Urbino marries Elisabetta Gonzaga of Mantua
1490	Francesco II Gonzaga of Mantua marries Isabella d'Este
1491	Lodovico il Moro of Milan marries Beatrice d'Este
1494	Charles VIII of France invades Italy
1494	The Medici are driven from Florence
1495	Savonarola's constitution proclaimed in Florence
1495	Charles VIII captures Naples
1495	League of Venice created
1496	Restoration of the Aragonese dynasty in Naples under Frederick III
1497–98	Vasco da Gama circumnavigates the Cape of Good Hope
1498	Savonarola is executed
1499	France, under Louis XII, captures Milan
1500	Pandolfo Petrucci consolidates his power as Il Magnifico, tyrant of Siena
1503	Naples under the Spanish Viceroy
1505	The Treaty of Blois establishes Spanish sovereignty in Naples
1509	Florentines starve Pisa into submission
1509	League of Cambrai defeats Venice at Agnadello
1511	Holy League formed by Pope Julius II
1512	The Medici resume power in Florence
1512	France defeats the combined papal/Spanish powers at Ravenna
1515	Francis I of France wins Battle of Marignano
1516	The Treaty of Noyon acknowledges French sovereignty over Milan

YEAR	EVENT
1516	Charles V becomes King of Spain
1517	Martin Luther initiates the Protestant revolts
1517	Turks consolidate control of Persia, Syria, and Egypt
1519	Charles V elected Holy Roman Emperor
1521	Pope Leo X excommunicates Martin Luther
1521	Sultan Suleiman of Turkey captures Belgrade and Rhodes
1522	Spaniards sack Genoa
1524	France captures Milan
1525	Battle of Pavia: Frances I of France imprisoned by the emperor's forces
1527	Sack of Rome
1527	Medici expelled from Florence
1527	Habsburgs driven from Genoa by Andrea Doria
1529	Charles V crowned Holy Roman Emperor at Bologna
1529	Treaty of Cambrai: France renounces all claims to Italian territories
1530	End of the Florentine Republic
1537	Cosimo I de'Medici (later, Grand Duke of Tuscany) assumes control in Florence
1545	Council of Trent called by Paul III
1552	Spaniards expelled from Siena
1555	Siena capitulates to Florence
1559	Treaty of Cateau-Cambrésis, establishing the shape of the European state system under the victorious Habsburgs
1569	Cosimo I elevated as Grand Duke of Tuscany
1570	Ottoman conquest of Cyprus
1571	Christians defeat the Turks at the Battle of Lepanto, halting Turkish expansion in the West

POPES FOLLOWING THE GREAT SCHISM

PAPAL NAME	BAPTISMAL NAME
Martin V (1417–31)	Oddone Colonna
Eugene IV (1431–47)	Gabriello Condulmaro
Nicholas V (1447–55)	Tommaso Parentucelli
Calixtus III (1455–58)	Alfonso Borgia
Pius II (1458–64)	Enea Silvio Piccolomini
Paul II (1464–71)	Pietro Barbo
Sixtus IV (1471–84)	Francesco della Rovere
Innocent VIII (1484–92)	Giovanni Battista Cibò
Alexander VI (1492–1503)	Rodrigo Borgia
Pius III (1503)	Francesco Todeschini Piccolomini
Julius II (1503–13)	Giuliano della Rovere
Leo X (1513–21)	Giovanni de'Medici
Adrian VI (1522–23)	Adrian Dedel
Clement VII (1523–34)	Giulio de'Medici
Paul III (1534–49)	Alessandro Farnese
Julius III (1550–55)	Giammaria Ciocchi del Monte
Marcellus II (1555)	Marcello Cervini
Paul IV (1555–59)	Giovanni Pietro Carafa
Pius IV (1559–65)	Giovanni Angelo Medici
St Pius V (1566–72)	Michele Ghisleri

ONE

DEFINING THE RENAISSANCE

BEFORE WE CAN DISCUSS the Renaissance as an historical phenomenon, we must determine exactly what we mean by the term. We all have certain visions of what defines the Renaissance, but, upon examination, those visions will probably be seen to arise from great figures of the arts: Giotto, Michelangelo, Leonardo, Raphael, Brunelleschi, or Palladio. What, however, do these different figures from different times have in common, besides a conveniently intimate juxtaposition in the same chapter of some general art-history textbook, or a wickedly sensual coffee-table book on the Renaissance? In short, why is something—or someone—*Renaissance* in character; or, more generally, what is the nature of the thing itself—what do we mean by *Renaissance*?

The Renaissance is usually defined as a particular "period." The old theory of periodization was based on an irrational faith in self-contained subdivisions that allowed for the fragmentation of human experience into scaled units. Although no longer fashionable in academic circles, this old concept of historical periods has some validity and some practical usefulness. The Rome of Augustus was obviously a world apart from the Rome of the year AD 700, when cattle grazed among the ruins of the Roman forum and the city had shrunk to a village perched on a malarial swamp. Similarly, the scientific, "progressive" nineteenth century differed from the classical rationalism and order of the eighteenth. Furthermore, periods such as the "Age of Louis XIV" can be accurately and easily determined by two dates (the year of Louis's accession in 1643 to the year of his death in 1715) and, to a lesser degree, by geography: Louis XIV was King of France and, although the effects on other countries should be noted, too, any study of his epoch must be focused on France itself. Historical periods, then, do exist in a very real way.

Furthermore, this periodization is useful: it allows for a careful study in complex ways of a unit of time with particular characteristics, helping to define the essential spirit of that time through identification of its most important and visible elements. For example, referring to the "Age of Faith" or the "Age of Revolution" has validity since it contributes

to an understanding of the period by investigating it in the context of a single, obvious, overwhelming principle as a means of access to a complex historical reality.

That said, historical periods are always difficult to define, largely because each period can be characterized by different things, each of which is in itself a variable: for example, the technology of one age may be behind or in advance of its art or social organization, economics or politics. Consequently, the opposing concept to periodization breaks down the barriers between periods and stresses instead continuity, emphasizing the inexorable progression—not progress—of cause and effect. The significant similarities of all men and women at all times are strongly remarked, and the special claims of individual groups and events discounted. Linkage, continuity, and movement make history valuable and most meaningful according to this theory: for example, the Rome of AD 700 was linked to Augustan Rome through language, institutions, laws, and the "idea" or memory of Rome.

The Renaissance as an historical phenomenon exemplifies these divergent views and opposing methodologies perhaps better than any other significant period. Consider that the concept of the Renaissance is different in English studies compared to Italian. Why? Because in Italy the Renaissance can be seen to begin in the fourteenth century, while in England it had to wait until well into the sixteenth century. So we must accept that the Renaissance is a fluid idea in time and place and therefore not a straightforward category like the Age of Louis XIV.

Despite this debate, Renaissance writers themselves were champions of periodization. They believed that the desire of newly converted Christians to wipe away all vestiges of idolatry and the violent visitations of barbarian invaders led to the destruction of the classical style; and Europe lay in a gloomy half-life until Giotto escaped from the Gothic tomb, as Paolo Giovio, the sixteenth-century bishop and historian, described it, and restored the relationship between art and nature. This belief in the dawning of a new age in art and letters—begun by Giotto in the former discipline and Dante or Petrarch in the latter—found its ultimate statement and development in the celebrated *Lives of the Artists* by Giorgio Vasari (1511–74), written in the middle of the sixteenth century. It was Vasari who popularized the idea of rebirth (*rinascita*) and most vilified the Gothic style.

If the Renaissance is to be defined as an historical period, when did it really begin and end? Where did it begin and why? Who invented it, if it is an invention, and why? What circumstances characterize it and distinguish it from other historical periods? How did it manifest itself in Italy, and how did it reflect its core principles in different parts of that still-fragmented peninsula over time?

To a large extent, that is what this book is about, and that is what we will be discussing. There are some points that will help us to begin and also that will help explicate the shape of the course of our investigation of Renaissance Italy. First, we must begin in the Renaissance itself because the Renaissance was, in many ways, the first self-conscious creation in historiography. By this I mean that writers in Italy, beginning in the fourteenth century, defined themselves and their world as something new, something special, something dramatically different from what preceded them. Indeed, it was the Renaissance that created the idea of the Middle Ages, that is, a period of decline between the high cultures

of classical antiquity and fourteenth- and fifteenth-century Italy. This medieval period was barbarous, as exemplified by its art, which was known as "Gothic"—after the Goths who invaded the late Roman Empire—savage and brutal and lacking all grace.

To illustrate this self-conscious recognition of changing times, let us rehearse some early Italian definitions of this belief. First, from Giovanni Boccaccio's biography of the poet Dante, written in the early 1350s:

> This was the Dante who was first to open the way for the return of the Muses, banished from Italy. 'Twas he that revealed the glory of the Florentine idiom. 'Twas he that brought under the rule of due numbers every beauty of the vernacular speech. 'Twas he who may be truly said to have brought back dead poesy to life.[1]

In his *Treatise on the Civil Life,* written c. 1435, Matteo Palmieri developed a similar theme:

> Thus the noble achievements of our far-off ancestors (the men of ancient Rome) had been forgotten, and had become impossible to modern men. Where was the painter's art till Giotto tardily restored it? A caricature of the art of human delineation! Sculpture and architecture, for long years sunk to the merest travesty of art, are only today in process of rescue from obscurity; only now are they being brought to a new pitch of perfection by men of genius and erudition. Of letters and liberal studies at large it is best to be silent altogether. For these, the real guides to distinction in all the arts, the solid foundation of all civilization, have been lost to mankind for 800 years and more. It is but in our own day that men dare boast that they see the dawn of better things. For example, we owe it to our Leonardo Bruni that Latin, so long a by-word for its uncouthness, has begun to shine forth in its ancient purity, its beauty, its majestic rhythm. Now, indeed, may every thoughtful spirit thank God that it has been permitted to him to be born in this new age, so full of hope and promise, which already rejoices in a greater array of nobly-gifted souls than the world has seen in the thousand years that have preceded it. If only our distressed land enjoys assured peace, most certainly shall we garner the fruits of the seed now being sown. Then shall we see these errors, deep-seated and long reputed, which have perverted every branch of knowledge, surely rooted out. For the books which an age of darkness puts forth into the world are themselves—how otherwise?—dark and obscure, and in their turn darken all learning by their subtleties and confusion.... But I see the day coming when all philosophy and wisdom and all arts shall be drunk from the pure fountain head—the great intelligences of old....[2]

Finally, there are the words of Giorgio Vasari, from his *Lives of the Artists*, written in 1550:

> As the men of the age were not accustomed to see any excellence or greater perfection than the things thus produced, they greatly admired them, and considered them to be the type of perfection, barbarous as they were. Yet some rising spirits, aided

by some quality in the air of certain places, so far purged themselves of this crude style that in 1250 Heaven took compassion on the fine minds that the Tuscan soil was producing every day, and directed them to the original forms. For although the preceding generations had before them the remains of arches, colossi, statues, pillars, or carved stone columns which were left after the plunder, ruin, and fire which Rome had passed through, yet they could never make use of them or derive any profit from them until the period named. Up to the present, I have discoursed upon the origin of sculpture and painting, perhaps more at length than was necessary at this stage. I have done so, not so much because I have been carried away by my love for the arts, as because I wish to be of service to the artists of our own day, by showing them how a small beginning leads to the highest elevation, and how from so noble a situation it is possible to fall to utterest ruin, and consequently, how these arts resemble nature as shown in our human bodies; and how we more easily recognize the progress of the renaissance of the arts, and the perfection to which they have attained in our own time.[3]

Obviously, then, writers and thinkers in the Renaissance itself saw themselves as special, different, and having more in common with the style and content of the classical age of Rome than with the intervening "Middle Age," a period that to them was a deep valley between two heights.

Also from these fourteenth-, fifteenth-, and sixteenth-century examples, certain elements emerge that we still identify today with the popular idea of the Renaissance: the return to a classical style of Latin prose, the growing importance of the vernacular, and the return of naturalism in art. All of these elements we shall investigate at length in their contexts; but for now it is important to emphasize that these characteristics were recognized by observers in the Renaissance itself and were not imported by retrospective historians seeking to define a portion of the past. Thus, to repeat: the Renaissance defined itself and identified its own contribution by distinguishing itself from the past. In this way, we can see the development of the modern discipline of history, a Renaissance art. Unless the past is seen as something distinct and remote, the perspective to study it with objectivity is obscured. The Middle Ages saw the past as an unbroken continuum beginning with the Creation, because the purpose of its study was to trace and understand as far as possible the working out of God's plan for mankind. The great moments were theological: the Creation, the events of the Bible, the Incarnation, the establishment of a Holy Roman Empire, the spread of the Faith. The world was theocentric (God-centered), not anthropocentric (man-centered); and man was never in control of his world, because human causality always yielded to the divine.

Also, from this attitude to the past, the scholars of the Renaissance who sought to transcend the period of the Middle Ages and return as much as possible to the world of classical antiquity invented the modern disciplines of archaeology, numismatics, philology, and textual editing: they wanted to know what the past was really like before the Middle Ages. The learning of the classical world had to be recovered, and consequently scholars of

the Renaissance—in order to define themselves more exactly in the vocabulary of antiquity—developed the tools to do it.

The next question is, of course, why the sensitive and learned scholars and statesmen of fourteenth- and fifteenth-century Italy believed the Middle Ages to be barbarous and unsympathetic: why was there a need to return to classical antiquity? Again, much of the first part of this book will discuss this issue because the concept of self-definition is so central to an appreciation of the Renaissance in all its manifestations, including those psychological and abstract elements, like self-confidence, ideals of beauty and art, styles of architecture, modes of learning and education, and much more. But, as a narrative hook, let me say that Italians of the fourteenth, fifteenth, and early sixteenth centuries believed that they had much more in common with the civilization of the ancient world than with the period immediately preceding their own, the Middle Ages.

This can be well represented in a study of Florence. The city exemplified so many Renaissance values and structures that it is often called, somewhat romantically, the cradle of the Italian Renaissance. Florence was a republican city-state ruled by merchant patricians dependent on long-distance trade, manufacturing, and banking for its wealth and power. Obviously, Rome in the age of Marcus Tullius Cicero (106–43 BC) had much more in common with such a place ruled by such men than with the aristocratic, agrarian, feudal subsistence world of the earlier Middle Ages. When the rulers of Florence needed a model, an ideology on which to build their lives and their state, the ancient world provided one that was ready-made—accessible, understandable, sympathetic, relevant, and self-supportive, especially since those fourteenth-century Italians were also able to identify themselves clearly as the true heirs of the greatness of Rome, which they sought to re-animate. To reiterate, then, the Renaissance in Italy was a self-conscious age eager to define itself based on principles borrowed and re-applied from the ancient world.

Thus, by 1550, the traditional view of the Renaissance as a time distinct from—indeed opposed to—the style and fabric of the preceding age, or Middle Ages, was well established and canonized by the most celebrated writers and thinkers of fourteenth-, fifteenth-, and sixteenth-century Italy. The Italian Renaissance was therefore a self-conscious age, aware of itself, interested in its own definitions, and determined to re-make the world on its own terms, according to the principles generally accepted as superior: that is, the cultural model of ancient Greece and Rome that the urban, cosmopolitan, often republican scholars and statesmen of the Italian communes thought much more relevant to their own experiences and tastes than the rural, feudal, usually monarchical values of Medieval Europe.

This view survived the Scientific Revolution and the Age of Reason. For example, in the eighteenth century, Voltaire (François-Marie Arouet de Voltaire, 1694–1778) developed Vasari's attacks on religion and praised the Renaissance as a great moment in human happiness in which freedom and human values challenged an obscurantist church and aristocratic privilege. He, too, idealized the glory that was Greece and Rome and detested the obfuscation caused by barbarians and religious disputes, as he called them. Edward Gibbon (1737–94), the great eighteenth-century historian of the decline and fall of the

Roman Empire, also echoed these themes, infinitely preferring the ancient to the medieval, also seeing Christianity as the lubricant in the slide of western Europe into darkness and ignorance, at least as eighteenth-century rationalists defined it.

The nineteenth century saw a return to a worship of the Middle Ages and the Gothic in the Romantic movement. "Gothic" novels and Gothic-revival buildings and style became very fashionable from the end of the eighteenth until the last decades of the nineteenth century. (This was the world of Sir Walter Scott, Augustus Welby Pugin, and William Beckford.) The Renaissance declined in aesthetic opinion, with Prince Albert purchasing Tuscan *trecento* primitives, avoiding the high art of the later painters; Pre-Raphaelites celebrating the style of an earlier time; and John Ruskin praising the medieval at the expense of the subsequent age.

Nevertheless, certain ideas remained strong, which were defined as "modern" in the progressive, "scientific" Victorian manner, principles that were applied not to true discussions of the past but rather to the contemporary disputes of the age of liberalism and "progress." Concepts such as individuality, secularism, free trade, republicanism, and divergent views of high culture all made their appearance in the struggle between cultural and social conservatives and liberal progressives among the European intellectual elites. Indeed, it was a French liberal, anti-clerical historian who reinforced these "modern" ideals that he saw evident in the civilization of the Renaissance in his monumental 1855 *History of France*. It is because of Jules Michelet (1798–1874) that the French word *Renaissance* is used, rather than the Italian *Rinascita* of Vasari.

JACOB BURCKHARDT

When we think of the Renaissance, we have certain images and ideas in mind, ideas determined by over a century of scholarship, a tradition largely exemplified by one man—Jacob Burckhardt (1818–97). Burckhardt wrote a book, published in 1860, called the *Civilization of the Renaissance in Italy*. It was not a history, but one of the greatest and one of the first of a whole new discipline of studies of the past, an original methodology that synthesized many aspects of the intellectual, social, and cultural elements of a society into a singular, unified vision to create a study of a mentality, a point of view that one identifies immediately as "Renaissance." The German word for this discipline is *Kulturgeschichte*; the English is *cultural history*. Seldom can any historical movement be traced to so significant a single source as can the Renaissance. The relationship between Burckhardt's *The Civilization of the Renaissance in Italy* (*Die Kultur der Renaissance in Italien*) and the historiography of what we now call the Renaissance is so profound that most studies of the period for the next century consisted of footnotes to Burckhardt. What is so remarkable about the great historian is not his discovery of new terms or new ideas, but his totally original and convincing manner of synthesizing material that had been known and perceived for about five centuries to create an integrated vision of a particular "Renaissance" point of view, an analysis

of the underlying principles of the age and a composite of a complex civilization. It was Burckhardt who gave us our conception of the Renaissance.

Jacob Burckhardt himself was an interesting man and one whose affinity for the Renaissance was, like the period he studied, born of a desire to return to what he believed to be a more sympathetic age, feeling, as he did, somewhat estranged from the industrial, bourgeois society of mid-nineteenth-century Europe. Burckhardt was born in Basel, Switzerland, in 1818 and descended from a wealthy and highly cultivated Protestant patrician family. Despite his studies in Berlin in the 1830s, when Romanticism was the ideology of the student elite, Burckhardt rejected this unfocused perspective in favor of a more disciplined classicism, an attitude strongly reinforced by visits to Italy. His books, such as *The Age of Constantine the Great* (1853), which records how the high culture of ancient Rome slid into something less compelling, and his *Cicerone* (1855), which is in effect a guidebook to Italy and its art, served as background work for his great "essay" of 1860, *The Civilization of the Renaissance in Italy*. This work was initially planned as an introduction to a monumental history of Italian art, but Burckhardt never completed the work, retreating from his high ambitions and aesthetic ideals as a consequence of the events of the Paris Commune and the militarism that had led to the Franco-Prussian War (1870–71).

Burckhardt was in truth an aesthete who saw the Italian Renaissance as the antithesis of the industrial, grasping, and increasingly vulgar age he believed was emerging in Europe. Like the early Renaissance humanist Petrarch (1304–74), he thought that he had been born outside his time: he was an art historian and connoisseur and consequently saw the world very much from the point of view of art and culture. Just as important, he arranged his book topically so that he was looking at the Renaissance not as a developing period of time unfolding chronologically, but as a series of different facets of the same experience in order to discover the mentality of the age. This is still the way in which the Renaissance is usually studied today, and we are all in many ways still Burckhardtians. Ideas such as the recovery of antiquity, the dignity of man, the state as a work of art, unbridled egoism, and naturalism all animate his book, not because he imposed this vision on the past but, as we have already seen, because these were the elements that observers in the Renaissance itself saw as important. In so doing, he added another dimension to political history, then dominant academically, because he emphasized the importance of what was willed, thought, and desired as well as what was actually done. The result was thus not a reference book of dates and events, not even a history—Burckhardt called it an essay, reflecting his attempt to achieve something new and different.

We must therefore spend some time on Burckhardt because the ideas and methodology he developed are still the basic assumptions of Renaissance studies. His book is divided into six parts, each viewing the civilization of Italy from the beginning of the fourteenth century to the early sixteenth century from different points of view. Part I gives a general political background, a summary that is highly simplified in the sense that it reduces the peculiarity of the Italian scene to the conflict between emperors and popes. In it, though, is the idea of the "state as a work of art," an elaboration of the idea that the state is the conscious creation of human beings and designed to achieve certain clear goals. As a result,

states and individuals were freed from the traditional restraints assumed to exist if states were the creation of God. It is because of this that the illegitimate despotisms of the *signori* play so important a role in Burckhardt's thesis: they were the creation of strong leaders, great, egotistical individuals who grasped power for themselves and did what they pleased.

Part II, "The Development of the Individual," develops the most important single idea in Burkhardt's book. In it he argues that a new kind of individual came about because the new social and political organizations required more personal responsibility, the result of which was the cult of the *virtuoso*, a man of *virtù* (not in the modern sense of "virtue" but, rather, of "dynamic resourcefulness" or "prowess") able to develop his potential to the fullest in all areas of human ambition and able to overcome any external restraints. Part III is "The Revival of Antiquity." Burckhardt contends, significantly, that the rebirth of classical studies was a *result*—not a cause—of the Renaissance mindset. In this chapter, Burckhardt also introduces the important figures of the humanists, a class with certain characteristics central to his argument: secularism and individualism. Like the *condottiere* (mercenary) princes he so admired, Burckhardt identifies the rising group of humanist practitioners as heroic individuals. Part IV, "The Discovery of the World of Man," illustrates how these principles operated in Renaissance Italy. He introduces the notions of the rediscovery of natural beauty and naturalism in art, the growing interest in exploration, and the primary place of man and human values in the literature, art, and thought of the age.

Part V, "Society and Festivals," places these heroic individuals in a social context, emphasizing, again significantly, the intermingling of classes in Italian towns and the importance of individual qualities rather than status based on birth alone. Part VI, "Morality and Religion," rehearses the familiar, accepted opinions on the personalities of the age. Unbridled egoism and passion had deplorable results, such as a decline in Christianity; and the lack of moral restraints eventually caused an ethical crisis for a sixteenth-century Italy where "vice" had become a manifestation of excessive individualism. However, by Part VI, Burckhardt—in his conflicted way, since he could not escape his Swiss Calvinism—comes almost to resent his Renaissance heroes who escaped this restrictive moral conditioning. Nevertheless, he still acknowledges that this "amorality" was an important precondition for the modern world.

Individualism and modernity: these two themes constantly arise in Burckhardt's essay, and, indeed, his argument is often blurred by his obsessive return to these two ideas, reducing overly complex concepts to these simple denominators. Also, there is little sense of historical change. Burckhardt's vision of Renaissance Italy is just as anachronistic as those Renaissance paintings that show biblical scenes populated by contemporary figures with a wide and curious mixture of costume and setting. To illustrate his argument, Burckhardt draws examples from all Italy over a period of two hundred years, and clearly the results are often simply wrong. And, of course, there are unavoidable lacunae in his analysis, ideas that were not important in 1860, such as economics and the more sophisticated structures of social history. Still, what is critical is that Burckhardt established the intellectual and methodological structure that still to a large extent determines our approach to the civilization of the Renaissance in Italy.

Burckhardt had no worthy successors, except for John Addington Symonds (1840–93), whose huge *The Renaissance in Italy* appeared in seven volumes between 1875 and 1886 and made the Italian Renaissance and its literature generally available to Victorian English readers. Like Burckhardt, Symonds was not an historian, but a man of letters. He used only secondary sources and literary works and engaged in unbalanced judgments: for example, unlike his contemporary John Ruskin, he knew nothing of and disliked the Middle Ages. His book is also characterized by his English liberal belief in progress and political liberty, evidence of which he searched for everywhere, whether it was there or not. Clearly, Symonds was heavily influenced by Burckhardt (as well as by Voltaire and Michelet) in both content and organization. Most significantly, like Burckhardt he devised a "cultural history," not a political, chronological narrative of events.

It is only with the career and scholarship of Hans Baron (1900–88) that the historiography of the Renaissance would find a scholar whose contributions merit comparison with Burckhardt's. Baron's attention was directed toward a complex analysis of the relationship between humanism and civic life in Florence. In a career that began in Germany in the 1920s and ended only a little more than a year before his death in the United States, Baron's many publications offered brilliant insights into the mentality of Renaissance Florence, reflecting a lifetime of study that found its conclusion in his *The Crisis of the Early Italian Renaissance* (1955). In this seminal book, Baron argues that the war between Florence and Giangaleazzo Visconti, Duke of Milan, which ended in 1402 with Visconti's death, created the ideal of civic humanism by focusing humanist attention on Florence's particular republican freedom, seeing the war with Milan as the struggle between republican liberty and princely despotism.

Burckhardt, then, during the century following the publication of his book, had many continuators and disciples, the most important of whom were those, like Hans Baron, who identified the central role of humanism in the creation of the Renaissance mentality. Humanism will be discussed in all of its manifestations in subsequent chapters, but for our purposes in this brief introduction, let us define it as both the method of teaching and studying classical texts so as to understand their essential meaning, and the application of the lessons learned from this study to a world ruled by leisured, wealthy laymen whose access to power was as much through their talents and accomplishments as through their births.

The connection between humanism and the definition of the Renaissance is critical. In part this is because the Middle Ages were not as dark as fourteenth- and fifteenth-century Italians thought. Also an historical period like the Renaissance that is not bound by time or geography must be reducible to some common variables; otherwise, discussion is pointless. The great contributions made in this area were offered by later scholars writing in the middle of the twentieth century: an art historian, Erwin Panofsky (1892–1968; *Renaissance and Renascences in Western Art*, 1960), and an intellectual historian, Federico Chabod (1901–60). What Panofsky and Chabod saw as the critical element in defining the Renaissance

was what was called the "energizing myth," that is, a belief—whether true or false—held by Italians of the fourteenth and fifteenth centuries that they were indeed different and separated from the values and styles of the Middle Ages. And, although the styles and themes employed in Renaissance art and literature were not new but were borrowed from antiquity and used during the Middle Ages—often skillfully—the Renaissance used these ideas differently. What is significant is that more than the form (classical genres, architectural styles, for example) was reproduced: the vital, dynamic spirit behind the form was recaptured. This was that "energizing myth," a self-perpetuating, self-defining belief that Italians of the late fourteenth and fifteenth centuries were practicing skills or creating art and ideas that brought them close to the classical past and provided a guide to life and letters, education and politics, morals and ethics, art and learning. These ideals could be shaped into a functional code of behavior, a structure of belief—an ideology—to animate a ruling elite: the well-educated, independent, urban, mercantile, bourgeois inhabitants of the city-state republics, or the courtiers and clients of the petty despotisms of the Italian peninsula.

This identification of humanism as an "energizing myth" or ideology is critical because it answers many questions and allows us to view the Renaissance as something other than a block of time. It is a vital concept that can be traced through republics such as Florence—where it had special importance and application—to small warrior principalities such as Urbino, to the majesty of theocratic papal Rome, and ultimately to the great feudal dynastic monarchies of northern Europe, whose traditions were different but whose ruling elite fell prey to a modified version of this "energizing myth" because such an ideology also met so many of their social, cultural, educational, and psychological needs.

What I have just presented is a definition of the Renaissance in the tradition of cultural history and through the legacy of Burckhardt. In the half-century after Baron, Panofsky, and Chabod developed their theories, other scholars, each with his or her own disciplinary, ideological, or geographical perspective, added much to this outline and often challenged the model of studying the Renaissance as a cultural or intellectual phenomenon, identifying the deficiencies in the cultural historians' methods and claiming that their perspective was too "elitist," as it could only reflect the experience of a small number of Italians during those years. There is much to credit in this elaboration of the traditional approach. Burckhardt was a scholar of the mid-nineteenth century who, as noted, had no interest in such topics as economic history, and his definition of society was indeed largely an analysis of the elite. Recent studies in social history have expanded Burckhardt's vision greatly by looking at the lives of Italians of all classes and conditions, including women and the poor. Also, economic history has been shown to be hugely important in illustrating how the city states of the peninsula produced the wealth that permitted the efflorescence of culture and encouraged social mobility. There has even been a challenge to the very idea of a Renaissance by medievalists who argue cogently that the break with the past identified by fourteenth- and fifteenth-century Italians was greatly overstated, that there was in fact a continuum in European life that should not be cut into sealed sections. They argue for continuity in institutions and ideas, and their contribution reinforces the

observation that while some members of the elite attempted to recover the pagan Roman world, the vast majority of the population continued to follow the examples and precepts of St Francis of Assisi and saw saints and Arthurian or Carolingian heroes as the equal or superior to even justified pagans such as Cicero or Seneca.

This so-called Revolt of the Medievalists added another layer of academic complexity to the study of the Renaissance in Italy and reinforced the principle of continuity or gradual change over time as opposed to sharp divisions between historical periods. The most important early book devoted to the restoration of the value of the Middle Ages vis-à-vis the Renaissance was C.H. Haskins's (1870–1937) *The Renaissance of the 12th Century* (1927). Drawing on a study of Latin literature and learning in fields such as law and philosophy, Haskins shows the immense strides taken during the "barbarous" and Gothic twelfth century, advances as important in their own ways as those attributed by Burckhardt to the Renaissance. Equally, Haskins and other scholars question the novelty of the "revival" of classical culture in fourteenth-century Italy and give powerful illustrations, for example, of the continuation of the "idea of Rome." Furthermore, although Haskins wrote a book on medieval science as well, it was left to two American scholars, Lynn Thorndike (1882–1965) and George Sarton (1884–1956), to state—at great length—during the late 1920s and 1930s that the Renaissance, far from being an advancement in human civilization, was a retrogression, at least in the field of scientific endeavor: scholars in the Middle Ages were much more interested in discovering new knowledge about the natural world than those in the Renaissance, whose desire was often to reiterate only what the ancients had recorded.

Roman Catholic medievalists, such as Jacques Maritain (1882–1973) and Etienne Gilson (1884–1978), argued not only that many of the important aspects discussed by Burckhardt were present during the Middle Ages, but also that these aspects were more vital, because ancient authors such as Aristotle were "living" sources in medieval learning, that is, growing and changing to fit a dynamic society rather than becoming ossified as sacred texts. Similarly, other modern historians have filled the gaps in Burckhardt's study and revealed that some of the subjects he avoided undermined his thesis. Roberto Lopez (1910–86), for example, was an economic historian who, like many of his profession, saw the Renaissance as a decline from the Middle Ages. The great spirit of mercantile and industrial entrepreneurial activity that had made Florence one of the largest and richest cities in Europe declined dramatically as merchant patricians like the Medici put their capital into consumption rather than investment and wasted their efforts on humanism, art, and display when they should have been making money.

It is in the present time that these pro- and anti-Burckhardt traditions can co-exist in some humane interdependence. Burckhardtians such as Hans Baron can share publications with anti-Burckhardtians such as Roberto Lopez because the old canonization of Burckhardt has evaporated under its critics. Although his method of cultural history and interdisciplinary studies remains indispensable to the Renaissance historian, his insistence on the novel elements of modernity and individualism victorious over medievalism and corporatism has been abandoned. The Renaissance is no longer viewed as a self-contained, insulated phenomenon, a closed period. Rather, it is now open at both ends

and constitutes not a sharp peak in human activity but instead a gentle slope. In part, this more balanced opinion is the result of studies in other areas so stringently ignored by the orthodox Burckhardtians, such as social and economic history. The great wealth of material and the enormous number of major studies that have appeared since World War II illustrate how much Burckhardt missed by not exploring the incredible riches of the state archives of Florence, Venice, and Rome—let alone the smaller but richly documented cities—where the publication of records, such as taxation, notarial, and census documents, has become a major growth industry. Scholars since the 1950s have added immeasurably to our knowledge of the Renaissance simply by making the records of that civilization available, illustrating how society, the government, the economy, and the Church actually worked and how the people lived—all of them, not just the great.

All of these elaborations and subsequent studies have filled in the many gaps left by those intellectual and cultural historians who still to some degree see the Renaissance in terms of the model first proposed by Jacob Burckhardt. We are greatly indebted to their work, and our understanding of the period is much richer indeed. However, I am myself a cultural historian, so my approach in this book will be very much in the established tradition of the Burckhardtians. Therefore, when I am asked what the Renaissance was, I answer that it was an historical force characterized by certain principles to which the educated elite conformed and which consequently transformed their entire mentality into a world-view heavily dependent on classical models and values, filtered through the experience of Italians of the fourteenth, fifteenth, and sixteenth centuries and ultimately grafted to a wide variety of structures that consequently took on identifiable aspects immediately recognizable as "Renaissance." Despite the differences of time, space, and experience, then, Michelangelo would have had much to say to Petrarch, and both would have understood the values of Alberti, because they all conformed to a similar perspective, animated by that "energizing myth" and dependent on the guidance of the ancients.

Therefore, as both a summary of what has been said and a preface to what is to come, we might ask the following: what have historians over the past five centuries recognized as peculiarly Renaissance characteristics, elements by which this rather abstract period might be identified? First, there was a change in the medieval structures of society that allowed for more secular, individual, and dynamic action. Second, the revival of interest in the classical worlds of Greece and Rome motivated artists, sculptors, architects, and writers to copy the styles of the antique past in their own work. Third, the centers of power, wealth, and culture were concentrated in towns, cultivated by rich laymen who had little interest in the feudal, agrarian immediate past of the Middle Ages but who saw great relevance in the examples of the classical age, especially republican and imperial Rome: like their own city-states, Rome was urbanized, cosmopolitan, educated, secular, and either republican in government or ruled by wise princes, like the good Roman emperors. Finally, these cultivated laymen, imbued with classical ideals, also represented the political classes of the Renaissance. In republics such as Florence or Venice, they were the merchant patricians who actively ruled; in principalities such as Mantua or Milan, or even in papal Rome,

they were the secretaries, the courtiers, the high civil servants. Therefore, the cultural and intellectual attitudes and values of these men—these humanists—had concrete political, social, and economic effects because they had the power to influence policy.

As Burckhardt suggested, the state was a work of art because its fabric might be molded to institutionalize the principles animating these men. Consequently, when the old psychological, economic, and social props of extended kin structure (*consorteria*), class, medieval models of piety, and other, older structures began to deteriorate under the restless power of "unbridled egoism," new institutions and principles might be erected in their place through the manipulation of the authority of the state, represented by the collective wills of the engaged political classes in republics, or through good counsel to a wise prince or pope in monarchies. There was indeed continuity, but at the same time new forces were at work changing the cultural and intellectual—and hence the political, social, and economic—structures of their world.

Italians of the fifteenth century saw themselves as special, gifted, fortunate, and almost omnipotent. One of the greatest of the universal geniuses, Leon Battista Alberti, remarked that man can do anything if he only has the will; or, in the mystical rhetoric of Giovanni Pico della Mirandola, "O highest and most marvelous felicity of man! To him it is granted to have whatever he chooses, to be whatever he wills!"[4] How men—and some women—decided to activate this new self-confidence and belief in their own authority varied according to the time, place, and circumstances of the individual's experience. However, regardless of status, whether bourgeois politician in republican Florence, papal secretary in Rome, or mercenary captain in Milan, what mattered most was *virtù*—a central element in Machiavelli's thought, as we shall see: that is, resourcefulness or prowess, an ability to command oneself and others. Here, obviously, is a reflection of Burckhardt's "unbridled egoism" or evidence of a renewed sense of independent human agency on earth. There is no other way to describe defining figures such as Cesare Borgia, Pope Julius II, Francesco Sforza, several different Medici, Michelangelo, Leonardo, or Isabella d'Este. The context of these shared beliefs within fourteenth-, fifteenth-, and sixteenth-century Italy depended on the environment in which such individuals lived. Burckhardt recognized this when he stressed the role of the illegitimate, ever-warring, contentious, factious character of the principalities of Italy, and much the same can be said for the many unstable republics of the Renaissance. However, it must be stressed that the very proliferation of states and constitutions abetted this principle of rugged individualism, as well as cultural and constitutional experimentation, because the large number of states were constantly competing with one another, if not in war then in grandeur and reputation, which can be seen as war by other means. The lack of unity and the very instability and fractiousness of the Italian states must be seen as elements in the development and the diffusion of the dynamic energy of the Renaissance. So it is to the fragmentation of the peninsula that we must first turn.

NOTES

1 Giovanni Boccaccio, *The Life of Dante*, in *The Early Lives of Dante*, trans. P. Wicksteed (London: A. Moring, 1904), 11.

2 Matteo Palmieri, *On Civil Life*, trans. W.H. Woodward, in *Studies in Education during the Age of the Renaissance, 1400–1600* (Cambridge: Cambridge University Press, 1906), pp. 66–68.

3 Giorgio Vasari, *Lives of the Painters, Sculptors, and Architects*, trans. A.B. Hinds, Everyman's Library Edition (London: Dent, 1963), vol. I, pp. 17–19.

4 Giovanni Pico della Mirandola, *Oration on the Dignity of Man*, in K. Bartlett, *The Civilization of the Italian Renaissance: A Sourcebook*, 2nd ed. (Toronto: University of Toronto Press, 2011), 106.

FURTHER READING

Baron, Hans. *The Crisis of the Early Italian Renaissance*. Princeton, NJ: Princeton University Press, 1966.

Bartlett, Kenneth R. *The Civilization of the Italian Renaissance. A Sourcebook*. 2nd ed. Toronto: University of Toronto Press, 2011.

Burckhardt, Jacob. *The Civilization of the Renaissance in Italy: Volume I: The State as a Work of Art, The Development of the Individual, The Revival of Antiquity*.

———. *The Civilization of the Renaissance in Italy. Volume II: The Discovery of the World and of Man, Society and Festivals, Morality and Religion*. New York: Harper & Row Publishers, 1975.

Chabod, Federico. *Machiavelli and the Renaissance*. New York: Harper Torchbooks, 1958.

Cochrane, Eric. *Historians and Historiography in the Italian Renaissance*. Chicago: The University of Chicago Press, 1981.

Kirkpatrick, Robin. *The European Renaissance 1400–1600*. New York: Longman, 2002.

Najemy, John M., ed. *The Short Oxford History of Italy: Italy in the Age of the Renaissance*. Oxford: Oxford University Press, 2004.

TWO

BEFORE THE RENAISSANCE

THE ITALY OF THE Renaissance was merely a geographical and historical term. It was in no way a united nation, but rather one that had suffered political fragmentation from the fall of the Roman Empire in the fifth century AD. Therefore, to understand the nature of the territory that we now identify as Italy we need to look at the development of the peninsula before the Renaissance.

Geographically, Italy is a peninsula surrounded by water on three sides and by the Alps on the fourth. Although this disposition affords some considerable protection and insulation from outside invasion by land, the peninsula is also only very short distances from what were, at various times, other alien, powerful, and often hostile cultures. For example, the island of Sicily is less than one hundred miles of easy sailing from North Africa, with its competing Muslim culture. The cape of Otranto is only fifty miles from Albania, during the Renaissance a Turkish possession inhabited by fierce pirates who preyed on Christian shipping from the peninsula.

Italy's internal geography divides it into several "natural" regions, that is, territories with defensible borders and often containing similar peoples. The extreme north climbs into the Alps, producing a hardy Alpine nation of self-reliant, proud, and rather xenophobic mountaineers. However, unlike some other regions, the extreme north is ethnically mixed, with a large number of Frenchmen in Savoy, for example, a principality that in the Renaissance period included the southern coast of what is now France, a littoral acquired by France only in the middle of the nineteenth century (Nizza became the modern city of Nice). Equally, the northwestern fringes of the Venetian mainland territories contained several German-speaking lands taken from the Holy Roman Empire by Venice during its mainland expansion. In the extreme south there were still speakers of Greek, survivors of the ancient Greek colonies that constituted Magna Graecia, and even significant numbers of people of North African descent, a reminder of the Muslim domination of Sicily for a period of almost three centuries. Nevertheless, generally, most of the Italian peninsula was home to people who spoke one dialect of Italian or another.

If the Alps formed a northern barrier against invasion, the Apennines served as an internal division that ran the length of the peninsula from the Lombard plain to Sicily, cutting the boot down the center and consequently driving settlements to the coasts and river mouths and providing a measure of security for small, independent, usually impoverished states within its rocky fastness. The Apennines complicated communications on the peninsula, and control of the passes through the mountains constituted military goals for ambitious cities wishing to take advantage of what trade there was, especially as internal commerce and long-distance trade increased.

The great Lombard plain, however, is a natural kingdom in every way, dominated by the city of Milan, once a capital of the late Roman Empire, the ancient seat of St. Ambrose, and later the capital of the powerful dynasties of the Visconti and Sforza. The plain is extremely fertile and always provided a superfluity of grain and livestock for the Milanese state, a simple fact that permitted the Duchy of Milan to remain strong and ambitious, despite suffering numerous military defeats as well as incompetent rulers. Also, this blessing of site ensured the integrity of the Duchy of Milan in the face of changes in dynasty, foreign invasion, and conquest. In other words, of all Italy north of the kingdom of Naples, Milan was the closest thing to a territorial state in the manner of a transalpine monarchy. The Po River, the largest in Italy, provided excellent means of transportation and communication in the modern provinces of Emilia-Romagna and Lombardy and sustained a generous supply of water. Consequently, around this river and its hinterland powerful despotisms such as Ferrara and Mantua arose, able, like Milan, to maintain their independence and wealth throughout our period. These principalities tended in general to be ruled by despots who used their armies as mercenaries rented to the highest bidder; hence these *condottiere* principalities maintained the traditions of medieval chivalric virtue while adopting newer humanist forms, resulting in a rich, idiosyncratic culture in which Arthurian knights mixed with classical heroes. For example, although theoretically dependent on the papacy, the Este lands (Ferrara, Reggio, and Modena, territories ruled by the rich, elegant, luxurious, and disciplined Duchy of Ferrara) operated completely independently, sustaining a fine Renaissance civilization characterized by the luxury of its princes and the talent of its poets, especially Lodovico Ariosto (1474–1533), author of *Orlando Furioso*, and Torquato Tasso (1544–95), author of *Jerusalem Delivered*. Similarly, the Gonzaga princes of Mantua established one of the most sophisticated and important Renaissance courts in Italy, and the Gonzaga patronage of Mantegna, Alberti, Giulio Romano, and a great many other artists, scholars, and writers gave this small territory a luster and reputation far beyond its military or economic power.

At the heart of the peninsula lies Tuscany, a hilly area of mixed fertile and rocky soil. The area is perfect for the survival and flourishing of small, independent city states—most usually republics—which jealously tried simultaneously to keep their independence and identity while expanding at the expense of their neighbors. Florence began as just one of these Tuscan city-state republics, but by the middle of the sixteenth century it had managed to unite much of the whole territory into a centralized, dynastic principality. This was not a simple or necessary development, however, and the history of Tuscany is

Map 2.1 (facing page) The Geography of Italy

one of continual petty warfare. Florence did not capture the republic of Siena until the 1550s; Pisa was captured only at the turn of the fifteenth century, but it was lost again before the century was out and was not finally incorporated into Florentine dominion until the first decade of the sixteenth century. Lucca, that tough, mercantile republic, was never conquered by Florence. Thus, republican virtue was certainly constitutional and temperamental, but it was also clearly supported by geography.

The states of the Church in the Renaissance fluctuated dramatically in extent. Generally, they cut a wide band across the peninsula running from Ravenna on the eastern Adriatic coast, bulging north to include Bologna, the gateway to the north, across to the west coast south of Tuscany, through to the northern limits of the kingdom of Naples. Parts of this territory, particularly areas of the Romagna and Abruzzo, were inhospitable and rugged and infested with bandits, as they were until late in the nineteenth century. The Church could never—with one or two very remarkable exceptions, such as the period of the Borgias—effectively rule this lawless territory. Thus, *de facto*, the states of the Church were ruled by petty tyrants who claimed *de jure* authority as papal vicars but who in reality were *signori*—professional thugs, mercenary captains, and petty despots who used their states as recruiting areas for their private armies. The attendant chronic instability of these lands caused the neighboring territories much grief.

Rome itself was, naturally, a unique city and territory. It was at once the see of St Peter and the headquarters of the universal Roman confession, ruled by the successor to St Peter who also claimed the authority of Roman secular rule in the West: the bishop of Rome, the pope. The city was an important ecclesiastical, intellectual, cultural, and banking center, completely dependent on the Holy See. There was very little manufacturing and few occupations outside those serving the needs of the papacy, cardinals, and other high ecclesiastics and the millions of pilgrims and office seekers who thronged to the center of Latin Christendom from all over Europe. In the Renaissance the physical city was a small fraction of the size Rome had reached under the Empire when it had boasted as many as a million inhabitants. Furthermore, the city and territory fluctuated with the fortunes of the papacy: Rome declined horribly during the so-called Babylonian Captivity (1305–77), when the papacy was in Avignon and Rome was neglected, and during the Great Schism (1378–1417), when first two and then three popes divided Christendom. Nevertheless, as we shall see, at no time, even during the worst years of the Babylonian Captivity, was there a decline in the memory of Rome as the *caput mundi* (head of the world), as the capital of the Roman empire, as the see of St Peter, and the site of the tombs of the martyred apostles Peter and Paul, or as the holiest place in the West.

The area south of Rome is a strange amalgam of rich fertile farmlands and barren rocky poverty. It was controlled by the kingdom of Naples and was feudal in organization and internally divided among great magnates who, although laws unto themselves, owed loyalty to the monarch in Naples, whether he was a Hohenstaufen, Angevin, or Spaniard. Because of the feudal nature of the kingdom (Naples was often referred to merely as *Il Regno*, the kingdom), the elements defined in Chapter One as "Renaissance" came only superficially to that region. Some moments of Renaissance culture enriched the capital,

in particular under rulers such as Alfonso the Magnanimous (1396–1458), but generally the fractious violence of the magnate families, the Church, and the dynastic struggles for the crown resulted in Naples and Sicily (the two kingdoms were occasionally separate and occasionally united) playing only a minor role in the emergence and institutionalization of Renaissance culture and humanism.

Finally we come to Venice, Queen of the Adriatic, built on millions of wooden poles driven into the shallow waters and sand bars at the top of the Adriatic Sea. Fed by rivers and protected from all invasions, Venice was settled in the fifth and sixth centuries by Romans fleeing the Lombard invasions. In the Renaissance, Venice changed an ancient policy and began expanding onto the Italian mainland to protect its food supply and trade routes, so that by the late fifteenth century, the Venetian *terraferma* empire (that is, the territories controlled by Venice on the Italian mainland) stretched from Lombardy to the coast and south almost to Ferrara. The most serene republic—*La Serenissima*, as Venice was known—expanded north to include the march of Treviso and parts of Friuli, while it continued to enjoy a great maritime empire that extended along the Dalmatian Coast (the eastern shore of the Adriatic) to include the great Dalmatian trading cities of what is now Croatia, such as Zara (Zadar) and Spalato (Split). In addition to this were the many fortified but only lightly colonized territories of the eastern Mediterranean between Venice and Constantinople, places such as Crete, Cyprus, and the Morea (part of mainland Greece); and there remained the advantageous Venetian privileges in important commercial centers in northern Europe and the Byzantine empire, including Constantinople. The late decision to enter into the territories of northeastern Italy in a substantial way meant that the Renaissance came late to Venice, and both the unusual social and political structure of the republic and the deep Eastern traditions in art and culture resulted in a unique and remarkable Renaissance civilization.

THE MEMORY OF ROME AND THE PROBLEM OF SOVEREIGNTY

In ancient times, the Romans had imposed unity on the peninsula, a centralization symbolized by the complex network of roads radiating from Rome. Thus, the memory of having been a great people—indeed the conquerors of the world—never left the Italians, even after centuries of invasion, fragmentation, and conflict, both internal and external. However, the collapse of the Empire in the late fifth century and the influx of barbarian invaders changed the face and character of Italy dramatically. Even place names such as Lombardy (from the barbarian tribe of the Longobardi) attest to the decisive and apparently perpetual fragmentation of the nation. Differences in laws, customs, and dialects among the barbarian invaders separated the fragments even more. For example, the laws and language of the Venetians or the Lombards grew ever more distant from those of the Romans or Neapolitans as contact declined, although the universality of Latin united

them all to some extent, as did a singular liturgy and some common obedience to the bishop of Rome.

The same can be said of the southern territories. The island of Sicily and the kingdom of Naples had a cosmopolitan character even under the Romans because of Greek settlements whose language survived. After the collapse of Rome came the Germanic invaders who had passed through the entire peninsula and who would even continue on to North Africa. They were subsequently challenged by the Byzantine Greeks in the sixth and seventh centuries, only to fall prey to the Muslims from North Africa (called, somewhat incorrectly, Arabs) soon after. In the eleventh century, the Normans—Northmen (Vikings, really)—under Robert Guiscard built a kingdom in the South that became the closest thing Italy had to a deeply embedded, large feudal society, agrarian and manorial. This kingdom of Naples, however, fell again and again through dynastic wars and inheritance to the house of France (Anjou) and later Spain. Here, the memory of Rome was shallow, except in Naples and a very few other centers, and the lure of a central Roman church was complicated by the continuation of Orthodox Christianity, dependent on Constantinople rather than Rome after the schism of 1054 separated the Latin and Orthodox churches forever. Indeed, it was more to ensure that the south of Italy would be subject to the Roman papacy and follow a Latin rite rather than to convert Muslims and Jews that the papacy was motivated to encourage the Norman conquest of Naples and Sicily.

There was, then, a single power in Italy that in theory might have provided the peninsula with some measure of unity, especially since the Roman Catholic Church saw itself as the heir to the Roman Empire. Based in Rome and enjoying primacy over all bishops, the popes ruled a large portion of central Italy from the very early Middle Ages until the final unification of the country in 1870. But, although they tried, especially during the Renaissance under warlike, ambitious pontiffs such as Alexander VI and Julius II, popes were never able to extend their dominion over the entire peninsula. Why? There were fundamental reasons. There was, for example, the problem of Italian particularism. The discussion above indicates why the peninsula remained subdivided into self-contained, independent territories with allegiance, as well as much economic and political activity, dependent on the locality. This is known culturally as *campanilismo*, the condition of feeling allegiance only to the territory visible from the bell tower, the *campanile*, of one's local church. Regardless of how powerful a pope might be, he could not dislodge that adhesion of an Italian to his or her locality in favor of a grander ideal. All might declare allegiance to Roman Christianity, but the administration and privileges of churchmen and churches were often local rather than universal, dependent as they were on local conditions and centers of authority.

The idea of a universal Church with a universal reach manifested in a united political movement did exist in theory. Several independent states belonging to the papal party supported the authority of the pope in Italy; states such as Ferrara and Naples admitted some vague sovereignty to the pope, but in practice, little interference was allowed. And there was an alternative, another source of universal sovereignty that challenged the claims of the papacy: the Holy Roman Empire that claimed direct succession from Roman secular

Figure 2.1 (facing page) Rome, Vatican, Apostolic Palace Sala dell'Incendio. Workshop of Raphael: *Coronation of Charlemagne* (Detail, 1516–17). The emperor Charlemagne (c. 742–814) was crowned in old St Peter's by Pope Leo III on Christmas Day, AD 800. This image of Charlemagne is actually a portrait of the emperor Charles V (1500–58), and the pope is portrayed as Leo X de'Medici (1483–1520). The use of Raphael's contemporaries as models for historical figures illustrates how the issue of sovereignty in Italy continued throughout the Renaissance.

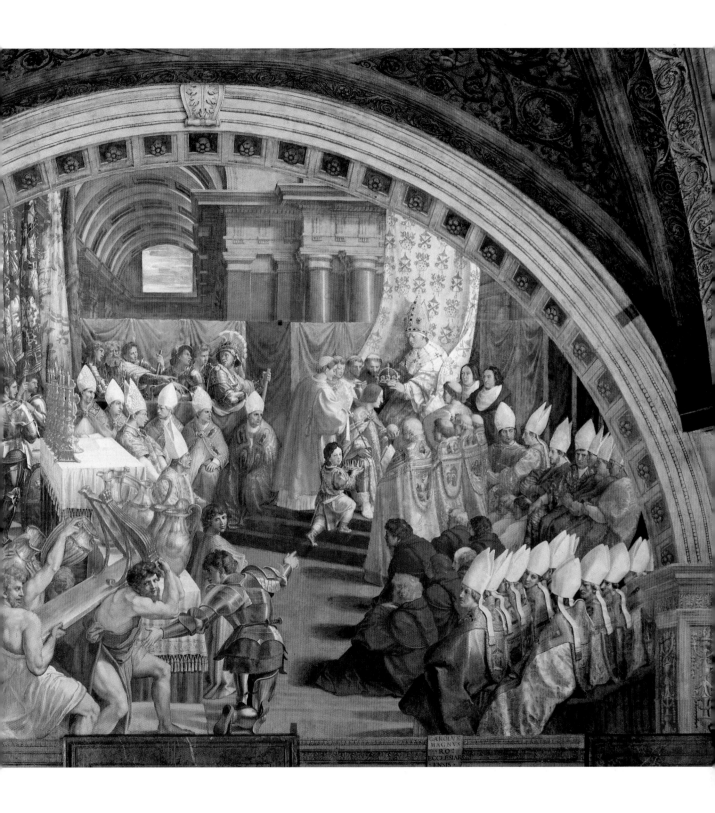

rule in the West. This conflict between papacy and empire would characterize much of the Middle Ages in Italy, provide competing sources of sovereignty and authority to *signori* in need of legitimization, and contribute greatly to the inability of popes—or emperors—to unite the peninsula into larger political units.

In fact the struggle between these two principal sources of sovereignty in the West during the early Middle Ages—the papacy and the empire—ensured that the Italian peninsula would not be united. The rulers of the mosaic of Italian states realized that they could maintain their independence by assuming authority in the name of the pope or the emperor, claiming to be papal or imperial vicars, ruling in the name of one of these two sovereign powers. These allegiances hardened into two exclusive factions: the Guelfs, or papal supporters, and the Ghibellines, or supporters of the empire. Many factors determined whether a ruler, a nobleman, or a community would belong to one or the other: social class (merchants tended to be Guelf; landed magnates Ghibelline); geography (states within the orbit of Rome were largely Guelf); opportunism (if a powerful noble overthrew an established family that was Ghibelline, he would use the Guelf faction as a power base and claim the alternate source of sovereignty); and history. Inevitably these dual, conflicting sources of power obstructed any attempts to unite the peninsula or even to create larger territorial states.

Both Guelfs and Ghibellines used their authority, as well as war, legal arguments, and propaganda, to further their causes. The alleged Donation of Constantine was purported to be a document in which the emperor Constantine in the 330s ceded rule of the West to Pope Sylvester in recognition of Constantine's having been cured of leprosy and his decision to move the imperial capital to the city of Byzantium on the Bosporus, renamed after the emperor as Constantinople. Although a Renaissance humanist scholar, Lorenzo Valla, proved this document to have been a forgery of the late eighth or early ninth century, the belief that the bishop of Rome had absolute authority over the West as a consequence of his apostolic descent from St Peter and his imperial authority as the successor to Constantine remained central to papal claims and continued to be represented in papal patronage, such as the room of Constantine in the apostolic palace in the Vatican, painted by the school of Raphael.

The Ghibellines had equal claims on authority, however, dating from that coronation of the emperor Charlemagne in Rome on Christmas Day 800 (see Figure 2.1). The resurrection of the idea of a Holy (that is, Christian) Roman Empire, receiving its sovereignty from God, was made manifest in the ambitions and policies of the many Germanic emperors who traveled to Italy for their coronation or to exact tribute. By the time of the Hohenstaufen emperor Frederick II (1194–1250), imperial ambitions resulted in constant friction with the papacy. With the death of Frederick, the claims of the Holy Roman Empire in Italy declined and the authority of the Holy See increased. But, as both pope and emperor were elected positions, it was difficult to sustain any policy over long periods, and the theoretical power of the empire stretched over vast areas of Europe, making concentration on the peninsula difficult. The result was that neither pope nor emperor was able to consolidate his authority sufficiently to undo the fragmentation caused by the collapse

of Rome, and Italy remained a mosaic of states, some recognizing the sovereignty of the pope (Guelfs) and some that of the emperor (Ghibellines). Even when the reality of these allegiances declined, the names remained as ideological and social divisions, again making any attempt at unity impossible. The dream of Italian unity and the memory of Rome remained, but the reality was one of fragmentation and local allegiance.

THE RISE OF COMMUNES AND LONG-DISTANCE TRADE

The questions of sovereignty in which universal authority was claimed by both pope and emperor might in themselves have provided a significant ideological bifurcation of the political life of the Italian peninsula in the Middle Ages, but it only further complicated an already complex situation. With the collapse of Roman imperial authority, the issue of who ruled the cities of Italy was of considerable importance. Under Roman law, cities were under the authority of the emperor, but the barbarian invasions and the chaos of the early Middle Ages made any such exercise of wide-ranging authority impossible. Who actually ruled on the ground? Who fulfilled the necessary obligation of sustaining urban power in these confused times? There was no single answer. In some cities the only individual powerful enough was the local bishop, who used his ecclesiastical as well as his political dignity to take charge of those functions required for urban life to survive. In other places the authority of the bishop was secondary to that of a powerful secular individual or family who assumed rule of the town and its dependent territory. Some of these individuals had been invested by Germanic emperors with sovereign power to act in their names; others simply filled a vacuum because they had the military might and wealth to do so. In the first instance, many cities in which bishops ruled became Guelf, with authority coming from the Church; in the latter model, many of these secular *signori* (lords) were imperial vicars and ruled in the name of an absent, distant emperor: these towns were usually Ghibelline.

There had, however, to be some kind of generally recognized authority in these towns. Walls and defenses had to be maintained or built and money in the form of taxation collected to accomplish these public works. There had to be generally accepted and enforced weights and measures, there had to be an accepted coinage, and there had to be some kind of legal system to settle disputes. In the early Middle Ages, these matters were often established ad hoc, depending on the local conditions of the city or town; however, by the tenth and eleventh centuries, there needed to be more complex structures and clearer lines of authority as a result of dramatic changes in Italy and the rest of Europe.

By the tenth century there was a rapid increase in population, the result of fewer and less virulent plagues and fewer invasions. Also, trade was beginning to expand from the local needs of the community to a wider marketplace, again as a result of the demographic and economic changes affecting all Europe but Italy in particular. For cities to expand, food was needed, as cities consume rather than produce food; also, as longer-distance trade

grew, there was even greater need for stable currencies and enforceable contracts. Add to this the coming of the Crusades, and the nature of Italian life—particularly urban life—changed dramatically.

The calling of the First Crusade by Pope Urban II at Clermont in 1095 was both a cause and an effect of the changes noted above. An increase in population, particularly among the warrior nobility, and the expansion of trade that brought Europe into conflict with Muslim states in the eastern and southern Mediterranean drove Europeans to seek land, wealth, fame, and salvation outside the confines of their continent, an adventure given validity and enthusiasm through the vocabulary of religion. The significance of the Crusades for the Italian peninsula was enormous, as the maritime states of Venice, Genoa, and Pisa benefited immediately and greatly by supplying transport, equipment, logistics, and loans to the hundreds of thousands of northern knights who embarked for the Holy Land from those ports. These events stimulated urban development everywhere in Italy, and the old arrangements by which a powerful individual or a bishop ruled largely unchecked began to break down under the growing pressures of too many demands, the need for highly professional and sophisticated services, and the influx of large numbers of people from the countryside into cities to service this new economy, changing the social structure and the political dynamic. As early as the tenth century, many cities began to recognize the participation of learned, wealthy, or influential men in the administration of the towns. Eventually these men were recognized as representatives of the general population—at least those with property who paid taxes—and a more broadly based administration emerged. Over time, emperors or the Church admitted these groups into a more collective authority and cities became communes, that is, urban centers with a measure of self-governance on the part of elite, lay citizens whose assent to fundamental policies was required. Taxation, the administration of justice, weights and measures, coinage, and some other aspects of economic and social policy, such as guild membership, fell under the control of these leading citizens. The self-governing commune, whether in the context of a republic or of a principality, became established, setting the platform on which the city-states of the Renaissance would develop. By the time of the First Crusade at the very end of the eleventh century, many of the major cities and towns of the Italian peninsula enjoyed some form of recognized communal government, and others followed soon after. This independence and the flexibility to take advantage of economic and political opportunities offered by the Crusades helped create the preconditions of the Renaissance.

The Crusades provided both the wealth and the opportunity for the expansion of the cities of Italy. Not only did the carrying trade needed to move huge armies of men and equipment across the Mediterranean enrich the maritime republics, but also Italy was advantaged by payments to the Church in lieu of going on Crusade, the provision of food to the Crusaders, and the need to sustain the communications network across the sea. The immediate profits from servicing the Crusades fell to Venice, Pisa, and Genoa, and the banking and credit structures needed to finance such an enormous undertaking also stimulated trade. Furthermore, the ships returning from the East carried to Europe the luxury goods that the European elite now saw as necessary to an aristocratic life: spices,

silks, oranges, carpets, and other exotic goods. The Crusades helped ensure that the Italian cities would control the financial, logistical, and luxury markets of the Mediterranean. Moreover, Italian cities established trading posts and fortified entrepôts throughout the region, with Italian traders functioning as the necessary brokers in the long-distance luxury trade with the East and, to a lesser extent, across the European continent. The financial structures permitted the foundation of banks throughout Europe and the Mediterranean, with Italian merchants assuming control of the major money markets of the continent. The power and wealth that accrued to Italy were remarkable, as was the level of influence, perhaps best illustrated in the Venetian manipulation of the Fourth Crusade in 1204 to capture Constantinople itself, as we shall see. By the thirteenth century, then, Italy was in a privileged position in Europe and the Mediterranean. It was in this environment that an indigenous, unique Italian culture emerged, reflecting a growing cosmopolitan perspective, a developing Italian vernacular, and a powerful sense of local self-confidence. This was the age of Dante.

DANTE AND THE LATE-MEDIEVAL ITALIAN WORLD

The role of Dante in the history of Italian cultural development was more a question of debate in the Renaissance than it is now. Dante's posthumous reputation underwent a change between the early Renaissance in the mid-fourteenth century, the age of Petrarch, and the mature Florentine Renaissance of the fifteenth century, the age of Bruni. Petrarch, as we shall see in the next chapter, was one of the most influential of the early Renaissance humanists in Italy. He admired Dante, although he had reservations, seeing him reduced in stature because wrote the *Divine Comedy* in Italian, the vernacular, rather than in elegant, classical Latin—a tongue that Petrarch believed Dante had mastered only imperfectly because his Latin writings reflect the style of the Middle Ages, a style Petrarch abominated. Also, Dante was different from Petrarch. He was a politician; he married and had legitimate children, and never lost his interest in the things of the world. He was not a pure scholar, on the model of Petrarch, who never married or held significant political office.

Petrarch's exact contemporary, Giovanni Boccaccio (1313–75), saw Dante as one of the first lights of a new age, although more a harbinger than a fulfillment of the rebirth in style and art. Boccaccio was born to a Florentine family in exile and lived the life of a wandering scholar and teacher, producing some of the most popular books of the early Renaissance such as his *Decameron*. Later, he lectured and wrote on Dante and the *Divine Comedy* in Florence; nevertheless, as his *Life of Dante* illustrates at some length, he felt that the older poet was flawed and tragic because he permitted political and conjugal concerns to complicate what might have been a life of scholarship and poetry. The complete victory of the memory of Dante over his earlier critics came only in the fifteenth century, a period when the vernacular was recognized as a legitimate medium for great literature, when an active, politically engaged, married life was admired more than the aloof profession of

the scholar, and when Dante's great service to his native Florence was perfectly in tune with the mature Florentine self-confidence and patriotism of that century. Indeed, Dante became a secular saint to Renaissance Florence, sharing the altar of civic humanism with Cicero, and the Florentine humanist chancellor Leonardo Bruni (d. 1444) wrote a new life of Dante in which he praised the very things criticized by Boccaccio.

However, interesting as this history is for understanding the Renaissance, there is more to it. Why is Dante being discussed in a chapter entitled "Before the Renaissance"? The answer becomes clear with a brief look at Dante's major literary works and his biography, at least as much as is known of it. (Boccaccio's *Life of Dante* is the primary source.)

Dante Alighieri was born in Florence in May 1265, the son of Alighiero Alighieri and Bella degli Abati. Dante's father was an aristocratic supporter of the Guelfs, an allegiance that had led to his banishment from Florence before Dante's birth. Dante's mother died when her son was only ten years old, and his father subsequently remarried. This event apparently led to Dante's being educated and boarded outside of the family home in a monastery of Franciscan friars whose mysticism and spirituality were to have a powerful effect on the future poet. Because of his high birth and political connections, the young Dante took part in many of the Florentine battles of the 1280s. At this time he had also met his great love, Beatrice Portinari. Dante says he first saw Beatrice when he was about ten years of age and she nine. And, almost ten years later, this same Beatrice saluted her admirer while passing on a public street, and Dante fell hopelessly into a perfect but unconsummated love.

The real Beatrice (b. 1266) was the daughter of a very rich and influential Florentine patrician, Folco Portinari (d. 1289), the founder of the hospital of Santa Maria Nuova; and by 1283, that is, before the second and momentous encounter with Dante, she had been married to another equally rich and influential citizen, Simone de'Bardi, a member of the great banking family. Beatrice died seven years later, in 1290, and Dante never completely recovered. The shock of Beatrice's death made Dante spiritualize her by believing that she was too perfect for this world, that she was really an angel who cared not about the wretchedness, squalor, pain, and misery of earthy life, and returned therefore to heaven where she belonged. Here, then, was the genesis of the Beatrice of Dante's *Paradiso*, his vision of heaven.

To recover from the depression caused by Beatrice's death, Dante sought solace in philosophy—Aristotelian philosophy—studying with the great Brunetto Latini (1220–94), whom Dante was reluctantly obliged in his *Comedia* to place in hell among the sodomites. Also, Dante began the cultivation of classical poets, especially Ovid and Virgil, the great favorites of the Middle Ages. At this point, the scholar started to draw connections between his two literary inspirations—Latin letters and philosophy—and came to believe in the unity of poetry and philosophy since both represented moral and absolute truths. Again, we can see the beginnings of the *Divine Comedy*.

Despite his sorrow over Beatrice's death, Dante married (probably some time before the end of the century) one Gemma Donati, by whom he had at least three children. During this first stage of Dante's life, the political world of Florence was confused and

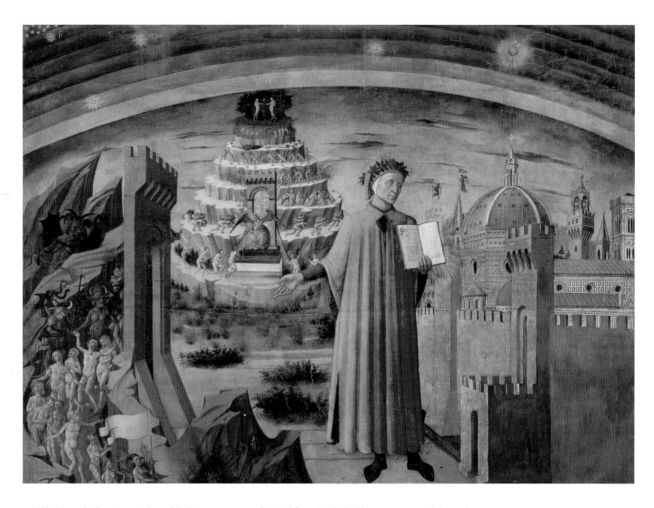

riddled with faction. The old distinctions of Guelf and Ghibelline remained, but during the later thirteenth century this division was complicated by the rise of a rich entrepreneurial class that was generally opposed to the feuding aristocratic thugs of both parties who made the city unstable and unsafe for commerce. Because of his birth and his interests, Dante found himself caught in the middle of these factional disputes. As a member of a greater guild (he entered the guild of physicians and apothecaries, although he was neither), he was eligible for high office and subsequently held several senior positions, both externally as an ambassador and internally as a prior, the highest office in the republic. Dante's performance appears to have been dedicated to maintaining harmony within Florence, as well as protecting the city's independence from Pope Boniface VIII. The result was that he became an enemy of the violent papal party, which, once it came to power with the help of the French army in 1301, began to try, condemn, and exile its opponents. Dante was one of the first to suffer. His sentence in two unfair trials was at first a heavy fine, loss of all political rights forever, and two years' exile. But his enemies,

Figure 2.2 Florence, Cathedral. Domenico di Michelino (1417–91): *The Divine Comedy of Dante Illuminates Florence.* This image, which portrays the Hell, Purgatory, and Paradise of Dante's *Divine Comedy*, was painted on the west wall of the cathedral in Florence long after the poet's death. The walled city illustrated to the right of Dante's book is the Florence of the fifteenth century—not the Florence of Dante's time. Dante's gesture suggests that hell is outside the walls of Florence, an obvious comment on his exile.

still unsatisfied, ordered a second trial that sentenced Dante to death. Away at the time on a diplomatic mission, Dante escaped this fate. However, he never again saw Florence.

Exiled in great poverty and depressed, Dante allowed his solitary melancholia to dwell on life, death, and human vanity. His suffering increased because his sons, too, were banished, although his wife remained in Florence. For consolation, his mind returned to his angelic Beatrice and the virtue of lofty thoughts—and the *Divine Comedy* was begun. Dante was very proud and hated the life of a wanderer, embarrassed by his need of continuous charity and hospitality. He never stayed in any one place very long, despite the warmth of his welcome. He lived briefly at the court of Verona and in France, where he may have studied at the University of Paris. In 1311 Dante went to Milan to pay homage to the emperor Henry VII, who had entered Italy to impose peace. Dante had great hopes for Henry, as his *De monarchia* (*On Universal Dominion*) was to show, but Henry's futile mission ended with the monarch's untimely death in 1313, leaving Dante and his Ghibelline hopes for revenge shattered.

Dante thereafter continued his travels, moving from one Ghibelline city to another: Verona, Lucca, Verona again, and, finally, Ravenna in 1315. Dante rejected an offer of pardon from Florence, refusing to cooperate with his former enemies. As a consequence, he and his sons were once again sentenced to death and proclaimed outlaws. Dante spent the remainder of his life in Ravenna, living as an honored guest in the house of Guido Novello until his death in the fall of 1321 at the age of fifty-six.

Dante's Works

Not long after the death of Beatrice, Dante collected several melancholy poems that he had written to her. Each poem is introduced by a prose preface describing its context. Then, following scholastic models, Dante appended an exegesis of his work, a didactic commentary on his own poetry. This is the *Vita Nuova* (*New Life*). The tone of the book is so reverential that it might have been written by a saint in praise of God, rather by a man in praise of a woman. There is no physical description of Beatrice, only of her purity. The only "other lady" who could attract the poet after Beatrice's death was, as he tells his readers in the *Convivio* (*The Banquet*), Dame Philosophy. Indeed, the *Vita Nuova* is about an allegory of divine grace whose links with real life are through abstract philosophy and reverence. The *Convivio* is in fact a philosophical document. The title refers to the feast of knowledge that Dante is offering to his readers. It is a series of four *canzoni,* or poems, together with explanations, arranged according to the scholastic method. Indeed, the poetic treatises are simply mirrors of Aristotelian learning and hardly Dante's own expression at all. The work's greatest merit rests in its attempt to use the vernacular for ideas previously limited to Latin, and it is so didactic that it almost seems to be a manual on the art of poetry.

De vulgari eloquentia, or *On the Eloquence of the Vernacular Tongue*, is a Latin prose work proposing the development of a new literary language of convention to replace the various

Italian dialects, Provençal, and even learned Latin. This is Dante's *vulgare illustre*, or illustrious vernacular, which could express the highest thoughts in a *dolce stil nuovo*, a sweet new style. None of the many variants of Italian could do this in his time, Dante writes, not even his own Tuscan, a dialect he specifically vilifies. Yet the great implication of this work is its irony: because of Dante's achievement in the *Divine Comedy*, his native Tuscan did indeed become the *vulgare illustre* and his style the *dolce stil nuovo*.

De monarchia, On Universal Dominion, is important as a work of political thought. In essence, it is simply a learned statement of the Ghibelline creed, a position to which Dante was driven by his exile: the world needs peace and harmony, and these qualities are best delivered by a universal monarchy, that is, the Holy Roman Empire. The papacy's claims in this regard are usurpations since priests rule in the spiritual rather than the temporal sphere.

But of course Dante's most famous work is the *Divine Comedy* or *Commedia*. In its simplest form, this great poem studies allegorically the movement of the soul's conversion to God through a wanderer's journey among the kingdoms of Hell, Purgatory, and Paradise. The first kingdom represents sin, the second repentance, and the third grace, or knowledge of God. The Latin poet Virgil functions as Dante's guide through Hell and Purgatory, Beatrice through Paradise. In these visions, the characters of Dante's age and from his historical knowledge are portrayed as individuals, being either rewarded or punished as the poet sees fit.

But to return to the question with which this section began: why place Dante in the Middle Ages rather than, as many other scholars have done, in the early Renaissance? The answer is clear from his attitudes and writings, especially the *Commedia*. Certainly, he illustrates many later characteristics in his work, such as a deep love and respect for the classical world, although this was true of the Middle Ages as well. He was an active citizen who took part in the civic life of Florence; he married and had children and he lived a secular life.

Nevertheless, in essence, the ideas Dante expresses are almost completely medieval, as was his education. The saints Dante meets in heaven are largely scholastics, for example, Sts Thomas and Bernard, the latter of whom, in fact, leads him toward God. His method in all of his work is Aristotelian—in other words, scholastic. He has little concern for classical Latin style and he saves his greatest respect for the Roman Empire rather than the Roman Republic; indeed, Brutus and Cassius, the betrayers of Caesar, share the lowest pit of Hell, the ninth circle, with Judas, the betrayer of Christ. The Middle Ages celebrated the Empire because it was at that time that the incarnation took place, established the conditions for the evangelization of the Roman world, and institutionalized Christianity; the adulation of the Republic was a later phenomenon.

Also, Dante's view of the past is medieval. He sees no gulf between the ancient world and his own; rather, he accepts the principle of a continuum, elaborating God's plan for humanity. As a consequence, his attitude toward history looks backward rather than forward. He does not differentiate between historical fact and legend, both of which help equally in establishing allegorical visions and examples for his readers. In short, Dante does not engage that critical faculty so important to the Renaissance. He is, to be sure, interested

in individual men and women and their experiences; however, he tends, like his medieval antecedents, to abstract them, allegorize them, and universalize them. Unlike Petrarch, as we shall see, who continually investigates his inner workings, his psychology, and his motivations, Dante accepts the teachings of an omniscient Church, illuminated by scholastic thought. In the *Divine Comedy*, for example, what are the areas of punishment and reward? The traditional rules and morality represented by the seven deadly sins that animate Hell. Catholic penance is the theme Dante develops on the plateaus of Purgatory; and both the worship of God and the Virgin—again explicated by scholastic philosophy—and the absorption of the individual soul in God dominate the *Paradiso*. Dante is, then, a medieval man, but one so remarkable and so great that he transcends any period.

One reason why several of Dante's characteristics seem to have been part of the later Renaissance is that they were resurrected as *ex post facto* arguments in favor of those elements of Florentine life that happened fortuitously to conform to the new requirements of the fifteenth-century republic. The early Renaissance deplored Dante's use of the vernacular. (Petrarch said that he had never even seen the *Commedia* before Boccaccio brought him a copy in Venice in his old age.) It was only with the rediscovery of the beauties of the Tuscan tongue that Dante's place in the hagiography of the later age became secure. Moreover, Boccaccio disliked Dante's having married and having engaged in politics. He thought it unseemly, as would have Petrarch if he had considered Dante much at all before his old age. However, half a century later, when civic, conjugal, and political life represented the norms and communal principles of society in Florence, Dante was again rehabilitated and polished for the altar of Florentine civic virtue. In short, Dante was great and contained multitudes, as does every true genius. The elements of his character that one chooses to stress will determine his place in the intellectual history of western Europe.

But in closing, let me repeat my claim that Dante, despite his civic rehabilitation in the fifteenth century as a prefiguration of Florentine civic humanism, was in all significant ways a very medieval figure. Let us use Burckhardt's criteria: Was Dante secular? In life he was, but in his thought he was a traditional medieval Roman Catholic in religion and a scholastic in education and method. Was Dante an unbridled egoist? He lived alone but sought no fame; indeed, it almost embarrassed him. He appeared not to have had Petrarch's interest in self-analysis and provided very little for the figures in his vision. And obviously, he did not conform to Burckhardt's accusation of amorality or uncontrolled individualism. Dante can hardly be compared to Cesare Borgia.

Was Dante "modern" in the Burckhardtian sense? He did write in Italian, and that was a new trend; but he wrote religious allegory about a world that comes down to a universal battleground between good and evil. His vision was circumscribed by the immediate concerns of his age: Guelf and Ghibelline, pope and emperor, friend and enemy, God and the devil. Finally, how did Dante relate to the classical past? His appreciation of antiquity was that of any good, sensitive medieval scholar. Virgil, the great Roman epic poet, is indeed his guide through Hell and Purgatory; but it is not so much the Virgil of *The Aeneid*, the poet of Rome, as much as the medieval Virgil, the poet of the Fourth Eclogue that was interpreted to foretell the coming of Christ.

FURTHER READING

Becker, Marvin B. *Medieval Italy: Constraints and Creativity*. Bloomington: Indiana University Press, 1981.

Larner, John. *Italy in the Age of Dante and Petrarch: 1216–1380*. A Longman History of Italy. Vol. 2. New York: Longman Group, 1980.

Lopez, Robert S., and Irving W. Raymond, trans. and intr. *Medieval Trade in the Mediterranean World*. New York: Columbia University Press, 2001.

Riley-Smith, J. *The Oxford Illustrated History of the Crusades*. Oxford: Oxford University Press, 2001.

Tabacco, Giovanni. *The Struggle for Power in Medieval Italy: Structures of Political Rule*. Cambridge Medieval Textbooks. Cambridge: Cambridge University Press, 1989.

THREE

SOCIAL CONTINUITIES

THE RENAISSANCE HAS BEEN largely defined as an experience of high culture and elite values, animated by privileged individuals with access to some significant surplus wealth and political power. Personalities such as Dante, before his exile and consequent personal poverty, anticipated this model, and his work reflects that complex mixture of experience, education, and genius that inspired the first lights of the Renaissance. Obviously not all Italians inhabited that world: for the great majority of poorer or less privileged Italians, the realities of daily life focused on the family, work, and religion rather than the elite elements that characterized Renaissance culture. Even those who did enjoy privilege, and whose actions and work will be described in the context of their public lives later in this book, returned home to wives, husbands, children, parents, and a community composed of kin, neighbors, and friends who shared a great many values, worshipped at the same churches, listened to the same popular preachers, or felt the exclusion applied to those who did not fall within the prevailing Christian worldview. These things were in many ways constants, not hugely affected by the culture of the Renaissance and common to almost every state and city within the Italian peninsula. These structures of everyday life merit some detailed discussion, as they contributed to the immediate experience of life in the Renaissance as much as—if not more than—the celebration of those ideals reflected in the various chapters of this book.

If any man or woman of the Renaissance had been asked what mattered most, the answer would probably be their families. People were defined by their extended kin group and their marriage alliances. Even names reflect this: poor Italians often used patronymics to define who they were, such as Giovanni di Pietro, that is, John, son of Peter. They did not have a clan or extended kin group names, so their fathers gave them a distinct identity. Even those who did enjoy a family name would identify with a particular branch by using a patronymic, such Lorenzo di Piero de'Medici—the Magnificent Lorenzo was the son of Piero in the Medici clan—and this would differentiate him from a cousin, such as Lorenzo di Pierfrancesco de'Medici. Occasionally, it was even indicated whether a father

was dead by the Italian *fu*, that is, son of the man who *was* Pietro (in this life). This small point illustrates an important reality of Renaissance Italian definitions of kin: family was both latitudinal and longitudinal, that is, inclusive of all related individuals descended from a common ancestor, whether living or deceased. This is reflected in the dedication to parish or neighborhood churches, in which wealthy families would have chapels. Events, such as baptisms, would take place in the presence of all relatives—the living who attended the ceremony and the dead who were buried in the crypts below—marking silent testimony to the continuation of family names, reputation, and honor.

The family, then, was seen as the fundamental building block of Renaissance society. Leon Battista Alberti (1404–72), in his treatise *On the Family*, repeats the classical trope that the family is the microcosm of the city or the state and should reflect the same hierarchy and values. It was rigidly patriarchal, with little public authority afforded to women though much domestic power relegated to them, particularly in the raising of children and the management of the family house, which could range from a grand palace containing dozens of inhabitants who had to be lodged, fed, and served, to a much humbler structure occupied by a single family, large or small.

MARRIAGE AND THE FAMILY

Marriage was consequently a fundamental element in the construction of such households, and the choice of a husband or wife one of the most important decisions taken by the family as a whole, as each new alliance affected almost every member of an extended patrician clan or provided the labor and support in poorer, less privileged families, where access to even small amounts of credit or labor could make the difference between success or failure, poverty or social mobility. Among families with property, marriages were arranged: they were not love matches freely entered into by a young man and woman. For those with no property, marriage was of less significance and was often serial in nature, depending on the availability of employment and patterns of mortality, with women and men having more than one partner, as early death or abandonment fragmented their domestic lives. In many ways marriage constituted the mechanism for the orderly transfer of property from one generation to the next and the instrument by which business and political alliances were forged. Love was not required for this, although most Renaissance writers on the subject expected—or hoped—that love would eventually emerge, based on mutual respect, shared life, and social ambition.

The choice of a mate was therefore of paramount importance to family strategy. Having many daughters provided opportunities to extend family interests in several directions; but there was a considerable expense involved, as all girls destined to marry had to be provided with a dowry, or bride-price, sufficient either to sustain them and the family's status, or to improve their standing by marrying above their station, an ambition that involved offering a substantial sum. Consequently, for economic reasons, a father with many daughters

would often place one or more of his girls in a convent to reduce the charge on his wealth. Convents required the equivalent of dowries as well—every novice had to be supported to some extent by her family—but much smaller than those of girls destined for prestigious matches. Girls were thus often put into religious vocations against their wills, although few would challenge their fathers' right to make such a decision. Occasionally the decision would be met with relief, as nunneries could offer girls the chance to continue their education and relieve them of the dangerous occupation of pregnancy. Death in childbirth was such a common occurrence that some young girls welcomed the offer to avoid such a fate, a painful and lingering death that many would have witnessed through the terrible experiences of relatives and friends.

The setting of a dowry or bride-price was an extremely sensitive and complex process. So many factors went into the settling of a dowry that it is difficult for us to imagine just how the number was finally determined. Was the girl attractive or not? Had her sisters married well and produced male children? Was her family established and apparently rising in status and wealth? Was her father successful in business or at court and seemed to hold good prospects for the future? Was there any hint of scandal or threat of political or economic sanction? Was the family respected in the community? All of these factors played a role. And then there was the strategy of social mobility: did the family wish to rise in the social hierarchy by forging a marriage alliance with an older, richer, better connected or more celebrated clan? Or was there a need to compromise because of financial setbacks that necessitated a quick infusion of cash to restore the family finances? Were there political exigencies impelling the connection of more aristocratic families with less noble but richer and more influential clans? It has been said that the best way to determine if a family was moving up or down in the hierarchy was to look at where the children were placed in marriage, especially the girls.

The means of securing a match was essentially the same throughout Italy during the whole of the Renaissance period. It should be noted, however, that in times of commercial expansion, dowries tended to rise in value. Moreover, certain institutions, such as the Florentine state dowry fund (*monte delle doti*) could inflate marriage portions by raising the base for middling families. This innovation in Florence in 1425 illustrates the importance the community placed on respectable dowries. When a girl was born, her father could deposit a sum of money with the *monte*. This investment matured when the girl reached the age of fifteen, with the original sum plus interest payable. If a girl died before reaching fifteen (a not infrequent occurrence), only the principal was returned, not any interest; as a consequence, the scheme was expected to be self-financing.

When a girl of good family reached an age and maturity appropriate for marriage (normally between about sixteen and eighteen), her family made it known that she was available for offers. In small Renaissance cities—or even large principalities characterized by restricted ruling elites—this moment was awaited patiently by families with adult sons who were at an age where marriage would be expected. The prospective grooms were often older, in their mid to late twenties or even early thirties, because the man was expected to have proven his business acumen and commercial success, to have succeeded

to the family property, and to have illustrated his character and political abilities or courtly skills. Girls, on the other hand, were to be married as soon as they reached physical maturity in order to ensure that no hint of scandal could be detected and that their entire fertile period could be used to produce as many children as possible to sustain the family name and reputation. It was, after all, a time of appalling infant and child mortality in which it was not uncommon for a mother to lose the majority of her children at birth or when very young—and often her own life as well.

The nuptial process began when a prospective suitor's family showed an interest in a young girl newly on the marriage market. Go-betweens—occasionally family members, prominent men or women in the community, or professional match-makers—would speak to the girl's father and ask whether a particular man would be acceptable. If a positive reply was received, there would be a formal inspection of the two parties, usually in church, to ensure that nothing was too impossible in their appearance or carriage to hinder the match. Then the two families would meet to discuss the terms of the union, such as the amount of the dowry and how it was to be paid and when. Usually the dowry was offered in several parts: the trousseau of the bride, including her wedding dress and jewels; cash; state bonds or shares in family companies; and, significantly, income from property that was to be the dower house or farm to provide income for the girl in the future, should she be left a widow. Legally, the dowry continued to belong to the bride's family, as it was to care for her regardless of the state of her marriage, but in practice the husband could use the dowry by investing the capital, lending it out, renting the dower property, or employing any other instrument that could generate wealth. It could then become a cause for litigation if the husband died, as access to the dowry was then to revert to the widow and her

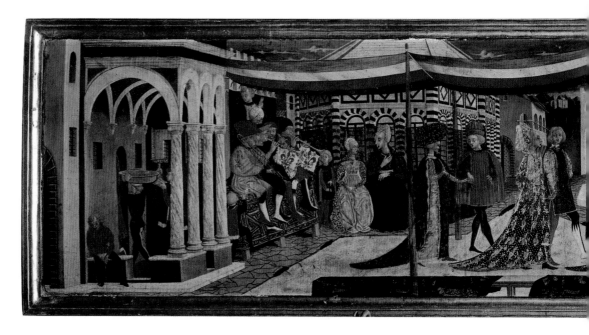

family. But, obviously, there was much room for malfeasance or failure, as securing the dowry income or property could take some time or prove impossible because of the business failure or financial complications of the late husband or his family.

If an agreement between the families was reached, the prospective couple met under chaperone, occasionally being permitted to speak privately, although never in a room alone. This meeting was important because the consent of both the man and the woman was absolutely required by canon (or Church) law, and the laws of the Church governed marriage. Divorce was almost impossible, although the Church did allow for the annulment of a marriage for specific reasons, such as non-consummation or forced union. According to canon law, both parties must have entered into the union freely, willingly, and knowingly; consequently, there was a great deal of emphasis placed on the consent of the bride. Consent given, a notary would be called to draw up the marriage contract, and it would be sealed by an exchange of betrothal tokens, usually rings. At this point, the couple and their families were united in almost every way except one. This final stage followed the ceremonial aspects of the marriage, which usually took place in the bride's house. A great feast would be held, and then the groom would lead his new bride to her new home—the groom's—surrounded by the groomsmen, often making salacious remarks or singing suggestive songs. The virgin bride, assisted by her bridesmaids, would then be taken to the bridal chamber, where the marriage would be consummated, at which time the union was complete and indivisible.

Marriage provided for the continuation of the groom's family line and the increase of the population through the production of children, who were expected to arrive as quickly as possible and in profusion. Male children were especially desired because they continued

Figure 3.1 Florence, Galleria dell'Accademia. Giovanni di Ser Giovanni Scheggia (Lo Scheggia, 1406–86): *Adimari Wedding Cassone*. A *cassone* was a chest intended to hold the bride's trousseau in anticipation of her wedding. When the girl was still a child, families would often begin collecting her household linen, made of fabrics that were usually decorated with initials or coats of arms embroidered by the girl herself. Before the wedding, wealthy families in the fifteenth century would engage celebrated artists, including those of such stature as Botticelli, to decorate these wooden chests with scenes from the Bible, medieval legend, or antiquity. In this example, the image is of music, dancing, and the participation of beautifully dressed guests, not unlike any wedding celebration of today. Tradition identifies this painting by Lo Scheggia as celebrating the marriage of Boccaccio Adimari (hence the name) to Lisa Ricasoli in 1420. But modern scholarship suggests that this is very unlikely. Also, the size of the painting indicates that it was the backboard (*spaliera*) rather than the front of the chest.

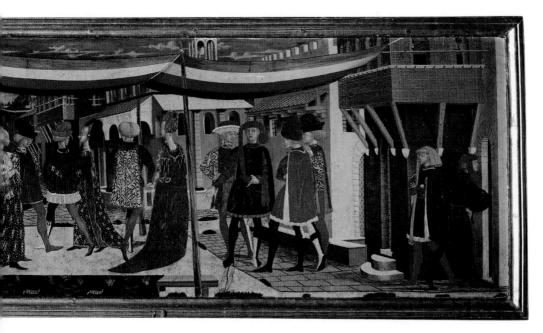

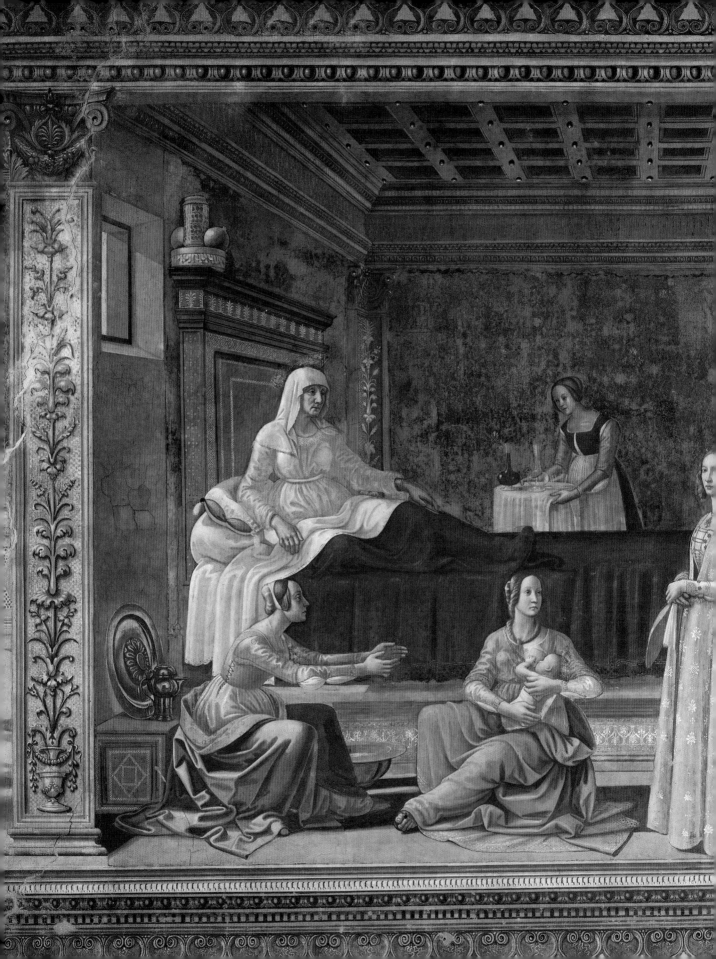

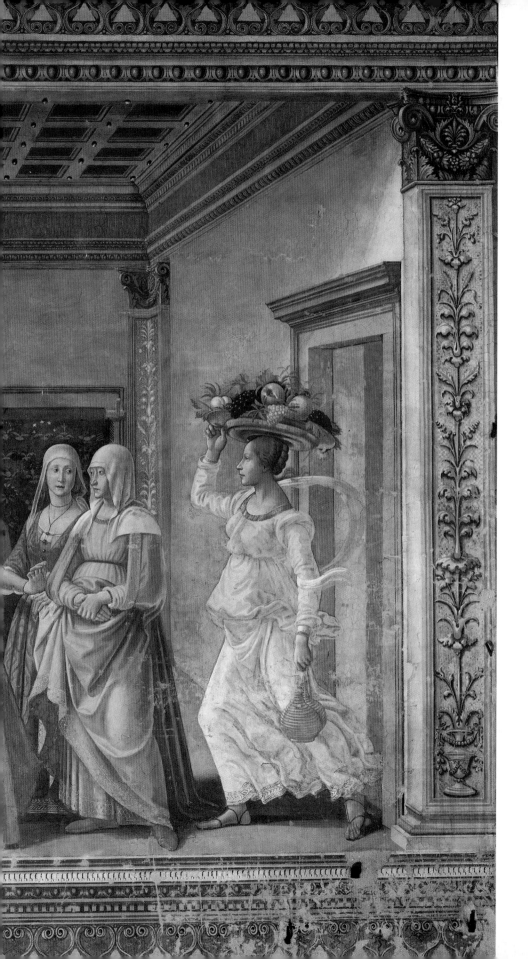

Figure 3.2 Florence, Santa Maria Novella, Tornabuoni Chapel. Domenico Ghirlandaio and Workshop: *The Birth of John the Baptist*. This scene depicts the hour of St Elizabeth giving birth to John the Baptist, anachronistically set in a patrician bedchamber of the late fifteenth century The child has been washed and given to his nurse, friends and relations of the mother are present to bring their good wishes, and a servant enters with fresh fruit and red wine, nourishment for the new mother to help replace lost blood, a practice still followed in isolated areas of the Mediterranean.

the patrilineal family name and could increase the power, influence, and wealth of the clan through political and economic activity, advantageous marriage, or military prowess. Even today a traditional toast at Italian rural weddings is *Auguri e figli maschi* (Good luck and may you produce boys). Female children were a financial drain because of the need for appropriate dowries; but girls, too, could be useful instruments in the family strategies of marriage and power, provided a good match could be made.

Life expectancies were short, with men dying early from disease, misadventure, or age, given that husbands were traditionally older than their wives. Women died in terrible numbers in childbirth. If left a widower, a man could always remarry, depending on his wealth and status, with age seldom a great handicap; women, however, often had to contend with years of widowhood after the loss of a husband. Children who had been born to a widowed mother remained in the care of the husband's family. Should the widow remarry, she would often have little contact with the progeny of her first marriage. The widow's birth family often was not keen on having her return, as she would prove a burden, if her dowry should be lost, and unmarried or widowed women were often seen as social dangers in the household or the community, as they appeared to be without male oversight. If young and still attractive, a widow might be suitable for remarriage, although often not at her rank or to a much older man, himself a widower. In marriage, power remained in the hands of men, even if the woman was mature, experienced, and a mother.

This was true in law as well. Women were greatly restricted in what they could and could not do. Their signatures were generally not valid in law; they could not hold property in their own names and usually had to be represented by a legal guardian, or *mundualdus*, regardless of their age. This *persona* in law was usually a close male relative or husband. Men controlled women's property and hence, to a degree, their persons, a situation that was rationalized by reference to ancient law, medieval law (the *mundualdus* derived from Lombard law), classical authors, and precedent. In this way, the recovery of antiquity proved not a support but a burden to the emancipation and freedom of women. That said, artisan women often ran shops and acted on their own in business, buying and selling, hiring and borrowing, especially if widowed. Poor women acted not unlike men, working next to them in the fields or the workshops, because all they had was their labor. It ironically was in the example of women of status with property that freedom was most restricted; and it is particularly ironic that in the republics, like Florence and Venice, the social and legal position of women was far more restricted than in the despotisms, where court life required both the company and participation of accomplished women.

The house into which the bride was led by her new husband reflected the wealth, taste, cultivation, and traditions of his family. A wealthy patrician in Florence or Venice or an aristocrat in a monarchy needed to advertise his power by constructing a great house that would be the center of almost every aspect of his clan's authority. In a city like Florence, these large palaces included the head office of the family's company, occasionally with warehouses on the street level. The ground floor could also be let to shopkeepers for regular income, without in any way compromising the dignity of the owner. The important rooms of these large buildings were located on the second floor, the *piano nobile*, which were used to display the collections of the family and serve as the site for business or political meetings or extended family gatherings and entertainment. As a result there was not much furniture, and those elaborately decorated pieces that were there were often large and multifunctional, like the rooms themselves. Except for bedrooms, which required the placement of imposing beds for the senior members of the household, rooms were not given over to specific purposes. For example, dining would occur in the room most appropriate for the size of the group, or with the warmest fireplace in winter or the coolest breezes in summer. Chairs would be moved from storage placement against the walls to where they were needed, and tables could serve as sleeping places for servants or desks for the transaction of business. Nevertheless, there was a cultivated atmosphere of magnificence to illustrate the financial security of the family (and the family bank or mercantile company as well); and objects, such as pictures, tapestries, furniture, silver, and *maiolica* (richly decorated and glazed earthenware pottery) would be displayed prominently to reflect not only the wealth but the taste and refinement of the owners. Functional rooms, including secondary bedrooms and work rooms, would be located on the floors above. These houses were very vertical because land within the protection of the city walls, particularly in convenient neighborhoods, was expensive; consequently, to maximize size, the owners built upwards.

The higher in a patrician palace that people lived or worked, the lesser their status. There were many stairs up which to climb and carry burdens. In the summer these rooms were hot and in the winter cold. Kitchens were usually located on the very highest floor to minimize the damage of fires, to prevent the heat and odors of cooking from pervading the entire house, and to dampen the noise. Food, then, was often delivered cold, and the servants who worked in the kitchens had uncomfortable lives, with much climbing, carrying of provisions, and delivering of meals. Above the kitchen there was often a loggia, a terrace built atop the house and open on three sides. The

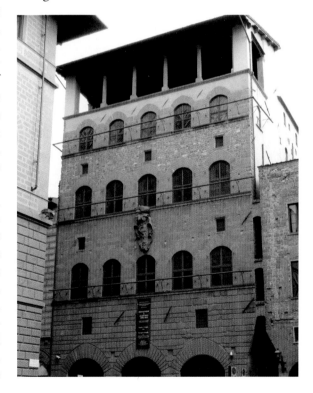

Figure 3.4 Florence, Palazzo Davanzati Exterior. This early Renaissance palace in Florence was originally built c. 1350 and was acquired by the noble Davanzati family in 1578; it is their arms that are displayed on the façade. Its design traces the movement from noble tower houses to urban patrician palaces, with its generous windows and attic loggia.

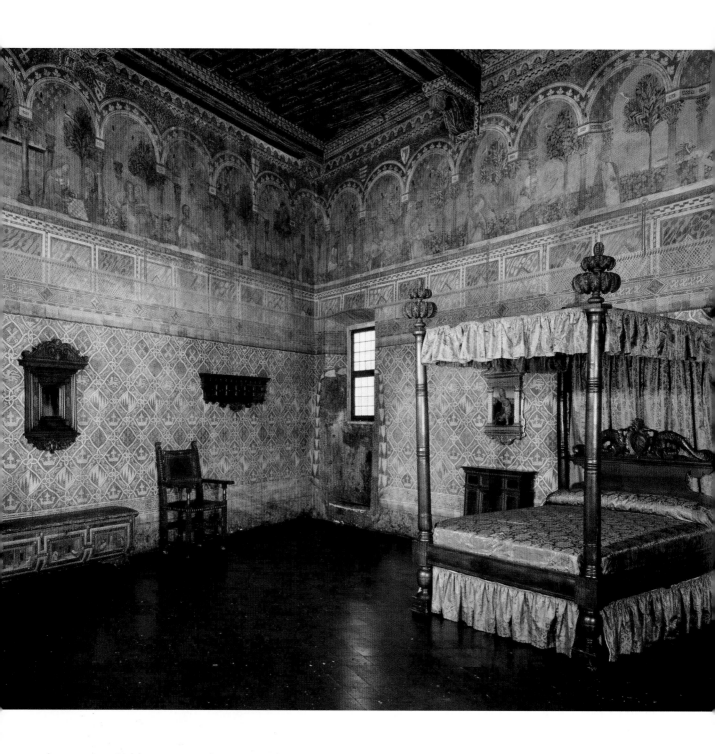

purpose of this outdoor room was to take advantage of the breezes high above the crowded streets and to escape some of the noise and the smells of the city in the summer heat. In spring and summer these were popular places to entertain and dine.

Most wealthy families throughout Italy also owned country villas to escape the city in summer (*villeggiatura*) and to provide wine, oil, some produce, and even meat for their table. A villa was a mark of status and a financial advantage, as it meant that not all food had to be purchased—and food was not cheap in the Italian Renaissance city. The villa also provided a reliable and loyal supply of servants, armed retainers (*bravi*) if needed, and wet nurses for young children, because patrician mothers seldom breastfed their own children so as not to suppress fertility.

The men in the family saw their power and authority in the public sphere outside the house; their wives and mothers saw theirs in the private, domestic world within the family home. The inside of the family home was very much the woman's world and the center of her authority. Most of the servants reported to her and she kept the accounts and the lists needed to operate such a complex household. She was almost altogether responsible for the education and rearing of her children: boys until they were about seven or eight, when they would be sent to a school, assigned a tutor or apprenticed; girls until they married or left home for a convent. In large aristocratic or patrician families, more than one branch often inhabited the palace, as each son was guaranteed a portion of the family home on the death of his father. This was often the source of tense domestic relations, as was the presence of a widowed mother who had little desire to transfer control of the household and its servants to the wife of her son. But often the young, teenaged bride of that son needed his mother's advice, as provisioning, supervising, and maintaining a huge building with perhaps a dozen servants, apprentices, and day laborers dedicated to serving the family and its enterprises were hardly easy tasks for an inexperienced girl.

Extended kin groups also tended to build their palaces close to one another in the same part of the city and near the family church and the neighborhood where they enjoyed traditional respect and power. Part of this resulted from the need in the Middle Ages and early Renaissance for security. The towers of the clan and their associates by alliance or marriage (*consorterie*) would offer joint protection and security. Also, the anthropological need for people to remain close to their family chapels and to the tombs of their ancestors remained strong. It is for this reason that streets or even neighborhoods took their names from the families whose palaces dominated them. Eventually, however, new family consolidations, feuds, or disagreement among relatives, or simple numbers required branches of the family to relocate to other parts of the town, a process accelerated by the fifteenth century when the need for security in most Italian cities was greatly reduced. And fashionable neighborhoods changed, particularly in monarchies when a prince constructed a new palace and expected his courtiers to be close by. The best example of this is Florence in the period of the Medici grand duchy when the *Oltr'Arno* (the area on the opposite side of the Arno river from the Palazzo della Signoria and cathedral—the centers of republican Florence) became the site of grand mannerist palaces on streets such as the Via Maggio close to the new grand ducal residence of the Palazzo Pitti.

Figure 3.5 (facing page)
Florence, Palazzo Davanzati Bedroom. This large room would have been a principal bedchamber for an important member of a patrician family. Its rich decoration consists of frescoed stories from a medieval romance around the cornices, separated by trees and architectural forms. The walls themselves are frescoed in a way as to appear almost like wallpaper. There is little furniture: the great bed, with bed curtains to keep in the warmth in winter and to allow a small degree of privacy; a chair; objects of religious devotion; but little else. The painted *cassone*, which might once have held a bride's trousseau, would later be used to store clothing, as there were no closets. The tile floor, high ceilings, and few windows kept the room cool in summer. In winter it would have been heated by a fireplace or several copper braziers filled with coals from the kitchen and distributed about the room as needed.

THE LIVES OF THE LESS PRIVILEGED

Such was the experience of the privileged elite. The life of the poor in the Italian Renaissance town, however, was altogether different. They rented space close to their work in crowded tenements that were often characterized by noxious odors, narrow, dark streets, and lack of security for their few possessions. In good times with sufficient employment, respectable wages could be earned, enough to sustain a stable, if not comfortable, quality of life. Good wages and high employment resulted in more family formations and the production of more children, as regular and nutritious food helped increase fertility; but bad times occasioned periods of unemployment, driving men out of the cities into the country to return to poor family farms where at least they would not starve. Often, the men would not bring their wives and children, leaving them to fend for themselves or manage on charity or the small amounts of money or food sent from the countryside. Orphanages were established to accept the surplus children the poor could not afford to feed; and if legitimate work could not be found, women and girls were occasionally driven into prostitution. When the economic situation improved, these desperate shifts could be abandoned, as men returned to the cities or women accepted other men as their mates. Outside of domestic service, employment for women was very scarce: there was seldom any choice for the poorest women but charity or prostitution.

Artisan women and families were much better off, as it was not at all unusual for them to work in the shops or workshops of their husbands. Shoemakers, innkeepers, and sellers of food and wine all required labor behind the counter or in the shop. Here women and children could make a significant contribution to maintain a stable lower-middle-class quality of life with some security. Unlike the poor who had to pawn the tools of their manual trades when the need for money was desperate, the lesser guildsmen, small businessmen, and artisans had the collateral of real estate and stock should an emergency occur. They therefore enjoyed a cushion that permitted members of this class to participate in government, manage their occupation through guild office, or even expand their operations, establishing a platform for social mobility.

Neighborhood and collective values assisted in this process. To be seen as an active participant in the community was an important element in the search for reputation and respectability that led to economic and social success, paving the way for better marriages for children and perhaps a significant degree of social mobility. In cities like Florence, where lesser guildsmen had access to elected public office, this is obvious, but even in principalities there were opportunities to contribute to the community and be recognized. The various structures of the Church provided many of these opportunities. Acts of charity and devotion were seen as reflections of good character and public spirit. Agencies such as confraternities gave voice to ambition and served well to provide necessary services and support in a world where there was little protection from sickness, early death, poverty or even the blessing of too many children to feed and dower. Confraternities were organizations of laymen dedicated to specific purposes, not unlike modern service clubs. Some of these took care of unwanted children or provided dowries for poor girls; some visited

the sick and dying and helped their families; some ministered to prisoners in the jails; some ensured an honorable burial for the indigent; others cared for the bodies and souls of condemned felons before and even during their executions. Often inspired by the example of a patron saint or by a perceived need, these confraternities brought together laymen in their clubhouses, followed prescribed rituals, and practiced good works. In some instances these confraternities existed solely to praise god through prayer, singing, and even flagellation, for they believed that divine protection was as important to the well-being of the community as caring for the sick and the poor. In every confraternity there was the responsibility to care for the families of members unable to work, to attend the funerals and to ensure a decent burial of their confraternal colleagues. Confraternities were not unlike providers of life and disability insurance, while still making contributions to their communities by addressing some of the ills of the Renaissance city in which publicly provided services were almost non-existent.

THE ROLE OF RELIGION AND THE CHURCH

Confraternities were lay organizations, but their inspiration was religious and their work a support to the institution of the Church itself—the most important universal structure in Italy during the Renaissance. It was believed that there was a single route to salvation, and that was through the Roman Church. To be outside the Church—for example, to be a Jew or Muslim, or even a schismatic Christian, such as a follower of the Eastern Orthodox faith—was to a great degree to be outside society. The Church was everywhere, and its power and mission crept into every crevice of one's existence. The significant moments of life—baptism, marriage, and death—were reflections of Christian practice and often presided over by priests. The day was punctuated by the tolling of the canonical hours from the church bell. Men and women were identified by their parish, and the local community was dominated by its church, to which all parishioners would go either for holy service or to hear one of the popular preachers who would fill the square in front with the faithful: these preachers were the celebrities of their time. Pride in the community was reflected in the size and decoration of its church, and the special meaning of the community's shared culture was defined by the legends and images of miracle-working madonnas or miraculous visions or occurrences. Because life was short and very uncertain, the church provided an element of confident hope and a sense of belonging.

Everywhere the Church fulfilled its role in providing for the spiritual welfare of the community and, in addition, its temporal welfare by operating hospitals and providing other social services. Many of these charitable functions would be managed by the regular clergy (monks and nuns who lived according to a monastic rule, *regula* in Latin). Convents and monasteries were consequently important to the well-being of the neighborhood as they often provided some measure of education, poor relief, care of the sick, succor for the dying, and prayers for the souls of the dead. Also, as we have seen, convents and

monasteries absorbed the surplus children of the propertied classes, giving them respectable and comfortable lives in addition to spiritual support for their families. It should not be surprising, then, that monastic institutions received significant donations from the people whom they served, either as gifts of money or land or as bequests. To endow a religious house was seen as immediately benefitting the community, both in body and soul, through divine protection and intervention. In times of crisis, such as a period of plague, these gifts increased, and the high rate of mortality ironically often brought great wealth through bequests to these institutions. These religious houses were seamlessly integrated into the communities that they served, and that provided them with novices. Even the strictest cloistered orders, separated by their vows from the world around them, were believed to contribute to the spiritual health of the faithful because the nuns said constant prayers for the community, offering protection and hope in an uncertain world where death or disaster was always imminent.

It was the complete identification of the people and community with a singular religion and ritual that caused the exclusion of those born or identified as outside the boundaries of established society. Jews lived in Italy during the Renaissance in considerable numbers in every major city and state. They were burdened with higher taxation, occasionally confined to certain parts of town, often ordered to wear distinguishing symbols, restricted in what professions they could practice, and even often forbidden to own farmland. Much of this exclusion resulted from the Jews' obvious separation from the Christian world through their belief system; but some resulted from the very restrictions placed on them. Unable to own certain kinds of property or practice certain trades, Jews became active in learned professions such as medicine or ran pawn shops that serviced the poor. The success of the Jewish community in achieving wealth was often resented and mistrusted, characterized by fear of the "other," a fear made worse by that very act of marginalization.

Ignorance and prejudice inflamed rumors and lies about what those outside the Christian community were doing. The response to Jews was often dependent on circumstances outside their control, like recurrences of plague, a particularly effective preacher inciting Christian anger against them, or even the personality and prejudice of the ruler. During times of stress, Jews were sometimes identified as the cause, blamed either for committing terrible deeds (such as murdering Christian children or stealing consecrated communion wafers for secret rites) or for angering God because they had been permitted to live among Christians. Yet the treatment of Jews by their Christian neighbors varied dramatically from place to place and time to time. This was nowhere more evident than in Rome, where a Jewish population had lived since ancient times. Certain popes were mild, and the worst assault on Jews consisted of the annual Easter prayer for their conversion; other popes were vicious in their proscription of Jews and their activities, humiliating revered old men by forcing them to run races or to listen to sermons demanding their conversion.

Nevertheless, compared to other places in Europe in the Renaissance, the treatment of Jews in Italy was usually much more humane. Part of this was the influence of humanism and leading scholars like Giovanni Pico della Mirandola and his fellow Neoplatonists. Neoplatonists not only argued for the unity of truth in which all religions and philosophies

benefitted from some absolute knowledge and divine inspiration but also recognized the association of Moses and the Jewish cabala tradition with the mysticism of Hermeticism (see Chapter Ten). Access to this recondite knowledge required men like Pico to learn Hebrew through which they could make profound connections between the Jewish and Christian intellectual traditions. Also, Italians were cosmopolitan, urban, and accustomed to encountering people of different cultures; consequently, Jews were often permitted to practice useful occupations with some degree of protection as their skill and learning were respected and needed. Still, there was no security for any community outside the dominant culture: everything could change on the whim of a crowd, a pope, or a prince, and excluded communities such as those of the Jews had little resort to the protection of the law or even charity when threatened or abused. They consequently relied heavily on their co-religionists and established communities within communities that often flourished, such as the Ghetto (from the word for the foundry that was once on the site) in Venice, the part of the city where Jews were required to live but where they could follow Old Testament law and govern themselves with little intimidation from the Christian majority.

Some Christians were marginalized and excluded as well. Some of these were members of confessions described as schismatic, especially followers of the Orthodox Church that had separated from Rome in the schism of 1054. Others were persecuted as heretics, those who did not follow the teachings of the Roman Church. During the Renaissance, heresy was a complicated matter as it often had political implications. For example, as we will see in Chapter Eleven, Girolamo Savonarola was condemned and burned as a heretic because he preached that his prophecies came from God and because he instigated a popular movement against the Medici in Florence and the papacy in Rome. Also, the *Fraticelli*, a branch of the Observant Franciscans, were declared heretical in 1296 because of their demand that the order remain completely faithful to the absolute poverty of St Francis, preaching against the wealth and worldliness of the church and against the rich in towns and cities, spurring revolutionary ideas among the poor and threatening the property and power of the privileged classes. Heretics were feared and hated by many in the population and condemned by the Church because of the widespread belief that they could lead simple, honest people into theological error and endanger their souls; more dangerously, the presence of heretics was believed to bring down God's anger on a community.

In cities, heretics were usually identified and punished after a legal process that provided them with an opportunity to recant, that is, admit that they were wrong and the Church right. If they refused or lapsed once more into heterodox belief and proselytized, they were given over to the secular powers to be executed publicly as examples. In rural or remote areas, however, the problem of heresy was somewhat more subtle. Cities and towns mostly contained educated priests and bishops who could watch for errors and correct them quickly. But in the countryside were too often found woefully uneducated parish clergy who did not mean to lead their flocks into heresy but who misunderstood the basics of the faith or who had been trained by other priests who failed to comprehend the essence of Catholic Christianity. Isolation allowed heterodox ideas to germinate and spread without detection for some time as bishops' visitations to the margins of their dioceses happened

only seldom, if at all. And the degree to which heresy was investigated depended very much on the vigilance and energy of a bishop and his officials. With the condemnation of Martin Luther as a heretic in 1521, however, and the subsequent assault on heterodox thought and practice in Italy, this situation changed, particularly with the foundation of the Roman Inquisition in 1542, which determined centrally from Rome what was orthodox and what was heretical. Soon after, the reforms occasioned by the Council of Trent (1545–63), which led to the Catholic Reformation, resulted in more active bishops, the better education of priests, and clearer instruction for the faithful. Still, heresy was never altogether suppressed, and the fear in the community of the "other," whether isolated by heterodox belief or by a different culture and experience, remained strong and was manifested in other ways, like the persecution of women identified as witches.

To be outside the officially sanctioned community was therefore to be marginalized in almost every way. Even in the more tolerant societies like Venice, Jews, Turks, Orthodox Christians, and others could exist in relative peace *in* the dominant Christian community, but they were not *of* the community. They were required to live lives apart, often in fear and always under surveillance for real or imagined transgressions. In less tolerant places, the lives and property of such groups were always under threat, with expulsion, confiscation, or even death at the hands of mobs being real possibilities. Thus, despite its intellectually open and searching imagination, the Italian Renaissance was not free from the prejudices and fears of the communities that produced it. The philosopher and noble friend of Lorenzo de'Medici, Count Giovanni Pico della Mirandola (1463–94), was charged with heresy and had to flee Italy in 1488; the Dominican philosopher, astronomer and mathematician Giordano Bruno (b. 1548) was burned as a heretic in Rome in 1600.

Finally, for those whose predilections or practices put them not only outside the law and conventions of the community but outside its moral structure as well, there were serious dangers. Homosexuals were actively persecuted by both Church and state, the former because it was believed that they were disobeying a biblical injunction, the latter because it was believed that they threatened the institution of the family and jeopardized the increase or recovery of population required in a growing and well-ordered society. The state brothels in Florence were established in part, it was argued, to turn young men's temptations toward women and away from other men and to protect the honest women of the city. Popular preachers, including Savonarola (1452–98), damned homosexual practices viciously. Nevertheless, the known habits of popes, like Julius III del Monte (d. 1555) who made his young catamite a cardinal, were tolerated; and generally men with powerful connections or wealth could escape the barbarity of the punishment of gay men.

Similarly, women who fell from grace by working as prostitutes were shunned and humiliated, despite the fact that there were government-sanctioned brothels and that wealthy men, including cardinals and popes, openly kept mistresses (cardinal and later pope Alexander VI Borgia had four acknowledged children); and courtesans in cities such as Venice and Rome worked openly and almost honorably, as they were seen as performing a necessary service in a society where men married late—or in the case of the Roman clergy, not at all—and the reputations of "honest" girls were scrupulously protected by

family and the law. In both of these examples there was as much an element of class and privilege as there is of transgression. Powerful and wealthy men in both the Church and the state could expect to enjoy the favors of courtesans, who were perhaps better educated and cultivated than street prostitutes but who still in essence practiced the same profession. Poor women driven to prostitution by poverty, seduction, abandonment, or simple fleeting opportunity were publicly humiliated by having to dress in certain colors (often yellow), wear tall hats, and carry bells or other symbols of their lawful but barely tolerated trade. These women usually serviced men of their own condition and were seen as low as much for reasons of class as of morality. On the other hand, grand courtesans—*le cortegiane oneste* (honest courtesans), those who served rich patricians, noblemen, cardinals and popes—lived in beautiful palaces, traveled in coaches, and had poetry written about them just as they wrote verses themselves. They appear in the paintings of some of the greatest artists of the time, and while their reputations may always have been somewhat disreputable, they were nonetheless titillating and even appealing.

<p style="text-align:center">★ ★ ★ ★</p>

The Italian peninsula during the Renaissance, then, was a very complex place, defined by a dynamic variety of history, region, dialect, class, family, gender, occupation, education, and privilege. Any one of these subjects would provide the material for a book; but this book is about the Renaissance as a cultural movement, one in which some of the complexity is removed by the very real fact that those who created and commissioned this culture, those who paid for the experiments in art and architecture and who wrote about how the ideals of classical antiquity might be applied to their own time, represented an elite. Scholarship, artistic skill, political power, courtly practice, and mercantile ambition all presuppose some measure of wealth and training that puts their practitioners somewhat outside the quotidian activity of laborious lives, destined from childhood to contribute in other ways to the social fabric. The Renaissance was an elite movement, at least in its cultural manifestations, and this is what we will be exploring in the chapters that follow. This is in no way to denigrate or dismiss the contributions of the less privileged, regardless of their poverty and lack of power; and, as will be argued later, it is presumptuous and patronizing to assume that the simplest day laborer could not appreciate the transformations in art and building that appeared newly painted on the walls of their churches or the shape of the churches themselves. The ideas that animated the Renaissance, particularly the revival of antiquity, were indeed the result of leisure, education, and usually wealth; but their realization in the cities and towns of the peninsula, and the possibility of social mobility offered by new principles of government and experiments in different models of society, affected the lives and experience of every citizen in some way. The Italian Renaissance, then, is the story of a civilization, consisting of closely integrated elements that coalesced into a design for life and living. What emerged was a new set of models and ideas that found fertile soil for development in the Italy of the Renaissance, a dynamic change that began with the life and works of Francesco Petrarca, Petrarch.

FURTHER READING

Bell, Rudolph M. *How to Do It: Guides to Good Living for Renaissance Italians*. Chicago: University of Chicago Press, 1999.

Brown, Judith C., and Robert C. Davis, eds. *Gender and Society in Renaissance Italy*. New York: Longman, 1988.

Burke, Peter. *The Italian Renaissance: Culture and Society in Italy*. Princeton, NJ: Princeton University Press, 1986.

Cohen, Elizabeth, and Thomas V. Cohen. *Daily Life in Renaissance Italy*. Westport, CT: Greenwood Press, 2001.

Fumerton, Patricia, and Simon Hunt, eds. *Renaissance Culture and the Everyday*. Philadelphia: University of Pennsylvania Press, 1999.

Servadio, Gaia. *Renaissance Women*. New York: I.B. Tauris, 2005.

Sider, Sandra. *A Handbook to Life in Renaissance Europe*. New York: Facts on File, 2005.

Welch, Evelyn. *Shopping in the Renaissance*. New Haven, CT: Yale University Press, 2009.

FOUR

PETRARCH

PETRARCH'S LIFE AND CAREER

FRANCESCO PETRARCA ("Petrarch" in English) was born in Arezzo in July of 1304, the son of an exiled Ghibelline Florentine notary who had suffered from the same proscriptions that had banished Dante in 1301. Initially, the family lived at one of their rural villas at Incisa, about twenty miles from Florence, hoping to return to the city when the emperor succeeded in overturning the Guelf faction that had banished them. However, Petrarch's father realized this dream to be impossible after the emperor Henry VII died in Italy in 1313, a realization shared, we recall, by Dante, who had written his *De monarchia* for that same Henry VII in anticipation of a similar success. Again like Dante, Petrarch's father saw no point in waiting to return to Florence, so he left Italy altogether and set out with his family, including his young son, Francesco, for Avignon, the new seat of the papacy, in hopes of securing a position at the growing papal court. The need for trained bureaucrats at the new center of the Church ensured the experienced notary a place, and Petrarch's father was granted a job as a *scriba*, or letter writer, for the curia. Thereafter the family settled permanently in Avignon, apparently giving up any hope of returning to their native land of Florence. As a consequence, Petrarch had no memories of any native city, a circumstance that led him increasingly into introspection and self-analysis, helping to create the Renaissance sense of individuality, self-exploration, and self-image so central to the mind of our period.

Petrarch's father, like the fathers of most precocious children, had great ambitions for his son. He sent Petrarch to the University of Montpellier to become a lawyer. However, all the young man acquired was a deep devotion to the Latin classics and Cicero, as well as to Provençal love lyrics. Petrarch's father then sent his son to Bologna, again to study law. There, Petrarch sought pleasure rather than legal knowledge, but in so doing he made a number of important and lasting friendships, including Giacomo Colonna (1270–1329),

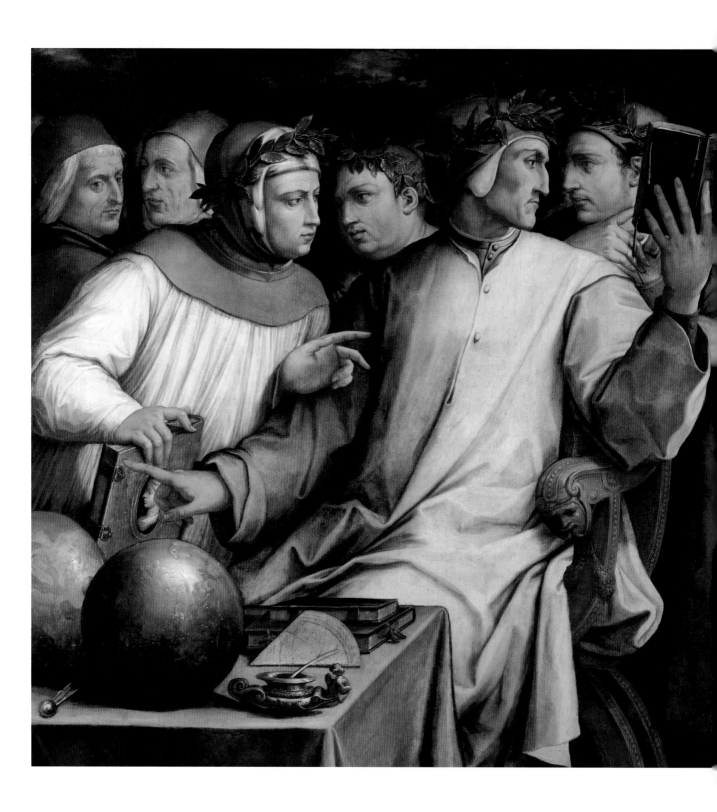

a Roman noble whose family was later to patronize the poet. Petrarch's father died in 1326 while his son was at Bologna, and subsequently his brother, Gherardo (b. 1307), to whom he had always been close, decided to enter a monastery. Hence, the young man was given sole possession of his family's modest fortune and devoted himself to a life of pleasure.

However, two events occurred that altered this rather attractive hedonism. First, in the Church of St Clare in Avignon on Holy Friday, 1327, Petrarch saw the woman who was to haunt him for the rest of his life: Laura. Like Dante with Beatrice, Petrarch believed he had seen the object of ideal, perfect love and proceeded, again like his predecessor, to idealize her in every way. Even more than with Beatrice, though, the reality was somewhat different. If the scholarly identification of the woman Petrarch called Laura is correct, then this Laura had been married for over twelve years to a French nobleman named de Sade (an ancestor of the infamous Marquis de Sade), had given birth to at least eleven children, and would die of the plague in 1348. Still, to Petrarch she was both earthly and heavenly perfection.

The second event was Petrarch's realization that he had wasted almost all of his inheritance on his elegant debauchery. Fortified with his new love and afraid of hopeless poverty, he decided to take a job. Fortunately, he was remembered by his old student friend from Bologna, Giacomo Colonna, who had become a bishop. This Colonna recommended him to his powerful brother, Cardinal Giovanni Colonna (1295–1348), of the papal court. So, in 1330, Petrarch entered the household of this man, one of the richest and most cultivated cardinals in Avignon.

During the next years, Petrarch's already remarkable personality experienced more profound influences. During 1333 he traveled widely through northern Europe and returned to Avignon thinking northerners to be barbarians, strengthening his sense of being Italian. (Petrarch does call the peninsula *Italia*, as reflected in his famous poem *Italia mia*, later used by Machiavelli in Chapter 26 of *The Prince*.) Also, the pope, in recognition of a flattering poem, gave Petrarch a benefice, one that required minor orders, which he gladly took: Petrarch formally entered the service of the Church as a cleric. And, significantly, he began a close reading of St Augustine, a figure who was to influence him throughout his life. This contact made Petrarch decide to devote himself more to God, now that the Church had provided a living.

He then traveled to Rome to see the Holy City. However, while there he was seduced, not so much by women this time, or even by religion, despite his good intentions, as by the glories of the ruins of antiquity already dear to him from his reading of Cicero. Petrarch's intuitive and temperamental love of classical antiquity was greatly strengthened by his personal contact with its ruins. He nevertheless returned to Avignon and built a small villa at Vaucluse in the valley of the Sorgue River, where he lived for the next fifteen years and produced the greatest part of his work.

These writings—especially his vernacular love sonnets to Laura—made him famous. Indeed, he was so famous that the citizens of Rome invited him to be crowned with laurel on the Capitoline hill, a public recognition of poetic ascendancy not seen in thirteen hundred years. Petrarch, vain man that he was, accepted, and on Easter Sunday 1341,

Figure 4.1 (facing page)
Minneapolis, Minneapolis Institute of Art (The William Hood Dunwoody Fund.) Giorgio Vasari (1511–74): *Six Tuscan Poets* (1544). This imaginary group portrait of the poets Dante, Petrarch, Boccaccio, Cavalcanti, Ficino, and Landino honors their contributions to the Tuscan dialect. Dante is the central seated figure holding a book high in his hand. Petrarch, crowned with laurel and wearing a white robe, leans across Dante's arm.

the poet was crowned by senators of Rome. Perhaps driven by sincere humility, but probably motivated by a natural sense of theater, the poet laureate laid his wreath on the altar of Old St Peter's. This lust for fame in this world was one of Petrarch's, and in fact the Renaissance's, determining characteristics. The lexical relationship between Laura and laurel is not, therefore, accidental.

After a few adventures in Italy—which was tearing itself apart in endemic warfare that seemed to follow Petrarch as he traveled—the poet returned to Avignon, where he learned the very disturbing news of the death of his old friend Giacomo Colonna. He also wrote another new poem for another new pope and hence got another new benefice. Subsequently he was sent by the pope on a diplomatic mission asserting the pope's claim to rule as regent during the minority of Queen Joanna of Naples since that kingdom was a papal fief. Petrarch, apparently, did not do too well, and he had come to dislike what he saw as the brutality of Neapolitan gladiatorial combat. So again he moved north, intending to live permanently in Italy; however, he eventually returned to Avignon, expecting to retire to his villa. But in the interim, the terrible Black Death, the plague of 1348–49, had broken out, and two of its victims were Petrarch's patron, Cardinal Giovanni Colonna, and his beloved Laura.

Petrarch, having lost his two fixed points in life, began to wander again: Padua, Rome, Arezzo, and back to Padua. His friend Boccaccio invited him to teach at the new university in Florence for a good fee, but Petrarch refused. Briefly, he returned to Vaucluse but found his position there greatly changed by the death of his patron. Moreover, the new pope, Innocent IV, disliked Petrarch, believing him to be a sorcerer because of his love of secular solitude. Therefore, in 1353, almost fifty years old, Petrarch returned permanently to Italy.

First, he lived at the court of Milan for eight years as an honored guest, much to the dismay of his friends, who saw the Visconti rulers of the city as tyrants and the enemy of Florence. Milan, though, was a Ghibelline city, and Petrarch had embraced the cause of the emperor Charles IV when that monarch sought his coronation and some tribute from Italy. Later, the poet was chosen by the Milanese to serve as an ambassador to this emperor Charles, so Petrarch attended upon him in Prague. Not long after, Petrarch was chosen for another diplomatic mission, this time to Paris: the poet was a valuable asset to the Visconti court of Milan. And he in turn had the opportunity to travel widely and expand his human experience, using his learning, fame, and eloquence in the service of the Milanese state, despite his love of scholarly isolation.

In 1361 plague drove Petrarch from Milan, first to Padua and then to Venice where he presented his magnificent library to the people of that city. The now old man lived there for some years with an illegitimate daughter, Francesca (b. 1343). (Petrarch had also sired a natural son, Giovanni [b. 1337], for whom he had aggressively sought patronage in the Church, but Giovanni, too, died of the plague in 1361.) Eventually, Petrarch set out again on his travels, this time back to Padua. He hoped to return to Rome, where there were expectations that the papacy would soon be re-established and where he had promises of great honor. Unfortunately, he took ill just outside the city of Padua and was carried

back to a small villa he owned at Arquà (now Arquà Petrarca), where he died soon after in 1374, his head resting on a book.

Petrarch's writing made him perhaps the most celebrated man of letters of his time, but there is much irony here. He himself saw his Latin works as his greatest contribution to literature and the revitalization of European culture. The *Africa*, for example, a Latin epic poem based on the life of Scipio Africanus, was believed by Petrarch to rival the greatest works of Virgil. Petrarch was quite alone in this opinion, however. The *Africa* was neither well received in the past, nor is it read today. In fact, Petrarch's contemporaries and his successors considered his true genius to be found in his Italian lyrics, his *canzoniere* (*Song Book*).

His letters, which he collected, edited, and copied himself, are another source of his enduring fame. These letters to men famous and obscure reflect his thought, attitudes, reading, and self-awareness. He wrote letters not just to important contemporaries, offering advice or responding to their questions, but also to posterity and to the ghosts of great Romans, such as Cicero, offering them advice as well, from the vantage of thirteen hundred years later. These letters illustrate a very self-conscious, reflective, learned, vain, but often conflicted man in search of who he was and the motivation for his actions, and the very real spiritual and psychological battle he was fighting with himself and his world. He wrote of books and of love and of his respect for classical antiquity, searching to reconcile the paganism of figures such as Cicero and Seneca (c. 4 BC–AD 65) with his sincere Christian belief. He was clearly struggling to accommodate the reality of his own world with his profound belief that he had been born outside his time—which would have been that of ancient Rome if he had enjoyed the privilege of choosing the date of his birth.

The great importance of Petrarch is as a transitional figure between the older values of the Middle Ages and the newer ones of the fourteenth century in Italy. He exhibits a rather severe ambivalence about his value structure, principles, and taste. For example, he wrote a long book on the glories of the monastic life (*De vita solitaria*), and he wrote a letter to the spirit of Cicero, attacking him for his continued involvement in politics in old age, a fact Petrarch only rediscovered for the world with his unearthing of the previously lost *Letters to Atticus*, which he found in 1345 in the cathedral library of Verona. And, of course, Petrarch himself lived the solitary life of a stateless wanderer, never settling anywhere for any length of time, except for at his villa at Vaucluse.

Despite this, Petrarch was also an early proponent of the active life for others if they could benefit their native lands. He wrote to a French nobleman, the ruler of the Dauphiné,

Figure 4.2 Petrarch's Villa at Arquà Petrarca. Apart from his work as a scholar and poet, Petrarch was an avid gardener. He experimented widely with rare plants and the grafting of trees at his country villa in the town of Arquà in the Euganean Hills.

who had expressed a desire to become a monk, that he should continue to carry his responsibilities, especially in challenging times; and he repeated this advice to a German merchant who wished to follow the example of St Francis. His duty, Petrarch wrote, was to his *patria*. Petrarch was clearly ambivalent about whether a man should live apart and exemplify the monastic ideals of the Middle Ages or enter completely into the life of the community and realize the principles of civic virtue, the ideology of the fifteenth-century Renaissance. Perhaps Petrarch's own solitude was a function of his experience as a *déraciné*, a child of exile. If he had had a *patria* himself, his life and ideals might have emerged more clearly on the side of the *vita civile* (active life); but they did not.

Equally, the role of human emotion and individual action is found to be a complicated matter in Petrarch's life and writings. He always remained alone, never marrying, and even accepting Church benefices that required him to take minor orders—but he had at least two illegitimate children, perhaps more unacknowledged, and perhaps by more than one woman. He idealized love in his worship of Laura, whom he compared to the Virgin Mary; but he engaged in a life of remarkable physical sensuality, especially in his youth, the very period of his adoration of the living Laura. He accused Virgil (70–19 BC) of having been too bold, almost lurid, in his description of the love between Dido and Aeneas (Book IV, *Aeneid*). However, Petrarch's own book describing life at the papal court of Avignon, his *Liber sine nomine* (*Book without a Name*), contains some of the most scurrilous passages then on paper. And so it continues: he believed in Christian humility and charity, he wrote, but he was also extraordinarily vain and desirous of fame in his life. He was a dedicated Ghibelline, a follower of the Holy Roman Emperor in Italy, on whom he actually attended as a diplomat, while at the same time he vilified Julius Caesar for destroying the Republic and the virtues of the Roman people; and he wrote what he believed to be his *magnum opus* on the republican hero Scipio Africanus. He said he hated tyrants, but he loyally served the Visconti of Milan, among the most tyrannical of them all, while carefully avoiding the city of Florence, the bastion of republican freedom. He continually attacked the ambition, nepotism, and venality of the Avignon papacy, but he used all of his contacts, energy, and some considerable wealth to have his illegitimate children legitimized and his irresponsible son, Giovanni, advanced in the Church, in contravention of canon law.

In short, Petrarch was a cultural schizophrenic, and he knew it. And it was perhaps in this self-knowledge that he made one of his greatest contributions to posterity. In a famous work, his *Secret Book* (*Secretum*, in Latin)—in some ways the first modern psychological autobiography—he tried to resolve this dichotomy by fabricating a dialogue between the two parts of this nature, one represented by the human Petrarch (Francesco), the other by his Christian hero and alter ego, St Augustine. In the end, Petrarch the man yields before the faith and reason of the saint. But no one is convinced: Petrarch will continue to seek fame, women, experience, and self-knowledge.

Here is Petrarch's true claim to be the first Renaissance man. Of course he shared many of the characteristics of his predecessors, but he also saw a new world opening up, through the study, recovery, and imitation of ancient texts. Moreover, Petrarch went one step

beyond this: he tried to live these principles. He was crowned on the capitol, an honor he almost certainly arranged for himself; he saw the glory of Roman civilization and felt that it could be restored through proper Latin style, modeled on those golden-age authors he so admired. He even tried—unsuccessfully—to learn Greek. The medieval scholastic method had to be rejected and a new regimen of humane letters, based on classical models, put in its place. Finally, and most importantly, Petrarch studied himself. He was introspective, curious about his human nature, and analyzed it continuously, not only in the *Secret Book*, but also in his letters, his poetry, and his prose. He thought of himself as a heroic individual, cut off from the past but still part of human history and culture. He was a man of no political allegiance, but still desirous of freedom as a principle, a Christian who recognized his inability—or unwillingness—to curb his propensity to the worst of the deadly sins, Pride. Petrarch, then, had many roots in his medieval past but powerfully recognized a new model of scholarship and behavior, based on individual achievement and self-knowledge in a secular context, and fortified by knowledge of the ancient world.

PETRARCH AND EARLY HUMANISM

It is because of these contradictions and confusions that the life and thought of Petrarch clearly exemplify the character of early humanism. In essence, humanism was the ideology of the Renaissance, a new method of education and thought that was designed to replace the scholastic method of Aristotelianism that Petrarch so hated. Dante had not only accepted scholasticism, but it was also part of his worldview; Petrarch, however, vilified it in all possible ways. It is for this reason, too, that Petrarch deserves to be seen as in the vanguard of the Renaissance.

Petrarch disliked scholasticism for a number of reasons. First, he thought that the style of Latin in which scholastic works were written was barbarous and loathsome and very unlike the classical prose of Cicero that he had learned to love and appreciate as a young man. In short, scholasticism was ugly and unaesthetic to Petrarch, and he wished a return to the pure Latin of the late Republic. Second, Petrarch disliked what the scholastics wrote. He saw no value in esoteric arguments about minute points of faith—how many angels can dance on the head of a pin—when men had the guidance of Church fathers such as St Augustine, who required no commentaries or glosses and who wrote, moreover, in a beautiful, rhetorical, classical style. Furthermore, Augustine's Platonism attracted idealists such as Petrarch far more than the analytical Aristotelianism of the scholastics. Third, Petrarch was most concerned with man's humanity, who he was and what he was born for, as he remarks himself: "What is the use—I beseech you—of knowing the nature of quadrupeds, fowls, fishes, and serpents and not knowing or even neglecting man's nature, the purpose for which we are born, and whence and whereto we travel?"[1] (*On His Own Ignorance,* 58). This central concern with self and the human experience dominates all of Petrarch's works. In a famous letter he wrote after climbing a mountain in France, Mont

Ventoux, for no other reason than because it was there, Petrarch suggests not only the potential of individual power, but also a new relationship with nature and even literature and the past. When he was on top of the mountain, Petrarch took out his copy of St Augustine—which he carried everywhere with him—and saw the connections between the experience, vision, style, and education of this late classical saint and his own sense of himself and the world, fortified, rather than simply rebuked, by the saint's advice.

Nevertheless, we must still place Petrarch at only the very beginning of the movement called Renaissance humanism. Petrarch might have popularized the principles of early humanism, but, given his transitional state, he personified them only imperfectly. And here it is important to stress *early* humanism. Petrarch's intellectual principles were not as developed as those of the fifteenth century: for example, his literary interests were only in Latin, because, although he tried, he never learned Greek. Also, he lacked any sense of civic involvement: he remained forever stateless and never sought to serve as a politician. Finally, Petrarch in no way institutionalized his humanistic interests, always choosing instead to lead a singular, wandering life unencumbered by responsibilities. Still, he must be seen as the spiritual father—or perhaps a midwife—of humanism.

Petrarch's role, therefore, is central. But how do we move from this unusual, gifted individual to the system of education and knowledge based upon a deep and profound reading of classical literature, a system that lasted virtually intact almost until our own time? In short, can we find in Petrarch's life and principles a clue to the intrinsically curious belief that all a statesman, governor, or civilized citizen needs to know is ancient literature, the foundation of the course of study in elite schools and the humanities curriculum of liberal arts colleges everywhere?

Indeed, there is a connection. When Petrarch studied at Bologna, he studied Roman Civil Law, the law of the Roman Empire encoded by Justinian and reflective of the values of Roman society. Also, to learn pleading and the practical use of the law, Petrarch read the forensic orations of Cicero, the greatest courtroom spellbinder of antiquity. However, when he read Cicero, Petrarch read him not only for the law and for legal procedure, but for the beauty and glory of his language—his use of Latin. Thus he was attracted to the elegant language and beauty of the style of Cicero through his natural sense of taste and his hatred of scholasticism and medieval Latin style. But he did more: he saw the practical value of the content of the Latin literature he was reading. Petrarch realized that human experience in this world could be extended by a thorough knowledge of, or at least a familiarity with, the great masters of antiquity. These ancients had more to impart than good style: they had knowledge of life and of human nature and represented the highest products of the mind and spirit.

Petrarch went further still, paraphrasing an important section of Quintilian's *Institutio oratoria* (first century AD) also found in Cicero, writing that speech functions as the index to the soul, and that dignity of speech is informed by the dignity of the soul. There is an indissoluble connection between the mind and speech, between word and thought. Good letters equal good people! And by extension, Petrarch continued, the value of speech lies in the fact that human conversation has the power to elevate. He wrote that we must

endeavor to help those with whom we live, and no one can doubt that we are of great use to their souls through our words. From eloquence comes truth.

This important observation of Petrarch's reveals that he discovered two of the most critical aspects of a humanist education. First, the works of classical antiquity have great value to humanity in themselves because of both their style and their content. By saying this, Petrarch once and for all destroyed the old double vision with which western Christianity had approached the classical past. Christians had always loved its beauty and profundity but hated its paganism and openly feared its sensual attractions, fearing the seductiveness of paganism and sin. This ambiguity is reflected in some of early Christianity's most poignant moments. When, for example, in a dream Christ accuses St Jerome, the translator of the Bible into Latin (the Vulgate), of being more a Ciceronian than a Christian, the heritage of ancient, pagan wisdom and literature is called into question; also, the Roman author Tertullian (c. 160–c. 225) asked in despair, "What has Athens to do with Jerusalem?" (*De praescriptione haereticorum*, ch. 7). For Petrarch, these concerns cease to be problematic because he implies that the pagan ancients were good men in themselves, as illustrated in their good letters and good works, and, as such, they have much to impart to modern readers. Morality and virtue are constants, transcending even the Christian dispensation because they relate to our own human experience in this earthly life.

Second, Petrarch introduces a theme that he himself did not closely pursue but that would dominate the humanistic thinking of the Florentine republic in the next century and hence lead humanism into a new sphere of importance, as we shall see. Good letters, good style, and good speech are *social* virtues. They are not only for the solitary, wandering scholar, like Petrarch, for example, but for all humanity. They serve to unify people, leading them to good actions and away from vice; they provide them with good government and destroy tyrants; they help us distinguish between the just and the unjust.

This dedication to the values of classical antiquity and the belief that good citizens with good rhetorical style could influence their fellows to good purpose, when merged with the political and social environment of Italian republics and even despotisms, gave rise to civic humanism. It reinforced the sincere conviction that individuals, acting alone or as a community, could do anything and that what they did would be good because their actions conformed to certain principles: the principles of classical antiquity as recorded in the best ancient texts by the best authors. The republican magistrate would follow the true and the just and convince his fellows through rhetoric and moral persuasion to adhere to just and fair values. The good counselor would provide good, moral counsel to his prince; and ideally the prince himself would be a philosopher king. These ideas came from humanism and entered not only the education but also the collective thought of western Europe. Petrarch had allowed for classical moral philosophy, especially the stoicism of Cicero and Seneca, to replace the subtle distinctions of the scholastics, whose attempts to justify the ways of God to man in a theocentric universe had resulted in a sterile, now pointless vision of fruitless debate over insignificant issues.

Petrarch's ideas had a power to animate a new approach to questions of the human condition; and his wide circle of correspondents and the popularity of his writing spread

these principles throughout Italy. First, ancient literature was recognized as important for its content as well as for its style; it had something fundamental to say to Italians of Petrarch's generation. Second, this message was closely linked to the power of words: good thoughts, good words, good style, and good citizens were all necessarily linked. The example of Cicero indicates this connection perfectly. Cicero was seen by Petrarch not only as a statesman, lawyer, and politician but as a moral philosopher. Moral philosophy is the study of human ethics based on an anthropocentric (man-centered) rather than a theocentric (God-centered) conception of the world. Justice, principles, and ethics must be seen to pertain to the human condition and human experience, not just to absolute divine injunctions. For Petrarch and his disciples, Cicero offered just such a guide for life; and the value and essential validity of his message is made clear by his rhetorical skill. His language convinces us that he is right, so he must be right, given the necessary connection between good letters and good thought.

For humanity in general the contribution of Petrarch in bridging the pagan and Christian worlds is of immediate importance. But what exactly did Petrarch find in ancient literature that led to his adoption of it as a guide to life? Obviously, he discovered answers to the questions that consumed him. These questions concerned the very nature of what it means to be human: Who am I? Why am I what I am? In short, through studying ancient literature, Petrarch conducted research into human nature in general and himself in particular. He was looking for a humane philosophy that would concern itself with mankind and with the terrestrial city built by man. The city of God, he insisted, is closed as far as the finite human mind is concerned; it would therefore be senseless and impertinent to attempt to penetrate it. Petrarch liked to rehearse the epistle of Paul from Acts 14:22: Who knows the secrets of God? Who is a party to his counsels? Since mankind's only reasonable concern was the human condition, there needed to be principles identified around which we might build our own lives on earth. These Petrarch found in the classics, especially Cicero. The moral philosophy of this ancient author, as well as that of Seneca and of St Augustine (whom Petrarch and most other Renaissance writers saw as a classical author), provided the moral principles for a good and humane life. They did not necessarily contribute to the salvation of the soul—that was the unequivocal privilege of religion—but they did offer a guide to living a worthwhile and successful life on earth in the human community.

If this was to be accepted as valid, then the wisdom and experience of the ancients had to be known in its entirety, at least to the extent possible after the passage of a thousand tumultuous years. It was necessary to recover ancient books and authors who had been neglected throughout the Middle Ages because their content was seen as of little value to the Christian life or the scholastic mind. The result was the ever more widespread search for classical manuscripts by Petrarch, his friends, and his successors. And how successful they were in recovering the learning and wisdom—not to mention the exquisite literature—of the ancients, which in some instances, such as that of Lucretius, had been effectively lost to western civilization for a millennium. Petrarch himself stimulated this process with his discovery, mentioned above, in 1345 in the cathedral library of Verona. He found the most

dramatic—and for Petrarch traumatic—treasure of his generation: Cicero's lost letters to his friend Atticus and his brother Quintus. These letters changed forever the Western appreciation of Cicero. He no longer appeared as the solitary scholar living in his villa in Tusculum, a misogynistic, stoic philosopher, concerned with age, duty, friendship, and political morality; he now emerged as the ambitious, grasping politician who worked his way to the top and could not let go, a failure that resulted in his murder as an old man at the hands of Marc Antony's thugs. It is this Cicero whom we would come to know and who would become the secular saint of the civic humanism of the fifteenth century. To Petrarch, though, his idol was tarnished, almost desanctified. Petrarch was so upset that he did what he always did under such circumstances: he wrote. Logotherapy seems to have been central to Petrarch's self-administered psychological regimen. He wrote a letter to the shade of Cicero, berating him for his political life and asking why he could not be content with philosophy and solitary wisdom. It was to be the next century before Cicero replied to Petrarch through the channeling of that civic humanist, Pietro Paolo Vergerio (1498–1565), who said that knowledge and experience are useless if not applied to the well-being of one's community and one's fellow man, and that it was Petrarch who was a disappointment, not Cicero.

Still, the search for lost classical works continued. In the half-abandoned monastic library of St Gall, in modern-day Switzerland, Boccaccio found two works of the first century AD: Asconius' commentaries on Cicero and Valerius Flaccus' *Argonautica*. Early in the next century, Poggio Bracciolini (1380–1459) recovered the complete text of Quintilian's *Institutio oratoria*, Lucretius' *De rerum natura*, and many other texts. As a result, in a very few years almost the entire corpus of surviving Latin literature was again available to the West. Of course, in the full flight of enthusiasm, the dross was received with the gold; but in essence the work of those first generations of humanist scholars reintegrated those shards of the fragmentary heritage of the ancient world that had fortunately survived and then transmitted them to us.

Besides finding lost works, these humanists desired to read what they found in their original form. Given the belief in the necessary connection between style and content, truth and words, it was important that contemporary readers have access to the pure thought and words of ancient authors. Their texts had to be cleansed of the errors of thousands of years of re-copying and misunderstanding in order to recover the pristine text. Therefore, the humanists invented the sciences of philology, textual editing, archaeology, numismatics, and comparative stylistics. These skills developed so quickly that before the middle of the next century Lorenzo Valla (1407–57) could reveal the forgery of the Donation of Constantine, illustrate through style and philology that the Apostles' Creed had nothing to do with the Apostles, and suggest that even St Jerome, a Doctor of the Church directed by the Holy Spirit, had made errors in translation in the Vulgate. Dionysus the Areopagite with his celestial hierarchies became the pseudo-Dionysus and was in fact identified as a committee working over a great many years.

Truth through the word had taken yet another form: true words had to be revealed before the truth of the content could be seen. Texts were investigated with the most

fastidious thoroughness, edited, re-edited, studied, and annotated. There was, of course, the Christian tradition of biblical exegesis in support of the message that the truth resides in the very words of texts. But there was a significant difference: these texts were not studied to support a message accepted as true *a priori*: they were dissected and studied to reveal truths not known before. With the humanist fixation on the word and the text, the modern concept of scholarship was born.

NOTE

1 Petrarch, *On His Own Ignorance,* in *The Renaissance Philosophy of Man*, ed. Ernst Cassirer, Paul Oskar Kristeller, and John Herman Randall, Jr. (Chicago: University of Chicago Press, 1948), 58.

FURTHER READING

Larner, John. *Italy in the Age of Dante and Petrarch: 1216–1380*. A Longman History of Italy. Vol. 2. New York: Longman Group, 1980.

Petrarch. *Canzoniere*. Trans. M. Musa. Bloomington: Indiana University Press, 1999.

———. *Invectives*. Trans. D. Marsh. Cambridge, MA: Harvard University Press, 2008.

———. *Secret* Book. Trans. J. Nichols. Foreword by Germaine Greer. London: Hesperus Press, 2003.

Wilkins, E.H. *Life of Petrarch*. Chicago: University of Chicago Press, 1961.

———. *Studies in the Life and Works of Petrarch*. Cambridge, MA: Medieval Academy of America, 1977.

FIVE

HUMANISM

HUMANISM HAS BEEN defined generally as the central cultural expression of the Renaissance. This definition has nothing to do with the twentieth-century belief in human or humane as opposed to material or purely scientific values. Instead, it traces its etymological roots to late medieval student slang. In the Italian universities a *(h)umanista* was a professor of the *studia humanitatis*, that is to say, humane—or secular—learning canonized in a course of studies that had developed in Italian universities by the early fourteenth century. This curriculum was one of liberal arts: the learning that was appropriate to free (*liberalis*) individuals. Its subjects were rhetoric, moral philosophy (ethics), history, and poetry. Clearly, the emphasis was on human values and experience; and, as we saw in Petrarch, it represented a reaction against the old scholastic curriculum of the trivium (grammar, logic, and rhetoric) and quadrivium (arithmetic, geometry, astronomy, and music) that were the foundation of the medieval, scholastic curriculum. Humanism, however, was far more than a method of education in the Renaissance. It was a large and often amorphous description of a body of knowledge based upon ancient sources and a particular set of attitudes, as well as a vehicle for taste and style in art, architecture, and literature.

All historians would see certain elements of Renaissance thought and culture as essential to an understanding of humanism. The most prominent of these is the recovery, study, transmission, and interpretation of the heritage of classical antiquity. Second, humanism is characterized by a transformation in the style and content of literature to reflect ancient models and principles (both Latin and Greek). Third, humanism implies an emphasis on moral philosophy (ethics) at the expense of theology and scholastic reasoning. And, finally, it promotes naturalism in art, in that what was portrayed reflected what the eye sees, with correct anatomy, accurate perspective, and true representation of the natural world. But what does this list of categories really tell us about the Renaissance mind? Why did Italians develop these elements of humanism in the fourteenth century when northern European scholars were still debating the scholastic interpretations of scripture and nature of John Duns Scotus (c. 1265–1308) or William of Ockham (c. 1288–c. 1348)?

The first thing to note is that scholasticism never did monopolize the Italian educational system as it had in northern Europe. Scholasticism was largely a trans-Alpine movement, centered at the University of Paris, despite the fact that its greatest exponents, such as Peter Lombard (1100–60) or Thomas Aquinas (1225–74), were Italians. Rather than developing from the scholastic system of thought or education, then, humanism developed from an institution peculiar to Italy: the profession of the lay rhetorician, that is, a practitioner of the *ars dictaminis*. This was a tradition of teaching formal rhetoric and letter writing for use in secular life. The need for effective writing skills in the secular sphere survived the collapse of the Roman Empire as did urban life: there was a continued need in Italy for professional letter writers, secretaries, orators, lay ambassadors, and merchants. Because there was in Italy some measure of local and even long-distance trade and hence the need for contracts and correspondence as well as the opportunity to contribute to the governing of one's native city, secular, practical learning and the management of words remained an important occupation.

Practitioners of the *ars dictaminis* began early to scour Latin prose works for elegant models, allusions, and phrases to ornament their own Latin style. With the worship of classical style came the motivation to uncover hitherto unknown classical texts. Throughout the late Middle Ages the *ars dictaminis* spread and grew in importance, not only because urban secular life was becoming more active in various Italian communities, but also because the best practitioners controlled the profession, acquiring the most prestigious university chairs in the *studia humanitatis* (such as those in rhetoric, poetry, or moral philosophy), the best school masterships, and the best jobs as chancellors, secretaries, and ambassadors in Italian city republics and at the courts of princes and popes. As a result, a market for Latin style developed, and the pace of production of such scholars quickened.

There are two important points to note about this development of early humanism from the *ars dictaminis*. First, the movement was secular in nature, training, and intent. Second, it was practical, a functional program that applied particular skills to the immediate needs of a secular society. Clerics, by contrast, were educated according to the old scholastic method in which theology was explicated by Aristotelian philosophy. The language and style and even the cast of thought of clerics did not equip them to pursue careers as notaries, secretaries, or administrators whose skills had to be rhetorical and who wrote to other humanistically trained secretaries in the conventions of their shared profession. In addition, the intent of these letters and dispatches was in no way abstract. Rather, they were concrete and immediate, addressing the practical needs of city governance, diplomacy, and international trade.

This developing practice of humanism flourished in the fertile soil of Florence. The reasons for this are many and varied: the city was rich and hence could support a large leisured class of learned laymen; it was a mercantile city and therefore had a long tradition of secular education and a large elite of merchant patricians; it was a cosmopolitan city with long-distance trading links throughout the world and consequently open to new ideas; it was a republic and hence very receptive to the republican, urban ideals of ancient Rome; it could provide much employment for secular scholars as writers, orators,

notaries, and secretaries; and it numbered Boccaccio and Coluccio Salutati (1331–1406) among its inhabitants.

Because Petrarch, for reasons already mentioned, refused to return to Florence, Boccaccio felt it his duty to bring Petrarch's ideas to his ancestral city. Boccaccio taught, spread, and popularized Petrarch's belief in the special value of ancient culture. Boccaccio's heir as the chief disciple of Petrarch's principles, Coluccio Salutati, became chancellor of the republic of Florence, a post he held until his death in 1406. Salutati had trained as a notary and had held important positions in a number of other Italian cities. He had long corresponded with his hero, Petrarch, and shared with Boccaccio a fervent desire to practice the values set forth in ancient literature. He, unlike the non-political Petrarch and Boccaccio, enjoyed a unique opportunity through being selected as chancellor of the republic. Although Salutati was a transitional figure in the development of humanism, he established an important example. He remained throughout his life a very devout Christian who fluctuated between sustaining the medieval values of a contemplative life while exemplifying an active, secular life of political and scholarly activity. He married and had children, and he attracted those whose commitment to an active, secular life was perhaps even greater than his own. This coterie of young men trained in secular learning and devoted to classical literature and the active life provided candidates for administrative offices in Florence and elsewhere; and the model of an engaged secular life increasingly was seen as a route to success, riches, and influence. Thus, the chancellorship of Florence from Salutati until the end of the republic reads like a catalog of Florentine humanists: Salutati, Leonardo Bruni, Carlo Marsuppini (1399–1453), and Poggio Bracciolini, just to note the most celebrated. Indeed, so many of the great figures of the humanist movement held that post that it became almost a measure of a scholar's stature.

The chancellory was the highest non-elected office in the state, and it was awarded for rhetorical elegance and power. The chancellor was the official letter writer of the *signoria*, its voice and style to the outside world. It was Salutati who used his eloquence to defend Florence and its republican liberties from the despots who wished to expand at its expense. He wrote, harangued, cajoled, propagandized, and attacked the Visconti of Milan, the papacy, and the kings of Naples, and any other threat to his city's freedom. Duke Giangaleazzo Visconti (1351–1402) was said to have remarked that one letter from Salutati was more effective than a hundred lances on the field.

In Salutati we can also see the growing maturity of that second aspect of humanist thought, embryonic in Petrarch but destined to develop in fifteenth-century Florence into civic humanism. The values of the ancient world had come to provide the energizing myth of the republic of Florence. In his studies of ancient literature, Salutati sought manuscripts with better or more complete texts of Latin authors; and he began to study Greek, although he never mastered the language. In 1396 as chancellor, he did, however, arrange for the Florentine *studio* to establish a chair in Greek, to which Manuel Chrysoloras (1355–1415), the great teacher in Italy of ancient Greek language and literature, was appointed. Salutati's collection of over eight hundred manuscripts became an important resource for later humanist scholars, and the methods of textual editing and philological analysis

he developed established Florence not only as a center for an engaged humanism of civic action but also as a place where young men could learn Latin and Greek and acquire the skills to understand ancient texts and apply their content and style to their own lives. His discoveries, including the lost letters written by Cicero to his friends (*Litterae Familiares*) and his historical studies of the Florentine state, which were to greatly influence later historians such as Leonardo Bruni, succeeded in shifting the perspective of educated Florentines away from their traditional assumptions about Florence's past.

Salutati was in many ways a transitional figure, however. He felt the need, like Petrarch, to seek to harmonize the morality of pagan letters with Christian revelation, and he continued to value the practice of the contemplative as well as the active life. He wrote in praise of the retreat from the world in monasticism (*De seculo et religione*, 1381) and believed that human reason was insufficient without divine guidance. Nevertheless, he wrote a book comparing the practice of medicine with that of law (*De nobilitate legum et medicinae*, 1399) in which he suggests that lawyers are of greater value because of their involvement with civic society and their active dedication to helping solve the problems of secular life. But his commitment to divine inspiration remained, and his conclusions were ambiguous. His political positions were equally traditional. In his *De tyranno* (1400), he praises monarchy as the ideal form of government and seems to be following the principles of Dante's *De monarchia* (c. 1312) by proposing a universal empire to bring peace and unity. Although working for a republic and using his rhetorical skills to help defeat Giangaleazzo Visconti, Salutati continued to be imprisoned by the Aristotelian belief that only monarchy could bring stability, a perspective perhaps reinforced by his close observation of the Florentine republic from within. Salutati, then, exhibited a kind of intellectual and cultural tension that made a complete commitment to civic humanism impossible. It was more in the model of his secular, conjugal, active, and engaged life that Salutati moved humanism increasingly into the sphere of political affairs and out of the realm of speculation.

THE CIRCLE OF SALUTATI

During the chancellorship of Salutati, a group of men, secular in their occupations and lives and humanist in their education and tastes, gathered around that statesman-scholar. Of these the most important were Niccolo Niccoli (1363–1437); Poggio Bracciolini; and Leonardo Bruni. Although all were associated with Salutati, they were not identical in outlook. Niccoli, especially, differed from his fellows and exhibited a character at once imperious and withdrawn. Born in Florence into great wealth, he chose to devote his life to antiquarianism and scholarship. Even more so than Petrarch, Niccoli thought that a scholar's life excluded government and civic responsibility, a belief that was greatly at variance with the later opinions of his colleague Bruni. Niccoli, although he lived well into the *quattrocento* (the Italian term for the fifteenth century), in reality represented the first phase of Italian humanism. Indeed, Niccoli was intellectually more conservative than

Boccaccio—who had died in 1375—in that he believed the vernacular to be infinitely inferior to Latin for all purposes, and hence for him even Dante, Boccaccio's hero, was a minor, lesser figure. Still, Niccoli is important for an analysis of Italian humanism in the fifteenth century because of this antiquarianism. Aided by his wealth, Niccoli collected the greatest private library in Florence, full of the best editions of Greek and Latin texts then available. Partly because of his absolute refusal to enter politics (and thereby rig the tax assessments in his favor as did other Florentine politicians), partly because he ceased to sustain the business ventures that his family had built, and partly because he spared no expense buying books, Niccoli died relatively poor. But the wonderful library with its hundreds of superb volumes that he bequeathed to Cosimo de'Medici became the nucleus of the great Laurentian Library in Florence, later deposited in a building designed by Michelangelo and destined to become perhaps the second most important public library in Europe, open to all scholars and thus a great source of material for study and inspiration to generations of Florentine humanists, a collection second only to that of the Vatican library in Rome.

If Niccoli represented the old-fashioned humanist, the aloof scholar who only aided his fellow citizens with personal patronage or indirectly through the gift of his library, Poggio Bracciolini must be seen as a humanist in the emerging civic mold, that is, a humanist who saw it as his responsibility to use his erudition, eloquence, and talent in the service of his contemporaries. Born near Florence in 1380, Bracciolini entered the Salutati circle as a young man. Because of his skill in writing—both the formation of letters and the recording of thought—he secured a position at the papal curia in Rome where he eventually rose to become a secretary. Although very successful in Rome and later at the Council of Constance, Poggio never altogether abandoned his native Florence. Indeed, he returned to that city to serve as chancellor from 1453 to 1458. Also, he wrote a *History of the Florentine People*, which covered the century before 1455.

It is to Poggio, more than any other humanist, that we owe the recovery of lost classical texts. He meticulously combed monastic libraries throughout Europe in search of treasures and succeeded in discovering some of the most sought-after texts from antiquity that had been altogether or partially lost: a complete text of the orator Quintilian's *On the Citizen Orator*; some previously lost orations of Cicero; and in 1417 the complete text of Lucretius' *De rerum natura* (*On the Nature of Things*).

However, it was in Leonardo Bruni that civic humanism found its most avid evangelist. Indeed, the figures of Salutati and Poggio largely signify only a prologue to the life of this great man in whom the ideal of civic humanism found its fullest expression. Bruni was not even born in Florence but in the town of Arezzo in the Florentine state; therefore, he was not a Florentine citizen by birth. He studied Greek with Chrysoloras and became a superb classical scholar, making a number of excellent translations of Greek classics into Latin. Through the patronage of Salutati, he secured in 1405 the office of secretary at the papal court, where he lived until 1415 and where he acquired some wealth and much fame. In that year, Bruni returned to Florence and devoted himself to secular learning and civic engagement, largely through the power of his pen. For example, Bruni

wrote an apology for riches, translated the spurious *Economics* of Aristotle, and expressed the novel belief that virtue could not exist independently of the physical world but was, rather, dependent upon it. The active life of civic virtue was now the ideal; and wealth had become intrinsically good because it supported the civic life. The saintly poverty of the high Middle Ages and the Franciscan distrust of wealth and the public life that was evident in Petrarch had thus been almost completely defeated.

The psychological shift between the early humanism of Petrarch and the fully developed civic humanism of Bruni is illustrated in the changing attitude to the great Roman orator and statesman Marcus Tullius Cicero. Initially, Cicero was seen as a contemplative thinker, virtually Christian in sensibility, seeking solitude and inward peace, a withdrawn monastic scholar associated with misogyny. As the importance of civic society later grew, the more political aspect of Cicero gained in importance.

The traditional view of Cicero appealed to Petrarch, who saw him much as did the Middle Ages, with, perhaps, a little republican virtue and stylistic elegance as ornaments. As discussed in Chapter Four, the shock Petrarch felt in 1345 when he discovered Cicero's letters to Atticus again shows how widely the worldview of mid-fourteenth-century Italy differed from the civic world of the next century, for it was these very letters, full of the crises of a public life, that ensured Cicero's veneration in the subsequent period. Salutati, studying not only the letters to Atticus, but also, after their discovery in 1392, the *Familiares* (familiar letters to friends), saw the greatest virtue in the Roman's participation in the state and thirst for political glory and renown. Similarly, Pietro Paolo Vergerio answered the letter that the disappointed Petrarch imaginatively addressed to Cicero by replying that philosophy, learning, culture, and wisdom were not for individual self-gratification alone but for the benefit of all: an obvious proscription of Petrarch's retreat from a full, secular life. And Bruni completed this revision of Cicero's legacy with his *Cicero Novus* (*New Cicero*, 1415), in which he praised the orator for his ideal union of political action and literary activity. Cicero had thus come to represent the new ideal of the Renaissance: the skilled politician rather than the withdrawn contemplative of monastic culture.

And just as Cicero was re-imagined, so, too, was Dante. To the Florentines of Bruni's generation, this poet was to share the altar of civic virtue with Cicero; for he, unlike Petrarch, had engaged in the struggles of politics, married, and had children while still creating great art. Bruni even felt compelled to write a revisionist *Life of Dante* to challenge Boccaccio's earlier biography so that the civic, engaged elements of the poet's life could be properly celebrated and Boccaccio's opprobrium refuted. The apotheosis of Dante and the new Cicero of the letters represented an obvious and fundamental change in the minds of Florentine humanists. This rehabilitation illustrates the idea of an "energizing myth" predicated upon the elevation of a new ideal of life, a revised intellectual and psychological program with one factor acting upon another until the structure of the world was changed and a recognizably new order had developed. Ultimately, the crucial factors for Florentine civic humanism were the coincidence of classical humanism and the republic, whose interaction created a new type of citizen exemplifying the new values of the age.

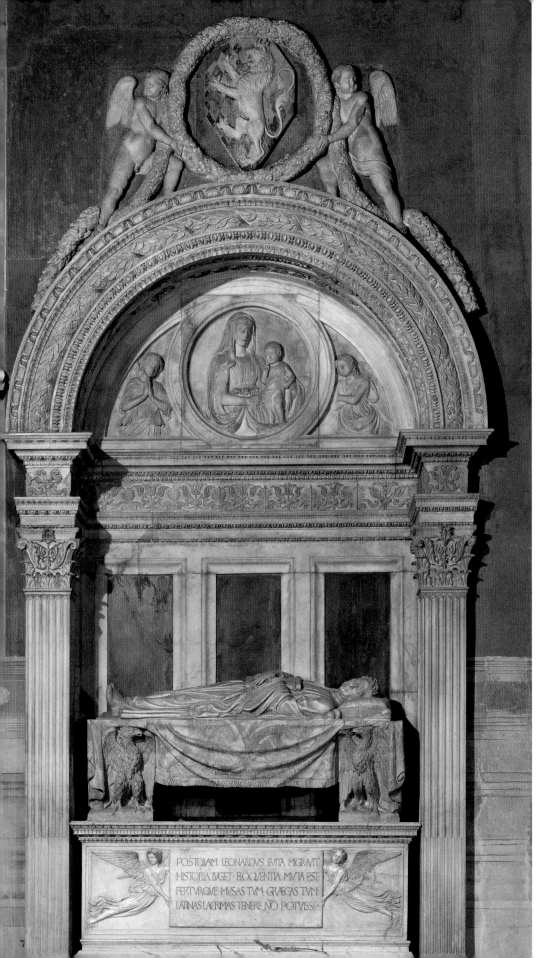

Figure 5.1 Florence, Santa Croce. Bernardo Rossellino (1409–64): *The Tomb of Leonardo Bruni*, c. 1448. This magnificent tomb depicts Leonardo Bruni lying upon his bier with a copy of his *History of Florence* on his chest. The complex mixture of pagan elements (such as the winged victories and the sarcophagus) with the Christian image of the Madonna and child, all set in a classical frame, reflects Bruni's humanist character. The lyrical epitaph declares that history is in mourning and eloquence has been silenced by his death (*Historia luget et eloquentia muta est*).

This victory of the active, secular, political life was further reinforced by the new form of historical writing and scholarship practiced by Bruni. It was in his role of official historian, a position that then became associated with the duties of the chancellor in the Florentine republic, that Bruni proposed a dynamic, civic perspective to historical studies. He wrote a huge *History of the Florentine People*, a work that exhibits his veneration both for history in the classical style and for his adopted city.

Bruni's two great loves, historical scholarship and Florence, emerge naturally from this great work, which was in part modeled on Livy's (59 BC–AD 17) *History of Rome from Its Foundation* (*Ab urbe condita*). Bruni re-evaluated the legendary accounts of the foundation of Florence, disproving the old belief that the city had been founded by Julius Caesar, destroyed by the Gothic barbarians, and re-founded by Charlemagne. This refutation helped weaken the old ties to the legend of imperial Rome and aided the growing recognition of Florence's leading role in the defense of republican liberty. Indeed, Bruni located the foundation of Florence under the Republic and argued that republican freedom had consequently always formed part of the city's civic legacy. Bruni's history was thus heavily ideological and contributed to the growing place of civic humanism in fifteenth-century Florence, an ideology that became the vitalizing force of the city.

In his history, Bruni exalts the virtues of republican Rome and vilifies the decline of the Roman Republic and the establishment of the Empire. He makes much of the mistaken belief that the Romanesque baptistery of Florence was built under the Roman Republic as a temple to Mars, the Roman god of war. Similarly, Bruni rejects the traditional pride in Florence's friendship with emperors, kings, and popes. The decadence of the western empire since the Roman Republic, he argues, had come from the tyranny of these very monarchs; and the revitalization of the Italian towns was possible only after Charlemagne moved the seat of the Empire north of the Alps allowing the natural Tuscan desire for freedom to once again flourish. Apart from its obviously ideological argument, Bruni's *History* also adds much to the modern concept of history as a scholarly discipline. In establishing his analysis, Bruni argues for a Middle Age between republican Rome and republican Florence. The belief in an intervening age of darkness between the original Roman Republic and the reflected or rekindled Florentine one was born: it was through Bruni that history discovered the Middle Ages.

HUMANISM AND WOMEN

Patrician women did not benefit directly from the development of Renaissance humanism, particularly in the great republics of Florence and Venice. The political, social, and economic structures that distributed power broadly across a significant number of the property-owning elite excluded the participation of women from political life. The world of the *polis* was seen as the public sphere, one uniquely appropriate to men. Because women could not normally hold property or engage in trade without the participation of male

relatives, there was little opportunity to escape the restrictions of family and the domestic sphere. Here, at least, women enjoyed considerable authority in the education of children, particularly daughters, and the oversight of servants and the maintenance of the household. But freedom of movement outside the home was circumscribed, even for married women, as their husbands or fathers exercised a great degree of control over their lives.

The recovery of antiquity and its application to the Italian world of the Renaissance in many ways reinforced this traditional role of women, excluding them from the public sphere. Advice from humanists, such as Francesco Barbaro (1390–1454) in *On Wifely Duties* (c. 1416), or Leon Battista Alberti in *On the Family* (1433–41), argued for the limiting of a woman's role to the domestic responsibilities attendant upon wife and mother. The ancient philosophers and physicians, elements of Roman law, and the practice of the ancients as reflected in their imaginative literature failed to provide a platform on which a more publicly engaged and active life for women could be built. Marriages of women from families with property were largely arranged, designed to bring additional resources, greater influence or honor to the bride's male kin. Limited in education usually to the domestic arts, women could not speak for themselves, and those who tried often were silenced by male relations or ignored by male humanists who thought their opinions without value merely as a consequence of their sex. As a result, it is difficult to identify women humanists in Florence during the Renaissance. To be sure, there were learned nuns who were to a degree freed from the control of men, but even in this instance the numbers were few. Venice also produced only a small number of learned women or female writers; here, interestingly, many of these were women on the margins of respectability, such as the courtesan Veronica Franco (1546–91), one of the most talented poets of her generation.

The examples of two remarkable women humanists—Isotta Nogarola (1418–66) and Laura Cereta (1469–99)—illustrate both the talent shown by those women who were given an opportunity to study and the disadvantages they faced in the community of scholars. Born in Verona, by then a Venetian dependency, Isotta Nogarola became perhaps the most learned woman of the fifteenth century in Italy. She studied Latin and Greek with a pupil of Guarino of Verona (1370–1460), and at the age of eighteen she began her own humanist correspondence, writing to Guarino himself. However, the scorn shown her by many hostile men drove her to stop writing in 1438, just two years later. Despite the opprobrium of many male humanists, she was determined to resume her intellectual and literary interests, but in more acceptable religious genres: Nogarola decided neither to marry nor to become a nun but openly to dedicate herself to sacred studies. This she did, and she managed to achieve some considerable distinction. In the early 1450s she became close to Venetian diplomat and humanist Lodovico Foscarini, her interlocutor in her most celebrated dialogue on the relative sinfulness of Adam and Eve.

Laura Cereta was born into an aristocratic family of Brescia, also then ruled by Venice. She received her early education in a convent, but at the age of nine she returned home to be educated by her father, a learned official. She was taught Latin and Greek as well as mathematics, in which she became particularly skilled. At fifteen she was married to Pietro

Serino of Brescia, but he died from the plague just 18 months later; Cereta was to remain a widow for the rest of her very short life. About the time of her marriage, she had begun a Latin correspondence with other humanists which she later supplemented with invectives and an important defense of humanist education for women. These continuing scholarly pursuits helped her recover from the loss of her husband. In 1488 she published a volume of her letters (*Litterae Familiares*, or *Letters to Friends*), a book that brought her to the attention of male humanists, many of whom treated her with condescension or contempt, while many others refused to believe that a young woman could have written such elegant Latin and argued that she must have had help from men. There were, however, a few scholars who supported her, sensitive and courageous men who saw the value of the work rather than its unorthodox authorship.

If women humanists in the great republics or in provincial cities without courts, such as Verona or Brescia, suffered the most daunting impediments to their being recognized for their talents or for practicing their art, the same cannot be said of the women of the princely courts, the inhabitants of the signorial regimes of the peninsula. Because power was not distributed by custom or constitution, all authority resided in the prince, and the means of accessing that power was concentrated at his court. Women could and did excel and rise in such environments. Usually of noble birth themselves, these noblewomen knew their own kin, and their husbands did not frequent the marketplace and the counting house but rather the palaces of other nobles and princes where a civilized and leisured life demanded entertainment and social finesse. In this context women could and did rise to the highest ranks of society, often through marriage but also through ability. The examples of Isabella d'Este (1474–1539) and Elisabetta Gonzaga (1471–1526) are obvious, as we shall see, both presiding over brilliant courts and leading the cultivated society of their states through their own remarkable talents and ability. Equally, gifted and powerful women, such as the poet and noblewoman Vittoria Colonna (c. 1490–1547), the close friend of Michelangelo, were far more than society bluestockings: they were extraordinary poets and authors and leaders of intellectual, cultural, and religious movements that had enormous implications for their times. Therefore, the search for educated, powerful women leads us to the principalities of Italy and, ironically, in the case of Vittoria Colonna, to papal Rome. It is curious that where political and economic freedom was greatest for men—in the republics—the restrictions were greatest on women; and in those monarchies where political action was limited by the absolute power of the prince, women were permitted to develop more freely. Coluccio Salutati and Leonardo Bruni, the great humanist chancellors of Florence, both wrote against the education of women as humanists; but in Mantua the celebrated humanist educator Vittorino da Feltre (1378–1446) offered his skills to girls as well as boys and was instrumental in the education of Cecila Gonzaga (1426–51), who became one of the most learned women of her time.

The women who succeeded in acquiring a humanist education, then, were small in number but important in influence. Some, like Laura Cereta and Isotta Nogarola, left important documents attesting both to their learning and, often, to their frustration at the roles society imposed on them. Others, such as Isabella d'Este and Cecila Gonzaga,

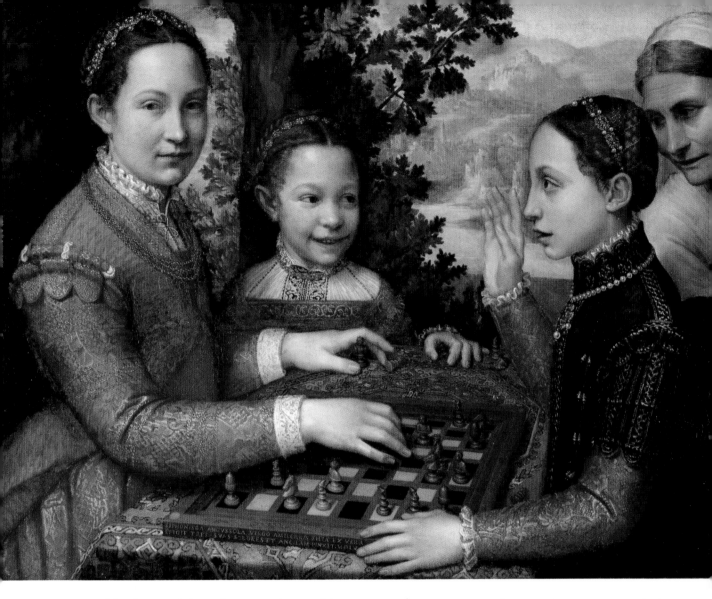

protected by their rank in society, were in a position to prove that women were just as capable as men in humanist pursuits.

Much the same can be said of women artists. There were some women who managed to achieve great renown and build a powerful reputation as painters in the Renaissance. Of these, Sofonisba Anguissola was perhaps the most significant. Born into a noble and very accomplished family in Cremona in the territory of Milan, Sofonisba and her sisters were encouraged by their father to develop their talents. Several of the girls became skilled artists, and one sister, appropriately named Minerva, was a superb humanist Latin scholar. Sofonisba—whose name alone reflects her parents' humanist interests: her ancient namesake was a third-century BC Carthaginian noblewoman who committed suicide rather than suffer the humiliation of being led as a slave in a Roman triumph—was sent as an apprentice to several local male artists, an unusual situation in the 1540s. Later, in Rome, she was recognized by the great Michelangelo (1475–1564), who encouraged her work and

Figure 5.2 Poznan, Poland, Muzeum Narodowe. Sofonisba Anguissola (c. 1532–1625): *Portrait of the Artist's Sisters Playing Chess* (1555). Painted when the artist was just in her early twenties, this group portrait of her sisters—Lucia (looking out of the picture), Minerva (on the right with a raised hand), and Europa (the child in the center looking on)—illustrates, even through the girls' names, the humanist cultivation of a family that permitted their daughter to practice painting as an art.

praised her ability. Her reputation as a portrait painter was sufficiently known that in 1559 she was invited by Philip II to the Spanish court, where she not only practiced her art but was also appointed as a lady in waiting to the queen, Elizabeth of Valois, with particular responsibility for training her in painting.

Sofonisba's popularity at the Spanish court resulted in the king's arranging a marriage between her and the son of the Viceroy of Sicily. Even this stellar match, made in 1571 when she was thirty-nine, did not interfere with her art, as her husband (the Prince of Paterno) encouraged her to continue to paint during their residence both in Spain and in Sicily. The death of her aristocratic husband in 1579 did not end her career, as she remarried in 1580 to a much younger man, a sea captain, who established her in a studio in Genoa. Later, she returned to Sicily, where she died in Palermo at the age of ninety-three, celebrated to the end.

It was possible, therefore, for women to succeed and achieve fame as humanists, writers, or painters. But it was difficult. As in the case of the female scholars and artists noted here, what was required was the support of fathers and husbands, and that support, sadly, was not often forthcoming.

HUMANISM AND EDUCATION

On its own terms the purpose of humanist education was to answer the question *Quam sit humaniter vivendum*? That is, how might one live a life consonant with human dignity? This concept of human dignity and its realization, fulfillment, and extension through learning and service was directed toward the development of the complete citizen. It was also, like humanism itself, practical in nature; and, unlike scholastic learning, which saw theology as the highest discipline, the *regina scientiae* or queen of all knowledge, humanist education stressed responsibility to this immediate world, not the scaling of the divine heights of the next. Learning, therefore, was not an excuse to withdraw from an active life, as it often had been in the clerically dominated schools and universities of the Middle Ages.

Humanist education for men was predicated on the training of the whole person in mind and body, through secular studies, which would be of some practical use to him as a citizen in either a republic, where wise counsel would be solicited to influence political affairs, or a principality, where his good advice would aid the prince in making correct decisions. In both cases, the operative principle was knowledge of human nature and practical affairs rather than speculation on the nature of God or the elegant scholastic complexities of theology. Indeed, education had as part of its definition a secular purpose: the boys taught and the master teaching were usually themselves laymen, and the material—the content of the disciplines assigned—was secular, and usually the students were destined for secular careers. These students of humanist educators were not young men in minor orders destined for places in the Church as they had been in the Middle Ages; they were to be bankers, merchants, politicians, ambassadors, notaries, or secretaries. In other words,

that critical strain of lay, practical education that had led through the *ars dictaminis* and through the *studia humanitatis* of the Italian cities remained central to the more sophisticated, wider humanist educational curriculum of the fifteenth century.

Because the students were laymen, these different purposes of study extended even beyond the basic notions of practicality. Whereas clerical, medieval education intended to develop the spiritual side of human nature—teaching mortification and denial of the flesh—humanist education praised man's human body and sought to develop it along with the mind. This also implied that the development of the individual self was privileged over the corporate or collective experience of the social classes from which the students came. The place of each individual in his society and his place in time and history, the notion of each person's distinctiveness, required a more liberal, personal method of study than the old, highly structured system allowed. Humanist education was designed to permit an individual to build his distinctiveness, albeit within the context of shared attitudes, values, and beliefs which provided society with its common experience. The common ideology of the privileged urban elite has been shown to have been humanism; and it was within this dedication to humanist principles as illustrated and exemplified in classical texts that the humanist educational system developed to foster each student's individuality and ability within its very generous confines.

It was in part this dedication to personal distinction that drove Jacob Burckhardt in *The Civilization of the Renaissance in Italy* to propose his theory of "unbridled egoism." This element of an individual's *virtù* or personal ability or prowess in his chosen areas—whether scholarship, government, warfare, art, architecture, or all of them together—obviously implied a strong personal belief not only in human power and dignity but also in individual qualities. *Virtù*, at least in theory, could overcome the disadvantages of low birth or poverty and raise an individual to the greatest heights; it could establish a reputation in history; it could spread fame throughout the world. Again and again, the same notions arose in humanist treatises: fame, glory, recognition by posterity. And it was in the humanist educational system that these principles were inculcated and the ways best suited to achieving them taught.

However, this "unbridled egoism" imagined by Burckhardt was not the true end of a humanist education, simply because such a belief denies a major element of humanity: moral character. Certainly individualism was sought, praised, and taught in humanist schools. On the other hand, this was not "unbridled egoism," but a supreme self-confidence tempered by mercy, justice, and humanity. Man indeed could do anything if he but willed, and indeed man was the measure of all things; but as Bruni wrote in his *Life of Dante*, man is also a social animal with responsibilities to his fellows. Man, at his best, is a citizen of a free republic or the loyal subject of a good and virtuous prince. Thus social qualities were equally stressed by humanist educators. Man could do anything, for sure, but he must always act in a way consonant with his human dignity. Hence, humanist education was not only intellectual and physical but also moral.

Morality was taught and seen as a reasonable subject for rational investigation based on ancient Latin and, later, Greek texts. But, unlike in the Middle Ages, this morality was

not otherwordly, demanding obedience to a list of religious injunctions. Morality was of the City of Man; in other words, it was a study of ethics, right and wrong, loyalty, and moral justice. Obviously, this morality was suited to future traders, great merchants, bankers, money-lenders, republican politicians, and the wise counselors of princes and popes. Christian morality was recognized as fundamental, but not altogether sufficient, because it did not respond to all of the problems inherent in these professions (consider, for example, the biblical and ecclesiastical bans on usury, the taking of money as interest). A secular but universally accepted morality was required, and that morality was provided by the study of ancient texts of writers such as Cicero and Seneca. Much more so than the mysticism of St Bernard or the rigorous injunctions of Leviticus and Deuteronomy, the classics provided a guide for life and were taught as such.

The Humanist Curriculum

As the purposes of humanist education differed from those of the Middle Ages, so too did the content, the curriculum, and the texts. Obviously given the prejudices of the humanists, ancient literature, including not only the great pagan authors but also the major early Christian fathers of the Church, constituted the foundation of the course of study. Classical literature thus formed the platform on which all subsequent studies were built. The acquisition of a humanist education, which was directed almost exclusively toward boys, consequently followed a remarkably consistent pattern throughout Italy in the Renaissance, at least for those students entrusted to professional educators. It was an elite education because it required considerable investment in both time and expense, and most boys, even of the privileged urban classes, followed instead a more practical training, with enough Latin to follow contracts and the liturgy but mostly learning the skills needed for business: mathematics (including the use of the abacus), accounting, and the requirements of buying, selling, and shipping.

The child began his education with Latin grammar some time just before or in his fifth year. There was no instruction in the vernacular because the assumption was that it was a maternal tongue and teaching it was not necessary. Latin, however, was the foundation of all humanist studies, and it was taught in a variety of ways, all of which were designed to make the pupil comfortable with it as an alternate first language. There was no belief in teaching Latin as a second language, nor any thought that the vehicle of Cicero and Virgil would be anything other than a spoken, natural, instinctive tongue. The child thus began his formal education learning to speak and write in Latin and being taught in it simultaneously. Memorization was an important element, beginning with the child's introduction to the Psalms, the Creed, and the Lord's Prayer, all of which he was expected to know by heart at a very young age.

Reading was begun by using blocks of letters which would be rearranged to spell words: paper and ink were very expensive and consequently hardly ever used for schoolboy practice. (The ancient tradition of employing a wax tablet and stylus appears not to have been

popular.) At about the age of six, the boy, accustomed to hearing Latin spoken for at least one year and now acquainted with the elementary vocabulary through his blocks and memorization, began to study the language and its grammar formally. The Latin grammar most popularly used in the fifteenth century was the *Doctrinale* of Alexander de Villa Dei (1175–1240), although almost every important humanist educator eventually wrote his own simple grammar. The advantage of the *Doctrinale* was that it was in verse and thus could be memorized more easily. Altogether, this element of committing material to memory is important because books were expensive, even for the class who employed humanist educators. Once the *Doctrinale* was mastered, students advanced to the standard ancient grammarians, consulted without interruption since the late classical period. Of these the two most famous were Donatus (fourth century AD) and Priscian (fl. c. AD 500).

It was universally believed that students learned not only Latin but also useful general knowledge and important moral precepts by actually reading ancient authors. Therefore, very soon after their sixth or seventh year, boys were introduced to ancient texts that they used both as a means of acquiring the principles of spelling, syntax, style, and more advanced grammar and as an introduction to the intellectual legacy of the ancient world. Initially, these were simple narratives in easy Latin, such as Valerius Maximus' (first century AD) *Facta et dicta memorabilia*; then came Virgil's *Aeneid* and the letters or orations of Cicero, especially the great orations against Catiline or Mark Antony. Once again, these were often committed widely to memory, a task made easier by the poetry of Virgil and the rhythmic prose of the rhetorical Cicero. After these basic texts, each master had his own favorites; but usually Ovid's (43 BC–AD 17/18) *Metamorphoses,* Seneca's tragedies, Lucian (second century AD), and the third-/second-century BC comedians Terence and Plautus were prominent among them.

Similarly, history was universally taught, but only the didactic histories of Greece and Rome. Almost never were national histories assigned, although of course fifteenth-century Italians saw Roman history as their national history; and positively never were the medieval historians or chroniclers mentioned. Evidently, given the humanist view of education, history was a central concern: it provided good insight into the political and military experiences of other nations; it illustrated the good practices that helped build great states and the vices that helped later to ruin them; it provided examples of good advice from wise men of the past in a great variety of circumstances; it extended individual experience across time and space; and, finally, it provided a huge mine of *exempla* or illustrations for writers, statesmen, and orators. Not only are the stories from history compelling and interesting, but they are also instructive. What is significant is what history was not: it was not seen as a coherent analysis of the past or any part of it; nor were historians studied on the basis of such criteria as accuracy or sound method, at least not until the very end of the fifteenth century and the rise of a new historiography in the sixteenth century with Machiavelli and Guicciardini. Instead, what mattered most were style and the extent of moralizing: history in fact was seen as a branch of rhetoric. Consequently, Plutarch (c. AD 45–120) was popular for younger boys in Latin translation; Caesar (100–44 BC) similarly suited the young pupil, largely because of his ease; and Livy (59 BC–AD 17) was also widely

used and was identified as a model writer, in part because of his straightforward style and in part because of his placing stirring speeches into the mouths of historical figures, again cementing the connection between history and rhetoric.

After history, then, rhetoric clearly reinforced humanist ideals most exactly. In general, oratory, which was viewed as a solution to all problems from cold feet to poor elocution, formed a very important part of education for boys once they had acquired a basic command of Latin. Rhetoric, after all, was central to the humanist purpose: it provided the means of impressing one's audience during embassies, council meetings, assemblies, and public ceremonies, thus adding to one's distinction. It helped provide audiences with moral persuasion, good advice, and sound counsel—a humanist duty—by giving speakers the power to convince opponents and win converts to the correct point of view. Consequently, it endowed the humanistically trained gentleman with all the faculties needed to put his good and virtuous learning to the service of his fellows. Cicero, of course, was by far the greatest example of rhetorical perfection, followed by Quintilian. Indeed, in many ways rhetoric became the logical purpose of all humanist education rather than just one element of the several as in the medieval curriculum.

Philosophy as a system of metaphysics was almost altogether ignored by the humanists, again in direct opposition to the ideals of the Middle Ages. Ethics—that is, moral philosophy—alone was important to the fifteenth-century Italian. It, too, was practical in application, not speculative, and was based far more on the stoicism of Seneca and Cicero than on the subtleties of Aristotle. Natural philosophy, or science in general, was virtually ignored, a pedagogical gap so despised by historians of science that they consider the Renaissance an actual step backward from the more scientifically curious Middle Ages. Still, there was some attention paid to natural philosophy, as illustrated in Pliny's first-century AD *Historia naturalis*. Also, some geography was taught (Ptolemy [AD 90–168] and Strabo [64 BC–AD 24]), as was astronomy. However, these disciplines were used mostly as a means of explicating ancient authors, for example describing the sites of nations, battles, and cities, or explaining the passages that refer to the zodiac or the constellations in the heavens. A coherent approach to the study of the natural world was, except among a very few remarkable individuals, altogether absent from the Renaissance humanist curriculum.

The significance of other subjects varied. Some teachers, in imitation of Plato and his Academy, required geometry and hence arithmetic, while others did not. Similarly, music, both vocal and instrumental, was often taught, especially in principalities, although with great care to avoid its sensuous connotations and some of the more popular and bawdy songs. In general, music was seen as a virtuous social and leisure activity: only string instruments were encouraged, because wind instruments were considered vulgar and unrefined as they distorted the face. Similarly, only solo performances were acceptable, except perhaps in family situations. And any boy who practiced so as to acquire true skill was to be discouraged because he might be thought a professional and hence of lower status and breeding.

The place of physical education was somewhat special, since it was so clearly of a different kind from the academic pursuits of the schoolmasters. Most humanists saw physical training as necessary, first because their pupils, as gentlemen, would have need of skill

in arms and fighting, talents closely linked to sports and a healthy body. Indeed many sports, such as fencing, riding, and even wrestling, were war games. Second, sports maintained a healthy body through exercise; the Juvenalian tag of *mens sana in corpore sano* (a healthy mind in a healthy body) was continually quoted. Third, sports served to provide a break from lessons: even the most diligent student needed some recreation during a long day of study. Fourth, sports were believed both to inculcate a sense of loyalty and cooperation against a common enemy and to promote the use of competition to excite the desire for victory—useful attitudes for future military captains and politicians. Fifth, physical training helped give a boy a sense of the dignity of the human body. Sixth, sports served as an escape valve for energy and kept boys' minds and bodies away from less salubrious physical outlets. And finally, and perhaps from the humanist perspective most importantly, the ancients had participated in sports: Roman baths had both libraries and gymnasia attached.

We cannot leave a discussion of the humanist curriculum without reference to the study of Greek. Before the fourteenth century, very few Italians had any knowledge of the language. The one great exception to this observation was in southern Italy. There, the Greek settlements that had been founded during the classical age continued, largely because a number of the monasteries of that region had adopted and sustained the Greek rite as opposed to the Latin liturgy and consequently had kept the language and culture alive. Later Robert of Anjou, King of Naples (d. 1343), a close friend of Petrarch—who wanted him crowned *poeta* in Naples rather than Rome—stimulated this Greek community by inviting a number of learned scholars to his court; in time, these Greek scholars taught Italians. Petrarch himself attempted to acquire the language and even owned Greek manuscripts; however, as noted in Chapter Four, he never managed to master it. Similarly Boccaccio tried to learn Greek, with somewhat more success, although he, too, could hardly have been considered a Greek scholar of any consequence.

The turning point in the humanist absorption of the Greek language came in 1396, when Manuel Chrysoloras, the most learned scholar of Constantinople, was invited to teach in Florence. Until his death in 1415, Chrysoloras taught an entire generation of Italian—and some northern European—humanists. By the early fifteenth century, then, the Greek language and literature were increasingly available in Italy. Some universities gave distinguished Byzantine scholars chairs of Greek studies throughout the Quattrocento. Padua, for example, founded such a professorship in 1483; still, in the development of Greek studies in the Renaissance, Florence led the way because of the great influence of Chrysoloras.

The rekindling of interest in Greek language and literature was to become increasingly important to Renaissance scholarship and thought. In many schools, Greek became almost parallel with Latin in importance. Indeed, one language was used to help explicate the other in a system of parallel passages: a Greek text was to be translated into Latin and then back again to master vocabulary, grammar, and style. Thus, both the language and literature of classical Greece were taught, beginning with the grammar written by Chrysoloras. The basic texts were those of the fifth-century BC historians Herodotus and Thucydides; the fourth-century statesmen-orators Xenophon and Demosthenes; the fifth-century

dramatists Aeschylus, Sophocles, and Euripides; and of course the great epic poet Homer. Also, just as Augustine (354–430), Jerome (347–420), and Lactantius (240–320) were studied in Latin, the Greek Fathers Basil (330–379) and St. John Chrysostom (347–407) were often read as well for both their elegant language and their Christian content.

The method of instruction varied to some degree from one humanist educator to another. When a father decided that he wished his son to enjoy a humanist education, there began a process that would encourage knowledge and polish, as well as social mobility. A humanist education was a caste mark, and those who had the advantage of that classical training spoke the same language and referred to the same shared texts and values of those identified as members of the elite. It was an entrée into a privileged class, and as such it was greatly sought after by ambitious parents of promising boys. The first consideration was the choice of school or tutor.

The Great Humanist Educators

Guarino of Verona (1370–1460) and Vittorino da Feltre (1378–1446) were the two greatest educators of the Italian Renaissance. Guarino had traveled to study Greek with Manuel Chrysoloras, accompanying the great scholar on his trip home in 1403 and living in Chrysoloras' family house until 1408. Returning to Florence with a precious library of original Greek texts, Guarino became widely acknowledged as the best native-Italian Greek scholar and one of only two or three who could speak the language naturally. It was at the University of Padua that he met and taught Vittorino da Feltre, who had entered the celebrated university when he was eighteen and stayed there as both student and professor for the next 20 years. Vittorino's great gift was his knowledge of Latin, though he studied mathematics and logic as well. When Guarino was invited to establish a humanist school in Venice in 1414, he invited Vittorino to join him.

Some time before 1420, Vittorino left Venice and returned to Padua, where in 1422 he was offered the coveted chair in rhetoric, a place that he yielded after only a year, most likely for reasons of personal disagreement with the university administration, but perhaps because his salary was insufficient. Then, in 1423, Vittorino was made an offer he could not refuse. Gianfrancesco Gonzaga (1407–44), Marquis of Mantua, offered him 300 ducats—almost twice his university salary—to educate Gianfrancesco's children at a special, enlightened palace school. Vittorino, it must be noted, was a second choice; the position had first been offered to Guarino in 1421. But Guarino, who by that time had moved to establish a public school sponsored by the local government in Verona, where he married and became very settled, had turned it down to remain in his home town. Vittorino, eight years younger than Guarino and anxious to have his own school, took up Gianfrancesco's offer with pleasure. He was to stay in Mantua until he died in 1446.

Once the great humanist schools of Vittorino da Feltre and Guarino of Verona were established, a perfect recommendation for humanist schoolmasters existed: former pupils of one of these great educators were certain to be men of both learning and character.

Other masters copied their methods and curricula, and both schools and private tutors used the texts written or assigned by the leading educators of their day. In this way, the schools of Vittorino and Guarino can be seen to have institutionalized, regularized, and transmitted humanist values, not only throughout Renaissance Italy but also throughout the Western world right until the technological revolution in education began in the twentieth century between the wars. A headmaster during the late nineteenth century would see little difference between his own curriculum and educational purposes and those of Guarino and Vittorino: the classics in Latin and Greek, physical education manifested in sports or "games," together with traditional morality and ethics were common to both eras; and these educational systems assumed that such schools existed to train the leaders of their societies, the ruling elite.

In the schools of humanist educators such as Guarino and Vittorino, students were not treated tenderly. Any kind of personal luxury was forbidden, including soft beds, silk shirts, and even gloves in the winter. Schools were never heated on principle, nor was there often hot water available. Sleep was to be regular but short: five hours per night was considered sufficient. However, corporal punishment was avoided, except where absolutely necessary, as thrashing was believed to brutalize and dishonor boys according to both Vittorino and Guarino.

Many schools, including those palace schools attached to courts, often insisted on accepting boys of all ranks, even the very poorest, who not only received free room, board, and tuition, but whose parents were reimbursed for the loss of their sons' labor. The reasoning behind this was truly enlightened: it helped aristocrats know the people and hence lose their natural hauteur; equally, it bridged the gulf between ruler and ruled, establishing a more harmonious and organic state. Also, of course, the humanists universally believed in the nobility of virtue and learning over the nobility of birth. Baldassare Castiglione (1478–1529; see Chapter Nine) was not unique in his observation in *The Courtier* that virtue and nobility of speech and action do not require aristocratic birth, although they do make their achievement easier.

In general, a boy would finish his education in his mid-teens although there are many individual cases of men documented as students into their late 20s. Exactly when these students entered the schools or households of their teachers, or what position they occupied, is not clear. Still, the probably correct impression of a school like Guarino's or Vittorino's is of a group of young men and boys—and occasionally girls in palace schools—dedicated to learning, regardless of their age.

The University of Padua

It was at Padua that Guarino had taught and Vittorino had been both student and teacher. During the Renaissance, Padua was perhaps the most celebrated of the Italian universities for the study of arts, law, and medicine, in part because it enjoyed exceptional academic freedom under the protection of the Venetian empire. The University of Padua, or the *Bò*

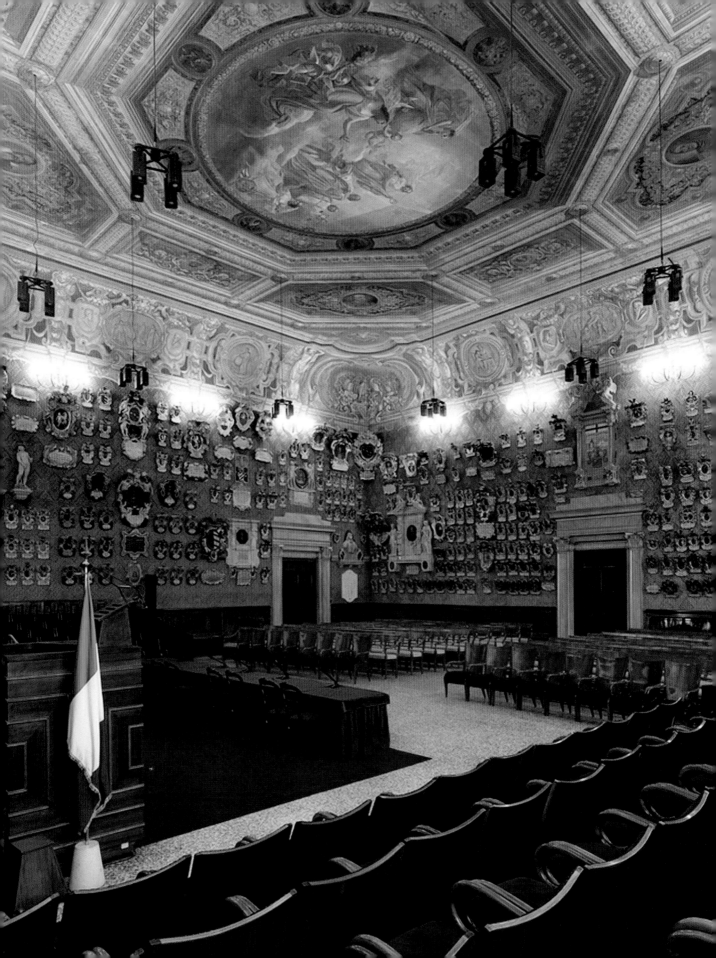

as it was called (the original hostel for students was an inn at the sign of the ox, or *bò* in the local dialect of Italian, from the Latin, *bovis*), was founded in 1222 by scholars from Bologna seeking more freedom from the town authorities. It was established as a guild of students rather than a guild of masters or professors. And from the beginning it was an international school. Both of these elements can be recognized in the organization of the University, divided as it was into nations or *nationes*, according to the geographical origins of students: there was an English nation, a German nation, a Polish nation, and even a Greek nation. For Italy there were several, depending on the locality from which the students came. Each nation elected a representative, who as a group, in turn, elected the rector of the university. The rector oversaw all aspects of education, including the hiring of staff and the establishment of the curriculum.

Figure 5.3 (facing page) Padua, University of Padua, The Great Hall (*Aula Magna*). Displayed on the walls of this central ceremonial room are the coats of arms of the student rectors and other officials of the guild of students who administered the university. The arms represent students from all across Europe—including places as distant as Scotland, Greece, and Poland—who flocked to the University of Padua because of the quality of its professional education and its relative freedom from religious control, protected as it was by the republic of Venice, in whose territory Padua was found.

Figure 5.4 Padua, University of Padua. Anatomy Theatre of Fabrizio Acquapendente (1537–1619). This magnificently restored theater was constructed in 1594 for the great anatomist Fabrizio Acquapendente. Students stood in the spiral galleries observing the anatomy lesson taking place below. Dissection was closely regulated by the Church and civic authorities, who allowed only a few cadavers to be used for anatomical education in any given year. By exceeding these limits, students and professors (who often left their own bodies for dissection) were exposed to prosecution. Consequently, the cadavers were positioned on a revolving platform that could be instantly turned, removing compromising evidence by dropping the body into a canal below.

Therefore, it was the students and not the masters who ruled. As is usually the case, the students were not so conservative as the faculty, who, after all, usually had vested interests in the status quo. Padua was thus very receptive to new ideas; and, once the new ideas had been introduced, they spread throughout other parts of Italy and Europe because the foreign students returned home. As the vanguard of Italian humanist culture and thought it was brought into the intellectual centers of northern Europe. This won the university a great reputation, perhaps the most famous of the Renaissance. Thus Shakespeare wrote in *The Taming of the Shrew*: "Fair Padua, nursery of the arts" (I.i.2).

This was especially true of the later Renaissance. Venice had conquered Padua in 1405, and in deciding to designate the school the *studium venetum*, gave it great privileges. At a time when most universities in Europe were run as ecclesiastical organizations, the Venetian senate granted Padua an almost secular status, making the university administration more subject to the Venetian state than to the Archbishop of Padua. This relative freedom from doctrinal inflexibility had great importance by the time of the Reformation in the early sixteenth century. Unlike in other universities, foreign students, even if Protestant, were not barred for religious reasons. There were no oaths of fidelity to the Roman Catholic Church required, and Venice maintained a very liberal posture toward the North. So it

was that Italian Renaissance ideals did not stop flowing from Italy across the Alps with the Counter-Reformation. Indeed, given Padua's place as a humanist school and as virtually the only Italian university still open to northern Protestants, this intellectual contact actually increased. Padua prospered while those other great universities more closely controlled by the Church—Bologna for example—declined almost immediately.

Just a few signal examples indicate the importance of Padua during the high Renaissance. Andreas Vesalius (1514–64), the anatomist and author of the revolutionary illustrated textbook on anatomy, *De humani corporis fabrica*, taught there. Pietro Pomponazzi (1462–1525), the greatest of the later Aristotelians, freely questioned in his classes and books the existence of an immortal soul, but died in his bed, honored, celebrated, and perhaps the best paid professor in Italy. The first botanical garden in Europe was laid out at Padua in 1546. The famous *lectura criminalium*, established after the law students requested it in the mid-sixteenth century, consisted of the study of cases and precedents of Roman law rather than abstract theory, thereby revitalizing legal education. Nicholas Copernicus (1473–1543) of Poland was a student of medicine and humanities at Padua after 1501 before he revolutionized astronomy with his *On the Revolution of the Heavenly Bodies* (1543), establishing the heliocentric universe; in his humanist studies he was a pupil of Niccolo Leonico Tomeo (1456–1531), one of the leading scholars and teachers of the *studia humanitatis* in Europe. The Englishman William Harvey (1578–1657), who discovered the circulation of blood, studied at its medical school, as did Thomas Linacre (1460–1524), the translator of Galen and founder of the English Royal College of Physicians. Galileo Galilei (1564–1642) taught there before being lured home to Florence where he confirmed Copernicus's work, changing forever the human understanding of the cosmos. Indeed, students and professors at Padua are a *Who's Who* of the intellectual leadership of the Renaissance.

The dynamic ideas of the Italian Renaissance were available to the students at Padua not only through the texts and lectures of these luminaries, but also through the visual culture of the Renaissance within the city itself. Giotto (1267–1337) had painted the frescoes in the Arena (Scrovegni) Chapel; Mantegna (1431–1506) had decorated the nearby church of the Eremitani; Donatello (c. 1386–1466) had spent much time working for the church of St Anthony both inside and out, where his famous equestrian statue of the *condottiere* Gattamelata (the honeyed cat) still stands. The University of Padua, then, was an extremely important disseminator of Renaissance ideas and values and should be seen with the schools of Vittorino and Guarino as one of the central institutions of the Italian Renaissance dedication to education.

FURTHER READING

Grafton, A. *Leon Battista Alberti*. Cambridge, MA: Harvard University Press, 2002.

Grendler, Paul F. *The Universities of the Italian Renaissance*. Baltimore: Johns Hopkins University Press, 2002.

Rabil, Albert, ed. *Renaissance Humanism: Foundations, Forms, and Legacy*. Philadelphia: University of Pennsylvania Press, 1988. 3 vols.

Schiffman, Zachary S., ed. *Problems in European Civilization: Humanism and the Renaissance*. Boston: Houghton Mifflin, 2002.

Vespasiano da Bisticci. *The Vespasiano Memoirs: Lives of Illustrious Men of the XVth Century*. Renaissance Society of America Reprint Texts 7. Trans. William George and Emily Waters. Intr. Myron P. Gilmore. Toronto: University of Toronto Press in association with the Renaissance Society of America, 1997.

Witt, R., and Kohl, B. *The Earthly Republic: Italian Humanists on Government and Society*. Philadelphia: University of Pennsylvania Press, 1978.

Woodward, W.H. *Vittorino da Feltre and Other Humanist Educators*. Toronto: University of Toronto Press, 1997.

SIX

THE REPUBLIC OF FLORENCE

IT WAS NOT an accident that Dante, Petrarch, and Boccaccio were Florentine and that Florence has been called by a great many historians "the cradle of the Renaissance." The relationship between the development of Florence—a guild republic dominated by a class of wealthy, cosmopolitan merchants—and the principles of Renaissance humanism must be investigated in detail. To do so, it is necessary first to see how and why Florence began its rise to spectacular wealth and influence during the Middle Ages and how these factors provided a platform on which the Renaissance as a cultural and intellectual movement could be constructed.

FLORENCE: GOVERNMENT AND ECONOMY

To a great extent, the background of Florence in the Renaissance is the history of the development of the Italian mercantile and financial capitalism that accounted for the remarkable wealth of Florence and of the merchant patriciate who institutionalized the values of the Renaissance. This merchant elite, having grown rich, challenged older authorities for control of the city's government and, once successful, turned the state into a vehicle for the promotion of their economic interests to the exclusion of their previous masters, the Tuscan nobility and their urban allies. How did this capitalism begin, and why was Italy the leader in this period of economic change? Part of the answer is geographical, the result of the peninsula's position between the eastern Mediterranean and western Europe. But the other part of the answer is political, the result of Italy's fragmentation after the collapse of Rome. Free from the interference of the pope or emperor, adhering often only to the broad and shifting allegiances of Guelf or Ghibelline, individual cities evaded the restrictive trade practices that hampered northern European commerce. Even such restrictions as the official church ban on usury could be circumvented, and the protective guild

practices of many northern cities were relaxed. And, with the pope and emperor often being far away and needing to seek support from allies on the peninsula, the heavy hand of royal taxation was lighter and the often extortionate actions of rural magnates were controlled. Political and mercantile freedom and the flexibility and control needed for large capital accumulations permitted a revolution in commerce and trade, a revolution that was restricted, at least initially, to Italy. What we can see, then, is that by about 1300, the great Italian mercantile cities had most of the essential techniques of capitalist business activity in place. New forms of business association and new methods of credit and exchange, as well as more complex relationships between finance and industrial production, were developed to serve both the Italian and the European markets, reinforced by the complex demands of the Crusades and refined in the highly competitive world of the Italian states.

For example, new forms of business association became necessary when emerging opportunities required more capital than a single merchant could realize or when the complexities of trade required shared responsibility. A legally binding mechanism was needed when several traders were involved in long-distance trade in which one would travel abroad as a resident factor, another would superintend the transport, and a third would arrange its resale. Add to this both the constant appetite for more capital to take advantage of the growing luxury market and the opportunity to travel greater distances or purchase in greater quantity. Few individual merchants or even extended families could risk much of their fortune on such ventures, so instruments for the pooling of capital had to be invented. Instruments like the *commenda* appeared, which specified both who would invest what and the rate of return for an individual voyage. Also, merchants in need of capital would take money from even small investors at interest, promising a fixed rate of return. This capital would then either be used to finance mercantile adventures or be lent to others to pursue economic opportunities. In short, merchant organizations and mercantile families—and these were initially often one and the same—developed into banks as well as trading houses, making money available to those who lacked the capital to fulfill their ambitions but whose plans offered the hope of substantial return on investment.

The growing interrelation between commerce and industry in early Renaissance Florence was also of critical importance in understanding the enormous wealth of the city and its merchants—as well as the enormous size of the city, which, before the Black Death of 1348, had about 75,000 inhabitants. The capitalist exploitation of industrial manufacturing on such a scale was peculiar almost to Florence. In other Italian cities with huge industrial complexes, such as Milan with its great armaments industry, manufacturing was controlled by artisan guilds and remained restrictive, even when large amounts of capital were required, as with goldsmiths, for example. In Florence, though, the great merchants controlled the importation of the raw material, the export of the finished product, and the actual production especially within the city's industrial giant: wool working and the textile trade. The reasons for this control are complex but help explain Florence's remarkable wealth. For some time, Florence, as a leading Guelf state with the necessary expertise, resources, and connections throughout Europe, made significant profits collecting papal

dues and transferring the money to Rome. In an age when "First Fruits" (the first year's income) and "Tenths" (10 per cent of annual income) were paid by newly appointed bishops and abbots and when huge sums were given to help finance the Crusades, the resulting amount of money involved was considerable. Furthermore, the stability of the Florentine coinage, the florin, after it was introduced in 1252, reinforced the role of the city in international trade.

The great profits to be made, and the wide network of commercial connections established by Florentine merchants, opened new opportunities for intelligent, farsighted Florentines. For example, English wool was the best in Europe and was widely sought after. A good deal of the pope's money came from monasteries or ecclesiastical estates in England, estates that typically engaged in large-scale sheep farming. As, in theory, a papal fief, England also owed the special tax to the pope known as "Peter's Pence." Observing this, the Florentines offered to accept such dues in wool, saving the Church the cost of realizing wool into cash. The Florentine merchants then shipped the wool to Italy and used their own capital in Florence to support an industry to turn the wool into high-quality finished cloth, which was then re-exported north to European markets. It was in part this mercantile access to English—and, later, Spanish—wool that built the great Florentine wool trade, despite the observation that the city was geographically unfit for it in so many ways, not having a secure year-round source of water power (the Arno is reduced to a slow-moving stream in the summer months) and not being on the sea or on a major trade route. The industry was built, instead, by Florentine commercial connections and skill.

In addition to supplying the raw material and the capital, the merchants controlled the labor force, making the vast majority of wool workers, or *ciompi*, subject to the merchant guilds, rather than to representation of their own. In part, this was because of the wide division of labor required by textile manufacturing, but in essence it was because the merchant elite controlled all aspects of the industry and controlled the government as well, turning the state into a vehicle to further their interests. The production of high-quality woolen cloth thus became the city's dominant industry. In the early fourteenth century, Giovanni Villani (d. 1348) estimated that about one-third of the population—about 25,000 people—was directly or indirectly involved in the manufacture of woolen cloth. In 1338, Florence produced 70–80,000 pieces of cloth with a value of more than one million florins.

The great merchant-industrialists' control over this industry was well illustrated by the fact that the two major guilds responsible for the textile industry, the *Arte della Lana*, or cloth manufacturers, and the *Calimala*, or finished cloth dealers, were not traditional medieval guilds of master workmen but, rather, cartels of the most powerful international financiers with interests in cloth. The guilds were used to maintain monopolies, pressure the communal government to adopt legislation in their favor, and, especially, to control the workers economically and politically. The merchant industrialists kept ownership and control of the industry, from the importation of raw wool to the export of finished cloth.

These economic conditions were the background to the Renaissance in Florence. The innovations in business practices, the new methods of credit and exchange, and the

Figure 6.1 The Florentine Florin. The Florin was introduced in 1252 and was used as the currency of Florence until 1523. The republic scrupulously regulated the gold content of the coin, thus rendering it a reliable, stable international medium of exchange. Consequently, Florentine merchants benefited in their trading and banking enterprises, as did the city's economy. The symbol of the commune (the *giglio*, or lily) and its Latin name (Florentia) appear on the reverse of the coin. An image of John the Baptist, patron saint of Florence, appears on the obverse.

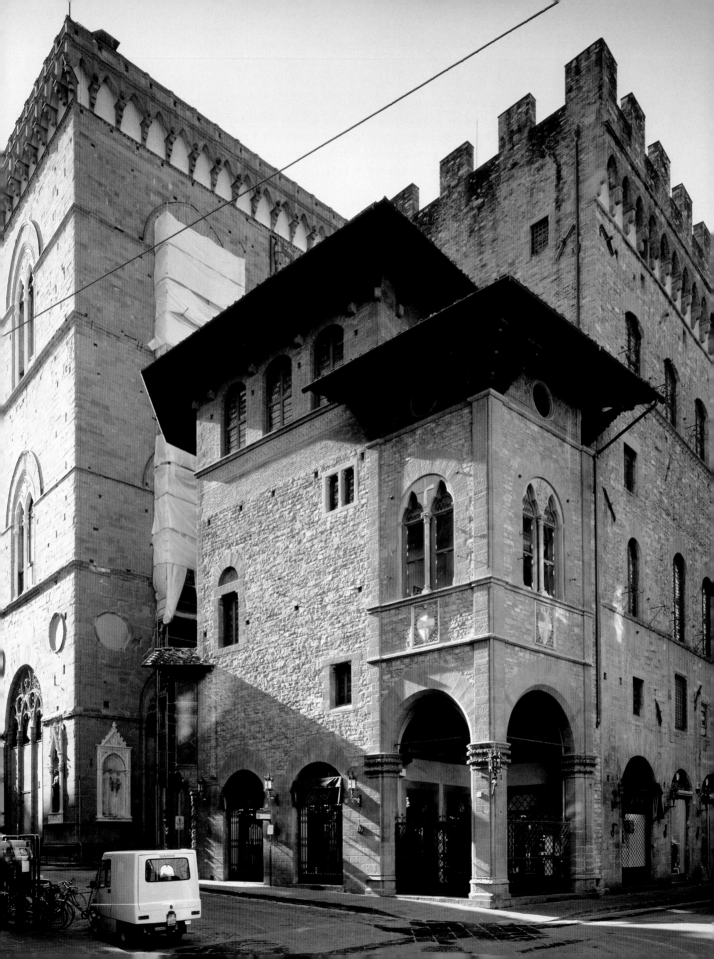

interdependence of commerce and industry in the late thirteenth and early fourteenth centuries created a class that was quite new in the context of medieval society: merchant patricians who were urban, lay, leisured, cosmopolitan, educated, powerful, and very, very rich. It was this class that combined the ideals developed and spread by Petrarch and expressed in Florence by humanist statesmen, such as the chancellor Coluccio Salutati. To these mercantile patricians, the aristocratic culture of northern Europe, to which the Tuscan nobility subscribed as a caste mark, was foreign, indeed hostile. Warfare was not noble, but dangerous because it interfered with trade; skill in arms was secondary to skill in languages, law, accounting, and mathematics, since the former talent did nothing to aid one's business, while the latter skills added to one's wealth and influence. The humane, anthropocentric principles of Petrarch, then, appealed more to these men, and they embraced them enthusiastically. Equally, the Franciscan or even apostolic respect for poverty and the abnegation of the earthly life in favor of a life of solitude and prayer was seen as useful only to those who had chosen a monastic or clerical life. Secular wisdom and experience in the things of this world were much more attractive to merchants who saw their ambitions and opportunities in secular terms.

Furthermore, these new principles, in conjunction with enormous wealth, new instruments of patronage, and new concepts of elite behavior—in addition to a good measure of humanist idealism—motivated such men to patronize the arts, beautify their leisured lives, and build palaces for their splendor and commodity rather than for their defensive capabilities. This class of merchant patrician was the vanguard of the Florentine Renaissance at the end of the fourteenth century, its sustenance in the fifteenth century, and, after the rekindling of the rural, aristocratic, princely values following the collapse of the republic in the sixteenth century, the cause of its demise. The great names and families of the Florentine Renaissance are the families of the bankers and the industrialists—the Medici, Strozzi, Pazzi, and Rucellai, among others, a group constituting perhaps three per cent of the population of the city who, through intermarriage, interlocking business partnerships, political alliances, and patronage, dominated the government, society, and culture of the city throughout our period. It was they who bankrolled the Florentine Renaissance. It was their taste that maintained its excellence. And it was their monopoly on political power that turned the state itself into a mechanism not only for their own benefit and profit, but also for the institutionalization of the Renaissance on a lavish, civic scale, turning the state into a work of art and turning the city of Florence into a vast storehouse of art as well.

It is necessary now to see in more detail how this class of elite, wealthy, powerful merchants took control of the administration of the city and came to dominate its culture and institutionalize their values in Florence. Humanism became the dominant ideology of this class, and its practitioners represented another group of elite citizens, close to the mercantile and political leaders of the commune and often their official voice, as we have seen illustrated in the career and writings of Leonardo Bruni.

Figure 6.2 (facing page)
Florence, the Palace of the Wool Guild. This imposing structure was completed in 1308 and is connected to the church of Orsanmichele. The importance of the wool trade is illustrated by the size of this building and the attached tower, reflecting the public authority of this *arte maggiore*, or "greater guild." Note the square crenellation along the top of the tower. This indicates the republic's Guelf allegiance. Ghibelline cities featured notched crenellation.

THE FLORENTINE REPUBLIC

The history of the Florentine Republic and its economy during the Renaissance is not a simple progression. The development of both the commune and its wealth went through various stages and alterations between the thirteenth and sixteenth centuries, stages that, although extremely complex in themselves, must be reduced to a relatively simple scheme.

During the late Middle Ages, that is in Italy before about 1300, the commune of Florence was dominated by the largely rural Tuscan nobility, or *magnati*, a feudal class of landed magnates, descended from the knights of the Middle Ages who had fought in the continuous warfare between pope and emperor and between states. (Many of these men had been ennobled by the Holy Roman Empire and were in fact of German extraction, although acculturated as Italians for centuries.) To this magnate class of truly feudal nobles in the northern European sense must be added the *grandi*, or wealthy, ancient, urban families, usually enriched originally by trade, who threw in their lot—both political and psychological—with the nobility, accepting their values, codes, ideals, practices, and children in marriage. What characterized this class of *magnati*, and to a certain extent the *grandi*, was their violence, propensity for family feuds, and generally antisocial behavior.

Besides the violence inherent in a group trained to do little else but fight and addicted to feuding, the further division of Guelf and Ghibelline exacerbated an already tense situation. Some *magnati* and *grandi* were Guelf, others were Ghibelline, and they set about murdering one another because of this division. After the battle of Montaperti (1260), the Ghibellines seized power in Florence and exiled the Guelf families; but in 1267 the banished Guelfs returned—backed by a French army—and threw out their oppressors, exiling them in perpetuity, confiscating their property, and despoiling them of all civil and political rights. To ensure the political purity of the city thereafter, the successful Guelfs formed the *Parte Guelfa* (Guelf Party), an extrapolitical organization of the richest and most powerful *magnati* and *grandi*, designed to influence the government of the commune in their own interests.

As the Florentines knew, the Guelf victory was more than a military success. The Guelfs, as the papal party, had great influence with the Holy See. Hence the *Parte* turned Florence into the leading pro-papal state in central Italy, and, in return, the city acquired the favor of being chosen as a centre for papal banking and tax collecting, operations that we have seen helped build the city's mercantile and industrial economies. However, this very success caused increasing social fragmentation. As the city became ever more wealthy during the thirteenth century, a new class quickly developed: rich merchants and entrepreneurs not born of the old *magnati* or *grandi* families, rather men whose wealth was considerable—even spectacular—but very recent. This new class was properly termed the *popolo grasso*, or "fat people." The *popolo grasso* had little in common with the values or ambitions of the old Tuscan nobility or with the great *grandi* families, who were almost indistinct from the magnates by this time. Consequently, they were incensed at being

ruled by these old families, often to the detriment of their commercial ambitions, and they were determined to get a place in government commensurate with their wealth and with their growing place as the dominant economic group in the commune, the payers of the highest taxes, the employers of the most people, and the class with increasingly the most liquid wealth.

Similarly, just below this new class of capitalists were the lesser tradesmen, often economically dependent upon the great financiers but still possessing prosperity and ambition. If the *magnati* and the *grandi* were odious to the rich financiers of the *popolo grasso*, they were doubly so to these lesser middle-class vintners, ironworkers, dyers, and stretching-shed operators who subcontracted a large portion of the wool industry. Also, this poorer bourgeois class shared a common fear of the tens of thousands of totally impoverished unskilled workers, the *ciompi*, who labored in their factories. Disenfranchised, possessing no property, education, or hope, these *ciompi* and their families were viewed in the same way as the Spartans viewed the Helots: their employers feared that the despised and oppressed poor who produced their wealth would in time rise to extract vengeance and seek redress. Thus both the rich merchants and the small shopkeepers felt the need to keep these workers carefully controlled, a perspective not shared by the dominant aristocrats who lived in great fortresses in town, surmounted by enormous towers, and who traveled about heavily armed, followed by a band of equally armed retainers who were, in reality, hired thugs usually recruited from their rural estates.

Obviously, the power structure had to be realigned to express the new realities of Florentine life; and some kind of order had to be imposed upon the city in which the feuding nobles carried on their vendettas and behaved lawlessly, all to the detriment of trade. That change began about 1280.

In 1279, the pope decided to impose some order on the political chaos of Florence in particular, and Tuscany in general, where Guelfs and Ghibellines were still murdering one another with consistent relish. The pope, Nicholas III, sent his nephew, Cardinal Latino (d. 1294), to restore order. In 1280, Florence was literally exploding with its new wealth and increased opportunities. The population, attracted to the city by these growing prospects, numbered at least 45,000, and the economic power of the great merchants increased even more with the concomitant increase in property values and the attendant building boom. Latino promulgated a constitution in which power remained in the hands of the old aristocrats, but he equally allowed for the entry of rich merchants into the government because of his obsession with the Guelf–Ghibelline distinction. These new men were manifestly good Guelfs, and therefore they deserved some representation in the commune. Their admission into government was the beginning of the Florentine bourgeois revolution.

In 1282, the greater guilds were permitted to send representatives, or priors, to speak on their behalf. During that year, these priors—educated, sophisticated merchants that they were—began to concentrate more and more of the executive authority of the government in their hands so that in the following year, 1283, they in effect staged a coup by promulgating a new constitution to replace Latino's simple-minded scheme and institutionalized the priors as the executive organ of government.

For the entire length of time that Florence remained a republic, the priors, nominated originally from among the seven greater guilds, were the executive power, a committee that represented the commercial wealth of the city. Guildsmen chose the priors from among themselves, that is, from among men matriculated in the *arti maggiori*, the greater guilds. The guilds were not craft but merchant guilds, cartels representing key spheres of influence and the new rising social class of merchants and professionals. The dominance of cloth and clothing was evident in the presence of three guilds based on textiles: *Calimala* (dealers who finished and dyed imported cloth), *Lana* (manufacturers who traded in raw wool), and *Por' San' Maria*, (silk merchants and weavers—so named from the street in which they had their shops, the Porta Santa Maria). The importance of long-distance trade was manifest in the guilds of *Pellicciai* (traders in fur pelts), *Speziali* (physicians and apothecaries, including spice merchants), and *Cambio* (bankers and money-changers). Finally, there was the greater guild of the *Giudici e Notai* (judges, lawyers, and notaries), a guild that reflected the continual need for notarized legal documents in commerce: the law follows trade. The bourgeois revolution of 1283 restructured only the executive of the commune; the other elements of Florentine government remained. For example, the *podestà*, the chief of police and military commander, always a foreigner appointed for only one year to minimize the chance of his using his military power to subvert the state, remained in place, as did the two councils, the greater and the lesser, both of which were dominated by *magnati* and *grandi*. However, the *podestà* was now subject directly to the priors.

There were six priors originally, serving a term of only two months. They, together with the heads of the *arti maggiori* and representatives of the six wards (*sesti*) of Florence, chose their successors. To solidify their new authority against the increasing hostility of the old aristocrats who were beginning to realize that they had lost control of the city, the guilds were further organized on a military basis as a bourgeois militia, under the command of a captain. In short, what was quickly developing was a form of guild republicanism designed to control the state in the interests of the *arti maggiori*.

This semi-revolution lasted a decade, during which time Florence continued to expand economically and militarily, winning, for example, the battle of Campaldino, in which Dante fought, and, ideologically, liberating all of the serfs in the Florentine *contado* (the rural territory surrounding a city) in the same year, 1289. However, the old aristocrats were becoming impossible. Enraged by their own stupidity, full of *bragadoccio* and violence after the battle of Campaldino and believing—partly correctly—that the liberation of the serfs in their feudal estates was a measure designed to weaken their power base and provide a fluid labor force for the expanding cloth industry, the *magnati* became even more violent, making the streets unsafe by fighting pitched battles in town. Something had to be done, and on 18 January 1293 something was. Led by a renegade nobleman, Giano della Bella, the Ordinances of Justice were passed, an act that completed the bourgeois revolution and gave the republic the basic shape it was to have until its extinction over two hundred years later, defining the political framework of the Renaissance in Florence.

Under the Ordinances of Justice, the control of the government by the seven guilds was strengthened by the addition of fourteen new guilds. Five were the *arti medie*, that is, the

intermediate guilds, while nine others were designated lesser guilds. Thus there were now twenty-one recognized guilds in the city, all of which had the right to be represented in government, although the guildsmen themselves remained divided into seven *arti maggiori* and fourteen *arti minori*. Further constitutional changes were also of great importance. An eighth prior was added with the special title of the Standard Bearer of Justice, *gonfaloniere di giustizia*, whose job it was to execute sentences imposed by the *podestà* on lawless nobles; and he was given a thousand soldiers to help him carry out this task. Later, a ninth prior was admitted to this collective executive committee.

The motivation for establishing the office of the *gonfaloniere di giustizia* was a decision by the new communal government to curb those aristocratic thugs who had been making life and commerce in Florence difficult. The magnate families were put under special restraints. Lists were drawn up to include all magnate families, perhaps 150 altogether, of which about seventy-two were *grandi*, that is, living in the city and originally of old mercantile wealth. Altogether this list of magnates comprised about a thousand adult male citizens. Each of these magnates had to swear a special oath to the new government that he and all his kin would keep the peace and post a bond to do so. If a nobleman failed to pay, his kin were responsible. And if any magnate committed murder (a crime previously common and seldom prosecuted) he would now incur the death penalty, confiscation of property, and the razing of the family palaces. Also, no magnates could be elected as priors, and they could not sit on the council of the captain; and even if already a guildsman, a noble could not hold any guild office. In short, the magnates were disenfranchised, stripped of political authority, and placed on parole as a class.

Arti Maggiori (7)	Arti Minori (14)	
	Intermediate Guilds	*Lesser Guilds*
Judges and Notaries	Butchers	Vintners
Cloth dealers	Blacksmiths	Innkeepers
Wool manufacturers	Shoemakers	Retailers of provisions
Bankers and Money-changers	Builders and Masons	Tanners
Silk merchants	Clothiers	Armorers
Physicians and Apothecaries		Ironworkers
Furriers		Saddlers and Harness-makers
		Woodworkers
		Bakers

Table 6.1 The Guilds of Florence
This table of the guilds shows how they were ranked within the three main categories. The rank order remained remarkably stable throughout the period of the republic with only minor variations dependent on changes in economic and political conditions.

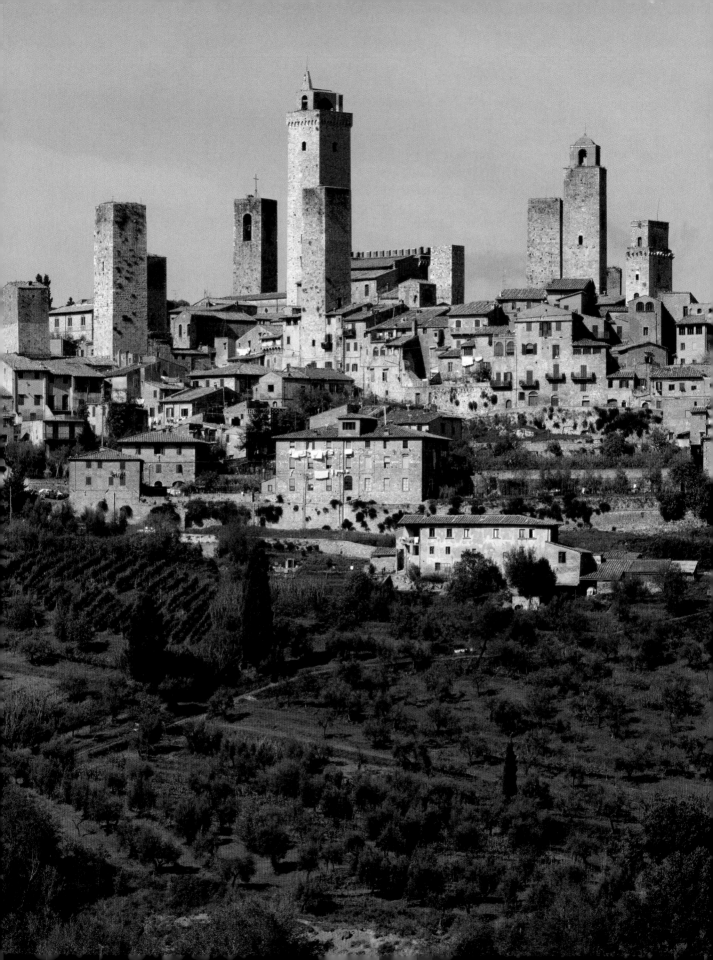

The Ordinances of Justice also decreed that the great towers attached to the fortress-houses of the *grandi* and *magnati* had to be pulled down to a certain height. These towers, functioning like castles, had made the nobles invulnerable and thus outside the law. With their destruction, Florence no longer was a spiky city of noble towers, but a bourgeois city of commercial activity, now dominated totally by a merchant patriciate. To symbolize this revolution, the commune commissioned Arnolfo di Cambio (c. 1240–c. 1310) to build the Palazzo della Signoria, now the Palazzo Vecchio, with a high tower to represent the humbling of the private power of the magnates and the establishment of the collective authority of the merchant patricians in power. These changes, then, gave Florence its political character until the very end of our period. They also gave it the basic architectural shape it enjoyed throughout the Renaissance and even today, where the towers crowning the city are those of the commune or Church, that is, the collective population, and not those of the nobility, which boasted power in private hands.

This is not to say that the republic did not change during the ensuing two hundred years. The first crisis occurred when the magnates fought back. The *Parte Guelfa*, that extra-constitutional organization of largely *magnati* and *grandi* families, was bitterly divided between the reactionary forces violently opposed to the Ordinances of Justice, called the Blacks (led by the most unrepentant and aristocratic rural feudal families), and the Whites, who tended to be *grandi* with large mercantile investments and close contact with the new patriciate, and were often new men themselves, admitted to the *Parte Guelfa* after Latino's 1280 constitution. The Whites can be described as liberals, desiring the admission of new men and generally favoring the basic intent, if not always the concrete measures, of the Ordinances. In 1302, this division broke out into open warfare: the Blacks staged a violent and successful coup, aided by an army sent by Pope Boniface VIII, who had anticipated a more direct role in Tuscan affairs. There followed the Florentine equivalent of the reign of terror, in which many hundreds of white Guelf families, including those of Dante and Petrarch, were banished, their property confiscated, and their liberal policies reversed. However, not even this reactionary revolution dared repeal the Ordinances that had given political authority to the powerful new class of greater and lesser guildsmen; only the most draconian measures were not strictly enforced.

Even before their ultimate collapse several decades later, the conservatives guiding the city after 1302 did not enjoy a stable rule. Under their command, Florence embarked upon a series of costly and unsuccessful wars against its Tuscan neighbors: Pisa, Siena, and Lucca. Unnerved by constant military failure and weakened economically by their own ineptitude and the exorbitant cost of mercenary warfare, the aristocratic *signoria* sought ways of overcoming their problems. One solution, and an example of the selfishness of this group, was to avoid paying sufficient taxes to finance the wars that their expansionist, militaristic policies had caused. To accomplish this they instituted the system of *prestanze*, or forced loans, in lieu of taxes. Each citizen owning property was assessed at a certain percentage, and this amount was owed to the commune; however, the money was not viewed as a transfer of tax from citizen to state, but was treated as a loan, on which interest

Figure 6.3 (facing page)
San Gimignano. An important town in the Middle Ages, San Gimignano was later dominated by Florence. Because the center of economic and political power shifted to Florence, there was little change in the urban topography. Consequently this small town is one of the few in Italy that has preserved many of its towers. From this we have an impression of how Florence must have looked before 1293.

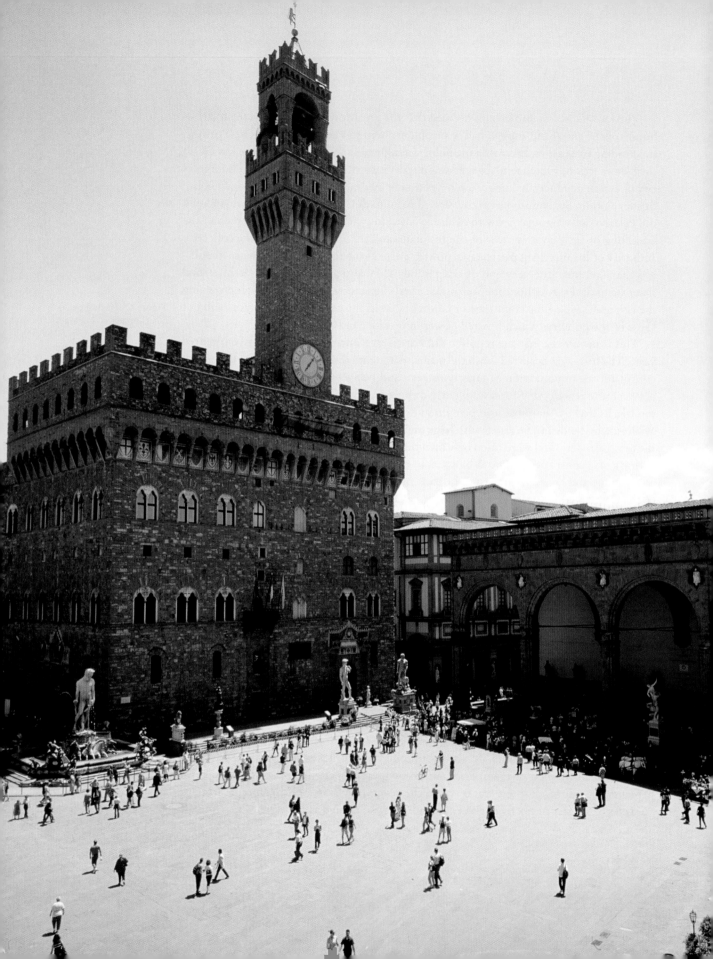

was paid. In this way, the aristocrats financed their wars and kept some of their capital, at least on paper, maintained a small but steady income from the *prestanze*, and established the important psychological connection between the fiscal well-being of the commune and their own economic position.

In addition, the aristocrats attempted to abdicate political and military responsibility during bad times. In 1313, for example, they invited King Robert of Naples (r. 1309–43), head of the Italian Guelfs, to rule Florence as *signore*, a prince. Luckily, his own affairs were in turmoil and he was unable to leave Naples. The same maneuver was tried again in 1325 when Robert's son, Charles, duke of Calabria (1298–1328), was offered the city. This royal prince actually came, and, to everyone's surprise—especially the aristocracy that invited him—began to rule energetically. One of his first efforts was to try to stop the ruling faction from not paying taxes, which they did first through the *prestanze* and second by rigging the assessment rolls so that their names did not appear at all or registered as far less wealthy than they really were. When Duke Charles needed money, he intended to get it from anyone. Hence, in 1326, he established the *estimo*, or direct tax on wealth that all solvent citizens had to pay. The rich oligarchs were alienated; they staged riots and tried to form an alliance with those lesser guildsmen whom they considered their social inferiors and whom they had kept out of the highest offices of government for years. Luckily, the *signore*, Charles of Calabria, died young in 1328. Had he not, Florence would very likely have developed into a principality, and the republican constitution, so favorable to humanism and the Renaissance, would have been short lived, as similar republican governments were throughout Italy.

Ironically, the alliance between the *grandi* and the lesser guildsmen against Charles required that the oligarchs give more authority to the fourteen lesser guilds. This was done by establishing a new method of choosing the priors that was more dependent on lot than nomination by the seven greater guilds. A complex system of lists of eligible citizens was devised that theoretically made the highest office of prior open to any guildsman who paid taxes and who was neither a felon nor bankrupt. However, either because the elections were fixed, or because of pure bad luck, most of the priors remained aristocrats. This system functioned until 1342 when yet another *signore*, a French adventurer, Walter VI of Brienne (c. 1304–56), duke of Athens, a relation of the Neapolitan Guelfs, was established as ruler. Walter lasted only a short time before he was removed in 1343 by a popular rebellion.

As with the period after the overthrow of the regime built by Charles of Calabria, the time after the expulsion of Walter of Brienne demanded a reassessment of the communal government. The commune was not only paralyzed but insolvent, for 1343 also saw the beginnings of the failure of two of Florence's greatest banks—those of the Bardi and of the Peruzzi—and, as a result, the collapse of the fortunes of the ruling conservatives who had, linked by marriage and kin to these conglomerates, entrusted those banks with their liquid assets. Consequently, many of the ruling class found themselves financially impoverished, and with their money went their political authority. Thus there began an experiment in wider government, indeed the most democratic government supported

Figure 6.4 (facing page)
Florence, Palazzo della Signoria (Palazzo Vecchio). The Palazzo della Signoria was designed by Arnolfo di Cambio. Begun after the Ordinances of Justice at the end of the thirteenth century, it was completed at the beginning of the fourteenth, although it was much altered during the period of the Medici monarchy, particularly the interior. The palazzo provided the council chambers, meeting rooms, and residences for the nine priors during their terms of office. These were the *signoria* for whom the palace was named (although it became known as the "Palazzo Vecchio" when Duke Cosimo de'Medici moved in the sixteenth century to the Palazzo Pitti). It was and remains to this day the town hall of Florence.

by the fairest taxation policies that Florence had yet seen. The office of prior (of which by this point there were nine to be elected) was open to all guildsmen; in fact, the 1343 arrangements required that at least six priors come from the fourteen less powerful *arti minori*, or craft guilds.

This government of 1343 was truly remarkable in that it was civically minded and less selfishly motivated than those of the aristocrats who had previously held power. Most importantly, the new regime saw the need to put Florence back in a secure fiscal position. Therefore, they united all outstanding public debts into a single publicly funded national debt, or *monte*. To service this debt, bonds were issued that bore an assured interest rate of five per cent per annum. These *monte* shares were negotiable and traded at varying rates, depending on the political and economic situation of the city. In other words, the finances of Florence were turned into a joint-stock company. This measure brought all citizens with any disposable capital directly into the political system as shareholders. Hence their deep concern with policy, whether promoting peace or war, stability or adventurism, since such things directly influenced the value of their paper wealth. Civic humanism certainly articulated the close relationship between citizen and state; but *monte* shares cemented it.

The second important institution was the re-enactment and enforcement of the *divieto*. This measure was designed to break up the influence of families whose extended kin structure could dominate the government. It excluded all members of any family represented in important communal offices; for example, if a Medici were elected prior, no other Medici might hold any important position. Hence the control of the *signoria* by the old aristocratic families declined, and more and more newly rich lesser guildsmen, as well as poorer greater guildsmen, entered the *signoria* in positions of authority. Once again, the aristocrats found themselves in a weaker position. The alliance of *magnati* and *grandi* had been carefully re-established during the period between 1302 and 1343, not through contravention of the Ordinances of Justice but through a legal faction that skirted it. Supported by a sympathetic communal government, the leaders of which were closely related by marriage, interest, and aristocratic psychology to the old nobility, the disenfranchised *magnati* had simply legally changed their names and denied any kinship with those 150 families excluded from government by the 1293 Ordinances. In this way, they were again able to enter the *signoria*. The bourgeois revolt of 1343, however, had once again put these patricians on the defensive through the *divieto* and out of actual control of the commune. But the setback was temporary. They simply waited for an opportunity to reassert their influence.

This opportunity came after 1378, following the revolt of the *ciompi*, the unskilled wool-workers. This popular rebellion had been initially successful: it gave the poorest elements in the city a taste of power and actually broadened the franchise dramatically through the creation of several new guilds, such as the tailors and dyers. Most significant, though, was the creation of the unskilled *arte del popolo di dio*—the guild of the people of God, or the *ciompi*. The property owners, especially the guildsmen of the *arti minori*, were terrified since they had the most to lose: most of their assets were invested in endangered property, buildings, workshops, homes, and warehouses in the city, all easy targets during social

upheaval. More afraid of the workers than of the aristocrats, the lesser guildsmen threw in their lot with the *arti maggiori* and overthrew the very democratic regime of the *ciompi* in 1381, executing its leaders. They re-established the old, closed aristocratic government and reinforced it through the subtle manipulation of the republican constitution. The pre-1343 status quo had been restored, although now perhaps with more sympathy and similarity of conviction, at least in politics and economics, between the great merchants of the *arti maggiori* and the prosperous tradesmen of the *arti minori*.

For the next fifty years, this is how the city was governed. This was also the period of the establishment of humanist values and Renaissance ideals in Florence. The government had achieved a measure of political stability. The interest on *monte* stocks provided a secure dividend income for most citizens and allowed for flexibility in public finance. And the complexities of institutions like the *monte*, the administration of the subject territories, and the operation of the chancery bureaucratized the government. No longer was it simply the preserve of aristocratic merchant politicians; it was also the realm of the professional civil servant, usually a humanist who applied his learning to the service of the state. The catasto of 1427 reflected the adoption of innovative fiscal policy. It was essentially an income and wealth tax not unlike those imposed today. Each citizen listed assets and liabilities and was taxed accordingly. Similarly, as we have seen, the *Monte delle doti* was introduced in 1425 to assist families in providing dowries for their daughters.

These years also saw the great period of the myth of Florence, vitalized by the ideology of civic humanism. The long wars (1385–1402) against Milan ended with the famous death of Giangaleazzo Visconti in 1402, an event interpreted as the result of the city's republican virtue. Pisa was finally captured (1406), giving Florence a direct outlet to the sea for the first time. Similarly, all of the rest of Tuscany except Siena and Lucca was brought under Florentine domination, turning the republic into one of the five great territorial states in Italy. Therefore, not only the effect of civic humanism, but also the political events of the first part of the fifteenth century reinforced Florence's self-confidence, wealth, and republicanism. The city was successful, and civic humanism as expounded by Leonardo Bruni provided an ideology for that success.

THE RISE OF THE MEDICI

Ironically, the years after the suppression of the *ciompi* revolt were also a period of increasingly restricted government. The victory of the property-owning guildsmen and the willingness of the *arti minori* to acquiesce to the ambitions of the most influential and richest members of the *arti maggiori* resulted in an oligarchic regime that worked to keep power concentrated in the hands of a few rich and long-established families, very much to the exclusion of lesser guildsmen. Opposed to this oligarchy was Cosimo de'Medici (1389–1464), head of the powerful Medici bank and the richest man in Florence. Cosimo had become the spokesman for the popular faction representing the lesser guildsmen and

others opposed to the oligarchy led by the patrician Rinaldo degli Albizzi (1370–1442). By 1433 the tensions in the city had grown acute. An unsuccessful war against Lucca (1429–33) had cost enormous amounts of money and had produced only humiliation. Fearing the growing popularity of Cosimo, the Albizzi oligarchy spread rumors that the Medici were in fact working with Florence's enemies and in 1433 manipulated the *signoria* to exile Cosimo from Florence. Cosimo's absence from the city lasted only until 1434, however, as the economic and political failures of the regime occasioned a popular reaction to the oligarchy. Albizzi and his fellow oligarchs were themselves exiled or neutralized, and Cosimo returned in triumph, thus beginning sixty years of Medici hegemony.

The victory of Cosimo and the Medici faction changed the nature of the Florentine republic; but Cosimo wisely respected the constitution of the republic and the city's commitment to republicanism. His influence, therefore, was subtle and managed discreetly to ensure that the pride and ambitions of the political elite were not compromised. Rather than exercise power openly, Cosimo manipulated the electoral process by controlling the *accoppiatori*, the committee that determined eligibility for office. In this way the Medici could govern the republic behind the scenes and the traditional rotation of magistracies would continue to operate. Moreover, Cosimo did not flaunt his power but held office only when chosen; he dressed soberly, like the wealthy banker he was, and respected the institutions of the state. The only public celebration of his position was the building of the huge Palazzo Medici, designed by the architect Michelozzo Michelozzi (1396–72). Cosimo also used his wealth to patronize art and building, making Florence an increasingly beautiful city. When he died in 1464 he was sincerely mourned and recognized with the title of *pater patriae* (father of his fatherland), the inscription that still identifies his tomb in the church of San Lorenzo, which he had rebuilt by the brilliant Filippo Brunelleschi (1377–1446), the architect of the dome on Florence's cathedral.

There could be no clearer indication of the solidity of Florence's acceptance of the hegemony of the Medici than the seamless assumption of power of Cosimo's son, Piero (1416–69), on Cosimo's death in 1464. Piero was a very different man from his father. He had been raised more like a prince than a banker. And, despite an excellent humanist education and the example of his father's success, he appeared haughty and aloof rather than a popular politician. Part of this was the result of his suffering terribly from gout, a disease that limited his mobility, caused leading citizens to visit the Palazzo Medici for political business, and even led to his having to be occasionally carried in a litter because of the pain of walking. His short period of control of the city (1464–69) had already begun to generate serious opposition as reflected in a major plot against him and his family. Nevertheless, when he died there was no question but that his eldest son, Lorenzo, later named *il magnifico* (the magnificent), would succeed him. With that young man's assumption of power, Florence entered the brilliant Laurentian age.

Lorenzo de'Medici (1449–92) was a remarkable man. Splendidly educated by the best humanist scholars, a natural poet and brilliant patron of art and learning, and possessed of a common touch that endeared him to all classes of citizens, Lorenzo has given his name to one of Florence's most celebrated moments. He did have failings, however: he had no

interest in the family bank, and so it declined greatly during his life, reducing his ability to use his private resources to support the public purse; he was inexperienced at the beginning of his rule, allowing, for example, the terrible sack of Volterra in 1472 by mercenary soldiers employed by Florence to control the alum deposits needed for the fulling of wool. Later in his life he used public funds for private purposes and began to manipulate even the *monte delle doti*, the state dowry fund. But, in general, his exercise of power was gentle and benign, even if not all Florentines agreed.

Lorenzo's greatest challenge resulted from an altercation with Pope Sixtus IV della Rovere (r. 1471–84). This nepotistic pontiff wanted to install his nephew, Girolamo Riario (1443–88), as ruler of the city of Imola, and so Lorenzo, as the head of the Medici bank and hence papal financier, was asked to extend the money to achieve this. Lorenzo, distrusting the ambitions of the papacy, refused. Sixtus was furious and transferred the papal account to the bank of the Medici's enemies, the Pazzi, an ancient, rich, and powerful clan opposed to the Medici hegemony. This resulted in an alliance emerging between the Pazzi, Girolamo Riario, and others who had become alienated from the Medici, including the archbishop of Pisa who, as a political opponent, was not permitted to take possession of his see and kept in Florence almost as a prisoner by Lorenzo.

The result was the Pazzi Conspiracy of 1478. An elaborate plan was devised to kill Lorenzo and his younger brother, Giuliano (b. 1453), and to dislodge the Medici faction from power and replace it with the Pazzi, supported by the Riario and the pope. After several failed schemes, it was finally decided to murder the brothers during mass in the cathedral at Easter. The signal was to be the ringing of the bell at the elevation of the host during mass. Only then could the conspirators be certain that both Medici would be together and unarmed. However, the moment chosen for the assassination so frightened one of the professional killers hired by the Pazzi—despite the pope's offer of a pardon in advance—that a substitute had to be quickly found. So, when the bell sounded and the assassins struck, Lorenzo was only wounded, although Giuliano was killed. Lorenzo's friends carried him into the sacristy and locked the doors, sucking his wound in case the knife had been poisoned.

Immediately the Pazzi and their supporters rode through the city shouting *Libertà, Libertà* (Liberty), and the archbishop of Pisa, in full ceremonial robes, went with others to the Palazzo della Signoria to demand a new government. When news spread through the city of the attempt on Lorenzo and the murder of the popular Giuliano, the city shouted down the conspirators with cries of *palle, palle* (literally "Balls," the symbol of Medici from their coat of arms). The *signoria* put ropes around the necks of the archbishop and his accomplices and threw them from the windows of the palace, leaving them to hang outside as symbols of the city's loyalty to the Medici.

The failure of the Pazzi Conspiracy and the murder of the archbishop of Pisa drove Pope Sixtus to declare war on Lorenzo—not Florence—and put an interdict on the city. He demanded that his vassal, the king of Naples, lead an army against Florence to punish the Medici: thus began the War of the Pazzi Conspiracy (1478–80). Florence had made no preparations for war, and the city was in great danger and suffered from hunger and the

economic catastrophe that the interdict occasioned. Still, there was no thought of surrendering Lorenzo. However, in an act of great courage and diplomacy, in 1480 Lorenzo left Florence for Naples, the capital of the king threatening his territory. In Naples, over many weeks of negotiation, Lorenzo convinced the king that it was in his best interest to make peace with Florence and distrust the ambitions of the papacy. In this way the war ended with a separate peace between Florence and Naples, and Lorenzo was secure in his authority. Pope Sixtus had no alternative but to end hostilities, seeing no hope of punishing the Medici.

The effect of the Pazzi Conspiracy on Florence was, nevertheless, significant. Lorenzo's personality changed into one of suspicion and fear. Unlike before, he began to travel with armed guards and never altogether lost the melancholy caused by the murder of his much-loved younger brother. To ensure Medici rule in those dangerous times, Lorenzo also changed the constitution. He created the Council of Seventy in 1480, the members of which were to be nominated first by him and its vacancies filled by the Council itself. It was a clear instrument of Medici control; no longer was the exercise of power to be discreet and subtle; it was now clear and institutionalized. Lorenzo had become ruler of Florence. Although patronage continued and Lorenzo remained the center of what was obviously developing as a kind of court, Florence was changing as well. The events of the Pazzi Conspiracy and the growing tensions within Italy and Europe diminished the luster of humanism and cultural patronage by the time of Lorenzo's last illness and ultimate death in 1492. Moreover, Lorenzo's eldest son, Piero (1472–1503), was obviously incompetent and unable to navigate the complex challenges emerging in Italy and across the Alps. This was the period of the rise of Girolamo Savonarola (see Chapter Eleven) and the apocalyptic challenge to the humanist principles and ideas that had animated the Renaissance in Florence.

FURTHER READING

Brown, Alison. *The Medici in Florence: The Exercise and Language of Power*. Florence: Olschki, 1992.

Brucker, Gene A. *Renaissance Florence*. Berkeley: UCLA Press, 1983.

Crum, Roger J., and John T. Paoletti, eds. *Renaissance Florence: A Social History*. Cambridge: Cambridge University Press, 2006.

Goldthwaite, Richard A. *The Building of Renaissance Florence: An Economic and Social History*. Baltimore: Johns Hopkins University Press, 1980.

Hook, Judith. *Lorenzo de' Medici: An Historical Biography*. London: Hamish Hamilton, 1984.

Martines, Lauro. *April Blood: Florence and the Plot against the Medici*. Oxford: Oxford University Press, 2003.

Parks, Tim. *Medici Money: Banking, Metaphysics, and Art in Fifteenth-Century Florence*. New York: Atlas Books, 2005.

Polizzotto, Lorenzo. *The Elect Nation: the Savonarolan Movement in Florence 1494–1545*. Oxford-
 Warburg Studies. Oxford: Clarendon Press, 1994.

Weinstein, Donald. *Savonarola and Florence: Prophesy and Patriotism in the Renaissance*. Princeton, NJ:
 Princeton University Press, 1970.

SEVEN

ROME AND THE PAPACY

ROME WAS MORE THAN just the see of the bishop of Rome; it was another Renaissance state, one that included territory well beyond the city boundaries: the states of the Church. Partly theocratic, partly hierocratic, and usually chaotic, the states of the Church, dependent upon the Holy See at Rome, exhibited a diversity quite unmatched by any other principality, a variety made even more complex by the contrasting personalities of the various popes who were elected to the see of St Peter during the Renaissance.

THE BABYLONIAN CAPTIVITY

The lifetime of Petrarch (1304–74) corresponded almost exactly to the period known as the "Babylonian Captivity" (a description that might have originated with him), that is, the period during which the pope resided not in Rome but in Avignon, a church territory in the south of what we now know as France. Petrarch's life and that of his father were closely associated with this curious period in papal history, and the sojourn of the bishop of Rome outside his see and city was an important element not only in the fate of the city of Rome but also in the development of Renaissance and European culture.

To understand what drove the successors of St Peter to abandon Rome for a territory outside Italy, it is necessary to return to the pontificate of Boniface VIII, who ruled as pope from 1294 to 1303. The claims of universal dominion by this pope, especially as defined in his bull *Unam sanctam* of 1302, were compelling, as he declared universal authority for the papacy over all other institutions, including the Holy Roman Empire and all dynastic territorial monarchies. In so doing he unconditionally supported the immunity of the clergy and its property from royal legal jurisdiction and taxation. The result of this assumption of universal dominion was not, as before, a conflict with the Empire as much as an angry reaction from the king of France, Philip the Fair (r. 1285–1314), whose intent was

to construct a centralized monarchy out of his feudal kingdom, one in which the Church would be more subject to the power of the Crown. To win this particular battle against Boniface, Philip even seized his person, holding him prisoner, a shock from which the old man never recovered.

Philip was not content with this victory and wanted to ensure that the papacy could not again interfere in the governing of his kingdom. Boniface's successor, the saintly Benedict XI, lasted less than a year on the throne of St Peter, and that provided an opportunity for Philip to influence the conclave that met in 1305 to elect the next bishop of Rome. In this the king's agents were successful, and the chosen pope was a Frenchman, the archbishop of Bordeaux, who took the name Clement V (r. 1305–14). Clement had been a loyal royal servant, one inclined to listen to Philip, who now counseled that Clement remain in France. Clement had had every intention of traveling to Rome after his election, but the situation in the city was unstable: it was being threatened by the same brawling, turbulent, lawless nobles who made so many Italian communes anarchic during this period. Also, despite his being French, Clement himself was keenly aware that the king of France was the Church's most powerful enemy, one who continued to threaten the Church's immunity, power, and wealth. Surely it was advisable that Clement stay close to the French throne; and Avignon was halfway between Paris and Rome. More important, it was not part of French territory but a fief of the Church as a result of a transfer of territory by the kingdom of Naples. Establishing residence there was in many ways a perfect compromise for Clement, a compromise that was to see the papacy in Avignon for the next seventy years.

To say that the pope was the creature of the king of France is in fact an exaggeration; but the perception was there throughout Europe, as witnessed by the description of the seventy-year sojourn in Avignon as the "Babylonian Captivity," a direct and scathing reference to the Old Testament story of the slavery of the Israelites in Babylon. And there was certainly evidence of French sympathy: all seven popes elected during the Babylonian Captivity were French, and of the 134 cardinals they created, 113 were French, as were the majority of high curial officials. These men had estates and family connections in France, up to and including the royal house itself; and they shared a cultural and emotional sensitivity to French policy. It seemed to some nations, then, that the pope was an officer of the French king, a view strongly held by those states opposed to France, like England and the Empire. This helped weaken the claims of universality that the papacy had defended during the Middle Ages and also made the Church itself even more associated with the secular power and ambitions of favored princes. Add to this the perceived moral decline in the Church during this period as a result of practices described by Petrarch in his *Book without a Name*, and the traditional position of the Holy See and the Roman Church was increasingly being questioned.

The absence of the papacy from Rome also weakened that city and the territories it controlled. With the center of power removed, the brawling, lawless nobles and *signori* ruling as papal vicars in the states of the Church sought to avoid any papal oversight and to rule and act independently of the Church. To attempt to remedy or control this fragmentation of papal authority in Italy itself, the popes of the Babylonian Captivity

employed mercenaries to reclaim what they had lost, adding both additional instability and great expense to the already weakened position of the Holy See. Popes lost revenue from their territories in Italy while paying huge amounts to mercenaries and granting greater autonomy to those papal vicars who claimed to be loyal sons of the Church. Every opportunity to increase an old fee or create a new tax was grasped to maximize the money payable to the pope. Legal or financial acumen or even military skill trumped spirituality or learning in the Avignonese curia, and corruption was widespread. The invention of venal offices, nepotism, pluralism, non-residence (the example of the pope himself being an undeniable model), and simony spread and sapped the moral authority of the Church.

The consequence was the alienation of those states in conflict with France that did not wish to contribute money to a Church that was believed to be used by the king of France to fight against them. There was a spiritual alienation of high-minded ecclesiastics and laymen who were appalled by the actions and reputation of the curia in Avignon; and there was an alienation of simple Catholics who felt that the shepherd had abandoned his flock, that he had broken the apostolic succession from St Peter and the secular succession from Constantine. These men and women began to seek moral and spiritual comfort in non-sacramental sects, led by men of piety but not closely associated with the established hierarchy of the Church. The Babylonian Captivity, then, was corroding the very center of Catholicism and undermining the faith of adherents across the continent.

THE RETURN TO ROME AND THE GREAT SCHISM

This situation was recognized by many sincere reformers. Of these, two female saints, Bridget of Sweden (1303–73) and Catherine of Siena (1347–80), were the most eloquent and persistent, calling for the return of the papacy to Rome to confront the institutional and spiritual damage that the Babylonian Captivity had inflicted on the Church. They preached insistently before the pope and his curia to the point that Gregory XI (r. 1370–78) finally made the decision to return to Rome, abandoning the beautiful and luxurious palace of the popes in Avignon in 1377 to reclaim the see of St Peter. Classical Rome, the city of Peter and Paul and of Augustus and Constantine, had been known as the *caput mundi* (head of the world), with accommodation for perhaps a million people within its massive Aurelian Walls. But what Gregory encountered was a sorry remnant of its classical past, a neglected city of largely abandoned and half-buried ruins housing about twenty thousand people huddled in the bend in the Tiber across from St Peter's basilica. Before the Babylonian Captivity, the city had been an administrative and pilgrimage center for the Church, but the flow of pilgrims had declined with the absence of the papacy, and there had been little industry to sustain the population in the interim, a population that was also reduced by malaria and other diseases.

Gregory had resolved to undertake the formidable challenge of restoring the city as a great capital. But his good intentions were unrealized, for he died in 1378, just one year

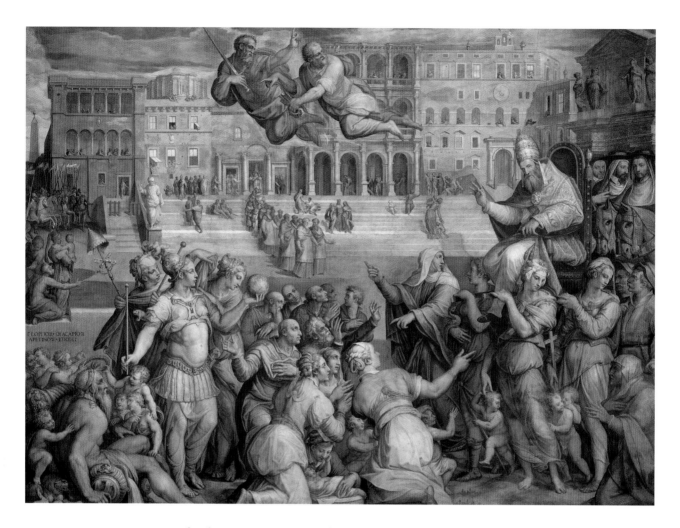

Figure 7.1 Rome, Vatican Apostolic Palace, *Sala Regia*. Giorgio Vasari (1511–74): *The Return of Pope Gregory XI to Rome*. This sixteenth-century image of the return of Gregory XI to Rome in 1377 depicts Saints Peter and Paul hovering above the returning pontiff as he is guided by St Catherine of Siena (who points the way) and welcomed by the personification of Rome (the woman on the left clad in armor). The background shows the façade of old St Peter's basilica and the papal palace.

after his return to Rome. The conclave that gathered to choose his successor contained only four cardinals of Italian birth, the long succession of French popes having elevated so many of their own countrymen to the Sacred College. Still, the Roman populace and nobles would not tolerate another foreigner as the bishop of Rome. Fearing that the papacy might again leave the city, thus depriving it of its major source of income, they rioted around the apostolic palace as the conclave met. And the cardinals, fearful of the mob, duly elected an Italian—Urban VI (r. 1378–89).

The former archbishop of Bari was indeed an Italian, and he was also intransigent and highhanded, intent upon imposing order and reform on the sybaritic cardinals of the Sacred College. Outraged at having to behave canonically, the French cardinals gathered in Agnani, a papal fortress close to Rome, and declared Urban's election invalid because of duress. Soon joined by the Italian cardinals who also liked their pleasures, the college declared Urban deposed and Robert of Geneva, another Frenchman, pope under the name

Clement VII (r. 1378–94). (Because he was later declared an antipope, that is, not a true bishop of Rome, his name could be reused, as it was in this case by Giulio de'Medici, the accepted Clement VII [r. 1523–34].) This was the beginning of the Great Schism. Clement VII went to Avignon, where he established his court. Urban, however, refused to abdicate and remained in Rome. There were now two popes, each of whom attracted followers, depending on the European alliance system. Each pope excommunicated not only the other but also all of his rival's supporters.

The death of Urban VI in 1389 did nothing to resolve the crisis; rather, it exacerbated it by perpetuating the schism through the election of his successor. The same happened in Avignon: Christendom had two—and, after 1409, three—popes until 1417. The schism was healed only after two councils—Pisa in 1409 and Constance in 1414–17—had deposed one set of popes—including the infamous antipope John XXIII—and had chosen a Roman noble, Oddone Colonna, as Martin V in 1417. Martin could not return to Rome until 1420 because it was unsafe, and when he did he saw the city in ruins, the papal states in total disarray, and the capital of Christendom more like a provincial town. A man of learning, he appointed Poggio Bracciolini as secretary and patronized Gentile da Fabriano, Pisanello, and Masaccio to decorate the derelict churches and palaces. He restructured the curia and appointed good men as cardinals, and he attempted sincere and substantial reforms at the Council of Pavia (1423) and Siena (to which place the original council moved to avoid the plague). Although blocked by vested interests, Martin V (d. 1431) at least laid the foundations of the Renaissance papacy by making the machinery of the Church work again and by producing revenue, using some of it to patronize art and letters. But his almost total failure at spiritual reform presaged the problem obvious to all concerned observers: the Church could not reform itself. As a consequence, most of his immediate successors did not bother even to try.

THE RENAISSANCE COMES TO ROME

One great attempt to resolve a problem that had divided the Christian world since 1054 was initiated under Martin's beleaguered and incompetent but well-meaning successor, Eugenius IV (r. 1431–47). Realizing that without Western aid the Byzantine empire and its capital at Constantinople would fall to the Turks, the Greeks asked the pope to call a council to heal the break. The Byzantine emperor himself, his patriarch, and seventeen metropolitans (bishops) traveled to Italy, where they met the pope, first at Ferarra and then in 1439 at the celebrated Council of Florence. After various difficult compromises, the schism between the Latin and Orthodox Churches was temporarily healed and the two churches declared united in the Duomo (cathedral) of Florence under Brunelleschi's just completed great dome in July 1439. The entire Greek emperor's court was provided with hospitality by Cosimo de'Medici, and Florence was filled with Greek scholars. This fact impelled the study of Greek even more among Florentine humanists and the scholars of the papal court, and reinforced the growing interest in neo-Platonism among the intellectual elite.

Indeed, even the pope was inspired to further embellish his court. He added Leonardo Bruni and historian Flavio Biondo (1392–1463) to his court and patronized Greek scholars. He brought Fra Angelico (c. 1395–1455) to Rome and commissioned Filarete to build doors for old St Peter's like Ghiberti's on the Florentine Baptistery. Eugenius, then, consciously brought the Renaissance from Florence to Rome during the 1440s, inspired by the circumstances and events of his life. These first lights of the Renaissance in Rome bore fruit under the papacy of Nicholas V (r. 1447–55). This pope was a humanist himself. A compromise candidate from the beginning, he had been born poor rather than into a noble family. He had spent many important years in Florence, where he became the close friend and companion of humanists such as Poggio and Bruni and spent most of his meager income on books. Once pope, Nicholas admitted to three aims: to be a good pope, to rebuild Rome, and to restore classical learning and art. The first ambition he fulfilled well. Nicholas avoided war and nepotism, the two great evils of later Renaissance popes. He himself lived simply and was generous only to advance his patronage of learning and culture. Even the last antipope, Felix V (r. 1439–49), elected at the schismatic Council of Basel, realized Nicholas's talents and resigned and was forgiven. Therefore, by 1449, all manifestations of a divided Christendom were gone.

Nicholas entered into his second ambition—the rebuilding of the city—with dynamic enthusiasm. He restored the city walls and gates, and he repaired a derelict ancient Roman aqueduct, giving Rome access to sufficient water for the first time in a thousand years, allowing for a healthier and larger population. He constructed public fountains, squares, and wide avenues with covered arcades to protect the citizens from the sun and rain. Streets were paved and bridges repaired. Papal money was lent to private citizens to encourage them to build palaces and beautify the city. The patriarchal basilicas, such as Santa Maria Maggiore (St Mary Major), San Paolo fuori le Mura (St Paul outside the Walls), and San Lorenzo fuori le Mura (St Lawrence outside the Walls), were renovated to attract and support more pilgrims to the city. The medieval palace adjacent to St Peter's basilica on the Vatican hill was renovated as the new permanent papal residence, replacing the still damaged Lateran palace attached to St John Lateran, the cathedral of Rome. And Nicholas introduced the idea of tearing down old St Peter's, the church built by Constantine over the tomb of the apostle, and replacing it with the greatest church in the world, a plan so audacious it required the personality of Julius II (r. 1503–13) to effect it.

His third ambition—to restore classical letters—occupied his entire pontificate. New translations were made of old works and new editions produced; books in all languages were acquired from throughout the world, and texts of beauty and antiquity flowed into Rome. Greek especially interested Nicholas, so that during the eight years of his pontificate more Greek authors were translated into Latin than in the previous five centuries. All of these books he put into one of his greatest legacies, the Vatican Library, which he founded and which, even during his lifetime, became the greatest library in the Western world.

Nicholas died in 1455 and was succeeded by a Spaniard, Calixtus III (1455–58), whose three-year pontificate is significant only for his elevation of his nephew, Rodrigo Borgia, the future Alexander VI and father of Cesare and Lucrezia Borgia, to the Sacred College. The

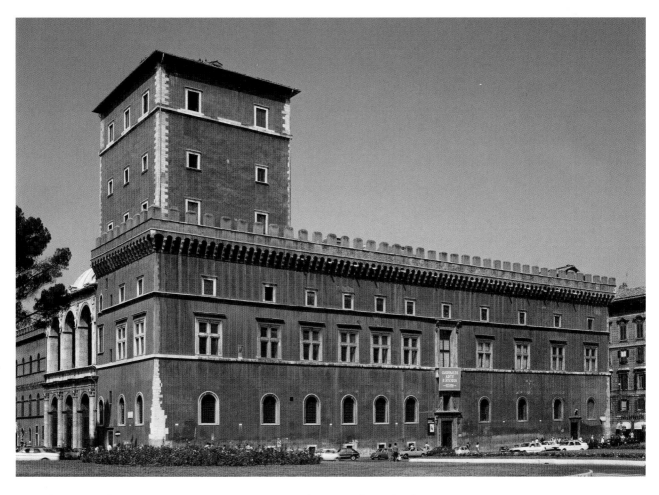

pontificate of Calixtus' successor, Pius II (r. 1458–64), however, brought the Renaissance back into the papacy with a wonderful new style. As Aeneas Silvius Piccolomini, Pius II had been a famous humanist and historian. He was thoroughly reprobate in personality when young and even had written a scurrilous novel (*The Story of the Two Lovers*) in the style of Boccaccio. A brilliant wit, he used his learning, including knowledge of scripture, to write against clerical celibacy, a mortification then quite beyond his power or comprehension, and in favor of fornication over chastity, letters that came back to embarrass him as pope. However, he was a literary genius and one of the Renaissance authors still quite consistently read, especially his historical and travel commentaries and memoirs. This brilliant but lascivious humanist underwent a kind of conversion in 1445–46 while on an embassy from the emperor to the pope. He took major orders and completely reformed his personal life. Made a bishop and then a cardinal, he was chosen pope in 1458, after which time he led an exemplary life. Although he continued to employ humanists and artists, Pope Pius' new vocation required more money for crusades against the victorious Turks

Figure 7.2 Rome, Palazzo Venezia. Palazzo Venezia was commissioned by the nephew of Eugene IV, Pietro Barbo, who later became Pope Paul II. Completed in the middle years of the fifteenth century, it was the first great private palace in the new Renaissance style in Rome. Its size and splendor were such that when he was elected pope, Paul chose to continue living here rather than moving into the official papal quarters, the Apostolic Palace in the Vatican.

than for extravagant patronage. His major policy was in fact the calling of a new crusade to recapture Constantinople from the Turks, who had taken the city built by Constantine in 1453. It is a sad irony that he died at Ancona just as the ships to carry the crusaders to the Bosporus began to arrive.

The pontificate of Pius' successor, Paul II (r. 1464–71), was not very important. A Venetian, he lived sumptuously and engaged in the traditional Venetian policy of hypnotic magnificence. As a result, the minor arts, especially goldsmithing, thrived (Paul's tiara cost more than his Roman palace), but literature and painting declined. Indeed, to save money, Paul fired from the chancery fifty-eight humanists who had been engaged by Pius II, a measure that led to his vilification by the most eloquent writers of the age.

If Paul II was magnificent and vain, Sixtus IV (r. 1471–84) was ambitious and nepotistic, although he was also a magnificent patron of art, learning, and building. Angered by a hostile gesture from Florence, he conspired with his nephews and the Pazzi family in numerous attempts on the lives of the Medici. Priests and an archbishop were suborned to support the murder of Lorenzo and Giuliano in the cathedral during mass; and, as we have seen, in 1478 Giuliano was slain and Lorenzo wounded, sparking the War of the Pazzi Conspiracy. What is more curious is that before his elevation—which was in part achieved through intrigue and bribery—Sixtus was known for his learning and integrity. Yet his pontificate was one of crass nepotism in which his worthless nephews were given other people's states, if lay, and the most lucrative church preferments if clerical. One of these relatives, Piero Riario (1445–74), was given four of Italy's richest sees, including Florence, collectively producing an income in modern currency of 1.5 million dollars per annum, a sum Piero not only spent but surpassed through debts of about a third as much again. He had every vice, and despite being a cardinal he loved to publicly parade his many mistresses, a virtual harem, dressed like princesses. He died, burned out by his excesses, at twenty-eight. The ambitions of his secular relation, Girolamo Riario (1443–88), we know from the latter's difficulties with Lorenzo de'Medici.

Still, Sixtus IV did much good for Rome. He widened and paved streets and built the first bridge across the Tiber since antiquity, the Ponte Sisto, which still bears his name. He erected and had decorated the walls of the Sistine Chapel, as he found the chapel of Nicholas V, decorated by Fra Angelico, too small. He founded the Sistine Choir, another institution that survives to this day. The University of Rome was reorganized under his supervision, and the Capitoline Museum, still in operation, was opened as Europe's first public museum. Sixtus also managed to find money to add eleven hundred volumes to the Vatican Library and decreed it to be an open public library, resulting in his recognition (after Nicholas V) as its second founder. Perhaps his most important policy was a simple administrative change in the law governing the property of high ecclesiastics working and living in Rome. Previously, all the property of these important curialists was to revert to the Church, as the Church had been the source of that wealth. However, this regulation discouraged grand buildings in the city by cardinals and others, for the palaces and villas could not be willed to their families. Sixtus altered that law, permitting high churchmen to leave their property to heirs, whether secular or ecclesiastical: the consequence was a great

building boom that saw the city grow in beauty and stature, as curial officials competed with one another for the grandest residences, a competition that soon after encouraged the lay nobility of the city to do the same. Rome, then, ceased to be a city of fortified noble tower houses and unimposing buildings rented to cardinals; it began to develop into an elegant city of stylish and significant palaces. A rising new nobility with close ties to the Church began to share power and prestige with the old nobility: the face of Renaissance Rome was emerging. Thus, despite his vices of simony, nepotism, and violence, Sixtus made important contributions to the Rome of the Renaissance.

Sixtus' successor, Innocent VIII (r. 1482–92), was the affable Giovanni Battista Cibò, whose irenic character brought some peace to the papal states. Innocent was a kindly—but not saintly—man who enjoyed his two children and scandalized even the worldly curia when he celebrated their marriages in the Vatican with princely ecclesiastical pomp. He was not particularly interested in artistic or literary patronage, although he did build the beautiful Villa Belvedere in the Vatican gardens and commissioned a fresco cycle from Mantegna.

Indeed, Pope Innocent was a wholly secular man. Once his rich son was married to the even richer daughter of Lorenzo the Magnificent, Innocent allowed the Florentines to direct papal policy so that the pope might enjoy his office without too much work. Always in need of money, Innocent brought great disrepute upon the papacy by the measures he took to secure more revenue. For example, he, the leader of Christendom, accepted a huge pension from the sultan of Turkey, the son of the recent conqueror of Constantinople, to prevent him from using a Turkish prince, then resident with the pope, as a threat to the Ottoman sultan. Also, Innocent sold dozens of offices to men whose only qualification was their ability to pay and whose greatest ambition was to become rich at the Church's expense. To maximize the curia's efficiency, technocrats were elevated to high office, including the Sacred College, because of their administrative ability rather than their sanctity. Confessional and canonical as well as secular crimes, sins that even Cardinal Borgia—himself no stranger to most of them—saw as too heinous for remission, were almost invariably reduced to cash fines to be added to the papal coffers.

All of this added to the moral decline of Rome. The city, although growing progressively more beautiful and decorated, was becoming increasingly corrupt. The Church behaved like any other Renaissance state and as such should not be overly condemned, because the States of the Church were one of the principalities of the peninsula, even though there were those who believed that the see of St Peter should be more than another petty principality and act as a moral example to the others.

Innocent VIII died in 1492, the same momentous year as did Lorenzo the Magnificent, and the year in which Christopher Columbus's voyages were to re-order the economic and political balance of Europe to the perpetual disadvantage of Italy. In death, Innocent left his greatest monument, Pollaiuolo's magnificent tomb in St Peter's, one of the few monuments transferred from the old to the new St Peter's. Less commendably, his pontificate prepared the way for the character of the papacy of Roderigo Borgia, Alexander VI, whose reign was to bring the Holy See to its ethical and moral nadir.

THE BORGIA PAPACY

Alexander VI (Rodrigo Borgia, r. 1492–1503) was a curious person for a number of reasons and a man very difficult to fully understand. He had been papal vice-chancellor for thirty-five years, and that had permitted him to build perhaps the largest personal fortune ever amassed by a cardinal. While a cardinal he built a huge network of personal debts by lending money and doing favors. As a result, when Innocent died and Roderigo Borgia was chosen pope, it was to the delight of the people of Rome whom he had always assiduously courted with bread and circuses. After so long at the center of power, it was generally believed he would bring substantive intelligence, experience, and administrative skills to the service of Rome and the Church. Everyone knew about his exceptionally uncanonical private life—he had never even tried to hide it—but very few really cared.

Let us begin with Alexander's good side (he chose his papal name after Alexander the Great). He distributed food to the people of Rome in difficult times and impressed them with his style, such as his Turkish guard. He also continued rebuilding the city to a degree. The coffered ceiling of Santa Maria Maggiore was decorated with the first gold brought by Columbus from the new world. Castel Sant'Angelo was reconstructed, together with the escape corridor from the Vatican. He rebuilt the University of Rome and helped it gain stature. And in just two years he balanced the papal budget, despite the enormous charges his ambitions placed upon it, although through methods now hardly acceptable. Finally, he did what no other Renaissance pope was able to do because most others would not or could not have adopted his means: he subdued the violent, warring noble families of the city and imposed order on the papal states, actually succeeding in establishing his rule over the Romagna through the energy, brilliance, and complete ruthlessness of his second son, Cesare Borgia.

Why, then, does Alexander VI have such a bad reputation? In fact, it is deserved. His administration was financially sound because he sold everything the Church had to offer. Papal offices were virtually auctioned, and he created dozens of new and largely unnecessary positions in the curia so that he could add more to his treasury. In 1500 he sold twelve cardinals' hats for 10,000 ducats each, raising a member of the Este family to the Sacred College at a mere fifteen years of age (at least he waited until his own son, Cesare, was eighteen before making him a cardinal). Just three years later, in need of more cash, he created another nine cardinals for the same fee. And, when a high ecclesiastic died in Rome, Alexander stripped his property bare.

Then there were his personal morals and those of his family to consider. He was absurdly generous to his Spanish relatives and fellow countrymen, but even more so to his immediate family. His four children benefitted the most, in part because these offspring were seen by the pope as instruments of papal policy. The children were those of Alexander's first long-term mistress, Vanozza dei Catanei (1442–1518), who was in many ways an ideal corporate wife who could do whatever was required with style and elegance and never upstaged her husband. She became a popular figure in Rome, and when she died she was truly mourned and given a papal state funeral since she bequeathed her considerable fortune to Holy Mother Church.

Well before her death, however, Alexander had found a new object of affection, the beautiful and brilliant teenaged Giulia Farnese (1474–1524), the celebrated "bride of Christ." She was conveniently married to a Roman noble so that her children might be legitimate from birth; and she, too, became a kind of queen of Rome, again emerging from the opprobrium of less tolerant observers, for she was a rather attractive, noble, and generous person. Indeed, it was her relationship with Alexander that led to her brother's becoming a cardinal and, later, Pope Paul III Farnese.

But it is Alexander's children who gave him the greatest hope and trouble. His daughter, Lucrezia (1480–1519), was in many ways like her father: intelligent but lascivious and ruthless. She was first married to Giovanni Sforza (1466–1510) when the pope needed an alliance; however, when the connection was no longer efficacious, the marriage was dissolved through perjury, as Lucrezia swore it had not been consummated. Her second marriage, to Alfonso of Aragon, duke of Bisceglie (1481–1500), an illegitimate son of the king of Naples, was ended by his murder, certainly at the hands of her brother, Cesare. (After the first assault—committed on the steps of St Peter's—on the young man failed to kill him, he was finally strangled in the Borgia apartments in the apostolic palace itself.) After her third marriage, however, Lucrezia ended her life as the greatly loved, pious duchess of Ferrara, despite her long affair with her brother-in-law, Gianfrancesco Gonzaga (1466–1519), marquis of Mantua, the husband of Isabella d'Este.

Alexander's eldest son, Juan (b. 1477), was the favorite. Given a Spanish duchy when young, he was raised to be the sword arm of the Church, while his younger brother, Cesare, was slated initially to be a future pope. Unfortunately, Juan had his father's obsession with women but lacked his judgment, and he had a very short attention span. In 1497, Juan was murdered, his body found floating in the Tiber riddled with stab wounds. Jealous husbands and angry fathers were generally suspected, but the most likely murderer was his own brother, Cesare (1475–1507), who wanted a secular life and thought Juan an incompetent soldier. Alexander, with Juan dead, would need another trusted general to defend the Church, and the natural choice was Cesare, who at twenty-three was released from his vows as a priest, despite enjoying the enormous income of the archbishopric of Valencia. This release was made quick and easy by the pope's simply withdrawing Cesare's legitimization, as bastards could not be priests, let alone cardinals.

Cesare's policy—because Cesare soon eclipsed even his father—was to build a Borgia kingdom out of the chaotic papal states of central Italy. Those city states that owed allegiance to the popes but whose papal vicars had ruled for centuries as independent *signori* would be forced to admit the sovereignty of the pope and his military leader, Cesare. Imola, Faenza, and Urbino, ruled by princes with names such as Sforza, Manfredi, and Montefeltro, despite having enjoyed centuries of hereditary lordship, were declared directly subject to the pope; and by 1500 Cesare was well on the way to succeeding where no ruler of the papal states had done before. Strengthened by an alliance with Louis XII of France, and married to Louis's niece and given the important French duchy of the Valentinois (the territory around Valence—hence Machiavelli's calling Cesare "Duke Valentino"), Cesare appeared invincible and so ruthless that he became a symbol of unbridled ambition and

power. As long as Cesare had time to consolidate his power and the pope lived, a Borgia kingdom in central Italy seemed a certainty.

However, the pope did not live: he died of malaria in 1503. On word of his death, Rome rioted, and the old noble families reasserted their power, with Orsini, Colonna, and Savelli soldiers taking over the city. Cesare, if he were to survive, would have to move quickly, especially to ensure the election of a friendly pope at the next conclave. Unfortunately, this did not happen. Cesare, too, had malaria and was near death. Still, he remained sufficiently powerful to ensure a compromise candidate in the 1503 conclave— the elderly Pius III Piccolomini, nephew of Pius II—but the old man died in less than a month. Then, in late October, Giuliano della Rovere, a man every bit as brilliant, ruthless, and implacable as Cesare—his and his father's enemy for years—was elected. Cesare tried to patch together a deal with this new pope, who took the name Julius II and who would rule until 1513, but it soon became clear that a settlement was impossible.

The cities of the Romagna, helped by other Italian states fearful of the new papal power in central Italy, revolted and recalled their old rulers or set up new ones. Cesare, afraid of Julius, disobeyed his order to give up those fortresses still loyal to him. Consequently he was arrested and imprisoned in Rome. This simple act of arresting Cesare meant that the Borgia attempt to rule Rome and central Italy was over. Cesare escaped to Naples, where he was again arrested on the order of the king of Spain, to which country he was ordered in chains and where he languished in prison for two years. Again he escaped, but in March 1507, at the age of thirty-one, he was killed in an act of foolish bravado during a skirmish.

JULIUS II: *PAPA TERRIBILE*

Alexander's successor (not counting poor old Pius III) was every bit as tough as he had been. Julius II was in his sixties and not much inclined to a saintly life, having been made a cardinal by his uncle Sixtus IV. Like Alexander, he sold church offices at great profit and in particular sold off to certain German Dominicans the right to sell indulgences, with half the proceeds to go to the archbishop of Mainz and half to Rome to pay for the rebuilding of St Peter's, thereby sparking the ire of Martin Luther in 1517. Unlike Alexander, though, he needed no Cesare, for Julius was really a soldier at heart and, dressed like a Roman emperor in full armor, led his own papal troops. He also needed war if he was to keep the papal states together. After Cesare's death, the kingdom Cesare had assembled as captain general of the Church had dissolved. And, of course, the old rulers, and even the new ones, were very hostile to the authority of the papacy and too familiar with the rapacity of the Borgias. Julius, however, was as ambitious as Cesare and in addition needed the income from these cities to complete his massive building projects for Rome as well as his expansion of the papal states.

Julius began with great success. He recaptured Bologna, and built the League of Cambrai to destroy Venice because that republic had seized much papal territory along the Adriatic. But the terrible defeat of Venice at Agnadello in 1509 left Italy at the mercy

of the northern European armies that Julius had originally summoned. He quickly changed sides and led the Italian Holy League against his former allies. Finally, after some terrible setbacks, the old man, at sixty-eight, began, with Swiss and German help, to defeat the French. He succeeded in driving them out and temporarily won Italy back for the Italians. He was truly the *papa terribile*, a huge man in full beard, often dressed in armor, who in his sixties walked beside his common soldiers in snow and led his own armies into battle. When he died in early 1513, he was truly mourned, despite the obvious fact that he was anything but a priest. It is in part because of Julius that the papacy kept its status in central Italy until 1870 and that the independence of the Holy See was assured.

As pope, Julius was also one of the most lavish and daring patrons of the arts in the Renaissance. Fortified by his immense papal revenues (even throughout the wars), he took upon himself the decoration and rebuilding of Rome. In 1506 he began to work on the task for which he is truly remembered today: the building of the new St Peter's, an act so audacious that only Julius could have done it. Pulling down the holiest place in western Christendom, a basilica ordered by Constantine the Great, the site of papal and imperial coronations, including that of Charlemagne in 800, reflected his powerful, egotistical character. Although not finished for 120 years, the new church would indicate forever the power, majesty, and glory of Rome, of the papacy, and—not insignificantly—of Giuliano della Rovere, Pope Julius II.

Furthermore, Julius was the major patron of Raphael (1483–1520), one of art's greatest geniuses, who was introduced to the pope by his relation and fellow citizen of Urbino, Donato Bramante, the architect of the new St Peter's. Raphael painted the *Stanze* for Julius, which in turn became settings for some of the greatest painting in the Western world. These rooms were to be the pope's private apartments, because Julius refused to occupy the Borgia apartments, painted by Pinturicchio (1454–1513), owing to the decorative predominance of the Borgia family portraits and its symbol, the bull. The new rooms (*stanze* in Italian) were to reflect the new Renaissance style and content, represented so well by the *stanza della segnatura*, the pope's study, with its frescoes of *The School of Athens* and *The Disputation over the Holy Sacrament* on opposing walls. The program of these rooms in so many ways encapsulates the mind of the Renaissance and the style of one of its most talented painters.

A brilliant patron, Julius also engaged Michelangelo for many years, cultivating a stormy but productive relationship. From 1505, Michelangelo worked for the pope, having accepted the enormous commission of sculpting his tomb, which was to be placed in the new St Peter's. The tomb was never finished, and, ironically, what was completed is not even in the basilica but in Julius' titular church of San Pietro in Vincoli, where Michelangelo's image of Moses gives an indication of how wonderful the tomb would have been if personal tensions, lack of money, and delays had not interfered. While Raphael was painting the *Stanze*, Michelangelo was commissioned from 1508–12 to decorate the ceiling of Julius' uncle's Sistine Chapel (see Fig. 14.12). Rejecting the proposed program of the twelve apostles, Michelangelo painted scenes from the Old Testament; it remains one of the supreme artistic achievements of all time. Both artist and patron had difficult and demanding personalities, but the combination of their talents and geniuses has left humanity some of its greatest monuments.

Figure 7.3 (following page) Rome, Vatican, Apostolic Palace, Stanza della Segnatura. Raphael Sanzio (1483–1520): *The School of Athens* (1510–11). This fresco represents human wisdom and depicts the philosophers of antiquity, but with portraits of Raphael's contemporaries as models. For example, the Greek philosopher Heraclitus is a portrait of Michelangelo (head resting on his hand, foreground, center left) while the figure of Plato (the bearded figure in an orange robe standing at the center, his right hand pointing upwards to heaven) is Leonardo da Vinci. The man in the black cap at the far right facing out of the picture is a self-portrait of Raphael. These worthies are gathered in an unfinished building, illustrating Bramante's design for the new St Peter's basilica. Bramante himself is fittingly portrayed as the geometer, Euclid, dressed in red and wielding a compass at bottom right.

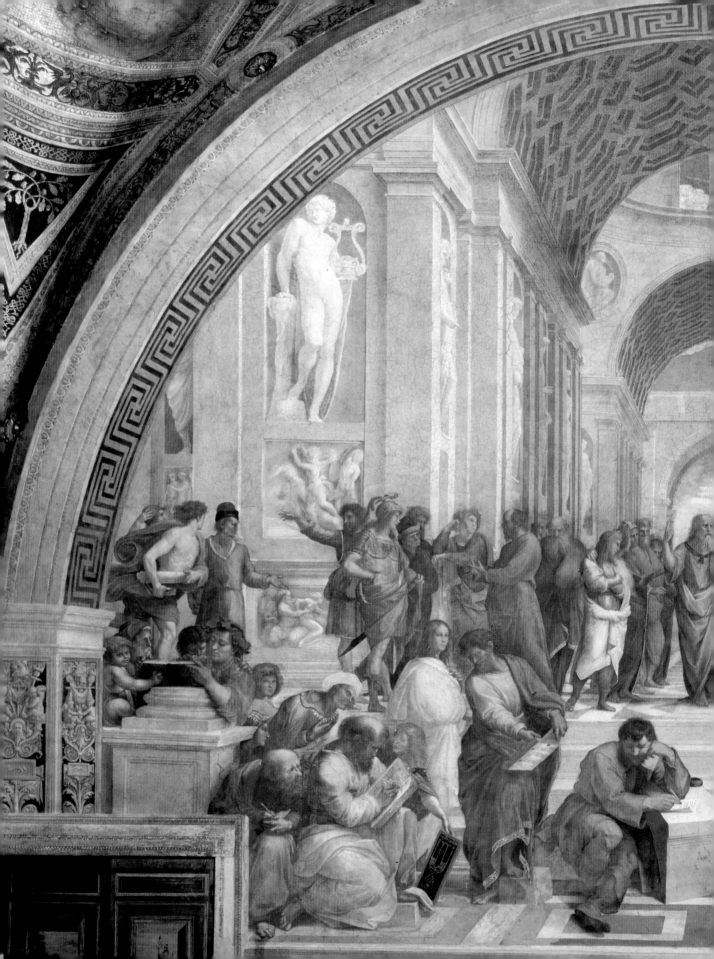

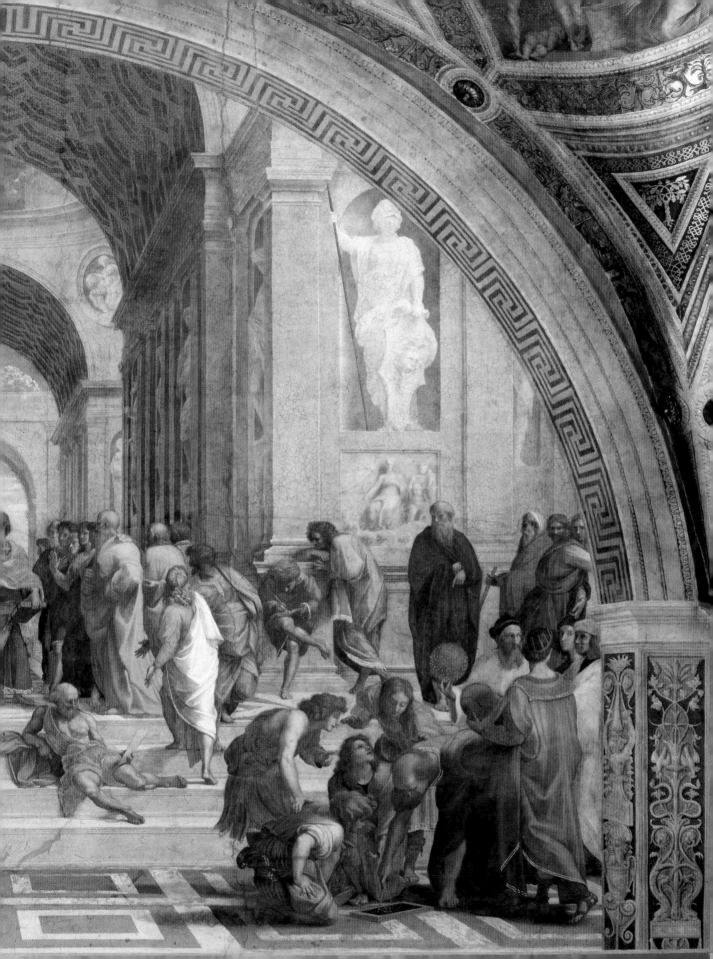

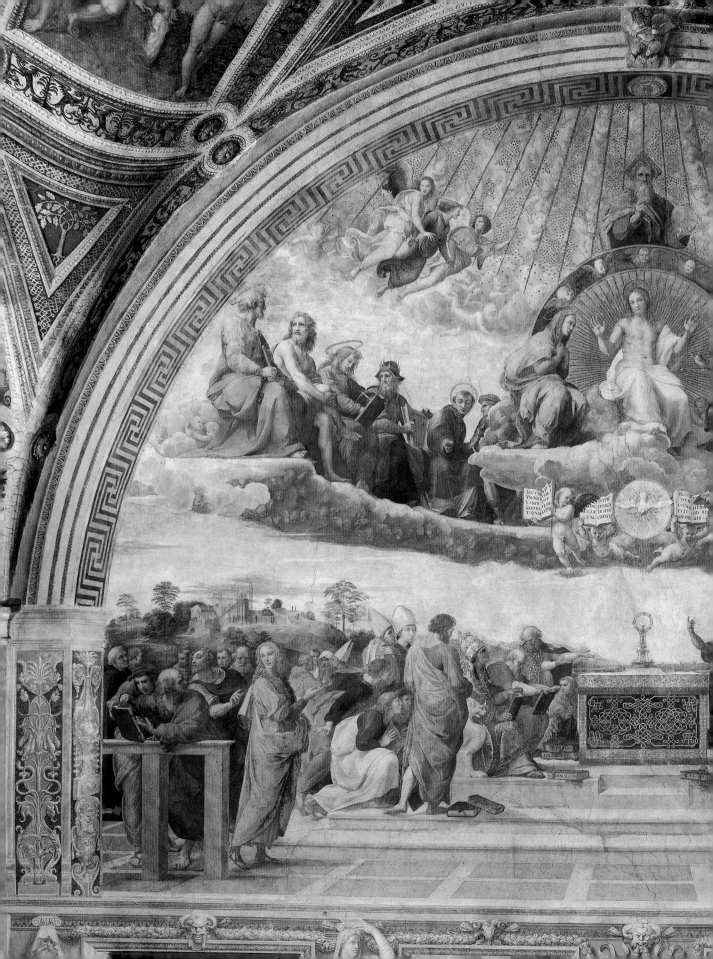

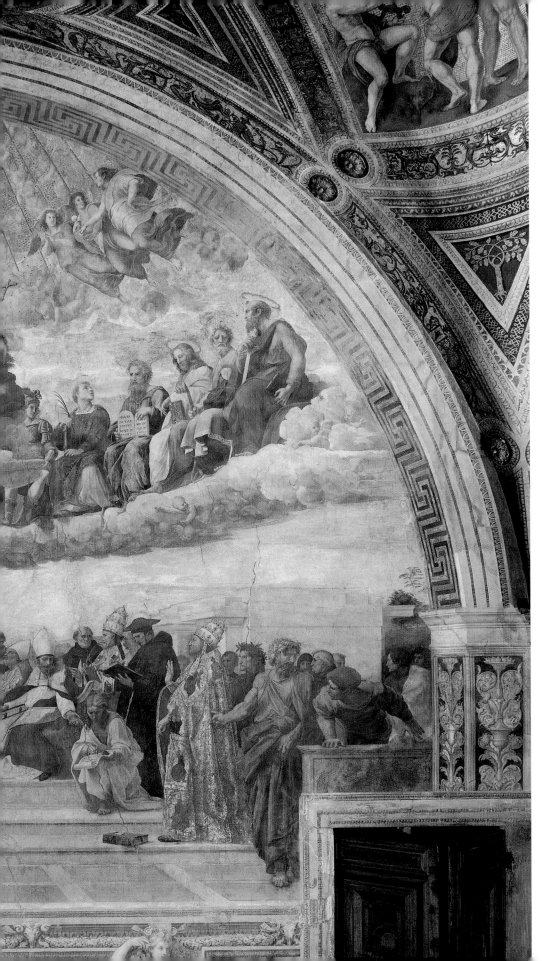

Figure 7.4 Rome, Vatican, Apostolic Palace, *Stanza della Segnatura*. Raphael Sanzio (1483–1520): *The Disputation over the Holy Sacrament* (1509–10). The wall opposite *The School of Athens* celebrates divine, or revealed, wisdom and contains portraits of theologians, doctors of the Church, apostles, and angels. Even the composition reinforces Catholic theology: the fresco is broken into three horizontal planes (to represent the Trinity), and the vertical axis leads from the monstrance on the altar, through the dove of the Holy Spirit, through Christ, and finally to God the Father (the three components of the Catholic Trinity).

Julius was succeeded by the Florentine Leo X de'Medici (r. 1513–21). Raised as a humanist prince by his father, Lorenzo the Magnificent, educated, refined, with exquisite taste, and with an irenic, if proud, spirit, he does not deserve the censure he has historically received for having the misfortune to occupy the see of St Peter when Martin Luther nailed his ninety-five theses on the door of the Castle Church of Wittenberg. A cardinal at fourteen, he became pope at thirty-seven on the death of Julius II in 1513. He thought his chances of election so small that he had not even bothered to become a priest and was not consecrated until four days after his election. He was universally liked because of his personality, wit, learning, and grace. Not invested in war or military glory like his immediate predecessors, and not at all interested in women, Leo centered his court on luxury, learning, music, and art, all of which he loved.

In 1513, he recreated the University of Rome as we now know it (La Sapienza), uniting the two old schools of the city. He endowed it richly, attracted the best professors with the inducement of high salaries, began new studies such as Hebrew, and greatly strengthened Greek. Texts from all over Europe were copied on the pope's authority and brought to Rome. Humanists flocked to the city to take jobs or advantage of the atmosphere of patronage and scholarship. Other scholars were appointed cardinals, and their own courts mirrored Leo's. Remarkable men sat in the Sacred College near Leo's throne, scholars such as Jacopo Sadoleto (1477–1547), with his refined spirituality as well as his humanism, and Bernardo Dovizi da Bibbiena (1470–1520), who was believed to be a pagan but recognized as a playwright and a patron of Raphael (who had been engaged to his niece before she died). Raphael, a very close companion of Leo's, was made superintendent of antiquities to excavate and study ancient Roman discoveries, including Nero's Golden House, in a scientific and systematic way.

Leo fought only one major war, the War of Urbino in 1517, and that was to provide a principality for his nephew, so peace as well as culture reigned. Rome was growing in beauty and importance, and Leo's Medici connections made the city not just the capital of Christendom but also an important banking and cultural center. Leo used his influence as pope to return the Medici to Florence, re-establishing the rule of his family, which had been expelled after the failures of 1494. But, in so doing, with the head of the Medici family in Rome and as pope, the reality was that under Leo's pontificate and that of his cousin Clement VII, Florence became almost a suburb of Rome. Leo's death in 1521 at the young age of forty-five ended not just the life of a great patron of art but also the unity of western Christendom. Martin Luther had been excommunicated in the last months of Leo's pontificate, and the forces of Protestantism were dissolving the integrity of the Church. Leo had not handled the situation well because he was unaware of how deep the resentment against the old Church had grown; he thought the tension was a local German matter and really between religious orders. He was tragically mistaken, an error that would soon result in over a century of bloody religious warfare and in the sack of the city he so loved.

It was in part to address the complaints of luxury, uncanonical living, and Italian parochialism that an ascetic Dutchman, Adrian of Utrecht, was elected as Pope Adrian VI in 1522. He had been the tutor of the emperor Charles V, had not been to Rome, and seemed a saintly man, able to withstand the attacks of the Protestants. However, in Rome he was soon thoroughly hated for his unwitting destruction of the economy by demanding simple living for curial officials and stopping the building of grand palaces, which were again to revert to the Church on the death of their curial owners. He had little interest in culture, and his inability to manage either the curia or diplomacy alienated everyone. He died, at the age of sixty-four, just over a year after his election, and his death was celebrated rather than mourned by the people of Rome, who carried his doctor through the streets of the city as a hero. He did leave for posterity, however, a wonderful tomb by Baldassare Peruzzi (1481–1536) in the German church of Santa Maria dell'Anima.

Adrian's successor was the first cousin of Leo X, Cardinal Giulio de' Medici, the posthumous illegitimate son of Lorenzo the Magnificent's brother, Giuliano, who had been murdered in the Pazzi Conspiracy. Taking the title of Clement VII (r. 1523–34), Giulio had the talent to be a great pope: he was learned, serious, intelligent, and willing to take advice. Unfortunately, he had difficulty following a single policy. He alienated the emperor Charles V by giving support to Francis I of France as a balance to Habsburg ambitions in Italy. The defeat and capture of Francis at Pavia in 1525 made the Habsburgs triumphant. The imperial army, led by a French traitor, the Constable of Bourbon, marched through Italy to Rome, where it sacked the city in 1527 in one of the most brutal events of early modern times, a barbarous act that can only be compared to the sack of the city in 410. Clement managed to escape into Castel Sant'Angelo where he watched the destruction of papal Rome. Eventually he was freed but at a great cost: Habsburg hegemony in Italy was recognized, and the dignity of the papacy was further weakened. All that Clement managed to get from his treaty with Charles V was the return of the Medici to Florence, as they had been earlier expelled as a result of the sack. Ironically, the unspeakable army that had plundered Rome was to be used to restore Medici rule in their native city, this time permanently.

Although a failure in war and diplomacy, as well as in suppressing the spread of Protestantism, Clement was still very much in the tradition of his cousin, Leo X. It was Clement who first commissioned Michelangelo to paint the altar wall of the Sistine Chapel with the *Last Judgment*. His goldsmith was Benvenuto Cellini (1500–71) (see Fig. 14.22), and before he became pope he had commissioned the *Transfiguration* from Raphael just before the painter's death. He also loved literature, and his cultivated court encouraged the use of classical models and genres in the humanist tradition. However, he was equally committed to working to heal the Church. New religious orders were recognized, and he advanced the careers of reformers in the Curia and even the Sacred College. Sadly, he was faced with some of the most intractable problems in the history of Europe, and he could not keep to any single plan of action. When he died in 1534, his papacy was seen as a failure, despite his contributions to culture and his acknowledgment of the voices of reform within the Roman Church.

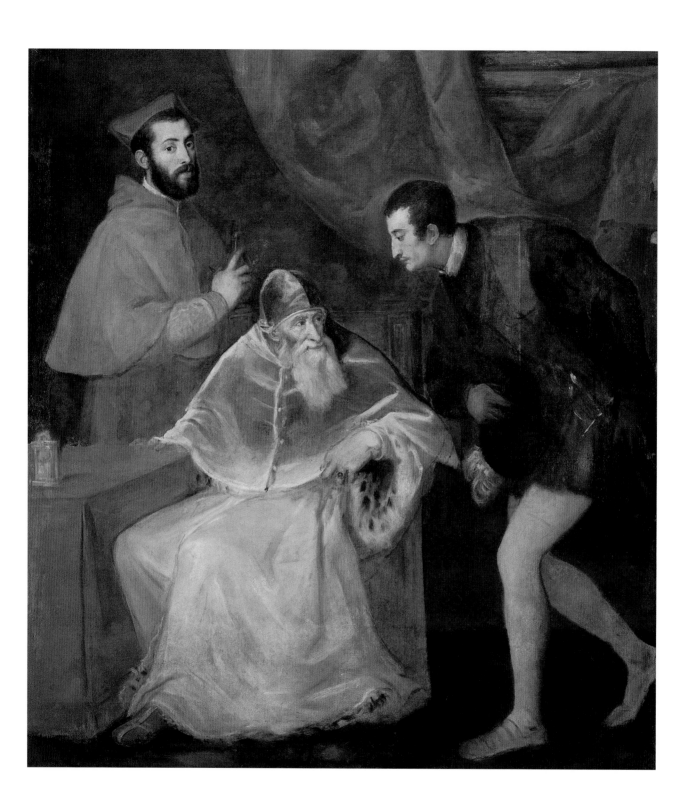

Clement was succeeded by a very different character, a man of the strongest convictions and administrative skill and possessing a natural appreciation for the place of art in Rome and the Church: Paul III Farnese (r. 1534–49). Alessandro Farnese, a Roman noble, had been raised to the Sacred College as a result of his sister Giulia's position as Alexander VI's mistress (and hence was ridiculed by being called "the cardinal of the skirts"). But as pope, Paul III was a powerful figure in his own right. He saw the dangers posed by the division of Christendom, and he decided to fight back. It was he who recognized St Ignatius of Loyola's Society of Jesus, or Jesuits, as a religious order, one that used preaching, teaching, and missionary work to ensure that the spread of Protestantism would be stopped or even reversed and that the recently contacted peoples of the new world would be Roman Catholic Christians. The Jesuits used a humanist curriculum in their excellent schools, designed to ensure that Europe's Catholic elite would remain faithful to Rome; and Jesuit baroque artists and architects built and decorated their churches to celebrate the glory of God and the Church. Paul III also saw the need to confront the complaints of the reformers, calling the Council of Trent, a great conference of the Church that would sit for almost twenty years, from 1545 to 1563. This Council re-animated Roman Catholicism by rejecting the theology of the Protestants, reaffirming the primacy of the pope, and celebrating the use of art and beauty in the liturgy and in churches. Trent was an important moment for the Church, and Paul emerged as an imperial pope, enjoying descent from both St Peter and Constantine. He saw the need for decisive action, rigid hierarchy, and the application of the tools of humanism to revitalize the Church.

Paul III himself was a man of exquisite taste. He maintained Michelangelo's commission for the *Last Judgment* in the Sistine Chapel; he continued work on new St Peter's after a hiatus occasioned by the sack of Rome, appointing Michelangelo as its architect. He also asked Michelangelo to redesign the secular political center of Rome, the Capitoline Hill (Campidoglio), with its powerful ancient memories, to create one of the world's most perfect urban spaces, anchored by the statue of Marcus Aurelius, the only full-size equestrian bronze to survive from antiquity. He also involved the greatest architects of the time, including Michelangelo, in designing and building a huge Renaissance palace for his family. Indeed, the Palazzo Farnese is a monument to high Renaissance grandeur and elegance to this day. Despite the unusual means of his elevation to the Sacred College, Paul III proved a great leader for the Church and a distinguished patron to his native Rome. He saw the need for both grandeur and a powerful papal monarchy: the result was a more splendid Rome, which clearly announced that the indignity and destruction of the sack of 1527 was past.

The war with the Protestants required from Paul's perspective a closer control of ideas. A positive result was the better training and education of priests and bishops, but a negative result was the establishment of the Roman Inquisition in 1542 to judge from Rome who and what were orthodox or heretical. In 1559 this was reinforced under Paul IV Carafa (r. 1555–59) by the Index of Prohibited Books, listing what Catholics could and could not read or even know. (One of the prelates responsible for drafting the Index was Giovanni Della Casa [1503–56], the author of *Il Galateo*, that handbook of elegant manners and deportment.)

Figure 7.5 (facing page)
Naples, Museo Nazionale di Capodimonte. Titian (Tiziano Vecellio, d. 1576): *Paul III and His Grandsons* (1546). This portrait of Paul III by one of Venice's most skilled portrait painters captures the intelligence and energy of the old pope and celebrates the continuation of his family's power through his grandsons, Cardinal Alessandro Farnese (1520–89) and Duke Ottavio Farnese (1524–86), who respectively represent clerical and secular ambition. Despite the canon law that decreed priests must be clean shaven, Paul III kept a beard, as did most popes until the seventeenth century. This practice was first observed briefly by Pope Julius II to lament the loss of Bologna in 1511 but was sustained for the remainder of his lifetime by Paul's predecessor, Clement VII, as an act of mourning to mark the humiliation of the terrible sack of Rome in 1527.

These events signalled a closing of the mind of the Renaissance and restricted the ability of individuals to think independently and challenge established principles. Perhaps more than the peninsular wars or the decline of the economy in the Italian peninsula, the Inquisition and the Index were responsible for the corrosion of the dynamic vitality of the Italian Renaissance as an intellectual and cultural movement.

In many ways the papacy might be seen as a barometer of the currency of ideas, principles, and styles during the Italian Renaissance. The central role played by the Church in every aspect of Italian life and the power of patronage available to popes, together with the huge legacy of Rome itself—both ancient and Christian—ensured that the papacy would reflect the circumstances of the peninsula. The individual ambitions and personalities of the successors of St Peter, who also claimed authority from Constantine, defined the character of the Renaissance in Rome and elsewhere in Italy. And, as a consequence, the policy of attempting to control ideas to counter the Protestant threat had a chilling effect on the dynamic energy, self-confidence, and bold experimentation that we have identified with the Renaissance. The effects were to hasten the decline of those factors that had initially given rise to the humanist mentality and that would, in time, calcify humanism itself, by insisting on orthodoxy of thought and belief rather than permitting the human imagination to soar.

FURTHER READING

D'Amico, John. F. *Renaissance Humanism in Papal Rome: Humanists and Churchmen on the Eve of the Reformation*. Baltimore: John Hopkins University Press, 1991.

Mallett, Michael. *The Borgias: The Rise and Fall of a Renaissance Dynasty*. Chicago: Academy Chicago Publishers, 1987.

Mollat, Guillaume. *The Popes at Avignon: 1305–1378*. London: Thomas Nelson & Sons, 1963.

Partner, Peter. *Renaissance Rome: 1500–1559: A Portrait of a Society*. Berkeley: University of California Press, 1976.

Ramsey, P., ed. *Rome in the Renaissance: The City and the Myth*. Binghamton: MRTS, 1982.

Stinger, Charles L. *The Renaissance in Rome*. Bloomington: Indiana University Press, 1998.

EIGHT

THE MARITIME STATES:
PISA, GENOA, AND VENICE

THE GEOGRAPHY OF ITALY—a peninsula extending into the heart of the Mediterranean Sea—determined that many of the Italian states would prosper through maritime adventure. In particular, Pisa, Genoa, and Venice built their wealth and power at sea, at times as allies but more often as enemies in pursuit of fortune and advantage.

THE ALLIANCE OF PISA AND GENOA

Pisa and Genoa were important ports from ancient times, both enjoying excellent harbors on the Ligurian Sea. However, during the late Middle Ages they were vulnerable to attacks by Muslim invaders who had captured Sardinia and Corsica, islands situated directly across from Pisa, which stands at the mouth of the Arno River. Genoa itself had been sacked by Saracens in the tenth century. Not surprisingly, the Church, concerned about keeping the Muslims out of the western Mediterranean, saw the two sea powers as the best protection for Christendom. So when the papacy assigned to Pisa and Genoa the responsibility of forcing the Muslim invaders from their strongholds, it took little to convince the two states to agree. Together they attacked the Muslims, and in 1016 they successfully drove the Saracens from Sardinia. As a reward, the pope, Benedict VIII (r. 1012–24), granted joint rule of Sardinia to Pisa and Genoa, with Pisa also given hegemony over Corsica in 1077.

Unfortunately, the economic interests of the two states were in direct competition. The natural alliance against Muslim expansion ultimately succumbed to rivalries between them, as well as with Venice and Amalfi, for Levantine wealth.

The Genoese used the Crusades to leverage huge wealth and strategic advantage, with the First Crusade (1095–99) seeing the Genoese as leaders in the carrying trade between Europe and the Holy Land. As compensation for their participation, they secured ports in Syria and Palestine, as well as important commercial privileges from the Crusader kingdom of Jerusalem to service their long-distance luxury trade with the East. For its part, Pisa also acquired great power and wealth during the Crusades, carrying Christian warriors across the Mediterranean and supporting their crusader states in the Levant. However, Pisa concentrated on developing trading posts in southern Europe, especially in Sicily, Spain, southern Italy, and on the coast of North Africa. Initially, this strategy was rewarded as it enabled Pisa to defeat another maritime rival, Amalfi, in 1137, by providing the invading Holy Roman emperor, Lothair II, with a fleet; but although one competitor was removed, the victory equally benefited Genoa and Venice.

Not surprisingly, the joint administration of Sardinia began to cause increasing tension, with the rivalry between Pisa and Genoa finally erupting into open warfare in 1240. Pisa used the struggle between the pope and the Holy Roman Emperor as a pretext to attack the Genoese fleet. The war initially went badly for Genoa, with Pisa decisively defeating its rival in 1241, destroying the Genoese fleet and cementing their relationship as mortal enemies. The Genoese recovered, however, and in 1284 at Meloria conclusively defeated the Pisans, who were themselves unable to recover because the city faced an even more dangerous threat on land—Florence.

PISA AFTER MELORIA

The defeat at Meloria had been devastating. But even worse, Pisa's naval and economic recovery was made impossible by the growing local ambitions of Florence, the Guelf power located upstream from the city. The Florentines needed a secure port from which to ship their vast production of woolen cloth to markets abroad, and Pisa's location at the mouth of the Arno made it the obvious target. Moreover, there was deep enmity between the two Tuscan states. Pisa had officially abandoned the Guelf cause in 1162 when it became an independent, self-governing commune. Subsequently, it had supported the Tuscan Ghibellines, led by Siena and Florentine exiles, against the Guelfs, even sending soldiers to fight in the battle of Montaperti (1260) where the Florentines were disastrously defeated. Consequently, Pisa found itself forced to focus on its landward side to defend itself against Florence. The money needed to rebuild its fleet and return to the Mediterranean to challenge Genoa after the disaster at Meloria was therefore not available. Pisan commerce greatly declined, with its maritime markets and trade appropriated by Genoa and Barcelona.

These desperate foreign and economic conditions were exacerbated by internal rivalry. Pisan politics had been unstable since Meloria, after which the *capitano del popolo*, Ugolino della Gherardesca (c. 1220–89), had assumed control of the city. Ugolino, however, had

Figure 8.1 (facing page) Pisa, *Campo dei Miracoli* (Field of Miracles). It was the wealth generated by the Crusades that permitted Pisa to construct this splendid complex of buildings, comprising the cathedral, the bell tower, and the baptistery. Although the cathedral was begun earlier, in 1054, its magnificence is the result of Pisa's contribution to the carrying trade during the Crusades. The baptistery was begun in 1153, and the bell tower (campanile) in 1173. It had, however, begun to tilt by 1178, long before it was completed, as a consequence of unstable soil beneath its foundations. Pisan merchants returning to Italy during the First Crusade carried as ballast in their ships soil from Jerusalem, hoping that at the time of the Second Coming and the Resurrection the Pisans would thereby gain an advantage over their fellow Italian Christians. The area was named "Field of Miracles" only at the beginning of the twentieth century by the Italian poet Gabriele d'Annunzio (1863–1938).

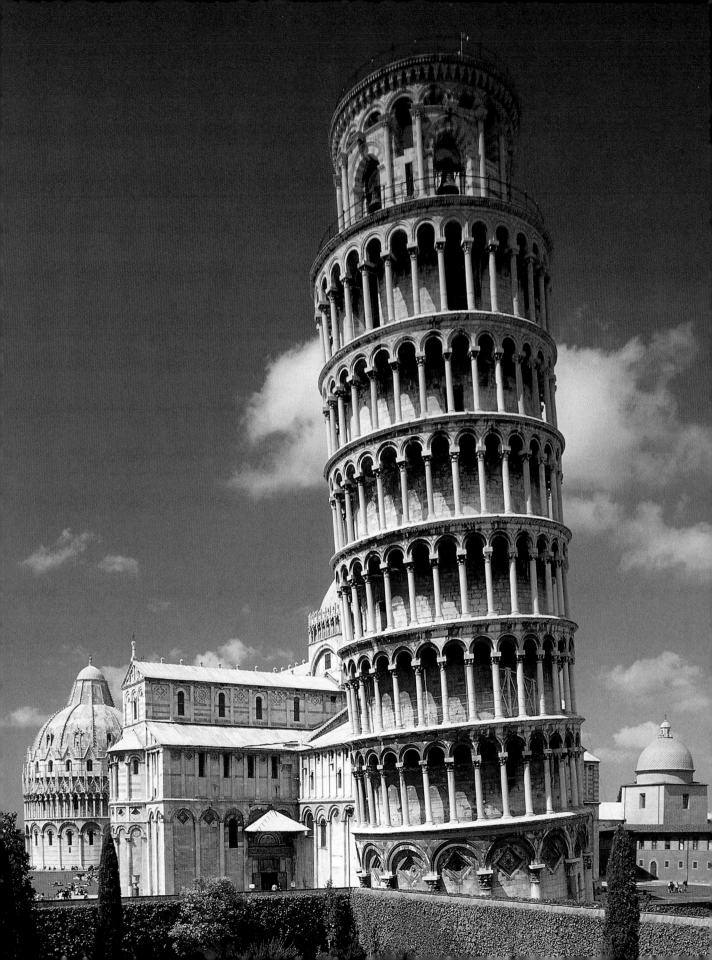

fallen out with the powerful archbishop and was starved to death in prison together with his sons, a story told by Dante in *The Inferno*. Then, after experimenting unsuccessfully with invited *signori* as rulers, Pisa was threatened by the ambitions of Emperor Louis IV (the Bavarian). Louis besieged and captured the city in 1327, staying two years and exacting a huge tribute. To pay for these misadventures, the Pisans increased taxes and duties on goods shipped through the harbor, causing an economic flight from the city that completed the economic collapse of the once mighty seaport.

In 1400, a final indignity was imposed on Pisa when Giangaleazzo Visconti, duke of Milan, purchased the city from Gherardo Appiani (c. 1370–1405), who had set himself up as *signore*. After the precipitous death of Giangaleazzo in 1402, his heirs then sold the city to Florence, despite the universal opposition of the Pisans. Pisa thus finally became part of the Florentine state, treated ignominiously as a subject territory. Although it did benefit to some degree because Florence shipped its exports through the city and there was greater stability and security, Pisan freedom had been lost. True, the French invasions, the expulsion of the Medici from Florence, and the rise of Savonarola allowed Pisa to recover its independence for a brief period after 1494. Nevertheless, its recapture was to obsess Florentine regimes until at last in 1509 the Florentines starved the seaport into submission. Thereafter, the history of Pisa merges with that of Florence and the Grand Duchy of Tuscany.

This was not altogether a disaster for Pisa, at least in economic terms, and the Medici monarchy did end the city's tendency to factionalism. Cosimo I (r. 1537–74) in particular patronized the Tuscan port because his ambition was to be raised to grand ducal status by the pope and to enter Mediterranean trade on a significant scale. Therefore, he commissioned a fleet of trading ships, but this trade was very different from the earlier trade in the Mediterranean that Pisa had once dominated. It now meant carrying goods to northern Europe, rather than participating in the lucrative trade with the East. On the other hand, it was equally Cosimo's dream to be a leader in the continuing naval war against the Turks. To advertise and support this crusading spirit, Cosimo established the knightly Order of Santo Stefano (St Stephen) as a maritime crusading order at Pisa. He equipped galleys and trained soldiers, and, as an illustration of the success of the order, Florentine ships from Pisa saw meritorious action at Lepanto in 1571. With this victory the Turkish threat in the Mediterranean was finally halted, and Pisa had once more established its reputation in the continuing European crusades against Islam.

Furthermore, Cosimo lavished patronage on the University of Pisa, turning it into an important center of learning, particularly science, that attracted scholars from across Europe, including Galileo Galilei (1564–1642). In part this new focus on learning was to compensate for the decline of the port. The harbor had begun to silt long before, and Cosimo was forced to develop an alternate seaport for Tuscany at Livorno (Leghorn), a short way up the western coast of Italy, leaving Pisa a frozen monument to its former power and grandeur.

GENOA AFTER MELORIA

While its decisive victory at Meloria guaranteed Genoese supremacy over Pisa, it created an even more implacable enemy in Venice. Indeed, occupied with the war against Pisa, Genoa was unable to protect her fleets from the Venetian navy, leading to defeat at sea in 1257 and 1258. Genoa's response was aggressive diplomacy. The Genoese supported the Greek pretender to the imperial Byzantine throne, Michael VIII, Palaeologus, in driving from Constantinople the Latin rulers who had been set up by Venice in the Fourth Crusade of 1204; as revenge the Venetian quarter of the city was burned to the ground. With the restoration of the Greek dynasty, Genoa was rewarded with rich trading concessions, which permitted the Genoese to compete directly with Venetian interests, making a long, terrible war inevitable.

The two great maritime states were very evenly matched. Both powers won major victories, until in 1298 the Genoese admiral Lamba Doria (1245–1323) disastrously defeated the Venetians at sea at Curzola (today Korčula in Croatia). Despite this convincing victory, the long years of desperate war had left Genoa weak and internally divided. The cost of the struggle with Venice set the mercantile patriciate, which had the most to gain from the war, against the common people, who had the most to lose. Venice, as an internally united republic, did not suffer this disadvantage and was able to continue to press the Genoese hard, despite having been defeated. Nevertheless, the skill of the Genoese admirals and the power of their fleets kept Venice in a precarious position for many decades. The climax came only in 1380–81 in the War of Chioggia, a life-or-death conflict between the two great powers. At Chioggia, just down the Adriatic coast from Venice, a fleet reinforcing the Venetian main force arrived just as the Venetians were on the point of defeat. This turned the tide of battle against Genoa, and the Venetians destroyed the Genoese conclusively. Although Genoa would remain an important mercantile center and sustain a fleet to service its now reduced trade, the struggle for supremacy was lost, and Venice emerged as the dominant economic and naval power in Europe. Furthermore, Genoa's internal conflicts and class divisions, together with the intervention of foreign states, meant that it would never recover sufficiently to challenge Venetian supremacy.

Events had shown that Genoa's greatest weakness was neither its fleet nor its strategies but its internal division between noble and plebian factions, even though during the long and desperate wars with Venice constitutional changes were made to address this crisis. To restore unity, the state was restructured as a republic on the obviously successful Venetian model. In 1339 the first Genoese *doge*, Simon Boccanegra (d. 1363), was elected for life and by popular suffrage. Boccanegra was a great leader: he revitalized Genoa, expanding the city, re-establishing lucrative trade connections, and defeating the Turks. But after his death, factional strife returned, with some *doges* serving less than a single day before being forced to relinquish power. Two competing factions, led by two great noble families, were evenly matched but represented very different interests. The aristocratic faction, led by the Adorno family, was associated loosely with the Italian Ghibellines, while the more popular party, led by the Fregoso family, was allied with the Guelfs.

These two families and their supporters alternated in power, depending on the fortunes of the state; but the resulting political chaos made any kind of reasonable accommodation difficult, if not impossible and led to the constant intervention of foreign powers. The geographically strategic importance of Genoa and the ideological division between Guelf and Ghibelline had resulted in a tradition of outside interference in Genoese political life. As early as 1311, the Holy Roman Emperor Henry VII had demanded and was granted the right to rule Genoa for twenty years. The Guelf party in the city responded after Henry's death in 1313 by calling in the support of the French house of Anjou to counter the Ghibelline claims of the ruler of Milan. Renewed war with Venice and the signal defeat of the Genoese at Venetian hands occasioned a Ghibelline victory and the acceptance of Giovanni Visconti of Milan as ruler of Genoa.

This pattern of instability and foreign rule was continued over the next 150 years. When Venice decisively defeated the Genoese at Chioggia in 1381, the Genoese responded by surrendering to foreign rulers: the French controlled the city from 1396–1409, 1464–78, 1487–99, and 1515–22; the marquis of Monferrato was in power from 1409–13; and the duke of Milan controlled Genoa from 1458–61 and 1499–1512. Political independence was in effect sacrificed in Genoa to ensure some internal cohesion, and stability was imposed from without as the Genoese factions proved unable to settle their differences for the common good.

Strangely, though, Genoa did not altogether lose its economic influence, and indeed protected its mercantile interests through the most novel of means. The economic power of Genoa was sustained through the creation of a bank, the Banco di San Giorgio (Bank of St George), in 1408 by a consortium of rich merchants. The bank was in effect a mechanism to obviate the instability and chaos of the republican government. The merchant patricians saw the factional strife as endangering their trade and profits, and political authority had been given to, or taken by, foreign powers. Thus the merchant elite established the bank to function almost as a parallel government, one controlled by and working in the interests of the city's wealthy merchants. Acting like a state within the state, the bank funded public debt, issued coins, raised armies, and even accredited its own ambassadors to foreign powers.

But there were forces at work outside the bank's control. The Turkish conquest of Constantinople in 1453 had as devastating an effect on Genoa as it had on Venice, and Turkish expansionism took away the Genoese trading posts around the Black Sea, together with other mercantile privileges that had been protected by the Byzantines since 1261. The most painful blow was the fall of Caffa to the Turks in 1475: Genoa was ceasing to be an imperial power with an important maritime empire. It was forced back into European politics and trade, arenas in which its strategic location and the importance of the Bank of St George were to make the city a rich prize.

But here, European power politics and the lack of political will within Genoa itself resulted in the decline of the city as a European state; and, in particular, French influence in Genoa meant that the city was vulnerable to international conflict. The French king, Francis I (r. 1515–47), desired to make France the hegemonic power in Europe, leading to

war with the Habsburgs. Through both his Spanish kingdom and his imperial crown, the Habsburg Charles V (r. 1519–56) had powerful claims to Italy, while the Valois of France had equally strong claims in the peninsula. Thus, the duel between Valois and Habsburg would be largely determined in Italy.

France had controlled Genoa from 1515, so if the Habsburgs were to be successful in north-central Italy, they realized that the city was too important to leave in French hands. The consequence was the capture of the city and its sack by the Habsburg Spaniards in 1522; the emperor Charles V then garrisoned Genoa and held it for the next five years. The French, however, were unwilling to leave the Habsburgs in control, especially as Genoa would be useful as a port close to France for the supply and support of a French army in Italy. The French therefore assisted the Genoese hero Andrea Doria (1466–1560) in driving out the Habsburgs in 1527 and restoring full Genoese sovereignty.

This victory did not end the problem of factionalism and internal instability, so Doria, the virtual *signore* of Genoa, realized it was necessary to restructure the government once more. Doria refused to hold the title of *doge* although the position was offered to him. Instead, he abolished the position of *doge* for life, replacing it with a reformed ducal office that held power for only two years. And the *doge*, now limited in term, was to be elected only by the mercantile nobility who would sit in a great council styled after that of Venice. The popular election of the *doge* thus ceased, with the common people no longer having a strong voice in the government, and Genoa became a mercantile oligarchy ruled by its nobles, finally ending the chaotic instability that had resulted from the sharing of sovereignty by all classes.

Despite his obligations to France, Doria saw that the future of Europe was with the Habsburg empire and its Spanish dominions. Consequently, Genoa made its peace with the Habsburgs, and Doria was named the supreme admiral of their fleets. The Bank of St George became an important instrument in Spanish public finance, particularly in the servicing of the immense wealth flowing into Spain from the New World; and Genoa and the bank became a financial and mercantile center for the Spanish empire. The result was the "Genoese Century," during which the Spanish connection made the merchant nobles of Genoa very rich, leading to the construction of splendid seventeenth-century baroque palaces and the patronage of artists such as Van Dyck to paint their portraits. Although the sea power of Genoa had collapsed, its mercantile finesse and banking traditions remained.

THE CREATION OF VENICE

Venice was born out of the chaos of the barbarian invasions of the late Roman Empire in the fifth to seventh centuries. As the Goths, Huns, Ostrogoths, Franks, and Lombards crossed the Alps to ravage the Roman settlements on the Lombard Plain, a number of refugees sought safety in the almost impenetrable lagoons and swamps of the Po delta, building a city by driving literally millions of wooden stakes into the often submerged

sandbars at the head of the Adriatic. The tough early inhabitants of the lagoons soon established a prosperous community, originally based on fishing and eventually enriched by trade, under the protection of the Byzantine empire, whose Italian provincial capital was at nearby Ravenna and its fleet at Classe.

This early history of the city explains the peculiar kind of constitution that the Venetians developed. The Roman refugees and their fisherman descendants were fiercely independent, self-governing freemen with a highly developed sense of individuality that merged with the obvious need to cooperate to overcome an extremely hostile environment. Because the city was new, there was no established elite, no *signore* or bishop, to be obeyed. A republic was obviously the natural form of government for such men. From the beginning, they chose their own leaders, originally tribunes; but after 697, the chief among these tribunes was called duke (or *doge* in the Venetian dialect) on approval from their Byzantine protectors. By 726 the office of tribune had disappeared, leaving only the *doge* as the republic's executive; and thereafter the emperor at Constantinople had no influence in the *doge*'s appointment, which was then purely elective and for life. The election, however, remained Byzantine in its complexity and secrecy such that no one man or family could ever establish a hereditary monarchy. The tough islanders of the lagoons refused to have any king, and the *doge* was only *primus inter pares* (first among equals), elected by his peers. However, as the city became richer, so did a number of the most important merchants and traders. Increasingly, then, the electors became a restricted class, but until the end of the thirteenth century only loosely defined and open to new talent.

Furthermore, the island city had no rural *contado* dominated by feudal nobles at odds with the urban patricians whose natural superiors they believed themselves to be, a problem we have seen illustrated in Florence and repeated in most of the other Italian communes. Thus the factional divisions between *magnati* and *popolo grasso* did not materialize. Because there was no land to buy, the early Venetian merchant nobility remained just that—merchants. All of their capital was reinvested in commerce rather than spent on secure but low-yielding ground rents. Also, since the whole patriciate had purely mercantile values, there was a single identification with the policy of the state: expand and protect trade at any cost. Moreover, Venice, unlike Florence, had no large volatile industrial working class to inject a characteristic measure of instability into the political process. All social groups in the city lived directly or indirectly by trade, and thus all supported the measures of a government dedicated to that occupation. In other words, Venice was a remarkably homogenous state.

The geographical position of Venice and its long-distance trading interests meant that the republic avoided the constant warfare of the Italian peninsula, at least in this early period of its history. There were no Guelf or Ghibelline factions in Venice because the question of sovereignty was not a factor in the same way as it was elsewhere in the peninsula. Venice's theoretical overlord was the Byzantine emperor in Constantinople, and its religious authority initially was the patriarch of Grado/Aquileia (the ancient, independent see of Venice) an appointment that later in our period fell under the control of the republic.

Therefore, during its rise to power and immense wealth, the Venetian republic established a functional constitution of the kind otherwise altogether absent from Renaissance Italian life. The city was stable, extremely well governed, and in reality almost the clearinghouse for the mercantile interests of its richer citizens. Government policy and commercial policy were identical: there was no difference between the naval galleys of the Lion of St Mark and the cargo vessels of the patricians. The state served the merchant patriciate, and they in turn served the state with complete devotion and considerable skill developed during the lengthy *cursus honorum* expected of a young Venetian patrician, an apprenticeship that included service at sea on a Venetian galley, offices abroad in the outposts of its empire, and, finally, high office at home.

VENICE IN THE RENAISSANCE

The constitution that operated during the Renaissance came into being at about the same time as the Florentine Ordinances of Justice. During the great commercial expansion of the thirteenth century, the richer Venetian merchants had increased their authority at the expense of both the poorer citizens and the elected *doge*. In 1297, this realignment of power was consolidated in another aristocratic coup, the celebrated *Serrata* (Closing) in which the merchant patricians closed the Great Council. This body, the source of all Venetian authority, was composed of the adult male representatives of the leading patrician families. And through the *Serrata* it was now limited to only those families who had sat there before. In other words, no new noble merchant families were ever to be created. The names of the old noble families were subsequently inscribed in the famous *Golden Book*, an official genealogy kept by the state to ensure that no interlopers could arise. The register, however, contained well over two hundred such noble families, comprising a great many adult males, so the class was not small; yet, significantly, it was to never be enlarged, despite genealogical extinctions.

The Great Council had about fifteen hundred to two thousand members—that is, adult, sane, solvent, male patricians—during most of the Renaissance, although not all of these would be present for meetings at any one time. Clearly, Venice was, like Florence, a patrician merchant oligarchy, except that merchant patricians were called nobles, members of those families who had achieved wealth and power before the *Serrata* of 1297. Unlike Florence, though, there was no room for the small property-holders (lesser guildsmen), who in Venice were politically disenfranchised, with little or no hope for high offices in the republic. For them, status was achieved only through service in the religious confraternities or *scuole*, or in those important, bureaucratic offices left exclusively for them, such as the chancery. Even this class of non-noble Venetians was divided into two groups, one privileged, one not. The former, or *cittadini originari* (original citizens), were eligible for high bureaucratic positions such as the office of chancellor or secretaries of embassies and often enjoyed special educational opportunities; they in time had their own version

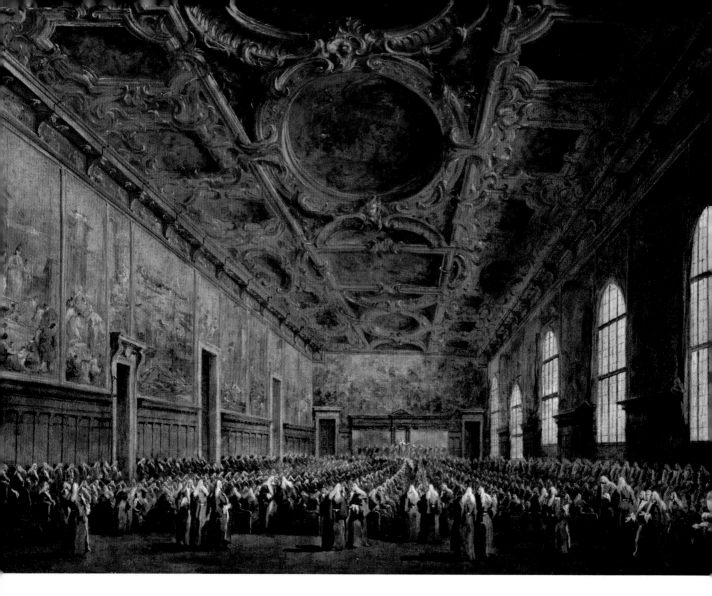

of the Golden Book—a Silver Book—to keep their ranks pure and free from upwardly mobile lesser citizens or immigrants. In general, these *cittadini* were of families every bit as old as the nobles in the Golden Book but not as economically or politically successful by 1297; nevertheless, they often rose to great wealth. What is truly remarkable is that the *cittadini* seemed content with their subsidiary role, for they enjoyed equality before the law, participation in *scuole*, and economic benefits, while avoiding the responsibilities of nobles. (Patrician officials, for example, were not usually paid and often had to bear the expense of their office.)

In addition, many of the other citizens of Venice had specific, carefully defined privileges. For example, workers in the arsenal (*arsenalotti*), that remarkable, government-owned and -operated shipyard and munitions works in the center of the city, had great privileges and high wages because of their importance to the maritime republic. Equally, though somewhat later, the workers in the great glassworks of Murano (an island in the lagoon to

which the glass factories had to move because of the risk of fire) were similarly prosperous. Venice enjoyed a virtual monopoly on the production of ornamental glass and mirrors in Europe until the later Renaissance, a monopoly that the government guarded jealously, both by treating the craftsmen extremely well and by threatening them with dire reprisals if they revealed their trade secrets: their families were prosecuted if the workers took their skills elsewhere, and they themselves were killed by teams of hired assassins who traced them to their new countries outside the republic. It worked: Venice maintained her monopoly on luxury glass for centuries.

The actual form of the Venetian constitution during the Renaissance was complicated to say the least. All adult male nobles were eligible to sit in the Great Council, the foundation of the political process. The Great Council then elected the Senate from among its own ranks. The Senate, whose numbers varied during our period but required a quorum of 180, was the legislative body of the republic. In addition, the Great Council elected—through direct or indirect balloting—the *collegio*, or cabinet of officials who were responsible for specific branches of the administration and implementation of executive decisions. Finally, the *doge* and his official counselors were chosen by the Great Council. The *doge* and the *collegio* in theory represented the executive authority. The *doge* was a kind of president of the Council, elected for life, but usually only at a very advanced age. His political role was restricted to the point of being merely ceremonial, stripped of all real power, originally by his six official counselors in the *collegio*, but after 1315 also by the notorious Council of Ten, the feared *Consiglio dei Dieci*.

The Council of Ten was the consequence of a quixotic attempt on the part of a young patrician, Bajamonte Tiepolo (d. c. 1329), and his associates to overthrow the republic in 1310. The revolt was a complete failure, but it disturbed the Great Council that the plot could have developed without any knowledge of it having been betrayed to the authorities. Intending that such a revolt would in future be revealed before it could mature, the Council of Ten, with its extraordinary powers, was established. The Ten were to be elected annually by the Great Council, and its members reflected the real political power in the state. The deliberations of the Ten were held in secret and concerned, in theory, questions of sedition or conspiracy. If, in its

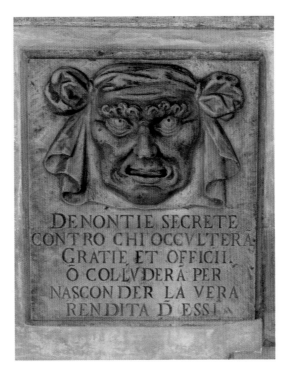

DENONTIE SECRETE
CONTRO CHI OCCVLTERA
GRATIE ET OFFICII
Ō COLLVDERA PER
NASCONDER LA VERA
RENDITA D ESSI

Figure 8.2 (facing page) Venice, Palazzo Ducale (*Doge's Palace*). Francesco Guardi (1712–93): *After his election, the Doge thanks the Grand Council in the Grand Council Hall of the Doge's Palace in Venice, Italy.* The Hall of the Great Council was decorated after a disastrous fire in 1574 with images of great Venetian victories and portraits of the *doges* by Tintoretto and Veronese and their schools. The *Paradise* by Tintoretto, behind the *doge's* throne was then the largest oil painting in the world. This room could hold up to fifteen hundred patricians sitting back-to-back on benches. Republican constitutions required such vast spaces for their citizens to meet. At the turn of the sixteenth century in Florence, Simone del Pollaiolo (1457–1508) and others created a vast space in the Palazzo della Signoria modeled on this Venetian hall in order to accommodate the council of five hundred mandated by Savonarola's new constitution for the Florentine republic.

Figure 8.3 Venice, Palazzo Ducale. *Bocca del leone.* Throughout Venice were constructed frightening lions' mouths (*bocche del leone*)—the most feared in the *Doge's* Palace itself—boxes in which secret denunciations of patricians, or any other citizen, were deposited. Safeguards protected the innocent from vexatious denunciations, and the Venetian elite was sufficiently small to ensure that few injustices actually occurred, but the prospect of official denunciation very effectively protected the integrity of the state.

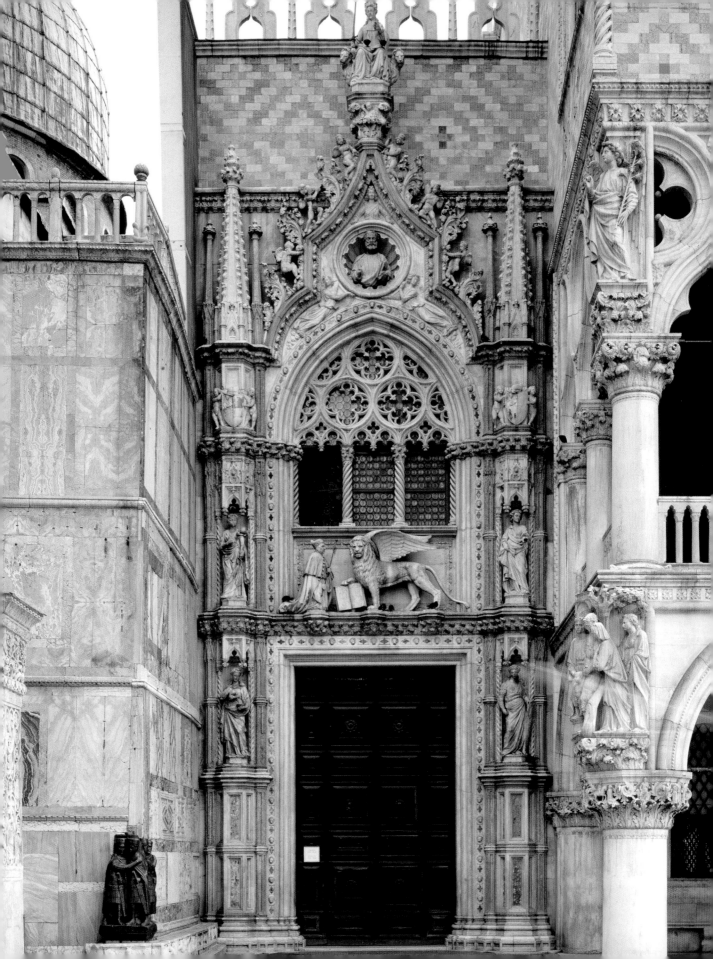

collective opinion, the situation warranted, the Ten could assume direction of any aspect of government, relieving any duly elected officer. It could, and on occasion did, prosecute the *doge* himself (for instance, Marin Falier in 1355; Francesco Foscari in 1457).

Indeed, Venice was a virtuoso mixture of principality and democracy, with real power in the Great Council and executive committees, especially the Ten. The state was in all matters absolute, and the state consisted of the noble families. Despite its obvious imperfections, the republic functioned brilliantly; in fact, it was one of the single most successful states ever devised in western Europe, and with the sole exception of the Holy See, it was the one that lasted for the longest time with the same constitutional arrangement. From 697 until 1797—that is, for exactly eleven hundred years from the election of the first *doge* to the abdication of the last—the republic functioned as a European power and a model of stability and political success.

THE EXPANSION OF THE VENETIAN EMPIRE

Although Venice had by the late eleventh century become a prosperous trading city, it was the Crusades, as it was for Pisa and Genoa, that made Venice a spectacularly rich European power. Indeed, the preponderance of the carrying trade between Italy and the Holy Land was managed by Venetian merchants using Venetian ships. This logistical role was shrewdly redirected when the wily Venetians convinced the northern knights of the Fourth Crusade and their leader, Baldwin of Flanders (1172–c. 1205), to attack Constantinople. Baldwin captured Constantinople in 1204, securing a victory that became the platform on which the Venetian empire would arise, for Venice received a substantial proportion of the spoils of the conquest of the Byzantine capital and thereby achieved significant control over the luxury trade with the East. It was even able to annex parts of the Byzantine empire in the eastern Mediterranean and on the Greek mainland.

Moreover, after the *Serrata* of 1297 the nobles embarked upon a daring plan to build not only a trading empire in the Mediterranean but also a territorial state on the Italian peninsula. The old three-way struggle for maritime supremacy among Venice, Pisa, and Genoa had been simplified when Genoa shattered Pisa in 1284 at Meloria, and was later consummated with the brilliant Venetian naval victory over Genoa in the War of Chioggia in 1380. Thereafter, Venice essentially monopolized the commerce of the eastern Mediterranean, establishing colonies and trading posts throughout the area. With her monopoly on eastern trade secure, Venice looked to northern Italy. This was the essential foreign policy of the *Serenissima* (Venice was known as the most serene republic) in the Renaissance period— to build a territorial empire on the *terraferma* (the mainland)—a policy that began in the second quarter of the fourteenth century. Although the republic had long held colonies in Istria and Dalmatia, along the eastern Adriatic coast, it had purposely and wisely remained aloof from the wars of the Italian mainland. However, that policy was soon to

Figure 8.4 (facing page)
Venice, Palazzo Ducale. The Foscari Arch or *Porta della carta* (paper gate, because the state printer posted material nearby) is the entrance to the complex of the doge's palace. It also joins the palace to the basilica of St Mark, which was the ducal chapel. An image of the *doge* Francesco Foscari (d. 1457) appears above the lintel kneeling before the lion of St Mark, the symbol of Venice. Also visible at the bottom left on the corner of the basilica are the four porphyry tetrarchs, taken by the Venetians from Constantinople in 1204, representing the four rulers of the Roman Empire after Diocletian. The crenellations are Turkish, reflecting Venetian stylistic borrowing, even from their enemies. The loggia on the right was the end of the *broglio* (from the Venetian word for "orchard," which long before had stood on the site), where patricians could try to influence votes: hence our word *imbroglio*.

be abandoned, and Venice entered the lists as another aggressive Italian state, linked in allegiance with others and open to attack.

The reasons for this policy of territorial expansion were simple. First, the city had grown and now had to import much of its food supply; a territorial state in the Veneto would therefore secure the feeding of the city. Second, the monopoly on long-distance eastern trade was the cornerstone of Venetian mercantile policy; however, the distribution of those luxury goods to the rest of Europe necessitated control of the passes through the Alps and even up the Rhine. If a hostile power—the Holy Roman Empire, Milan, or the papacy, for example—was to establish a strong state on the mainland adjacent to Venice, those routes would be closed. Hence, Venice decided to forestall such threats by building a territorial state in Italy to protect its exposed landward side.

The initial step in this policy was Venice's peninsular war against Verona, at that time the most powerful state in the region. As a consequence, in 1339 Venice acquired her first mainland territory, the rich March of Treviso. Following this success, perilous conflicts

Map 8.1 Venice and the *Terraferma*, including Dalmatia. The Venetian *Terraferma* empire included territory at the head of the Adriatic, the Istrian peninsula, and the Dalmatian coast of what is now Croatia.

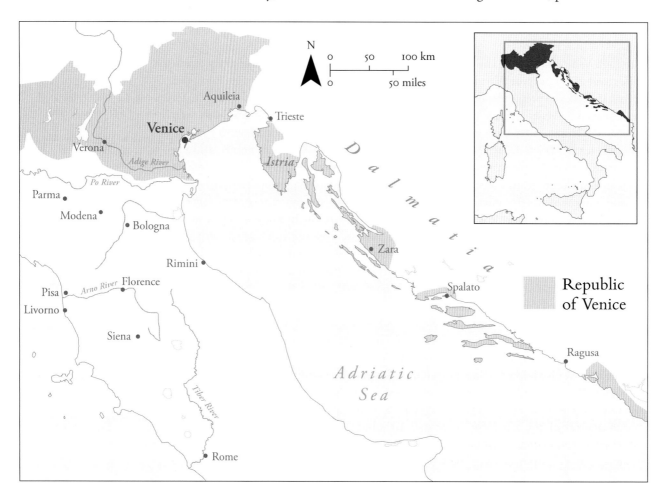

with Hungary, the Empire, Padua, Genoa, and especially with the ambitious Visconti of Milan taught Venice that it had to expand even farther to protect its position. In 1404 Venice conquered Vicenza, Verona, and Bassano; and in 1405 it captured the city of Padua. In a northeastward turn and through a long war with the Holy Roman Empire, Venice achieved the whole province of Friuli from the Adriatic to the Alps. The republic seemed destined to unite all of northern Italy and the Adriatic coast of Dalmatia into a huge territorial state. However, in 1425, Milan fought back in a war lasting until 1454, forcing Venice to use ever more mercenaries for the campaign, hemorrhaging the city's resources. Then Constantinople disastrously fell to the Turks in 1453, wiping away Venice's trading advantages in that city and confronting the republic with an aggressive, hostile Ottoman empire. Finally, Florence, under the generally cautious, peace-loving regime of Cosimo de'Medici, sought to contain Venetian ambitions by suggesting an alliance with Milan. Thus, Venice in 1454 adhered to the general peninsular stability after the Peace of Lodi, a stability that ensured the integrity of the republic's empire—both the *terraferma* and *stato da mar* (the maritime empire to the east)—which by then extended from the Alps to the borders of Milan, until the French invasions of 1494 shattered the peace and independence of Italy until the mid-nineteenth century.

THE MYTH OF VENICE

The vision of Renaissance Venice is one of a wonderfully stable, integrated, rich, and functional republic, the marvel of the world. And, indeed, such was the myth of Venice, a myth perpetuated by both the state and foreign observers alike. Even Florentine humanists were among the most avid disciples of this myth: Poggio Bracciolini wrote in praise of Venice, rehearsing in the most florid terms all of the assumptions about the republic. However, we must ask ourselves whether this was in fact a mere fable, representing the official propaganda of the republic, manipulated by a controlled intelligentsia and maintained by a conspiracy of silence and fear; for this is the opinion increasingly put forward by historians who discount the reality of the Venetian myth.

It is necessary to acknowledge these challenges to the traditional Venetian myth in more detail. Yet we have already seen that the state was successful, lasting 1,100 years with essentially the same constitution, and during most of this time it enjoyed remarkable power and wealth. Such a bald historical fact is inescapable. Also, the basic purposes of the republic's policy—to expand trade to enrich the city and to protect the lines of supply and trade thus acquired—changed little over the entire period of the republic's history. The only exception came in the Renaissance, when the Venetians took the decision in the fourteenth century to build a *terraferma* empire in addition to the ancient empire *da mar* in the eastern Mediterranean. Maintenance of policy certainly implies a continued shared perspective among the political classes. And although individual senators might counsel against individual courses of action, from the time of the Fourth Crusade until

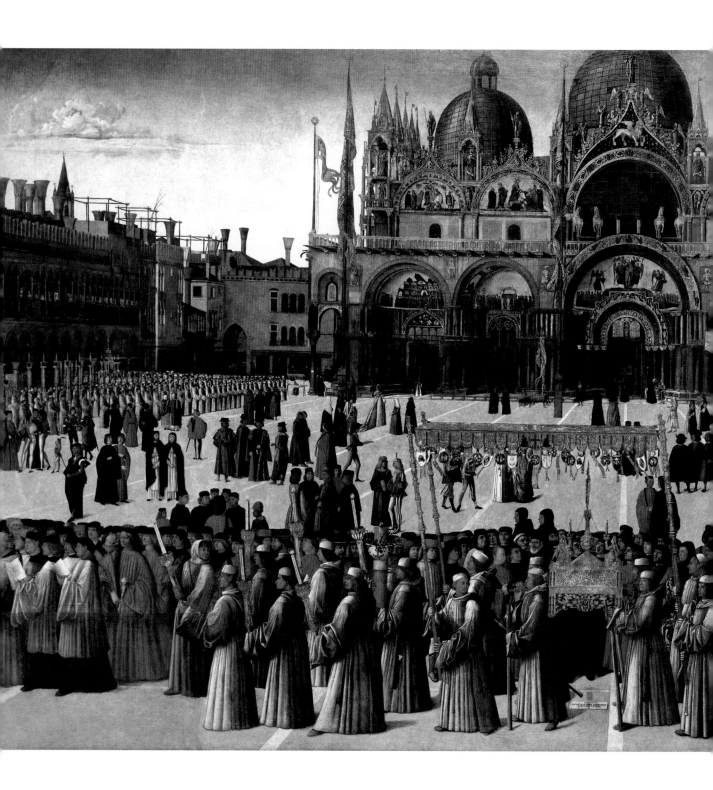

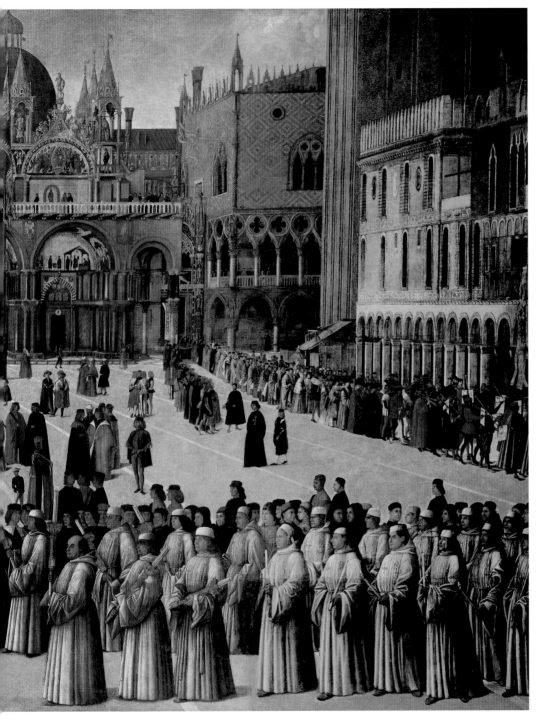

Figure 8.5 Venice, Accademia. Gentile Bellini (c. 1429–1507): *Procession in the Piazza San Marco* (1496). This painting shows a procession celebrating a relic of the true cross acquired by a Venetian confraternity. The reliquary holding the object is visible beneath the canopy, and the members of the confraternity (*scuola*) in their white robes follow the relic, together with other leading citizens and magistrates of the republic. The Piazza San Marco (St Mark's Square) has changed little in the centuries since this image was painted.

the crushing Turkish wars that finally ruined the republic's source of wealth, no patrician would ever depart from the cornerstones of Venetian policy: keep Crete and Cyprus strong to sustain Venice's privileged and dominant position in the eastern Mediterranean, protect the food and supply lines, control Istria and Dalmatia, and maintain stability at home.

Besides the obvious maintenance of single-minded policy in the constitutional and economic spheres, Venice did not have a history of internal disruptions or instability. The two great internal insurrections—that of Bajamonte Tiepolo in 1310 and of Doge Marin Falier in 1355—were not symptoms of popular, or even aristocratic, unrest. Rather, the first occasion represented an attempt by one ambitious aristocrat and his followers to seize the government for their own purposes and in effect turn the republic into a lordship; the second represented the inexplicable plot by an old, honored man, with no immediate family, to establish himself as king, probably for a patriotic desire to see a strong executive that might prosecute better the war against Genoa, which at that time was going very badly.

There was no *ciompi* revolt in Venice: there was no fear of the populace among the nobles, unlike the fear felt by the Florentine patricians toward the masses of their workers. Indeed, both major revolts in Venice were led by nobles and were largely discovered and put down by the absolute refusal of their fellow citizens to support them and by defectors who betrayed the conspiracies to authorities. Also, unlike the Pazzi Conspiracy's aftermath in Florence, there was no orgy of killing and retribution. Marin Falier and his associates were subject to due process of law and sentenced accordingly, with the *doge* beheaded on the very place where he had been crowned not long before. Therefore, there must have been some reality indeed to the myth of a stable Venice, united civically in ambition and strategy.

But was there an alleged conspiracy of silence? It cannot be denied that the Venetian republic was very secretive. All deliberations—including trials in the courts—were carried out in secret, and no one was allowed to discuss official business outside of the proper chambers, unlike Florence, for example, where government policy was often determined in the *piazze* and private palaces of the city. Venetian nobles were discouraged from associating privately with foreigners, or even from discussing factional strategy among themselves. The only exception made to this rule of governmental secrecy was the famous *broglio*, the arcade of the *doge*'s palace facing the *piazzetta*. Only patricians were allowed to walk there in the shade, and thus whatever factional strategies that emerged were determined there: hence, an *imbroglio* (see Fig. 8.4). The courts were located in the *doge*'s palace and were later attached to the infamous Venetian prisons, or "leads" (so named because of their lead roofs) by the beautiful Bridge of Sighs. Executions were most usually carried out at midnight by weighing down the convicts and dropping them quietly over the sides of boats into the lagoon, or less frequently there were public executions, especially when there was an example to be made, as was the case with Marin Falier.

There were also the feared secret denunciations to the Council of Ten. Although it was contrary to all Western notions of justice, we must remember that Venetian justice was essentially Byzantine. Consequently, the state had precedence over the individual, a concept still practiced ruthlessly in our own times in certain places. However, there was

a difference. The Venetian ruling class was small and closely connected: the Council of Ten knew personally the men denounced and could judge the reliability of the denunciations, which required evidence to support any accusation. Moreover, the penalties for vexatious denunciations were severe. In reality, the *bocche del leone* (see Fig. 8.3) were seldom used: they were more a symbol of the omnipresent, omnipotent state than a functioning means of secret oppression.

We must acknowledge that the educated classes in Venice subscribed almost uniformly to the myth of Venice and hence did not question it, producing another kind of silence. Venetian patricians appear to have sincerely believed the myth, as did, significantly, the commons. Finally, it is from our perspective difficult to know how the Venetian government actually worked. Of course, we have innumerable constitutional descriptions, but constitutional power and real power are often two different things. Relatively minor offices took on great significance if held by men of great authority. Clientage and patronage were highly developed: the offices of state were in fact often managed by powerful men behind, rather than in them, situations known to the nobles who elected men accordingly. The Venetian state was probably in the hands of fifty to one hundred very powerful, rich, experienced patricians who determined policy and controlled the government through their connections and clients. But how exactly this model worked over time is hard to trace, as it depended completely on personal inside knowledge and experience. This control of the state by a small number of powerful men helped ensure a kind of continuity and stability.

Still, there were factions in Venice, and the classes themselves were hardly homogenous. In essence, throughout the history of the republic in our period there were four major factions: the ancient or "long" patrician families; the newer or "short" lineages who were often in opposition to them; the young patricians—ambitious, energetic, imaginative, and adventurous; and their opposites, the old patricians—cautious, wary, and possessed of all power.

The long families traced their entry into the Great Council to well before 1297, indeed often to the election of the first *doge* in 697. This faction was led by the twenty-four ancient families who had produced the first *doges*. The short families were those who had entered the Great Council later, sometimes as late as the period of the wars against Genoa in the fourteenth century, when certain old, rich citizens and certain *terraferma* aristocrats were accorded membership in the nobility on payment of an enormous fee. In essence, this division between old and new families was based on snobbery, but there were also real economic differences in our period. The old families represented the traditional trade patterns of the old republic, especially long-distance commerce with Constantinople, the Levant, and the eastern Mediterranean, whereas the new families tended to be more closely associated with the *terraferma* empire, engaging in local trade or in new routes in northern Europe.

The second factional dispute was defined by age, a quality the Venetian state revered: Venice functioned very much as a gerontocracy. Young men were kept out of the Great Council until they turned twenty-five, and out of the Senate until forty. Almost all high offices were monopolized by septuagenarians and octogenarians, a fact probably

determined more by the need to build large followings for elections as by respect for experience; for example, the average age of *doges* at election in the Renaissance was over seventy. Still, there was a *cursus honorum* that Venetian nobles had to undergo. When young, they were kept out of the city by holding minor offices in the empire *da mar* or on galleys; and, if they wished higher education, after the early fifteenth century they were restricted to studying at Padua, within the *terraferma*. Obviously, there was resentment, but not enough to effect a change.

Similarly, not all patricians were rich. Because birth alone determined entry into the Great Council, a not insignificant proportion of nobles, known as *barnabotti* from the part of the city (San Barnaba) in which many of them lived, were virtually penniless, supported only by the sinecures maintained for them by the state. These men were open to corruption and bribery, selling their votes in return for cash. Although despised by the high-minded nobles, they constituted such a part of the Venetian legislative process that they were not only tolerated but in fact cultivated. Had there been any other response, the principle of aristocratic exclusivity would have been compromised. Thus, there were divisions and cracks in the picture of flawless republican stability, perpetuated by the myth of Venice. Still, ultimately, it must be emphasized that it worked, that it was successful, and that any divisions did not overtly disrupt the operation of the state. In short, the myth of Venice had a foundation in reality.

HUMANISM IN VENICE

Despite the close contact that the republic enjoyed with major figures of humanism such as Petrarch (whose library, we recall, he bequeathed to the state), little influence resulted from his sojourn there. Greek was known continuously at Venice because of the intimate relations enjoyed with Constantinople, and, later, in 1438, Cardinal Basilios Bessarion (1403–72), a learned Greek cleric who settled in Italy, left his marvelous collection of Greek texts to the republic, thereby establishing the best Greek library in the peninsula. However, this association with the Greek world had little or no literary or scholarly effect. Greek was a useful tool of business and diplomacy, not an entrée into the classical world of Athens.

Obviously there were individual patricians who were attracted by Florentine humanism and adopted its precepts. Venetians such as Ermolao Barbaro (1454–93) and later Pietro Bembo (1470–1547) would be important spokesmen for the humanist movement, but there was no general adoption of the ideals of humanism as a class ideology by the patriciate, as happened in Florence. Instead, the ideology of the Venetian patriciate was the myth of Venice, and this adherence to the cult of the state clearly made Florentine humanism at best a secondary interest. And, of course, there were other reasons besides the power of the myth of Venice. First, the class and political structure did not as easily allow for the institutionalization of humanism as they did in Florence. In Florence, the office of chancellor was the great pinnacle of a humanist's career, a position from which patronage

and principles could be disseminated. It was a position of great respect and honor and considerable influence. In Venice, however, the office was constitutionally different, as by law patricians were barred from the job. The chancellor of the *Serenissima* and his secretaries had to be of the citizen class (*cittadini originari*). Thus, the nobility—class with the greatest access to and potential interest in humanism—was cut off from the very position that might have best institutionalized it and brought it into the fabric of the state on the highest level. The Chancery did not have the prestige that it had in Florence and for that reason was not part of the *cursus honorum* of offices sought after by rich influential men of genius who wished to vitalize the state with humanism, as in Florence, and spread the word through example and patronage.

Second, until the later Renaissance, the Venetian nobility was almost totally concerned with trade. Their education, then, tended to be practical, almost a merchant apprenticeship rather than an introduction into the sophisticated world of classical letters and ideas. There was little interest on the part of a Venetian patrician in sending his sons to humanist schoolmasters because he saw their futures best provided for in learning the tools of commerce, navigation, and perhaps some foreign languages to expedite diplomacy. This limited background, however, made the personal experience of travel and life abroad less valuable because it cut the young man off from some meaningful perspective on his experience. Also, the traditional Venetian *cursus honorum* worked against humanism, because young patricians had to serve at sea and then fill minor posts in far-flung cities of the *stato da mar* until they were quite old—often in their forties—and only then could a patrician return to Venice to hold very significant office; so for many this meant not having much responsibility until their sixties or seventies. As a result, Venice was ruled by elderly men who tended to be conservative and not greatly interested in new things and ideas such as humanism.

Then there was the nature of the state itself. Florence not only expected but encouraged the free flow of ideas, whereas Venice discouraged private opinions in public places or public opinions in private places. The result was an intellectually repressed society, very uncritical of itself and rather self-content and self-congratulatory. Venetian thought consequently was often highly formulaic and conventional, and there were few major Venetian thinkers; nevertheless, the influence of the University of Padua, with its international reputation and leading law and medical schools, resulted in some important innovations and provided those who desired a more dynamic intellectual life with the opportunity to pursue their studies. In fact, it was the expansion of the Venetian state onto the mainland that most powerfully reinforced any developing interest in the new ideas of the Renaissance. This was true not only in scholarship and letters but particularly in art, where painters such as those of the Bellini family were inspired by Florentine models and brought their techniques and principles home to the *Serenissima*. The need for a recognized vocabulary of architecture was also stimulated by the entry of Venice into the broader culture of Italy. Tuscans, such as Jacopo Sansovino (1486–1570), worked in the city; but architects from the *terraferma*, such as Vincenzo Scamozzi (1548–1616), Michele Sammicheli (1484–1559), and most importantly Andrea Palladio (1508–80), contributed to the creation of

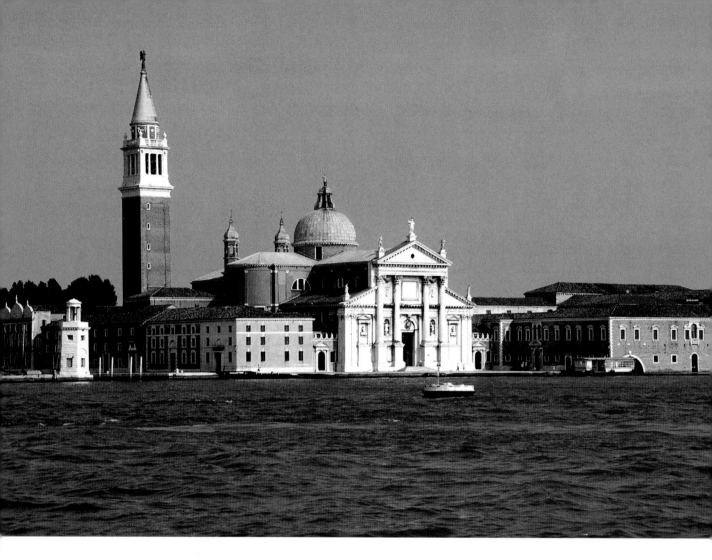

Figure 8.6 Venice, San Giorgio Maggiore. This exquisite church, finished in 1565, is one of Andrea Palladio's masterpieces: it stands on an island immediately across the basin of St Mark from the Piazza San Marco, and its bell tower reflects the design of the campanile of St Mark's basilica. Palladio has united the classical vocabulary of ancient Roman building on the façade with the Byzantine inspired dome, illustrating the complex debts of Venetian culture.

a particularly Venetian Renaissance style that is to this day to be seen in the city and its former territories.

It must be remembered that Venice was not an ancient city, but one founded after the collapse of the Roman Empire. Thus, the living memories of the ancient world so readily visible elsewhere were not immediately available to stimulate interest, although the subsequent expansion of both the *stato da mar* and the *terraferma* provided much contact with the monuments of antiquity. Also, the character of the Venetian Church contributed to the late arrival of humanism in Venice. The Church was effectively a branch of the government and often an employment agency for the younger sons of patricians. The Inquisition (the official name was the *Tre savi sopra l'eresia*: "three wise men responsible for heresy") was an office of the republic, not the Church; and a good many of the most important Church appointments were virtually in the possession of powerful patrician families. But it was the recurring tension between the republic and the papacy that reinforced this circumstance. The ambitions of Venice down the Adriatic coast of Italy resulted in conflict with the northern perimeter of the papal states; and the independence of Venice from any outside

interference, including that of the Holy See, made for often acrimonious relations, particularly after the establishment of the Roman Inquisition. Nevertheless, the Church did provide an entrée for Venetian nobles into the culture of humanism, and Venetians made a particular contribution to the attempts to reform the Roman Church around the decades of the Reformation. Men such as Pietro Bembo were superb humanist scholars as well as clerics, and Bembo gave much to the culture of Renaissance Europe with his canonization of vernacular usage in *Prose della vulgar lingua* (1525). Great collectors, such as several clerical members of the Grimani family, brought antiquities to Venice, again linking the classical humanist culture of Italy to the city on the lagoon.

Venice, then, developed somewhat later as a Renaissance center, but once the movement was domesticated in the city and territories of the republic, it assumed a powerful and dynamic character, creating a particularly Venetian model of Renaissance style that has contributed to the beauty and significance of the city right to the present day.

CHRISTIANS AND TURKS: THE STRUGGLE FOR THE MEDITERRANEAN

The period of the Crusades and the concomitant growing power of Venice, Genoa, Pisa, and Amalfi had given Europeans some advantage by putting the Muslims on the defensive. The maritime might of these states, supported by a Crusader mentality and enriched by trade and ecclesiastical subsidies, largely protected the general perimeter of western Europe, and, together with the Byzantines, patrolled the eastern edges of Christendom. Also, the Saracen kingdoms were divided and uncoordinated in their ambitions, determined only to protect what they had from Christian ambitions while taking some additional plunder through piracy. There was no singular Saracen threat; rather, the danger came from individual pirate bands and small states that lived by plunder.

The rise of Ottoman Turks changed this situation dramatically. The fall of Constantinople to the Turks in 1453 and the consequent elimination of the Byzantine empire permitted Ottoman expansion into and around the Mediterranean. This expansion was a coherent, well-planned, and well-supplied policy of imperial ambition. It had begun even before Mohammed the Conqueror (Mehmed II, r. 1444–46, 1451–81) captured Constantinople, as the Turkish assault on the Balkans, for example, had been made decades before. Serbia fell into vassalage after the battle of Kossovo Polje in 1389, with the rest of the territory becoming a province of the Ottomans by 1459. In 1396 the Turks defeated an international crusader army in Bulgaria, and most of the Greek peninsula had fallen by 1460; Bosnia was captured in 1464. This continuous series of victories resulted in complete Muslim control of the eastern Balkans and established bases from which to expand into Europe.

It appeared that nothing, at least no Christian maritime power, could halt the Muslim advance. Even the most powerful of the Italian city-states failed to protect Christian

territory, property, or lives from the Turks. And, in a final humiliation of Christian Europe, the Turks captured the cape and city of Otranto in the kingdom of Naples (Puglia) in 1480, holding the city for a year before abandoning it and illustrating their ruthlessness by slaughtering those who had refused to convert and those, including the archbishop, who had taken refuge in the cathedral where their bones still rest today. Even the citizens who did convert were nevertheless taken to Albania where they were sold into slavery. The huge Turkish fleet of perhaps as many as seventy ships then proceeded up the Neapolitan coast and destroyed the monastery of San Niccolo di Casole, burning its large and celebrated library; still not content with their plunder, the Turks subsequently assaulted the port cities of Brindisi, Lecce, and Taranto.

The beginning of the sixteenth century saw a respite in the Turkish attacks on Europe, as the triumphant sultan Selim I (r. 1512–20) sent his seemingly invincible armies against his Muslim neighbors, overcoming Persia in 1514, Syria in 1516, and Egypt in 1517. But this proved only to be a diversion. Turning once more against Christian Europe, Sultan Suleiman the Magnificent (r. 1520–66) expanded his base in the Balkans and the Mediterranean in preparation for a concentrated drive into the heartland of central Europe. Belgrade was captured in 1521; and in that same year, Selim's fleet took Rhodes from the Crusading Order of the Knights of St John of

Figure 8.7 Venice, *Fondamenta dei Mori*. This sculpture of a Turk placed in the façade of the house of the painter Tintoretto illustrates the complexity of the Venetian relationship with the Muslim world and the Turks in particular. The Turks were simultaneously enemies and trading partners and manifestly constituted part of the cultural frame of reference of the republic.

Jerusalem. It appeared that the entire Mediterranean could become a Turkish lake and that Europe itself might altogether fall to the Ottomans.

Between 1453 and 1550 the Ottoman Empire had tripled its territory and emerged as the most powerful state in the Western world, controlling an arc around the Mediterranean from the Balkans to Gibraltar. It was feared and hated, and its victories against the Christians of Europe challenged the very confidence that had helped give rise to Renaissance values in Italy and elsewhere. And the fear was justified. In 1526 the Turkish army broke out of the Balkans to meet and slaughter the international Christian force led by King Louis of Hungary at Mohàcs. Continuing north across the flat Hungarian plain, the Turks subsequently laid siege to the imperial capital of Vienna in 1529, raising the specter that central Europe might fall to the Ottoman invaders, and that one of the great Habsburg capitals might suffer the fate of Otranto.

Fortunately for Europe, the siege was unsuccessful; but that did not allay the fears of the continent. The Turks, seemingly invincible, continued to advertise their restless might and skill by assaulting the islands of the Aegean, the Peloponnesus, and the Balkans. Venetian fortified trading strongholds, such as Crete and Cyprus, fell; the Genoese saw their celebrated and important Black Sea outposts surrender to the Turks, with the pivotal trading post at Caffa taken in 1475. Ottoman fleets and Muslim pirate admirals such as the feared Barbarossa (Khayr al-Din, d. 1546) continued to prey on Christian shipping.

As the Turkish expansion seemed endless, Christians increasingly felt the need to take the offensive against the Turks. It was in this environment of Muslim victory that the 1479 dynastic union of Spain under Ferdinand of Aragon and Isabella of Castile set about driving non-Christians from Iberia. The union of Castile and Aragon in 1479 dynastically created not only a new Christian power in the Mediterranean but also one intent on winning Christian victories. After all, the Muslim states of North Africa were just across the narrow straits of Gibraltar, potentially posing a threat to Europe in the minds of frightened Christians. In addition, it was feared that southern Europe could be invaded again, as it had been in the eighth century with the beginning of the Muslim kingdom of Al-Andalus in Iberia. Although we know that the Ottoman Turks and the North African Moors were very different peoples and not part of a Muslim conspiracy—indeed the North Africans also feared the conquering Turks—Christians in Europe in the Renaissance did not: they saw all Muslims as a singular enemy intent on eradicating Christianity and reducing Christians to servitude such as the populations in the Balkans and part of eastern Europe had suffered. The defeat and expulsion of the Moors of Granada, the expulsion of the Jews in 1492, and their forced conversions to Christianity must be seen in this context.

And there were other Christian victories that began to give both comfort and confidence to Europeans. In particular, the lifting of the siege of Malta was seen as a turning point, an example of Christian defense against the mightiest power in the Mediterranean. Despite overwhelming odds and impossible conditions, the Knights of St John of Jerusalem had determinedly stood against the Turkish assault on their island of Malta given to them by Charles V after they had been driven by the Turks from their previous base on Rhodes. For months in 1565–66, despite appalling losses, the knights had held the island for Christendom, thereby also protecting Sicily and the Italian South from certain invasion.

The Turks were still a formidable power, however, as illustrated by their capture of the island of Cyprus in 1570, one of the most strategic and symbolic of all the Venetian territories in the Mediterranean. Cyprus had been ceded a century before to the Venetian republic by Caterina Cornaro (1454–1510), its last queen, the widow of the last Lusignan king, who

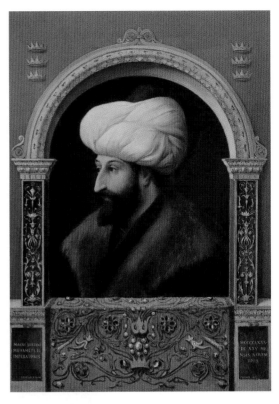

Figure 8.8 Istanbul, Topkapi Museum. Copy of Gentile Bellini (c. 1429–1507): *Portrait of the Ottoman sultan, Mohammed, the conqueror of Istanbul* (1480). This dramatic portrait of the warrior who ended the Byzantine Empire is Venetian in style but includes oriental elements that give it a particular power in connecting East and West. Because of the Muslim interdiction against painting human figures, it was necessary for the sultan to employ an infidel. He also wanted the finest available. Consequently, Mohammed requested that the Venetians send him Giovanni Bellini. But in a precautionary move to protect their greatest living painter, the Venetians sent his brother Gentile, instead, to be a guest at the sultan's court while he painted the portrait.

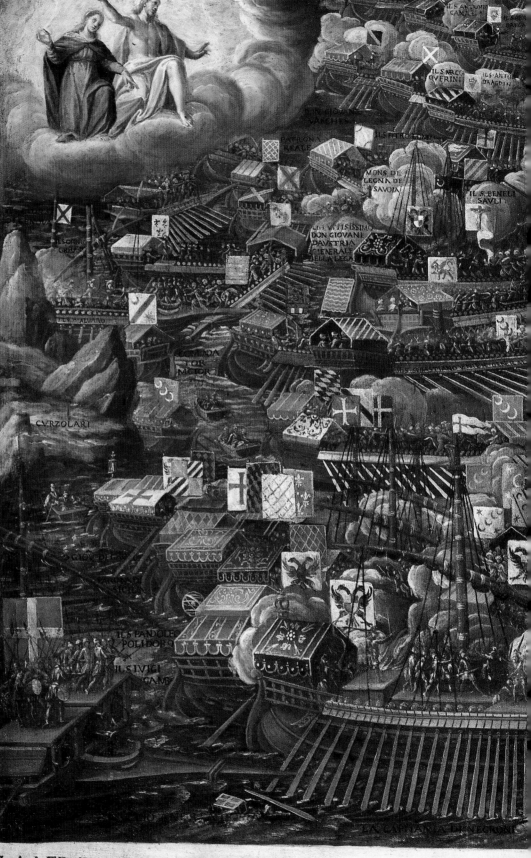

Figure 8.9 Museo Correr, Venice. Venetian School: *Battle of Lepanto, 1571*. This victory over the Turkish fleet in 1571 blunted the Turkish drive to the west. The Christian fleet was commanded by Don John of Austria, the illegitimate son of Emperor Charles V. As this image indicates, major sea battles were often close encounters between enemies. Artillery was so inaccurate that it necessitated sailing close to one's enemy, often resulting in hand-to-hand combat, for which purpose naval galleys carried detachments of soldiers.

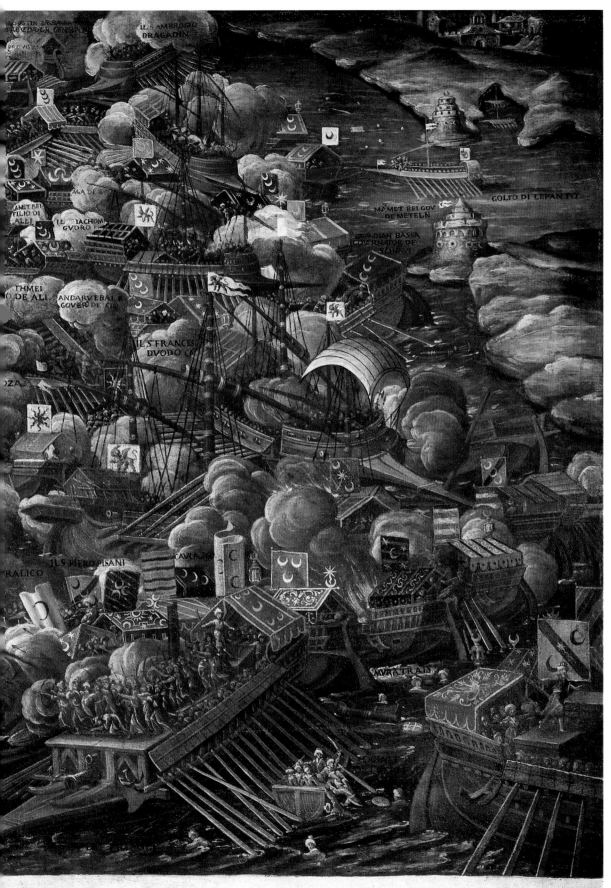

...NI CONTRA TVRCHI ALLI SCOGLI CVRZOLARI LANO 1571 A.1 70.0

was also the king of Jerusalem, the heir of the great crusading dynasty that had once won victories in the Holy Land over the Saracens. Cyprus was a bitter loss to Venice and at once both hastened the republic's withdrawal from the eastern trade and strengthened its desire for revenge. The opportunity to rehearse the victory of Malta and savor the possibility of stopping the Turks presented itself soon after the loss of Cyprus. In 1571 there came off the coast of Greece near the Gulf of Corinth the battle of Lepanto, in which Christian Europe at last succeeded in halting the Ottomans. The victory of the combined Christian fleets led by Don John of Austria (1547–78), illegitimate son of the emperor Charles V, gave Europe some respite from the Turkish advance. All of the great maritime states participated, adding to the renewal of a crusader mentality, and Italian galleys played prominent roles.

THE VOYAGES OF DISCOVERY

An unintended consequence of the Turkish control of much of the Mediterranean was the European voyages of discovery. The Portuguese under Prince Henry the Navigator (1394–1460) began a systematic exploration of the coast of Africa. Each year Portuguese ships sailed ever farther down the coast and mapped their routes meticulously. In this way, not just the coastlines but the winds, currents, and dangers were recorded, making exploration faster and safer. It is important to stress, however, that Prince Henry was a Crusader. He was the brother of the Portuguese king and was the head of a militant crusading order; and he was a devout, almost fanatical Christian who saw it as his mission to drive out the Muslims wherever he found them and to convert the native population to Christianity. Henry's ambition to chart Africa was profoundly connected to his intention of attacking the Muslim states of North Africa from the rear. He hoped to connect with a mysterious, indeed legendary, Christian ruler, known as Prester John (probably the king of Ethiopia), and mount an attack from in front and behind to drive the Muslims into the sea. To accomplish this, though, he needed bases in Africa; and the capture and fortification of Ceuta in Morocco in 1415 had been part of this policy.

This was the context of the Portuguese voyages of discovery, adventures at sea that would alter the place of the Mediterranean forever in the affairs of Europe and permit merchants from the states on the Atlantic coast to compete with Italians for the long-distance luxury trade with the East. Their success would also ensure that the dangers of the Turks and the Muslim pirates could be avoided. This desire to circumvent the dangers of the Mediterranean largely motivated the circumnavigation of the Cape of Good Hope in 1497–98 by Vasco da Gama, thus shifting the economic center of Europe from the Mediterranean to the Atlantic kingdoms of Portugal and, later, Spain. For the first time in recorded history, the great inland sea was no longer the *media terra*, or, as its name signifies, the center of the earth. The Portuguese had shown that Africa could be circumnavigated and that European knowledge could be extended beyond what the ancient Greeks and Romans had known. The ancients had never explored or colonized sub-Saharan Africa,

and the fanciful stories in Pliny's *Historia naturalis* of what was to be found there were seen as fables as well as warnings. But experience proved the ancients wanting and wrong: Africa could be rounded and the fears of the monsters and dangers to be found there disproved.

The economic impact of the successful voyages of Bartholomew Dias (c. 1451–1500) and Vasco da Gama (d. 1524) along and around the African continent was cataclysmic for Renaissance Italy. The price of spices and other luxury goods from the East collapsed dramatically, and Christian merchants could now avoid the dangers of the Mediterranean, still trade in Eastern luxuries, and not have to deal with the Italians. The huge profits that had flowed into the commercial centers of the peninsula had provided the wealth that permitted the Italian Renaissance to experiment with new models of thought and culture and allowed for social mobility and different kinds of institutions. And not only was the wealth that came from long-distance trade eroded, but so, too, was the self-confidence that equally derived from controlling the economy, trade, and even diplomacy of a continent. To be sure, Venice, and even Genoa and Florence, maintained considerable riches and sustained many elements of their Renaissance values; but the energy was reduced, the surplus wealth was dissipated, and the institutions of the state were challenged. No better illustration of this loss of purpose and energy can be offered than the observation that the once formidable Italian maritime states did not experiment with new kinds of ship design, despite what the Portuguese and Spanish were proving with their caravels and carracks in the Atlantic. The Italians were too complacent and conservative to venture much beyond the straits of Gibraltar or without sight of the coast; and they continued to build traditional galleys, ships that suited Mediterranean trade. Furthermore, it is a sad commentary to observe that the celebrated Italian captains of the age of discovery—Columbus, Cabot, Verrazano, Vespucci—sailed not for their native cities but for northern, Atlantic monarchies. In Italy, their services and imagination were no longer needed.

FURTHER READING

Abridge, T. *The First Crusade: A New History: The Roots of Conflict Between Christianity and Islam*. Oxford: Oxford, 2005.

Chambers, D.S. *The Imperial Age of Venice: 1380–1580*. London: Thames and Hudson, 1970.

Epstein, Steven A. *Genoa and the Genoese, 958–1528*. Chapel Hill: University of North Carolina Press, 2001.

Finlay, Robert. *Politics in Renaissance Venice*. New Brunswick, NJ: Rutgers University Press, 1980.

Heywood, William. *A History of Pisa in the Eleventh and Twelfth Centuries*. Cambridge: University of Cambridge Press, 1921.

Kirk, Thomas Allison. *Genoa and the Sea: Policy and Power in an Early Modern Maritime Republic, 1559–1684*. The Johns Hopkins University Studies in Historical and Political Science. Baltimore: Johns Hopkins University Press, 2005.

Konstan, A., and T. Bryan. *Lepanto, 1571: The Greatest Naval Battle of the Renaissance*. Oxford: Osprey Publishing, 2003.

Muir, Edward. *Civic Ritual in Renaissance Venice*. Princeton, NJ: Princeton University Press, 1981.

Norwich, John Julius. *A History of Venice*. New York: Alfred A. Knopf, 1982.

Queller, D. *The Fourth Crusade: The Conquest of Constantinople*. Pennsylvania: University of Pennsylvania Press, 1999.

NINE

THE PRINCIPALITIES

MANY OF THE MOSAIC of states we have been discussing in detail were republics such as Florence, Venice, Genoa, and even papal Rome, where the pope was elected although by a theocratic method unique unto itself. Nevertheless, there were in the Italy of the Renaissance a significant number of monarchical states ruled by individuals and families, sometimes representing long-established and celebrated dynasties, sometimes consisting of usurpers or adventurers who exercised power as princes. These princes and their principalities contributed greatly to the culture of the Italian Renaissance through the patronage of art, architecture, and literature, although theirs was a monarchical aristocratic culture more indebted to the Roman Empire than to the Roman Republic.

Because the culture of these princes (or, in Italian, *signori*) varied according to the characters of the individuals and the requirements of their states and times, it is neither possible nor useful to generalize about them as a single category. For example, the kingdom of Naples was very much a dynastic feudal monarchy in the northern European tradition and a huge territorial state that constituted the southern half of the peninsula and often included the island of Sicily as well. In contrast were principalities such as tiny Urbino, whose rulers were warrior chieftains, often available as mercenary captains (*condottieri*) using their citizens as armies to fight others' wars for pay.

Indeed, the culture of signorial regimes often illustrated the knightly values reminiscent of the feudal character of northern European society: the knights of Arthur's round table and of Charlemagne's court enjoyed equal, if not greater, reputations in these principalities than did the ancient Greek and Roman rhetoricians and statesmen who defined the principles of civic humanism in the Italian republics. The search for fame and glory among these princes put them in competition with one another, not only on the battlefield but also as patrons of art and culture. Their patronage of and competition for the best among the painters, writers, architects, and sculptors of Renaissance Italy can be seen to have constituted war by other means.

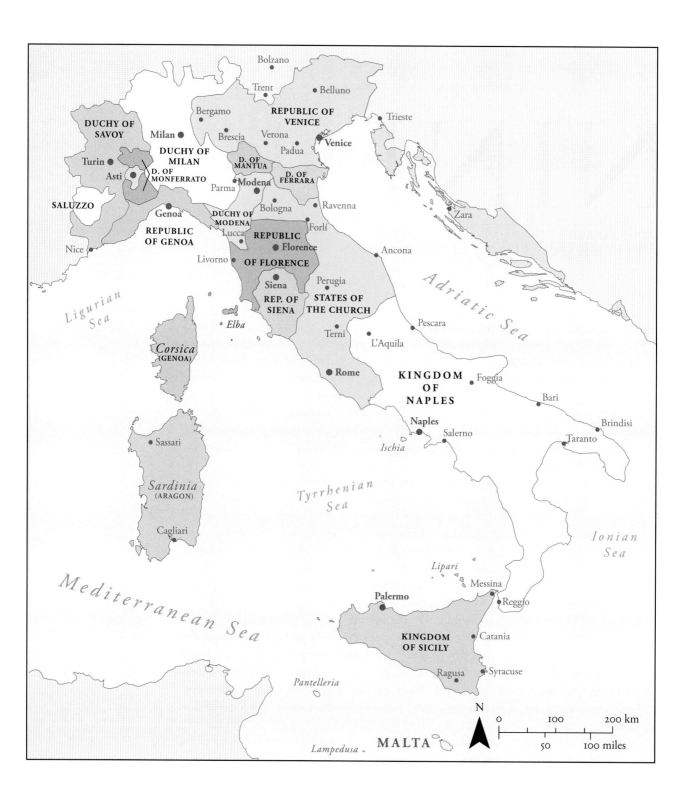

Bolzano

Trent

Belluno

Bergamo

REPUBLIC OF VENICE

DUCHY OF SAVOY

Milan

Brescia

Verona

Trieste

Turin

DUCHY OF MILAN

Padua

Venice

Asti

D. OF MONFERRATO

D. OF MANTUA

SALUZZO

Genoa

Parma

Modena

D. OF FERRARA

REPUBLIC OF GENOA

DUCHY OF MODENA

Bologna

Ravenna

Nice

Lucca

Forlí

Zara

Livorno

REPUBLIC OF FLORENCE

Florence

Ancona

Adriatic Sea

Ligurian Sea

Corsica (GENOA)

Elba

Siena

REP. OF SIENA

Perugia

STATES OF THE CHURCH

Terni

Pescara

L'Aquila

Sassari

Sardinia (ARAGON)

Rome

KINGDOM OF NAPLES

Foggia

Bari

Cagliari

Naples

Salerno

Brindisi

Taranto

Ischia

Tyrrhenian Sea

Ionian Sea

Mediterranean Sea

Lipari

Messina

Reggio

Palermo

Catania

Pantelleria

KINGDOM OF SICILY

Ragusa

Syracuse

N

0 100 200 km

50 100 miles

MALTA

Lampedusa

IL REGNO: THE KINGDOM OF NAPLES

Naples (often simply called *Il Regno* in Italian: "The Kingdom") was a huge monarchy where policy was often undermined by dynastic threat and where the central authority of the king was habitually challenged by the enormous residual power of landed magnates and the Church. As a consequence, the culture of the Italian Renaissance was not so deeply felt in the south of the peninsula, where urban life, social mobility, and the dynamic principles modeled on classical antiquity were at best decorative or individual interests. The history of Naples in our period, then, was largely driven by the political and dynastic policies of its kings, a stratagem we will see repeated often in our discussion of principalities, large and small. This is important because these dynastic machinations injected still another continuing source of instability into Italian affairs, an instability that in the fullness of time would bring about the destruction of the independence of Italy and turn the peninsula into the battleground for the great northern territorial states of France and Spain.

To understand this situation, we must return to the thirteenth century. The Imperial House of Hohenstaufen (and its Ghibelline allies) had been challenging the claims of the papacy to universal lordship for generations. In 1266 the pope requested that the French king, Louis IX (r. 1226–70), help destroy the power base of the Germanic Holy Roman Empire in southern Italy. King Louis complied, sending an army under the command of his younger brother, Charles of Anjou (1226–85), to claim Naples and establish a French Angevin dynasty. This victory ensured the dominance of the papal party (Guelfs) in Italy but caused its own problems in Sicily. Angry with the rapacity of the French officials sent from Naples and possessing a lengthy particularist tradition underscored by geographical separation, the people of Sicily rebelled against the French Angevins in 1282. This Revolt of the Sicilian Vespers, as it was called, was totally successful and detached the island from the rest of the Angevin kingdom. The Sicilians then gave themselves in fiefdom to the Spanish king of Aragon, Peter III (d. 1285). The kingdom of Naples was now divided: the mainland territories were ruled from the city of Naples by a French dynasty, the Angevin, while the island of Sicily was ruled from Palermo by a Spanish dynasty, the Aragonese.

This divide had been in force for an uneasy century when the security of *Il Regno* was again undermined by dynastic crisis. In 1382, the reigning monarch, Queen Joanna I of Naples, after almost forty years of unstable rule, died without an heir. In her will she named Louis, duke of Anjou (1339–84), the younger brother of the French king, Charles V, as king of Naples. However, for political reasons Louis of Anjou was never able to acquire Queen Joanna's bequest. The French monarchy supported the Avignon branch of the papacy during the Great Schism: consequently the Roman pope, Urban VI, refused to accept the claim of Louis to Naples, which was not only the leading state of the Italian Guelfs but also a territory that extended strategically along the southern border of the states of the Church. This unfulfilled will of Joanna I was to have disastrous effects upon the future of the entire Italian peninsula.

The crown of Naples ultimately went to the pope's candidate, Charles, duke of Durazzo, a very distant cousin of the unfortunate Queen Joanna I. However, in 1435

Map 9.1 (facing page) The Major States of the Peninsula (c. 1494)

malevolent fortune once again intervened when this branch of the Neapolitan Angevins also died out with another childless Queen Joanna—Queen Joanna II. In her will, Joanna II repeated the offer of Naples to the French house of Anjou, nominating René of Anjou (1409–80), the grandson of the same duke of Anjou whom Joanna I had named as her heir but who had not been allowed to accept the bequest. It seemed, then, that the French Angevins would at last get Naples.

However, Joanna II was not known for her consistency. Before writing that final testament giving her kingdom to René of Anjou, Joanna had promised to name the Spanish king of Sicily as her heir so that the two southern Italian kingdoms might once again be reunited. Despite Joanna's change of mind represented by her final will, the king of Sicily, Alfonso the Magnanimous of Aragon (r. 1416–58), held to her prior bequest and crossed the Straits of Messina in 1435 with his army. The Angevins called in support from the duke of Milan, and Alfonso was initially defeated—even taken captive—but he convinced the Milanese that the House of Aragon would offer less of a threat to their independence than would the French House of Anjou because of its dynastic claim on Milan. Released from captivity, Alfonso continued his assault on Naples in the face of both French and papal opposition. It was only in 1442 that Naples finally fell, but by 1443 Alfonso had consolidated his rule and by 1446 had extended his power into the northwestern Mediterranean with the conquest of Sardinia, providing an important link between his Iberian and Italian dominions.

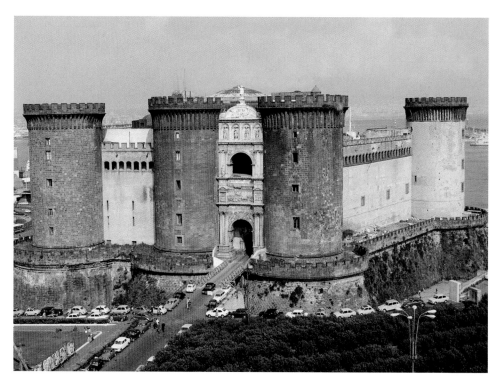

Figure 9.1 Naples, *Castello Nuovo*. Although the Angevin castle dates from the thirteenth century, King Alfonso the Magnanimous commissioned Francesco Laurana (c. 1430–c. 1502) to build the imposing entrance for his triumphal entry into the kingdom. The contrast between the Renaissance gate and the medieval fortress reflects very effectively the complex character of the *Regno*.

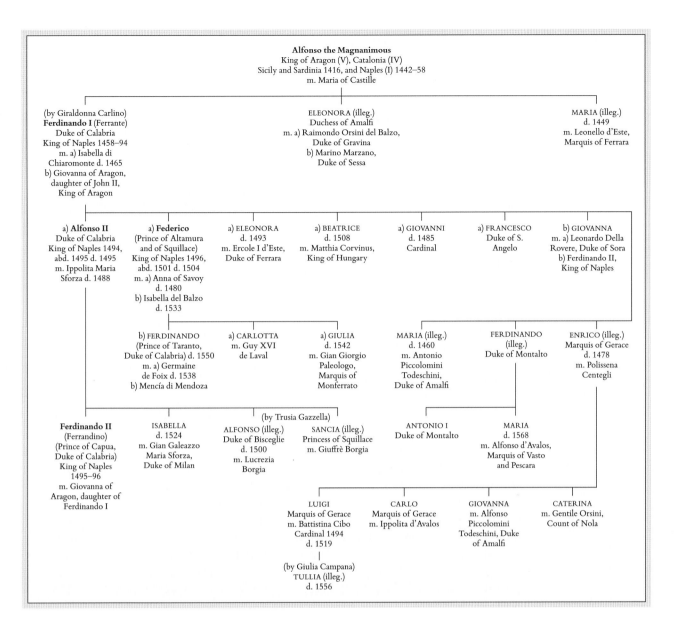

Alfonso the Magnanimous
King of Aragon (V), Catalonia (IV)
Sicily and Sardinia 1416, and Naples (I) 1442–58
m. Maria of Castille

(by Giraldonna Carlino)
Ferdinando I (Ferrante)
Duke of Calabria
King of Naples 1458–94
m. a) Isabella di
Chiaromonte d. 1465
b) Giovanna of Aragon,
daughter of John II,
King of Aragon

ELEONORA (illeg.)
Duchess of Amalfi
m. a) Raimondo Orsini del Balzo,
Duke of Gravina
b) Marino Marzano,
Duke of Sessa

MARIA (illeg.)
d. 1449
m. Leonello d'Este,
Marquis of Ferrara

a) **Alfonso II**
Duke of Calabria
King of Naples 1494,
abd. 1495 d. 1495
m. Ippolita Maria
Sforza d. 1488

a) **Federico**
(Prince of Altamura
and of Squillace)
King of Naples 1496,
abd. 1501 d. 1504
m. a) Anna of Savoy
d. 1480
b) Isabella del Balzo
d. 1533

a) ELEONORA
d. 1493
m. Ercole I d'Este,
Duke of Ferrara

a) BEATRICE
d. 1508
m. Matthia Corvinus,
King of Hungary

a) GIOVANNI
d. 1485
Cardinal

a) FRANCESCO
Duke of S.
Angelo

b) GIOVANNA
m. a) Leonardo Della
Rovere, Duke of Sora
b) Ferdinando II,
King of Naples

b) FERDINANDO
(Prince of Taranto,
Duke of Calabria) d. 1550
m. a) Germaine
de Foix d. 1538
b) Mencía di Mendoza

a) CARLOTTA
m. Guy XVI
de Laval

a) GIULIA
d. 1542
m. Gian Giorgio
Paleologo,
Marquis of
Monferrato

MARIA (illeg.)
d. 1460
m. Antonio
Piccolomini
Todeschini,
Duke of Amalfi

FERDINANDO
(illeg.)
Duke of Montalto

ENRICO (illeg.)
Marquis of Gerace
d. 1478
m. Polissena
Centegli

Ferdinando II
(Ferrandino)
(Prince of Capua,
Duke of Calabria)
King of Naples
1495–96
m. Giovanna of
Aragon, daughter of
Ferdinando I

ISABELLA
d. 1524
m. Gian Galeazzo
Maria Sforza,
Duke of Milan

(by Trusia Gazzella)
ALFONSO (illeg.)
Duke of Bisceglie
d. 1500
m. Lucrezia
Borgia

SANCIA (illeg.)
Princess of Squillace
m. Giuffrè Borgia

ANTONIO I
Duke of Montalto

MARIA
d. 1568
m. Alfonso d'Avalos,
Marquis of Vasto
and Pescara

LUIGI
Marquis of Gerace
m. Battistina Cibo
Cardinal 1494
d. 1519

CARLO
Marquis of Gerace
m. Ippolita d'Avalos

GIOVANNA
m. Alfonso
Piccolomini
Todeschini, Duke
of Amalfi

CATERINA
m. Gentile Orsini,
Count of Nola

(by Giulia Campana)
TULLIA (illeg.)
d. 1556

During the remainder of Alfonso's lifetime, the two ancient parts of the southern Italian kingdom were united. When in power, Alfonso attempted to strengthen the central authority and benefit the poor, feudal South. He invested in necessary public works, draining marshes and patronizing the construction of buildings in the classical, Vitruvian style, as well as rebuilding the city's defensive walls. Personally highly cultivated, Alfonso patronized scholars, such as Lorenzo Valla, who while in Naples wrote his revelation of the Donation of Constantine as a forgery, providing support for his king's struggle with the pope. Alfonso read classical authors, particularly the historians, and campaigned with their manuscripts always in his baggage. He even attempted to support trade and urban life in his territory, which with the exception of the city of Naples had not greatly benefited

Genealogy 9.1
Naples: The House of Aragon

from the revival of trade and mercantile activity; but even here, the huge capital of the *Regno* was mostly an administrative center where commerce served the court.

Despite his accomplishments, Alfonso was continually opposed by the fractious feudal barons in the countryside, who resented his foreign rule and his use of Aragonese officials and soldiers. Consequently, Alfonso's death in 1458 returned Naples to a condition of dynastic instability and division. Alfonso had no legitimate heirs, so the two halves of the *Regno* were divided once more, with Naples passing to Alfonso's energetic illegitimate son Ferrante (r. 1458–94) and Sicily remaining with the direct line of Aragonese kings.

Almost all of Ferrante's reign was troubled. First, the lawless barons, always resentful of their foreign kings, were doubly hostile and uncooperative when ruled by a bastard, especially given the common belief that Ferrante was not even Alfonso's son, but the result of his mother's affair with another noble. Also, the papacy continually made trouble because the pope considered the crown of Naples in his gift, since it was in theory a papal fief and since a pope had arranged for the kingdom's succession in 1382. Furthermore, Ferrante distrusted the ambitions of Venice along the Adriatic coast and feared that the Venetian policy of establishing a *terraferma* empire might eventually lead them to attempt to conquer the Neapolitan territories bordering the Adriatic to parallel their cities in Dalmatia.

Ferrante, then, was never comfortable during his long reign. Having to humor the papacy while not allowing it to acquire too much authority, having to strive for internal order in a traditionally ungovernable kingdom, having to be vigilant against the Venetians while not provoking them and thereby initiating the very war he so feared, Ferrante had to tread carefully. Only the balance of power—given force by Cosimo and later Lorenzo de'Medici's brilliant peninsular policy after 1454—kept Naples together. This period of relative Italian stability between the Peace of Lodi in 1454 and the French invasions of 1494 allowed Ferrante to maintain his rule. However, with his death in 1494, the tragedy was finally played out. The French monarchy—to which the cadet branch of Anjou had succeeded—determined to fulfill at last the two unfulfilled bequests of the Crown and launched a massive invasion of Italy under King Charles VIII (r. 1483–98). It was this reckless, ambitious act of dynastic aggression that destroyed, first, the stability of the Italian peninsula and, second, the independence of many of the Italian states for over three centuries to come.

Charles VIII's triumphal march into Naples was initially welcomed by all citizens of every class; but soon his regime was also seen as that of a foreign prince interfering in southern Italian affairs. French officials behaved badly, especially in their actions toward Neapolitan women; the lesson clearly had not been learned from the Sicilian Vespers of two centuries before. Moreover, the barons saw that they would not enjoy more power under the French than they had under Ferrante, and the other states of Italy began to form alliances against the invader. Pope Alexander VI, Venice, and even Milan determined that the French had to be expelled. Charles then decided to return to France but was confronted in 1495 at Fornovo where he was indecisively defeated by the Milanese and their allies.

It was therefore not difficult for the Great Captain (as Machiavelli describes him in *The Prince*), Gonzalo de Córdoba (1453–1515), to drive out the remaining French garrison

in 1496 and restore Naples to the Aragonese dynasty of Federigo III (r. 1496–1501). This victory did not end the suffering of Naples, however, or ensure stability in the South. The death of Charles VIII in 1498 without issue resulted in the accession of his cousin, Louis XII (r. 1498–1515), to the French throne. Louis had dynastic claims on Milan, which he captured in 1499. This French victory in Italy spurred Ferdinand of Aragon (r. 1479–1516) to ally himself with the French for the conquest of the south of Italy, which was to be partitioned between them. The Spanish pope, Alexander VI, approved of this plan and declared Federigo of Naples deposed. The French then attacked Naples while Ferdinand of Aragon, through the brilliant military leadership of Gonzalo de Córdoba, captured territories in the south from his relation, Federigo, who had fled his kingdom. These victories soon caused tension and jealousy between the allies, and open warfare broke out between France and Aragon, which resulted in the Great Captain eventually driving the French from Naples. Through the 1505 Treaty of Blois, Louis XII was forced to recognize Ferdinand of Aragon as king of Naples and Sicily, solidifying foreign domination of the Italian *mezzogiorno* (the Italian term for southern Italy) for centuries to come.

MILAN

Milan, like Naples, formed a state that had been heavily influenced by northern, monarchical values. The large, rich, and fertile territory, centered on the Lombard plain and the valley of the River Po, was a natural dynastic territorial state; however, unlike Naples it benefitted from a highly centralized regime dominated in our period by just two Milanese dynasties. Much smaller than *Il Regno* and not subject to the disruptive influences of powerful fractious feudal magnates, Milan was among the most important and influential of the tyrannical regimes. The archetypal example of a monarchical state ruled by a *signore*, it almost succeeded in building a huge, centralized, territorial state stretching between Venice and the papal dominions. With respect to Florence—the focus of so much of our earlier discussion of Renaissance Italy—Milan was the leading antagonist and the greatest threat to its republican liberty. Indeed, at least within the interpretation of the Baron thesis (see Chapter One), the wars between Milan and Florence in the late fourteenth and early fifteenth centuries were the catalytic force that crystallized the concept of civic humanism among the Florentine intelligentsia.

It is extremely difficult, if not impossible, to reduce the tangled, bloody, violent history of Renaissance Milan into a short discussion. The rule of Milan, the holy city of St Ambrose, was formally entrusted to the Visconti family in 1311 by the emperor Henry VII, the city's nominal overlord. Reigning merely as *signori* until Giangaleazzo purchased the ducal title from the emperor Wenceslas in 1395, this one family, the Visconti, controlled the destiny of the Milanese until 1447; and, in general, their rule was very successful. Cruel, extravagant, and ambitious, as well as rapacious in taxation, they were tolerated because of this very success. During the centuries when the Visconti controlled

Milan, virtually all of northwestern Italy was at some time brought under Milanese hegemony and subsequently well administered by Visconti officials. A woolen manufacturing industry was established, as was the cultivation of silkworms. Trade in all forms was supported, and Milan's great armaments industry furnished the materiel for many of Europe's wars. Because of this enlightened patronage, the city grew increasingly rich. Hence the populace was able to pay more easily the excessive Visconti taxation and better able, too, to ignore its own almost complete lack of political liberty. Also, the city was beautified and made famous for its paved streets, marble façades, and remarkable Italian Gothic cathedral. Indeed, patronage of art was practiced lavishly in Milan, a tradition that in our period begins with Giovanni Visconti's reception of Petrarch in 1353 and continues through Leonardo da Vinci's residence there under Lodovico il Moro.

Petrarch's host, Giovanni Visconti (1290–1354), well illustrates the character of the Milanese *signori*. Not only secular lord of his city but also archbishop of Milan, he ruled in addition the towns of Parma, Brescia, Lodi, Piacenza, Bergamo, Como, Asti, and eventually Bologna, as well as dozens of lesser municipalities and castles. To acquire Bologna from the papacy, he endured excommunication (the first of four such papal rebukes during

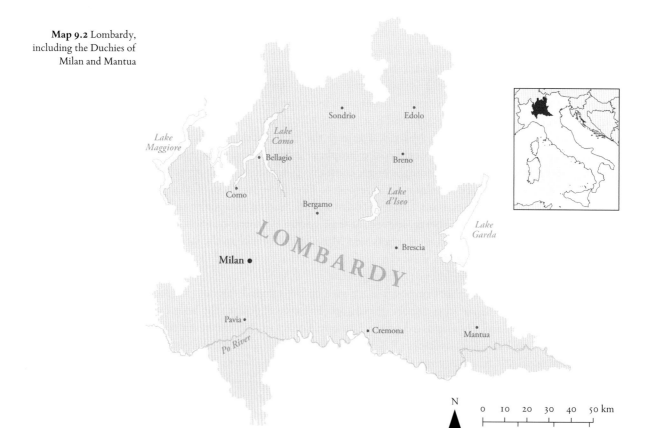

Map 9.2 Lombardy, including the Duchies of Milan and Mantua

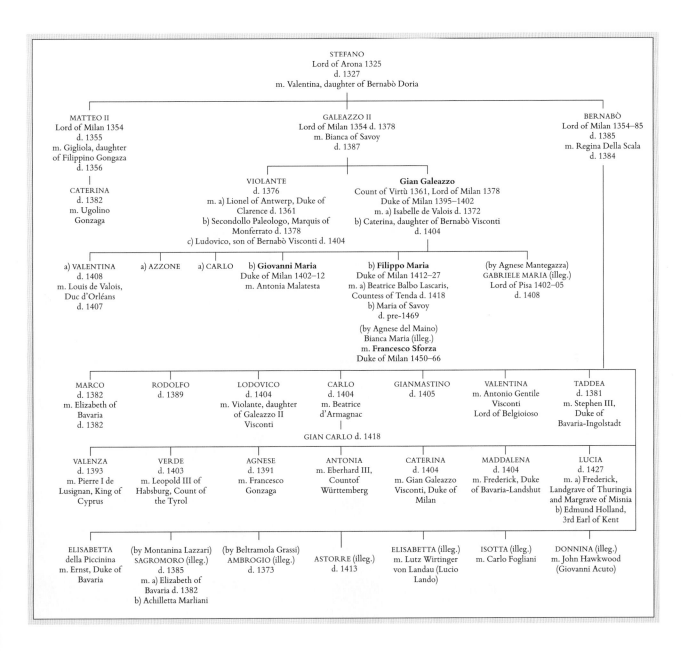

STEFANO
Lord of Arona 1325
d. 1327
m. Valentina, daughter of Bernabò Doria

MATTEO II
Lord of Milan 1354
d. 1355
m. Gigliola, daughter
of Filippino Gongaza
d. 1356

CATERINA
d. 1382
m. Ugolino
Gonzaga

GALEAZZO II
Lord of Milan 1354 d. 1378
m. Bianca of Savoy
d. 1387

VIOLANTE
d. 1376
m. a) Lionel of Antwerp, Duke of
Clarence d. 1361
b) Secondollo Paleologo, Marquis of
Monferrato d. 1378
c) Ludovico, son of Bernabò Visconti d. 1404

Gian Galeazzo
Count of Virtù 1361, Lord of Milan 1378
Duke of Milan 1395–1402
m. a) Isabelle de Valois d. 1372
b) Caterina, daughter of Bernabò Visconti
d. 1404

BERNABÒ
Lord of Milan 1354–85
d. 1385
m. Regina Della Scala
d. 1384

a) VALENTINA
d. 1408
m. Louis de Valois,
Duc d'Orléans
d. 1407

a) AZZONE a) CARLO

b) Giovanni Maria
Duke of Milan 1402–12
m. Antonia Malatesta

b) Filippo Maria
Duke of Milan 1412–27
m. a) Beatrice Balbo Lascaris,
Countess of Tenda d. 1418
b) Maria of Savoy
d. pre-1469

(by Agnese Mantegazza)
GABRIELE MARIA (illeg.)
Lord of Pisa 1402–05
d. 1408

(by Agnese del Maino)
Bianca Maria (illeg.)
m. Francesco Sforza
Duke of Milan 1450–66

MARCO
d. 1382
m. Elizabeth of
Bavaria
d. 1382

RODOLFO
d. 1389

LODOVICO
d. 1404
m. Violante, daughter
of Galeazzo II
Visconti

CARLO
d. 1404
m. Beatrice
d'Armagnac

GIANMASTINO
d. 1405

VALENTINA
m. Antonio Gentile
Visconti
Lord of Belgioioso

TADDEA
d. 1381
m. Stephen III,
Duke of
Bavaria-Ingolstadt

GIAN CARLO d. 1418

VALENZA
d. 1393
m. Pierre I de
Lusignan, King of
Cyprus

VERDE
d. 1403
m. Leopold III of
Habsburg, Count of
the Tyrol

AGNESE
d. 1391
m. Francesco
Gonzaga

ANTONIA
m. Eberhard III,
Count of
Württemberg

CATERINA
d. 1404
m. Gian Galeazzo
Visconti, Duke of
Milan

MADDALENA
d. 1404
m. Frederick, Duke
of Bavaria-Landshut

LUCIA
d. 1427
m. a) Frederick,
Landgrave of Thuringia
and Margrave of Misnia
b) Edmund Holland,
3rd Earl of Kent

ELISABETTA
della Piccinina
m. Ernst, Duke of
Bavaria

(by Montanina Lazzari)
SAGROMORO (illeg.)
d. 1385
m. a) Elizabeth of
Bavaria d. 1382
b) Achilletta Marliani

(by Beltramola Grassi)
AMBROGIO (illeg.)
d. 1373

ASTORRE (illeg.)
d. 1413

ELISABETTA (illeg.)
m. Lutz Wirtinger
von Landau (Lucio
Lando)

ISOTTA (illeg.)
m. Carlo Fogliani

DONNINA (illeg.)
m. John Hawkwood
(Giovanni Acuto)

his lifetime for this archbishop, who was said to have celebrated mass only once in his career) and sustained constant war against Avignon. He ultimately won Bologna through a 200,000-florin bribe in 1352, the year before Petrarch left papal Avignon for Milan. During his eight years at the Visconti court, based variously in Parma and Milan, Petrarch composed his famous *Trionfi*, in which he portrays the power of man's spirit to overcome all obstacles, including time and death; and he also wrote more of his beloved Laura in Milan, expanding the *canzoniere*.

Giovanni Visconti's heirs continued his glorification of the city, especially Galeazzo (1320–78), Giovanni's nephew, who embarked upon a policy of making Milan a European

Genealogy 9.2
Milan: The House of Visconti

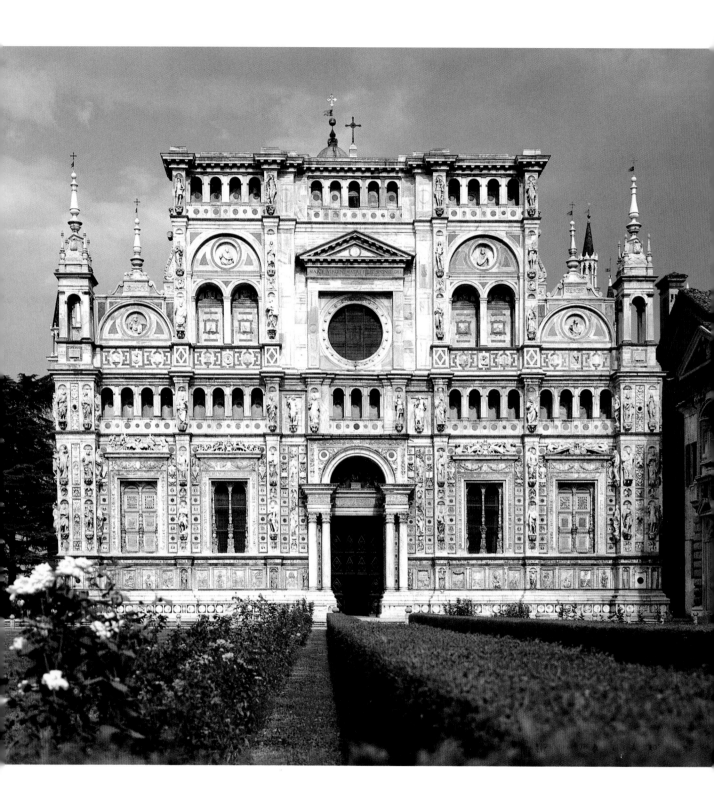

power by marrying into the royal houses of northern Europe. For example, he married his daughter, Violante (1354–86), to Lionel, duke of Clarence, son of King Edward III of England, furnishing her with a huge dowry of 200,000 gold florins, the same amount his uncle had paid for the city and territory of Bologna. Galeazzo died in 1378 and left the Visconti states divided between his brother Bernabò (1323–85) and his son, the talented and restlessly ambitious Giangaleazzo. Making his capital first at Pavia, Giangaleazzo appeared an ideal Renaissance prince. He established a great library in his palace; he initially taxed his subjects less than usual to maintain their absolute devotion; and he cultivated the Church, living a rather pious life. All of this was in preparation for the most ambitious attempt to build a great Italian territorial state before the better known Cesare Borgia's campaign at the beginning of the sixteenth century.

First it was necessary to unite all of the Visconti patrimony. Ruling the Milanese was his uncle Bernabò, a tyrant feared and hated by his subjects. In Milan, the taxation on all classes was extreme, peasants in the countryside were brutally rack-rented, and felons had to endure torture before execution, all under the pretense of the Visconti love of justice. Bernabò also hated and despised his pious, lettered nephew, Giangaleazzo. In 1385, Bernabò decided to act. He planned to kill Giangaleazzo and seize his territory to reunite the Visconti dominions. However, Bernabò's enemies leaked the plot to Pavia, so Giangaleazzo determined that it was time to realize the plan he had been meticulously and brilliantly preparing since he had come to the throne. Bernabò was invited to meet with his nephew outside Milan. Suspecting nothing of this despised, monkish young man, Bernabò not only accepted but also brought his two eldest sons as companions. All three were arrested and imprisoned, where they subsequently died, probably through poison.

Capitalizing quickly on this opportunity, Giangaleazzo extended his rule to Milan, Novara, Parma, Piacenza, Cremona, and Brescia. In 1387 he captured Verona; in 1389 Padua; and in 1399 he purchased Pisa for 200,000 florins. The next year, 1400, Giangaleazzo annexed Perugia, Assisi, and controlled the republic of Siena. In 1401 Lucca and Bologna (which had earlier reasserted its independence) fell. Only Florence stood between Milan and the domination of all of north and central Italy, a domination that doubtlessly would spread because of the weakness of the papacy during the Great Schism, a weakness on which the Milanese had played brilliantly. Were Giangaleazzo to succeed in subjugating Florence, he subsequently anticipated an assault on Naples by land and sea. In other words, the duke of Milan had the plan, the talent, and the resources to unite all of Italy—but not the opportunity. For in 1402, Giangaleazzo died of a fever, just as his armies were about to confront Florence.

Had Giangaleazzo succeeded, Italy's history would have been quite different. The duke was more than a military adventurer; he was a profound ruler whose interest in learning, government, and patronage occupied him at least as much as his own ambition. He regulated public health throughout his dominions, including requiring the isolation of all infectious diseases. He initiated an extensive program of public works, building a canal from Milan to Pavia, creating in effect an inland water route across the peninsula. Thousands of acres of previously barren soil were irrigated and made fertile. All

Figure 9.2 (facing page) Pavia, *The Certosa*. As well as starting construction on Milan's remarkable cathedral—to this day an instantly recognizable symbol of that city— Giangaleazzo Visconti began building the similarly emblematic Carthusian monastery at Pavia. Designed by architect Marco Solari and considered one of the great monuments of the Milanese Renaissance, it contains the tombs of the Visconti.

Milanese industries were fostered, particularly armaments, which were so necessary for Giangaleazzo's wars. Nor did Giangaleazzo ignore scholarship. He invited to Italy Manuel Chrysoloras, the celebrated Byzantine teacher of Greek, honoring him with the chair of Greek in Milan; and the university at Pavia was comfortably endowed. All artists and poets were welcomed at court and were treated handsomely and given prominent places in the duke's entourage.

These benefits were extended by the duke's own wise rule, which ensured equitable treatment before the law, a reliable currency, and a remarkably fair taxation system, although the exigencies of almost constant war did take their toll. Still, the tax structure in Milan was among the fairest in Italy since it was completely the result of the duke's own authority. There were no privileged groups who benefitted from the levies while others languished, as often happened in Florence, for example. The tax rate fell on all Milanese equally, including both the nobility and the clergy. In addition, Giangaleazzo established one of the first public postal systems in Europe. Eventually, well over one hundred riders daily (and nightly, so safe were the roads) journeyed from town to town carrying public and private letters deposited in post offices set up by the duke. All of this—including the wars—was made possible by the city's wealth, which, largely because of Giangaleazzo's policies, became stupendous in the early fifteenth century. While Florence was experiencing a recession, exacerbated by war and a depressed economy badly managed by the ruling oligarchs, Milan soared. Indeed, it has been estimated that the state revenues of Milan were about three times those of Florence in this period, or about twelve million florins: that is, about the same as the income of the great Venetian republic.

Therefore, we must look at the Milan of Giangaleazzo Visconti with an open mind. He is often portrayed as a venal tyrant, the viper of Milan (an epithet reflecting the serpent on the Visconti coat of arms), because our sympathies tend to lie historically with Florence, conditioned by the brilliant propaganda of Leonardo Bruni and Coluccio Salutati, who equated the republic with liberty, justice, and virtue, and the duchy of Milan with cruel despotism. Also, in the end, Florence won, inasmuch as it retained its independence and integrity; and later the Medici imposed order and renewed prosperity, with Lorenzo the Magnificent raising his city to heights not achieved even by the patronage of Giangaleazzo. Yet Italy remained fragmented, engaged in internecine warfare that before the end of the century would reduce it to humiliation at the hands of invaders from across the Alps. What if Giangaleazzo had survived and succeeded? Would his enlightened despotism have achieved the dream of Italian unity cemented by wise government? He was a despot; but in comparison with the Habsburgs who inherited the peninsula after 1529, he was a model of wise rule. Italy, except Venice, sadly fell under the tyranny of foreign domination. Perhaps historians should pay more attention to those rather neglected humanist apologists of monarchy and Milan, writers such as Pier Candido Decembrio (1399–1477) or the more famous Pietro Paolo Vergerio (c. 1498–1565) and investigate the possibilities offered by Milan under Giangaleazzo Visconti.

Giangaleazzo was succeeded by a thirteen-year-old boy, Gianmaria (1388–1412). As with most royal minorities, there was a violent struggle for the regency. The result was

the collapse of the Visconti empire. Florence took Pisa; Venice took Vicenza, Verona, and Padua; Siena, Perugia, and Bologna re-achieved their independence. The traditional mosaic of states reappeared, although increasingly dominated by a more powerful Venice to the north and a renewed Florence in central Tuscany. Also unfortunately for Milan, Gianmaria was an image of his tyrannical great-uncle Bernabò and altogether unlike his pious, cultivated father. His rule consisted of leaving the government to rapacious, cruel regents while he spent all of his time with his beloved dogs. Not even the rather cynical Milanese could tolerate seeing the city reduced to incompetent tyranny. Gianmaria was stabbed to death by his nobles in 1412, to be succeeded by his brother Filippo Maria (1392–1447).

This prince appeared to be more like his father: very intelligent, pious, and devoted to good government. Unfortunately, having had a tyrant brother who had been assassinated by his own attendants made the young man mistrustful and wary. He locked himself up in his castle, never emerging and continually eating until he became hopelessly obese. Devoted to astrologers and magicians, he still had enough of the natural intelligence and Visconti gift for cruelty to rule virtually unopposed until the end of his long, rather bizarre life. He had first married a woman of lesser birth, Beatrice Balbo Lascaris (b. c. 1372), for her dowry, but soon executed her, in 1418, for supposed infidelity. He then married Mary of Savoy (1411–69), but was so afraid of her being unfaithful that he isolated her with her women attendants. Despairing of a son and heir, despite his payments to magicians and astrologers, the duke took a mistress who in time produced for him a child—not a son, but a daughter, Bianca (1425–68).

Although decidedly curious in character, Filippo Maria was by no means an inept ruler. He enjoyed learning and patronized it wisely. The university at Pavia was further endowed, and important commissions were given to foreign artists and architects like Pisanello. Also, he was an efficient autocrat. The territories were well, if harshly, governed. Parma and Piacenza were recaptured; indeed, all Lombardy as far as Brescia again fell to Milan. Filippo Maria had a great ability for choosing good administrators and generals. And, of these condottiere captains, he had the greatest respect for one Francesco (Sforza), son of Muzio, called Sforza because of the great strength of his body. To Sforza, the duke gave his natural daughter, Bianca, along with two cities, Cremona and Pontremoli, as dowry. Consequently, when the curious old duke died in 1447 without legitimate heirs, Francesco Sforza resolved that he should attempt to seize his father-in-law's state.

The Sforza were a remarkable family. Francesco (1401–66) was the ideal of a *condottiere* and one of the most successful. In many ways, he was the perfect replacement for the Visconti. However, he had first to convince the Milanese to accept him. On Filippo Maria's death, the people had risen to return the city to its communal roots, establishing a republic named in honor of its patron St Ambrose. During the resulting chaos, a number of cities declared independence; Venice expanded at Milan's expense; and, most ominously, the French, the emperor, and the king of Aragon all claimed Milan. The Milanese therefore asked Francesco Sforza to save the city. He did so; but without consulting him, the Ambrosian republic made peace and dismissed his army. Angered as well as ambitious, Sforza turned against his former employers and laid siege to the city. Starved

Francesco I
Duke of Milan 1450
d. 1466
m. a) Polissena Ruffo, Countess of Montalto d. 1427
b) Bianca Maria Visconti d. 1468

ISOLEA or
ISOTTA (illeg.)
d. 1485/87
m. a) Andrea Matteo
Acquaviva, Duke of Atri
b) Giovanni Mauruzi

POLISSENA (illeg.)
d. 1449
m. Sigismondo
Pandolfo Malatesta,
Lord of Rimini

TRISTANO (illeg.)
d. 1477

SFORZA SECONDO (illeg.)
Count of Borgonovo
d. 1491
m. Antonia Dal Verme

DRUSIANA (illeg.)
d. 1474
m. a) Giano Fregoso
b) Iacopo Piccinino

b) Galeazzo Maria
Duke of Milan

POLIDORO
(illeg.)
d. 1475

b) IPPOLITA
MARIA
d. 1488
m. Alfonso of
Aragon, Duke of
Calabria

b) FILIPPO MARIA
Count of Corsica
d. 1492

b) SFORZA MARIA
Duke of Bari 1464
d. 1479

Ludovico Maria
il Moro
Duke of Milan

FIORDELISA
(illeg.)
d. 1522
m. Guidaccio
Manfredi

b) ASCANIO
MARIA
Bishop of Pavia,
Novara, Cremona
and Pesaro
Cardinal 1484
d. 1505

b) ELISABETTA
d. 1472
m. Guglielmo VIII
Paleologo Marquis of
Monferrato

BIANCA
FRANCESCA (illeg.)
d. 1516
Abbess of S. Monica,
Cremona

b) OTTAVIANO
Count of Lugano
d. 1477

BONA FRANCESCA
(illeg.)
d. 1498

GIULIO (illeg.)
d. 1495

GIOVANNI MARIA
(illeg.)
Archbishop of Genoa
1498
d. 1520

*
Galeazzo Maria
Count of Pavia, Duke of Milan 1466
d. 1476
m. a) Dorotea Gonzaga d. 1468
b) Bona of Savoy d. 1503

CARLO (illeg.)
d. 1483
m. Bianca Simonetta

(by Lucrezia Landriani)
|
CATERINA (illeg.)
d. 1509
m. a) Girolamo Riario,
Lord of Imola
b) Iacopo Feo
c) Giovanni de'Medici

ALESSANDRO (illeg.)
d. 1523
m. Barbara Balbiani
|
Camilla
m. Giulio Malvezzi

CHIARA (illeg.)
d. 1531
m. a) Pietro Dal Verme
b) Fregosino Fregoso

b) Gian Galeazzo Maria
Count of Pavia, Duke of Milan 1476
d. 1494
m. Isabella of Aragon, Duchess of
Bari and Princess of Rossano 1500
d. 1524

b) ERMES
Marquis of Tortona
d. 1503

IPPOLITA
d. 1501

FRANCESCO
known as il Duchetto
Abbot of Marmoutier
d. c. 1512

BONA
Duchess of Bari and Princess
of Rossano 1524 d. 1557
m. Sigismond I Jagellon,
King of Poland

b) BIANCA MARIA
d. 1510
m. Emperor
Maximilian I

b) ANNA MARIA
d. 1490
m. Alfonso I d'Este

GALEAZZO (illeg.)
Count of Melzo
d. 1515

OTTAVIANO (illeg.)
Bishop of Lodi 1497
Bishop of Arezzo 1519
d. c. 1541

*
Ludovico Maria il Moro
Duke of Bari 1479, Duke of Milan
1494–99 and 1500 d. 1508
m. Beatrice d'Este d. 1497

Massimiliano
Prince of Pavia
1499
Duke of Milan
1512–15
d. 1530

Francesco II
Duke of Milan 1521–24,
1525, 1529–35
Prince of Pavia 1530
d. 1535
m. Cristina of Denmark
d. 1590

MADDALENA
(illeg.)
m. Matteo Litta

BIANCA (illeg.)
d. 1497
m. Galeazzo
Sanseverino

LEONE (illeg.)
Abbot of S. Vittore,
near Piacenza
d. 1501

(by Lucrezia Crivelli)
|
GIAMPAOLO (illeg.)
Marquis of Caravaggio,
Count of Galliate
d. 1535
m. Violante Bentivoglio

CESARE
(illeg.)
d. 1512

into submission, Milan capitulated and Sforza entered the city, distributed bread to the desperate populace, and called together an assembly composed of the male heads of all households. This unusual council agreed to grant him the ducal title, despite the protests of the emperor whose fief the city was.

Milan was lucky in its new duke, who ran the city as he did his army. He lived simply, dispensed even justice, and protected the weak against the strong. His court was sober, and he and Bianca lived a very domestic, almost bourgeois life together in a fruitful union that produced eight children. Prosperity returned to Milan, and the duke embarked upon a renewed policy of patronage and rebuilding. He began the enormous Castello Sforzesco and the Great Hospital; he patronized education and humanism, as well as painting; he made brilliant diplomatic connections, first with Cosimo de'Medici, and then with France and Naples, in order to blunt their claims on his state. But it was in the midst of these successes that Francesco Sforza died in 1466.

The personality of his heir, Galeazzo Maria (1444–76), was a reversion to the Visconti tyranny of Bernabò and Gianmaria. Fantastically cruel, violent, and sensual—not to mention incompetent—Galeazzo Maria was ambitious to possess both the women and the property of his nobles. Finally exasperated with having the wives, daughters, and sisters of their fellow citizens demanded by this satyr of a duke, and also afraid of losing their patrimonies, three officials from aristocratic families assassinated Galeazzo Maria in church. Although two of the conspirators were immediately killed, the third, Girolamo Olgiati (1453–77), was not and consequently underwent the most horrifying torture. Still, he died a hero, uttering as his last words, *Mors acerba, fama perpetua* (my death may be bitter, but fame is everlasting).

Genealogy 9.3 (facing page)
Milan: The House of Sforza

Galeazzo left only a seven-year-old son, Giangaleazzo (1469–94), resulting in another struggle for the regency. The ultimate victor was an uncle of the young duke, Lodovico (1452–1508), called il Moro, the Moor, because of his dark complexion. This prince deserves a chapter of his own since, like the more famous Lorenzo de'Medici, he was one of the most fascinating and accomplished, if unfortunate, figures of Renaissance Italy. Like Lorenzo, Lodovico was a true connoisseur, a great patron and appreciator of art and beauty. Also like Lorenzo, he was far less cruel than his contemporaries and showed consistent generosity and forgiveness. And again like Lorenzo, he was a master diplomat. Lodovico governed Milan as regent for thirteen years, both needed and resented by the young duke and his ambitious Spanish Neapolitan wife, the duchess Isabella (1470–1524). The years of his rule were fortunate for his city. Besides good administration, he established experimental farms and expanded the silk industry so that it eventually employed twenty thousand workers and began to take markets away from Florence and Lucca. Artists, architects, and painters of all kinds entered the city to beautify its churches and palaces. Streets were widened and the great cathedral continuously embellished. Also, the city grew dramatically, so that at the end of Lodovico's regency it contained about twice the population of Florence. Hospitals and universities were expanded, and experiments in agriculture provided a plentiful source of wholesome food.

In 1491, Lodovico brought his bride to Milan, the beautiful Beatrice d'Este (1475–97), sister of the incomparable Isabella (the marchioness of Mantua) and daughter of the duke of Ferrara. The 14-year-old princess was lovely, light-hearted, and talented as well as remarkably intelligent. She compensated greatly for Lodovico's gravity and functioned successfully, as did her sister Isabella for her husband, as an ambassadress. Led by Lodovico and Beatrice, the court of Milan became the center of Italy for several years, celebrated in all things, including luxury and taste. This elegant Renaissance court was presided over to some extent by Leonardo da Vinci (1452–1519), who lived with the Sforza as a treasured friend from 1483 until 1498, entrusted with the official commissions of the state, such as the huge, never realized equestrian statue of Lodovico's father, Francesco, and the decoration of the Castello, all in addition to his work creating extravagant and inspired court entertainments for the duke and his attendants.

Behind this façade of brilliance, the French invasions were about to destroy the independence of Italy; and Milan played a central part in the tragedy. In 1493 Beatrice and Lodovico had a son. Realizing that his family would be in great danger should his nephew, the legitimate duke, produce an heir, or if his nephew's jealous wife, the duchess, should ask her father, the king of Naples, to restore her husband to his rightful place as the real head of the state, Lodovico secretly petitioned the emperor Maximilian to grant him permanently the office of duke. In return he offered the emperor his niece in marriage, together with an enormous dowry of 400,000 Venetian ducats. In the following year, 1494, the deluge came. Charles VIII of France invaded Italy, and Lodovico at first welcomed him ostentatiously and provided him with money, hoping that the French might destroy the threat that Naples offered to his continued rule. Also, Lodovico's nephew, the true duke, died just at this time. All Italy thought that he had been murdered; but it might well have been merely a fortuitous coincidence. Regardless, Lodovico was now duke of Milan both *de facto* and *de jure*. At this point it appeared that Lodovico had steered a clever course between the French and the Neapolitans and was secure on his throne.

However, the reality of the situation soon became apparent. Recognizing the danger in maintaining his friendship with the French, once the extent of their ambitions was clear, Lodovico reversed his position and joined the anti-French alliance, meeting the king's retreating army at Fornovo where he defeated them inconclusively. Again Lodovico had apparently succeeded. But malicious fortune intervened, overturning the brilliant world that the duke had created in Milan. His popular wife, Beatrice, already melancholy over Lodovico's continual infidelities, died at the age of twenty-two while delivering a stillborn child. The city and the court were shattered and entered deep mourning. The duke's mistresses fled from fear and shame, and Lodovico fell into despondency, spending his days alone in solitary prayer, just at the time when the international situation required dynamic action. Charles VIII died without heirs in 1498 and was succeeded by his cousin, the duke of Orleans, as Louis XII. Seeing the painless victory of his cousin's *promenade militaire* through the Italian peninsula, Louis decided in 1499 to rehearse Charles's success by asserting his claim on the duchy of Milan, which was his through his grandmother who had been a daughter of Giangaleazzo Visconti. The French again marched into Italy, again

Figure 9.3 (facing page)
Milan, Brera. Anonymous (Master of the Pala Sforzesca): *The Sforza Altarpiece.* This altarpiece portrays Lodovico il Moro, his wife Beatrice d'Este, and his children as donors kneeling before the Virgin. Painted by an anonymous artist about the time of the French invasions, it captures the dignity, gravity, and authority of Lodovico and the charm of his young wife. The boy close to Lodovico is his illegitimate son, Cesare, by Cecilia Gallerani; the baby, Massimiliano, his legitimate heir by Beatrice, is represented still in swaddling clothes.

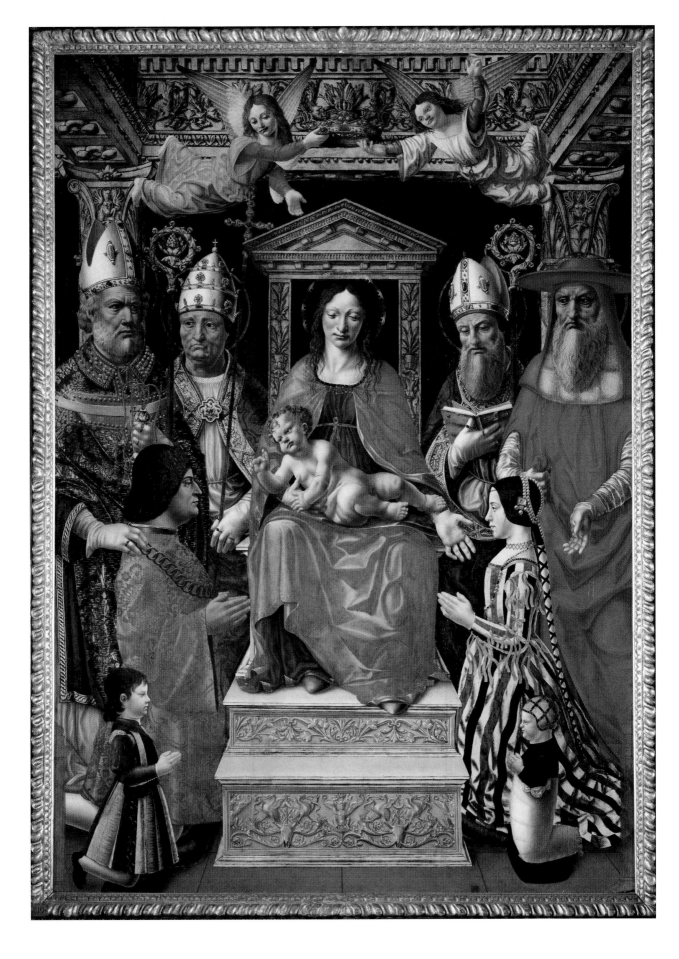

virtually unopposed, and in 1500 the almost impregnable Castello Sforzesco was handed over to them without a fight through the treachery of its captain. Lodovico had escaped in disguise to his nephew, the emperor, in an attempt to arrange his return. This plan temporarily succeeded, and Lodovico re-entered the city of Milan for a short time, but he was unable to hold it against the strong garrison stationed in the fortress he had so lovingly decorated and embellished. Again he was betrayed, this time by his Swiss mercenaries and his own brother-in-law, Gianfrancesco Gonzaga, marquis of Mantua. Handed over to the French, Lodovico asked only that he be allowed, of all of his treasures, to take with him his copy of Dante. After April 1500, Lodovico il Moro ceased to reign as duke of Milan. Brought to France as a prisoner, he died there in a subterranean dungeon on 17 May 1508. Thereafter, until the nineteenth century, the history of Milan is one of foreign domination.

MANTUA

The marquisate, later duchy, of Mantua was one of the shining capitals of the Italian Renaissance. Illustrating the complex relationship among the families of the *signori*, it enjoyed a dynastic connection with Ferrara through the marriage of Isabella d'Este of Ferrara to the marquis Francesco Gonzaga, while her sister Beatrice, as we have seen, was wed to Duke Lodovico il Moro of Milan. The Gonzaga were also among the most fortunate in terms of dynastic stability during our period, making a sharp contrast with the crises caused by rival claimants to the throne, dynastic extinction, or foreign intervention that we have seen in Naples and Milan and that will again emerge in Ferrara. From the time that Luigi Gonzaga seized the lordship of the city in 1328 until the extinction of the main branch of the dynasty in 1708, the history of Mantua is inextricably intertwined with the family of its rulers, men who used the patronage of art and the practice of arms to maintain the independence of their small Lombard principality and win a reputation for elegance and grandeur that remains until today.

Mantua was an ancient foundation. The city developed on a secure site, indeed almost an island, where the river Mincio meets two lakes, providing protection from invaders. Conquered in the third century BC by the Romans, it became an important provincial town and, notably, was the birthplace of the poet Virgil. The period of the barbarian invasions saw the town fall to several invading tribes until it became part of the enormous inheritance of Countess Mathilda of Tuscany (1046–1115) in the eleventh century. After her death there was a struggle between the communal government, which had declared itself a free commune, and the Holy Roman Emperor. The division between Guelfs and Ghibellines complicated this already difficult situation until a noble family, the Bonacolsi, assumed power in 1273, ruling the city until 1328, under the protection of the Empire. In that year, the nobleman and podestà, Luigi Gonzaga (1267–1360), with the help of an army sent by Cangrande della Scala, lord of Verona (1291–1329), overthrew the Bonacolsi in a bloody coup and established his family, first as captains of the people, then as *signori* of Mantua.

Figure 9.4 (facing page)
Mantua, Ducal Palace, *Camera degli Sposi* (*Camera Picta*). Andrea Mantegna (c. 1431–1506): *Family of Lodovico Gonzaga* (1474). Mantegna painted this family portrait of Lodovico Gonzaga, his wife, Barbara of Brandenburg, their children, and courtiers as recognition of their reputation and his debt to them as court artist. It captures a particular moment—the arrival of a letter—which begins a narrative continued throughout the frescoes decorating this very small room. The Gonzaga love of animals is also celebrated in the fresco; and the court dwarf is portrayed as a member of the household as dwarves were employed as children's companions.

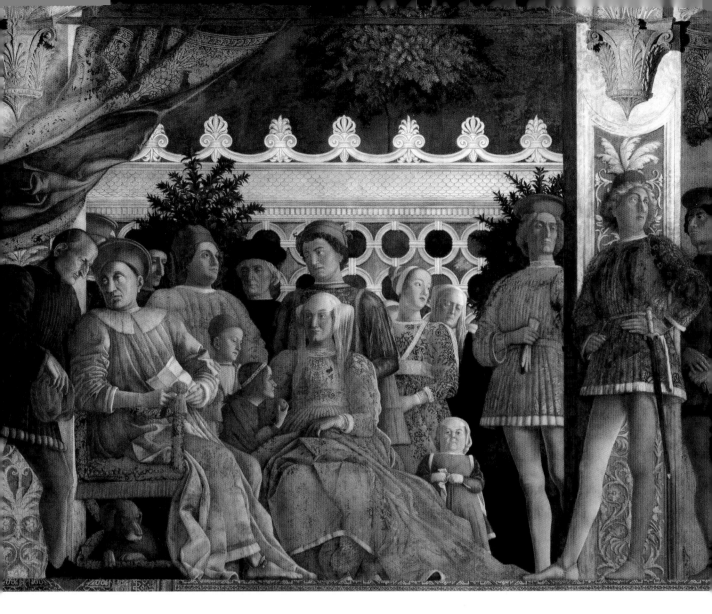

Its natural protection and its strategic location between Venice and Milan, as well as its imperial allegiance, permitted the Gonzaga to construct a brilliant court. Although the city itself is surrounded by marsh, the territory is extremely fertile, and its control of river traffic in the region provided rich returns through tolls. Consequently, Mantua became an elegant Renaissance city, celebrated for the polish of its court and its art. In 1433 Gianfrancesco Gonzaga had purchased from the emperor the title of marquis and married his son and heir, Lodovico (1412–78), to the emperor's daughter, Barbara of Brandenburg (1423–81): this is the family famously portrayed by Andrea Mantegna (c. 1431–1506) in the *Camera degli sposi* in the ducal palace. Mantegna was a native son of Mantua and became court painter to the Gonzaga princes. Also, Leon Battista Alberti was invited to the city, where he designed the great church of Sant'Andrea to contain the sacred relic of the holy

blood, believed to be the blood of Christ collected by St Longinus. Other celebrated artists, such as Pisanello, also worked in Mantua, making the Gonzaga famous throughout Italy for their patronage. The memory that Mantua was Virgil's birthplace was important as well, stimulating a literary tradition. The great Renaissance writer Baldassare Castiglione (1478–1529), author of *The Book of the Courtier*, was born in Mantua and grew up in a family closely connected by blood and service to the Gonzaga court. Finally, there was a military tradition among the Gonzaga. Although rich from trade and agriculture, they saw the profession of arms as most appropriate for princes, resulting in their becoming sought after and successful *condottieri* and generals.

The Renaissance also came to Mantua in the form of the incomparable Isabella d'Este who married the marquis Francesco Gonzaga (1466–1519) in 1490. Isabella had been born in Ferrara in 1474, daughter of Duke Ercole I and Eleonora of Naples. The girl was educated at her father's court by the brilliant scholars, poets, dramatists, musicians, and artists whom the cultivated Ercole brought to Ferrara. In addition, she was a child prodigy who, even when the usual Renaissance hyperbole is taken into account, certainly would have held her own with one of Thomas More's daughters. At six she was engaged to the fourteen-year-old heir to the marquisate of Mantua, Francesco Gonzaga, simply because Ferrara needed Mantuan assistance against Venice. However, the marriage was not celebrated for ten years.

Her husband was a rather typical Renaissance Italian prince. He maintained Mantegna and other artistic and humanistic luminaries at his court; but he really preferred to spend his time hunting, fighting, and seducing court women. Of course, he did all three with the usual Renaissance abandon. He fought the French with more courage than intelligence, hunted continually, and took his first official, and acknowledged, mistress during Isabella's first pregnancy: the medical wisdom at the time and Francesco's natural inclination toward concubinage were apparently to blame. His early death from syphilis in 1519 made Isabella a dowager and the regent for her young son

Despite whatever grief her husband's constant infidelity—including with her own sister-in-law, Lucrezia Borgia—might have caused her, it helped make her reputation, because she sought solace in the arts, letters, and in the humanists and artists who practiced them. She spoke Latin better than any other woman of her generation; she commissioned translations from the Greek; and even commissioned a famous rabbi to translate the Psalms from Hebrew so as to have a better text of them, one of the earliest instances of the growing interest in Hebraic studies. She amassed a magnificent library, arranging special purchases with the great Venetian printer Aldus Manutius for his superb editions of Latin classics. Equally, she collected works of art and artists, both of which became passions: Isabella collected statues, paintings, maiolica, classical marbles, and gold and silver objets d'art. Michelangelo, Mantegna, Perugino, and Bellini, among others, all were represented in her apartments. Leonardo da Vinci actually sketched her, a famous drawing now in the Louvre.

In 1524, Isabella convinced Raphael's greatest pupil, Giulio Romano (c. 1499–1546), to settle at her court, and he worked in Mantua thereafter, redecorating the enormous palace, although his greatest contribution to the city, the Palazzo Tè, he built not for

Isabella but as a pleasure palace for her son, Federigo II (1500–40), who was somewhat estranged from his strong-willed mother. Its single-storey structure was designed for entertainments and as an escape from the strictures of court life. Indeed, Federigo banned his mother from entering, especially after he acquiesced to her demands that he enter a strategic marriage with a neighboring princess whose dowry would be her small principality of Monferrato. Federigo's real love was his mistress Isabella Boschetti, and it was in Palazzo Tè that they celebrated their amours. Giulio Romano frescoed the halls with the story of Amor and Psyche, with portraits of the duke's favorite horses, and with images of the labors of Hercules. The celebrated Room of the Giants in the little palace is one of the great mannerist programs in Italy.

In addition to her brilliant patronage of the arts, Isabella was a skilled diplomat and ruler when necessary. She saved Mantua from her ravenous brother-in-law, Cesare Borgia, from Louis XII and Francis I of France, and even from the emperor Charles V. This diplomacy was of a personal kind. Her reputation was weakened by her flattering of and dancing

Figure 9.5 Mantua, Palazzo Tè. Giulio Romano (c. 1499–1546): *Amor and Psyche*. The story of Amor and Psyche that decorates the ceiling of the great hall in Palazzo Tè became one of the most popular Renaissance tales. It was found in an ancient text, *The Golden Ass,* written by a second-century author, Lucius Apuleius. The manuscript was recovered in its entirety by Boccaccio in 1355 in the library of the monastery of Monte Cassino.

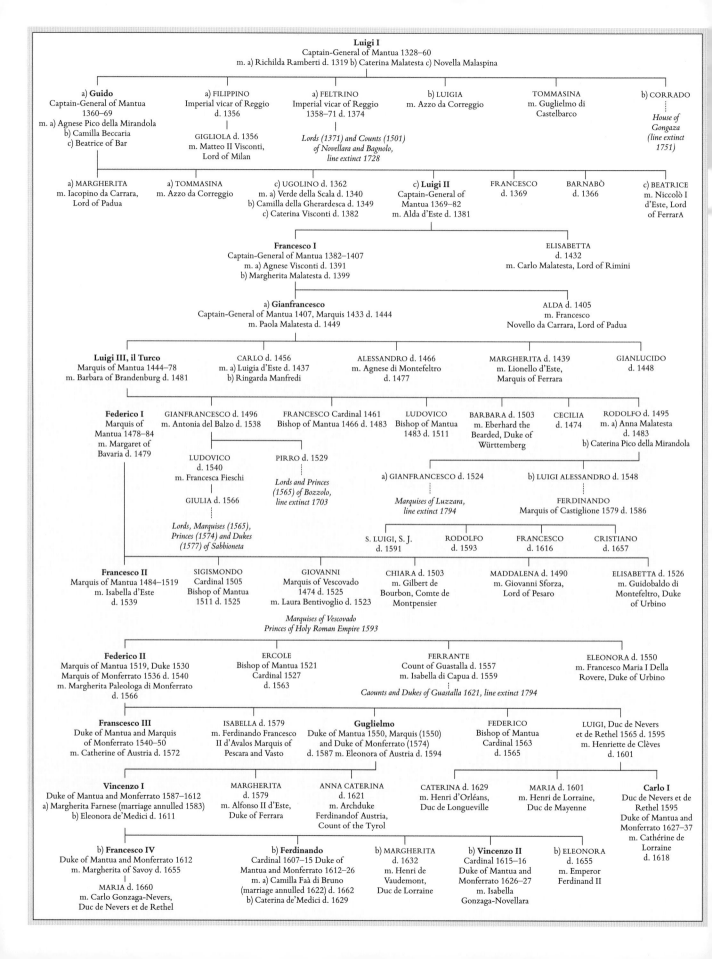

Luigi I
Captain-General of Mantua 1328–60
m. a) Richilda Ramberti d. 1319 b) Caterina Malatesta c) Novella Malaspina

a) **Guido**
Captain-General of Mantua
1360–69
m. a) Agnese Pico della Mirandola
b) Camilla Beccaria
c) Beatrice of Bar

a) FILIPPINO
Imperial vicar of Reggio
d. 1356

a) FELTRINO
Imperial vicar of Reggio
1358–71 d. 1374

b) LUIGIA
m. Azzo da Correggio

TOMMASINA
m. Guglielmo di
Castelbarco

b) CORRADO

*House of
Gongaza
(line extinct
1751)*

GIGLIOLA d. 1356
m. Matteo II Visconti,
Lord of Milan

*Lords (1371) and Counts (1501)
of Novellara and Bagnolo,
line extinct 1728*

a) MARGHERITA
m. Iacopino da Carrara,
Lord of Padua

a) TOMMASINA
m. Azzo da Correggio

c) UGOLINO d. 1362
m. a) Verde della Scala d. 1340
b) Camilla della Gherardesca d. 1349
c) Caterina Visconti d. 1382

c) **Luigi II**
Captain-General of
Mantua 1369–82
m. Alda d'Este d. 1381

FRANCESCO
d. 1369

BARNABÒ
d. 1366

c) BEATRICE
m. Niccolò I
d'Este, Lord
of FerrarA

Francesco I
Captain-General of Mantua 1382–1407
m. a) Agnese Visconti d. 1391
b) Margherita Malatesta d. 1399

ELISABETTA
d. 1432
m. Carlo Malatesta, Lord of Rimini

a) **Gianfrancesco**
Captain-General of Mantua 1407, Marquis 1433 d. 1444
m. Paola Malatesta d. 1449

ALDA d. 1405
m. Francesco
Novello da Carrara, Lord of Padua

Luigi III, il Turco
Marquis of Mantua 1444–78
m. Barbara of Brandenburg d. 1481

CARLO d. 1456
m. a) Luigia d'Este d. 1437
b) Ringarda Manfredi

ALESSANDRO d. 1466
m. Agnese di Montefeltro
d. 1477

MARGHERITA d. 1439
m. Lionello d'Este,
Marquis of Ferrara

GIANLUCIDO
d. 1448

Federico I
Marquis of
Mantua 1478–84
m. Margaret of
Bavaria d. 1479

GIANFRANCESCO d. 1496
m. Antonia del Balzo d. 1538

FRANCESCO Cardinal 1461
Bishop of Mantua 1466 d. 1483

LUDOVICO
Bishop of Mantua
1483 d. 1511

BARBARA d. 1503
m. Eberhard the
Bearded, Duke of
Württemberg

CECILIA
d. 1474

RODOLFO d. 1495
m. a) Anna Malatesta
d. 1483
b) Caterina Pico della Mirandola

LUDOVICO
d. 1540
m. Francesca Fieschi

PIRRO d. 1529

*Lords and Princes
(1565) of Bozzolo,
line extinct 1703*

a) GIANFRANCESCO d. 1524

b) LUIGI ALESSANDRO d. 1548

GIULIA d. 1566

*Marquises of Luzzara,
line extinct 1794*

FERDINANDO
Marquis of Castiglione 1579 d. 1586

*Lords, Marquises (1565),
Princes (1574) and Dukes
(1577) of Sabbioneta*

S. LUIGI, S. J.
d. 1591

RODOLFO
d. 1593

FRANCESCO
d. 1616

CRISTIANO
d. 1657

Francesco II
Marquis of Mantua 1484–1519
m. Isabella d'Este
d. 1539

SIGISMONDO
Cardinal 1505
Bishop of Mantua
1511 d. 1525

GIOVANNI
Marquis of Vescovado
1474 d. 1525
m. Laura Bentivoglio d. 1523

CHIARA d. 1503
m. Gilbert de
Bourbon, Comte de
Montpensier

MADDALENA d. 1490
m. Giovanni Sforza,
Lord of Pesaro

ELISABETTA d. 1526
m. Guidobaldo di
Montefeltro, Duke
of Urbino

*Marquises of Vescovado
Princes of Holy Roman Empire 1593*

Federico II
Marquis of Mantua 1519, Duke 1530
Marquis of Monferrato 1536 d. 1540
m. Margherita Paleologa di Monferrato
d. 1566

ERCOLE
Bishop of Mantua 1521
Cardinal 1527
d. 1563

FERRANTE
Count of Guastalla d. 1557
m. Isabella di Capua d. 1559

ELEONORA d. 1550
m. Francesco Maria I Della
Rovere, Duke of Urbino

Caounts and Dukes of Guastalla 1621, line extinct 1794

Franscesco III
Duke of Mantua and Marquis
of Monferrato 1540–50
m. Catherine of Austria d. 1572

ISABELLA d. 1579
m. Ferdinando Francesco
II d'Avalos Marquis of
Pescara and Vasto

Guglielmo
Duke of Mantua 1550, Marquis (1550)
and Duke of Monferrato (1574)
d. 1587 m. Eleonora of Austria d. 1594

FEDERICO
Bishop of Mantua
Cardinal 1563
d. 1565

LUIGI, Duc de Nevers
et de Rethel 1565 d. 1595
m. Henriette de Clèves
d. 1601

Vincenzo I
Duke of Mantua and Monferrato 1587–1612
a) Margherita Farnese (marriage annulled 1583)
b) Eleonora de'Medici d. 1611

MARGHERITA
d. 1579
m. Alfonso II d'Este,
Duke of Ferrara

ANNA CATERINA
d. 1621
m. Archduke
Ferdinandof Austria,
Count of the Tyrol

CATERINA d. 1629
m. Henri d'Orléans,
Duc de Longueville

MARIA d. 1601
m. Henri de Lorraine,
Duc de Mayenne

Carlo I
Duc de Nevers et de
Rethel 1595
Duke of Mantua and
Monferrato 1627–37
m. Cathérine de
Lorraine
d. 1618

b) **Francesco IV**
Duke of Mantua and Monferrato 1612
m. Margherita of Savoy d. 1655

b) **Ferdinando**
Cardinal 1607–15 Duke of
Mantua and Monferrato 1612–26
m. a) Camilla Faà di Bruno
(marriage annulled 1622) d. 1662
b) Caterina de'Medici d. 1629

b) MARGHERITA
d. 1632
m. Henri de
Vaudemont,
Duc de Lorraine

b) **Vincenzo II**
Cardinal 1615–16
Duke of Mantua and
Monferrato 1626–27
m. Isabella
Gonzaga-Novellara

b) ELEONORA
d. 1655
m. Emperor
Ferdinand II

MARIA d. 1660
m. Carlo Gonzaga-Nevers,
Duc de Nevers et de Rethel

with French kings, but it worked. She obviously had the kind of personality and sinuous intelligence to convince men of the soundness of her advice. The poet Lodovico Ariosto, never at a loss for words, could not decide how best to praise her; and Pietro Bembo, that arbiter of taste in the later Renaissance, wrote that men "desire to serve her and pleasure her as if she were the pope." Bembo, as an embryonic cardinal, knew what that meant, and even the pope himself appeared to agree. Although Clement VII usually refused to make up his mind about anything, he seemed to have decided that Isabella was a person worth cultivating. She rode to Rome in 1525 and set up almost a rival court at the Colonna palace, which became the most sought-after salon in the city. She was trapped there during the horrors of the sack in 1527, protecting hundreds of Romans who sought refuge with her in a building that even the murderous thugs looting the city were unwilling to plunder.

Isabella then returned to Mantua not only intact but in triumph, carrying a cardinal's red hat for her younger son, Ercole (1505–63). In 1529 at the great council of Bologna, where Charles V asserted his control over the Italian peninsula, Isabella's remarkable personality somehow saved the states owned by her relations in Ferrara and Urbino, as well as her own state of Mantua. In addition, she convinced the emperor to raise her son Federigo's dignity from that of a marquis to duke of Mantua. Unfortunately, her estrangement from Federigo drove her to spend her last years away from his court, ruling a small dependency on her own where she actively encouraged the education of women. Her death in 1539 deprived Italy of one of its most remarkable and successful personalities.

Genealogy 9.4 (facing page)
Mantua: The House of Gonzaga

The later Gonzaga continued to use patronage on a vast scale to augment their reputation as *condottieri* princes. Federigo's son, Francesco III, died in 1550 without issue and was succeeded by his brother Guglielmo (b. 1538) who reigned until 1587. This duke married Eleonora of Habsburg (1534–94), the daughter of the Holy Roman Emperor, a union that brought him into the imperial orbit in Italy and helped protect his state from the ambitions of the papacy. But it was duke Vincenzo (d. 1612) who returned the Gonzaga to the first rank of European patrons, despite the increasing evidence that he was bankrupting the duchy in so doing. His family was painted by Peter Paul Rubens (1577–1640). And the music at his court was famous everywhere: it was in Mantua that Claudio Monteverdi's *Orfeo*, the first surviving opera, was premiered in 1607. The poet Torquato Tasso (1544–95) was the duke's friend, and in 1604 Galileo spent time under the patronage of this intellectually ambitious and generous duke.

Subsequently, the history of Mantua is tragic, as the main line of the Gonzaga became extinct in 1627, resulting in the War of the Mantuan Succession in 1630, a conflagration that really was part of the Europe-wide Thirty Years' War. The city was sacked, the great art collections were sold, and disease decimated the population. Although the French candidate for the throne was eventually recognized, the glorious reputation of Mantua as a Renaissance principality was over, a sad fate reinforced after 1708 when it was incorporated into the Italian dominions of the Habsburgs.

FERRARA

The duchy of Ferrara, the home of Isabella and Beatrice d'Este, was, like Mantua, a monarchy whose history and culture were determined by its princes, complicated by dynastic struggle and strategy, and subject to the ambitions and threats of larger states. Ferrara prospered from its location near the River Po, as it commanded strategic communication routes through Italy and into northern Europe. Its position in Italian affairs and the influence of its ruling house of Este benefitted from and were challenged by these complex circumstances, making the story of Ferrara in the Renaissance an engaging but convoluted narrative.

The Este were originally a Germanic family descended from the House of Welf, the dynasty opposed to the Swabian Hohenstaufens and hence, from the beginning, a Guelf power. The city passed to one Azzo d'Este (d.1212) in 1146 as part of his wife's dowry, but the family did not fully gain control until Obizzo d'Este (d. 1293) captured Ferrara with the support of Venice in 1264, a victory that the wily Obizzo ensured was formally ratified by the population, giving him the clear authority to rule. By 1289 Modena and Reggio were added to the territory of the Este, making Obizzo among the most powerful *signori* in the region of Emilia-Romagna.

It was the period of the Renaissance that gave Ferrara and its Este rulers the reputation that they enjoy to this day, presiding over an extraordinary period of Ferrarese efflorescence in patronage and culture, using art, architecture, and literature to celebrate and extend their luster throughout northern Italy and beyond. The long reign of Niccolò III d'Este (r. 1393–1441) began a period of heightened Ferrarese influence, including hosting the celebrated council (later moved to Florence) that was to heal the schism between the Orthodox and Latin Churches. However, his reign also corresponded with the ambitions of Giangaleazzo Visconti, duke of Milan, and his plan to build a great dynastic state on the peninsula. Consequently, Niccolò was required to follow a career at arms, commanding part of the league formed against Giangaleazzo, to the extent of having to defeat his own relation, another Azzo d'Este (1344–1415), a *condottiere* fighting for the Milanese against his native Ferrara. Although Niccolò was successful in sustaining the independence and integrity of his inheritance, his death introduced a recurrent danger in the history of the Este: the threat of dynastic extinction and division. Niccolò had no legitimate heirs, but a number of illegitimate children. Thus his successor was his illegitimate son, Lionello, in 1441, the succession being approved by the pope, as the rulers of Ferrara were recognized as papal vicars.

Ferrara was fortunate indeed in the new *signore,* despite his illegitimate status. In his short life, Lionello (1407–50) exemplified the ideal of a Renaissance prince: a skilled general, trained in arms and strategy by leading *condottieri,* while simultaneously enjoying a splendid humanist education. As marquis of Ferrara he patronized Leon Battista Alberti, whose *De re aedificatoria (On Building,* his treatise on architecture) was composed for Lionello. The marquis also patronized, among others, the painter Pisanello (c. 1395–1455), and he began construction of the great hospital of Ferrara and richly endowed and expanded the university, which grew in status and reputation.

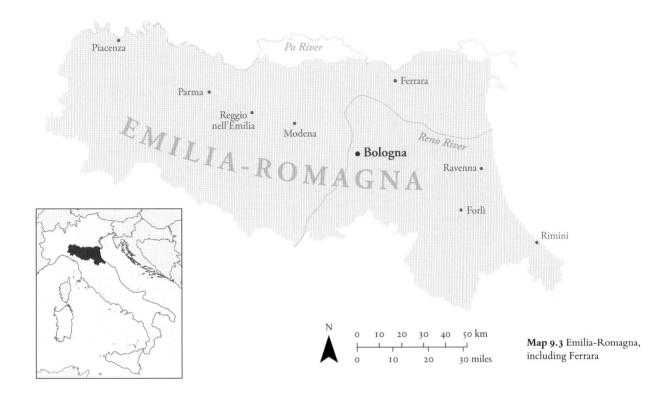

Map 9.3 Emilia-Romagna, including Ferrara

Lionello's early death complicated the succession, which was made uncertain by provisions in Niccolò's will that saw Lionello's equally illegitimate half-brothers pitted against his son in their claims to the throne. The ultimate victor in this great dynastic competition was Borso d'Este (d. 1471), a younger of Niccolò's natural sons, who found himself playing the old Guelf-Ghibelline game of double allegiance by applying to the Holy Roman Emperor Frederick III for title to the duchies of Modena and Reggio in 1452, that is, those territories seized at the end of the thirteenth century by Obizzo d'Este. In fact, it was not until 1471 that Pope Paul II Barbo granted Borso the title of duke of Ferrara. This disjunction in the granting of the ducal titles reflected the skill of the Este in negotiating through the complex politics of Renaissance Italy.

The Este duchies, particularly Ferrara, were fortunate indeed in their new duke. He patronized local painters, reinforcing the reputation of the Ferrarese school, represented by artists such as Cosmè Tura (c. 1430–95), Ercole Roberti (c. 1451–96), and Francesco del Cossa (c. 1430–c. 1477). The splendid fresco cycles in his pleasure palace of La Schifanoia in Ferrara were celebrated for their astrological significance and the subtle insights into the rule of Borso, who appears often in these images as the center of both time and his immediate universe. Like so many of his family, he appreciated learning and beautiful books, accumulating an important library and commissioning a wonderful bible.

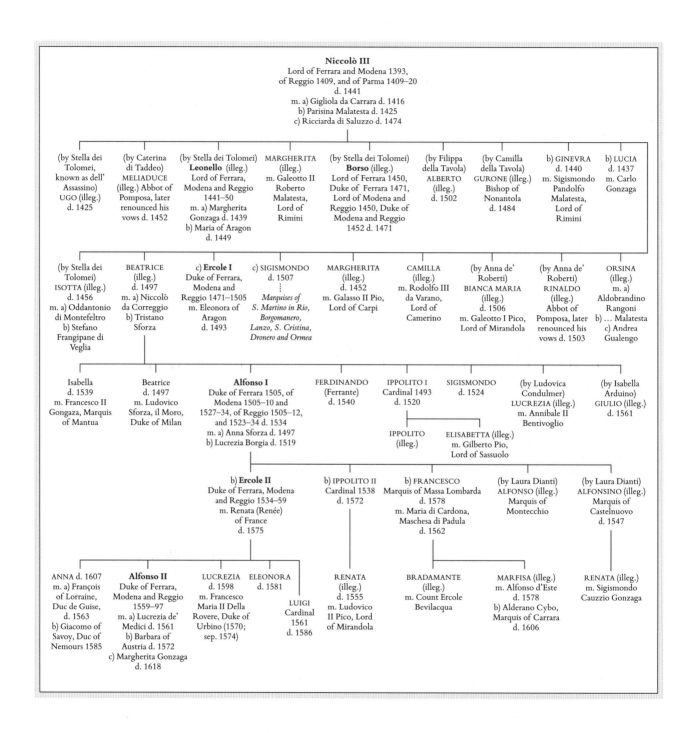

Niccolò III
Lord of Ferrara and Modena 1393,
of Reggio 1409, and of Parma 1409–20
d. 1441
m. a) Gigliola da Carrara d. 1416
b) Parisina Malatesta d. 1425
c) Ricciarda di Saluzzo d. 1474

(by Stella dei Tolomei, known as dell' Assassino) UGO (illeg.) d. 1425

(by Caterina di Taddeo) MELIADUCE (illeg.) Abbot of Pomposa, later renounced his vows d. 1452

(by Stella dei Tolomei) **Leonello** (illeg.) Lord of Ferrara, Modena and Reggio 1441–50 m. a) Margherita Gonzaga d. 1439 b) Maria of Aragon d. 1449

MARGHERITA (illeg.) m. Galeotto II Roberto Malatesta, Lord of Rimini

(by Stella dei Tolomei) **Borso** (illeg.) Lord of Ferrara 1450, Duke of Ferrara 1471, Lord of Modena and Reggio 1450, Duke of Modena and Reggio 1452 d. 1471

(by Filippa della Tavola) ALBERTO (illeg.) d. 1502

(by Camilla della Tavola) GURONE (illeg.) Bishop of Nonantola d. 1484

b) GINEVRA d. 1440 m. Sigismondo Pandolfo Malatesta, Lord of Rimini

b) LUCIA d. 1437 m. Carlo Gonzaga

(by Stella dei Tolomei) ISOTTA (illeg.) d. 1456 m. a) Oddantonio di Montefeltro b) Stefano Frangipane di Veglia

BEATRICE (illeg.) d. 1497 m. a) Niccolò da Correggio b) Tristano Sforza

c) **Ercole I** Duke of Ferrara, Modena and Reggio 1471–1505 m. Eleonora of Aragon d. 1493

c) SIGISMONDO d. 1507 *Marquises of S. Martino in Rio, Borgomanero, Lanzo, S. Cristina, Dronero and Ormea*

MARGHERITA (illeg.) d. 1452 m. Galasso II Pio, Lord of Carpi

CAMILLA (illeg.) m. Rodolfo III da Varano, Lord of Camerino

(by Anna de' Roberti) BIANCA MARIA (illeg.) d. 1506 m. Galeotto I Pico, Lord of Mirandola

(by Anna de' Roberti) RINALDO (illeg.) Abbot of Pomposa, later renounced his vows d. 1503

ORSINA (illeg.) m. a) Aldobrandino Rangoni b) ... Malatesta c) Andrea Gualengo

Isabella d. 1539 m. Francesco II Gonzaga, Marquis of Mantua

Beatrice d. 1497 m. Ludovico Sforza, il Moro, Duke of Milan

Alfonso I Duke of Ferrara 1505, of Modena 1505–10 and 1527–34, of Reggio 1505–12, and 1523–34 d. 1534 m. a) Anna Sforza d. 1497 b) Lucrezia Borgia d. 1519

FERDINANDO (Ferrante) d. 1540

IPPOLITO I Cardinal 1493 d. 1520

SIGISMONDO d. 1524

(by Ludovica Condulmer) LUCREZIA (illeg.) m. Annibale II Bentivoglio

(by Isabella Arduino) GIULIO (illeg.) d. 1561

IPPOLITO (illeg.)

ELISABETTA (illeg.) m. Gilberto Pio, Lord of Sassuolo

b) **Ercole II** Duke of Ferrara, Modena and Reggio 1534–59 m. Renata (Renée) of France d. 1575

b) IPPOLITO II Cardinal 1538 d. 1572

b) FRANCESCO Marquis of Massa Lombarda d. 1578 m. Maria di Cardona, Maschesa di Padula d. 1562

(by Laura Dianti) ALFONSO (illeg.) Marquis of Montecchio

(by Laura Dianti) ALFONSINO (illeg.) Marquis of Castelnuovo d. 1547

ANNA d. 1607 m. a) François of Lorraine, Duc de Guise, d. 1563 b) Giacomo of Savoy, Duc de Nemours 1585

Alfonso II Duke of Ferrara, Modena and Reggio 1559–97 m. a) Lucrezia de' Medici d. 1561 b) Barbara of Austria d. 1572 c) Margherita Gonzaga d. 1618

LUCREZIA d. 1598 m. Francesco Maria II Della Rovere, Duke of Urbino (1570; sep. 1574)

ELEONORA d. 1581

LUIGI Cardinal 1561 d. 1586

RENATA (illeg.) d. 1555 m. Ludovico II Pico, Lord of Mirandola

BRADAMANTE (illeg.) m. Count Ercole Bevilacqua

MARFISA (illeg.) m. Alfonso d'Este d. 1578 b) Alderano Cybo, Marquis of Carrara d. 1606

RENATA (illeg.) m. Sigismondo Cauzzio Gonzaga

Borso's death in 1471 followed the pattern set by his immediate predecessors, as he died with no legitimate male heirs. Again, though, the house of Este produced another brilliant prince from the illegitimate sons of Niccolò III: Borso's half-brother, Ercole I (1471–1505), one of Ferrara's greatest rulers. The new duke had been educated in Naples at the brilliant court of Alfonso the Magnanimous, where he had acquired both a cultivated humanist mind and sound military training. Also, he cemented his connection to Naples by marrying Alfonso's daughter, Eleonora of Aragon (1450–93).

It is as a patron of art, literature, and music and as a great builder that Ercole I is best remembered. His love of music attracted the most famous composers and musicians of Europe to his court, such as Josquin des Prez (d. 1521, who wrote the *Mass for Duke Hercules of Ferrara* in his honor), turning Ferrara into the leading center for music on the continent. He was a generous patron to poets such as Matteo Maria Boiardo (d. 1494) and the young Torquato Tasso. With Ercole, the Ferrarese tradition of epic poetry was firmly established; Boiardo's *Orlando Innamorato* (*Roland in Love*) and Tasso's *Gerusalemme Liberata* (*Jerusalem Delivered*) have put Ferrara forever in the galaxy of Renaissance courts. Finally, Ercole was a great builder, ordering the expansion of the city and filling it with splendid Renaissance palaces and buildings. To protect his beloved Ferrara, he extended the city walls to encompass the thriving capital, which had grown considerably under his long reign.

Although famous and honored as a discerning patron of culture, he was not respected as a general. This was a difficult period for Ferrara as it was forced to defend its integrity against the expansionist policies of both Venice and the papacy. The pope, Sixtus IV, attempted to annex Ferrara, as it was technically a fief of the Church and the duke illegitimate. Venice joined with the papacy to challenge the Este lands, and Ercole was defeated in a war against his two adversaries in 1482–84. Nevertheless, the Este good fortune held once more, and the dynastic territories of the family remained intact to pass, after Ercole's death in 1505, to his son, the equally cultivated Alfonso d'Este (1505–34), who maintained his father's legacy while confronting equally dangerous military and political threats in an unstable and particularly perilous time.

Duke Alfonso attached Ferrara to the League of Cambrai against Venice, the traditional enemy of Ferrara. But his father's other enemy, the papacy, became hostile once more when Alfonso married the daughter of Pope Alexander VI, Lucrezia Borgia. The new warrior pope Julius II hated the Borgia and wanted revenge on them for what he had suffered under Alexander VI. Thus, after Pope Julius II changed his policy of aggression against Venice and created the Holy League, Alfonso remained hostile to the papacy and allied to Louis XII of France, capturing Bologna from the papacy and fighting with the French at Ravenna (1512). The pope consequently excommunicated Alfonso and declared him deposed, citing as grounds that Ferrara was a papal fief and Alfonso a rebellious vassal. But, fortunately for Ferrara, there was little the pope could do to execute his deposition, and Ferrara under Alfonso remained an implacable enemy of the Holy See. Alfonso fought for the Habsburgs against the papacy and supported the imperial army of 1526–27 that humiliated Pope Clement VII and sacked Rome, an allegiance that was rewarded in 1530 when the victorious Charles V demanded that Alfonso be reconfirmed in all his ducal

Genealogy 9.5 (facing page)
Ferrara: The House of Este

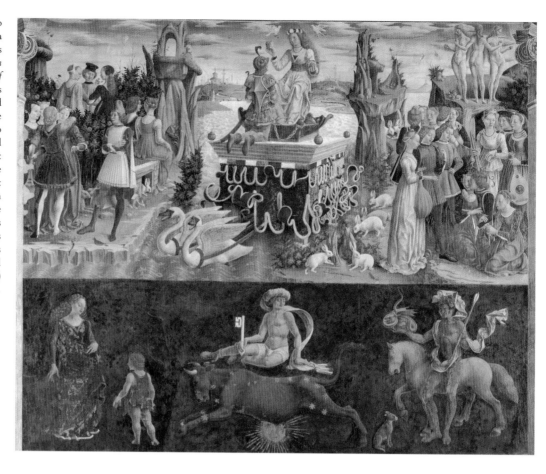

Figure 9.6 Ferrara, Palazzo Schifanoia. Francesco del Cossa (c. 1430–c. 1477, with perhaps Ercole Roberti): *April, the sign of Taurus, and the Triumph of Venus* (1469–70). Rooms in this pleasure palace were decorated with frescoes to celebrate the elevation of Borso d'Este to the duchies of Modena and Reggio, and soon after to that of Ferrara. The entire cycle symbolizes good government on earth in accordance with nature and astrology under the rule of a munificent prince. This section of the fresco illustrates the astrological sign of Taurus in the center of the lower panel and the triumph of Love (Venus) in the upper panel.

territories, especially Ferrara, which he held from the Church. (Alfonso's heir, Ercole II [d. 1559], however, returned Ferrara to its papal allegiance, fighting on the side of the pope against the Habsburgs.)

Despite these shifts in allegiance and the decidedly mixed success of the Este as warrior princes, Ferrara increased its reputation for its brilliant and generous patronage of culture. As Italy was recovering from the horrors of the sack of Rome, the duke built a magnificent long gallery to display the Este collections. Indeed, the reputation of Ferrara and the Este was sustained largely through their magnificent patronage of culture in all of its forms, using patronage as a means of spreading both their fame and the illusion of their wealth. In many ways for the Este, as with the Gonzaga of Mantua and the Montefeltro of Urbino, patronage was competition, almost war by other means, establishing glory and fame through art rather than arms alone. However, the extravagant patronage of the house of Este in effect bankrupted the court, and Ferrara began a political and economic decline in the later sixteenth century. The cost of patronage, especially when added to the expense of war, eventually exhausted the ability of the Este to maintain their position,

and the house declined. In 1598 Ferrara itself was captured by a papal army and incorporated into the states of the Church, again because of the succession of an illegitimate heir whom the pope refused to recognize. The imperial vicariates of Modena and Reggio continued to be ruled by the Este, as the Holy Roman Emperor recognized the illegitimate branch that the Church did not. This line of the family ceased to rule in 1796, when Napoleon expelled the last duke and incorporated the territories into the French puppet state of the Cispadane Republic.

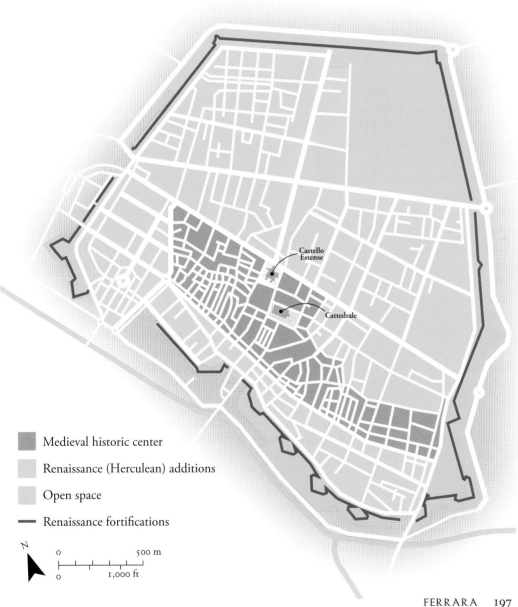

Map 9.4 The Urban Plan of Ferrara. The first successful example of Renaissance town planning, Ferrara has been designated a World Heritage site. The plan was the vision of Duke Ercole d'Este, who saw the need for a new, modern quarter to allow for a larger population. The medieval center of Ferrara is shaded in lilac on the map; around it, in gold, lie the straight, wide streets and the massive new walls (in brown). This area was named in honor of the duke: *addizione erculea* (Herculean Addition). Architect Biagio Rossetti (c. 1477–1516) designed the area according to Renaissance humanist principles, with palaces and other structures powerfully reflecting the influence of ancient building.

Castello Estense

Cattedrale

- Medieval historic center
- Renaissance (Herculean) additions
- Open space
- Renaissance fortifications

N

0 500 m

0 1,000 ft

URBINO

Milan, Mantua, and Ferrara achieved such splendor and power during the Italian Renaissance in large part because of their strategic locations, the fertility of their soil, access to transportation, and the enjoyment of a varied economy. Other signorial regimes lacked these natural advantages; any fame and authority arose from the policies and intelligence of their rulers rather than geographical good fortune. Of these principalities, the tiny duchy of Urbino is the most dramatic example. Only twenty miles from the Adriatic, high in the Apennines, the territory of Urbino had very little to recommend it. It was only forty miles square, and most of that area consisted of rugged terrain, pine forests, and narrow valleys. The population could hardly subsist—even in severe poverty—on the meager harvests coaxed from the inhospitable soil; but the inhabitants' difficult lives made them tough and reliable, the perfect qualities for military service.

Since no possible wealth could ever be produced by the labors of peace, from the thirteenth century the Montefeltro rulers of Urbino and their subjects had been mercenary soldiers living by war. Were it not for the remarkable personality of one of these *condottiere* Montefeltro dukes, Urbino might always have been relegated to the obscurity of history. However, during a reign of thirty-eight years (1444–82), Federigo da Montefeltro turned his impoverished, isolated, minuscule state into one of the most civilized courts of all time, a center of culture that was subsequently immortalized by one of the Montefeltro's most loyal servants, Baldassare Castiglione, in his *Book of the Courtier*.

Although given early to his necessary profession of arms, Federigo was a humanist in taste. As a young man, he had studied with the great humanist educator Vittorino da Feltre. Dedicated to the classics, he was thoroughly familiar with the ancient philosophers, especially Plato and Aristotle, even though he placed the study of history above the abstractions of pure thought. The library he collected was famous throughout Europe, amassed by scouring the continent for the best editions and having them copied. (The celebrated Florentine stationer, Vespasiano da Bisticci (1421–98), saw Federigo as one of his prime clients.) For fourteen years Federigo maintained a staff of thirty scribes working continuously on Greek and Latin texts. Also, as a connoisseur of bindings and decoration he acquired beautiful codices, richly illuminated, illustrated, and bound, such as the justly celebrated Urbino Bible, a two volume masterpiece in purple and gold and with miniatures by the Ghirlandaio workshop. Eventually this wonderful book passed with the rest of the library into one of the only other collections in Italy that could match it: the Vatican Apostolic Library.

Besides books, he loved art and beauty. In 1468, Federigo began the remarkable palace that is half *condottiere* fortress and half sumptuous pleasure dome, a structure that can still be seen climbing up the steep cliffs of the Apennines. Filled with architectural wonders, the palace has splendid carved decorations on the fireplaces, doorframes, and panels, which reveal the exquisite taste of the duke who saw war only as a means of supporting his true vocation: the acquisition of beauty. Indeed, the galleries in the great palace of Urbino—thought such a marvel that Lorenzo the Magnificent sent an artist to make drawings of them—were filled with paintings and tapestries by contemporary artists from across Italy and Europe: Justus

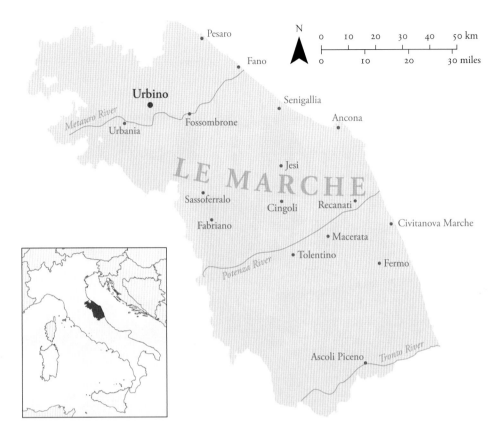

Map 9.5 Le Marche, including Urbino

van Ghent, Pedro Berruguete, Piero della Francesca, Melozzo da Forlì, and Sanzio, the court painter who was also the father of Raphael. In addition to art, the duke collected eminent men of all professions as members of his court. No figure of the eminence of Petrarch or Leonardo ever resided with him as they did with the Visconti and Sforza of Milan, but a number of lesser figures, not the least of whom was Pietro Bembo, contrived to make the Montefeltro court recognized for taste, elegance, and decorum throughout Europe.

How did Federigo da Montefeltro do it? How could one man, however gifted, bring about such a renaissance in such an impoverished territory? Although by taste and temperament a patron, Federigo lacked the resources of his contemporaries Lorenzo de'Medici or Lodovico il Moro. He had to live by war; and he did so brilliantly and honorably, even elegantly. He never lost a single encounter with the enemy, and he never let war get too near to his beloved Urbino. His reputation was such that he could demand the highest fees for his services, and he was almost always scrupulously honest and honorable, traits altogether absent from the traditional *condottiere* character. For example, when Venice feared that Urbino might take advantage of a disastrously managed campaign during a peninsular war, the Senate offered Federigo 80,000 ducats to keep the peace and maintain the friendship between them. Federigo refused the money and assured the republic of his honor,

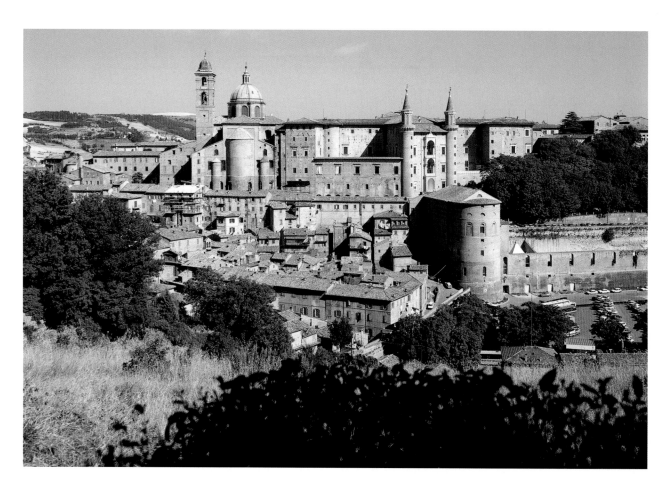

Figure 9.7 Urbino, the Castle of Federigo da Montefeltro. The great castle was built by Luciano Laurana (c. 1420–79) for Federigo, beginning about 1466. It still dominates the town of Urbino, as it did when Federigo held court in its magnificent rooms. The rough topography of this Apennine town is also clearly visible.

replying that keeping his word was better and of greater value than ill-gotten treasure. He served three popes, two kings of Naples, two dukes of Milan, and the Florentine republic, but he never betrayed an employee or an alliance. This reputation for honor and fidelity worked well. A number of states kept him on retainer perpetually in case his services should be needed; and honors came from all quarters. One pope made him a knight of the ermine, another standard bearer of the Church, and Edward IV of England appointed him a knight of the garter.

As a prince, his generosity and magnanimity were astounding. He provided dowries for the orphaned daughters of his soldiers and bought huge stores of grain during good harvests to sell at cost during famines. He forgave his individual debtors and insisted upon equality before the law to the point that on one occasion he demanded that a subject sue him as an example—serving the writ upon himself—for non-payment of a debt. Each early morning was spent walking unarmed and unattended about his city, inquiring in shops and businesses about the problems of his people; the afternoons were passed in his garden, where he was available to render justice to supplicants.

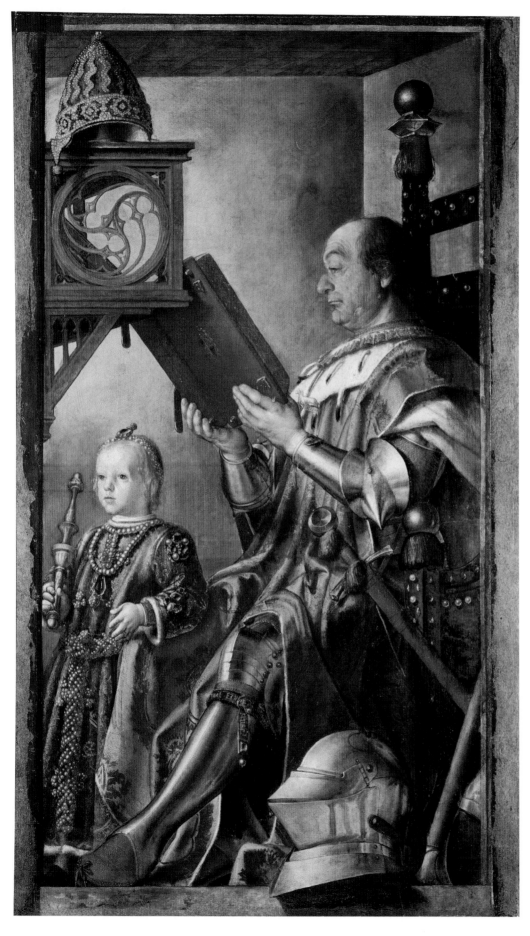

Figure 9.8 Urbino, Galleria Nazionale delle Marche. Pedro Berruguete (c. 1450–1504) or Justus van Ghent (c. 1410–c. 1480): *Federigo and his son, Guidobaldo.* This wonderful portrait of father and son reveals much about the duke: his princely status, represented by his ermine-tailed robes; his mercenary prowess, shown by his full suit of armor; his chivalry, symbolized by the order of the garter; and his learning, illustrated by the magnificent book he is reading. His son, Guidobaldo, represents the future of Urbino and the dynasty. Federigo's distinctive nose was the result of a jousting accident that blinded him in one eye. He asked his physician to remove some of the nasal cartilage in order to widen his field of vision.

In 1460, Federigo married Battista Sforza (1447–72), the very young niece of Francesco Sforza, duke of Milan. Highly polished herself and well educated by the standards for women at the time, her natural abilities in statecraft often proved an asset to her husband when he was absent from Urbino. However, they despaired of an heir. Only the last of her eight pregnancies produced a son, Guidobaldo, but his birth unfortunately cost Battista her life at the age of just twenty-six. Federigo himself died ten years later.

Although very promising in his youth, Guidobaldo (1472–1508) was struck down very young by a disease that left him an invalid for most of his short life. In 1488, Guidobaldo was married to Elisabetta Gonzaga (1471–1526), the sister-in-law of the celebrated Isabella d'Este, marchioness of Mantua. Gentle and shy, she was to discover that her invalid husband was impotent from the beginning of the marriage, an affliction that Elisabetta appeared to accept with equanimity—at least, no steps were taken to release her from this canonically invalid union. Content to live with the unfortunate Guidobaldo as a sister, she furthermore refused to abandon him, despite the disasters that subsequently befell him and Urbino.

The crises began in 1502 when Cesare Borgia, son of Pope Alexander VI, after having declared himself a friend and protector, treacherously marched on Urbino, claiming the principality for the Church. Having believed Cesare's earlier promises of peace, the duke and his duchess could not arrange for the defense of their state, although the courtiers and citizens gave freely all of their personal valuables to sustain an army. Rather than cause unnecessary bloodshed, the couple fled to Elisabetta's home at Mantua and from there to Venice to protect the duchess' family from the Borgia wrath. In the meantime, Cesare and a papal garrison resided in Urbino's beautiful palace, only to loot it. However, justice arrived a few months later when malaria carried off the Borgia pope and brought his son, Cesare, to the brink of death. Although Cesare recovered, he had lost his power base and his financial resources. The people of Urbino rioted and drove out the papal vicar and his garrison, demanding and achieving the return of Guidobaldo and Elisabetta. To secure his reign and arrange a peaceful succession for his territory, Guidobaldo adopted his young nephew, Francesco Maria della Rovere (1490–1538), who was also the nephew of the new pope, the warrior pope Julius II. The last five years of Guidobaldo's reign were a reflection of the polished society of his father's time, although more in tune with the Italian vernacular culture of the later Renaissance than the classical Latin character of the fifteenth century. It was this world that Count Baldassare Castiglione recorded in his famous *Il Cortegiano* (*The Book of the Courtier*).

Castiglione (1478–1529) was the son of a nobleman who had married into Mantua's reigning house by choosing as his bride a relation of the marquis Francesco Gonzaga. In 1496, the young Baldassare traveled to Milan, where he served at the splendid court of Lodovico il Moro and where his obvious gifts made him a great favorite. Possessing a Platonic attitude to women, he avoided marriage after the death of his father, despite the encouragement of his mother to produce an heir, and instead joined Urbino's mercenary army. However, a fortuitous accident led to Baldassare's convalescence at Guidobaldo's court and his consequent entry into the society of Duchess Elisabetta where he was to remain for eleven fulfilling years.

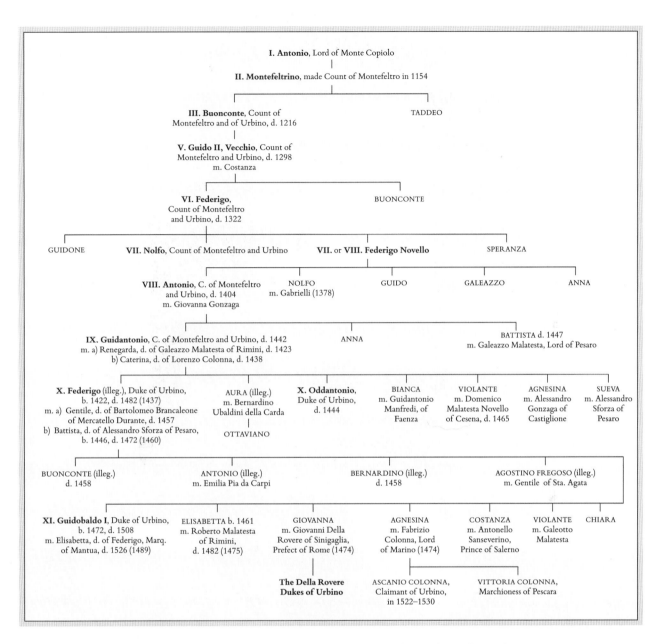

I. Antonio, Lord of Monte Copiolo

II. Montefeltrino, made Count of Montefeltro in 1154

III. Buonconte, Count of Montefeltro and of Urbino, d. 1216 — TADDEO

V. Guido II, Vecchio, Count of Montefeltro and Urbino, d. 1298 m. Costanza

VI. Federigo, Count of Montefeltro and Urbino, d. 1322 — BUONCONTE

GUIDONE — **VII. Nolfo**, Count of Montefeltro and Urbino — **VII. or VIII. Federigo Novello** — SPERANZA

VIII. Antonio, C. of Montefeltro and Urbino, d. 1404 m. Giovanna Gonzaga — NOLFO m. Gabrielli (1378) — GUIDO — GALEAZZO — ANNA

IX. Guidantonio, C. of Montefeltro and Urbino, d. 1442 m. a) Renegarda, d. of Galeazzo Malatesta of Rimini, d. 1423 b) Caterina, d. of Lorenzo Colonna, d. 1438 — ANNA — BATTISTA d. 1447 m. Galeazzo Malatesta, Lord of Pesaro

X. Federigo (illeg.), Duke of Urbino, b. 1422, d. 1482 (1437) m. a) Gentile, d. of Bartolomeo Brancaleone of Mercatello Durante, d. 1457 b) Battista, d. of Alessandro Sforza of Pesaro, b. 1446, d. 1472 (1460) — AURA (illeg.) m. Bernardino Ubaldini della Carda — OTTAVIANO — **X. Oddantonio**, Duke of Urbino, d. 1444 — BIANCA m. Guidantonio Manfredi, of Faenza — VIOLANTE m. Domenico Malatesta Novello of Cesena, d. 1465 — AGNESINA m. Alessandro Gonzaga of Castiglione — SUEVA m. Alessandro Sforza of Pesaro

BUONCONTE (illeg.) d. 1458 — ANTONIO (illeg.) m. Emilia Pia da Carpi — BERNARDINO (illeg.) d. 1458 — AGOSTINO FREGOSO (illeg.) m. Gentile of Sta. Agata

XI. Guidobaldo I, Duke of Urbino, b. 1472, d. 1508 m. Elisabetta, d. of Federigo, Marq. of Mantua, d. 1526 (1489) — ELISABETTA b. 1461 m. Roberto Malatesta of Rimini, d. 1482 (1475) — GIOVANNA m. Giovanni Della Rovere of Sinigaglia, Prefect of Rome (1474) — AGNESINA m. Fabrizio Colonna, Lord of Marino (1474) — COSTANZA m. Antonello Sanseverino, Prince of Salerno — VIOLANTE m. Galeotto Malatesta — CHIARA

The Della Rovere Dukes of Urbino

ASCANIO COLONNA, Claimant of Urbino, in 1522–1530 — VITTORIA COLONNA, Marchioness of Pescara

Soon the idealistic young courtier, much given to Platonic relationships, formed a remarkable and pure idolization of the virgin duchess, an obsession that continued until Pope Leo X de'Medici captured the state, deposing Duke Francesco della Rovere and giving Urbino to his nephew Giuliano de'Medici (1479–1516). Castiglione was now unemployed and disconsolate. He returned to his family estates in Mantua, where he married a very young girl, and this relationship proved to have been more than Platonic, since a daughter was born to them. Tragically, the young Countess Castiglione died in childbirth. Castiglione, again shattered, entered the Church, becoming a bishop. He also continued

Genealogy 9.6 Montefeltro Counts and Dukes of Urbino

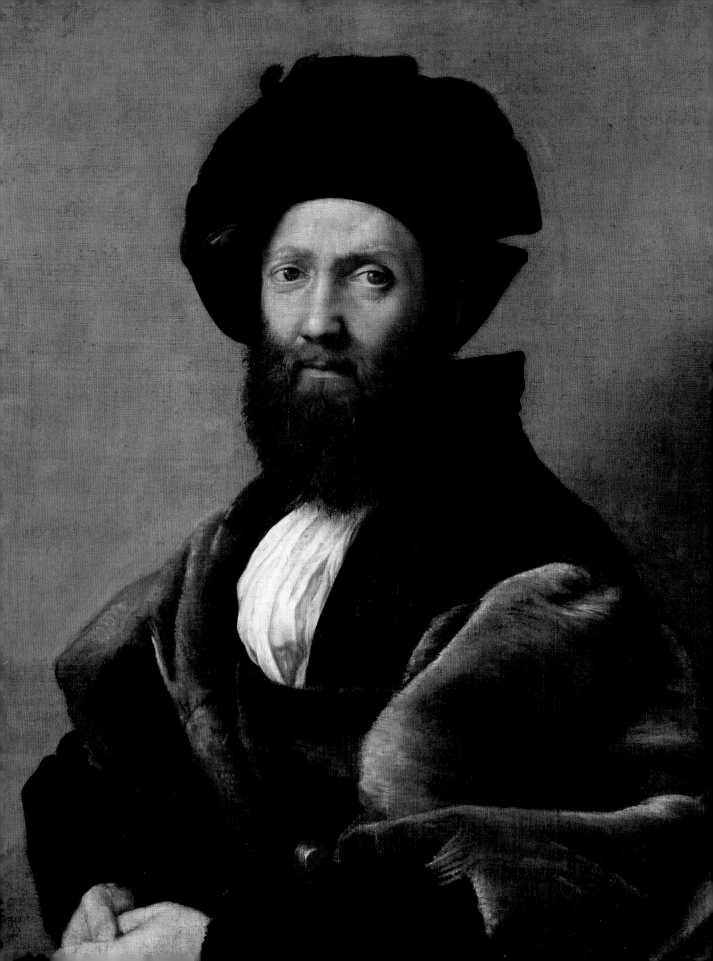

his employment as a diplomat, but with increasing sadness, especially after the sack of Rome in the year before his death.

Castiglione had begun his great book while still resident in Urbino in 1508—although it is set in 1506—and spent the next twenty years polishing it, deciding to have *The Courtier* printed only in 1528 after unauthorized copies had begun circulating in Rome. The work is divided into four sections or "books," each one recording the dialogues among the members of Guidobaldo's court over the course of four consecutive evenings. Although Duke Federigo, whom Castiglione named "the light of Italy," was dead, Urbino's court continued to attract men bearing the greatest names in Italy: the Orsini, Colonna, Della Rovere, Doria, Farnese, Medici, and Fregoso all sent their sons or traveled themselves to breathe the rarified air of this remarkable place. *The Courtier*, then, is not the fictionalized idealization of another petty Italian tyranny: it is the fond remembrance of things past by an intimate of the society that for close to half a century had turned a barren patch of rugged rock into an aesthetic and intellectual garden.

The book begins with a game created to pass the time, an invention that was to define the ideal court gentleman in the first two and last of the books, and the ideal court lady in the third. The discussion is ruled by the duchess, Elisabetta, as Guidobaldo is an invalid in bed; but the duchess turns the game over to the Neapolitan noblewoman and relative by marriage, Emilia Pia, who in life remained a rigorously chaste widow after the early death of her husband. Thus, *The Book of the Courtier* records a world ruled by women where important discussions take place in the duchess's rooms as they talk through the night, only retiring to bed at first light. Consequently, it is, from the Renaissance perspective, a world turned upside down, an imperfect representation of an ideal court, subject to the weaknesses of the body and the effects of malicious fortune.

The book, then, evokes a world long past; it is suffused, despite the light tone and frequent jokes, with an intense sense of melancholy. In part, this is nostalgia for the forever lost world of Duke Federigo, a world Castiglione never personally knew. The environment of *The Courtier* is Guidobaldo's Italy, a world governed by rulers who could not sustain the civilization that their ancestors had created and that had led Europe in all of the arts of human civilization. Although on occasion diplomatically praising Guidobaldo, Castiglione clearly saw the duke as weak in the face of brutality, represented by the Borgias, and as a ruler whose impotence was symptomatic of the cause of Italy's disasters and decline. Castiglione observes that certain shards can be collected against the ruin of a civilization: pieces of culture, manners, cultivated society; but Castiglione thinks these to be insufficient, even though there is no other recourse and nothing more can be done. Hence, a strong impression of *après nous le deluge* pervades *The Courtier*. For Castiglione, Urbino under the Montefeltro was indeed a quest for a golden age, an ideal society, but clearly one that could not survive in an imperfect, fallen world where decline, decay, and ultimately death are the realities of earthly life.

The Courtier can be read as a somewhat popularized version of Renaissance neo-Platonism. This was a philosophy that built not only on the dialogues of the great Athenian philosopher Plato, but also on the writings of his followers, such as Plotinus and Clement of Alexandria,

Figure 9.9 (facing page)
Paris, Louvre. Raphael Sanzio (1483–1520): *Portrait of Baldassare Castiglione*. This elegant portrait of Castiglione by his friend, Raphael—whose father was Federigo da Montefeltro's court painter—reflects the gravity and dignity, as well as the melancholy, of the sitter. From 1504 until 1516 he resided at the court of Urbino and became a leading figure in the service of the Montefeltro duke Guidobaldo. Castiglione's evocative text, *The Book of the Courtier,* depicts the court of Urbino during his residence with Guidobaldo and his duchess, Elisabetta Gonzaga. Returning to Mantua, Castiglione re-entered the employ of the marquis, functioning mostly as a diplomat. In 1524 Castiglione was appointed papal nuncio in Spain and, soon after, bishop of Avila. He died in Toledo in 1529.

who took the disparate ideas they found in Plato's *Dialogues* and rationalized them into a more coherent system of thought. In so doing, they incorporated certain mystical ideas from Eastern traditions such as the hermetic books and the writings of the pseudo-Dionysius.

The Renaissance version of neo-Platonism reflected late Renaissance courtly society, becoming the ideology of the new ruling class of courtiers like those portrayed in Castiglione's *Courtier*. As we will see in Chapter Ten, neo-Platonism was an ideology far better suited to the new dispensation of the latter part of the fifteenth and early sixteenth centuries than the civic humanism that had informed the now waning republican societies of Italy. It was an elitist, hierarchical, exclusive theory perfectly compatible with a world where thought and action had necessarily become divorced. Civic humanism was the ideology of a free, engaged citizenry whose responsibility was to their fellows and the state; neo-Platonism was the ideology of an extremely highly cultivated and educated but politically powerless aristocracy whose only responsibility was to further polish itself and provide for its own development: a world of talk and little action. Civic humanism was dynamic, inclusive, and dedicated to the concept of general liberty from external restraints; neo-Platonism was passive, introspective, exclusive, and dedicated to the liberty of the inner spirit, despite the existence of irreversible restrictions in social, political, and economic affairs. It was particularly suitable, then, for the cultural world of the *signori*, whose interest in chivalric romance had begun to decline and an interest in classical ideas and ancient letters develop.

FURTHER READING

Bentley, Jerry H. *Politics and Culture in Renaissance Naples*. Princeton, NJ: Princeton University Press, 1987.

Bertelli, Sergio. *Italian Renaissance Courts*. London: Sidgwick and Jackson, 1986.

Castiglione, Baldassare. *The Book of the Courtier*. Trans. G. Bull. Harmondsworth: Penguin Books, 1976.

Cole, Alison. *Virtue and Magnificence: Art of the Italian Renaissance Courts*. New York: Harry N. Abrams, 1995.

Croce, Benedetto. *A History of the Kingdom of Naples*. Chicago: University of Chicago Press, 1970.

Dennistoun, James. *Memoirs of the Dukes of Urbino*. New York: John Lane Company, 1909.

Gundersheimer, Werner L. *Ferrara: The Style of a Renaissance Despotism*. Princeton, NJ: Princeton University Press, 1973.

Looney, Denis, and Deanna Shemek, eds. *Phaethon's Children: The Este Court and Its Culture in Early Modern Ferrara*. Tempe: Arizona Centre for Medieval and Renaissance Studies, 2005.

Lubkin, Gregory. *A Renaissance Court: Milan under Galeazzo Maria Sforza*. Berkeley: University of California Press, 1994.

Simon, Kate. *A Renaissance Tapestry: The Gonzaga of Mantua*. New York: Harper and Row, 1988.

Tuohy, Thomas. *Herculean Ferrara: Ercole d'Este, 1471–1505, and the Invention of a Ducal Capital*. Cambridge: Cambridge University Press, 1996.

TEN

RENAISSANCE NEO-PLATONISM

THE TRANSITION TO A COURTLY SOCIETY

IN OUR DISCUSSION of Urbino in the previous chapter, we looked at the Platonic vision of the perfect court and courtier as represented by Castiglione's *Book of the Courtier.* From that wonderful book emerged an excellent indication of how neo-Platonic concepts had become disseminated to the point where they began to function as a popular, elite ideology, another kind of energizing myth but one more suitable to the aristocratic courtier class for whom civic humanism was always potentially—or in some cases, as with the assassination of Duke Galeazzo Maria Sforza of Milan—manifestly seditious. Concepts such as Bruni's praise of republican liberty, human dignity, and the right to actualize human potential and social mobility through the acquisition of wealth, were irrelevant—if not dangerous—in a society ruled by absolute despots, even if many of these were enlightened and sympathetic to the cultural values of the Italian Renaissance. Civic humanism might flourish and provide an ideology to vitalize a republic like Florence; but, given the kinds of characters who occasionally ruled the *condottiere* principalities, it could at best function as a kind of literary or educational ideal that could never be fully activated in a state like Milan or even Mantua or Urbino.

In Florence, the values of civic humanism were institutionalized in the person of the chancellor and in the mechanism of the state itself. Indeed, the idea of the state as a collective of the citizens, created like a work of art that operated to serve the needs and aspirations of its political classes, was clearly a republican ideal, peculiar almost to Florence where, as suggested in Chapter Six, the modern idea of the state as a collective of its citizens was born. The concept of the state in the despotic principalities was something completely different: it was the personal property of the prince to do with as he pleased, and the citizens had no liberty or rights outside of those that the prince chose to grant them. Some princes, such as Federigo da Montefeltro and even Giangaleazzo Visconti of Milan, were on balance good,

just, and noble rulers who saw to the welfare of their subjects. But, obviously, this paternalism was not a question of the rights of these subjects: it was instead a reflection of the personalities of the rulers who were still unrestricted, arbitrary, and absolute in their authority.

To be an intellectual or to have enjoyed the benefit of a humanist education, as did many of the young aristocrats of the petty principalities throughout Italy, was to be in a dilemma. These young aristocrats were filled with the self-confidence and principles of humanism, but they lacked the forum and often the instruments necessary to practice them. Although born to rank, they enjoyed power and influence only at the pleasure of a ruler whose bidding they had to do, whether just or unjust. How were they to behave? How were the counsels of the ancient republican Romans, such as Cicero, or the republican Florentine humanists, such as Bruni, to serve them? Obviously there was a disjunction between the classical world of the republicans of Rome or the tyrannicides of Greece and the reality of many of the states of the peninsula.

Some princes, such as the Este of Ferrara and the Sforza of Milan, tried to build a classical humanist culture by exchanging the republican world of the Roman Republic for the monarchical world of the Roman Empire. Poets, theorists, and propagandists compared these princes to Caesar or to the good emperors, such as Augustus, Trajan, Titus, or Vespasian; and the traditional Aristotelian, medieval praise of monarchy was creatively sustained. The real accomplishments of the Empire were then seen to triumph over the instability and chaos of the Republic. Add to this the Christian dimension, reflected in God's choice to locate the incarnation during the Roman Empire rather than the Republic, and the role of Constantine, Theodosius, Charlemagne and any number of Christian emperors and kings, and the traditional view of a monarchical, hierarchical, and more settled government and society emerge. Therefore, as more and more republics fell under the rule of despots during the fifteenth and sixteenth centuries, the concepts of civic humanism became more and more irrelevant: they had developed in the peculiar environment of republican Florence and did not translate well to arbitrary despotisms, despite the heroic attempts of loyal humanist courtiers and clients of enlightened princes.

Perhaps, then, there was need for another energizing myth, another ideology more suited to an Italy of princes. What could replace civic humanism among the classically educated nobility of Lombardy or Umbria, the curial officials in Rome, or even the wealthy mercantile patriciate of Italy? Through humanist educators like Vittorino da Feltre and Guarino of Verona, these men had been taught to think of themselves and their places in the world in different ways than had their ancestors. Concepts of aristocratic behavior not fully consistent with the warrior nobility of the past, and diverse applications of the models of antiquity, had been made available to them as guides for life. Feudal values, chivalry, violence, and warfare no longer sufficed, even though, to some extent, they were still often their *raison d'être*.

Renaissance neo-Platonism filled this need; and, as a new ideology, or energizing myth, for the courtier of the later Italian Renaissance it functioned perfectly. All of the ideals of humanism were present, but in a significantly altered form. Renaissance neo-Platonism inexorably became the ideology of the political classes of Italy, as courts dominated republics and as the values of Florentine civic humanism became ever more divorced from the

reality of the political, social, and intellectual traditions of the later 1500s. First, for the neo-Platonists liberty was no longer an external, political liberty manifested in a pluralistic republic enjoying a rotation of officials and assuming some measure of social mobility; it was now internal, spiritual liberty, something that could easily co-exist with despotism. Second, the style of the Renaissance was for most observers manifested externally in the adoption of particular vocabularies of art and architecture, none of which had a political dimension. Naturalism, perspective, and correct anatomy all obtained equally in a despotism as in a republic, and, indeed, genres such as portraiture could be seen to celebrate not just the individual but the privileged individual, such as a prince. Consequently, the search for beauty, proportion, elegance, and order in art translated well across every jurisdiction. And how this art was to be appreciated and used determined very much the program for its creation.

The concept of one's life as a work of art remained, but only at the level of the individual, and then often rather superficially: life in all of its complexity became theater, an entertainment, or an allegorical charade. The self became the only reality, and how one behaved, appeared, and acted indicated one's place in the world more than the honor of a republican magistracy, or material or political success. Thus, the essential values of humanism are clearly maintained in this neo-Platonic interpretation of life, as is obvious from Castiglione. Individualism remains paramount, and cultivation of the self is the only real, possible development. Upward mobility is possible because nobility, virtue, and ability are individual, internal possessions. Man can still be anything he wills, provided that it remains in the context of its proper environment: that is, if he is decorous.

From this, then, emerges the third and perhaps the most important reason for the victory of Renaissance neo-Platonism as the ideology of the later Italian Renaissance to replace civic humanism: the recognition that the world in which we live is imperfect. We can only approximate the ideal; we can never attain it. Hence, there is a recognition that we must work with what we have, in terms of the reality of our individual situations. Decorum, that quality so significant for Castiglione, is therefore the highest social and intellectual good. The Christian tradition of the Fall and the search for spiritual, not worldly, redemption clearly reinforced this belief and gave it a foundation with deep roots in the culture of Italy and the West. Thus, the courtier of the sixteenth century in Italy was able to function in a world very different from that of the fifteenth, fortified with the basic tenets of Renaissance neo-Platonism that both helped make this cultural transition and provided a vehicle for the interpretation of a society under threat and experiencing great change.

THE PLATONIC TRADITION

What was this new ideology of Renaissance neo-Platonism? Obviously, the philosophical structure and basis came from the great Athenian philosopher and teacher Plato, whose Academy lasted until AD 529, disseminating and occasionally altering its basic

tenets. This tradition was enriched by the so-called Middle Platonists, largely centered at Alexandria in the first century AD, who introduced a mystical, strongly oriental strain into the already complex canon of received Platonism, adding the divine Hermes Trismegistus (see below) to the Platonic hagiography. Christianity made contributions, too, when the early Greek fathers, Clement and Origen in particular, associated a number of significant Platonic ideas, such as the immortality of the soul, with basic Christian beliefs. Finally, there were the neo-Platonists, led by Plotinus, who, again in Alexandria, during the third century attempted to rationalize the huge and often contradictory or obscure corpus of Plato's work and its subsequent tradition into a coherent system. So many of the doctrines that one immediately identifies as Platonic, such as the hierarchical universe spanning all things from the absolute of God, or the One, to the lowest, inanimate objects of creation, are really neo-Platonic ideas, drawn from various Platonic sources. And these notions, through the mediation of the shadowy figure of Dionysius the Areopogite, the Pseudo-Dionysius, who was believed to have been the Greek disciple of St Paul, converted on the Areopagus of Athens, entered the Christian theological tradition by way of a large number of the early church fathers trained in Platonic concepts and whose very theological vocabulary and frame of reference revealed an enormous debt to the neo-Platonists.

All of these strains of Platonism were available to the Renaissance from the earliest period because of their inclusion in the great works of Latin antiquity. Cicero had studied at the Academy in Athens, and his philosophical works are full of such ideas. Seneca was in essence a Platonist, as was Apuleius, whose *Golden Ass* was, after its rediscovery in the early fourteenth century, among the most popular stories of Renaissance Italy. Boethius' widely read *Consolation of Philosophy* was a Platonic document in many ways, and St Augustine, one of the most influential Christian thinkers of all time, and almost the patron saint of many Renaissance figures such as Petrarch, was in many ways a representative of the Academy. Indeed, his continued assertion that Platonism is closer to Christianity than any other classical model of thought or religion contributed a great deal to Plato's reception in the West. Finally, some of the Platonic dialogues themselves were known, but, oddly, these were not as important as the popularized versions found in Latin writers such as Cicero and Macrobius. Still, the *Timaeus*, *Phaedo*, and *Meno* were known to the Middle Ages and early Renaissance in Latin translations.

Nevertheless, it was not until after 1350 that a serious rekindling of interest in the original thought of Plato and his students, especially Plotinus, developed—that is, not until a number of Byzantine Greeks actually visited Italy to work and teach. In fact it was the Byzantine scholar and teacher Manuel Chrysoloras who suggested the first Latin translation of Plato's *Republic*. Later, during and after the Council of Florence of 1439, a large number of learned Greeks made significant contacts with many learned Italians, motivating them to devote more energy to Greek studies, which obviously included Plato. Men such as Leonardo Bruni, the humanist chancellor of Florence and former pupil of Chrysoloras, translated Platonic dialogues such as the *Gorgias* and *Phaedrus*, and these translations achieved significant popularity.

In addition to this movement of increasing knowledge of Plato during the Renaissance there was the incentive to replace the now despised Aristotelianism of the scholastics with another, more humanistically oriented philosophical system. And, clearly, Platonism did this quite well. Plato enjoyed at least equal classical respect as Aristotle, if not more. His works had been thoroughly studied and rationalized and thus provided a neat, self-contained replacement; and they still had the advantage of novelty because the original Greek of the Athenian himself was only recently widespread among scholars in the Renaissance. Finally, the general medieval lack of interest in classical Platonism meant that there was no natural hostility to it, engendered by a quantity of medieval scholastic accretions, commentaries, and glosses on the original text, misfortunes suffered by Plato's pupil, Aristotle.

Furthermore, the Renaissance concept of Platonism was in many ways a philosophical system in itself separate from, albeit indebted to, earlier Platonic manifestations. Let us very quickly review the ideas that characterize the Renaissance neo-Platonic movement. First, it maintained its close associations with some of the ideals of Christian humanism through a deep commitment to human dignity and our place in the universe, indeed to our place between the divine Godhead and the lesser forms of life not possessing souls. Also, humanity's place was variable in this scale of perfection, this chain of being: we could be either bestial, like the lower end of the scale, or quasi-divine, like the higher; and this position depended on free will. Second, obviously, there were close links with traditional Christianity; consequently, the immortality of the soul was not questioned but reasserted, with the soul associated intimately with human reason and the gift of speech which externalized that reason. Third, at least as described by Marsilio Ficino (1433–99), Renaissance neo-Platonism's great proponent, the neo-Platonic hierarchy or cosmology was clearly divided into five basic substances: 1) God, 2) the angelic mind, 3) the rational soul, 4) quality, or the essential nature of substance (which Plotinus divided into two parts—the sensitive and the vegetative), and, finally, 5) the body.

Harmony was seen as a necessary feature in this scheme; and the idea of love, associated so closely with the divine and the soul, was considered the principle of dynamic unity. Equally, there were other elements common to all Platonists, such as the existence of ideal forms of which all representations on Earth are but pale reflections. These perfect forms the Christian Platonists evidently associated with God. Thus, there was, as Augustine had suggested, no necessary disjunction between neo-Platonism and Christianity, a belief that allowed Ficino, although a priest, to burn candles before the altar of St Socrates and to entitle his magnum opus the *Platonic Theology*.

PLATONIC LOVE AND THE PLATONIC ACADEMY

If love and harmony were the motivating principles of the Renaissance neo-Platonic universe, it is important to see what exactly the Renaissance meant by love. Platonic love has entered the popular vocabulary, although its meaning in the Renaissance is hardly

what we think today. To begin, Platonic love transcends what we, in our post-Freudian world, comprehend as love. To the Renaissance neo-Platonist, love was much more: it was a principle of life, of which sexual love formed but one small, almost insignificant element. Love is the essence of the good in the universe manifested in the beauty of the world, beauty being but an externalization of goodness. It is our natural attraction to beauty that leads us toward the good, and, ultimately, to God, the source of all goodness. Love, which so often begins with one person's love for another, is thus the beginning of an ascent toward the divine, accomplished in stages, each one of which removes the lover one step further away from the body, and hence from sensual love, as he progresses toward God, who is pure love: ideas widely disseminated through Marsilio Ficino's *Commentary on Plato's Symposium on Love* (c. 1475–80).

Therefore, the concept of love in the later Renaissance took on a quality removed from the somewhat earthier connotations of the earlier period. Previously, the classical tradition in love was that of Ovid and Catullus: truly physical, directed toward satisfaction and gratification, concepts illustrated well from the *Decameron* of Boccaccio. However, we must remember that Dante's vision of Beatrice and Petrarch's of Laura were much closer to the Platonic ideal of love, although the immediate roots of the poets were much more in the medieval tradition of courtly love than in fully developed neo-Platonism. Still, the significant point is that we are led back to an earlier vision based upon a transcendent view of the world. Just as neo-Platonism was consonant with basic Christianity, so too was Platonic love compatible with physical self-denial for spiritual gratification: the spirit is once again conquering the flesh, and the heavenly city has increased in importance at the expense of the earthly. Has man perhaps ceased to be the measure of all things in a physical, earthly way? Is it now the human spirit and inner potential that impart our dignity, rather than political freedom, republican liberty, and success in commerce or in arms? To reiterate, for many Renaissance neo-Platonists, freedom was internal and spiritual rather than external and physical. It appears that the tough, hard-headed bourgeois bankers and merchants of Florence were, at least ideologically, abandoning their realism, a realism that was manifested in republicanism, commerce, social mobility, and the reproduction of what the eye sees in art as a reflection of the real world. To a true neo-Platonist, commerce or political office—indeed any kind of work outside pure speculation and study—would interfere with spiritual progress.

Furthermore, for neo-Platonists beauty in art no longer rested in the ability of the artist to reproduce nature, obeying, for example, the laws of perspective developed by Donatello, Brunelleschi, and Alberti and appreciated so much by the painter Paolo Uccello (1397–1475) that it cost him his sleep. Beauty now was transcendent, too, a manifestation of something else, an abstraction closer to the ideal rather than to observable nature. From this developed the Renaissance conceit, the elaborate allegories, and the deliberately obscure representations and emblems. This is clearly illustrated in the work of the Florentine painter and member of the Platonic Academy around Lorenzo de' Medici, Sandro Botticelli (c. 1445–1510). Certainly Botticelli's images are beautiful; his naturalism remains—that is, the real world is still reproduced, but with an allegorical "higher" significance—as does his exquisite sense of color. But what else is there in a picture such as *The*

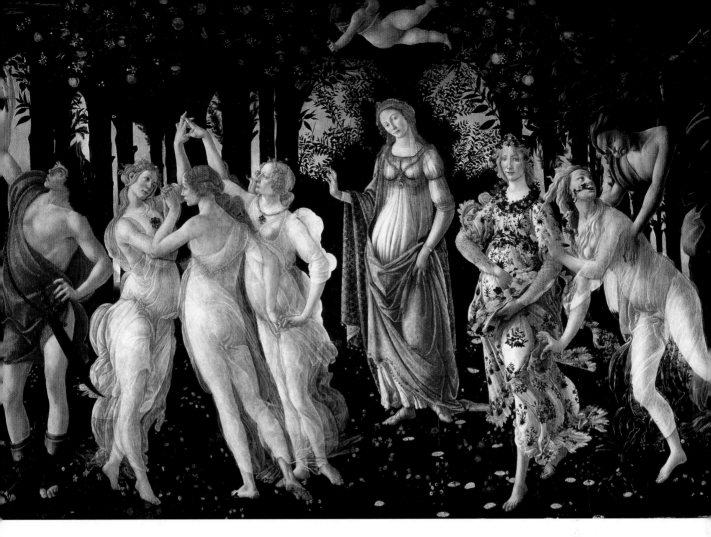

Birth of Venus, *Primavera*, or the *Calumny of Apelles*? By this time, beauty and narrative were no longer sufficient in themselves. Art now had to be appreciated intellectually as well as visually; it had become an allegory, a route to deeper understanding and abstract truth, not easily reached purely by reason or logic.

The significance for the Renaissance of this desire to invest experience with a deeper, often opaque meaning should be clear. Even in Florence, where the Medici had established a court in all but name, these new ideals took the patricians out of their counting houses and shops and put them into their libraries and studies—indeed almost into the cloister, since how different is Platonic love from that love of God which inspired monasticism, without, of course, the asceticism and celibacy? Politics, business, or diplomacy ceased to be the highest callings: contemplation surpassed them. The world of action gave way to a world of introspection. The self had conquered the *polis*. If humanism had taken men out of the contemplative life of the hermit's cell and placed them in the midst of the real world, neo-Platonism put them back into another kind of cell, the solitary scholar's study, where reality existed only in the ideal sphere of perfect forms; the external world was imperfect and hence unworthy of serious involvement.

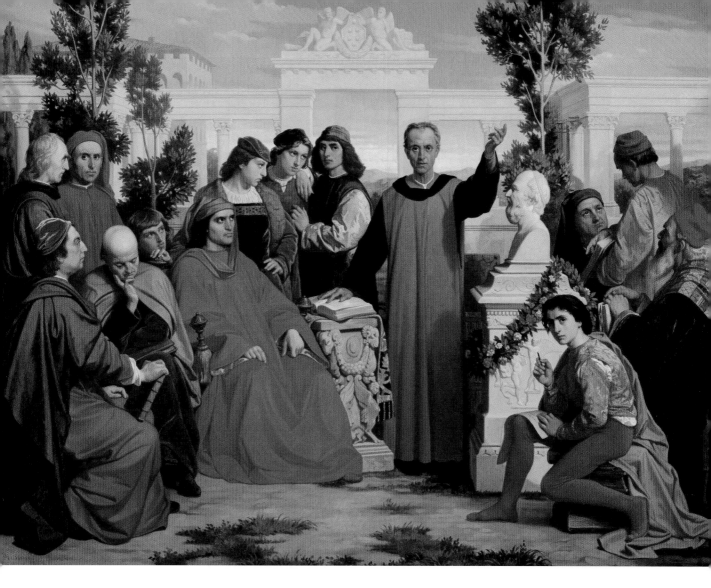

Figure 10.2 Bourg-en-Bresse, France, Musée de Brou. Luigi Mussini (1813–88): *Lorenzo il magnifico and the Platonic Academy (Célébration néo-platonicienne à la cour de Laurent de Médicis)* (1851). This nineteenth-century historical painting portrays Lorenzo de' Medici at Careggi surrounded by the members of the Platonic academy on the day of Plato's birth, November 7. Each year on this occasion an ancient bust believed to be that of Plato was crowned with laurel and a votive flame burned before it.

The center of Renaissance neo-Platonic activity was, ironically, Florence, the birth-place of civic humanism and of the belief in the power of republican liberty. Largely, this was because of Cosimo and Lorenzo de'Medici's personal patronage and interest in Plato. The Platonic Academy—which was in no way a school or institution, but rather an informal gathering of like-minded friends—had actually begun when Lorenzo's grand-father, Cosimo, gave Marsilio Ficino a villa at Careggi and a pension to translate Plato into Latin and popularize his ideas. Under Lorenzo, this simple foundation grew into a participatory coterie of Medici clients, friends, and associates, devoted to Platonism and nourishing the leading Platonists in Italy. The gatherings were informal, consisting not of masters and students, but of a number of men who were attracted by the ideas of the Athenian philosopher and his continuators, and men who wanted to be part of the personal entourage of Lorenzo the Magnificent by sharing his intellectual and cultural enthusiasms. They met either in Lorenzo's palace on the Via Larga (now Via Cavour) or at Ficino's villa,

usually the latter. There they dined and drank (the tradition of the symposium was obviously respected), and later there followed a recitation of Platonic dialogues.

THE CIRCLE OF LORENZO THE MAGNIFICENT

The members of this rather unstructured Platonic Academy were the leading intellectuals of Florence: Angelo Poliziano (1454–94), Giovanni Pico della Mirandola (1463–94), Luigi Pulci (1432–84), as well as Ficino, Botticelli, and, of course, Lorenzo himself. Of these, the most important—indeed the leading Platonist of the Renaissance—was the remarkable Marsilio Ficino. Cosimo de'Medici had in 1445 established the idea of a group for the study of Plato, inspired by the Greek scholars living in his house during the Council of Florence. Not long after, a young Tuscan from Figline, a town near Florence, who had studied philosophy and medicine in the city, caught Cosimo's attention. This youth, Marsilio Ficino, had already published a major philosophic work in 1454, at the age of twenty-one. Two years later he began the study of Greek in order that he might know Plato in the original, a task that he accomplished so well that Cosimo established Ficino in his villa at Careggi in 1462 so that he might dedicate his life to translation, thought, and Plato.

The immediate results were astonishing. In 1463, Ficino translated the Hermetic Books, thought to be the writings of Hermes Trismegistus (Hermes the Thrice Blessed), who was associated with the Egyptian god Thoth, although these were actually a compilation of the works of several authors written over many centuries; and by the next year, he had translated ten books of Plato's dialogues, a huge undertaking that he completed sometime before 1469. The next five years, 1469–74, were taken up with his *magnum opus*: the *Theologia Platonica*, or *Platonic Theology*. Ficino continued to work at this pace until his death in 1499, although he appears to have retired from the city after the expulsion of the Medici in 1494. His funeral oration, nevertheless, was given by the chancellor of the republic, and a monument to him was erected in the Duomo.

Ficino was a rather curious individual. As a young man he had a reputation for being the handsomest man in Florence and had many women admiring him; however, he spurned them all in favor of Plato, not even apparently showing any interest in realizing his own belief in Platonic love for women. His first deep study of Plato turned him into a pagan, ostentatiously signing his letters "beloved in Plato" rather than the conventional "beloved in Christ." Nevertheless, Christianity reclaimed him when he read St Augustine and was convinced of the essential harmony between Platonism and Christianity. In fact, be became a priest about 1473, although he never foreswore his belief that Plato and Socrates partook of divine revelation just as the prophets of the Old Testament had done.

The second great Platonist of the Academy was the fascinating Giovanni Pico, count of Mirandola (1463–94), his lordship near Modena. After having studied at Bologna and Paris, this brilliant, noble, and precocious youth was coaxed to Florence by Lorenzo the

Figure 10.3 Florence: The Villa at Careggi. The villa was purchased by the Medici in 1417. Cosimo de'Medici commissioned the architect of his city palace, Michelozzo, to renovate this villa, which then became a favorite refuge for the family. Cosimo *il Vecchio* died there in 1464, as did his grandson, Lorenzo the Magnificent, in 1492. Marsilio Ficino continued to live in the villa after the fall of the Medici and died there in 1499.

Magnificent. Pico was spectacularly brilliant. He was accomplished in poetry, architecture, music, and of course, philosophy. His memory was unparalleled and his energy stupendous. Gracefully fluent in several languages, he was a popular figure with scholars. Pico's learning was truly encyclopedic, including all of the traditional spheres of knowledge in the classics as well as such exotic studies as Hebrew, Arabic, magic, and mysticism. He felt one of his duties was to prove for all time the concept of the unity of truth and to reconcile the great religions of the old Roman Empire—Judaism, Christianity, and Islam—as well as Platonic and Aristotelian philosophy.

In 1486, the twenty-four-year-old Pico caused some trouble by going to Rome and publishing nine hundred theses for debate. Some of these ideas were distinctly heretical, especially the rejection of the idea of eternal punishment for sin. Pope Innocent VIII decreed three theses totally heretical and drove Pico to abandon Italy for a brief period; however, the Borgia pope, Alexander VI, not caring much about such theological details as heresy, recalled Pico from Paris where he had traveled to study. But Pico returned instead to Florence, where he was converted—as were a number of leading Florentine neo-Platonist intellectuals, including Botticelli—by Savonarola to his puritanical fundamentalism. This new Pico rejected his past and his earlier quest for perfect knowledge; he destroyed all of his love poetry during the burning of the vanities; he gave away his fortune, not for learning but to aid the poor; then he began a monastic life, although he died (at only thirty-one) before he could take his final vows as a Dominican.

The third member of the Platonic Academy, Angelo Poliziano, is remembered more for his poetry than for his philosophy. Born, like Ficino, outside Florence near Montepulciano, he took his name from the hill, Monte Poliziano, where his family lived. Having come to Florence as a boy, he studied Latin with Cristoforo Landino (1424–98); and Greek and Platonism with Ficino himself. At sixteen he began a translation of Homer into Latin verse that exceeded any previous version, thereby demonstrating a talent that Lorenzo de'Medici recognized and encouraged, eventually giving the young man the important position of tutor to his son, Piero. This job gave Poliziano access to the great books in the Medici library as well as much leisure. He took advantage of the situation by editing and translating Greek and Latin texts. His lectures in classics were famous throughout Europe, attended by Lorenzo, Pico, and foreign students from every country. His Latin and Greek were so perfect and his style so exact that his original work could easily be mistaken for an ancient piece, a talent he employed by prefacing his commentaries and editions with dedicatory poems in the style of the author studied.

Also, Poliziano was a master Italian poet, perhaps the greatest vernacular poet since Petrarch. Bringing Italian poetry up to date, Poliziano used more modern diction and vocabulary, giving a greater sense of ease and naturalism, breaking finally the stranglehold of the *canzoniere* over the Italian vernacular lyric. In addition, he sought out new literary forms. He studied the popular songs and ballads of the local peasantry, restructuring them into elegant, finished pieces. Similarly, he attempted to restore Greek Dionysian theater, uniting drama, poetry, and music by writing in 1472 his *Fable of Orpheus (La Favola di Orfeo)*. Although Poliziano's original music is lost, what he did was not to recover an ancient mode, but discover a new one, opera, whose development can be traced to the Florentine experiments in uniting drama and music.

Poliziano truly loved the Medici. It was he who in part saved Lorenzo's life during the Pazzi Conspiracy in 1478 by bolting the doors of the sacristy after the murder of Giuliano and taking turns sucking the wound. All Medici triumphs, loves, and sorrows were celebrated in his verse, especially *Le Stanze per la giostra di Giuliano de'Medici (Poems on the Joust held by Giuliano de'Medici)*, an unfinished poem begun in 1474 that the poet could not complete because of Giuliano's tragic death. If Botticelli is the Medici's painter, then Poliziano was their poet. Like the artist, he often used his patrons as figures in his work, and like Botticelli again, he was a thorough Platonist whose poetry is full of that vision of love. Botticelli used his poetry as the program for some of his most important paintings, such as *Primavera* and *The Birth of Venus*, which are animated by Poliziano's verse and allusions to many of the themes and ideas of ancient literature. Polizano never recovered from Lorenzo's death, mourning wretchedly until his own death in that most fateful of years, 1494. Nevertheless, his devotion and that of Botticelli and Pico della Mirandola live still in their portraits found in the company of Lorenzo and his family in Botticelli's *Uffizi Adoration*.

Before leaving this world of the circle of Lorenzo the Magnificent, it is necessary to mention another intimate of this coterie who, although not really a consistent Platonist, was a participant of the Platonic Academy and an important contributor to the civilization

of Laurentian Florence: Luigi Pulci. Pulci was a comic poet, a man celebrated throughout Italy for his wit and sense of humor; and in a humane way he provided some necessary relief from the intellectual and philosophical rigors of Renaissance neo-Platonism. His famous poem is the satiric epic *Morgante Maggiore*, which during its composition was read by the poet, canto by canto, to Lorenzo and his friends during their social gatherings. The poem is a satire on the chivalric epic (like the *Song of Roland* or, in Italian literature, Ariosto's *Orlando Furioso* and Boiardo's *Orlando Innamorato*), but constructed by giving the noble knights of Charlemagne's court bourgeois values and speech patterns. Pulci used sources from legitimate romances and epics and other obscure tales and books that Lorenzo lent to him from his library. The Church is often the object of his satire—Morgante is a Saracen—but the tone is that of Boccaccio, not that of atheism. Anti-clericalism was—and is—a Florentine character trait. Theology is burlesqued and each canto is introduced by a sanctimonious divine invocation: the more ridiculous the canto's action, the more pious the hymn to God and his saints. Still, Pulci deserves mention with the Academy around Lorenzo because his poem was influenced, as was almost everything in Laurentian Florence, by Renaissance neo-Platonism. *Morgante Maggiore* ends with a statement establishing the essential goodness and truth of all religions. Some critics have read this as an attempt to offend the pious Christian reader. But, given what we know about Lorenzo and his companions in the Platonic Academy, this is evidently not true. Lorenzo was a very sincere, indeed devout Christian, and he would not have been amused by such blasphemy. And we know about Pico's concept of the unity of truth and the general Platonic belief in harmony and love. Perhaps Pulci is saying something of that through humor and satire.

Finally, then, let us review our observations about neo-Platonism, particularly in the Florentine context. Civic humanism developed before 1434 while Florence was still a functioning republic; its ideals were suited to engaged and active humanism, given that a pluralistic government was assumed and indeed required. But neo-Platonism entered Florentine thought at almost exactly the same time as the Medici hegemony. Cosimo came into contact with it from Greek scholars living at his house during the Council of Florence of 1439, just five years after he had captured the communal government. He fostered, propagated, and legitimized these neo-Platonic ideas through his support of Ficino and his gift of the villa at Careggi where the work could be conducted without interference. He gave these new ideas social cachet by associating them with his new political dispensation. Lorenzo continued this flirtation, out of both sincere personal interest and a desire to define the dominant culture of the intellectual elite according to those interests. To be a Renaissance neo-Platonist was to be close to Lorenzo, a member of the inner circle of the intelligentsia, aware and informed of the elaborate allegories, puns, and ideas of the art of Botticelli and the poetry of Poliziano. In a republic without a court, intimacy with the uncrowned prince Lorenzo de'Medici was through shared ideas, personal contact, and friendship. This suited the young Florentine patricians whose humanist education had turned them into intellectuals, but in a world where the exercise of that learning and those values had been circumscribed by the Medici hegemony. The Medici and their closest advisors made decisions, and little independent authority remained outside their

Figure 10.4 (facing page)
Florence, Santa Maria Novella, Tornabuoni Chapel. Domenico Ghirlandaio (1449–94): *The Platonic Academy, 1485–90.* Ghirlandaio was commissioned to fresco the chapel of the Tornabuoni family, who were closely related by marriage to Lorenzo the Magnificent. This detail from the lower left of the section of the fresco, which depicts the New Testament story of the angel appearing to Zacharias, contains portraits of Ghirlandaio's contemporaries and friends, including in this detail members of the Platonic circle: Marsilio Ficino, Cristoforo Landino, Angelo Poliziano, and Demetrio Chalchondiles (1423–1511).

faction. Access to that power was therefore paramount to the educated elite, and therefore these sophisticated and ambitious patricians accepted Renaissance neo-Platonism as a substitute for civic humanism. The republican world that had given such impetus and nourishment to civic humanism was gone, and what was left was a court culture dependent on ideas that did not challenge the political reality of Medici control.

FURTHER READING

Allen, M.J.B. *Marsilio Ficino: His Thought, His Philosophy, His Legacy*. Leiden: Brill, 2002.

Cassirer, E., Kristeller, P., Randall, H. *The Renaissance Philosophy of Man*. Chicago: University of Chicago Press, 1956.

Field, A.M. *The Beginning of the Philosophical Renaissance in Florence, 1454–1469*. Ann Arbor: University of Michigan Press, 1980.

Hankins, James. *Plato in the Italian Renaissance*. Leiden: Brill, 1990.

———. *Humanism and Platonism in the Italian Renaissance*. Rome: Edizioni di storia e letteratura, 2003.

Raffini, C. *Marsilio Ficino, Pietro Bembo, Baldassare Castiglione: Philosophical, Aesthetic, and Political Approaches in Renaissance Platonism*. New York: Peter Lang (Renaissance & Baroque Studies & Texts), 1998.

Robb, Nesca. *Neo-Platonism of the Italian Renaissance*. London: Allen and Unwin, 1969.

ELEVEN

THE AGE OF CRISIS

THE FRENCH INVASIONS of 1494 were to end forever the special, protected place of Italy in Europe. As the great territorial monarchies of northern Europe—France, Spain, and the Habsburg lands—grew restless and ambitious, the rich cities of the peninsula began to attract invaders, each struggling for control of disputed territory. Italy after 1494 became the battlefield of Europe, and the fate of a pan-European balance of power among the major dynastic monarchies and the Holy Roman Empire was to be determined by their success in the peninsula. The Italian Renaissance had irrevocably entered the era of European politics.

THE AGE OF THE PEACE OF LODI, 1453–94

Italy before 1494 still represented the full flower of the phenomenon of the Renaissance. It would be too dramatic to call the forty years before the armies of Charles VIII crossed the Alps to claim Naples a lull before the storm. There was a peculiar quality about those years that in some ways conditioned not just Italy but all of Europe to prepare for a significant realignment of perspective; indeed, many historians have seen the period between 1453 and 1494 as one of reassessment in European affairs, a time when the complexions and institutions of most European, including Italian, states changed dramatically for a number of reasons, all mutually interdependent. To a certain extent, it was this very period of 1453–94 that determined the course of Italian affairs for the future in such a way as to take the initiative out of the hands of the leaders of Italy, so that a malevolent *fortuna* appeared to rule mankind's affairs, despite the heroic resistance of *virtù*.

The character of those forty years as a coherent historical period depends somewhat on the cataclysmic event that began them: the conquest of Constantinople by the Turks in 1453. Although the Byzantine empire had been limping along weakly for years, the fall

of the city built by and named for Constantine the Great (r. 312–337), the emperor who recognized Christianity, and for so long the center of a continuous tradition that linked it to Romulus and Remus, was shocking. Constantinople had been conquered by infidels, Turks who turned the great church of Hagia Sophia (Holy Wisdom) into a mosque and slaughtered the red-shoed emperor. The Byzantine collapse was a disaster comparable only to the sack of Rome by Alaric in 410 or the later looting of that city by similar barbarians in 1527.

Besides the psychological effects, the collapse of Byzantine rule in the eastern Mediterranean had pernicious effects on long-distance Eastern trade. Gone forever was the virtual monopoly that Venetian merchants had enjoyed there. The vigorous Muslim regime in Constantinople demanded, and got, higher customs duties and prices, resulting in a severe reduction in profit for the Italians. In addition, the region was now open to competition. Although in theory a good stimulus to trade, competition in the Ottoman empire too often simply encouraged the expensive duplication of missions, resulting in reduced trade for all. And, more ominously for Italy, the decline in profits coming from the traditional overland and Mediterranean routes from Europe to India and China drove investors and adventurers to look for alternative ways of securing luxury goods from the East, first by circumnavigating Africa and, by the end of the century, by sailing west across the Atlantic. These experiments were destined to remove the necessary place of Italy as the middleman between East and West, the circumstance that had originally built the peninsula's wealth. In addition, the greater insecurity of trade drove many Italian merchants—especially Venetians—to invest in safer areas, most notably landed estates that produced a small but relatively secure income. Precious capital was thus diverted from commerce into ground-rents, turning the ambitious merchant patricians into rural *rentiers*.

The year 1453 marked another great event in European history. It was in that year that the Hundred Years' War between England and France and several of their neighbors and allies finally ended. From the beginning, the Italians had profited from this wide conflict, first by extending credit to the kings of both countries in their campaigns against each other, and, second, by being unopposed in their commercial ventures both in the peninsula itself and in northern Europe. The territorial monarchies of northern Europe had needed the Florentine, Venetian, and Genoese businessmen who resided in their territories; and those merchants made significant fortunes by playing on the constant warfare and need for goods and credit, exporting their profits home to build the culture of the Italian Renaissance.

However, once some stability returned to northern Europe, the place of Italian merchants was not as secure. The prolonged peace of the second half of the fifteenth century allowed northern Europeans to develop their own credit institutions and industries to compete with the Italians. Great mercantile houses arose, built by men such as Jacques Coeur (c. 1395–1426) in France and Jacob Fugger (1459–1525) in Germany. Similarly, peace and the absence of marauding troops permitted the development of the indigenous Flemish cloth industry, which increasingly began to steal markets away from the ancient Florentine companies. Equally, at just this same time, the English civil wars, the Wars of the Roses, compromised the continuous production and export of English wool, a major

source of the Florentine cloth industry's supply of raw material. Faced with having to compete with the Flemish not only for markets but also now for a dwindling supply of wool, Florentine companies were driven to increase the price of Florentine cloth, exacerbating an already weakened position; the foundation of the city's prosperity languished almost beyond repair, causing reduced profits for entrepreneurs and huge unemployment and low wages among the *ciompi*.

The end of hostilities in northern Europe also allowed the great territorial monarchies, especially France and Spain, to consolidate their states. The rule of the king of France was imposed upon the entire nation, reducing the great feudatories to subject vassals in reality as well as law and increasing the dignity of the king in Paris. Equally, Spain began to unite under the crowns of Castile and Aragon, a development ultimately cemented by the dynastic marriage of Ferdinand of Aragon and Queen Isabella of Castile and signified by the attack on the Moorish kingdom of Grenada, which occupied the southern half of the Iberian Peninsula. Therefore, by the end of the fifteenth century, France and Spain had become very powerful, much more unified, centralized, and ambitious territorial states, eager for domination of Europe and somewhat free of serious third-party challenges because of England's exhaustion after the Wars of the Roses and the continued divisions in the Habsburg lands. The ambitions and desire for glory and riches within these two kingdoms, France and Spain, were to have devastating results for Italy, on which they both had dynastic claims.

It was these dynastic claims that to a large extent determined the course of European history for the next centuries. Feudalism had ceased to be a viable foundation for a large state, but national self-awareness had not yet sufficiently developed to provide for the concept of the nation-state. Thus, the ambitions of the king and his family, whether Valois, Habsburg, Anjou, or Aragon, determined the direction of affairs; and, unfortunately, the great number of Italian states had so often provided brides for northern royals that a number of outstanding claims on Italian principalities existed, most importantly those of France and Spain on Milan and Naples.

Superficially, events in Italy paralleled the developments in trans-Alpine Europe between 1453 and 1494. The last part of the fourteenth and the first half of the fifteenth century, as we have seen, witnessed almost continuous warfare among the Italian states. Milan, Venice, and Florence had all expanded dramatically at the expense of their weaker neighbors and had built what were, in effect, territorial states on the peninsula. The papacy had fought hard merely to resist having the pope's territorial patrimony reduced by the aggressive expansionism of other states and hence had taken part vigorously in these wars. Also, the large, feudal kingdom of Naples had intervened on a number of occasions to ensure a kind of reasonable balance of power in the peninsula so that its undisputed control of the country south of the states of the Church might be secure. However, in 1454, this period of constant, hemorrhaging warfare declined precipitously when the five largest territorial states—Milan, Venice, Florence, the states of the Church, and Naples—signed the Peace of Lodi. This treaty recognized the five powers collectively as the arbiters of Italy's destiny and established a rough balance of power among them, dependent upon agreed spheres of influence.

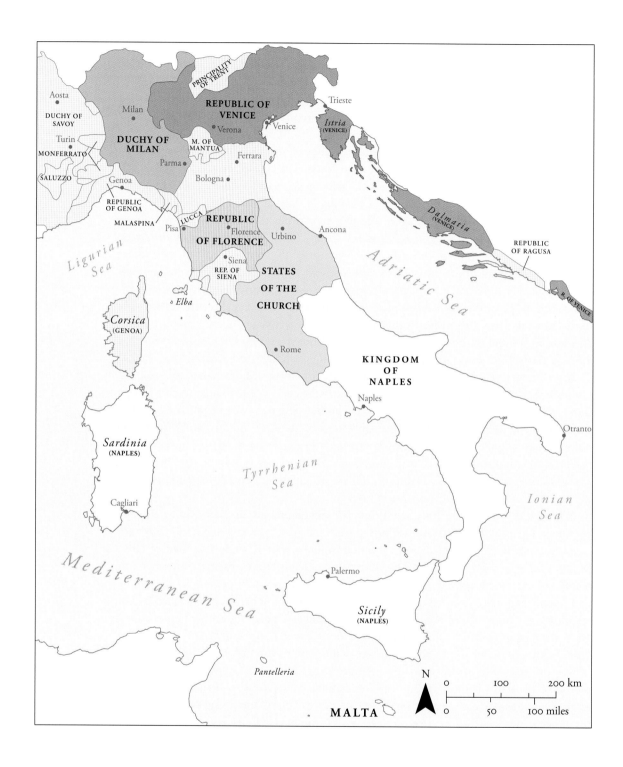

PRINCIPALITY
OF TRENT

REPUBLIC OF
VENICE

Aosta

DUCHY OF
SAVOY

Milan

Trieste

Istria
(VENICE)

Verona

Venice

Turin

DUCHY OF
MILAN

M. OF
MANTUA

MONFERRATO

Parma

Ferrara

SALUZZO

Genoa

Bologna

REPUBLIC
OF GENOA

Dalmatia
(VENICE)

MALASPINA

LUCCA

REPUBLIC
OF FLORENCE

Pisa

Florence

REPUBLIC
OF RAGUSA

Urbino

Ancona

Ligurian
Sea

Siena

REP. OF
SIENA

STATES
OF THE
CHURCH

Adriatic
Sea

R. OF VENICE

Corsica
(GENOA)

Elba

Rome

KINGDOM
OF
NAPLES

Naples

Otranto

Sardinia
(NAPLES)

Tyrrhenian
Sea

Ionian
Sea

Cagliari

Mediterranean Sea

Palermo

Sicily
(NAPLES)

Pantelleria

N

0 100 200 km

0 50 100 miles

MALTA

In the north, the duchy of Milan and the republic of Venice divided Lombardy between them (although Mantua, ruled by the *condottiere* marquises of the Gonzaga family, retained its independence). Florence, despite its lack of an army, dominated Tuscany, maintaining control by paying mercenaries from its enormous financial reserves. This wealth in gold was augmented by the republic's wealth of diplomatic and political talent, directed by the heads of the house of Medici. Cosimo de'Medici, known as *il Vecchio* (the elder, 1389–1464), had much to do with arranging the peace, and his grandson Lorenzo (1449–92) had everything to do with its proper and smooth operation. Siena and Lucca both remained independent republics in Tuscany, but they were just ciphers in the wider diplomatic and political picture.

The heterogeneous and decentralized papal states surrounded Tuscany on three sides. In this area, there were several *de facto* independent states, and some, like the Este family lands of Modena, Reggio, and Ferrara, were also free principalities *de jure* (although Ferrara was claimed as a fief of the pope). These Este states were respected—indeed supported—because they served as a buffer between the papal states and the territories of Milan and Venice. To the south, occupying nearly half the peninsula, and, occasionally, the island of Sicily, was *Il Regno*—the kingdom of Naples.

The Peace of Lodi was in many ways an internally directed strategy, one that established stability among the rulers of the peninsula. Areas of influence were recognized by the five major Italian powers; and Florence and Milan, under the direction of their parvenu leaders, Cosimo de'Medici and Francesco Sforza, needed peace and security to secure their regimes. However, the real threat to peace in Italy came from without. Freed from war with England, France was positioned to reassert its claims on the kingdom of Naples and dispossess the Aragonese dynasty ruling there. Equally dangerous, the dukes of Orleans, the cadet branch of the French house of Valois, had a legitimate claim on Milan through their Visconti descent. (When the Visconti had died out in the primary male line with Filippo Maria in 1447, the succession had fallen by conquest to Filippo Maria's son-in-law, the *condottiere* Francesco Sforza.) Because of these threats, the two leading statesmen in Italy, Francesco Sforza and Cosimo de'Medici (both of whom had only recently achieved their positions in their respective states and both by unorthodox means), required a mutual defense pact. It was clear to them that the loss of one state to the barbarian invaders from across the Alps would jeopardize the liberty of all Italy. Renewed war or instability would be an invitation for the French to invade, and that catastrophe had to be avoided at all costs.

Consequently, the year after it was signed, the Peace of Lodi was extended into the Italian League (1455). This agreement promised that should one of the states be attacked by a foreign or other Italian power, all other states would come to its aid. The ostensible purposes of this League were to establish a political equilibrium throughout the Italian peninsula and to stop the endemic warfare that was bleeding all Italy. There was also some blustering talk of another Crusade against the Turks to reconquer Constantinople. However, the real purpose of the League was to present a united front against France. Despite these intentions, the ambitions and capacity of the northern European powers could not be withstood, as was seen in Chapter Nine in our discussion of the internal

Map 11.1 (facing page) States Participating in the Peace of Lodi, 1454

development of the principalities. Just as if the Renaissance vision of *fortuna* had been exactly correct, the last years of this era of peace witnessed a number of catastrophic coincidences strange enough to warrant any wise individual's belief in the absolute power of malevolent deities. These circumstances led to the French invasions and Italian wars that were ultimately to reduce the peninsula to a backwater of Europe.

THE RISE OF SAVONAROLA

However, the unraveling of the Peace of Lodi resulted not so much from foreign intervention but from events in the republic of Florence itself, an instability that arose in the benign form of an itinerant preacher from Ferrara. Girolamo Savonarola (1452–98) began as a Dominican friar of considerable learning and talent but, building upon the strong Italian popular mystical tradition (illustrated, for example, by Joachim of Fiore) gradually transformed into a fiery self-appointed prophet of the apocalypse, the second coming of Christ, whose reign of saints was first to be prefaced by the rule of the Antichrist.

Savonarola's sermons and prophecies caught the attention not only of the disenfranchised, especially the poor and women, the traditional audience of apocalyptic preaching, but also of influential men such as the philosopher and scholar Giovanni Pico della Mirandola, who was rapidly turning into something of a mystic himself. In 1491, Pico, playing upon Lorenzo de' Medici's natural piety, suggested Savonarola as the new prior of the monastery of San Marco, to which the Medici enjoyed some rights of patronage. Thus began one of the strangest experiments in theocracy in Italy, an experiment incongruously played out in the anti-clerical, brilliant, sophisticated, and wealthy Florence of Lorenzo the Magnificent. Savonarola seduced the city with his prophecies and style. No one was secure from the virulent verbal assaults that he claimed came from God himself. He castigated the regular clergy, the papacy, the patricians, the bankers, and even Lorenzo de' Medici, whom he called a tyrant. All of the glory of what we now honor as the Renaissance was attacked by Savonarola as heathen or pagan: for him literature, painting, secular learning, and classical studies all deserved destruction.

At first, Lorenzo tried to win over Savonarola: Medici supporters put large sums of money in the collection plate, but Savonarola only returned these gifts, saying that payment for sin was of a different kind. Also, Lorenzo himself tried to reason with the Dominican, who after all was prior of the house built by his family; but again Savonarola refused to compromise and indeed was encouraged when Lorenzo suggested that such inflammatory preaching might lead to civil discord. Moreover, apparently, Lorenzo himself was falling under the Dominican's spell. The disciples of Savonarola called this to witness for Savonarola's divine gifts and powers and, obviously, his veracity. However, at this time (1491–92), Lorenzo was very sick, dying in fact, and the thoughts of a dying man might easily move to even this strange source of comfort. At the end, Lorenzo did, as was traditional among the Medici, call for Savonarola to administer extreme unction.

Savonarola's followers interpreted this as Lorenzo's acceptance of the Dominican's position. But common sense suggests that Savonarola was summoned in his role as prior of San Marco rather than as the millenarian preacher.

Whatever the significance of his final confession, by the time of Lorenzo's death Savonarola's following in Florence was enormous. He moved out of San Marco into the vast cathedral to proclaim his prophecies; and even then the large piazza surrounding the Duomo was jammed with those unable to enter because of the crowds inside. Also, the Dominican became bolder, separating his convent of San Marco from the rest of the Dominican province, an act of clever independence reluctantly agreed to by the new pope, Alexander VI, who failed to understand anything of Savonarola's influence until later. The attacks on the Medici became savage, as did the attacks on the moral failings of the pope and his Church. Savonarola preached vehemently against the power of Rome, the worldly wealth of the Church, and, without acknowledging the irony of his position, all political involvement by clerics. Most effectively, though, he attacked the Medici as tyrants, attacks that were easier to sustain because Lorenzo's son and heir was the weak, silly, and ineffectual Piero de'Medici (1472–1503).

A lucky series of prophecies had brought much of the populace of the city under Savonarola's spell. He had predicted, correctly, that Lorenzo de'Medici and Pope Innocent VIII would both die in 1492. Then, in 1494, he correctly foretold the invasion of Charles VIII of France and declared him a divine agent sent to punish Italy for its sins of pride, luxury, paganism, and idolatry. The Dominican was also very clever in flattering the Florentines' egos. He said that the city had been chosen by God for the second coming, but it had first to cleanse itself of sin. This promise was clearly a link back to Bruni's praise of the exceptionalism of the Florentine republic. Bruni, writing during the apogee of the influence of civic humanism in Florence, had in his *History of Florence* and other books claimed that Florence was exceptional because of its commitment to, and practice of, republican liberty. Florence was the heir of republican Rome and had proved its worth fighting tyrants such as Giangaleazzo Visconti. Savonarola also recognized the exceptional nature of the republic, but to him it was exceptional because of the religious and moral purity that was to be perfected through his personal spiritual leadership. The idea of Florence as the new Rome or Athens was replaced by its role as the new Jerusalem. Florence was still the guiding light of Italy, but now as a spiritual and devout rather than a cultural or political model.

THE EXPULSION OF THE MEDICI AND THE THEOCRACY OF SAVONAROLA, 1494–98

In September 1494, Charles VIII of France had crossed into Italy in order to assert by force of arms his claim, through the house of Anjou, to the kingdom of Naples. But in order to reach Naples, he had first to march through the length of the Italian peninsula.

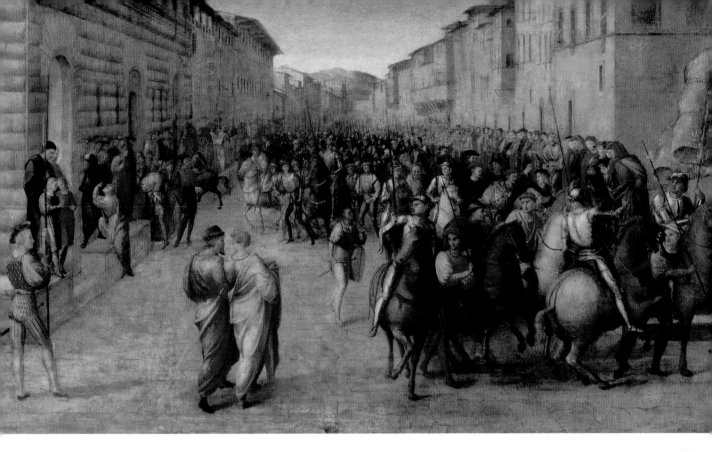

By October, the French army, composed not of professional mercenary soldiers led by *condottieri* captains but of feudal levies led by the great nobles of France, invaded the territories of the Florentine republic. Florence had supported the new Neapolitan king, Alfonso, against the regent of Milan, Lodovico il Moro, despite the traditional Medici alliance with the duchy. Thus, Florence found itself at war with France and open to attack by the huge national army that the ambitious king had brought with him. The French opened the campaign by besieging the fortress of Sarzana. Anxious to avoid a battle, Piero de'Medici determined to counter the French threat through personal diplomacy as his father had done against Naples during the War of the Pazzi Conspiracy. But the silly and cowardly Piero could not have hoped to repeat his father's brilliant feat. Instead, when Piero met with Charles at Sarzana, he collapsed immediately in the face of the tough, aggressive, patronizing French demands for total capitulation. Florence was required to yield both of her ports—Pisa (the object of Florentine ambition throughout the fifteenth century) and Livorno; and all Florentine fortresses and bastions on the western perimeter of the republic's territories, including Sarzana, were opened to the French. And, finally, as a humiliating insult, the city had to pay Charles 200,000 florins to finance the French campaign: in effect the Florentines were forced to pay for their own defeat.

When the Florentines heard of this abject debasement, they revolted. Piero had not consulted with his *signoria* beforehand, and even his most loyal supporters were scandalized and humiliated. Consequently, led by the old opponents of the Medici faction, now greatly strengthened by the party of Savonarola, and even Piero's cousins of a collateral

Figure 11.2 Florence, Uffizi. Francesco Granacci (1469–1543): *The Entry of Charles VIII of France and His Army into Florence on 17 November 1494* (1518). The entry of Charles's army into Florence following the expulsion of the Medici and the humiliation of Piero de'Medici was a huge blow to Florentine esteem, as it appeared as though the French had entered the city as a conquering army. The arrogance of the French king and his nobles was reflected in the exchange between Charles and the Florentine republican magistrate, Piero Capponi (1447–96). Charles threatened to sack the city, saying he only needed to blow his horn and the French troops would attack. Piero Capponi famously responded, "If you blow on your horn, we shall ring upon our bells," the traditional signal for all Florentines to gather in the Piazza della Signoria for the defense of the city.

Medici line, the people revolted, deposed Piero, and restored the institutions of the pristine republic. The Palazzo della Signoria was barred to him; the common people insulted and threw mud at him as he rode through the streets. Recognizing the danger, Piero and his immediate family fled the city. The great Medici palace on the Via Larga was looted, as were the houses of all their supporters. The marvelous art collection amassed over four generations was carried off and the remainder sold. A bounty of 5,000 florins was offered for Piero or his clever brother, Cardinal Giovanni de' Medici (later Pope Leo X), if captured alive, two thousand if dead. The new government sent an embassy to Charles VIII trying to undo Piero's damage to Florentine security, prestige, and commerce, but unsuccessfully. Pisa declared its independence immediately and collected an army for its defense, while Charles of France rode through Florence in triumph, en route to Naples.

After the French had departed, the *signoria* summoned the ancient, traditional council of all the people, a *parlamento*, convened by ringing the great bell in the tower of the Palazzo della Signoria. The priors asked for and were granted the authority to name twenty men who would then appoint a new *signoria* and magistrates to rule for one year; thereafter, all offices were again to be filled by lot, with candidates chosen from all eligible male voters. This emergency council, the Twenty, abolished all of the mechanisms by which the Medici had controlled the city, giving the responsibilities to themselves. However, with the Medici gone, the Twenty could not agree on anything. The focus and leadership had been removed from public policy, leaving the government open again to factional, family, and personal antagonism and class warfare: all the old, pre-Medicean republican plagues returned to Florentine public life.

Realizing that public order was about to break down in this moment of extreme crisis, the Twenty suggested that Savonarola be admitted to their council. Only he, it was argued, enjoyed significant respect by all groups of citizens. Invited to address the Twenty, the Dominican prior promulgated a new revolutionary program of political, economic, and moral legislation. On the basis of this, the Twenty, then led by Piero Soderini (1450–1522), constructed a new constitution, modeled on the Venetian republic that was everywhere seen as a perfect design for a stable, mercantile state. As in Venice, the authority of the state was to reside in a great council, this one to be comprised of five hundred members drawn from old political families, specifically all of those families whose ancestors had held high office for three generations. This Council of Five Hundred, as it was named, was then to elect twenty-eight additional members per year to prevent the council becoming a closed caste, as in Venice, and to allow new men of talent to rise in service of the state. Altogether, this innovation was a dramatic mixture of Venetian aristocratic and Florentine democratic constitutionalism. Also, never before had the corridors to power been open to so many citizens.

The Great Council was in addition to elect the executive, which remained essentially as it had been constituted for the previous two centuries. Eight priors and a *gonfaloniere* served for their traditional two-month periods, and various committees charged with specific responsibilities, such as taxation, administration, and war, were nominated to ease their duties. Supported by Savonarola, this new constitution was publicly proclaimed and came

into force on 10 June 1495. The new government and its officers began indulgently. A general amnesty was issued against all previous supporters of the Medici. All taxes except the ten per cent levy on real property were abolished, thereby exempting once again the class who controlled the government: the merchants. This was a return to pre-Medicean fiscal irresponsibility, as the heaviest taxation again fell on the land-holding aristocracy and, of course, the poor, whose rents were vulnerable to any increase in property taxes. Also, an important new bank, the Monte di Pietà, was established, largely through Savonarola's instigation. Its purpose was to lend money to the poor at low rates so that they might escape the hopeless treadmill of the moneylenders and perhaps find ways of improving their lot. Despite the bank's obvious popularity, a number of the Florentine banking families were displeased, since previously in bad times they had been able to squeeze their debtors for as much as thirty per cent interest.

The wide range of moral legislation also reflected Savonarola's puritanical influence: horse races, salacious songs, swearing, and gambling were outlawed. Torture was encouraged as much as possible to heighten the people's fear of sin. Servants were required by law and exhorted in sermons to inform on their masters. Blasphemers had their tongues cut, and sexual crimes, especially homosexuality, against which Savonarola had a strong personal animus, were severely and mercilessly punished as only a celibate Dominican could imagine. This harsh new moral dispensation was enforced by the frightening Savonarolan brigade of boys, pledged when very young by pious parents to attend mass and sermons regularly and to stay away from entertainments such as plays, acrobatics, jugglers, and other popular Renaissance childhood pastimes. They also avoided wicked company, any kind of erotic literature (including Boccaccio and Ovid), dancing, music, and stylish fashions; and they wore their hair unfashionably cut short as a badge of their loyalty. Organized into what were called "Bands of Hope," these boys wandered the streets breaking up card parties and other wicked gatherings and actually ripping the clothes of women whom they considered to be indecently dressed. It has been said that only the worst kinds of repressive regimes give power to children; and this theory appears to have been true in Savonarolan Florence.

Still, this feeling of puritan enthusiasm took hold of the city with a frightening intensity. Society women dressed modestly, hid their jewels, and changed their social activities. Hymns replaced the traditional carnival songs, churches were always filled to overflowing, and personal fortunes, like Pico della Mirandola's, passed to the poor. Savonarola called upon the rich to avoid luxury and work harder than their employees to set an example to regenerate the economy. Government, said Savonarola, belonged not to the Florentine citizens but to Christ, and he urged the people to abandon their traditional factions and ambitions, yielding instead all power to their "invisible king." In this way, Florence would become the new Jerusalem and cleanse all Italy, indeed the Church and the papacy—and eventually the world—of sin. Civic virtue had given way to a millenarian theocracy.

However, popular as Savonarola was, he had powerful enemies. The first among these were the men of the great patrician families who were furious at having finally thrown out the Medici without reaping what they considered their natural rewards: a return to the

old oligarchy. The Savonarolan republic—theocratic and democratic—disgusted them. Part of this disgust resulted from their very worldliness. The young patricians had always enjoyed their gambling, drinking, and brothels, as had a sizeable portion of all the other classes. These men saw the new reign of virtue as a bore and were determined to end it as soon as possible. Also hostile to Savonarola were the powerful Franciscans of Santa Croce. Rivalry had always existed between the two mendicant orders, and the enormous success of the prior of the Dominican house of San Marco infuriated the Franciscans, who had lost many paying customers to the friar's sermons. They attacked Savonarola from their own pulpits, just as he attacked the secular clergy, planting serious doubts in the minds of many Florentines about the wisdom of following Savonarola's theocratic program. Finally, there were the humane skeptics, the humanistically trained gentlemen who were horrified by the friar's success and excesses. The Bands of Hope appeared like a bad dream, dividing families, and driving sons to denounce fathers and servants their masters. Good government must be more than an apocalyptic vision of the Rule of Christ and his saints.

Thus the city divided into two huge, mutually antagonistic, hostile camps of about equal size: first, the Savonarolans, or *Piagnoni* (that is, the Snivelers, because of the weeping and crying among Savonarola's followers during his sermons); second, the anti-Savonarolans, or *Arrabbiati* (the Enraged), so called because they were violent men with neither souls nor reason, according to the Dominican. The first major confrontation came in early 1496, just months after the promulgation of the new constitution. An *Arrabbiato gonfaloniere* was elected, one who particularly hated Savonarola. He attempted to weaken Savonarola's authority by summoning him before the *signoria*, to which were added learned theologians, including a Dominican. Savonarola was required to answer two elemental questions: first, *Do your prophecies come from God?* and second, *Why do you seek to involve yourself, a monk, in politics where you have no business by your vows and the Florentine constitution?* Savonarola, riding high, contumaciously refused to answer and just walked away.

Savonarola still might have succeeded in his attempt to convert Florence into the heavenly city except for two factors: his total failure in foreign affairs, where he was a silly bungler; and, as we have so often seen, the refusal by the people of Florence to forgive military failures. The loss of Pisa in 1494 was a disaster to Florentine pride and commerce, and the Pisans made the situation worse by allying with Milan and Venice against Florence. Savonarola made the mistake of preaching that Pisa was his to command, since God had given it to Florence. The Pisans, however, thought otherwise, and neither God, nor his Dominican instrument, could convince the object of their intentions to yield. In addition, Charles VIII was driven from Italy. Of all the major Italian states, Florence alone had not taken part in what was seen as a glorious moment in Italian history: the victory at Fornovo. Savonarola remained stubbornly loyal to Charles VIII, for which the French repaid him by selling the Tuscan perimeter fortresses, garrisoned by French soldiers, to Genoa and Lucca. This military humiliation also led to the revolt of other subject states, such as Arezzo and Volterra, against Florentine control. In short, the Florentine state was disintegrating while Savonarola preached, the magistrates wept and sang hymns, and the youths of the city tormented their elders.

The loss of the rich territories of the *contado* (which paid a much higher tax levy than the city) and of the ports on the Mediterranean resulted in a fiscal crisis for the city as well: the government was bankrupt. *Monte* stock, the barometer of the city's solvency, traded at ten per cent of its face value; and money was even borrowed illegally from the *Monte delle doti*, the girls' dower fund, to help finance the commune. Nevertheless, it was not enough: the city approached fiscal collapse. The almost complete incompetence of the *Piagnoni* officials exacerbated this situation. Contempt for the material world and mortification of the flesh do not make for good administrators. Faced with continued and valid criticism of the government, the *Piagnoni* denied the *Arrabbiati* admission to the Great Council if they were behind in paying taxes, which almost everyone was because of the depression. Only followers of Savonarola were allowed to address the Council, and all Franciscans not loyal to the Dominican were to be exiled.

Although all of these acts were illegal and resented, they were enforced by the highly organized fanatics of the *Piagnoni* party. Then a truly remarkable series of events, comparable only to Savonarola's correct prophecies of 1492–94, occurred. These had an effect opposite to those earlier miracles, again driving Florentines into a belief in *fortuna*. For eleven consecutive months after the *Piagnoni* mini-coup, it rained. The crops were destroyed, and famine and plague struck the city. By early 1497, people were dying in the streets; and when the government tried to alleviate the suffering by opening the communal reserves, hundreds of women were crushed to death by the riot that ensued. Later that year, five patricians of ancient lineage were accused of plotting in favor of the Medici. Their rights before the law were taken away, and they were summarily executed. Such open breaches of the law, and the repression, failure, and incompetence of the *Piagnoni* administration, began to alienate increasing numbers of Florentines. Long enough had passed to forget Piero's stupidity and remember instead the peace, glory, and prosperity of Lorenzo the Magnificent. Riots broke out before Savonarola's monastery of San Marco: mobs of *Arrabbiati* fought *Piagnoni* in the streets. An attempt was made on Savonarola's life during a sermon, and a bloody battle ensued both within and just outside the church where he was preaching. Florence was declining into total chaos.

However, it was not internal opposition that ultimately brought down Savonarola, but the great power of the Borgia pope, Alexander VI, who was becoming increasingly annoyed by the friar's attack on him and his clergy. In addition, Savonarola's continued allegiance to the French king frightened the pope, who was the head of another Italian League organized to keep the barbarians out of the peninsula. Both of Pope Alexander's fears were realized when Savonarola wrote to Charles VIII suggesting that he call a general council of the Church to depose the pope as an infidel and a heretic.

Alexander invited Savonarola to Rome to discuss the differences between them. Knowing that he would never come back alive, the friar replied that he was too ill to travel. Then the pope ordered Savonarola to stop preaching and come to Rome as soon as he was well; however, Alexander did not want to alienate Florence altogether, and as the *Piagnoni* had again captured the *signoria*, he relented and permitted Savonarola to preach during Lent. But then the pope had an inspiration: offer the fanatical Dominican

a cardinal's hat. Co-opt the opposition and bring him to Rome where he could cause no trouble. However, rather than accept this honor, Savonarola was insulted and enraged. He wrote to the pope that he would respond to his offer in his next sermon.

The friar's answer was a vicious attack on the papacy and on Alexander in particular. Moreover, he had this inflammatory sermon printed so that everyone might read it; it even reached the sultan of Turkey. Also, Savonarola increased his reign of moral terror in Florence. In preparations for Lent in 1497, the friar sent his Bands of Hope around the city, knocking on doors and demanding vanities, that is, cosmetics or unseemly literature—including the *Decameron* and *Morgante maggiore*, Catullus, Tibullus, and Ovid, among others—musical instruments, games, pictures, even beautiful clothes. Properly intimidated, or sympathetic as in the sad case of Botticelli, the citizens yielded their property. The loot was carried in solemn procession to the Piazza della Signoria, where the Bands of Hope, led by four boys dressed as angels and carrying a statue of Christ by Donatello, built a huge pyre five feet high and twenty feet in circumference. The fire consumed everything, including a number of precious classical texts of erotic poets and unique paintings by masters such as Botticelli. Meanwhile, the friar was intensifying his attacks on Pope Alexander.

These denunciations played into Savonarola's enemies' hands in Florence. Because the city was divided almost equally into two hostile camps of pro- and anti-Savonarolan zealots, the alternation of priors every two months changed the majority in the *signoria* from *Arrabbiati* to *Piagnoni* and back to *Arrabbiati* regularly. In April 1497, the *Arrabbiati* took control again and were determined to silence the rebellious monk. Sending agents to Rome, the Florentine patricians demanded that Savonarola be excommunicated to silence him. Alexander agreed, but he promised the Dominican leniency if he would come to Rome. Savonarola refused and further insulted the Pope by publicly celebrating mass, despite his excommunication.

The friar knew that the pope needed Florentine support against the French and therefore could not afford to break totally with the single most powerful figure in the city and the force behind at least half of all officials. Similarly, even a number of *Arrabbiati* began to fear the growing ambition of Pope Alexander VI, who was constructing a strong papal state around Florentine territories. Everyone resisted the idea of a papal army on Florentine soil. Because of those two contrary external fears, Savonarola remained secure for the moment.

However, once again the Dominican's vanity and his enemies' cleverness overcame him. A Franciscan challenged Savonarola to an ordeal by fire. The friar initially rejected the challenge but let one of his followers accept. And ultimately, even this was withdrawn. The challenge had the desired effect: those people who before had believed Savonarola to be God's instrument, despite the growing signs to the contrary, wavered. The *Arrabbiati* seized the opportunity. The next morning a mob marched to San Marco, killing the political leaders of the *Piagnoni* en route. They broke into the monastery and took Savonarola and his Dominican disciples prisoner. The bell calling the *Piagnoni* to assemble to protect Savonarola was rung, but none came. Savonarola and his leading companions were led in chains through a jeering mob to cells in the Palazzo della Signoria.

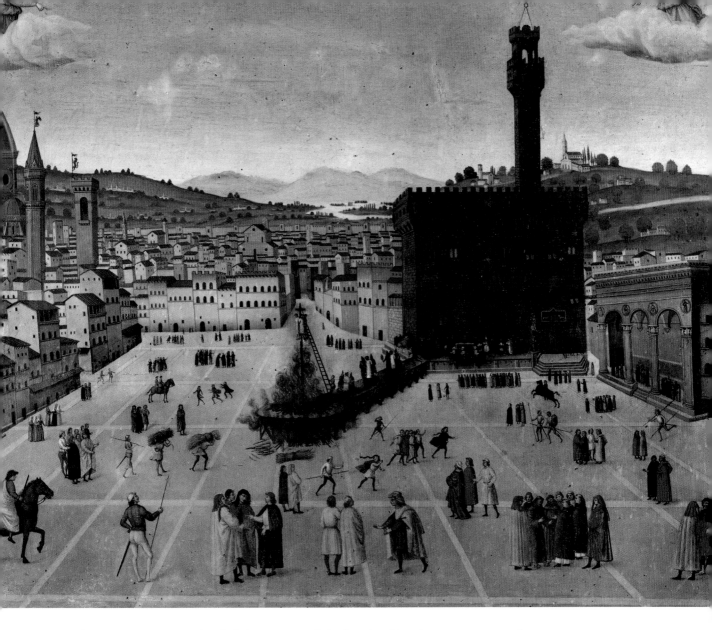

The *Arrabbiati Signoria* decided that Savonarola had to die if his faction was ever to be dissolved. Only then could the tragic division within the city be healed and the questionable policy of allegiance to France reconsidered. Under torture, Savonarola confessed that his prophecies were not from God and that he had fomented faction and disorder in the state for his own gain. Savonarola and the two disciples were thus condemned and handed over to the secular authorities for execution. On 23 May 1498, Savonarola and two associates were hanged and burned. Their ashes were thrown into the Arno so that Savonarola's faithful followers could not collect relics to be used to sustain his religious faction.

The execution of Savonarola and the subsequent collapse of the *Piagnoni* party permitted the return of a republican regime reflective of the established traditions of Florentine government. Although freed from the millenarian dreams of the Dominican, it

Figure 11.3 Florence, Museo di San Marco. Anonymous: *The Burning of Savonarola, 23 May 1498*. Savonarola and two of his closest followers were hanged and burned in the Piazza della Signoria on the same spot where he had burned the vanities, a site still marked by a plaque in the pavement and on which flowers are often left by modern sympathizers. His ashes were thrown in the Arno so that his faithful followers could not collect relics to be used to sustain his religious faction.

was not able to suppress the factionalism and instability that had plagued Florence before the Medici had imposed a functional stability through their authority and manipulation of the offices of the state. The constitutional experiment that Savonarola had proposed remained largely in place, with the Council of Five Hundred continuing to meet in the huge space carved out of the Palazzo della Signoria. There followed a noble attempt to provide good government and revitalize the institutions of the guild republic; but the exigencies of external threats and internal factional and class divisions resulted in the call for some kind of permanent office to sustain a coherent policy in the face of foreign invasion and political instability. Consequently, the position of *gonfaloniere* for life was created in 1502, and Piero Soderini, the political patron of Niccolò Machiavelli, was given the post. However, not even this compromise of the republican constitution or the abilities of statesmen such as Machiavelli could save the regime from the ambitions of the Medici and their supporters within and outside the city. In 1512 Florence fell to a Spanish army assembled by the Holy League; the citizen militia that Machiavelli had trained and put to the defense of the city at Prato abandoned their fortifications with barely a fight. Soderini fled, and the Medici returned once more to Florence.

ITALY AFTER 1494

The French invasion of 1494 had not only occasioned the expulsion of the Medici and the rise of Savonarola's faction in Florence, but also destabilized the entire Italian peninsula. Although Naples was the goal of Charles VIII, his army nevertheless had to travel the length of Italy and pass through a number of states to achieve his victory. All of Italy was driven either to welcome the French, as did Lodovico il Moro of Milan and later Savonarola, or stand against the invader. By 1495 it had become clear that alliances in Italy would be with or against great powers from across the Alps, and Italians came to see that their territory was destined to become the battlefield of Europe where the competing ambitions of great kings would be realized.

Still, there were small victories which, at least initially, signaled hope that some significant measure of independence might be sustained. Charles VIII was driven out of the peninsula by the combined forces of the major Italian states, except for Florence, which, because of Savonarola's influence, chose to continue to adhere to the French alliance, much to the republic's shame and discomfort. Lodovico il Moro of Milan, however, had recognized his mistake in welcoming King Charles and took the lead in harassing the French out of Italy when he won the battle of Fornovo in 1495. But, despite the expulsion of the French on this occasion, the Italian states realized that never again would the northern territorial monarchies be content with the natural frontiers of the Alps and the Mediterranean: dynastic aggrandizement and ambition would constantly drive subsequent, perhaps even more powerful, kings into the peninsula to press obscure claims of dynastic right or to plunder the very rich states of Italy, thereby felicitously merging profit with glory.

The anticipated second wave of invasions began in the year of Savonarola's execution, 1498. In that year, King Charles VIII of France died young and without issue, and his cousin, the duke of Orleans, became king as Louis XII (r. 1498–1515). Almost immediately this royal adventurer decided to mount an invasion of Italy in order to make good a claim to the duchy of Milan, which he enjoyed through the Visconti. (King Louis's grandmother, Valentina Visconti [1368–1408], had been a daughter of Duke Giangaleazzo.)

In anticipation of this assault on Milan, Louis began a diplomatic offensive designed to take advantage of the division and hostility among the major Italian states. Playing upon the ambitions and greed of the various Italian principalities, Louis succeeded in diplomacy so that he might conquer through arms. He gained the neutrality of Ferdinand of Aragon (and Sicily) by declaring that he had no ambitions on his kingdom, despite his family's long-established claims through the house of Anjou. Venice was transformed into a willing accomplice of King Louis by his promise to transfer to the republic some territory to be taken from Milan, including the rich city of Cremona. The papacy was neutralized in a most cynical way: Louis gave Pope Alexander VI's son, Cesare Borgia, the French duchy of the Valentinois (the territory around Valence), a French royal bride, and a promise of powerful support in his plan to conquer the Romagna and build a central Italian kingdom. Florence remained tied to France, despite the fall of Savonarola, and consequently did not pose a problem. Finally, despite his connection to the Milanese house of Sforza, the emperor Maximilian could be ignored, since the Holy Roman Empire was fighting a losing war with the Swiss Confederacy, a war that was to result in the creation of a new, independent country, Switzerland.

Thus Milan was totally isolated by Louis's shrewd diplomacy. In 1499, the French drove through the territories of the duchy, and Duke Lodovico il Moro, as we have previously seen, was forced into exile at the court of his relation by marriage, the emperor. The next year, 1500, saw Lodovico's temporary return to Milan with an army of Swiss mercenaries, who, however, soon betrayed him to the French, as did his own brother-in-law, the marquis of Mantua. Carried to France as a prisoner, Lodovico died in captivity and the French occupied his territory.

Having succeeded in this initial conquest through brilliant diplomacy and military power, King Louis decided to expand his foothold in Italy by annexing the kingdom of Naples, despite his earlier protestations of respecting its neutrality. Louis negotiated a totally dishonorable treaty with Ferdinand of Aragon and Sicily to partition the mainland kingdom of Naples between them and depose the legitimate ruler in Naples, Ferdinand's cousin, Federigo of Aragon. Caught between the powerful French army in the north, now established in Milan, and the equally powerful Spanish-Sicilian armies of Ferdinand the Catholic, the kingdom of Naples was crushed. By 1502 all Naples belonged to the two powers.

However, almost immediately the French and the Aragonese began to quarrel over their spoils. In 1503 the celebrated great captain, Gonzalo de Córdoba, familiar to us from Machiavelli's encomium (see p. 174), defeated the French armies in two extremely brutal, bloody battles. The French had to withdraw, and Naples was left to Ferdinand of Aragon

and Sicily, uniting the two parts of the southern peninsula under a single Aragonese ruler. Therefore, by 1503, the Italian peninsula saw a new balance of power emerging, dependent not at all upon Italians: France, centered in Milan, dominated the north, and Spain, centered in Naples, the south. Florence, as we have seen, was becoming a feeble vassal state of the kingdom of France and was concerned only with reclaiming Pisa, regardless of whatever else might happen in Italian affairs. Consequently, of the five major Italian states that had signed the Peace of Lodi just fifty years before, only two, Venice and the papacy, remained significant independent powers. Clearly, the future of Italy rested with the barbarians (as Machiavelli called the northern Europeans, reflecting both his humanist education and Italian particularism) unless these two states could dislodge them and take over their spheres of influence.

Venice was in no position to do so. Fearful of its mainland possessions, given the proximity of the French, and always fighting or about to fight a life-and-death struggle with the Turks in the eastern Mediterranean and Adriatic, the republic desired isolation and neutrality at all costs. Once again, its own particular interests, its *particolari* (to use Francesco Guicciardini's term) were the chief concerns.

The papacy reacted somewhat differently, but from equally selfish motives. The Borgia pope, Alexander VI, wanted to build a monarchy in central Italy, not as an effective buffer between the two foreign presences, but as a means of establishing his own Borgia family as rulers of the Romagna. Indeed, in order to complete this ambition more effectively, Pope Alexander solicited French aid in destroying the independent *signori* of the Romagna, including, as we have seen, the brilliant court at Urbino, despite the damage such a policy did to the Italian national consciousness and hopes of renewed independence. But in 1503 Pope Alexander died and his son, Cesare, was severely ill. The first conclave to elect a successor to the Borgia pope produced Pius III, the nephew of the humanist pope Pius II Piccolomini; however, he died after just a few weeks, and in his place was elevated Cardinal Giuliano della Rovere, a man with an indomitable will and clear purpose that would inspire him to be not only the warrior pope but also one of the greatest patrons of art and architecture of the Renaissance: Julius II.

Julius II was the nephew of the ambitious, nepotistic Sixtus IV, who had been deeply implicated in the Pazzi Conspiracy of 1478. Julius, however, was completely consumed with the desire to build a centralized papal monarchy rather than a state for his family. Cesare Borgia had established the necessary conditions for the conquest of the Romagna, and Julius took care to solidify those gains. Indeed, Julius' attempt to construct a centralized, absolute territorial state for the Church puts him in the same category as his northern dynastic contemporaries, such as Ferdinand of Aragon and Louis XII of France. Julius began his policies by imposing order upon the turbulent Roman noble families of Colonna and Orsini. He then led his own troops, dressed more like a Roman emperor on campaign than the successor of St Peter, against Perugia and Bologna in 1506. He then attacked Venice, which had greedily annexed a number of important Romagnole cities from the Church after the collapse of Cesare Borgia's state: Ravenna, Cervia, Rimini, Faenza, and Forlì—all had to be retaken.

Nor did Julius' election and policies support the cause of the independence of the Italian states; indeed, his strategy almost destroyed the only Italian power with the potential to restrain the northern monarchies. Realizing how unpopular the Venetians had become in Italy through their territorial acquisitions made at the expense of Milan, Naples, Mantua, Ferrara, the Empire, and the papal states, Julius II gathered a great alliance to crush the ambitious republic, which appeared to be positioned to unify much of the northern peninsula. This resulted in the devastating War of the League of Cambrai. Beginning in 1508–09, the League, composed of the pope, Emperor Maximilian, Louis XII of France, Ferdinand of Aragon and Naples, the duke of Ferrara, and the marquis of Mantua, determined to partition the entire Venetian *terraferma* state, except for the city itself. The pope, then, had given the northern powers a further opportunity to interfere militarily in Italy and against one of the few fully independent, rich, and strategically located Italian states.

All went perfectly for the League of Cambrai. Shattered by a humiliating defeat at Agnadello in 1509, the Venetians could only watch as northern powers occupied their territory and almost all of the subject cities of the Italian *terraferma* reasserted their liberty from Venice. The *Serenissima* seemed doomed. Julius II, however, recognized his error. The complete destruction of Venice would surely give the French and the Habsburgs too much power in northern Italy, for its role as a buffer state would thereby be removed. Consequently, in 1510, the pope turned against his former allies, negotiated a secret peace with Venice and then began to assemble a new league, this time directed against some of his former allies, the victors of Agnadello, in particular the French. This is the genesis of the Holy League of 1511, dedicated to driving the French out of Italy and re-establishing an independent Venetian *terraferma* state as protection against French ambitions. "Out with the barbarians" became the rallying cry, despite the observation that Henry VIII of England, Ferdinand of Aragon, the Emperor Maximilian, and the Swiss Confederacy were members.

Nevertheless, even this impressive alliance had difficulty in defeating the powerful French under the famous Gaston de Foix (1489–1512) who succeeded in smashing a League army at Ravenna but at the cost of his own life. Still, the odds were too overwhelming, and so, in late 1512, the French abandoned Milan and withdrew from Italy. Lodovico il Moro's son, Massimiliano Sforza (1493–1530), was recognized as duke under the protection of a Swiss army, the same soldiers who had betrayed his father twelve years previously.

Problems with England occupied the French king, Louis XII, until the end of his reign, leaving Italy to realign itself internally without French interference until 1515. In that year, a new character entered the scene of the Italian tragedy: Francis I, king of France from 1515 to 1547. Seeing himself as a Renaissance prince, desirous of glory and fame, this vain, intelligent, brave, but rather silly young man invaded Italy a third time, once again driving for Milan to assert his dynastic claims. But the situation in Italy had changed dramatically. Julius II, the warrior pope, had died two years before, and his Medici successor, Leo X, lacked the vigor necessary for sustaining a protracted, difficult war. Also, Henry VIII of England had withdrawn from the Holy League, as had Venice, which actually sought an alliance with France to balance the ambitions of the

Holy Roman Empire. Therefore, the only major force standing between Francis's ambition and the duchy of Milan was a Swiss mercenary army. The huge levies of France, consisting of heavy cavalry, much artillery, and savage German mercenaries, met the Swiss pikemen at Marignano (1515) and crushed them in one of Italy's most decisive defeats. To all observers, warfare clearly now belonged only to those powers with sufficient resources to build huge, diversified armies, supported by great numbers of guns: the age of the small power was over forever, and with it had passed whatever hope there might have been of Italian independence.

The French re-occupied Milan, which they held for six more years until the new, young emperor Charles V challenged France from his Italian territory in the kingdom of Naples (which had passed into the hands of the Habsburg dynasty with its Spanish inheritance). With the election of Charles V as emperor in 1519, the balance of power in all Europe altered irrevocably. The entire continent was divided into two hostile camps, supporting either the Spanish and imperial Habsburgs or the Valois kings of France. The strongest power of the two would be supreme on the continent, and the final decision between them was inevitably going to be determined in Italy. The Habsburgs dominated the south from Naples, whereas the Valois controlled the north from Milan. All other Italian states, including a now somnolent papacy, were only ciphers in this great power struggle. Ultimately, the Habsburgs won, although Francis's defeat was somewhat avenged in the nineteenth century during the Italian wars of liberation, when the emperor Napoleon III helped Victor Emmanuel II of Savoy drive the Habsburgs out of Italy forever.

FURTHER READING

Cochrane, E. and Kirshner, J. *Italy, 1530-1630*. London: Longmans, 1988.

Hanlon, Gregory. *Early Modern Italy, 1550–1800*. London: Macmillan, 2000.

Mallett, M.E. and Shaw, Christine. *The Italian Wars, 1494-1559*. Cambridge: Pearson, 2012.

Stephens, J.N. *The Fall of the Florentine Republic: 1512–1530*. Oxford: Clarendon Press, 1983.

TWELVE

MEDICI POPES AND PRINCES

THE CRISIS IN Italian life that resulted from the French invasions of 1494 and the subsequent incursions of northern powers into the peninsula drove a great many Italians to seek some element of security and stability in a world that seemed to have lost its equilibrium and order. The form that this search for stability took depended on a great many factors: geography, class, occupation, ideology, and chronology. Nevertheless, there were some shared elements, particularly a willingness to sacrifice the traditions and practice of political freedom, a desire for clear rules and expectations, and an acceptance of a more rigid class structure. All of these restrictive elements were identified as protection against the dangers of the time. It is important, then, to investigate how this desire for stability and order was manifested in the various states and institutions of the peninsula during the later years of the Italian Renaissance and to understand how so many of the principles we have been discussing as central to the formation of a Renaissance mentality were compromised by necessity and fear. To begin, we must return to Florence, the city that gave rise to so many of the ideals of humanism and republican liberty, to see how that once dynamic republican state fell to the tyranny of the hereditary Medici monarchy after 1537.

THE MEDICI POPES

The events leading up to the establishment of a monarchical despotism in Florence under Duke Cosimo de'Medici in 1537 are, to say the least, complicated. Nevertheless, we must simply and quickly trace the general patterns of the years between the collapse of the Republic on 1 September 1512, the day the *gonfaloniere* for life, Piero Soderini, fled the city into exile, leaving the government to the renewed power of the house of Medici.

In that year, Cardinal Giovanni de'Medici (1475–1521), the clever second son of the great Lorenzo, was head of the family and a power in Italian and papal politics. His elder

brother, Piero, who had been overthrown in 1494 as a consequence of the French invasions, had very conveniently died some years before, drowned while retreating with a French army. This tragedy for Piero (who, unlucky all his life, historically earned the epitet *Il Sfortunato*—Piero the Unfortunate) was pure good fortune to the family's interests because there was no severe loss of face incurred by Florentines in receiving another representative of that house. After first sending his younger brother, Giuliano (1479–1516), to Florence with an advance party, Cardinal Giovanni marched into his capitol in triumph, leading fifteen hundred papal troops, arranged in power and splendor. He returned to the family palace on the Via Larga and appeared to signal that he intended to rule the city in the manner of his father, Lorenzo the Magnificent, as a backstage power-broker, permitting all of the institutions of the republic to remain intact, if impotent. The fickle and volatile population responded warmly to this manifestation of good will and rioted in the streets, this time in favor of their new masters, demanding a new government which, through the exceptional device of the *Parlamento*, gave rule to a special committee, or *Balìa*, of forty members of the cardinal's faction.

Giovanni swore that the peace and prosperity of his father's period had returned, and gone forever were the harsh days of the puritan republic of Savonarola and the unstable regime of Soderini. Indeed, in a truly theatrical way, the Medici, brilliant stage managers that they were, appeared to turn the clock back thirty years. The popular and often obscene entertainments, carnival songs, and lusty pleasures forbidden by Savonarola returned, to the delight of everyone except for the most rigorous adherents of the *Piagnoni* faction. The cardinal's younger brother, Giuliano (1479–1516), so much like his namesake uncle, became a popular figure, adopting simple republican dress, seducing all around, and even shaving his beard because at the time beards were associated with princely power. Laurentian Florence had apparently been restored, and Heaven itself seemed to rejoice with Florence and the Medici. Just six months after his entry into his native city, Giovanni de'Medici was elected pope, taking the name Leo X. And from his election until the death of the next Medici pope, Clement VII, in 1534, the history of Florence and that of the papacy, and therefore Rome, became inseparable.

Giovanni de'Medici is worth a moment's pause. He was a rather attractive personality, if obese and chronically ill. A cardinal for twenty of his thirty-seven years at the time of his elevation to the see of St Peter in March 1513, he enjoyed at once the reputation of a *bon vivant* and that of a relatively respectable cleric. Quite well educated and interested in theology, he also obeyed fasts—an anomaly among Renaissance aristocratic clerics—and took a number of his vows seriously, even to the point of relinquishing the pleasures of the flesh. Equally, though, he was vain, loved luxury, favored the position of his family's interests at all costs, and hunted incessantly, despite canonical injunctions against blood sports. Leo X was quite serious when he remarked after his elevation that God had given him the papacy to enjoy; but, well-bred Florentine aristocrat that he was, he would not overstep, unlike his predecessor of pious memory, Alexander VI, the bounds of good taste. Florence greeted the election of Cardinal Giovanni as Leo X with incredible joy. Four days of continuous festivities almost destroyed those parts of the city not made of

stone; bonfires were everywhere, fuelled largely by all the possessions of those families known not to be Medici supporters.

Florentines are sophisticated, worldly, and intelligent political observers, then as now. They realized that having a Medici pope would ensure prosperity for their city by recreating the old economic connections between Rome and Florence. Moreover, they knew that Florence might benefit because it was a more secure foundation for Medici ambition than the papal states, given the latter's traditional anarchy and disorganization. And they were right. Leo determined to follow an old papal policy—that of establishing a strong state in central Italy that could dominate the whole peninsula and even drive foreigners from Italian soil. However, whereas previously this ambition had always terrified Florence, which feared a powerful, expansionist state on its eastern frontiers, the idea was now attractive: Medici territory would now comprise the states of the Church as well as Florence. In short, what was imagined was a greater Florence, built at the expense of the Holy Catholic Apostolic Church. Leo began by contemplating uniting the duchies of Ferrara and Urbino and then annexing to them Parma, Modena, and Piacenza and placing this significant new principality under one of his nephews, probably Piero's son, Lorenzo. Thereafter, this new state, together with Florence and the papacy, would drive out the Spaniards first, from Milan and then from Naples, leaving the crown of that kingdom for Leo's brother, Giuliano. In other words, the pope dreamed of turning all Italy south of Venice into a dynastic, federated state.

Unfortunately, fortune intervened, this time disguised as a lusty teenaged bride of an elderly king. Louis XII of France died in 1515 from, it was generally believed, the demands of his very young English wife, Mary Tudor, sister of Henry VIII, no stranger to lust himself. Louis's successor was a cousin, the young count d'Angoulême, who became King Francis I (r. 1515–47). Francis rather narcissistically saw himself as an ideal knight and intended to prove it by invading Italy to reclaim Milan (as we saw at the end of Chapter Eleven), a mission that he accomplished with great success, capturing the city and forcing Pope Leo to make peace on France's terms. Leo's other major military campaign, as we saw in our earlier discussion of the principality of Urbino, was more successful. Through the War of Urbino (1517) he did manage to place his nephew, Lorenzo, on the ducal throne, reinforcing his dynastic ambitions. Despite this success, Leo, irenic by nature, resented the prodigious expenditures of energy and money required for continuous war on the scale of Pope Julius. As a result, he simply became resigned to peace, returning to the Vatican to enjoy his office to the best of his ability, which, as we have seen, was prodigious in luxury and style.

After leaving Florence, the pope had entrusted the city's affairs to his attractive and intelligent brother, Giuliano de'Medici. Unfortunately, Giuliano died of consumption in March 1516, leaving only an illegitimate son. Thereafter, the rule of the city fell to Pope Leo's nephew, Lorenzo (Piero's son), who was granted the curious title of Captain General of the Republic. Lorenzo (1492–1519) saw himself as a prince, not a republican magistrate. He was young, in his twenties, and accustomed to living with princes; hence he established a court, ignored the elected magistrates, listened only to his favorites, and moved the seat of government from the Palazzo della Signoria to the Palazzo Medici. Fortunately

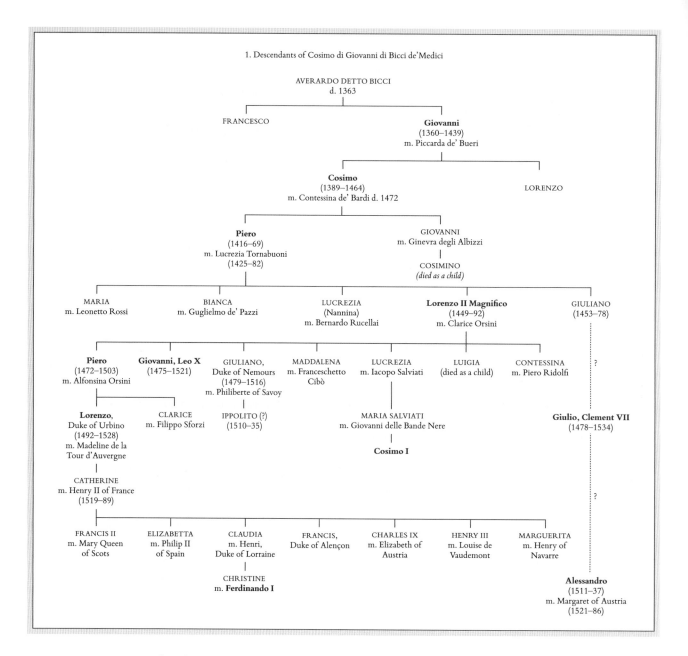

1. Descendants of Cosimo di Giovanni di Bicci de'Medici

AVERARDO DETTO BICCI
d. 1363

FRANCESCO

Giovanni
(1360–1439)
m. Piccarda de' Bueri

Cosimo
(1389–1464)
m. Contessina de' Bardi d. 1472

LORENZO

Piero
(1416–69)
m. Lucrezia Tornabuoni
(1425–82)

GIOVANNI
m. Ginevra degli Albizzi

COSIMINO
(died as a child)

MARIA
m. Leonetto Rossi

BIANCA
m. Guglielmo de' Pazzi

LUCREZIA
(Nannina)
m. Bernardo Rucellai

Lorenzo II Magnifico
(1449–92)
m. Clarice Orsini

GIULIANO
(1453–78)

Piero
(1472–1503)
m. Alfonsina Orsini

Giovanni, Leo X
(1475–1521)

GIULIANO,
Duke of Nemours
(1479–1516)
m. Philiberte of Savoy

MADDALENA
m. Franceschetto
Cibò

LUCREZIA
m. Iacopo Salviati

LUIGIA
(died as a child)

CONTESSINA
m. Piero Ridolfi

?

Lorenzo,
Duke of Urbino
(1492–1528)
m. Madeline de la
Tour d'Auvergne

CLARICE
m. Filippo Sforzi

IPPOLITO (?)
(1510–35)

MARIA SALVIATI
m. Giovanni delle Bande Nere

Giulio, Clement VII
(1478–1534)

Cosimo I

CATHERINE
m. Henry II of France
(1519–89)

?

FRANCIS II
m. Mary Queen
of Scots

ELIZABETTA
m. Philip II
of Spain

CLAUDIA
m. Henri,
Duke of Lorraine

FRANCIS,
Duke of Alençon

CHARLES IX
m. Elizabeth of
Austria

HENRY III
m. Louise de
Vaudemont

MARGUERITA
m. Henry of
Navarre

CHRISTINE
m. Ferdinando I

Alessandro
(1511–37)
m. Margaret of Austria
(1521–86)

Genealogy 12.1
The Medici

for Florence, Lorenzo died young before the indignant citizens could revolt against his tyranny. He did leave a daughter, however, born only a few days before his death: Catherine de'Medici (1519–89), destined to become Queen of France as consort to Henry II.

The search for a new Medici governor of Florence led back to Rome. Lorenzo was succeeded by Giulio de'Medici (1478–1534), his cousin, the illegitimate son of Lorenzo the Magnificent's brother, Giuliano, who had been killed in the Pazzi Conspiracy of 1478, dying unaware that one of his mistresses was pregnant. Through Medici influence, forgery, and persuasion, Giulio had been named a cardinal, despite canon law that forbids bastards from holding such church offices. Florence, however, was very lucky in the young Cardinal

de'Medici. Giulio was altogether more in the Laurentian tradition: he was a wise, thoughtful ruler who attempted not to offend republican sensibilities or patrician ambitions.

Pope Leo X died in December 1521. Giulio de'Medici immediately left Florence in hopes of succeeding him. However, there was a powerful anti-Medician party in the Sacred College, led by Cardinal Soderini, the brother of Piero Soderini, the former *gonfaloniere* for life who had fled Florence in 1512. Soderini influenced the conclave to elect as pope not Giulio, as had been widely anticipated, but an ascetic Dutchman, Adrian VI, who had never even been to Rome and whose sympathies lay with Emperor Charles V. Adrian, terrified by his papal office, had the good grace to die soon after (1523). There followed another long, discreditable conclave from which Giulio de'Medici did emerge as Pope Clement VII (r. 1523–34). But the glory was short-lived, for Clement's pontificate proved to be one of the most unfortunate of any successor to St Peter. Many of his misfortunes he brought upon himself by his vacillating nature and his refusal to establish any kind of coherent policy. But few could say that either he or the people of Rome anticipated or deserved the fate that awaited them.

Clement made one disastrous miscalculation. Instead of acknowledging the power of Emperor Charles V in Italy, the pope was convinced to restore the papal alliance with the French. By so doing, he alienated the most powerful ruler Europe had seen since Charlemagne, and, it transpired, he backed the losing side. In a battle at Pavia near Milan in 1525, the French army was totally defeated and the French king, Francis I, was taken prisoner. The imperial army was victorious but was left unpaid, because Charles had not only run short of funds but also no longer had a pressing need for this large force of expensive professional soldiers. Under the leadership of a French traitor, the Constable of Bourbon (Charles III, 1490–1527), the army, which consisted largely of German Lutherans and Spanish veterans, marched south, intending to acquire wealth through plunder and extortion.

By May of 1527 the unruly army had reached the walls of Rome in anticipation of laying siege, expecting to extract gold in exchange for their withdrawal. Instead, the morning after they arrived, a deep fog enveloped the city. Emboldened by the unexpected camouflage, the imperials chose to mount the walls, encouraged by members of Roman noble families from the vantage of their estates in the surrounding countryside. These great Roman clans were eager to regain some of the authority they had lost to the papacy in the preceding decades, especially under Julius II, and saw Bourbon's army as the perfect instrument for revenge. But Bourbon was killed almost immediately after the offensive was launched (Benvenuto Cellini claimed to have fired the shot!), leaving the hungry and desperate army without any control. The walls were breached, as there were insufficient defenders and too many supporters of the great Roman clans inside. There was no time to cut the bridges over the Tiber. The entire city lay open to the barbarians.

Pope Clement VII and those members of the curia who were able to follow him rushed along the *Passetto*, the corridor between the Apostolic Palace and Castel Sant'Angelo, seeking safety in the fortress that had been constructed from the tomb of the emperor Hadrian. From this humiliating vantage, Clement and his court watched the wholesale destruction

Figure 12.1 (following page) Florence, Palazzo della Signoria (Palazzo Vecchio), *Sala di Clemente VII*. Giorgio Vasari (1511–74): *The Siege of Florence, 1529–30* (1558). This fresco celebrates the final capture of the city by the Medici. A Spanish army besieged Florence and starved it into submission, despite a heroic defense on the part of its citizens. Michelangelo himself served as an engineer of the fortifications.

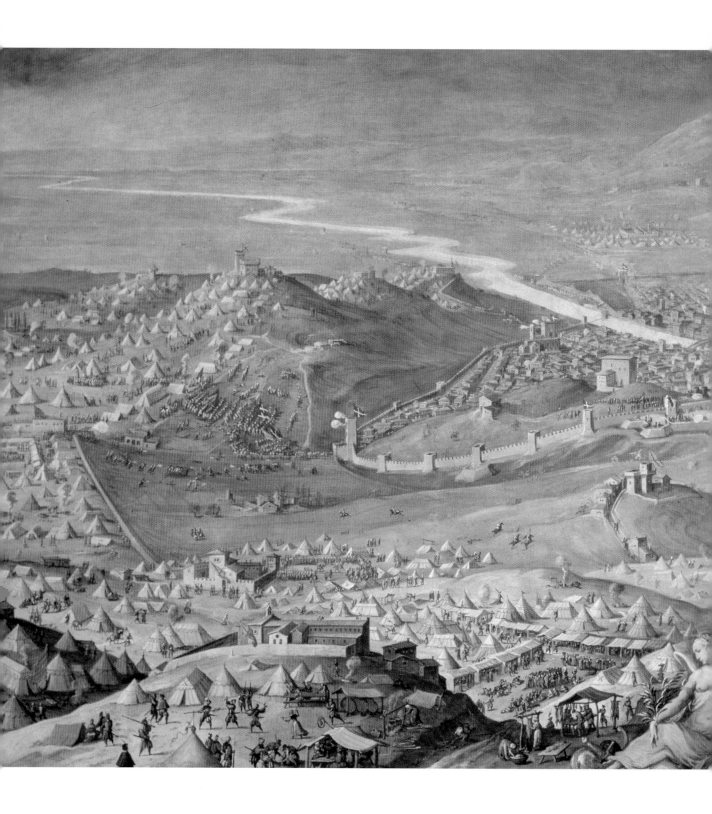

252 TWELVE: MEDICI POPES AND PRINCES

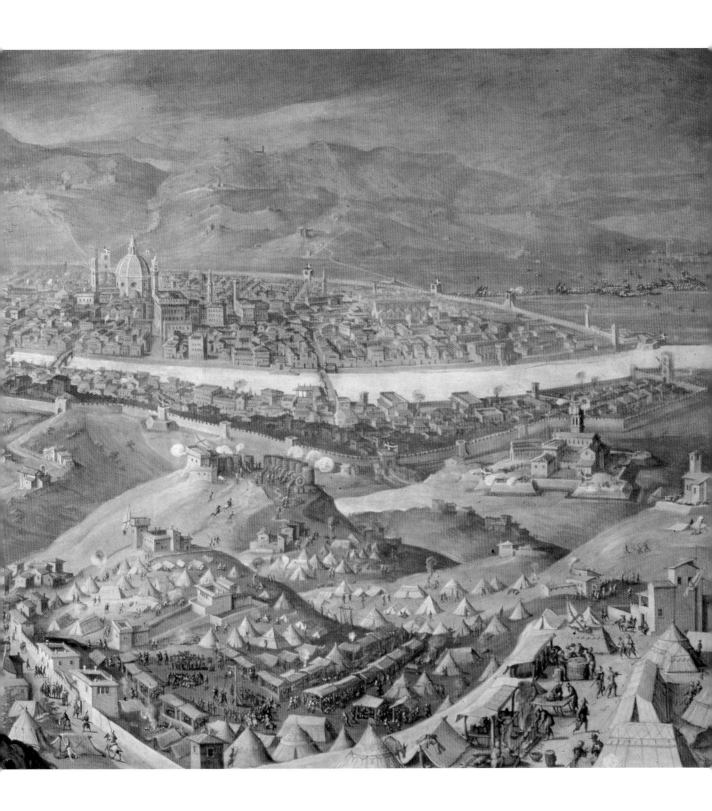

of the city and the slaughter of its inhabitants. The imperials spent the next nine months ravaging the city in an outrage of bloody mayhem. The evangelical Lutherans, in particular, committed unspeakable acts in their desire to punish the pope and the city, seeing Clement as the Antichrist and Rome as the whore of Babylon. They methodically desecrated, despoiled, or destroyed virtually every church. Nuns were raped, captured priests were killed, and any resistance from citizens met with murder. The collected artistic heritage of millennia was brutally destroyed by barbarians so savage that their very humanity was questioned. Even the dead were robbed, as tombs were pried open, including that of Pope Julius II, and the bodies of prelates stripped of rings, cloth of gold or silver burial vestments, and anything else of value; their bones were left where they fell. Cardinals, bankers, and artists were captured and suspended from roof beams by their hair until they confessed where their valuables had been hidden; even then they were often killed. There was also the calculated philistine destruction of art: the words "Martin Luther" were carved with a pike on the walls of the *stanza della segnatura* on the *Disputation over the Holy Sacrament* of Raphael. And the graffiti of German soldiers can be read to this day on Baldassare Peruzzi's *Sala delle prospettive* in the beautiful villa of Agostino Chigi, which had been commandeered for barracks.

Clement's position was perilous in the extreme, even if the catholic soldiers in the imperial army and the emperor Charles V himself did not want to be responsible for the murder of a pope. Clement agreed to pay a large indemnity and give significant territories to the Habsburgs, including Parma and Modena, to guarantee his own safety. Still afraid, after many months a prisoner in his own city, Clement bribed soldiers to let him escape to Orvieto disguised as a common workman. He returned to Rome only in 1528, finding the city ruined and abandoned. In winter, lacking fuel for heat, the soldiers had torn off doors, roofs, and shutters to burn. Even the inhabitants who evaded the imperials by escaping to the countryside were not safe from harm. Bands of peasants, angry at high taxation and willing to take out their hatred of papal policy on the common people fleeing Rome, hunted them down and stole their few belongings before killing them. Nothing of value remained in the city.

The destruction of Rome and of Pope Clement's power also had profound effects upon Florence. After Giulio de'Medici had left the city to become Pope Clement VII, he put in his place a succession of foreign cardinals, all of whom were insensitive and extremely unpopular, ruling the city as though it were a subject territory. Also unpopular were the two surviving Medici bastards, especially Alessandro, who already showed signs of his future disturbed personality. Consequently, the events in Rome led to a revolt in Florence. The pope's representatives were driven out and the republic restored for a last brief time before the Napoleonic invasions. The Savonarolan Council of Five Hundred was re-established, and a new *gonfaloniere* was elected from among the anti-Medicean faction. Clement was powerless, granting in a treaty with Charles almost everything the emperor demanded, including an imperial coronation (which took place in Bologna in 1529, the last imperial coronation on Italian soil), together with the recognition of Charles's conquests and his hereditary rights on the Italian peninsula. Clement demanded and received only one thing: a promise by Charles to restore Florence to the Medici by force.

Faced with an imperial threat, the wiser, older leaders of the restored Florentine republic suggested a compromise that would represent a return to the old method of Medici rule within the façade of republican institutions. But young, excited republican zealots refused, hired soldiers, prepared defenses, and put Michelangelo in charge of the military architecture to protect the city (see Figure 12.1). War was consequently inevitable. The largely Spanish army of forty thousand reached Florence in the early fall of 1529. Deciding to starve the Florentines into submission rather than fight, they laid siege to the city. The populace fought brilliantly and endured terrible hardships for ten months; then, plague-ridden and starving, the city surrendered. A new *Balìa* was proclaimed, a Medicean *gonfaloniere* was elected, the unfortunate republican *gonfaloniere* who had been ousted was executed, and the republican party leaders tortured to death. Hundreds of leading citizens were banished perpetually and their property confiscated.

THE MEDICI PRINCIPATE

All of this revenge was to prepare for Pope Clement's new Medici ruler, nineteen-year-old Alessandro de'Medici (1510–37), who was probably Pope Clement's illegitimate son by a Moorish slave girl. Nine months after his entry into Florence, Alessandro was proclaimed duke of Florence, although he was far from an autocrat and had no immediate right of succession. He had still to consult the councils of the republic and heed their advice; and while Pope Clement was alive, Alessandro obeyed these restrictions and even appeared to be improving his personal life. However, in September 1534, Pope Clement died, and with him went the last rational restraint on young Alessandro. He ceased paying attention to the councils and ruled arbitrarily. He symbolized his new style of regime by smashing the great bell in the Tower of the Palazzo della Signoria, the bell which had historically called all free citizens to the *parlamento* in the Piazza. The bronze from the bell he had recast into medals of himself. The republic's lilies were taken down and replaced with his personal arms. And, perhaps most despotically, he built the huge Fortezza da Basso, a fortress inside the city: for the first time in Florentine history, Florence's guns were aimed inward at its own citizens rather than outward against their common enemy.

Such acts antagonized everyone, including the other Medici bastard, Ippolito (1511–35), who was the illegitimate son of Giuliano, duke of Urbino. This young man was talented and sober, successful as a soldier in Hungary against the Turks, and wise enough to be named a cardinal. Ippolito tried to use his influence with Charles V to control Duke Alessandro and was likely intending to reveal his cousin's personal excesses to the emperor. But very conveniently in August of 1535, Ippolito died, probably of poisoning. Other Florentines, exiled by Alessandro, did bring charges against the duke to the emperor, whose natural daughter, Margaret of Austria (1522–86), Duke Alessandro wanted to marry. The respected historian Jacopo Nardi (1476–1563), speaking on behalf of the Florentine exiles, delivered before Charles an impassioned catalog of Alessandro's political repression,

disregard for the law, and bizarre sexual activities. But the Medici's devoted spokesperson, Francesco Guicciardini, provided so brilliant a defense of Alessandro that Charles dismissed the exiles' charges and decided to indeed give his own daughter in marriage to young Alessandro.

In 1537, Alessandro was assassinated at the age of twenty-seven, but by a very unusual liberator. His young cousin, Lorenzino, called Lorenzaccio because of his loathsome personality and unpleasant countenance, was sent to Florence for safe keeping. Lorenzino (1514–48) had grown to late adolescence in Rome but had destroyed so much classical statuary by attacking it with his sword during fits of drunkenness and madness that he had to be put under closer control. Lorenzino and Alessandro shared many attributes. Both, for example, were transvestites and omnivorously bisexual. They became both lovers and raping companions, and Lorenzino so well suited Alessandro's tastes that the ugly young man with the twisted mind became his greatest favorite at court. Sometime in the midst of these circumstances, Lorenzino, who was patently mad, determined to make his place in history by killing Alessandro. To accomplish his plan, he developed a typically depraved scheme. He told Alessandro that he should try to seduce—or, failing that, rape—Lorenzino's exceptionally chaste sister, Laudomia, a young widow. Of course Alessandro agreed, so he fell in with Lorenzino's scheme. In this way, Lorenzino managed to catch Alessandro naked, unarmed, and in bed with no guards to protect him. Together with his hired murderer, Lorenzino stabbed Alessandro to death and subsequently fled to Bologna, not knowing quite what to do next. Without doubt, had the opponents of the Medici risen in revolt at that time, the republic could have been restored. But no one knew what to do until the Medici spokesman Guicciardini took affairs back into his own hands.

The next day Guicciardini called all the Medicean faction together to discuss the succession. The pope's governor, Cardinal Cibò (1491–1550), wanted Alessandro's illegitimate four-year-old son named duke, with himself as regent. Guicciardini suggested instead the seventeen-year-old Cosimo de'Medici, son of the *condottiere* hero Giovanni dalle Bande Nere (John of the Black Bands, named for the black stripe added to the insignia of his mercenary army in mourning for Pope Leo X in 1521). Another faction demanded a return to the oligarchic republic, controlled by the principle patrician families. This impasse was broken when Guicciardini bribed the captain of the guard to style a "spontaneous" demonstration outside the Palazzo della Signoria in favor of Cosimo. This broke down all resistance among the fearful *signoria*, and Cosimo de'Medici was brought to the city. Guicciardini was fully expecting to become the power behind the throne, ruling in the name of the inexperienced youth.

Cosimo (1519–74) had been born in Florence, but after the death of his father when Cosimo was only a boy, he was forced to lead a peripatetic life because his mother (quite justifiably) feared the jealousy and instability of Alessandro. Cosimo's personality was complex: extremely intelligent, only modestly educated because of his wandering, and unnaturally secretive—most observers found the young prince a rather cold individual. Indeed, he distrusted his mentors, Francesco Vettori (1474–1539, Machiavelli's friend and correspondent; see Chapter Thirteen) and Guicciardini, recognizing that they intended

Figure 12.2 (facing page)
Florence, Uffizi, Tribuna. Agnolo Bronzino (1503–72): *Eleonora of Toledo* (1544). This magnificent court portrait depicts Eleonora of Toledo, the wife of Duke Cosimo I (the first hereditary duke of Florence), and their young son Giovanni (b. 1543). The artist, in addition to capturing Eleonora's beauty and strength of character, reveals her immense wealth through the remarkable court dress she is shown wearing. Eleonora was the daughter of the Spanish viceroy of Naples and was married to Cosimo only after Emperor Charles V refused to permit him to wed Margaret of Austria (Charles's illegitimate daughter, the widow of the assassinated Duke Alessandro). Nevertheless, Eleonora and Cosimo formed a happy union that produced eleven children, thus ensuring the Medici dynasty in Florence.

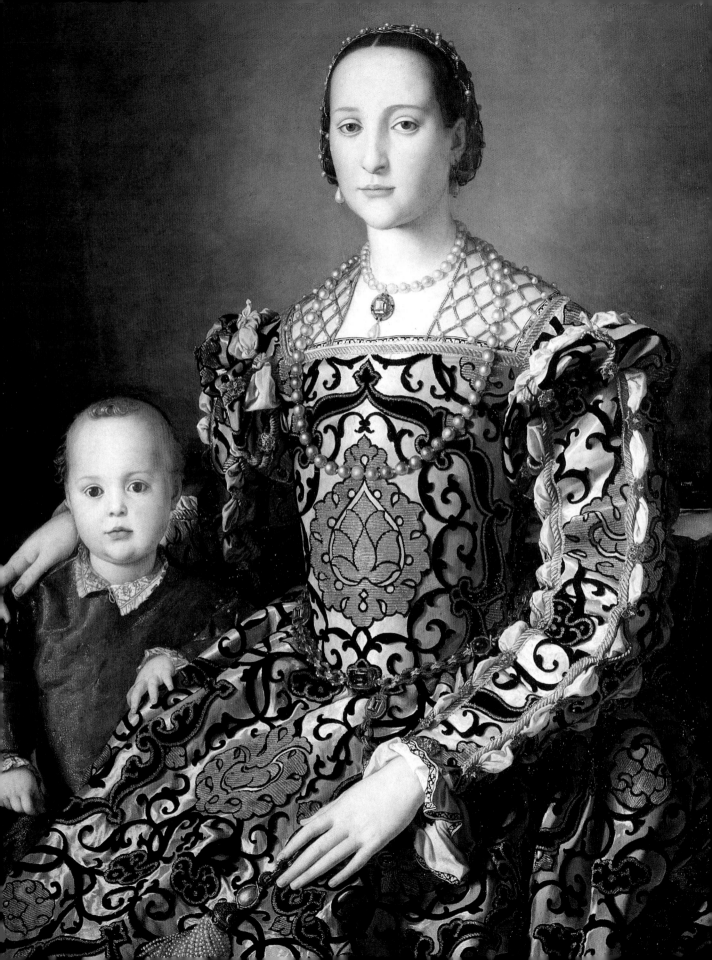

to rule in their own interests, not his. Hence, he determined to rid himself of all his debts and restrictions. Guicciardini lost favor and was exiled to his villa when Cosimo decided to govern autocratically. The same fate befell all of those who attempted to limit the new duke's authority. Although only seventeen, Cosimo was decisive, intelligent, and ruthless. In June 1537 the emperor Charles V, seeing Florence as little more than a client state, recognized Cosimo as the sole ruler.

Afterwards, Duke Cosimo had to secure his throne from the threat of the republicans who wished to re-establish the old constitution. After the imposition of the tyranny of Alessandro, a large number of patrician youths and their supporters had fled into exile, hoping to raise an army to drive out the Medici and restore the republic. Consequently, using a Spanish army provided by Charles V, who expected to keep Florence under Habsburg control, Cosimo encountered the exile republican army at Montemurlo, near Prato, in 1537, just after his elevation to power. The republicans were defeated and their leaders captured. Cosimo publicly executed them in the Piazza della Signoria over four consecutive days, despite the fact that all were members of great Florentine patrician families. There could be no better warning to aspiring republicans that Duke Cosimo expected absolute obedience.

Now secure in Florence, Cosimo had to establish his credibility externally. His first move was to marry. The emperor Charles V decided that Cosimo was not to be allowed to marry Alessandro's widow, Margaret of Austria, whom the emperor gave instead to the pope's grandson, Ottavio Farnese (1524–86), who had been named duke of Parma. Therefore, Cosimo had to look elsewhere. In 1539 he found a perfect match with Eleanora of Toledo (1522–62), daughter of the Spanish viceroy of Naples, who was a man of considerable power, great wealth, and useful assistance in Cosimo's ultimate purpose: the freeing of Florence from Habsburg control. In addition—and this is rare in Renaissance dynastic marriages—the couple appeared to have been very fond of one another and enjoyed a true conjugal partnership until the duchess's death.

Cosimo's second undertaking was to ensure the withdrawal of Spanish troops from the territory and city of Florence where they had occupied the Fortezza da Basso and made the streets unsafe at night because of their brawling. Also, Cosimo realized that he would always be thought a tyrant imposed by the barbarians upon a free people as long as a Spanish garrison seemed to maintain him on his throne. Although at first Charles absolutely refused to consider withdrawing from Florence, the emperor reconsidered when he recognized, partly because of Cosimo's Spanish marriage, that a close alliance with Florence instead of with the unpredictable papacy might be more useful than trying to hold yet another Italian state by force. Therefore, Spanish troops were withdrawn from Florence and Cosimo ruled thereafter as a free prince.

Cosimo, now a legitimate ruler, was equally determined to be an autocratic one. Having made himself subject to no powerful advisors, such as Guicciardini, or to any external power, such as Charles V, Cosimo forever destroyed the ancient republican institutions and traditions that had governed Florence for 250 years. By decree he abolished the *signoria,* including the offices of the priors and the *gonfaloniere,* and he made himself president of the

old councils so that they became merely rubber-stamp appendages of the ducal will. Any magistrate or citizen who complained was thrown into the horrible medieval dungeons of Volterra from which few men ever emerged. Lorenzaccio, the assassin of Alessandro, was hunted down over Europe for ten years until Cosimo's band of professional assassins finally caught and killed him with a poisoned dagger in Venice. Indeed, Cosimo was not one to forget outstanding debts or crimes unavenged. Cosimo even moved against the Church, especially against the monastery of San Marco, the Dominican convent where Savonarola had been prior and from which he had virtually ruled Florence between 1494 and 1498, and still the site of residual *Piagnoni* power. Monks were expelled and replaced by others more amenable to the duke's tyranny. He remarked to the prior before relieving him of his position that Cosimo *il vecchio* (the old) had refounded the monastery, but Cosimo *il duca* (the duke) was now taking control.

Not content with overthrowing the republican constitution, Cosimo also wanted to root out its traditions. This destruction of republican practice, memory, and sympathies was accomplished through Cosimo's brilliant appreciation of human nature. Clearly needing a court, but lacking any real courtiers, he offered the great patrician families patents of nobility and eventually titles, if they could prove ancient lineage and continuous service to the state. The plan worked perfectly. Always jealous of one another and factious by nature, the Florentine patriciate ransacked their private archives, and those of the republic, to prove their antiquity and service, each attempting to overshadow the other. Thus, in a very short time, Cosimo turned the proud families of the old mercantile republic into an obsequious courtier nobility which, because it lacked any power, dedicated itself to pleasure and antiquarian research. This new class largely ceased their ancient mercantile and business occupations, deciding instead to spend their fortunes on conspicuous consumption and leisure, as befitted their new rank. Partly through the models of the other Italian courts, partly through the examples of the Spanish officers garrisoned with them for so long and surrounding the duchess, and partly through pure exhaustion, the republican patriciate gravitated toward—indeed embraced—the new order with relief and enthusiasm. The republic was truly dead, just a decade after the patrician families had sacrificed their sons during the siege of the city and on the field of Montemurlo.

The intellectual and cultural traditions of the old republic had found meaning and expression in service to the communal government, the civic humanist emphasis on good letters, eloquence, learning, wit, and personality, and a belief in the dignity of the individual, free men within a free community. Such ideas were clearly unwelcome, and indeed in opposition to the monarchical tyranny that Cosimo was erecting on the ruins of the old, dead republic. But he also knew that Florentines are incapable of lassitude and intellectual torpor: they love ideas, debate, art, and beauty. The solution was to channel these characteristics into safe and controlled institutions that would at least give the impression that talk and ideas were still free. Hence, the Tuscan academies were established in which gentlemen of good birth would gather to recite the latest poetry, perform scientific experiments, read the latest histories, or probe the new developments in archaeology, botany, music, and other "safe" subjects. Politics was ignored. The environment of the Rucellai

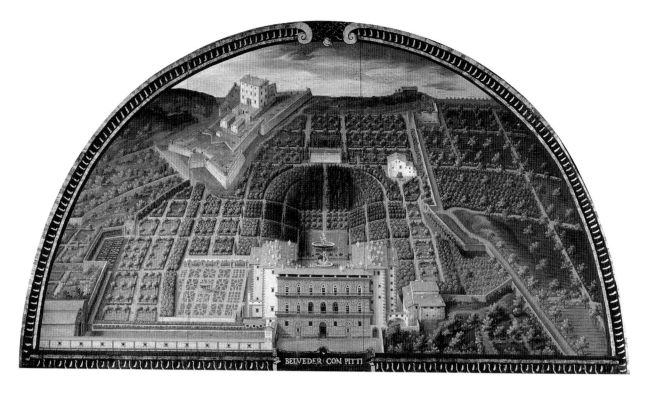

BELVEDER CON PITTI

Figure 12.3 Florence, Museo di Firenze com'era (The Museum of Florence "as it used to be"). Giusto Utens (d. 1609): *Palazzo Pitti, with the Boboli Gardens and Belvedere Fortress* (1599). Because of their large family, Cosimo and Eleonora found living in the Palazzo della Signoria too confining. Furthermore, the Palazzo della Signoria, built as a city hall rather than a royal residence, proved inadequate for court ceremonies. Cosimo, using his wife's immense dowry, purchased the incomplete palace that Brunelleschi had designed for the banker Luca Pitti over a century before. The Medici laid out the exquisite formal gardens and constructed the Fortress of the Belvedere (upper left of the image) for their security. A walkway designed by Giorgio Vasari—the Vasari corridor—links the Palazzo della Signoria through the Uffizi, across the Arno to the Boboli Gardens.

gardens in which Machiavelli had read his *Discourses on Livy* and his *Art of War* had changed to the environment of the Platonic Academy. Florentine intellectuals became at best antiquaries and self-congratulatory amateurs. These meetings kept their minds active, and they enjoyed the social interaction, but they were kept far from political action or even debate, an area that had completely become the preserve of the duke. And, after the instability and failure of the years since the death of Lorenzo the Magnificent in 1492, many were very content with this compromise: at least Cosimo provided security, stability, and honor. The old republic, in fact, was increasingly seen as a failed experiment, full of danger and division.

Duke Cosimo also wanted to be more than just duke of Florence. His ambition was to ultimately become grand duke of a unified Tuscany, a grand territorial state; and to this end he attacked the ancient republic of Siena in 1554. The war to capture Siena was brutal, expensive, and long: it was not until 1555 that the city finally yielded and was incorporated into the Florentine dominion. Cosimo, to gain further honor, launched the Order of St Stephen (Santo Stefano, 1562) as a maritime crusading order to fight the Turks in the Mediterranean; and, finally, in 1569, Pope Pius V at length yielded to Cosimo's incessant petitions and granted him the title of grand duke of Tuscany, carrying with it the royal appellations of *Altezza, Serenissimo*: the scion of bankers had become Your Serene Highness. Thus, after 1569, Florence lacked none of the attributes of a monarchy, not even a great palace.

After the marriage of Cosimo and Eleonora of Toledo in 1539, the couple moved from the splendor of the Palazzo Medici to the old seat of the republic, the cramped Palazzo della

Signoria, which had been partly transformed from a town hall to a royal palace. Clearly, the inconvenient medieval building was being inhabited by the duke to symbolize his personal government and to connect his arbitrary rule to the traditional location of authority in the city. However, symbols may be fine for the populace, but Cosimo and Eleonora had to live there. The quick production of a large family—seven sons and four daughters, only six of whom, though, survived to adulthood—provided a perfect excuse for Eleanora to find another, larger, more regal palace in which to raise their family and hold court. In 1549 they bought the enormous Palazzo Pitti, which Filippo Brunelleschi (1377–1446) had begun for the rich banker Luca Pitti (1398–1472) over a century before but which had remained unfinished following the bankruptcy of the family. The next year was spent refurbishing the palace, a task given to one of Cosimo's most talented court architects, Bartolomeo Ammanati (1511–92), who added the great cortile, and Bernardo Buontalenti (c. 1531–1608), who built the famous grottoes. Behind the great palace, acres of open land stretching in high vistas within the city walls were purchased and the wonderful, justly celebrated Boboli gardens were laid out. The great amphitheater behind the palace was added, as were the pond of Neptune and the beautiful walks, contributions to Florence's exquisite beauty that are still the delight of all visitors.

Unfortunately, the Duchess Eleonora lived only two years after moving into the new palace, a blow from which the rather uxorious Cosimo never completely recovered. He became even more solitary and secretive to the point that by 1564 he had virtually ceased to rule, allowing his heir, Francesco (1541–87), to carry out the business of the state. After a series of unfortunate amatory experiences, including a disastrous second marriage with Camilla Martelli, Cosimo suffered a series of strokes that left him an invalid until his death in 1574.

In general the rule of the first hereditary duke of Florence and grand duke of Tuscany was a success. Florence was stable, if politically repressed, independent, relatively prosperous, and well governed: the territory of the duchy was greater than that of the old republic, and this alone gave cause for rejoicing among the most patriotic of her citizens and partly compensated for their lack of freedom. Also, Cosimo had built a fleet, making Florence, through the ports of Pisa and Livorno, a maritime power strong enough to have won great renown for service during the Battle of Lepanto in 1571. Also, the city was growing even more beautiful, first because of Cosimo's patronage and second because of the rush of the newly minted Florentine noblemen to advertise their new rank through building and conspicuous consumption. The year 1559 saw the beginnings of the complex of the Uffizi (Offices), designed by Giorgio Vasari and intended to house under one roof the government offices of the state. Cosimo wanted all the various state agencies and departments centralized, not only for efficiency, but also so that he might keep an eye on their operation.

The rebuilding of the Palazzo Pitti and the laying out of the Boboli Gardens have already been mentioned. However, the movement of the first family of Florence across the Arno attracted a number of the leading noble families there as well, resulting in the construction of the wonderful late Renaissance Mannerist palaces along the Via Maggio.

And although dating from the next reign, the remarkable palace of Duke Francesco's mistress and later wife, Bianca Cappello, with a façade adorned with *sgraffito* decoration, symbolizes the refined world of the early grand duchy. This new construction added a great deal to the beauty in the world, but it also signifies through bricks and mortar the end of the Florence of the Renaissance. The style, character, organization, and taste of the Medici monarchy of Cosimo I were altogether different from those of the republic of Bruni and Salutati, even of Machiavelli. And perhaps this new courtly society is best illustrated by the great grand ducal residence of the Pitti Palace across the river from the old *signoria*, surrounded, like Cosimo and his court, by the increasingly sumptuous palaces of his courtiers, radiating out from the Piazza Pitti and containing, not the shops and banks of the *quattrocento*, but the sumptuous spaces used for display, advertising newly minted titles and honors in a way that the solid burghers of the time of Bruni would have scarcely comprehended.

FURTHER READING

Cochrane, E. *Florence in the Forgotten Centuries, 1537-1800*. Chicago: University of Chicago Press, 1973.

Guicciardini, F. *The History of Italy*. Tr. S. Alexander. Princeton: Princeton University Press, 1984.

Hale, John. *Florence and the Medici*. London: Phoenix Press, 2001.

Hibbert, Christopher. *The House of Medici: Its Rise and Fall*. New York: HarperCollins, 1982.

Hook, Judith, and P. Collinson. *The Sack of Rome, 1527*. London: Palgrave Macmillan, 2004.

Van Veen, Henk. *Cosimo I de' Medici and his Self-representation in Florentine Art and Culture*. Cambridge: Cambridge University Press, 2006.

THIRTEEN

THE COUNSEL OF EXPERIENCE IN CHALLENGING TIMES

THE RETREAT INTO a repressive but more predictable and stable tyranny in Florence illustrates the changing political and social shape of Italy as a consequence of the crisis of the sixteenth century, which we have explored in detail in the preceding chapters. There were also intellectual responses that offered various solutions to the dangers posed by foreign intervention and the disruption of the Italian state system after 1494. Some of this advice came from men deeply experienced in public life, either as magistrates in republican regimes or as counselors to princes or popes. The fruits of this experience came in the form of historical assessments of the causes and implications of, as well as possible solutions to, the upheavals in the peninsula; other texts emerged as precise advice to those who might save Italy from the "barbarians." Of these counselors, historians, and political advisors, none had the experience, knowledge, insight, or perspective of Niccolò Machiavelli (1469–1527) or Francesco Guicciardini (1483–1540). Although these two men offered quite different evaluations of the crisis and how Italians might respond, both writers reflected the growing mood of cynicism and occasionally despair that seemed to be engulfing Italy. It is important, then, to look in detail at these two profound writers, both very experienced political operatives, who spoke for their generation. Both men used history as an instrument to study the contemporary world, and both produced work that revitalized that discipline, because, as Machiavelli wrote in his verse chronicle *The First Decade*, it was important for future generations to understand how Italy had fallen so far so fast.

NICCOLÒ MACHIAVELLI: *THE PRINCE*

Niccolò Machiavelli has had a bad press for 450 years, usually at the hands of critics who either have never read or have never understood his work. In part this is because his most read title, *The Prince*, cannot be taken in isolation as an abstract piece of political theory

but must be seen as an address to the rulers of Italy in 1513 to do something to save the Italian nation from the "barbarians" (Machiavelli's term) and incidentally to take advantage of the experience and knowledge that Machiavelli himself had acquired during his public career, a career that coincided with the most cataclysmic, brutal, and disastrous period of Italian history since the earlier barbarian invasion of the Roman Empire and before the more technologically advanced and savage barbarism of the 1940s.

Niccolò Machiavelli was born in Florence in May 1469, the year Lorenzo the Magnificent took over the Medici party machine that managed the Florentine republic. Machiavelli's family was of the impoverished Tuscan nobility, which like so many of the impoverished gentry class of Europe had a lengthy tradition of service to the state for which they received very little recompense. Indeed, Machiavelli's father had to practice law to feed his family and maintain appearances. The first twenty-one years of Niccolò's life were lived in a period of unusually peaceful co-existence among the states of Italy, largely engineered by Lorenzo de'Medici's political skill. This was also the period of Michelangelo, Leonardo, and the remarkable efflorescence of Renaissance culture. But Machiavelli was twenty-three when Lorenzo died and his son, Piero, assumed his father's position. He was twenty-five when King Charles VIII of France invaded Italy in 1494 to claim the kingdom of Naples, to which he had an obscure dynastic right, and to win some military glory. This invasion marked the end of peace in Italy for over sixty years, beginning a period of continuous foreign intervention into the affairs of the peninsula and turning Italy into the battlefield of Europe.

What was so remarkable to Italians in 1494 was that it was so easy. The French were virtually unopposed, and the march to Naples was more like a parade than a military campaign. In fact, there was no one to stop them. Wars in Italy were fought not by feudal levies or citizen armies, but by mercenaries, usually local rural noblemen who could not make a living from their poor patrimonies and who had bands of armed retainers to form the nucleus of an army. These small mercenary forces were no match for the huge feudal levies of France, led by heavily armed knights, all of whom were professionals as well and supported by great hosts of soldiers armed with diversified weapons and supported by mobile artillery.

As we rehearsed in detail in our discussion of the crisis in Chapter Eleven, Italy simply collapsed before the French. Piero de'Medici capitulated immediately; and when the French finally left Florence, the Medici were expelled and the government of the city reconstituted as a broadly based republican regime under the fanatical Dominican preacher Girolamo Savonarola. Savonarola's brilliant oratory, lucky prophecy, and anti-Medici propaganda sustained a radical regime for only a brief time before in 1498 he was burned as a heretic. In his place a more secular but still broadly based republic was instituted.

One of the first people to be elected to office in this new regime was twenty-nine-year-old Niccolò Machiavelli. The office that Machiavelli held was that of second chancellor of the republic, responsible for translating executive decisions into policy and for some diplomatic work. He was brilliant at it, a natural administrator and a born diplomat. During the next years he was seen in numerous foreign missions as well as being continuously involved in the development of all important Florentine policies. The important diplomatic missions

given to Machiavelli began with his embassy to King Louis XII of France in 1500. It was an illuminating experience; for two years Machiavelli had been thinking constantly of Italian affairs and politics, making judgments and writing reports, but when he visited France he realized that the fate of Italy was being determined there, north of the Alps, not in the peninsula itself. Also in France he saw a centralized, nation-state monarchy at work. And he learned another lesson: he wrote back to a friend saying that Florence paid a high price for being a republic. Certainly internal liberties were greater than in a despotism, but foreign relations were made difficult by the lack of a singular policy and by the frequent rotation of executive authority. The Florentine executive committee, the nine priors, held office for only two months and were then ineligible for the following three years. Whatever continuity there was in Florentine politics was provided by men like Machiavelli, senior civil servants. Because of this, France despised Florence, a supercilious loathing reinforced by the fact that the republic did not even possess an army and had to pay others to fight for it. To a noble French knight such an attitude was disgusting and worthy of total contempt.

As a result, Machiavelli's first visit to France was a great education and a painful experience for such a fervent republican and an even more fervent patriot. To Machiavelli and others of his class and education, Italy was the true heir to Rome and the lodging place of human civilization. The kingdoms north of the Alps were at best bastard daughters, defiled by barbarians to such a degree that they remained still barbarous themselves. Like all of Machiavelli's learned Italian contemporaries he always called the French, the Spanish, the Germans—indeed all northern Europeans—"barbarians."

Machiavelli returned to Florence in 1501. At that time he married, managing a match to a woman of similar aristocratic background but of more important connections, a clear indication that Machiavelli's career was on the ascendant. The next year Machiavelli had his second great political education: he was sent as an ambassador to Cesare Borgia, the son of Pope Alexander VI, who, with his Holy Father's help, was building a powerful kingdom in central Italy, carved mostly from the states of the Church. The embassy was short lived, but Machiavelli had met Cesare (the Duke Valentino of *The Prince*) and had observed for the first time an Italian taking affairs into his own hands and achieving remarkable success.

One of Cesare's suggestions to Florence was to take back the Medici, because without a principal family, the republic would remain internally divided and hence vulnerable to outside attack. Machiavelli, as a dedicated republican, disagreed, as did most other Florentines. However, everyone saw the need for some kind of continuing executive. A compromise was reached: the republic established in 1502 a permanent chief executive office (the *gonfaloniere* for life); and the post fell to Machiavelli's political associate and close friend, Piero Soderini. Machiavelli's future seemed secure and promising.

At the beginning of 1503, Machiavelli was sent back to Cesare Borgia. On this occasion his mission was to tell the duke that Florence was friendly, while still trying to protect its territory from Borgia ambitions. This time Machiavelli attended on Cesare for three months and lived in the closest proximity with him. The dispatches sent back to Florence were brilliant and increasingly reflected the Machiavelli's growing adulation of this man of action. Furthermore, his views on Florence were changing as he saw the image of the

city from without. Machiavelli still remained dedicated to Soderini and the republic, but he became increasingly concerned about its ability to survive in the harsh, brutal world represented by Cesare Borgia and the French.

Later that year the pope died, and with him went his son's prospects for uniting all of central Italy between Venice and Rome into a single powerful state able to control invasions from the north or, given the Aragonese foothold in Naples, from the south. Machiavelli was sent to Rome to observe—and probably try to influence—the papal election; and at the end of the year he went back to France to witness the Treaty of Lyons between France and Spain.

Those three years were important for Machiavelli as an author and politician. During his diplomatic missions he had written dispatches and short treatises on the situ¬ations in which he found himself. All were remarkable for both their shrewd observation and brilliant language and style. However, during the years 1504–06, he also began a work of leisure, a literary work, a verse chronicle called the *First Decade* devoted to the years since 1494. The theme of this book is critically important to any understanding of Machiavelli, for it suggests that it was the internal problems of Italy itself that had led to the intervention of the barbarians and that the peninsula will remain in ruins as long as these dissensions persist and Italy lacks at least one ruler strong enough to galvanize his fellows into a concerted action and marshal the Italian people into a national army to drive out the northerners. Machiavelli acknowledges his book tells a sad tale; but he says it is an important one to write, because by demonstrating how the states of the peninsula have fallen from great heights of wealth and culture Italians should be encouraged to reclaim their dignity and greatness.

These years also provided Machiavelli with a second elemental experience—the chance to establish a militia to be used in place of mercenaries. In 1507 Machiavelli's friend Soderini gave him the position of secretary to the new war office, which was concerned with the formation of the militia. He loved it with the intense pleasure of an idealist finally allowed to practice his ideals, and on it he lavished all his time and much of the republic's money. Ironically, however, the barbarians made his plans to use his militia against Pisa useless. The war of the League of Cambrai, in which Louis XII, Emperor Maximilian, and the King of Spain (Ferdinand of Aragon), exhorted by Pope Julius II, dismembered Venice, perhaps the most powerful and viable Italian state, led to the capture of Pisa by Florence. Utterly alone, starving, and demoralized, the Pisans capitulated. Machiavelli marked the events of 1509 by writing the *Second Decade*, a continuation of his verse chronicle.

After another embassy to France, Machiavelli returned to Florentine affairs, which had become disastrous. As we saw previously, the total defeat and near annihilation of Venice in 1509 had resulted in enormous barbarian armies wandering unchecked about northern Italy. The allies had already fallen out among themselves. The pope and Ferdinand of Aragon (and Naples) declared war on France under the absurd and ironic pretext of their battle-cry, "Out with the barbarians!" Florence was desperate. The city had always had close ties with France, and Soderini thought that a continuation of the alliance would help preserve the balance of power. It didn't. The Holy League army, composed of Spanish

veterans, attacked Tuscany at Prato. Machiavelli marshaled his cherished, beloved militia, armed at public expense and trained for three years. Prato was very well defended by walls, and the Florentines outnumbered the Spaniards. However, it was a complete rout. The militia fled after a single hole was made in the walls by the enemy artillery. The Spanish advanced, Soderini resigned and fled into exile, and the Medici were returned as rulers. Machiavelli, as a leader of the republic and a close associate of Soderini, was out of a job. Indeed, he was considered dangerous. He was implicated—falsely—in a conspiracy and was tortured and imprisoned. Then, despite conciliatory attempts on his part, he was turned out with no money or honor. In 1513, unable to afford Florence, he moved out of the city to live on his tiny farm nearby at San Casciano.

After having devoted all the energies of his adult life to politics and the service of the republic, Machiavelli found the republic gone and his career shattered. He was too closely associated with the regime of Soderini to switch his allegiance to the Medici easily, although he did offer. Also, he was poor and forced to live away from Florence, far from his political friends. He did, however, continue to correspond with them. In particular he maintained his close association with Francesco Vettori, another former republican, but one who had managed to ingratiate himself with the new regime. Vettori kept Machiavelli informed about politics, both Florentine and international. In April 1513, Vettori wrote to his friend about the dangers posed by the truce between Spain, France, and Venice, a truce obviously negotiated by King Louis to renew his claims in Italy. Consequently, another invasion was expected. Remembering the quality of Machiavelli's diplomatic dispatches, shrewd judgments, and observations from happier days, Vettori despaired at not having his friend's counsel in such times. These letters between Vettori and Machiavelli continued throughout the summer of 1513, following the events of the latest series of French defeats and the increasing danger from the Spaniards.

In the course of these letters the two friends proposed suggestions for bringing peace to Italy and driving out the barbarians who had disrupted Italian affairs since 1494. It was from Machiavelli's side of this correspondence that *The Prince* arose. Indeed, most of the central elements of *The Prince* were raised during that summer's correspondence: the disunity of the Italian states; the lack of national armies and the continual reliance on mercenaries; the apparent success of brutality and insolence; and the failure of ambition not supported by sufficient force, in Machiavelli's opinion a cause of much of Italy's present trouble. By early December, Machiavelli informed Vettori that he had produced a short treatise, *De principatibus* (Latin for *On Principalities*), the result of their musings on the Italian crisis. This letter to Vettori is probably the single most famous piece of private correspondence in the Italian language. It not only announces the birth of *The Prince*, but also gives us a rather melancholy, poignant, indeed pathetic, insight into the life of a great man who believed that the world had forgotten him, just when he had so much to give. It merits a lengthy paraphrase:

> In the morning I get up with the sun and walk to a woodlot I am harvesting
> where I spend a few hours reviewing yesterday's work and pass the time with the

woodcutters who are always ready to complain about their own or their neighbours' misfortunes.

I go from the woodlot to a spring and from there to my bird snare, always traveling with a book—Dante, Petrarch or a minor poet like Tibullus, Ovid or another. As I read of their loves and passions, I am reminded of my own, and this reverie gives me some brief pleasure. I continue walking along the road to the inn, where I talk with the travelers who pass through, asking for news from where they came. In this way I find out what is happening and observe the many and varied interests and tastes of men.

By then it is time for dinner. Together with my family I eat whatever food my small property provides. After lunch, it is back to the inn where I find the innkeeper, often the butcher, miller, and a one or two kiln owners; and with these companions I slip into rusticity for the rest of the day, playing cricca or backgammon. Our games trigger a thousand arguments and endless name calling, even though we only argue over pennies. Still, they can hear us shouting as far as San Casciano. Stuck with such vermin I keep my mind active and let the ignominy of my fate take its course, content to be driven down this road if only to see if Fortune blushes with shame.

In the evening I return home and go into my study. Before entering I strip off my clothes, dirty and dusty from the day's work, and change into my courtier's robes. Then, appropriately attired, I enter the courts of the ancients, and they receive me as a friend. I dine on the food that is for me alone and for which I was born. I am not afraid to ask them what motivated their actions, and they graciously answer me. For the next four hours I know no boredom, forget my troubles, no longer fear poverty or even death. I am completely immersed in their company.

Dante says that we forget what we have heard if we do not write it down, so I have transcribed everything useful from my conversations with the ancients, composing a little book, *De principatibus*, in which I delve into my thoughts on the subject, investigating what a principality is, the forms they take, and how they are won, kept and lost. And, if you have enjoyed any of my trifles, you should like this one; and it should be well received by a prince, especially a new one. Thus, I have dedicated it to his Magnificence Giuliano (de'Medici).[1]

In his book, Machiavelli returns to his own real loves: external relations and the militia. During his tenure of office in Florence, Machiavelli never showed the slightest interest in internal, constitutional, or even factional politics—hence his failure to continue in power. He was interested only in diplomacy, in how states relate to one another, and in how they can best defend themselves, since the whole lesson of his experience had been that states exist to make war and expand at the expense of their neighbors. To survive, a state must be able to protect itself and must think only of its security. His experience in Florence from 1494 to 1502 especially—but also under Soderini's regime—had taught him that republics are not resolute and defense requires resolution. Therefore, the only hope is for a prince to assume authority and dedicate himself and his state to the greatest ambition an Italian could have—the expulsion of the barbarians.

Such was the genesis of *The Prince*. Although we have no concrete evidence of how closely the Latin treatise resembles the finished, polished version of *The Prince*, there is little doubt that they were essentially the same: Machiavelli was coherent in his thought. Even in its advocacy of despotism, brutality, and faithlessness, *The Prince* can be seen as consonant with Machiavelli's fervent republicanism, as illustrated by his own career and his later, more thoughtful abstract discussion of politics, *The Discourses on Livy*, which portrays a profound devotion to republican ideals. The apparent contradiction is only one of the paradoxes of *The Prince*. Equally, there is Machiavelli's choice of genre, the medieval *Speculum principis*, or Prince's handbook, which attempted to counsel rulers on how to govern according to the absolute moral laws of God and the contingent laws of tradition. For Machiavelli, the genre becomes a vehicle for absolute power. Finally, there is the paradox of the citizen army. By suggesting that the prince arm his people, Machiavelli is advocating that the ruler effectively abdicate his authority. Machiavelli himself repeatedly stresses in *The Prince* that brute force is the foundation of authority; therefore, in Machiavelli's principality it is the people who rule, not the prince, since they have the arms. It is in these paradoxes that the real character of Machiavelli's thought emerges. He remains a republican in every way; his retreat into despotism (a term, like tyranny, that Machiavelli studiously avoids) is the idealist seeking temporary refuge in cynicism, but never able to abandon the essence of his beliefs, so strong are they at the foundation.

In fact, rather than being the bible of Realpolitik, *The Prince* is a naïve hypothesis that shocks simply because it was articulated at all and in the form it was. Princes have always behaved the way Machiavelli describes, and he admits as much when he writes in Chapter 15 that the gulf between how one should live and how one does live is so wide that a man who neglects what is actually done for what should be done learns the way to self-destruction rather than self-preservation. Machiavelli confronts that which experience has shown him to be human nature. He brings it into the open, analyzes it, pushes it to its ultimate extreme, and codifies it. Thus he forces his reader to deal with it in terms of actual political situations. Morality he will leave to sermon literature or utopians; his concern is with reality, the way men are and the way things are.

Also, his intention is good; he has a mission. Italy has been laid waste by the barbarians because the Italians have not learned to play the game of power politics. Cesare Borgia came close, but fortune overturned him. Fortune to Machiavelli is more than bad luck; it is the whole web of events surrounding history. A prudent man, one of *virtù*, can at least mitigate the effects of fortune by shrewdness or resolution. And to Machiavelli the ultimate bad fortune was Charles VIII's invasion of Italy in 1494 and everything that it precipitated. This event was the real occasion, the first cause, of *The Prince* because it exemplified all of the evils inherent in Italian politics. These evils were the result of human weakness, and human weakness can be cured only by harsh medicine. Machiavelli, in fact, says exactly this later, in his *Discourses on Livy*, and thereby shows how this high-minded republican came to write *The Prince*. He observes that although Florentines were best suited to a republic, the people had grown too weak to sustain the demands of self-government, as was the case in the ancient Roman Republic. The only recourse was to accept a prince who

would instill a military discipline in the population in order to restore their dignity; but, once that was accomplished, he should resign as his duty required. Machiavelli's prince, then, is a drill-sergeant, or a cold shower designed to put fortitude back into an enervated people whose weakness has led to their inability to govern themselves. Equally, the harsh rule of the prince is almost a punishment for Italy's failure to stop the French in 1494, a sin that is still with the country.

If all of these justifications for Machiavelli's little book are still insufficient, there remains the testimony of Chapter 26, "The Exhortation to Liberate Italy from the Barbarians." The conclusion states the purpose of *The Prince* and the rationalization for the prince's rule. Italy, the only legitimate heir of Rome, must be freed from the barbarians. The Italians appear still unable to throw out the invaders, given their present character; hence, a strong man must discipline them to do so. Thus *The Prince* is a desperate cry for both national renewal and national freedom, which expresses a deep belief in the value and the uniqueness of the culture of Renaissance Italy. Modern critics who either refuse to discuss the last chapter of *The Prince*—after all it does end with the poem of Petrarch— or suggest that it is a later addition or a rhetorical flourish have not understood the book. Chapter 26 is its *raison d'être*.

Finally, what immediate effect did Machiavelli's *The Prince* have? Precisely none. Machiavelli offered it to Lorenzo de'Medici, duke of Urbino, after the death of its original dedicatee, Giuliano. Lorenzo probably never read it, although there is a later story reporting that Lorenzo asked whether this Machiavelli was incapable of writing in the grand style. Machiavelli presented *The Prince* at the same audience to which another would-be official gave Lorenzo a pair of hunting hounds; the prince preferred the dogs. Indeed, Machiavelli never saw his book in print, nor did he ever recapture his old office. The Medici did use him in minor posts until another republican revolution in 1527 very briefly restored the old constitution. Ironically, because he had had any dealings with the Medici at all, Machiavelli was refused a position in the new republic, even though it was staffed by his former friends. He never recovered. Machiavelli died just weeks after this disappointment, in June 1527, one month after the barbarians had committed the worst atrocity yet to Italy, the sack of Rome.

It is ironic that Machiavelli is most remembered for *The Prince*, which, in the course of a fertile literary and political career, was a minor work. Besides his poetry, diplomatic dispatches, and personal letters, which fill two volumes of marvelous reading, Machiavelli wrote a great number of major prose works that show him to be one of the best, if not *the* best, Italian prose stylists of the sixteenth century. His play *Mandragola* is still performed and is still hilarious. His *Discourses on Livy*, a long, rambling commentary on Roman history, is really a study of contemporary Florentine affairs; his *Life of Castruccio Castracani*, lord of Lucca, is a brilliant portrait of a Machiavellian prince in action; and his *History of Florence*, commissioned by the Medici, is one of the great landmarks of historiography. In addition, there were short stories, another play, much poetry, and numerous political works, ranging from the famous *Art of War*—the only of his books to be printed in his lifetime—to his bureaucratic report on Florentine fortifications.

THE *DISCOURSES ON LIVY*

The *Discourses* are divided into three books, each following a different theme and illustrated by whatever sections of the Roman historian's work suited Machiavelli's purposes. As with *The Prince*, this superficial adherence to an accepted, conventional genre—the learned, humanist commentary on an ancient author—made the novelty of Machiavelli's opinions all the more effective. Of course, there was another reason for Machiavelli's clever, almost perverse, use of conventional formats: the tradition of humanist studies of both republics and principalities tended toward an abstract, general discussion. This was insufficient for Machiavelli. He was a practical politician, as we have seen, and dedicated to the application of his practical experience to the problems of Florence. Hence, he really had to alter the traditional forms that were perfectly suitable to theoretical studies but, because of their internal organization, were not suitable for coherent analysis. The ultimate purpose of the *Discourses* was to reveal the laws of human behavior that animate politics, not to investigate the historical method or vision of Livy.

Besides his humanism and his obsession with Florentine affairs, Machiavelli revealed his own prejudices and opinions clearly in the *Discourses*. This is perhaps best illustrated by his constant assaults on the nobility. According to Machiavelli, the Roman Republic began to decline as it became wealthy; the solid patricians of the period of Cincinnatus and the Punic wars became weak and dissipated through luxury and wealth. Factions arose and luxury became the highest moral good. Clearly Machiavelli is suggesting a comparison with republican Florence, where the patricians worked against Soderini and the Council of Five Hundred in favor of a return to patrician oligarchy, an internal division that led to the victory of the Medici. Both for Rome and for Florence, Machiavelli argued, the best corrective was to ensure maximum participation of the people in the affairs of the state. During the republic, the Great Council served this purpose and best assured a functional, well-organized society. Through such organizations and institutions, Machiavelli suggested, an entire people might acquire and exercise *virtù*, partly through the leadership of eminent men of *virtù* and partly through the collective action of a great many good men.

From this it is easy to deduce Machiavelli's own hatred of the great Florentine families who despised him because of his poverty, despite his lineage. Also, it is evident that Machiavelli put a great deal of the blame for the collapse of his beloved republic on the machinations of those very aristocrats who refused to compromise their private ambition for the general good of the state. It is from such personal and painful circumstances that Machiavelli's cynicism about human nature arose. Indeed, the *Discourses* can, to a limited extent, be reduced to the question of whether a corrupt state can sustain a free government. Machiavelli suggested not; hence the advice of *The Prince*.

Paradoxically, though, this view does not preclude Machiavelli's advocacy of a ruling elite and of political divisions. Although factionalism, especially aristocratic factions, had destroyed the Florentine republic according to Machiavelli's analysis, it had provided vitality for the Romans. Machiavelli got through this messy contradiction by discussing at length the differences between the ancient Romans and the fifteenth-century Florentine

ruling elites, obviously coming out in favor of the former; however, he also injected another quality: leadership. The Romans had in part prospered in the face of internal political divisions because of good leadership by good men who could direct the state for the common good. Florence, on the other hand, lacked decisive leadership because her natural elites were consumed in self-interest and allowed the state to collapse. Once again, we see Machiavelli's movement toward the necessary corrective of *The Prince*.

There are an infinite number of additions and further observations that one might make about the *Discourses*. After all, Machiavelli, who worked very quickly, spent considerable time on this great synthesis of history and politics, laboring intermittently on it from 1513 to 1521. His analysis challenges the received theories and practices of his contemporaries. Machiavelli, as we have seen, saw Italian diplomacy, statecraft, and defence as failures, illustrated first by the French invasions and then by the collapse of the Florentine republic. And, because he believed success to be the only acceptable outcome of political action, Machiavelli needs to explain these failures. To do so, he demolishes with a perverse pleasure the accepted military theories of his time because, he observes, they clearly did not work. Thus, the *Discourses* function both as a rehearsal of brilliant observations on the nature of government and security and an insight into the mind and character of their author, a much more fertile and original mind than is evident from *The Prince* alone.

Finally, we must discuss the great *History of Florence and the Affairs of Italy*. Although Machiavelli never again entered the stellar sphere of Italian politics that he had enjoyed prior to 1512, the Medici did on occasion yield to the desperate republican's petitions and those of his friends by granting him minor, indeed insignificant, jobs for the new rulers. The one exception to this description of Machiavelli's employment after Soderini's fall was turned into a great endeavor, not because of the Medici's kindness, but because of Machiavelli's own genius: the commission to write *The History of Florence*.

In November 1520, the Florentine University's director, Cardinal Giulio de'Medici, cousin of Pope Leo X and destined to become Pope Clement VII, agreed to employ Machiavelli as the author of a new, official history of the city. In part, this job was designed to silence the importunate and impoverished ex-second chancellor. Machiavelli worked laboriously on the text until 1525, at which time he had brought his study up to 1492 and the death of Lorenzo the Magnificent. In 1525, Machiavelli took the work to Rome to present it to Pope Clement. While there, Machiavelli was given other minor, make-work assignments, leaving him no time to continue his history. And, soon after his return to Florence, the Medici were overthrown again, an event that preceded Machiavelli's death by only a few weeks. Therefore, Machiavelli's history ends with the death of the great Lorenzo. However, it should be added that it is equally possible that Machiavelli never intended to complete the work. Any discussion of the humiliation of the Medici after the accession of Piero to his father's position might have lost him his still recent and still only half-hearted acceptance by Florence's new regime. Furthermore, the book has a natural conclusion with Lorenzo's death: the dramatic moment of lightning striking Brunelleschi's dome of Florence's cathedral signified an end to the peace and prosperity of Lorenzo's Florence and appeared to presage the divisions, factions, and humiliations

of Piero, Savonarola, and Soderini. Thus, even if unfinished—which can be debated—the *History of Florence* remains an artistic and historical unity.

In many ways, Machiavelli's commission corresponded to the traditional position of official historian, a role associated in the fifteenth century with the office of chancellor. The production was not to be an investigation of new facts leading to fresh conclusions; rather, it was a formal exercise in the classical manner, full of praise for the city and magnifying the accomplishments of its past and contributing to its honor. Any panegyric was permitted, provided that it did not too obviously violate truth. Leonardo Bruni had written such a history, as had Poggio Braccriolini, and, according to tradition, Machiavelli should have begun where their work had finished. However, Machiavelli had a problem with the Medici: what should he explain in the light of his own intelligence and experience, and what should he suppress? This was a serious problem for the historian, as he remarked to two of his close correspondents, one of whom was the other great Florentine historian of his generation, Francesco Guicciardini.

These traditions and difficulties account for the nature of Machiavelli's *History.* First, he had, according to tradition, to follow a rather literary, rhetorical format, even though he did not find such a style comfortable. Second, he had a responsibility to the traditions of earlier Florentine histories. Whereas Guicciardini could investigate original documents in his attempt to arrive at an accurate analysis of past events, Machiavelli had to rely on previous secondary sources; indeed, it was expected of him. Hence, large sections of his book are borrowed from other historians and chroniclers, such as Flavio Biondo, the Villani, or Leonardo Bruni. If two sources appeared contradictory, Machiavelli himself judged which was the more probable and left it at that.

Still, despite these conventional restrictions, Machiavelli did much that was new. For one thing, his *History* begins with the fall of the Roman Empire, although the period from that time until the fifteenth century is covered only briefly within the first book. The next three books describe Florence's domestic developments until the rise of the Medici in 1434, and the last four books—half of the whole text—are dedicated to the years since Cosimo's acquisition of power. This section devotes much space to foreign affairs as well, a subject dear to Machiavelli's heart. Also, this emphasis on foreign policy allowed Machiavelli to pursue his own interests and to escape ingeniously from the dilemma of having to praise or criticize the Medici. The Medici were good at foreign relations, and Machiavelli could say so. This problem is further solved by Machiavelli's comparison of the characters of Cosimo and Lorenzo with their enemies. Truly and with little or no exaggeration, the early Medici were heroes in contrast with Florence's enemies both internal and external.

Machiavelli's *History*, then, is a great work of conventional Renaissance commissioned historiography that exhibits all of the weaknesses of that official genre: reliance on previous work, a rhetorical literary style and construction, self-conscious classicism, selective use of sources, and selective discussions of events, among others. However, the genius of Machiavelli has made it something else. Foreign affairs take their own place as a significant influence on internal policy; individual great men are seen in the context of their times; and general themes link the otherwise chronologically connected passages, themes

that Machiavelli had developed earlier in *The Prince* and the *Discourses*. Because of these themes, the *History of Florence* is permeated with the same pessimism that is found in the *Discourses* and even *The Prince*, a despair born of tragedy and certain knowledge of eventual failure. Thus, although the rule of Lorenzo is portrayed sympathetically as a last flicker of a golden age, the disasters to follow are clearly foretold or, as Machiavelli describes in his conclusion, compared to evil plants that began to germinate and very soon after destroyed Italy and kept it oppressed.

FRANCESCO GUICCIARDINI

Until quite recently, Francesco Guicciardini was among the most ignored major figures of the late Italian Renaissance. In itself, historical obscurity is no crime, often indicating simply that the individual inhabited that cultural limbo of the "minor figure," or that he was an individual whose time had not yet come. For Guicciardini, the latter is clearly the case. However, Guicciardini's importance rests with the contention that he was the greatest historian between Publius Cornelius Tacitus in the second century and Edward Gibbon in the eighteenth. His *History of Italy* is a great moment of brilliant scholarly method and production, a superb example of Italian writing, and one of the first major European histories to use primary sources to reveal the past as it actually happened, rather than how it should have happened or might have happened.

Why Guicciardini has been neglected is also all too evident. First, his *History of Italy* was published posthumously in 1561, in a world where the author's enlightened, conservative, aristocratic ambition, tinged with realistic pragmatism, no longer held much relevance. His very rationalism and rather strident Florentine anti-clericalism (despite his service to the Church) were inimical to the intellectual values of the counter-Reformation imposed to protect the Catholic faithful from the dangers of heterodox thought. These obscurantist values increasingly animated the Italian intelligentsia of the 1560s, a group slipping progressively and apparently hopelessly into the numb provincialism and superficiality that were to characterize the peninsula until the nineteenth-century *Risorgimento* (the movement for Italian unity), despite the contributions of figures such as Galileo, Vico, and Volta.

Even the rebirth of Italian intellectual energy that resulted in the united kingdom's return to the arena of general European culture as a nation, rather than as an oppressed people, either ignored or vilified Guicciardini. Indeed, it was with extreme obloquy that in 1869 one of the greatest of Italy's early literary and historical critics, Francesco De Sanctis (1817–83), with his powerful invective (camouflaged as a learned article entitled "The Guicciardinian Man") sentenced the noble Florentine to obscurity a second time, at the very moment when circumstances were rehabilitating Guicciardini's friend, compatriot, and contemporary, Niccolò Machiavelli. De Sanctis's celebrated article stamped Guicciardini and his writings with a reputation that only in our time is passing. What De Sanctis saw in Guicciardini was nothing less than a distillation of the cause of Italy's

debasement after the glorious flowering of the Renaissance, an outrage precipitated by ideas that would hold the peninsula in bondage until the dawn of the *Risorgimento*. Guicciardini was seen as a selfish, shifty, disreputable, dishonorable defeatist who used his great gift of intelligence in cynical ways.

Indeed, Guicciardini, to De Sanctis and his disciples, was the exact opposite of the liberator raised by Machiavelli at the end of *The Prince*, a man whose ability and patriotism might unite Italy and protect her from the ravages of the barbarians. For despite Machiavelli's pessimism, there is hope in Chapter 26 of *The Prince*, and even throughout the book there is a sense that all is not necessarily lost, provided that a man of sufficient *virtù* can rise to lead the Italians to freedom. In Guicciardini, on the other hand, there is no prince, no hope. One must accept the world as it is and work with it; all circumstances are different; and abstract belief of any kind is irrelevant at best and self-destructive at worst. Moreover, not only did Guicciardini write such thoughts—quite explicitly in the *Ricordi* (his collection of maxims)—but he also exemplified them in his own life and career, a biography that reflects almost exactly the same attributes of an austere, calculating, but brilliantly clear-sighted genius born to rule in a time of crisis, traits most clearly paralleled in the careers of other statesmen who exercised power in turbulent times, like Cardinal Richelieu in the France of Louis XIII.

Francesco Guicciardini was born in 1483 into a family that then, as now, was one of the noblest in Florence. Since the establishment of the merchant republic, the Guicciardini had in almost every generation held the great offices of the state. This ancient tradition was reinforced by an ancestor who was a leader of the Medici faction, helping Cosimo return from exile in 1434. Such loyalty was rewarded not only by Cosimo but also by his son Piero and grandson Lorenzo, who were both well served by several Guicciardini. The family's luck held even after 1494 because Francesco's father, rather than dedicate himself to active politics as befitted his rank and family tradition, was instead seduced by the scholarly, contemplative atmosphere of neo-Platonic late Laurentian Florence—indeed Marsilio Ficino himself was young Francesco's godfather—and chose to withdraw into his books and study while the Medici ruled the republic.

Because of the withdrawal of the Guicciardini from political life, they did not suffer the fate of the other Mediceans after the overthrow of the unworthy and unfortunate Piero in 1494. Thus, young Francesco was permitted to grow up and take part in the political, cultural, and social life of his native city. Guicciardini began his education like any other very rich patrician son of an extremely learned and cultivated father. His early lessons were in the classics, but he soon chose the formal study of law, requiring residence at the celebrated Renaissance universities of Ferrara and Padua. However, even at this very young age Francesco was unusual. He saw his life as an opportunity and privilege, and he decided to act on his ambitious appreciation of duty and self-interest. For example, he exhibited very little sense of loyalty to anything except his social class and his family. Blessed with a remarkable intelligence, he traveled from professor to professor at the two universities, leaving one institution to join another when he felt he had acquired as much as he could. Also, despite his famous godfather and his own father's proclivities, Francesco became a

life-long Aristotelian, finding more comfort in that highly rational, categorized philosophy than in the abstract considerations of the Platonic Academy. In 1504, ironically, he almost entered the Church: not because of any vocation, but because his uncle, the bishop of Cortona, had died, leaving the see open to the young man. Francesco believed that because of his genius and legal background, he might easily and quickly rise to the Sacred College of Cardinals and make his fortune there.

But the twenty-one-year-old Francesco was discouraged by his father from taking orders. Two years later, at twenty-three, Francesco was appointed professor of law at the Florentine university, although he appears to have spent most of his time traveling rather than teaching. In 1508, Giucciardini married Maria Salviati for reasons that also reveal his character. He confessed that he had chosen this woman, not for any of her personal qualities (in fact, he did not even seem to like her), but because her family had wealth and power, the two characteristics Guicciardini most desired in a marital union. Also, the Salviati were the leaders of the aristocratic faction opposed to Piero Soderini's broadly based republic and hence acceptable not only to the dominant social and economic group in Florence but also to the pro-Medici party who hated Soderini and his policies.

Guicciardini's position, brilliance, and connections resulted in his legal practice becoming exceptionally rich, to the point that he considered refusing the almost unprecedented honor of becoming the youngest Florentine ambassador to king Ferdinand of Aragon (and Naples); however, Guicciardini's ambition was even stronger than his respect for wealth, and he accepted in 1511. His embassy, which began in January 1512, lasted quite some time and was very successful. Also, it was at this period that he began his *Ricordi* (or personal maxims) in earnest. Just prior to his embassy, Guicciardini had begun another work, a history of Florence, *La Storia fiorentina*, which covered the years 1378 to 1509. This history was perhaps the most significant contribution to historiography since the ancients, although it was not widely known because its author himself was ultimately to surpass it. The short period of the work—from the *ciompi* revolt until his own time—is perfectly accurate and based upon a brilliant, critical analysis of original sources, thus overcoming the traditionally derivative character of Florentine historiography. Written in elegant Italian as opposed to learned Latin, *La Storia fiorentina* is a major document, an important moment in the development of history as a discipline.

While Guicciardini was abroad in Spain, the republic of Soderini was overthrown and fell into the hands of the Medici popes Leo X and Clement VII. Increasingly, Florence became a principality in all but name, and only the ecclesiastical positions of the heads of the Medici family kept them from assuming a princely title. On returning to his city in 1515, Guicciardini was immediately made a member of the *signoria*; furthermore, in 1516 he had obviously distinguished himself in the eyes of the Medici pope, as Leo X appointed him papal governor of Modena in Emilia-Romagna.

Guicciardini proved to be a genius at administration. Upon arriving in the city, he found his province in chaos. Really a part of the Este lands of Ferrara rather than the states of the Church, Modena felt no loyalty to the pope and less to his governor. The previous six years had seen four changes of government, and the whole area was in desperate anarchy and

confusion. In fact, this was the perfect circumstance for a man of decision and ambition to build a reputation. Guicciardini's organizational skills and ruthless discipline brought the area back to order, and his remarkable honesty—a trait certainly not common among Renaissance governors—even made bribery impossible, thereby reducing the authority of the rich patricians and great rural feudatories. Guicciardini's success brought him another province in 1517, that of Reggio, also naturally dependent upon Ferrara. Again, he dealt brilliantly with a difficult situation.

In 1521 came his greatest challenge. After the French withdrew from Parma, Guicciardini had to hold it for the pope. The city was in desperate condition: the walls had been destroyed, the inhabitants and their leaders totally demoralized and defeated. But when the French counter-attacked, they were repulsed. Guicciardini's reorganization of the territory and his ruthless authority and soft cajoling made Parma a safe city again. This victory led in 1524 to Guicciardini's receiving the high office of president of Romagna, responsible for such dangerous, violent, insecure papal cities as Ravenna, Rimini, Imola, and Forlì. No province in all Italy was so fractious, divided, bloody, and dangerous. Local violence had largely stopped all agriculture and trade; and those previously in power had contributed to this breakdown in law and order. Again, Guicciardini worked a miracle through administrative and organizational ingenuity, enforced with ruthless severity. And, again, he was rewarded with a coveted promotion.

Guicciardini was recalled to Rome to become an advisor to Pope Clement VII (the former Giulio de' Medici). Unfortunately, this time, Guicciardini made a disastrous miscalculation: he convinced Clement to restore support to the French to balance the power of the emperor Charles V in Italy. A papal army was assembled and given to Guicciardini, who was appointed a general. He proved a remarkably good commander, saving Florence from being sacked by both the French and imperial armies as they wandered south out of Lombardy toward Rome. This was the imperial army commanded by the Constable of Bourbon that sacked Rome in 1527.

After the sack of 1527, the authority of the pope collapsed, and Guicciardini was seen as partly responsible, guilty of faulty advice. He lost his position and was out of favor, so he returned home to Florence. The city had also taken advantage of the dissolution of the Medici pope's power by re-establishing the pristine republic and expelling the pope's governor. Because of his long and honorable service to the Medici, the new regime distrusted Guicciardini and he was persecuted—in the best Florentine republican tradition—with confiscatory taxation. Soon after, however, in 1530, the pope, after having reached a *modus vivendi* with Charles V, turned the imperial army that had previously looted Rome against Florence. Despite a wonderfully heroic defense (see Figure 12.1), Florence had to capitulate and the Medici returned, this time forever.

Pope Clement VII gave Guicciardini the position that in part has led to his vilification, especially since subsequent historians have maintained their sympathy to the republic; and no one could ever have any sympathy for some of the Medici governors established in their native city. Indeed, Guicciardini's support of Alessandro de' Medici's regime in Florence can only be seen as careerism and opportunism of the worst kind. Guicciardini

himself was sober, upright, and scrupulously honest; hence, his devoted service to perhaps the single most loathsome ruler in Florentine history can hardly be overlooked. As we have seen, Alessandro was a horror of a duke, and Guicciardini helped him rule; but after Alessandro's murder by his equally reprobate young cousin Lorenzaccio, Guicciardini simply changed allegiance and arranged for the government to devolve upon the seventeen-year-old Cosimo de'Medici in 1537, soon to become the first hereditary duke of Florence, then grand duke of Tuscany, and the founder of the dynasty that would provide two French queens and rule Tuscany until its extinction in the male line in 1737.

Guicciardini's cynicism is disturbing. He believed that together with his associate Francesco Vettori (Machiavelli's correspondent of 1512–13), he could dominate the young and inexperienced prince. Unfortunately for Guicciardini and Vettori, Cosimo declared himself an autocrat and proved a ruthless and successful duke, despite his relative youth. Therefore, distrusted by everyone, Guicciardini retired, vilified, hated, and scorned, to his country estate, where he spent the last three years of his life writing incessantly, completing his great *History of Italy* and polishing his *Ricordi*. Regardless of what we might think of Francesco Guicciardini as a man—and he is very hard to like—his contribution to the discipline of history and to our comprehension of the late Renaissance Italian frame of mind is incalculable.

To understand Guicciardini's contribution to Western culture, one need only look at the *History of Italy* and its circumstances. In so many ways, the real purpose of Guicciardini's monumental *History* was an attempt to explain why and how he had lost his job, how a man with such talent, experience, and energy had been reduced to a kind of internal exile, far away from the corridors of power. In this, his mood and intent were not extremely different from Machiavelli's, for Machiavelli was obsessed with a very similar question at almost the same time: why did brutality and violence succeed when intelligent, subtle, educated humanists and cultivated rulers failed?

Guicciardini was fifty-five years old when he began his *History of Italy* in retirement in 1538. The work is of great importance for two reasons in relation to the author's biography. First, it covers only those events that he had observed and indeed participated in over the previous forty years. Second, it was Guicciardini's only work written for public rather than for his own use. Guicciardini's purpose was to produce a "true history" in the humanist sense, that is, an account restricted to political or military events. Speeches are inserted into the mouths of historical personages in the classical and humanist manner, just as both Livy and Leonardo Bruni had done, but with Guicciardini these are often paralleled by other orations from the opposing side to provide two points of view. Guicciardini allowed these events to speak for themselves: he did not argue a particular position; rather, he left the reader to judge the merits of competing perspectives. This was in part because Guicciardini did not have a firm ideological or principled position. Unlike the civic humanist historians, such as Bruni and Poggio Bracciolini, Guicciardini saw no absolute value in freedom and liberty. If he saw anything of transcendent value, it was and remains hidden. Indeed, Guicciardini claimed that freedom is not even a reality: all who preach liberty, Guicciardini

wrote, serve only their own self-interest. Principles and values are worse than useless, he counseled; only experience has any utility in the real world.

Because of these assumptions, reinforced by Guicciardini's personal disappointment after 1537 and his cynical opinion of human nature, *The History of Italy* becomes a coherent study, almost a tragedy in the classical sense, and its theme is the fall of princes. The wisdom and experience of Lorenzo the Magnificent and Ferdinand of Aragon harbored the vices and weakness of their sons who allowed the French into Italy and destroyed Italian independence. In large part, the tragedy in Guicciardini's brilliant analysis arises naturally, necessarily, from his elaboration of the chain of cause and effect that no Italian either could or would break. Each event after 1492 deepened the crisis and made peace, harmony, and independence more difficult to maintain until the debacle of 1527 became truly inevitable. First, governments were overthrown, and then whole peoples suffered; artistic treasures were destroyed, and finally morals and customs broke down so that the Italy that had existed before 1494 existed no longer. In short, in the view of that cynical Florentine the world of 1537 was different in every way from that of the high point of the Renaissance. Clearly, what arises from this tragedy of Guicciardini's *History* is the belief that *virtù* had failed because of human weakness, stupidity, and self-interest. Fortune had become the mistress of the peninsula; and the chief lesson of Guicciardini is that man, because of his faults, is helpless and impotent in the face of fortune.

These assumptions are illustrated by Guicciardini's brilliant analysis of the characters and motivations of the protagonists of his tragedy, especially those of the two Medici popes, Leo X and Clement VII. They, like all men, failed, writes Guicciardini, because they followed not the general good but their *particolare*, their own interests. If *virtù* versus fortune and necessity is the scheme of Machiavelli's history, Guicciardini's conclusion is that immediate self-interest (*particolare*) combined with malicious fortune has resulted in the current tragic condition of Italy. Thus, despite his retreat into an abstracted concept of fortune, what Guicciardini is truly saying is that history will usually turn out badly because of human error and illusions, and it is this record of errors and illusions that in essence constitutes historical study. For Guicciardini, history—and his *History of Italy* especially—always functions on two levels: that of factual narrative and that of human motivation. But the two are indeed inseparable, since the purpose of the latter is to give meaning to the former.

One important reason why Guicciardini was able to get at the roots of history is that he had access to and made use of the original documents necessary to prove his assumptions. Not content to follow any single source, Guicciardini studied every available account of an event and weighed them all to determine the most trustworthy. Furthermore, to document his study he brought back to his family palace the official diplomatic archives of the Florentine state and worked through them until he could build a masterful analysis of events as they truly happened. Therefore, Guicciardini and his *History*, including his very methodology in compiling it, provide a superb insight into the mentality of Italy just at the point when the values of the Renaissance, which we have been so careful to trace, were breaking down in the face of a new order. Certainly, many of Guicciardini's

observations can be found in other early *cinquecento* (sixteenth century) writers, most notably Machiavelli, who espoused the recurring theme that great men must fight against fate and fortune. Only with Machiavelli there is still hope, but with Guicciardini there is none, because experience has shown him little cause to trust human power or dignity or the vain belief that events will turn out well.

Still, there may be one aspect of Guicciardini that is positive and completely in the tradition of Italian Renaissance humanism: the ability to reason. Human rationality is a kind of hope because it can free the individual at least from the snares and traps of wicked men and malicious fortune. Guicciardini's *History* is heavily dependent on the analysis of character, and in this he is recognizing the primary place of individuality in the causal chain of history. Perhaps the concept of human dignity is not dead, but merely altered from a general concept applicable to the educated citizen in a community to the examples of a few experienced individuals trying to make sense of a dangerous and menacing world. In Guicciardini, then, the concept of human dignity has been reduced to the only factor with limited variables—the self—the only operative principle in a solipsistic universe.

For Guicciardini, the one constant in the political world is change and challenge, always menacing, sometimes fatal, as the events of his *History* demonstrate. He faults Machiavelli in the *Ricordi* for always quoting the Greeks and Romans when he really should have relied on experience and the events of his own time. For Guicciardini, his history is not merely a record of what happened but simultaneously a cautionary tale and an attempt to offer the only thing of value he can to his readers: his experience. History to Guicciardini consists of the web of events in which we are all caught. Most men, particularly princes and popes, are unable to escape the web because they look only to their own immediate advantage rather than take into account the competing self-interest of others and the forces at work against them. What Guicciardini offers in his *History* are some examples to be used in making better decisions, even though he acknowledges that not even his evidence and advice are enough, a lesson he learned when he advised Clement VII to favor the French over the Habsburgs. His evidence, then, can have no universal validity or offer any precept by which to live or act; indeed, Guicciardini often discards the whole notion of prescriptive values. Francesco Guicciardini, therefore, can make a contribution to human civilization by increasing the available data, digested and recorded and illuminated by experience, so that individual men, particularly the leaders of their people, might be better able to make rational decisions in their own lives and policies: that is all that history can ever hope to do.

NOTE

1 M. to Vettori, 10 December 1513. Original from Niccolò Machiavelli, *Opere*, ed. M. Bonfantini (Milan: Ricciardi, 1954), Lettera XI, reproduced in Progetto Manuzio e-book, 2003. Trans. Kenneth Bartlett.

FURTHER READING

Gilbert, Felix. *Machiavelli and Guicciardini: Politics and History in Sixteenth Century Florence*. New York: Norton, 1984.

Guicciardini, F. *The History of Italy*. Trans. S. Alexander. Princeton: Princeton University Press, 1984.

———. *Maxims and Reflection (Ricordi)* Trans. M. Domandi. Philadelphia: University of Philadelphia Press, 1972.

Machiavelli, Niccolo. *The Discourses on Livy*. Trans. H. Mansfield and N. Tarcov. Chicago: University of Chicago Press, 1998.

———. *The Florentine Histories*. Trans. H. Mansfield and L. Banfield. Princeton: Princeton University Press, 1990.

———. *The Prince*. Trans. and ed. Robert M. Adams. New York: Norton, 1977.

Phillips, Mark. *Francesco Guicciardini: The Historian's Craft*. Toronto: University of Toronto Press, 1977.

Viroli, M. *Niccolo's Smile: A Biography of Machiavelli*. Trans. A. Shugaar. New York: Hill and Wang (Farrar, Straus, Giroux), 2002.

FOURTEEN

ART AND ARCHITECTURE

EARLIER IN THIS BOOK we saw how Petrarch's desire to know himself and his fellow men and women resulted in an almost obsessive fascination with language as a vehicle to externalize and share individual experience. Elegance in language and a fine rhetorical style had the ability to elevate the mind and spirit and reflected what was seen as unique in the human experience. The ability to speak and reason were characteristics unique to mankind, as was the soul; hence there must be a connection among these attributes, and the nurturing of one should then inform the others. When Petrarch wrote that it is not a mystery that we can be of assistance to the spirits of others through our words and that words are no mean index of the soul, he was stating one of the most fundamental principles of humanism, the ideology that was to become the cultural frame of reference for the entire Italian Renaissance and that developed into a caste mark of an elite, a privileged and cultivated patrician perspective. It was for this reason that Petrarch and his friends and followers sought ancient classical texts: the style was to be a model on which their own writing could be based, and their content could lift the veil of time imposed on the wisdom and knowledge of the ancients, a golden age when authors such as Cicero and Quintilian saw that indissoluble connection between words, thought, and a life well lived.

The same pattern can be seen in the development of the arts during the Renaissance. Indeed, painting, sculpture, architecture, and the decorative arts form part of our understanding of humanism and Renaissance culture; and the principles developed by Petrarch and continued in a coherent manner by humanists of the fifteenth and early sixteenth centuries were applied to texts dedicated to the practice of art and architecture. Their contents became guides to Italian artists and architects who wished to recover the elegance and beauty of ancient forms and structures through knowledge of what remained of their buildings and art. The skills defined by humanist editors and philologists, particularly their powerful desire to return to the original forms of classical texts, were consequently applied to the arts as well. It is not an accident that archaeology was largely invented by Italian Renaissance humanists who wanted to know, not only what ancient buildings looked

like, but also where they were and who had constructed them and for what purpose: this knowledge would make even more profound the Italians' appreciation for, and access to, the ancient world they so admired and would function as additional information or even correctives to the content of classical books. To know where the rostrum stood and the exact location and design of the great basilicas in the Roman forum would reveal something about the environment of Cicero's eloquence and how his magnificent speeches were received by his audience. The sites of important buildings described by Roman authors and the shape of famous sculptures, such as the *Laocoön* mentioned by Pliny, would both reinforce the Renaissance sense of wonder at the size and beauty of such creations and unlock yet another point of entry into the ancient world.

Consequently, the humanist desire to know and understand the human condition was associated with the models of ancient art. Naturalism reflected both a desire to follow the contours and anatomy of the human body—especially the recovery of portraiture as a genre to define what an individual actually looked like in the flesh—and a reverence for the human form. This included the nude figure, which was seen as a homage to ancient art and as a celebration of the human condition; it was not something to be ashamed of, but rather a celebration of God's most perfect creation and the beautiful vessel that contained the soul. The Renaissance imperative to reproduce what the eye sees, therefore, was the foundation of that style of art animated by humanism.

Moreover, the role of the artist as creator was recognized as parallel and equal to that of the humanist poet or rhetorician. The medieval concept that art should not be signed—that is, claimed as an original work attributed to a sculpture or painter—was rejected. To the medieval mind, man could not create, as he himself was a creation of God (*creatura non potest creare*); it was God who did the creating, and the artist was merely an instrument of the deity. In the Italian Renaissance, however, the artist became the originator of an individual and unique vision, one who would, as the Renaissance progressed, be seen as almost divine as a creator. It is for this reason that the celebrated Michelangelo was described as *il divino*.

Figure 14.1 (facing page)
Padua, Scrovegni (Arena) Chapel. Giotto (1280–1337): *The Lamentation* (1305). Giotto has created an illusion of real space, despite his imperfect perspective. His figures not only have mass and volume but also display moving and powerful emotion in this scene of the lamentation over the body of the dead Christ.

RENAISSANCE ART AND SCULPTURE

The shift in the style and content of art began really before Petrarch. Indeed, in a circumstance again similar to the rise of humanism, a new perspective created a bridge between the medieval and Renaissance worlds at the time of Dante. Just as Dante was essentially a medieval writer who embraced new and dynamic principles in his writing, so Giotto (Giotto di Bondone, 1280–1337), Dante's contemporary, introduced elements that pointed the way toward later changes in how people and landscape were represented pictorially but did not fully realize images that reproduced accurately what the eye sees. The parallels are instructive: Giovanni Boccaccio praised Dante as the Italian who brought dead poetry back to life, and Matteo Palmieri (1406–75) described Giotto as the artist who at

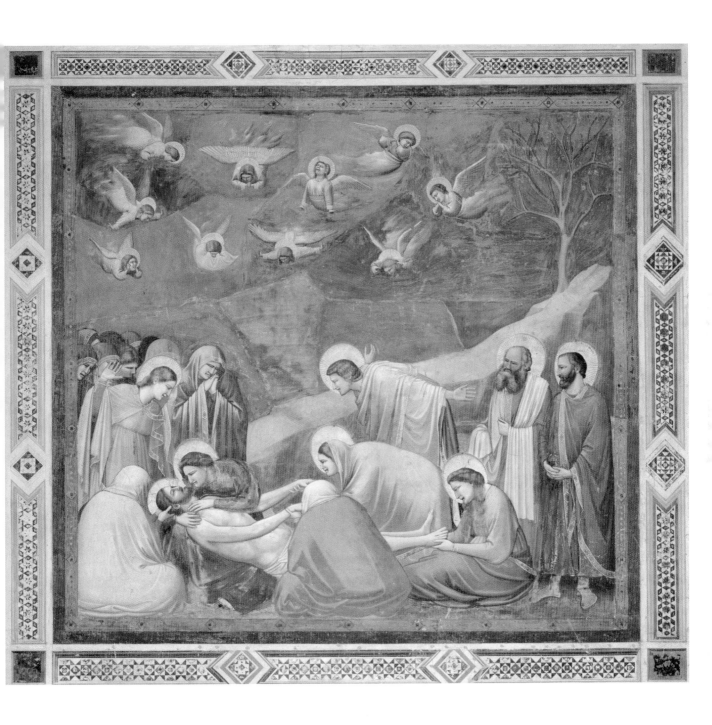

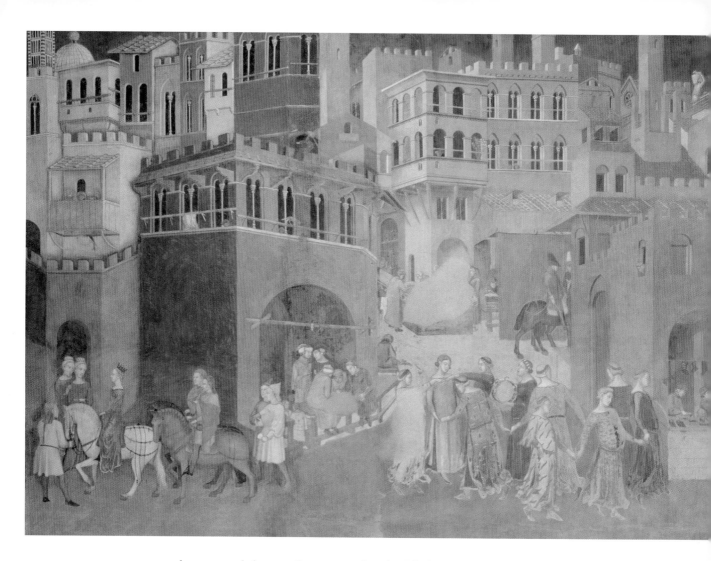

last restored the art of painting after the "darkness" of the Middle Ages. For the great sixteenth-century author of the *Lives of the Artists*, Giorgio Vasari, Giotto and his contemporaries represented *i primi lumi*, the first lights of the new style of naturalism that would not be fully developed until the fifteenth century.

Giotto was born in or near Florence into a rather humble family. A popular legend describes his discovery by the great artist Cimabue (1240–1302) when the young Giotto, who was working as a shepherd, amused himself by scratching an image of his flock on a rock. Whether true or not, the story associates the master of the formalized and flat Gothic style with the new principles of pictorial depth and more natural figures linked visually and emotionally in compositions. Giotto's frescoes in the church of St Francis in Assisi (where he worked with Cimabue) and the Scrovegni chapel in Padua, as well as his work in Rome, Milan, and Naples, made him perhaps the most celebrated artist of his time. He also worked in his native Florence, completing frescoes in chapels in Santa Croce and in the chapel of the Bargello. His reputation was such that he was commissioned in 1334 to design the bell tower (*campanile*) of the new cathedral of Florence, and

Figure 14.2 Siena, Palazzo Pubblico, Hall of the Nine. Ambrogio Lorenzetti (c. 1290–1348): *Image of Good Government* (1338–39). In this allegorical image of good government, Lorenzetti illustrates the harmony, peace, and civic enterprise that result from virtuous and enlightened leadership. Note in the upper right the construction crew building the city and the representation in the middle foreground of various classes of citizens working in harmony. This is manifestly an image of Siena, as the cathedral campanile is visible at the upper left of the fresco.

he was recognized by the communal government as a great master, held in high regard, not as a mere craftsman.

What differentiated Giotto from his predecessors and indicated the direction that painting was to take was his ability to create figures that had volume and substance, seemed to inhabit three-dimensional space, and had a measure of emotional connection to one another. These are the nascent principles of humanism in art, reflected at a time when the cultural and intellectual values of Italy were shifting. Giotto does not represent these ideals in a fully developed manner, however; his perspective is imperfect and there remain strong memories of the Gothic style and pictorial vocabulary in his art. But he is so obviously different from even his immediate predecessors that it was clear to his contemporaries that a new artistic world was being born—or reborn.

Giotto's new style and fame attracted an entire school of followers, known as *Giotteschi*. Many of these painters had seen his work in Florence and sought to continue his naturalism and realism. Of these, Taddeo Gaddi (1310–66) and Bernardo Daddi (fl. 1312–1345) were the most successful. Despite this movement to follow and refine the work of Giotto, however,

other great masters continued to employ a Gothic style but with increasingly naturalistic elements. This was particularly true in Siena, a close neighbor but consistent enemy of Florence. Artists such as the brothers Pietro (fl. 1305–48) and Ambrogio (fl. 1319–48) Lorenzetti combined the powerful medieval traditions of Sienese paintings with new ideas about what art could represent. The Lorenzettis' famous allegory of good and bad government (Fig. 14.2), a large fresco in the town hall of Siena, is a purely secular illustration of the consequences of political success and failure, of virtuous and depraved public action, rendered in a way certain to inspire the leading citizens of the commune of Siena as they debated the policies of the state. In the same building a portrait of the condottiere Guidoriccio da Fogliano (1328) by Simone Martini (1284–1344) depicts a proud and elegant warrior in profile on horseback, surrounded by the subject cities of Siena and his military camp. Thus politics, indeed propaganda, had entered the visual and artistic world of Italy by the first decades of the fourteenth century, and the humanist refrain that people exist in a community to provide instruction, guidance, stimulation, knowledge, and government for one another began to emerge, again paralleling the principles of humanist scholarship that were laying down deep roots in that receptive and rich Italian soil.

The Lorenzetti brothers died in the same year—1348—the year of the Black Death in Tuscany. The effect of this cataclysm on every aspect of life cannot be overstated: consider that approximately half the population of Europe died from this plague, creating tremendous social and economic instability, disruption, and despair. A particular consequence of the Black Death was not only the loss of a great many Italian artists and patrons, but also the loss of confidence, an element required by creative imaginations to experiment with new forms and ideas. Consequently, there was a period of about half a century during which art was again conventional: a society in crisis is not inclined to experiment, especially when there are deep economic consequences and an obviously angry deity to propitiate. However, by the turn of the fifteenth century the conservatism engendered by the plague was replaced by a new optimism, based on the receding memory of those terrible events, a newly recapitalized wealthy merchant class (those who had fortuitously benefitted by inheriting the estates of relatives lost to the plague), and newly enriched religious institutions (which had also profited from the estates of the dead and thankful gifts from the living).

Furthermore, the effects of the Black Death had not impeded the development of humanism, particularly in Florence. We have already seen the importance of the Florentine chancery, led by men such as Coluccio Salutati, that friend of Petrarch who served as chancellor of the republic from 1375 until his death in 1406. During these years the humanist ideals of a deep knowledge of classical literature, elegant language, and republican virtue came to be applied to the city of Florence and adopted as almost an ideological guide for socially mobile and ambitious patricians. It is not an accident, then, that when the naturalistic realism of *quattrocento* (fifteenth-century) art re-emerged, it happened in Florence. Greek and Roman models, ancient historical, literary, and philosophical allusions, elegant depictions of the human condition, and a deep concern about the nature of individual men and women all developed in that city. Genres that had not been practiced for a

Figure 14.3 (facing page)
Florence, Santa Maria Novella.
Masaccio (1401–28): *The Trinity* (1425). The Christian concept of the Trinity (God the Father, Christ the son, and the Holy Spirit) is represented in this masterpiece of early Renaissance painting. The frame is a Roman triumphal arch, with exact perspective achieved in the coffering in the arch. The figures of the donors are the same size as those of Christ and Saints Mary and John, although the living donors (perhaps the Lenzi family) are depicted outside the frame.

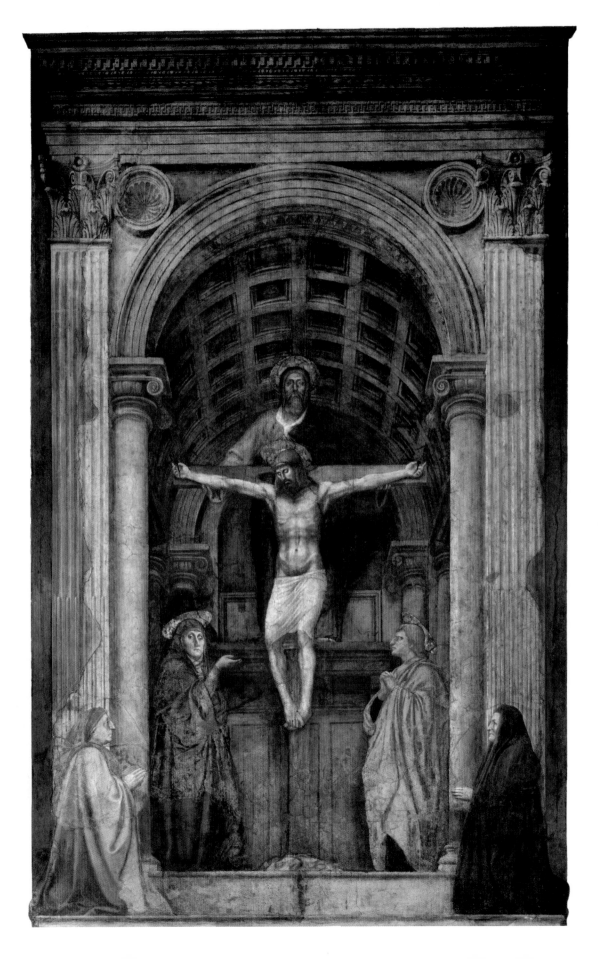

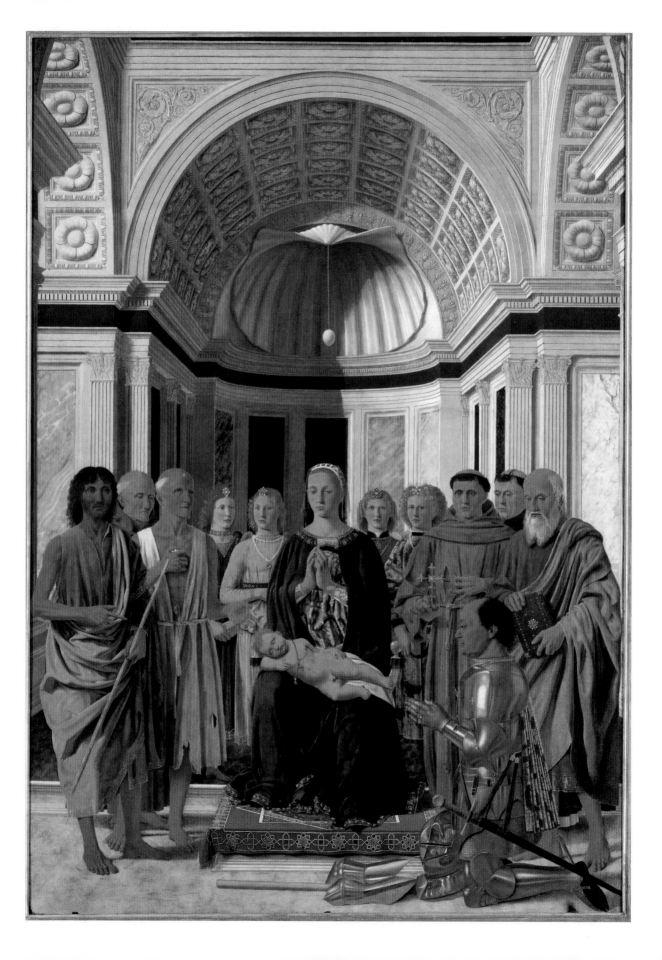

millennium—such as the free-standing male nude figure, portrait busts based on Roman models, and linear perspective (the ability to portray a three-dimensional scene on a two-dimensional plane)—came to define Florentine art. What the eye sees became an obsession, as did classical elegance and symmetry informed by human understanding and emotion.

By the turn of the fifteenth century, experimentation in painting was accelerated by the work of Masaccio (1401–28), a formative genius who sadly died young before fulfilling his potential. Still, what remains is a statement of a renewed and even more dynamic Renaissance style of art, heavily invested with humanist values. For example, his *Trinity* (1425) in Santa Maria Novella (Fig. 14.3) contains an entirely different way of bridging the human and divine, privileging in many ways the power of human perception while admitting the ultimate authority of Catholic teaching. The figures of the Trinity—Christ on the cross, God the father, and the dove of the Holy Spirit—are framed in a reproduction of an ancient Roman triumphal arch, signifying here not the victory of an emperor over his adversaries but the victory of Christianity over death. The perspective is perfect. Moreover, the donors, outside the frame of the Trinity, are life-sized, as are the saints within, indicating the recognition of the role and dignity of humans in the divine scheme, a world where the perception of the divine is filtered through human eyes and experience.

The role of perspective became central to the practice of Tuscan painters. The work of Uccello (Paolo di Dono, 1397–1475) illustrates this, as he was not only a painter but also a mathematician, one who had the facetiously held reputation of neglecting his wife for his mistress—Perspective—because she was so perfect and beautiful. Similarly, Piero della Francesca (1415–92) created wonderful images with startling perspective in their dramatic compositions, mediated by vibrant colors in rich landscapes. His *Legend of the True Cross* (1452–c. 1456) in the church of San Francesco in Arezzo established his fame. He was subsequently invited to the court of the celebrated Duke Federigo da Montefeltro in Urbino in the 1470s where he not only produced some of his most splendid pictures, such as the *Brera Madonna* (Fig. 14.4) and *The Flagellation*, but also met the mathematician monk Fra Luca Pacioli (1445–1517), with whom he would have held intense discussions on perspective and geometry (and who is portrayed in the *Brera Madonna*).

But of all the Tuscan painters, it is Sandro Botticelli (1445–1510) who is perhaps the most famous and among the most influential. He represented Florentine painting and reflected events in Florence in so dramatic a way that he has become almost synonymous with Laurentian Florence. He spent time in the workshops of Filippo Lippi (c. 1406–69) and Andrea Verrocchio (c. 1435–88), becoming associated with the Medici faction through his painting of the *Uffizi Adoration* (Fig. 14.5), in which the Medici dynasty is represented in an almost theological context, uniting three generations of the family despite the fact that both Cosimo and Piero had died by the time of the painting (c. 1475).

Botticelli's connections to the Medici and Florentine events are profound. His *Pallas and the Centaur* (Fig. 14.6), for example, is an allegory of the Pazzi Conspiracy. But it is in the pendant pictures of *Primavera* (see Fig. 10.1) and the *Birth of Venus* that Botticelli's connection to the Platonic Academy and the Medici fuse, as we saw in our discussion in Chapter Eight of Botticelli's neo-Platonic inspiration. These works were commissioned by

Figure 14.4 (facing page) Milan, Brera Museum. Piero della Francesca (1415–92): *The Montefeltro (or Brera) Altarpiece* (1474). Federigo da Montefeltro, duke of Urbino, clad in a full suit of armor, kneels before the Madonna and child in thanks for a military victory. Piero, a master of perspective, shows his skill by placing a hanging egg at the center of the niche and through the brilliant creation of a three-dimensional plane. Piero's debt to the celebrated mathematician Fra Luca Pacioli is acknowledged through his portrait: he appears as the Dominican St Peter Martyr, the second standing figure from the right.

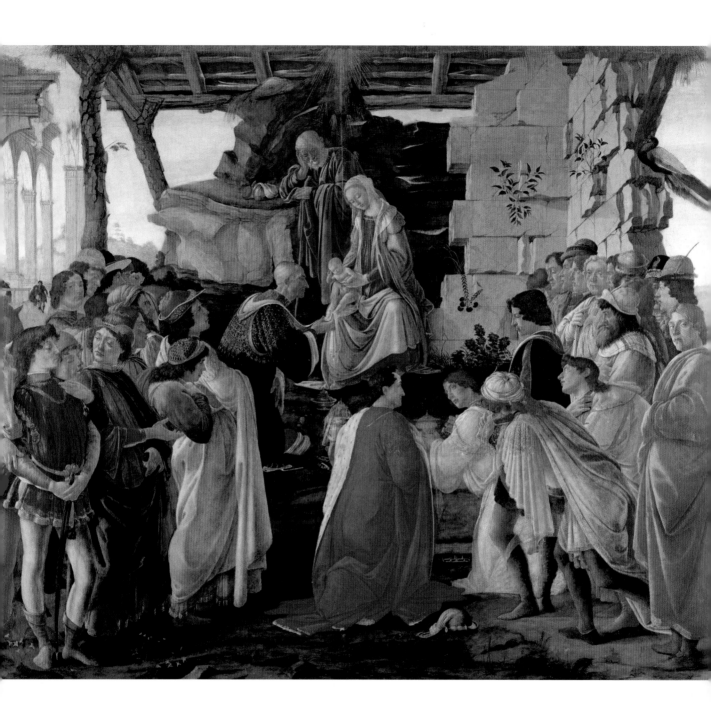

Lorenzo the Magnificent's cousin, Lorenzo di Pierfrancesco de'Medici, and were inspired by the poetry of Poliziano, specifically the *Stanze per la Giostra di Giuliano de'Medici*. These are mythological images with little or no traditional Christian iconography; instead, their inspiration comes from the poetry of Lorenzo's circle and a vision of an ideal world informed by classical thought, as interpreted by Poliziano and Marsilio Ficino.

Botticelli was the painter of the Medici, just as Poliziano was their poet. However, with the death of Lorenzo and the rise of Savonarola, Botticelli fell under the spell of the Dominican monk's preaching and became an adherent, joining his colleague from the Platonic Academy, Pico della Mirandola, and the large numbers of other Florentines who exchanged the humanist principles and values of Laurentian Florence for the apocalyptic vision of the preacher.

Sculpture followed the same general patterns as painting, and reflected in a plastic form the principles of humanism in a dynamic manner. The Florentine sculptor Donatello (Donato di Niccolò di Betto Bardi, c. 1386–1466) crafted figures in marble, bronze, and wood in which the structure of the human body beneath the clothing was clearly articulated. His sculptures have weight and movement as well as a reflection of character and mood. His *David*, for example (see Fig. 15.1), portrays the young David as a beautiful nude youth with a serene control of both himself and the conflict with Goliath, indicating his faith and his confidence. He is both a symbol of God's providence and of the republic of Florence, in addition to being a celebration of the perfection of the human body and a model for later images of David, including that of Michelangelo in the next century. This application of correct anatomy and naturalistic execution made the depiction of the human body a powerful recognition of the influence of humanism, where man became the measure of things. Figures from antiquity, both historical and mythological—even saints and Christ himself—could be sculpted as nude figures in order to emphasize their humanity above all else, creating an association with the observer and a powerful emotional bond. Sculpture, then, like painting, came to illustrate the interpenetration of classical models and humanism.

Much the same can be said of portraiture in sculpture. Portrait busts on the ancient Roman model became ever more popular after the third decade of the fifteenth century, again beginning in Florence. Individuals were depicted as they really appeared, and even if portrayed in a Roman toga or armor, or as Venus or Mars, their faces and characters were instantly identifiable as Renaissance Italian men or women. Allegory and symbolism remained and added complexity, but the primary statement was the image of the subject as he or she really was in life. Mounted figures, beginning with Donatello's Gattamelata (the condottiere Erasmo da Narni, the "Honeyed Cat") in Padua, completed in 1450, restored for the first time since antiquity the free-standing equestrian statue (see Figure 14.7).

Very different in style but still powerfully indicative of the humanist imperative in sculpture is Bernardo Rossellino's (Bernardo Gamberelli, 1409–64) tomb of Leonardo Bruni in the Church of Santa Croce in Florence (c. 1448, see Fig. 5.1). The tomb is built into the wall of the church, conforming to a common medieval practice; however, despite an image of the Virgin Mary, the sculpture is purely classical and alludes to ancient sarcophagi. The

Figure 14.5 (facing page)
Florence, Uffizi. Sandro Botticelli (1445–1510): *The Uffizi Adoration of the Magi* (c. 1475). Cosimo *il Vecchio* is portrayed as holding the feet of the Christ child, who is sitting on the Virgin Mary's lap. Cosimo's son Piero the Gouty is in the center foreground wearing a splendid red cloak, waiting his turn. The figure in the front row at the far left of the image is Lorenzo the Magnificent, embraced by his friend Angelo Poliziano and accompanied by Pico della Mirandola, who is gesturing for Lorenzo to take his place in succession to his father, Piero. Botticelli himself appears in a self-portrait at the far right, looking out of the scene and wearing a gold cloak. Also present is Girolamo Lami, the man who commissioned the work for his family chapel. He is standing in the back row on the right, looking directly out of the picture. The ruined structures that form the context of the scene symbolize simultaneously two new dispensations. In the literal reading of the adoration, it is the old law of the Old Testament being superseded by the Christian dispensation of the Incarnation. In the political reading of the image, the old, oligarchic republic of Florence is being replaced by the Medici hegemony, a new political regime.

Figure 14.6 (following page)
Florence, Uffizi. Sandro Botticelli (1445–1510): *Pallas and the Centaur* (1482–83). In this allegory of the Pazzi Conspiracy, Lorenzo is represented by Pallas Athena, crowned and draped in laurel and wearing a dress embroidered with the Medici symbol (three intertwined diamond rings) as she tames the half bestial centaur, who represents Ferrante of Naples. The ship that brought Lorenzo to Naples is in the center of the composition, and the buildings in ruin refer to a new dispensation in Florence.

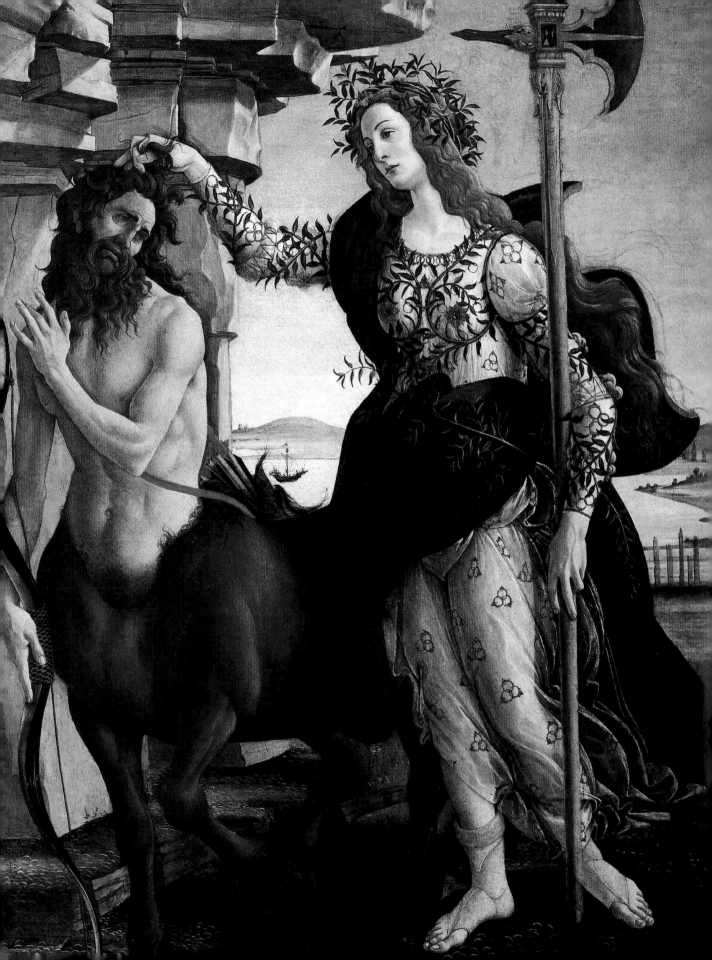

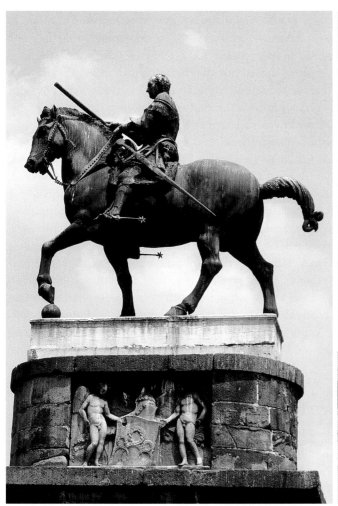

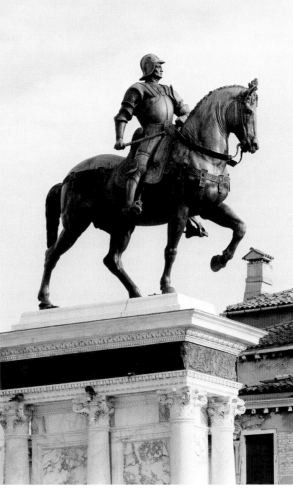

The equestrian bronze of the emperor Marcus Aurelius in Rome (the only life-sized equestrian bronze to survive from antiquity) stimulated the rebirth of a portrait form both technically challenging and without medieval antecedents. Donatello's *Gattamelata* (Fig. 14.7) was so powerful an example that in 1483 the Florentine Andrea Verrocchio was given the commission to create an equestrian statue of the condottiere Bartolommeo Colleoni in Venice (Fig. 14.8). Even more technically courageous (one of the horse's hooves is raised, distributing the great weight of the bronze statue on just three legs), Verrocchio's figure illustrates how sculpture had progressed. Donatello's Gattamelata was portrayed as a serene commander in confident control of his universe, like the image of Marcus Aurelius. Colleoni was shown as a dynamic, focused, and intense man riding to face adversity.

Figure 14.7 Padua. Donatello (c. 1386–1466): *Gattamelata* (1450)

Figure 14.8 Venice. Andrea Verrocchio (c. 1435–88): *Bartolommeo Colleoni*

great Florentine humanist chancellor is represented as lying on his bier, crowned with laurel, and holding open his celebrated *History of Florence*. The epitaph is supported, not by angels, but by winged victories, and the frame uses a purely classical vocabulary. There can be no doubt but that the tomb is a symbol of Bruni's civic humanism and devotion to ancient republican values. So successful and iconic was Bruni's monument that the tomb of his successor as chancellor, Carlo Marsuppini (d. 1453), by Desiderio da Settignano (c. 1430–64) engages it directly across the nave of the church. Different in ornament and much less elegantly simple than the Rossellino tomb, it nevertheless states the power of the humanist tomb effigy as a symbol of both the man and his position in the republic.

These tombs should be compared to Michelangelo's Medici tombs, with their opposing images of Dawn and Dusk and Day and Night, in the new sacristy of San Lorenzo in Florence (see Fig. 14.13). These figures on the tombs of the later Medici princes Lorenzo, duke of Urbino, and Giuliano, duke of Nemours, are purely allegorical and illustrate, not the serenity of the recumbent likenesses of the Florentine chancellors, but images of time and change, abstractions rather than reality. The highly stylized sculpted portraits of the two dukes above their sarcophagi are a complex mixture of an allegorical representation of character and classical models of princes in armor. In these works Michelangelo created a complex tableau of images, building them into the structure of the room itself while simultaneously setting them apart. There is movement and static majesty, idealized portrait and allegorical symbolism, all within a classical structure inspired by ancient funerary monuments. In this room Michelangelo crystallized much of the humanist application of architecture and sculpture while creating an integrated statement of how these elements work together in harmony within a singular vision.

Figure 14.9 (facing page) Venice, Accademia. Vittore Carpaccio (c. 1465–c. 1525): *Miracle of the True Cross* (1494). This evocative image of Renaissance Venice portrays the old wooden Rialto bridge before the construction of the stone structure we know today. Characteristic Venetian elements, such as the distinctive chimney pots, gondolas, and costume, all bring a powerful sense of immediacy to this painting.

PAINTING IN VENICE

The other powerful tradition in Italian Renaissance painting was that of Venice and its *terraferma* empire. The earlier traditions of Venetian art were closely associated with the Eastern orientation of the republic, as its connections with the Byzantine empire and its aloof posture toward the peninsula made this "Greek style" popular and well established. Furthermore, the movement into a more naturalistic style was hindered by the innate conservatism of Venetian culture. But, by the early fifteenth century, the movement of the Venetian republic onto the Italian mainland had stimulated an interest in the new forms and styles of Renaissance art and architecture. Jacopo Bellini (c. 1400–70) and his two sons, Gentile (1429–1507) and Giovanni (1430–1516), together with his son-in-law, Andrea Mantegna (1431–1506), who worked for the Gonzaga marquises in Mantua, would change the nature of Venetian, indeed northern Italian, painting. The workshops of the Bellini were large and prolific, producing a great number of altarpieces, Madonnas, and portraits. The Bellini's training in the Italian tradition and their control of color gave birth to a particularly Venetian style of painting in which

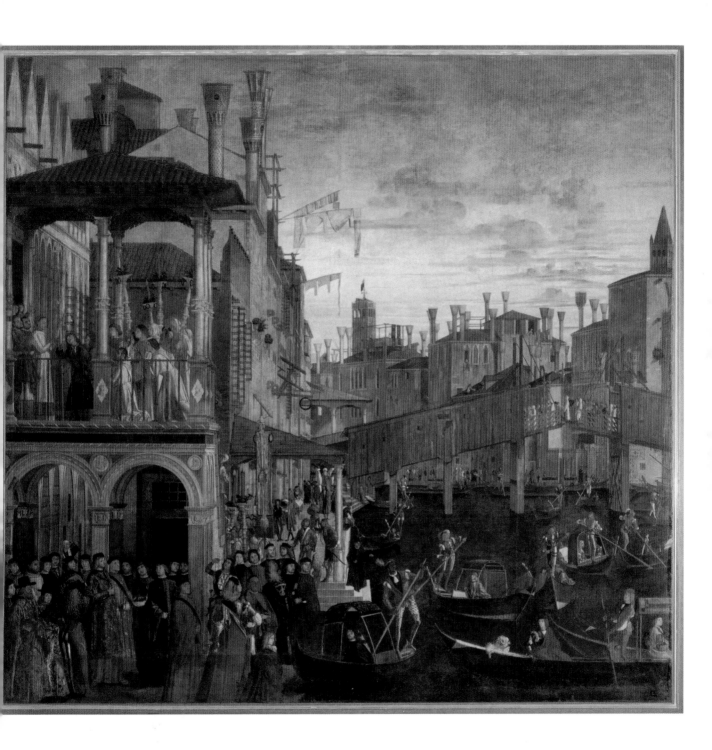

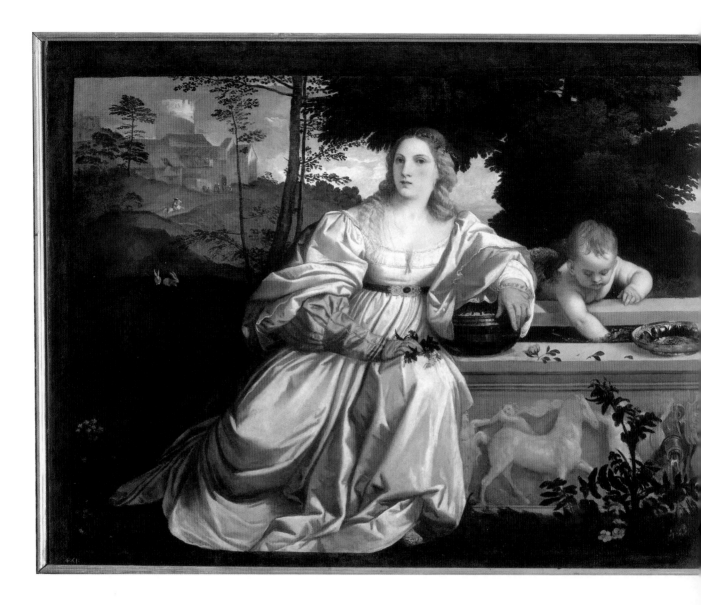

color (*colore*), rather than the composition (*disegno*) of the Florentines, would be seen as dominant. Indeed, the hues of the robes of a Bellini Madonna are experiments in color; and the close observation of the personalities of the subjects of the Bellini portraits—whether of Doge Loredan (Giovanni Bellini) or Mohammed the Conqueror of Constantinople (Gentile Bellini)—indicates a deep insight into character that would define later Venetian art.

Subsequently, Giorgione (Giorgio Barbarelli da Castelfranco, c. 1478–1510) and Titian (c. 1488–1576) would continue this tradition, with Titian becoming one of the most prolific, versatile, and celebrated painters of the sixteenth century. His ability to portray

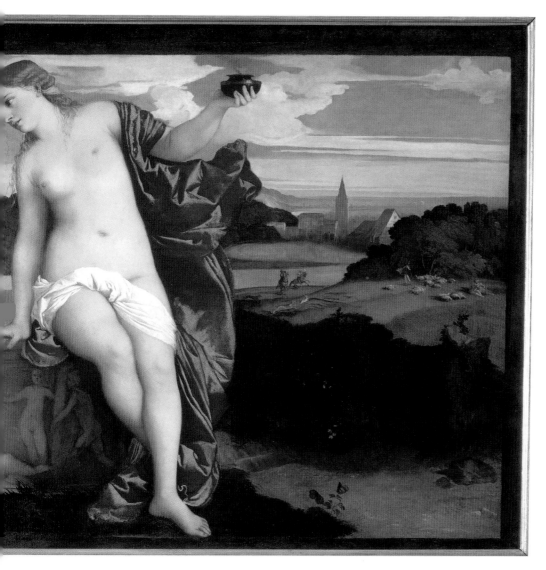

Figure 14.10 Rome, Museo Borghese. Titian (c. 1488–1576): *Sacred and Profane Love* (c. 1514). This highly allegorical picture (which received its name well after it was painted) has caused much debate. It is generally agreed that the unclothed figure represents sacred love, while the clothed woman is profane love. On the other hand, the *putto* (young cupid) stirring the water in the sarcophagus, the flowers, and the idealized landscape can mean many things, even the possibility that this image is celebrating a marriage.

so many different subjects—portraiture, landscape, religious and mythological scenes, and allegory—resulted in fame so wide that he was pensioned, ennobled, and knighted by the emperor Charles V. It was evident that the position of artists, at least the leading artists in their field, was rising rapidly to the point where their skill was no longer disparaged as a mere mechanical craft: artists were now creators in a hierarchy of talent that recognized the contributions that such geniuses offered to the societies in which they lived and worked. Patrons sought them to add luster to their names and courts; and competitions were held to ensure that the best would triumph and hence rise in reputation and esteem.

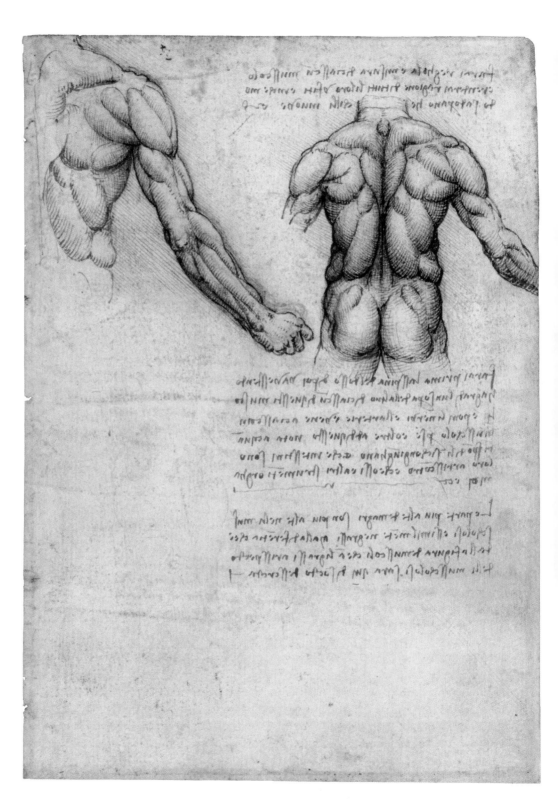

Figure 14.11 Windsor, Royal Library. Leonardo da Vinci (1452–1519): Notebooks (c. 1510), Anatomical Drawing. Leonardo began anatomical studies in Milan as early as the 1480s, observing dissections and making detailed drawings. It is in part because of his knowledge of anatomy that his human figures seem so physically real. Leonardo recorded his thoughts and observations in his notebooks, written as mirror images and therefore legible only if they are viewed in a mirror. The writings and drawings in these notebooks reflect his wide-ranging mind and boundless curiosity about every aspect of human experience and the natural world.

THE HIGH RENAISSANCE

The last decade of the fifteenth century saw the fulfillment of the promise of the earlier Renaissance painters on the peninsula, particularly the powerful influence of humanism on painting. Elements such as classical references, correct anatomy, naturalism in landscape, and a rigorous perspective all combined to create a platform on which the geniuses of the high Renaissance could build. Seldom have there been such a concentration of talent and such willing and discerning patrons as in the years between the death of Lorenzo the Magnificent in 1492 and the sack of Rome in 1527. Moreover, the status of the artist was rapidly changing, as we saw in the example of Titian. This movement of artists into the rarified sphere of the Renaissance Italian elite was well illustrated in the careers of other painters—Leonardo da Vinci (1452–1519), Michelangelo Buonarroti (1475–1564), and Raphael Sanzio of Urbino (1483–1520)—all of whom became not only the most illustrious practitioners of their art but also the companions of popes and princes.

Leonardo was the ideal genius of the Italian Renaissance. His almost unsurpassed skill in so many areas is truly remarkable: painting, architecture, sculpture, drawing, and many aspects of scientific observation and experimentation, including anatomy, hydraulics, mathematics, and botany. He was born in 1452 near Florence, the natural son of a notary, and sent to Florence as an apprentice in the workshop of Andrea Verrocchio, where he was to remain until 1477. In 1482–83 he left for Milan to enter the court of Duke Lodovico Sforza, with whom he would remain until forced to flee by the French invasions. Returning to Florence, he worked on important civic commissions for the republic, such as the now lost frescoes of the 1440 Battle of Anghiari that decorated the Palazzo della Signoria. His return to Milan in 1506 was requested by the French governor of Lombardy, and subsequently he was appointed royal painter and engineer by King Louis XII of France. The expulsion of the French from Milan in 1513 required Leonardo to leave; however, in 1516 his service was again sought by the French, and the next year he left Italy for France, where another royal patron, Francis I, had given him a chateau at Cloux and the freedom to work on whatever his imagination dictated. It was there he died in 1519.

While Leonardo represented the multi-faceted genius of the beginnings of the high Renaissance, he actually finished relatively few commissions in his sixty-seven years. In comparison, his younger contemporary Michelangelo delivered a very large body of work in almost every genre—painting, sculpture, architecture, and even poetry—making him a major star in the galaxy of Renaissance art and culture. Michelangelo was born into a patrician family in Florence and trained in the workshop of Domenico Ghirlandaio (1449–94). He also absorbed the broader humanistic culture of the age through his close association with the circle of Lorenzo de'Medici, whose patronage he had acquired while still a youth. His early work in both painting (the *Doni Tondo*, c. 1506) and sculpture (*Pietà*, 1499, and *David*, 1504 [see Fig. 15.3]) earned him such a reputation that he was summoned to Rome by Pope Julius II to carve his monumental tomb, a massive commission that was interrupted by that same pope for the painting of the ceiling of the Sistine Chapel (1508–12; see Fig. 14.12). When Michelangelo returned, some thirty years later and at the behest

Following pages:

Figure 14.12 Rome, Vatican Apostolic Palace, Sistine Chapel (1508–12). Michelangelo Buonarroti (1475–1564). Julius II convinced Michelangelo to paint the huge vault of the papal chapel that his uncle, Sixtus IV, had built (hence the name "Sistine"). The ceiling's program depicts stories from Genesis as well as images of prophets, who brought revelation to the Jews, and sibyls, who brought revelation to the Gentiles. This chapel is the place where popes are elected to this day. The proportions of the building were determined from the biblical description of the Temple of Solomon in Jerusalem. The intention was to illustrate the continuity from the Old Testament to the New through the institution of the Roman Church.

Figure 14.13 Florence, Church of San Lorenzo, New Sacristy (1520–33). Michelangelo Buonarroti (1475–1564). Michelangelo was also a gifted architect. In 1520, Cardinal Giulio de'Medici, the future pope Clement VII, commissioned him to design and build a new chapel to house the Medici family tombs. The basic structure was in place by 1524, but the sculptures as we now see them were not completed until 1533, and the entire program was never altogether finished. Pictured here is the tomb of Giuliano de'Medici, duke of Urbino. Beneath his statue are the allegorical figures of Night and Day. Facing this tomb, on the opposite wall, is the companion tomb of Lorenzo de'Medici, duke of Nemours, beneath whom are the figures of Dawn and Dusk.

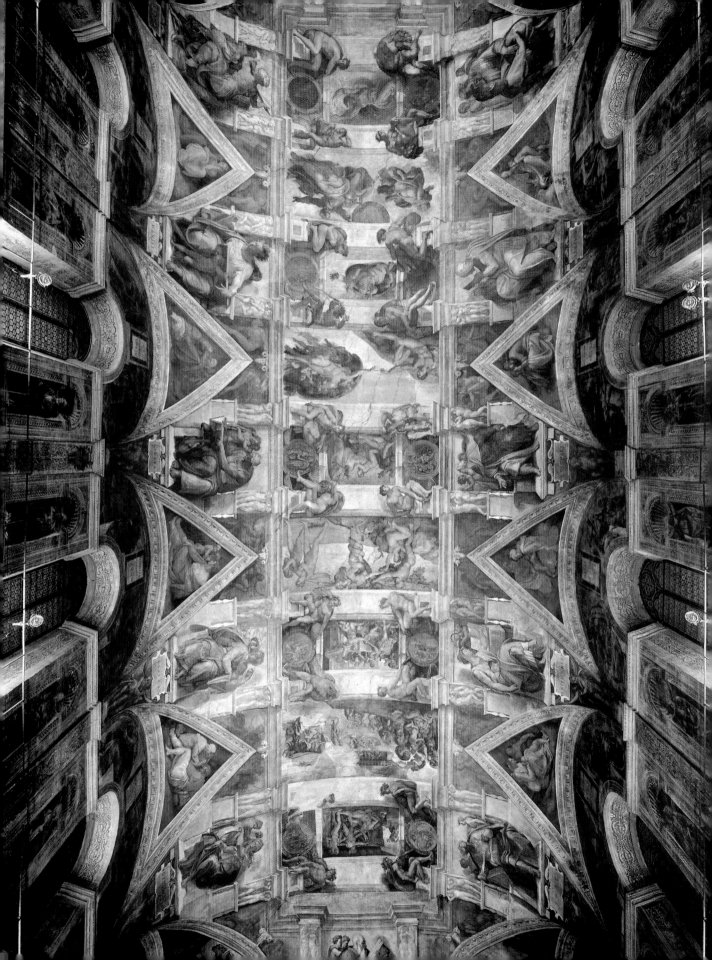

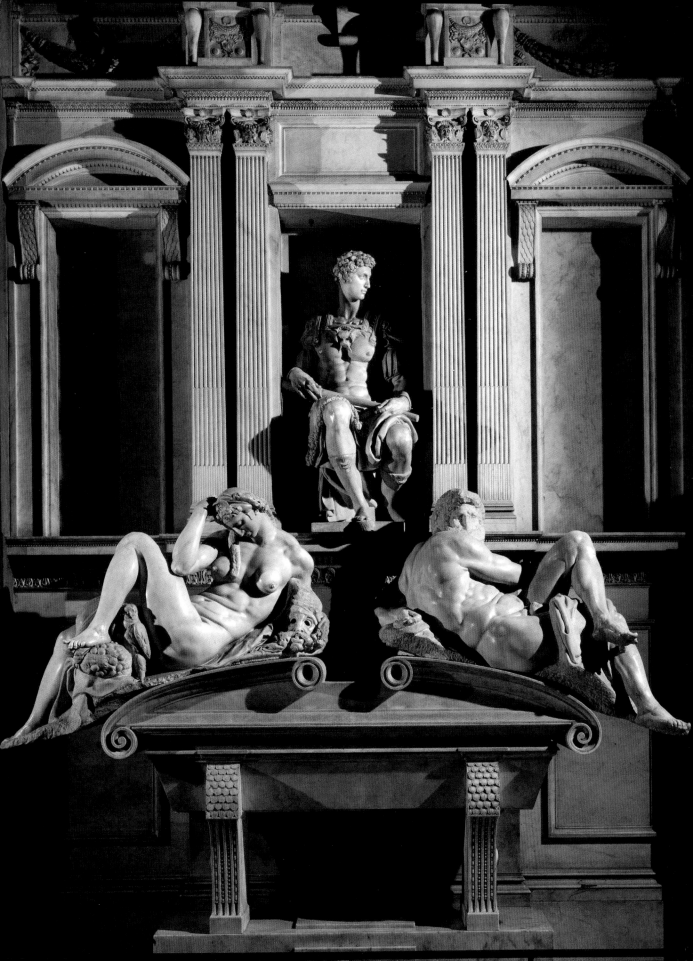

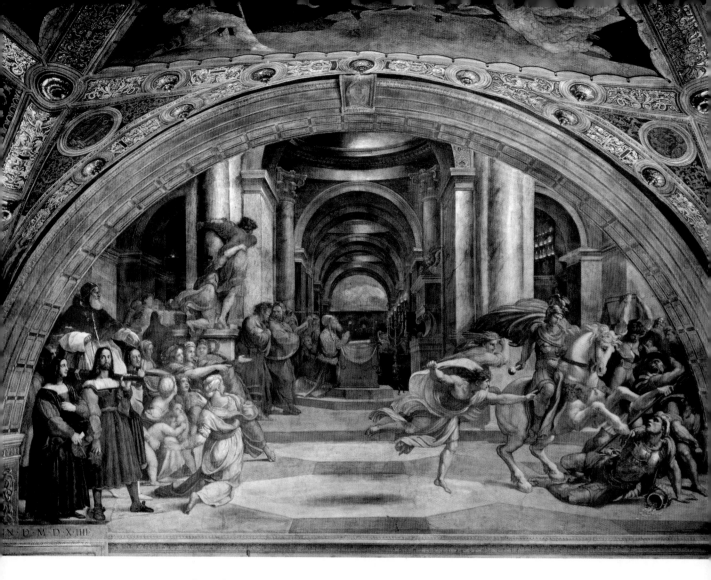

INDMDXIIII

Figure 14.14 Rome, Vatican Apostolic Palace, Room of Heliodorus (1511–14). Raphael Sanzio (1483–1520). The narrative for this powerful scene comes from the apocryphal biblical Book of Maccabees. Heliodorus, intent on stealing the treasure of the temple in Jerusalem, is driven out by a celestial horseman. At the far left of the fresco, Julius II is carried in to observe the Old Testament event. The image served as a warning to foreign and Italian princes that if they dared try to capture papal territory they would face divine retribution.

of another pope to paint the Sistine altar wall, his work reflected the tumultuous events that had overtaken Italy. The confidence and optimism apparent in the exuberance of the Sistine vault frescoes contrast powerfully with the dark vision of *The Last Judgment* (1536–41), which reflects the turbulence of such crises as the Reformation and the sack of Rome.

Michelangelo illustrates dramatically the interpenetration of humanist values and art. His figures display an elegant respect for the human form while equally recognizing the struggles attendant on the human condition. He was a vernacular poet of great talent, producing both devotional and love poetry infused with neo-Platonic ideas and images. By the time of his death in 1564, he was celebrated as the epitome of artistic genius, and his great public funeral and tomb in the church of Santa Croce in Florence recognize the position he had achieved in the art of the Renaissance.

If Michelangelo was, like Leonardo, a universal genius so skilled in every form of artistic expression that he was a master of them all, Raphael achieved his fame almost exclusively through his painting, even though he did experiment with architecture,

including in service as the chief architect of the new basilica of St Peter in Rome. Born only a few years after Michelangelo but in the remote city of Urbino, where his father, Sanzio, was court painter to Duke Federigo da Montefeltro, Raphael died tragically young at thirty-seven at the height of his fame. He received his initial training from his father but was apprenticed in the workshop of Pietro Perugino (c. 1446–1523) about 1500, achieving the status of master at the early age of eighteen in 1501. Already in great demand, Raphael left for Florence, where he would spend some extremely important years (c. 1504–08). Like Michelangelo, Raphael traveled to Rome on the invitation of Julius II in 1508, an invitation probably arranged through his relative, the architect Donato Bramante (1444–1514). Armed with a commission to decorate the rooms— or *stanze* in Italian—of the pope's private apartments in the apostolic palace, Raphael created one of the greatest fresco cycles of the Renaissance, painted at almost exactly the same time as Michelangelo was at work in the Sistine Chapel vault. These *stanze di Raffaello* (see Figs. 7.3 and 7.4) reflect Raphael's genius in creating a narrative that functions on a great many levels while still immediately engaging the eye. His ability with perspective, color, composition, and anatomy, together with the many references to antiquity as well as catholic teaching, in rooms such as the *stanza della segnatura* (Pope Julius' library, where documents were signed) established the painter as one of the most accomplished in Italy and in command of a brilliant workshop. In addition to the *stanze*, he worked on other commissions, including portraits, religious pictures, and mythological images, such as the *Galatea* in the villa of his friend Agostino Chigi (1466–1520). It was in the midst of this success that Raphael died of fever, and the *stanze* in the Vatican palace had to be completed by his workshop; nevertheless, the effect of his contribution to Western art would be felt forever thereafter. Like Michelangelo, he was given a great funeral and buried in the Pantheon, that temple first built under Augustus and rebuilt by Hadrian, and the best preserved of all ancient buildings in the city, a fitting tomb for this humanist painter, even if he knew no Latin.

ARCHITECTURE

Architecture, perhaps even more than painting, illustrated the dynamic role humanism played in the new Renaissance definition of the arts in Italy. Animated by ancient classical models and texts—some only recently recovered by book-hunting humanists—and a discipline particularly appropriate to the expanding world of the Italian cities, where new statements of wealth and power were required, architecture became a pre-eminent art, and one that attracted some of the most innovative minds who constructed some of the most iconic structures of the Renaissance. It is most appropriate to begin once more in Florence, where the expansion of the city and the construction of new churches, public buildings, and palaces for the wealthy abandoned the medieval appearance of fortresses or the Tuscan Gothic of the builders of the structures that followed the Ordinances

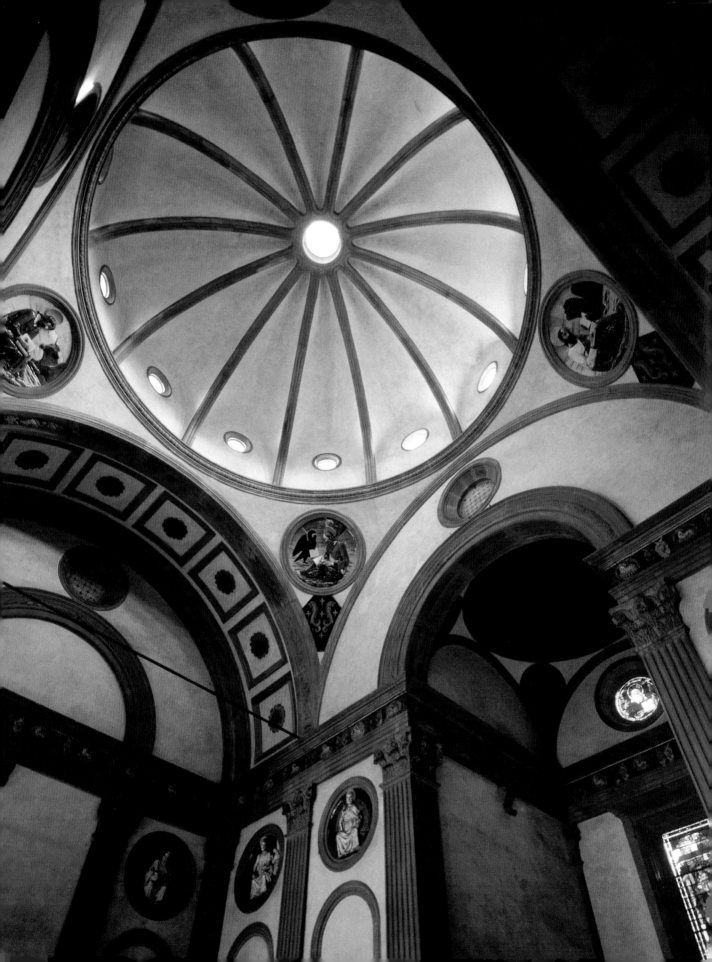

of Justice (1293). Arnolfo di Cambio's cathedral and Palazzo della Signoria remained, but their appearance was now seen as dated, to be replaced by a new humanistic style of architecture based on the buildings of ancient Rome as described in the text of the ancient Roman architect of the time of Augustus, Vitruvius (Marcus Vitruvius Pollio, c. 80 BC–after AD 15).

Vitruvius wrote his *Ten Books on Architecture* in about 15 BC and dedicated them to the emperor Augustus, his patron. It was likely a compendium of building practices and principles, a book that discussed many kinds of structures and the engineering required to build them. The manuscript was rediscovered in 1414 in the monastery of St Gall in Switzerland by the humanist writer and statesman, Poggio Bracciolini, who later would rise to be chancellor of Florence. With the discovery of Vitruvius, the vocabulary of ancient building could be applied to Italian Renaissance needs, resulting in a new style that would rank with painting and sculpture to define the taste of the Italian Renaissance itself.

The effect of this discovery, as well as the general role of humanism in the development of architecture, can be seen clearly in the life and work of Filippo Brunelleschi (1377–1446). Brunelleschi was powerfully influenced by the attraction of the ancient world, so at the beginning of the fifteenth century, with his friend the sculptor Donatello, he traveled to Rome to measure and study ancient Roman buildings. His almost three years in the city gave him the opportunity both to learn the style and structure of ancient buildings and to acquire sufficient knowledge of engineering to design a dome for the unfinished cathedral in Florence. His plan was audacious, but he won the competition and was given the commission in 1419 to construct the great dome on the cathedral, a monument to Renaissance confidence and its debt to antiquity. Not only his practical experience studying ancient buildings in Rome but also his clear knowledge of Vitruvius was an advantage, as he both designed and supervised the construction of the structure that was to define Florence and even invented the equipment required to lift the materials to the great height of the dome. Besides the dome of the cathedral (1419–61), Brunelleschi contributed a great many other monuments to the Florentine Renaissance, structures that reflected the harmony and human proportions of ancient architecture and also served well in their purposes as churches, chapels, palaces, and even the city's orphanage. In particular, the old Sacristy of San Lorenzo (1424), the Pazzi Chapel (1430–46; see Fig. 14.15), and the Innocenti (foundling hospital, 1421–44) illustrate his gifts and his vision. In many ways, Brunelleschi's buildings in Florence represent the ideals of humanism in bricks and mortar and prove that the practices and principles of the ancients could be applied usefully to the needs of contemporary Italians in all areas of human endeavor, including building.

The role of ancient models and theory was deeply set in Florentine architecture. Leon Battista Alberti (1404–72), for example, was a theorist of architecture as much he was a theorist of painting and sculpture, and a humanist author in his own right. His book on architecture (*De Re aedificatoria,* [*On Building*]), written around the middle of the fifteenth century, was in many ways heavily dependent on Vitruvius. The structures he built, such as the palazzo Rucellai in Florence (1446–51) and the façade of the Dominican church of

Figure 14.15 (facing page)
Florence, Church of Santa Croce, Pazzi Chapel (1430–46). Filippo Brunelleschi (1377–1446). The perfect proportions of this elegant structure reflect the classical definitions of harmony, based on those of the human body, as described in ancient sources such as Vitruvius. The union of a dome with a square base illustrates the connection between heaven and earth; and the triumphal arches are a reference to Roman structures. The material of the gray *pietra serena* (serene stone) and the painted and glazed terracotta roundels contribute a particularly Florentine element.

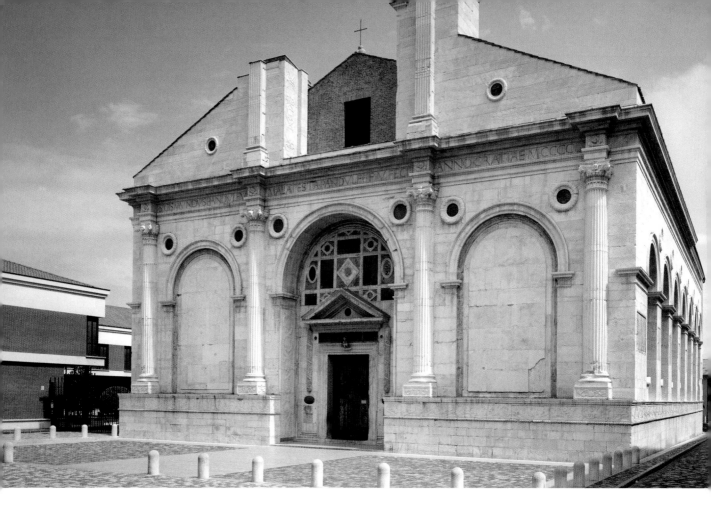

Santa Maria Novella (after 1448), illustrate his debt to antiquity and to the abstract ideals of ancient models put to the service of local needs. Equally, his work elsewhere diffused these humanist principles from the Florentine republic into the principalities of the peninsula. He worked for the Malatesta *signori* of Rimini, building the almost pagan Malatesta temple (*tempio malatestiano*) (c. 1450–60) around the thirteenth-century Gothic church of San Francesco (see Fig. 14.16); and his great work in Mantua, the façade of Sant'Andrea (after 1471), again represented a Renaissance humanist façade and rebuilding of a medieval pilgrimage church.

After the turn of the sixteenth century, the models of Renaissance architecture were transplanted to Rome, supported by the vast resources and ambitions of Renaissance popes eager to achieve fame and make the city a capital of a Christian empire equal in splendor to that of the ancient city. Donato Bramante, born near Urbino in 1444, had arrived in Rome some time in 1499 after a successful sojourn in Milan. It was in the eternal city, however, that he was to establish his reputation and build structures that would change the face of Rome and establish forever the role of humanist architectural principles, based clearly on ancient models. His first important commission was the Tempietto (1502), on the Janiculum hill next to San Pietro in Montorio (see Fig. 14.18), over a place that local legend held to be site of the crucifixion of St Peter (an

Figure 14.16 Rimini, Tempio Malatestiano (c. 1460). Leon Battista Alberti (1404–72). This church, which almost resembles a pagan temple, was constructed around the Gothic church of San Francesco by order of Sigismondo Malatesta, lord of Rimini, as a monument to his dynasty. Alberti uses the vocabulary of ancient architecture very effectively to reflect the authority and humanist aspirations of a minor despot who was seeking immortality and reputation through building. The triumphal arches and the incomplete pediment reminiscent of Roman structures illustrate Alberti's debt to Vitruvius and his skill in applying these elements to pre-existing structures.

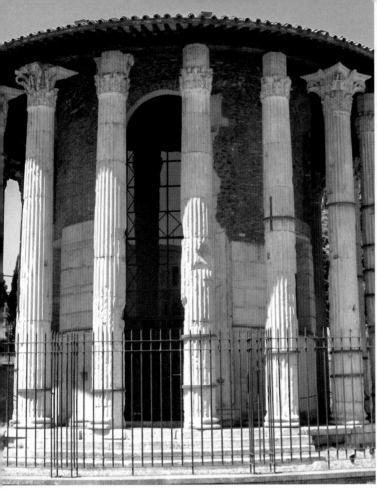

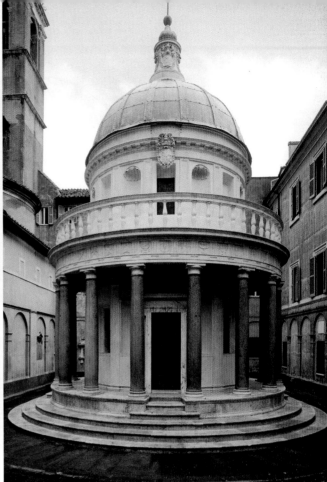

alternate—and less probable—location to the site near the basilica of St Peter). The influence of the ancient circular temple near the Tiber known as the Temple of Vesta (it was probably actually a temple to Hercules) is clear (see Fig. 14.17); again, the beauty and proportion of a republican-era temple were applied to a very sacred place in the Christian city, a principle Bramante would again apply to his greatest commission: the new basilica of St Peter.

In 1503 Pope Julius II gave Bramante—who would also build the huge *cortile del belvedere* in the apostolic palace—the commission to design an enormous and wonderful new church that would replace the Constantinian basilica that by then had been dangerously compromised by over a thousand years of heavy use and remodeling. The result was a huge Greek-plan church (the transept and nave are of equal length), surmounted by the greatest dome constructed since antiquity. Not only was the model of an ancient, centrally planned martyrium (a shrine to a martyred saint) to be used in the church over the tomb of the apostle, but also the dome, reminiscent of the Pantheon and even the cathedral of Florence, was to define the cityscape of Renaissance Rome. The church would take more than 120 years to complete, and the final design varied greatly from Bramante's (it became a Latin cross, with a longer nave); but the dome remained, given final shape by Michelangelo and recognized as one of the wonders of the Renaissance.

Figure 14.17 Rome, Forum boarium, Temple of Vesta (more probably Hercules) (first century BC)

Figure 14.18 Rome, Tempietto, San Pietro in Montorio (1502). Donato Bramante (1444–1514)

The elegant, small church on the right was constructed under pope Alexander VI Borgia to mark an alternate site for the crucifixion of St Peter on the Janiculum. The inspiration for this centrally planned structure clearly derives from the Temple of Vesta (Hercules) on the left.

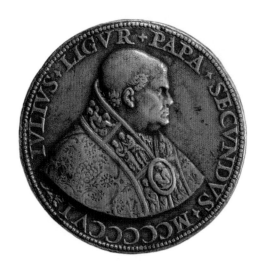

Figure 14.19 London, British Museum. Pope Julius II Medal. Cristoforo Foppa Caradosso (1445–1527). This medal was struck in 1506 to commemorate the beginning of the construction of the new Basilica of Saint Peter. The obverse features the head of Pope Julius II. The reverse illustrates Bramante's original plan for the church, a Greek cross structure with a classical pediment, a large dome, and a tower at each end. It has recently been suggested that the medal was cast by Bramante himself, rather than Caradossa, a leading Renaissance goldsmith.

THE DECORATIVE ARTS

The desire of wealthy and cultivated patrons to enjoy small objects and beautiful things of daily use as tributes to their taste and erudition resulted in the perfection of the decorative and minor arts during the Italian Renaissance. This is illustrated not only in the observation that many sculptors, architects, and painters were goldsmiths and bronze casters as well, but that little distinction was made in the hierarchy of genres. For example, Brunelleschi was trained as a goldsmith but still entered the competition to create the bronze doors of the Baptistery of Florence (see Figs. 14.20 and 14.21). The three sets of doors on this building reflect the growth in technical skill and the role of humanism in the Florentine republic. The doors of the Baptistery were of particular significance because of their liminality: one born in the city became a full citizen and a full member of the Christian community after passing through those portals.

The building itself was constructed around the end of the eleventh century, although most Renaissance Italians believed it to have been originally an ancient Roman temple to the god Mars. The first set of doors was designed by Andrea Pisano (c. 1290–1348) on the recommendation of Giotto, beginning in 1329. These doors were divided into twenty-eight Gothic quatrefoil panels, mostly following the story of John the Baptist. As with Giotto, these panels mark a bridge between the medieval and nascent Renaissance style, and the overall impression is that of Gothic design. Moreover, there was insufficient skill in bronze casting and chasing in Florence at that time, so the doors had to be cast in Venice, where the ability to produce very high-quality bronze panels had been perfected. They were finally completed in 1336.

The competition for the second set of doors was run by the cloth merchants' guild (*Calimala*) in 1401. The importance of the commission resulted in the most celebrated artists in Florence submitting entries, including Brunelleschi and Donatello. The winner, however, was a twenty-one-year-old sculptor named Lorenzo Ghiberti (1378–1455), who was to work on this commission for the next twenty-one years. The program provided to

Ghiberti reflected the still conservative environment following the Black Death; indeed, these doors were seen as a commemoration of that terrible event. The twenty-eight Gothic quatrefoil panels of Pisano were to be maintained, and the narrative of the panels was to depict the life of Christ; but this time the doors were cast and chased in Florence.

The success of this commission made Ghiberti extremely famous. When he was offered the commission for the third set of doors in 1425, he was accorded a great deal of creative license: the result was a totally different set of rectangular panels that employed brilliant perspective in varying depths of relief, incised decoration that made the bronze seem almost a plastic medium, and a realism in anatomy and a narrative power that resulted in Michelangelo's remarking that these doors were suitable to serve as the gates to paradise. Ghiberti worked with his assistants on these doors for twenty-seven years, and when they were complete the orientation of the three pairs of doors was altered so that those of Ghiberti faced the cathedral. And, in recognition of the humanist cult of fame and pride in his ability to create, Lorenzo Ghiberti placed his own sculpted image and that of his

Figure 14.20 Florence, Cathedral Baptistery (San Giovanni). Lorenzo Ghiberti (1378–1455): *The Entry into Jerusalem* (1404–24)

Figure 14.21 Florence, Cathedral Baptistery (San Giovanni). Lorenzo Ghiberti (1378–1455): *The Sacrifice of Isaac* (1425–52)

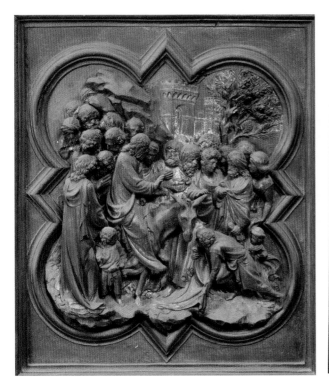

Ghiberti was still a very young man when he was awarded the commission for the north doors of the Baptistery. He was required to work within the structure established almost a century before by Andrea Pisano and confine his images in Gothic quatrefoil frames. When he received the commission for his second set of doors (the third set for the Baptistery), Ghiberti's skill and reputation were such that he was permitted to abandon the quatrefoil frame and allow his reliefs to occupy the complete panel. The splendid example of the Sacrifice of Isaac attests to the bronze caster's art. It employs brilliant perspective, levels of relief, and highly naturalistic landscapes and anatomy.

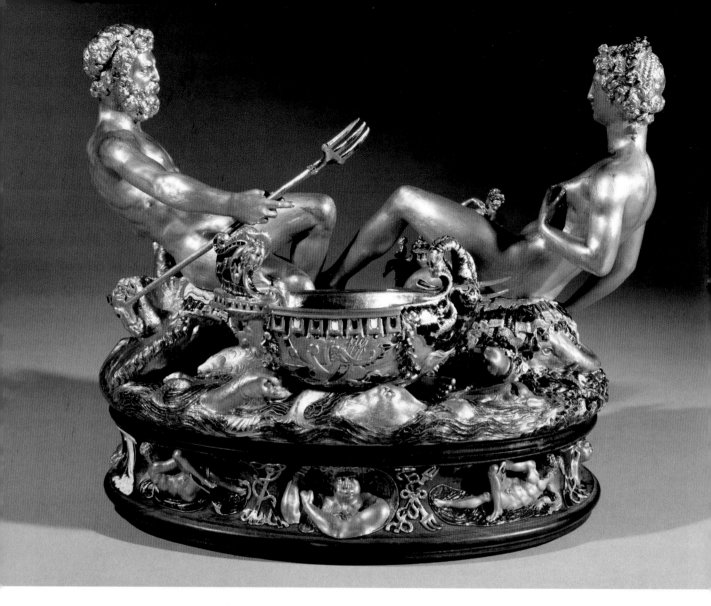

Figure 14.22 Vienna, Kunsthistorisches Museum. Benvenuto Cellini (1500–71): Salt Cellar (*Saliera*) (1543). This golden salt cellar was made for King Francis I of France. The figures of Neptune (the god of the sea) and Ceres (the goddess of agriculture) represent the fruits of the ocean and the earth. Even the minor arts, such as those of the goldsmith, exhibited the humanist references to classical antiquity, an elegance of form and design, and a quality of workmanship that rival even the greatest Renaissance commissions.

son, Vittorio, on the frame of his celebrated doors so that all would know forever who the genius was behind this remarkable creation.

Pride, fame (indeed notoriety), genius and self-promotion all came together in the career of Benvenuto Cellini. Cellini (1500–71) was born in Florence, where he was initially apprenticed to a goldsmith. He traveled widely in his life, however, in part to follow his patrons and in part to escape from the difficult circumstances that resulted from his complex personality, at once polished (he was also a brilliant musician) and brawling. In 1519 he moved to Rome, where he worked for the Medici pope, Clement VII, and was with him during the 1527 sack of Rome, an event that caused him to melt some of his golden objects for easier transportation. In 1540 he traveled to France to attend the court of Francis I, for whom he made an exquisite saltcellar (see Fig. 14.22), one of his most celebrated objects, and his much larger Fontainebleau nymph. But in 1545 he was summoned to Florence,

where he cast for Cosimo I de'Medici, duke of Florence, the almost life-sized Perseus that can still be seen in that city's *loggia dei lanzi*. At the same time he cast a bronze portrait bust of Duke Cosimo that reflected both Cellini's position as court sculptor and his ability to craft a wonderful image that accurately portrayed the intelligence and ruthlessness of that ruler. But, somewhat ironically, it is as a writer that Cellini is primarily known. He wrote an important treatise on the arts of the goldsmith and sculptor, and sometime between 1558 and 1562 he dictated his famous *Autobiography*.

There were very few autobiographies by artists before Cellini, and his set a tone for the artist as hero that mixed memory with fiction to fashion himself into a heroic figure. He describes his many love affairs with men and women, his dealings with popes and princes, his violent brawls in which men died. He became a figure larger than life and one destined by his creative ability to achieve great things on earth. He saw himself the equal and companion of the great and powerful, while never hesitating to describe the low-life characters and situations he encountered, often with relish and delight. In *The Autobiography of Benvenuto Cellini*, we have a statement of the artist as hero, the creative genius freed from all restrictions by his art and proud of his life's work, regardless of what that may have required him to do. Humanism and art, the creative and the narrative, and the cult of the extraordinary individual emerge all together from Cellini's autobiography. He was in so many ways the model of Jacob Burckhardt's unbridled egoist; but he was not a prince or a *condottiere*: he was an artist.

Cellini's lifetime corresponded with some of the greatest threats that Italy would confront, events he describes, often vaingloriously, in his *Autobiography*. He was attendant on Pope Clement VII during the 1527 sack of Rome, and, like Leonardo da Vinci, he was lured to France by Francis I, because the potential for rich commissions proved greater in the kingdoms of the "barbarians" than in his native Italy. And, when he returned to his native Florence, he served the despotic Cosimo I, duke of Florence and later grand duke of Tuscany. The world of the Renaissance artist had changed by the 1540s, as had the Italy of the Renaissance.

Finally, any discussion of art and architecture in the Renaissance must recognize the singular contribution of Giorgio Vasari (1511–74), both as a practicing artist and architect and as the author of *The Lives of the Painters, Sculptors and Architects*, which first appeared in 1550. Much of what we know about Renaissance artists such as Leonardo, Michelangelo, and Raphael comes from Vasari, who blended an appreciation of their work with a discussion of their personalities. One of the ironies is that Vasari does not give Cellini a full biography of his own, first because Cellini was still living when the *Lives* appeared, and second because Vasari noted pointedly that Cellini had told his own story in his flamboyant and self-serving *Autobiography*.

Vasari was born in Arezzo to humble parents, but he attracted the attention of the cardinal responsible for the education of the young Medici princes. Vasari was taught with them and studied painting with Michelangelo and Andrea del Sarto. His close association with the Medici led to an invitation from Cardinal Ippolito de'Medici to travel to Rome, where Vasari was able to study classical monuments and begin his own long career as a painter and architect.

When the Medici were restored to Florence in 1530, Vasari accompanied them and consequently entered the Medici court, where he would work between 1555 and 1572 as the *de facto* official artist of Duke Cosimo I. Very gifted and natural as a painter, architect, and cultural bureaucrat, Vasari represented in his career the artist as client, courtier, and advisor to a prince. He became, in fact, almost a minister of the arts, one favored both with important commissions, such as the decoration of the Palazzo della Signoria, once it was transformed from republican city hall into a ducal palace, and with the construction of the Uffizi, a huge new building that was to contain the state offices (*uffizi*) of the centralized, despotic autocracy of the Medici dukes and grand dukes. In his commissions, particularly the work in the Palazzo della Signoria, we see art developing into propaganda for the prince, with images of the apotheosis of Cosimo I and portraits of the duke giving justice, planning military campaigns, and doing everything that a dedicated autocrat saw as his duty, responsibilities that had been distributed over a great many magistracies during the period of the republic but that now resided in the sole authority of the prince.

However, it is as the author of *The Lives of the Artists* (as the large collection of biographies is often simply known) that Vasari achieved his greatest fame. In many ways he invented the modern discipline of art history by studying changes in style evident among artists, organizing his book in a rough chronological order differentiated by region. It was he who codified the roles of Cimabue and Giotto as *I Primi Lumi*, the First Lights, of Renaissance painting; and it was Vasari who suggested that perfection in art culminated in the "divine" Michelangelo. Although painters from other parts of Italy are discussed and recognized, there is no doubt when reading the book that Florentines are given greater emphasis and praised for their consistent genius, even those whom Vasari himself did not much appreciate. Significant features of the *Lives* are a sense of progression in the arts, the idea of perfectibility, and the role of genius. The characters of artists are described, and their individuality and humanity celebrated. In many ways, Vasari's biographies constitute an artistic equivalent to the lives of the saints so important during the Middle Ages, and even later, as inspiration for greater faith. In Vasari's case, these artists are hardly saints, but their skills were seen as somehow equivalent to holiness: a secular sanctity born of genius. For this reason Michelangelo can be labeled *divino*, as artistic ability was as divine an attribute as holiness among the faithful.

Vasari, then, like so many of the artists discussed in the *Lives*, was making a rich contribution to the culture of the Italian Renaissance of the first half of the sixteenth century. Equally, though, he was a client of princes who determined the program for his work, whose every act was celebrated as just and glorious, and whose image was ubiquitous. Leonardo, Raphael, and even Michelangelo were also the clients of popes and princes, but their work was not as closely tied to the glorification of their patrons as was Vasari's. Florence after 1530 was a very different place from the Florence of the fifteenth century, and even very different from the Milan of Lodovico il Moro or the Rome of Julius II and Leo X. The traditions of excellence and the quality of workmanship remained; but the patterns of patronage and the nature of commissions now reflected a world almost exclusively of princes and courtiers. The character of Italian culture was in a state of transition,

a response to the crises that followed the French invasions of 1494 and the eventual loss of Italian liberty. Art became the medium through which Italy defined itself, as it had lost its political, economic, and, after the Reformation, even its religious pre-eminence. Nevertheless, the creative culture of humanist scholarship and Renaissance art and architecture remained powerful, even if it now increasingly resulted from the patronage of despots.

FURTHER READING

Barkan, Leonard. *Unearthing the Past: Archeology and Aesthetics in the Making of Renaissance Culture*. New Haven, CT: Yale University Press, 1999.

Brown, Patricia Fortini. *Art and Life in Renaissance Venice*. Princeton, NJ: Princeton University Press, 1998.

Goldthwaite, Richard A. *Wealth and the Demand for Art in Italy: 1300–1600*. Baltimore: Johns Hopkins University Press, 1993.

Holmes, George, ed. *Art and Politics in Renaissance Italy*. Oxford: The British Academy, 1993.

Kempers, Bram. *Painting, Power, and Patronage: The Rise of the Professional Artist in Renaissance Italy*. London: Penguin, 1987.

Miller, Keith. *St. Peter's*. London: Profile Books, 2007.

Partridge, Loren. *The Art of Renaissance Rome: 1400–1600*. New York: Harry N. Abrams, 1996.

Portoghesi, Paolo. *Rome of the Renaissance*. London: Phaidon, 1972.

Vasari, Giorgio. *Lives of the Artists*. Trans. George Bull. 2 vols. New York: Penguin, 1965.

Walker, Paul Robert. *The Feud that Sparked the Renaissance: How Brunelleschi and Ghiberti Changed the Art World*. New York: William Morrow, 2002.

Welch, Evelyn. *Art and Society in Italy 1350–1500*. Oxford: Oxford University Press, 1997.

FIFTEEN

THE END OF THE RENAISSANCE IN ITALY

A CONTENTION OF this book is that the Italian Renaissance had a beginning and an end and that it is consequently possible to trace the life cycle of the values, style, and institutions that defined the Renaissance from the time of Petrarch.

Obviously the structures that contributed so significantly to the development of Italian Renaissance culture and values all had different life spans and circumstances, as did the several styles that today are characterized as "Renaissance" by art historians, literary scholars, or musicologists. Particular places central to the establishment of these principles all enjoyed different trajectories of growth and decline. The narrative of the history of every state in Italy changed under the influence of what we have defined as Renaissance values; and those histories all reflected varied responses to the opportunities and challenges of that time.

As we began with Burckhardtian conceptions and definitions, so must we return to those assumptions. In his great book *The Civilization of the Renaissance in Italy*, Jacob Burckhardt stressed that the Renaissance was in essence the history of a mentality, an attitude, or, in the terminology of another scholar, Federico Chabod, the energizing myth of an age. Thus, although institutions and styles might survive in a kind of half-life after the extinction of the animating spirit that provided their vitality, we must consider the end of that spirit, that energizing vitality, as the effective death of the organism. A corpse can be embalmed and made to appear almost lifelike, but it is no longer the same person as it was when alive. Consequently, the end of the Renaissance in Italy is the end of the spirit that gave it its particular life, character, and energy. This vital force was in itself complex, including such elements as ideas, artistic styles, political and social institutions, and even the environment in which individual genius could flourish. But, taken as a whole, the evidence is clear that much had changed, because we can see the Italy of the mid-sixteenth century as dramatically different from the Italy of 1402, or 1450, or even 1512.

It is necessary, then, to suggest some reasons for the vivid transformation that Italy experienced in the Renaissance. We must explain why the energizing myth of the Italian

Renaissance no longer obtained, or had been diluted or even extinguished, replaced by another, narrower, more traditional and less humane spirit, best illustrated in the movement of the counter-Reformation and the victory of despotic monarchies. To do so, it is important to make some general comments about the peninsula as a whole before embarking on a more detailed discussion of three of the most important centers of Italian Renaissance culture: Florence, Venice, and Rome. The conditions signaling the end of the Renaissance in Italy mark, in addition, a very significant turning point in European civilization in general, initiating a new period of Western history animated by different values, institutions, and myths.

The foundations of Renaissance values exemplified in both early and civic humanism imply certain preconditions that were absolutely necessary for the development and sustenance of those values. Therefore, if we consider the decline and eventual rejection of these preconditions, we are investigating the collapse of the Renaissance energizing myth itself. Humanism, as the ideology of the Renaissance, can perhaps be reduced to a limited number of categories, such as self-confidence and the application of the lessons and language of classical antiquity to the conditions of the Italian states. The first element, self-confidence, was also reflected in the application of ancient models to the various circumstances of fifteenth-century Italian life and thought: man is the measure of all things; man can do anything if he but wills it. The critical importance of the classical past as a guide to life and letters allowed the Renaissance its self-definition; therefore, it divided history into clearly distinct eras, permitting such concepts as historical periodization and historical self-awareness. In short, the Renaissance discovered the modern concept of time, as well as the modern concept of the self, that is, the importance of each individual human being with the potential to realize a good and meaningful life on earth. Put the two together, and a not too schematic vision of the Renaissance frame of mind emerges: men and women exist in time to reap the wisdom of the past and apply it to the needs of the present. Implicit in this are the desire for fame, the understanding of historical cause and effect, and the function of naturalism in art as an instrument of self-awareness. These concepts are necessary to the ideal of humanism as a program of education, leadership, and personal fulfillment, a program that, through classical studies, reinforced Italians' belief in their superiority and gave them a sense of their special place in history.

FLORENCE

These values of humanism played an extraordinary role in the development of one particular Italian state: the republic of Florence. By the early fifteenth century, Florence had institutionalized many of the principles that Italians had been developing during the previous half-century, adopting humanism as its own particular energizing myth, its elite ideology. This set of beliefs explained its commitment to republican liberty, illustrated in the survival of the republic, despite the threat from Milan and the collapse of almost every other Italian state in the face of Giangaleazzo Visconti. It was in Florence, then,

that the necessary connection between humanism and liberty was born—to borrow Hans Baron's terminology (see Chapter One), civic humanism. Humanism had found a home and a regime to support it officially in return for the psychological buttressing of the republican state.

Through writers and statesmen such as Coluccio Salutati and Leonardo Bruni, the connection was drawn clearly. First, the Florentine civic humanists saw a critical parallel between the classical republic of Rome, and even the *polis* of Athens, and their own patrician republicanism. Therefore, the classical texts, values, and education that formed the curriculum of humanism were seen as especially relevant to Florentines; hence, these values were assiduously cultivated by the political classes to make the connection between humanism, elite education, and politics even stronger. Indeed, humanist principles were increasingly built into the structure of the state, as humanists and humanistically educated patricians began to monopolize the offices of the republic. The benefits of that education—eloquence, knowledge of history, and good Latin style—all became prerequisites for success. Florence became a humanistic republic.

Another element of the Baron thesis deserves proper credit: the idea of the republic as a community, an association of free citizens. What was defined as good was not a transcendent theological virtue, but those elements that would produce collective benefit for the commune. This idea is altogether opposed to the principle of monarchy, as public policy should be of value to all citizens, not just of benefit to the ruler, the prince. In the ideal of the republic, good policy should benefit the free association of citizens who rule for one another's interests as well as for themselves. In such a republic, the place of the individual citizen, especially the man of genius, was secure and protected. The homogeneity required in monarchies whereby all citizens except the prince occupy a subservient, secondary rank became hateful. Each man of property had the potential and the right to rise to the highest office in the state provided he enjoyed the necessary qualifications on an individual basis. Hence the emphasis on the individual, whether simple citizen or egregious genius, is a direct result of the function of the republican constitution and a social structure that allowed for social mobility and participation. The myth of Florence, then, was a myth of republican liberty and shared values.

And this was, of course, a myth. The Florentine patricians, regardless of their humanist educations, governed in their own interests, which often were contrary to the benefit of the whole community. Only approximately three per cent of the Florentine population, represented by the wealthy, well-born, adult male guildsmen, had secure access to positions of responsibility. Nevertheless, despite these valid objections, the myth remained and evidently affected the disenfranchised majority of the population in positive ways. Among the political classes there were of course tensions, but lesser guildsmen did rise to become priors, even if through luck or patronage. Their examples were common enough to cement their natural affection for their city, manifested in their support for the republic, even if the political structure was in reality stacked against them. As for the mass of the politically impotent, often illiterate, impoverished, occasionally desperate *ciompi* and other workers, conclusions are difficult to reach; they revolted successfully only once, but rallied to the republic often.

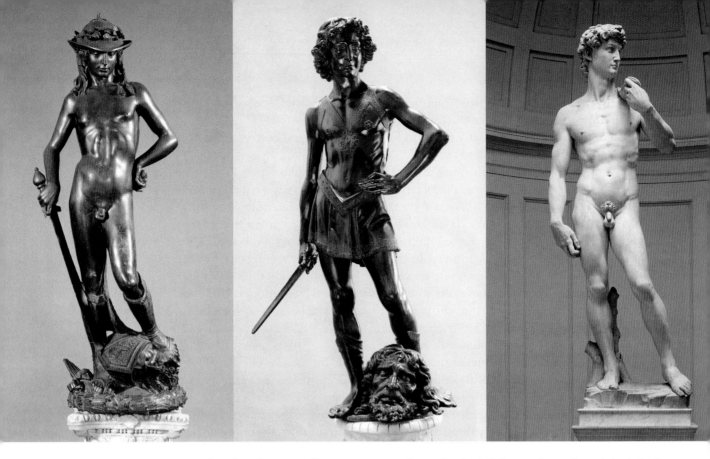

Figure 15.1 Florence, Bargello. Donatello (c. 1386–1466): *David* (c. 1430)

Figure 15.2 Florence, Bargello. Andrea del Verrocchio (c. 1435–88): *David* (c. 1475)

Figure 15.3 Florence, Accademia. Michelangelo Buonarotti (1475–1564): *David* (1504)

The biblical David became a symbol of the Florentine republic after the defeat of Giangaleazzo Visconti. The parallel reflected the self-confidence of the republic: by standing alone, Florence had defeated a seemingly invincible enemy, illustrating the special destiny of the city and its future promise. In almost every generation, great sculptors fashioned images of David.

This identification of humanist principles, individual ability and worth, and the belief in Florentine republican liberty also manifested itself in art. The republic as a community patronized art to beautify and symbolize the city that housed it. For example, Michelangelo's *David* (see Fig. 15.3), conceived as an iconographical representation of these very principles, was commissioned as a public monument, and it represents a continuation of a theme of Florence as David begun by Donatello (Fig. 15.1) and sustained by Verrocchio (Fig. 15.2). A great many other examples can be found as well, from the guild-commissioned sculptures in the niches of Orsanmichele to Ghiberti's bronze doors on the Baptistery (see Figs. 14.20 and 14.21).

However, in such occupations and commissions, the principles of humanism and civic pride blurred the distinctions between public and private patronage, just as the operation of the republic, as we saw at length, blurred the distinction between public and private wealth. Therefore, the old corporate principles motivating commissions and charity during the Middle Ages, that is, before the institutionalization of humanism in Florence, tended toward otherworldly, theological ideals; but after about 1400, the pattern of such charity and patronage became civic, directed toward this world, aiding man in his terrestrial life and dedicated toward endowing the community. Bequests to convents and monasteries increasingly gave way to bequests to hospitals, orphanages, libraries, and dowries for poor girls. The humanist doctrine of learning to live humanely was indeed applied at the community level by taking active responsibility for one's fellow citizens, as well as for oneself and one's family.

This tendency increased during the fifteenth century until it, too, became institutionalized in the state. The republic was increasingly seen as the reflection and the executive of the entire community, so these functions were assumed by the state, operating in its capacity of *alma mater* for its citizens. It was from such considerations that institutions like the *Monte delle Doti* arose, and even the income and wealth tax of the 1427 *catasto*. Private, family, and corporate duties were assumed by the state in its role as community organizer and public administrator. In some ways, the modern state was born when the community identified itself with the needs and aspirations of its constituents and then attempted to meet them through instruments such as taxation and *monte* shares.

It was for these reasons that Florence saw one of the greatest explosions of culture and human genius in western Europe since the time of Augustan Rome. The individual was admired and protected and identified with his fellows through the mediation of the republic, acting as the collective of the community. The ideals of civic humanism anointed the state, and the state grew in competence so that these values percolated through the community, despite the limited number of citizens actually directing events in the *signoria*.

What happened, then? Why did this happy circumstance dissipate? A single reason manifested itself in many ways. There was a failure of will, a collapse in humanistic self-confidence, which was the result of a crisis that could not be solved and eventually served to weaken Florentines' belief in their own ideology, their energizing myth, resulting in a decline into cynicism, exhaustion, and a need for order that paved the way for the absolutist monarchy of Cosimo I and the intellectual and spiritual obscurantism of the counter-Reformation.

First, the crisis. This crisis came initially from without in the form of the French invasions of 1494 and then was manifested from within by the focused attack on the principles of humanism exemplified by Savonarola. The exile of Piero de'Medici in 1494 represented the banishment from Florence, not only of a powerful family, but also, more broadly, of Renaissance values and civic humanism. There was a power vacuum, exacerbated by a spiritual vacuum, which resulted from the growing doubts concerning the energizing myth of humanism that Piero's father, Lorenzo the Magnificent, had raised to its greatest height. Humanism had failed them, Florentines believed. A superior culture, superior art, and republican liberty had not halted the French armies of Charles VIII. Perhaps they had been wrong all along—perhaps the answer lay not in individual genius and human dignity, human potential, and good letters, but in Savonarola's omnipotent, angry, vengeful, jealous God, who was now punishing them for their pride. At least enough Florentines agreed with this vision to grant the Dominican friar over three years of power and influence.

These years, 1494–98, represent the first coordinated, serious, substantial attack on the energizing myth of humanism that the city had seen. The burning of the vanities was more than a typical act of religious fanaticism: it was a statement of intent, a declaration of war on humanist values. In the context of those years this assault was significant, as not just Florentines but all Italy collapsed before the barbarians. Was Savonarola right? Was God reasserting the authority that man had usurped over the previous century, and was He now determined to punish mankind for the sin of pride? Or, in the classical, secular

terminology of patrician intellectuals, did *fortuna* forever vanquish *virtù*? The doubts had been sown.

The republic that lasted until 1512 attempted to restore the old balance, but again it failed. All of the old humanist principles were put back in place, but again malicious fortune—or inadequacy—resulted in continued failure. Machiavelli best exemplifies this. A fervent republican, he sought solace in a prince who might restore the spirit of his people. Machiavelli still had hope, yet his measures were no longer altogether dependent on a free community of individuals but instead upon a tyrant, at least in the context of *The Prince*. The events of 1513 made the situation worse because Florence ceased to be independent in any real way. The elevation of Giovanni de'Medici to the papacy turned the city into an extension of papal Rome, ruled by papal governors or the most decadent illegitimate scions of the pope's family. After 1513, the center of power shifted to Rome; Florence had, in effect, begun her lengthy decline into provincialism. The republic and all that it represented had collapsed, and now even the freedom so important to a discussion of the ideal of the Florentine Renaissance had disappeared, as had the political independence of the state. Pope Leo X had unwittingly achieved what Giangaleazzo Visconti could not.

During the reign of Duke Cosimo, Florence clearly recovered some of its external political independence, but at the expense of internal liberty. Florence quickly became a courtly society centered on the person of the new duke. The very transformation of the class of previously proud republican patricians that just twenty-five years before had struggled to restore the old fifteenth-century pre-Medicean oligarchy indicates that this class was exhausted. Their will had also failed. The events of 1494 had provided them with one opportunity to regain the pristine republic, 1527 another; but on both occasions they were defeated and savaged. The most idealistic young scions of the patriciate had died on the barricades during the siege, and the survivors were beheaded like common criminals in the Piazza della Signoria after their defeat at Montemurlo. Their fortunes were ruined, their mercantile interests in disarray after forty years of instability, warfare, and confiscatory taxation: the principles of republican liberty, civic virtue, humanism, and responsibility belonged to a state now dead. In exhaustion, cynicism, and defeat, they rushed to embrace Duke Cosimo I as a last hope for some kind of order. In short, Florentines of the 1530s sacrificed their political traditions, freedom, and institutions in return for protection from external assault and a promise of domestic order and stability. When these blessings befell them under the Medici monarchy, they never looked back. Instead of seeing the republic nostalgically as a past golden age, it was perceived as a failed experiment, thankfully now in the past, where faction and disorder had reigned: liberty just wasn't worth the price.

This shift in attitude is perfectly illustrated in art. The civic patronage, based on competition to allow individual genius to rise, gave way to the ducal patronage of subservient courtier-artists, exemplified by Giorgio Vasari. The prince and his chief bureaucrat in charge of culture—and Vasari was something of a minister of culture—decided privately what to endow and build and whom to patronize. The scope of this patronage best indicates this transformation. Gone were the public manifestations of shared taste and civic-community patronage exemplified in Michelangelo's *David* or Ghiberti's Baptistery doors, which

represented a healthy and free association of men dedicated to humanistic principles. What were the great projects of Cosimo I? The Uffizi, a block of civil-service buildings announcing the victory of the absolutist centralized state; the Medici tombs in San Lorenzo, grand reliquaries for the rulers of the city; and, perhaps most significantly, the ostentatious decoration in the Palazzo Pitti where the new court resided after 1550. In other words, art was no longer competitive, but official art, glorifying the ruler, not the genius of its creator; moreover, art was no longer communal, but royal. It was private, often hidden away in private places like the Palazzo Pitti, or in the *capella dei principi* at San Lorenzo. Humanism as an ideology, the energizing myth of the Florentine state, was dead. What replaced it was the myth that had energized absolutist principalities elsewhere in Italy: glorification of the ruler who became increasingly identified with the state. Loyalty to—almost worship of—Cosimo I de'Medici and his regime was the new ideology, and one that the people of Florence of all classes gladly accepted in return for stability.

VENICE

The example of Venice followed a similar pattern, although for very different reasons. Here again there was a failure of will, a collapse of the spirit that animated the city. Granted, Venice remained a republic and a leading center of culture and ideas right through the sixteenth century and beyond. Never did the great *Serenissima* decline into the impoverished provincial backwater that Florence did in the seventeenth century. Still, the traumatizing experience of Venice, culminating around the turn of the sixteenth century, altered Venetian life critically, forever changing the entire nature of the republic and its patrician elite.

Venice was always unusual. Until the late fourteenth and early fifteenth centuries, the republic possessed little territory except for the city built on the lagoons and small territories in Istria, on the Dalmatian coast, and throughout the Mediterranean. Then the Venetians began a concerted policy of building a large territorial state on the Italian mainland in order to ensure their food supply and protect their trade routes. Venice became a significant, dynamic, and expansionist Italian power and one of the richest states in Europe: well governed, stable, efficient, and influential. At about this time, the late fifteenth century, Renaissance painting came to the *Serenissima* via the Bellini, as did humanism through individual scholars and the University of Padua. The reasons why the cultural and intellectual manifestations of humanism arrived late in Venice are complex, but they probably relate to the purely mercantile interests of the patriciate: unlike in Florence, chancery offices—the traditional vanguard of humanism—were closed to Venetian nobles and open only to *cittadini originari* and hence removed from the real sources of power, wealth, and patronage; and the Eastern, Byzantine traditions and models remained strong and ubiquitous in a conservative society. Thus, civic humanism was not a relevant concept until well into the *cinquecento* (the fifteen hundreds).

However, once Renaissance humanism and principles in art and culture reached the republic, they made great and rapid advances. The incredible wealth of the city made private patronage available to artists painting in the new style, and the art of portraiture especially flourished in Venice, for reasons associated with the importance of genealogy. In addition, the wonderful propaganda required for the Venetian myth of the state led to major commissions in public buildings. The Palazzo Ducale itself, the great *scuole*, and religious houses were developing into resplendent repositories of brilliant art created by the Venetian colorists.

Once again, though, we must ask what changed this situation in a relatively short period of time. Certainly neither the physical nor the cultural changes in Venice from 1400 to 1550 were as dramatic as those in Florence, partly because the officially sanctioned view of Venetian life tended to dominate all accounts. But there was a change in attitude, a change in values, and, to a large extent, a loss of self-confidence similar to that which infected Florence. The French invasions of 1494 had not affected the Venetian republic to the same degree as they had other cities on the peninsula, but another related and equally disastrous event made Venice retreat into itself. The War of the League of Cambrai was the manifestation of the jealousy and alarm felt by the papacy, the Habsburgs, and the French over Venetian success and territorial expansion. Faced with this overwhelming might, Venice was defeated disastrously at Agnadello in 1509, leaving the entire state, including the capital itself, *la città dominante*, open to destruction. Of course, this barbarism did not take place, but Venice temporarily lost its *terraferma* empire and just barely recovered its political and economic equilibrium in the subsequent decades. Furthermore, the disintegration of the *terraferma* state, consisting of such rich and sophisticated cities as Padua, Verona, and Vicenza, again separated Venice from its living connections to Italian humanism. Although Padua was quite quickly recovered from the imperial army that had occupied it, the university was effectively closed until 1517, breaking an important link in Venice's humanistic development; and many of its most celebrated professors, including Pietro Pomponazzi, left the Veneto: the famous Aristotelian moved first to Ferrara, and then to Bologna, where he would teach until the end of his life, never returning to Padua.

It was the psychological rather than the military consequence of Agnadello that affected the Venetian republic the most. Always politically conservative, the nobles were gripped by fear. Venice ceased trying to play a major role in Italian affairs for some time, looking always for safety through balances of power, protective alliances, and diplomatic security. If Agnadello had been the only threat to the Venetian concept of self-confidence, the recovery might have been quicker. However, it was only the most visible of a series of disasters that changed the mentality of the ruling classes and hence the state. First, Constantinople was taken by the Turks in 1453; then, in 1486, the Portuguese had proved that one might sail around the African continent to get spices from the East, a fact reinforced by the voyage of Vasco da Gama in 1497. The great and ancient Venetian network of commercial links with the eastern Mediterranean and her virtual monopoly of the overland and sea routes that supported them were now clearly doomed to extinction. The new routes were open to competition and were safer and potentially cheaper. With

Facing page:

Figure 15.4 Rome, Pantheon (second century AD)

Figure 15.5 Vicenza, Villa Rotonda (Capra) (1567–80). Andrea Palladio (1508–80)

Palladio was inspired by ancient buildings, as is clearly demonstrated through a comparison of the Pantheon and the Villa Rotonda, despite the fact that the Pantheon was constructed as a temple and the villa as a country retreat.

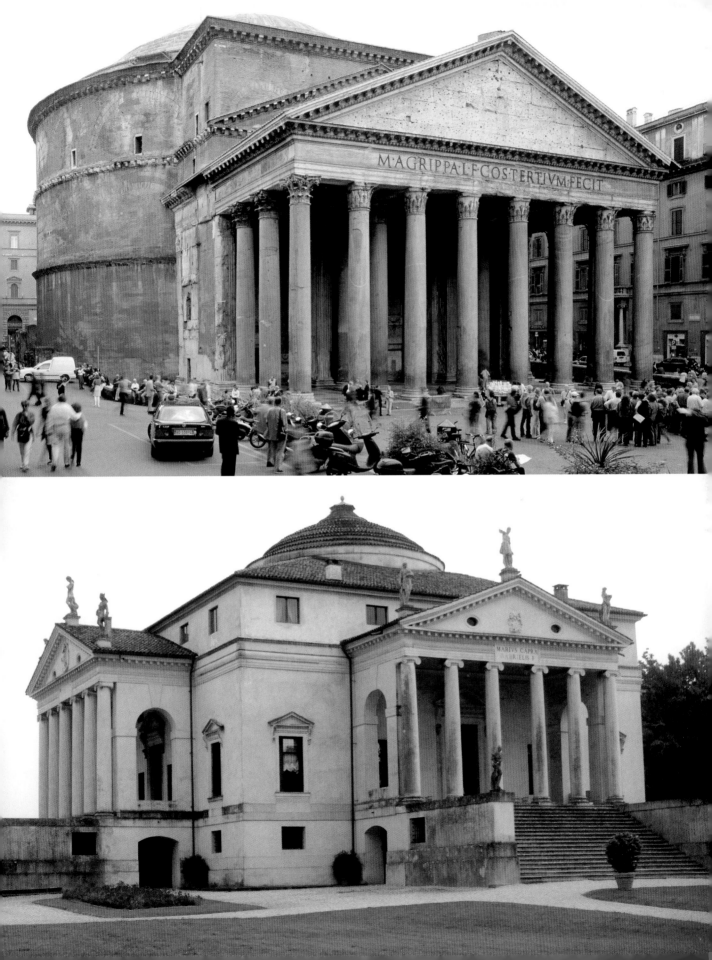

the loss of its Eastern luxury trade, the republic's economy suffered irreparable damage, as did the self-confidence of those patricians who had been the vanguard of Renaissance values and patronage.

Similarly, the consolidation of the Habsburg Empire made Venetian intermediary activities in the Low Countries, Spain, and up the Rhine increasingly obsolete. Now, German and Flemish firms began challenging the traditional Venetian trading and banking firms, aided by the imperials who obviously wished to keep as much profit as possible at home. Furthermore, the Turks had spread widely into the Mediterranean and Adriatic. Christian shipping was continually endangered by Turkish privateers, driving up the cost of Venetian trade and bringing the republic into almost constant warfare in the Mediterranean. The ancient trading centers on the Black Sea, on the Greek mainland, and on the Aegean islands fell to the Turks one by one or were kept only through the expenditure of huge sums of money and men on defense. The Mediterranean and the Adriatic were no longer Venetian enclaves, even though the Turks were stopped for half a century at Lepanto (1571). Venice may have married the sea, but it was known to be a cuckold to the Turks.

By the sixteenth century, Venetian confidence had begun to collapse. The previously audacious and successful mentality of the Venetian nobility altered quickly and radically into a new attitude of very conservative *rentiers*. Trade was unsafe, both economically and personally. The chances of success and glory and great riches had declined substantially. Hence there arose the old pattern of wealthy men who, when faced with bad times, seek safe investments; and one of the safest was landed property. After the republic regained its former *terraferma* territories, the Venetian nobility invested more and more capital in acquiring estates and building great country houses. The class that just half a century before had lived only for trade and service to the republic now began to live for pleasure and conspicuous consumption. Like their Florentine counterparts, they had become landed aristocrats, with all the tastes, prejudices, and limitations of that class. The naval traditions, such as the requirement for all patricians to serve at sea, could be avoided through cash payments. Even the closed caste of nobles was opened on occasion and entry sold for 100,000 ducats. This modification of the intent of the 1297 *Serrata* had, however, a salubrious effect on the patriciate. New families, often with fresh energy and experience of the Italian mainland, entered the center of Venetian authority, and the great families of the *terraferma* were co-opted into the structure and culture of the republic.

Furthermore, the dynamic principles of humanism and Renaissance ideals were applied more as decorative elements than engines of change and engagement. The new style of humanist art and architecture thrived in the Venice of the sixteenth century, especially after mid-century when Venetian patricians were encouraged to live on their estates in the *terraferma* rather than risk everything at sea. The subject cities of the Veneto changed their appearance as Venetian governors or wealthy residents constructed new palaces and public buildings in the classical manner, a style immediately emulated by the indigenous nobility of the region. It was thus that the architect Andrea Palladio (1508–80) came to be seen as the institutionalization of Venetian rule in bricks and mortar. Born in Vicenza, Palladio created the style of the new Venice of landed magnates. His villas throughout the

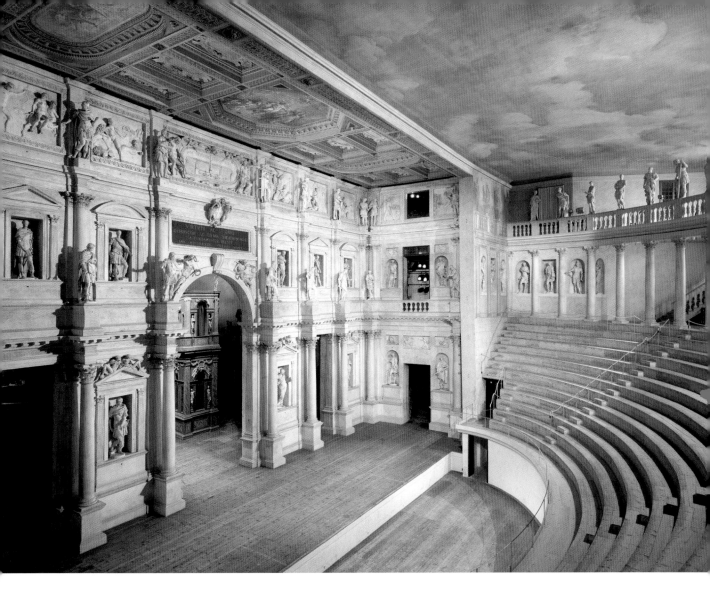

Venetian empire were both country houses and the centers of working estates. Using the classical vocabulary of Vitruvius, his buildings reflect the dignity, gravity, and elegance of a Venice that had expanded into Italy forever beyond the lagoon and the East. His churches are models of proportion and symmetry, with little flamboyant decoration, suiting the Venetian tradition of propriety while blending their façades into the fabric of the city.

Palladio in many ways can be seen as a metaphor for this superficial application of the language of humanism and classical architecture to late-sixteenth-century Venice. Although looking splendid, his villas are often built of local brick faced with stucco to look like more expensive stone; and the grand façades incorporate the working structures of the farm to add grandeur, while not detracting from the function of intensive agriculture. His last work, the Teatro Olimpico (Olympic Theatre, named for the coterie of intellectuals and nobles who commissioned it), illustrates this perhaps best (see Fig. 15.6). It is a wonderful building with excellent acoustics and a vision of an ideal Renaissance streetscape

Figure 15.6 Vicenza, Teatro Olimpico (1580–85). Andrea Palladio (1508–80). The Teatro Olimpico was designed by Palladio based on his study of the ruins of ancient Roman theaters. It was commissioned by the Olympic Academy of which Palladio was a member and which since 1555 had comprised many of the leading intellectuals and nobles of the region.

behind its stage, in which linear perspective turns a shallow space into a complex urban scene. However, this vision is an illusion, as are the statues around the auditorium, which look like stone but are, in fact, inexpensive plaster. Despite its harmony and Vitruvian elegance, then, the Venice of Palladio was itself something of an illusion, a stage upon which humanism was a convention rather than a dynamic, functional reality.

The dignity of the Venetian patriciate and the ideals of human dignity in general were corroded by a flight into consumption or a search for security. The entrepreneurial spirit that had created the vast wealth of the republic and driven the expansion of Venice from the lagoon onto the Italian mainland was dissipated in luxurious living. Pleasure increasingly absorbed the time and wealth of the patricians, and the vision of Venice as a city in which the carnival lasted for months was born. Courtesans were in profusion and recognized as economic assets, and gambling was seen as an attraction as much as was the treasury of St Mark. The patricians were beginning their decline into moral bankruptcy, even if economic bankruptcy was avoided by the enormous amounts of wealth accumulated during the previous millennium. It took 300 years of constant consumption before the Venetian nobility was exhausted: 225 years separated Lepanto and the collapse of the Republic in 1797; 550 separated Doge Enrico Dandolo (d. 1205), the conqueror of Constantinople, and Giacomo Casanova (1725–98).

ROME

If Renaissance values in Venice were undermined by events outside the control of the governing patriciate, events that corroded the self-confidence and traditions of the ruling elite, driving them into safe investments, conspicuous consumption, and superficiality, Rome was threatened by forces just as dangerous. Rome as always presented particularly complex problems, given its role as the capital of an Italian state, the spiritual heart of western Christendom, and the locus of the enduring memory of Roman antiquity. The centuries after the collapse of the Roman Empire had witnessed lengthy periods of material and demographic decline that had been reversed only by the attraction to pilgrims of the city of Peter and Paul and the centralization of ecclesiastical administration in the city. The terrible period of the Babylonian Captivity, followed by the Great Schism, had resulted in a material and demographic catastrophe. It was in many ways the coming of the Renaissance that reversed this unhappy situation and turned Rome once again into a leading center of culture and power. Art and building were used both to renovate the decaying structures of the medieval city and to signal the re-entry of Rome into the company of major Italian—in fact European—powers, in part through the new medium of Renaissance style. The patronage of several popes—beginning with Martin V, who returned a united papacy to Rome in 1420—celebrated papal power, permitted greater revenue by improving the experience of pilgrims, and renewed the claims of universal dominion through visual propaganda and grand structures. Patronage was required both

by the role of Rome as the *caput mundi*, the head of the world, destined to revive the glories of the ancient city, and by the needs of individual popes to celebrate their reigns, glorify the Church or their families, and assert boldly that Rome was still a center of culture and art. In the seventy years between the election of Nicholas V and the sack of Rome, the commission of great art in the capital city of western Christendom was astonishing: Fra Angelico, Bramante, Michelangelo, and Raphael, among so many others, worked to make Rome beautiful and a wonder to behold. Furthermore, the curious nature of the Roman curia as a training ground for administrators and prelates, as well as the social mobility that the Church continued to offer, made it an attractive center for humanists and scholars, both lay and ecclesiastical. Leonardo Bruni, Poggio Braccriolini, and Francesco Guicciardini all worked for the papacy and helped institutionalize humanist values in the central offices of the Church.

However, the prestige and authority of Rome was further undermined by the policies of several popes which contributed to its slide into moral opprobrium. The pontificates of men more familiar with battlefields and bedrooms than with altars might have added to the artistic and humanist traditions of the city, but popes such as Sixtus IV, Alexander VI, Julius II, and even the Medici popes Leo X and Clement VII reduced the spiritual power of the papacy, which was the main foundation of Rome's place in Italy and the world. This rot was first challenged by the Lutheran revolt of the 1520s, which split the Church into two hostile camps forever. The concomitant, horrible sack of Rome of 1527 was a psychological shock at least as great as Luther's apostasy. Moreover, the papacy thereafter became the plaything of the Habsburgs, with Clement VII forced to recognize imperial hegemony in Italy. Throughout the next thirty years, the attacks on the authority of the pope, on the precedence of Rome in the West, and on the Church itself as an institution continued, fomented by men such as Henry VIII of England (r. 1509–47) and John Calvin (1509–64); the place of the Roman Catholic Church and the Roman pontiff seemed mortally endangered.

Here, though, certainly because of the nature of the institution under siege, there was a response opposite to the exhaustion and capitulation seen in Florence and later, to a degree, in Venice. Rather, in Rome there was a salvaging of will, but in a way that compromised the dynamic quality of the Renaissance. The defense of Catholicism manifested in the counter-Reformation successfully stopped the erosion of Roman Catholicism, but at the cost of Renaissance values and principles. The Roman Inquisition was established in 1542; the Index of Prohibited Books was imposed by Paul IV in 1559. The Jesuit Order turned classical humanism against itself and used the methods of Valla to discipline boys in the ways of absolute obedience to the faith, rather than free inquiry. The *campo dei fiori* in Rome saw the burning of Giordano Bruno in 1600; and the Inquisition silenced Galileo. In short, the re-emergence of will in the Church provided an alternative to those very principles of the Renaissance that had given rise to the glory of the age. And the values of the counter-Reformation filled the intellectual and moral vacuum of other Italian states as well, including Florence. Only Venice resisted, supported by its ancient tradition of independence from Rome and a Byzantine model of a proprietary Church. Ideas were

Figure 15.7 (following page) Rome, Basilica of St Peter. The Basilica of St Peter, begun in 1506 under Julius II with Bramante's design, was not completed for 120 years. The church we see today reflects the new power of an imperial papacy. Michelangelo's dome and Carlo Maderno's façade project an overwhelming sense of power and majesty. The very architecture and size of the building reflect the counter-Reformation and the renewed authority of the Church.

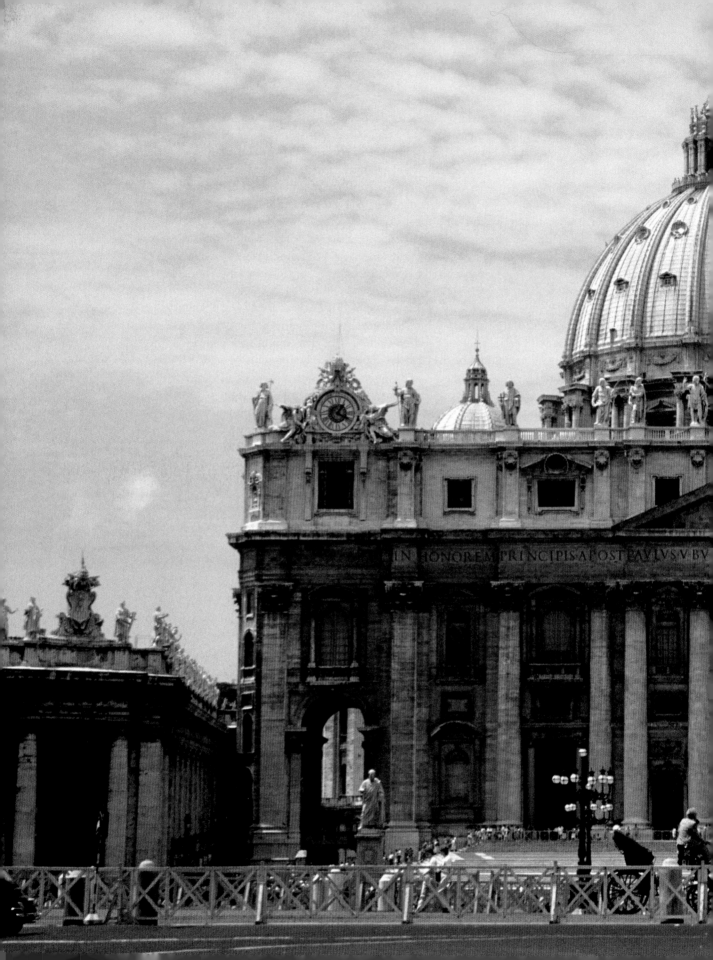

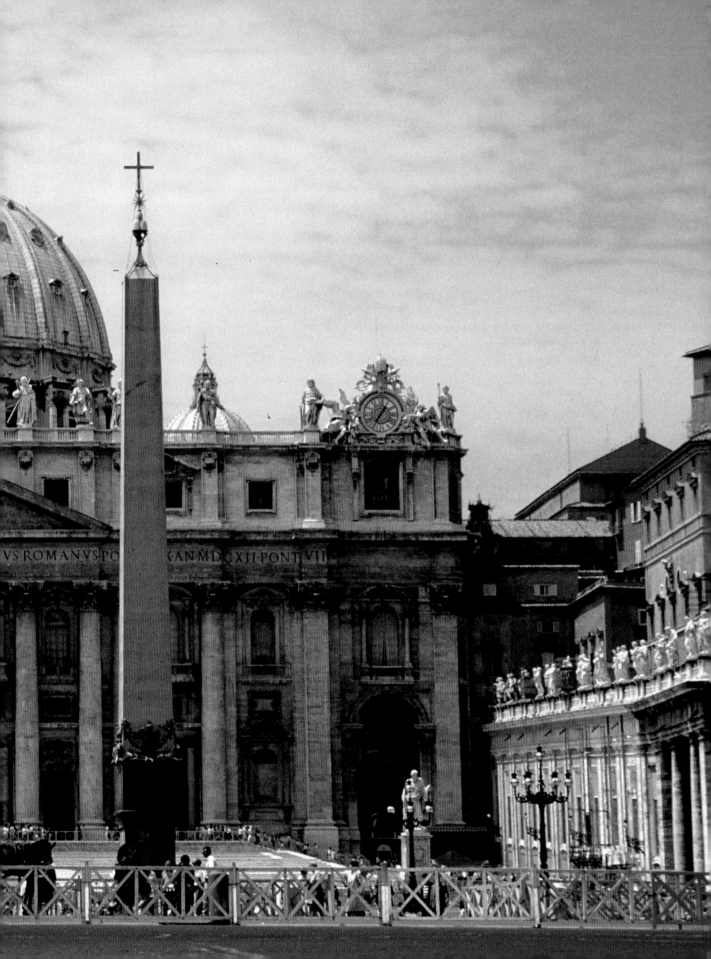

still relatively free in Venice, unlike elsewhere in Italy, but few Venetians were interested in cultivating them; they were enjoying their villas and the *ridotti* (gaming parlours) too much to care.

In the world of the counter-Reformation, faith and total obedience to authority became the operative and dominant attitudes. The concepts of individual worth, belief in creative genius, free inquiry, and bold ideas that had animated the Florentine republic and the minds of men such as Ficino, Pico, Valla, and Pomponazzi, would now lead to the stake, as in the case of Giordano Bruno and almost Galileo. Access to all knowledge, around which Pico had built an entire philosophy that had captured the minds of Laurentian Florence, was now forbidden. Knowledge, learning—everything—was dependent on the intermediary role of the Church and the clergy, whose judgments were enforced by fear and ruthlessness. Faith again replaced reason. The anthropocentric universe of the humanists had given way to the renewed vigor of the theocentric universe of the clerics. These notions then became the energizing myths in Italy by the seventeenth century. The union of throne and altar—so perfectly manifested in the Florence of the later Medici—had completely overcome the notions of civic humanism. The Renaissance was indeed over; the only consolation was the creation of a grand new style of absolutist art and ideas made manifest in the Baroque.

FURTHER READING

Cochrane, Eric, ed. *The Late Italian Renaissance: 1525–1630*. Stratum Series. General Editor J.R. Hale. London: Macmillan and Co. Ltd., 1970.

Hanlon, Gregory. *Early Modern Italy, 1550–1800*. London: Macmillan, 2000.

Rabb, Theodore K. *The Last Days of the Renaissance and the March to Modernity*. New York: Basic Books, 2006.

CONCLUSION

THE INTENT OF THIS book has been to introduce the Italian Renaissance as a cultural phenomenon in the context of the city states of the peninsula. I have argued that the defining elements of the Renaissance were cultural, but that the significant changes in the political, economic, and social structures of the Italian states made the efflorescence of art, architecture, and learning possible. Although the disjunction between the medieval world and the time of Petrarch was hardly as dramatic as earlier historians—and the writers of the Italian Renaissance themselves—had believed, I nevertheless began my analysis with a discussion of Dante and the vision he described for his time, which has been shown to have been largely dependent on the scholastic assumptions of medieval thought and scholarship. Thus I suggested that it was with Francesco Petrarch that the basic elements that drove the identification of new values began, ideas associated with the recovery of classical antiquity and a more active role for individuals within the community. Petrarch himself never fully exemplified a life of civic engagement through active participation in politics and a sense of social obligation, remaining always a wandering scholar and poet. He was, then, the progenitor of the intellectual and cultural movement called humanism, but he was in no way its final model.

I have suggested that humanism represented the most complete and effective statement of the cultural, intellectual, political, and social ideals of the Italian Renaissance. Humanism comprised a set of skills needed to discover, investigate, and mine the surviving legacy of antiquity; it was a program of education that institutionalized these skills and made control of the spoken and written word its essential function. But ultimately humanism was a perspective, an attitude, the energizing myth that gave collective and individual meaning to the application of the content of ancient texts to the needs of Italians from the later fourteenth to the mid-sixteenth century. Humanism infused so much of what occurred in every facet of life in the Italian city-states that I might well have entitled this book *The Age of Humanism*.

In order to see how humanism both developed and manifested itself in the various environments of the peninsula, I investigated a number of Italian states and revealed the variations in their constitutions and complexions. It is obvious that ducal Milan or Urbino was a world apart from republican Florence or Venice and different again from the hybrid theocratic, yet elective, monarchy of papal Rome. Nevertheless, humanism operated in all of these places, animating the privileged elite to speak in a similar rhetorical style and with reference to the same classical texts. Humanism, therefore, provided the lubricant for social and geographical mobility: it is necessary only to follow the careers of leading humanists from city to city or artists from patron to patron to reveal the degree to which mobility was made possible by a shared perspective on the world and a set of skills that was transplanted from court to commune to the curia. This is not in any way to say that the humanism of the Renaissance was a singular ideology; it could not have been, because of the emphasis placed from at least the time of Petrarch on the role of individual

experience and increasingly on the concept of individual genius. Each practitioner of humanist learning or artistic skill was seen as a unique contributor to the fame and reputation of his patron and his native city. The competition for great artists and scholars, then, must be seen as part of the struggle for recognition, in fact legitimacy, that characterized both states and rulers. To have a work by an acknowledged master or to have in one's entourage a great poet or rhetorician was to establish a reputation for patronage and power.

Through the chapters of this book there is a recurring attempt to indicate how this humanist movement adapted to and changed the character of the Italian states and the privileged classes within them through the active participation of humanists in government, either as courtiers or magistrates, or, in a few instances, as enlightened rulers in their own right. Because a common vocabulary of excellence and power was recognized, humanism became the vehicle for the celebration of success and renown. Almost every court had polished humanists in the entourage of the prince, and almost every commune employed secretaries or chancellors with sterling humanist credentials to ensure that a high level of Latinity would inform their written correspondence and that a shared sense of authority would emerge.

It was in the second half of the fifteenth century that this energizing myth of humanism reached its greatest expression; consequently, I spent a considerable part of this book investigating those years, as well as the characters of the individuals who gave the decades after about 1430 their luster. There emerges an interdependency among the creative geniuses of the age, those who described it, and those who governed it; it is neither possible nor useful to separate out the artist from his patron or the individual from his community as one required the active engagement of the other.

In the last half of the book I discuss the crisis occasioned by the French invasions of 1494. This event gave rise to a new set of circumstances that not only changed many of the assumptions of that self-confident, humane perspective we know as humanism, but also simultaneously changed the very nature of the Italian Renaissance itself. No longer could the refined ideals of the fifteenth century be polished in the protected environment of the peninsula; no longer were the Peace of Lodi and the Italian League sufficient to control the forces of malevolent fortune or human folly. From the characters of the Borgias to the theocracy of Savonarola, from the failed wisdom of Machiavelli to the cynical careerism of Guicciardini, the values of the peninsula are clearly different. Italy no longer enjoyed freedom, and the competition among its various states was no longer an internal struggle for fame and glory but instead, after 1494, a struggle for survival against northern dynastic monarchies whose guiding principles were altogether opposed to the civilizing force of humanist scholarship and art. Italy would lose its freedom as a consequence, and the duel between the houses of Valois and Habsburg would take place on Italian soil, leading to the destruction and humiliation of much of the peninsula.

This world after 1494 gave rise to a different kind of humanism, represented by Machiavelli and Guicciardini and a new form of patronage represented by Cosimo I de'Medici, duke of Florence, and Pope Paul III. Although both of these princes were often inspired and generous patrons, the product of that patronage was now an instrument to

serve the larger causes of international politics as required by the events of the Reformation and the victory of despotisms over republics, all informed by the Habsburg hegemony over the peninsula after 1529. Just to articulate the disasters of the years after 1494 is to reflect on how hollow the concepts of the dignity of man must have appeared to contemporary Italians: the fall of Naples and Milan and the expulsion of the Medici with the concomitant rise of Savonarola, Agnadello, Ravenna, the sack of Rome, and Montemurlo. Add to this dispiriting list the establishment of the Roman Inquisition and the Index of Prohibited Books, and the story of the Italian Renaissance seems to be ending in tragedy.

However, what ultimately emerges from these disasters is the clear recognition that the institutions of humanism founded the century before had set down such deep roots that those elements of culture that we celebrated during those years can still be seen in the architects, painters, writers, and educators of the sixteenth century. Michelangelo, after all, lived until 1564, and the ideology of humanism was equally sustained in the later life of the Renaissance. To be sure there were great changes: the civic humanism of Bruni was transformed into the neo-Platonism of the courtier, so wonderfully exemplified by Castiglione's *Book of the Courtier.* The competitive search for shining excellence was changed into the personal patronage of princes; and the free exercise of ideas and their expression was restricted by the imposition of religious and even political uniformity. This was clearly a metamorphosis of Ovidian dimensions, but it was a transformation that still sustained many of the definitive elements of the humanism of the *quattrocento,* particularly the reliance on ancient authors and the styles of art and architecture that continued to evolve and grow even more splendid. To use building as a metaphor, Brunelleschi's dome on the cathedral in Florence is visible in the dome on the basilica of St Peter, and both owe their inspiration to the Pantheon.

It is for these reasons my discussion of humanism ended with a discussion of literary figures—writers and historians—to represent the changing complexion of the Italian Renaissance between Petrarch and Guicciardini. This was a conscious decision because, as I have often noted, I believe the Italian Renaissance to have been a cultural and intellectual phenomenon, supported by social, political, and economic conditions. I wished to privilege the mind of the Renaissance and celebrate its culture of humanism. In fact, the comparisons between the early figures of Petrarch and Salutati and the later writers Machiavelli and Guicciardini should clearly illustrate how Italy had been transformed in the two centuries between about 1330 and 1530. Although the reverence for the ancients remained and interest in an anthropocentric world of human agency still obtained, the way in which these principles were applied and the conclusions drawn from them reflect the differences between the early and later Renaissance better than any purely historical analysis.

BIBLIOGRAPHY

Abridge, T. *The First Crusade: A New History: The Roots of Conflict Between Christianity and Islam*. Oxford: Oxford, 2005.

Allen, M.J.B. *Marsilio Ficino: His Thought, His Philosophy, His Legacy*. Leiden: Brill, 2002.

Aston, Margaret, ed. *The Panorama of the Renaissance: The Renaissance in the Perspective of History*. New York: Harry N. Abrams, 1996.

Atiya, Aziz S. *Crusade, Commerce and Culture*. Bloomington: Indiana University Press, 1962.

Barkan, Leonard. *Unearthing the Past: Archeology and Aesthetics in the Making of Renaissance Culture*. New Haven, CT: Yale University Press, 1999.

Baron, Hans. *The Crisis of the Early Italian Renaissance*. Princeton, NJ: Princeton University Press, 1966.

Bartlett, Kenneth R. *The Civilization of the Italian Renaissance. A Sourcebook*. 2nd ed. Toronto: University of Toronto Press, 2011.

Becker, Marvin B. *Medieval Italy: Constraints and Creativity*. Bloomington: Indiana University Press, 1981.

Bell, Rudolph M. *How to Do It: Guides to Good Living for Renaissance Italians*. Chicago: University of Chicago Press, 1999.

Bellonci, M. *A Prince of Mantua: The Life and Times of Vincenzo Gonzaga*. Trans. Stuart Hood. New York: Harcourt Brace, 1956.

Bentley, Jerry H. *Politics and Culture in Renaissance Naples*. Princeton, NJ: Princeton University Press, 1987.

Bertelli, Sergio. *Italian Renaissance Courts*. London: Sidgwick and Jackson, 1986.

Black, Chris. F., et al. *Cultural Atlas of the Renaissance*. New York: Prentice Hall, 1993.

Bloomquist, T., and Mazzaoui, M. *The Other Tuscany: Essays in the History of Lucca, Pisa and Siena during the Thirteenth, Fourteenth and Fifteenth Centuries*. Kalamazoo, MI: Medieval Institute Publications, 1994.

Blumenthal, U. *The Investiture Controversy: Church and Monarchy from the Ninth to the Twelfth Century*. Philadelphia: University of Pennsylvania Press, 1991.

Boorstin, Daniel J. *The Discoverers: A History of Man's Search to Know His World and Himself*. New York: Random House, 1983.

Bowsky, William. *The Finance of the Commune of Siena, 1287–1355*. Oxford: Oxford University Press, 1970.

———. *A Medieval Italian Commune: Siena under the Nine, 1287–1355*. Berkeley: University of California Press, 1981.

Bradford, Ernle. *The Great Siege: Malta 1565*. Harmondsworth: Penguin, 1964.

Brown, Alison. *The Medici in Florence: The Exercise and Language of Power*. Florence: Olschki, 1992.

Brown, Judith C., and Robert C. Davis, eds. *Gender and Society in Renaissance Italy*. New York: Longman, 1988.

Brown, Patricia Fortini. *Art and Life in Renaissance Venice*. Princeton, NJ: Princeton University Press, 1998.

Brucker, Gene A. *Renaissance Florence*. Berkeley: University of California Press, 1983.

Burckhardt, Jacob. *The Civilization of the Renaissance in Italy: Volume I: The State as a Work of Art, The Development of the Individual, The Revival of Antiquity.*

———. *The Civilization of the Renaissance in Italy. Volume II: The Discovery of the World and of Man, Society and Festivals, Morality and Religion.* New York: Harper & Row Publishers, 1975.

Burke, Peter. *The Italian Renaissance: Culture and Society in Italy.* Princeton, NJ: Princeton University Press, 1986.

Cassirer, E., Kristeller, P., Randall, H. *The Renaissance Philosophy of Man.* Chicago: University of Chicago Press, 1956.

Castiglione, Baldassare. *The Book of the Courtier.* Trans. G. Bull. Harmondsworth: Penguin Books, 1976.

Chabod, Federico. *Machiavelli and the Renaissance.* New York: Harper Torchbooks, 1958.

Chamberlin, E.R. *The Count of Virtue: Giangaleazzo Visconti.* London: Eyre and Spottiswoode, 1965.

Chambers, D.S. *The Imperial Age of Venice: 1380–1580.* London: Thames and Hudson, 1970.

Cochrane, Eric, ed. *The Late Italian Renaissance: 1525–1630.* Stratum Series. General Editor J.R. Hale. London: Macmillan and Co. Ltd., 1970.

———. *Florence in the Forgotten Centuries, 1537–1800.* Chicago: University of Chicago Press, 1973.

———. *Historians and Historiography in the Italian Renaissance.* Chicago: The University of Chicago Press, 1981.

———. and Kirshner, J. *Italy, 1530–1630.* London: Longmans, 1988.

Cohen, Elizabeth, and Thomas V. Cohen. *Daily Life in Renaissance Italy.* Westport, CT: Greenwood Press, 2001.

Cohn, Samuel Kline. *The Laboring Classes in Renaissance Florence.* New York: Academic Press, 1980.

Cole, Alison. *Virtue and Magnificence: Art of the Italian Renaissance Courts.* New York: Harry N. Abrams, 1995.

Croce, Benedetto. *A History of the Kingdom of Naples.* Chicago: University of Chicago Press, 1970.

Crum, Roger J., and John T. Paoletti, eds. *Renaissance Florence: A Social History.* Cambridge: Cambridge University Press, 2006.

D'Amico, John. F. *Renaissance Humanism in Papal Rome: Humanists and Churchmen on the Eve of the Reformation.* Baltimore: John Hopkins University Press, 1991.

Dennistoun, James. *Memoirs of the Dukes of Urbino.* New York: John Lane Company, 1909.

Epstein, Steven A. *Genoa and the Genoese, 958–1528.* Chapel Hill: University of North Carolina Press, 2001.

Field, A.M. *The Beginning of the Philosophical Renaissance in Florence, 1454–1469.* Ann Arbor: University of Michigan Press, 1980.

Finlay, Robert. *Politics in Renaissance Venice.* New Brunswick, NJ: Rutgers University Press, 1980.

Finley, M.I., et al. *A History of Sicily.* New York: Viking, 1987.

Fumerton, Patricia, and Simon Hunt, eds. *Renaissance Culture and the Everyday.* Philadelphia: University of Pennsylvania Press, 1999.

Gardner, Edmund G. *Dukes and Poets in Ferrara: A Study in Poetry, Religion and Politics of the Fifteenth and Sixteenth Centuries.* London: Constable, 1904.

Goldthwaite, Richard A. *The Building of Renaissance Florence: An Economic and Social History.* Baltimore: Johns Hopkins University Press, 1980.

———. *Wealth and the Demand for Art in Italy: 1300–1600*. Baltimore: Johns Hopkins University Press, 1993.

Grafton, A. *Leon Battista Alberti*. Cambridge, MA: Harvard University Press, 2002.

Gilbert, Felix. *Machiavelli and Guicciardini: Politics and History in Sixteenth Century Florence*. New York: Norton, 1984.

Grendler, Paul F. *The Universities of the Italian Renaissance*. Baltimore: Johns Hopkins University Press, 2002.

Guicciardini, F. *The History of Italy*. Tr. S. Alexander. Princeton: Princeton University Press, 1984.

———. *Maxims and Reflection (Ricordi)* Trans. M. Domandi. Philadelphia: University of Philadelphia Press, 1972.

Gundersheimer, Werner L. *Ferrara: The Style of a Renaissance Despotism*. Princeton, NJ: Princeton University Press, 1973.

Hale, J.R. *Florence and the Medici*. London: Phoenix Press 2001.

Hankins, James. *Plato in the Italian Renaissance*. Leiden: Brill, 1990.

———. *Humanism and Platonism in the Italian Renaissance*. Rome: Edizioni di storia e letteratura, 2003.

Hanlon, Gregory. *Early Modern Italy, 1550–1800*. London: Macmillan, 2000.

Hay, Denys, and John Law. *Italy in the Age of the Renaissance: 1380–1530*. Longman History of Italy. Essex: Longman, 1989.

Heywood, William. *A History of Pisa in the Eleventh and Twelfth Centuries*. Cambridge: University of Cambridge Press, 1921.

Hibbert, Christopher. *The House of Medici: Its Rise and Fall*. New York: HarperCollins, 1982.

Holmes, George, ed. *Art and Politics in Renaissance Italy*. Oxford: The British Academy, 1993.

Hook, Judith. *Lorenzo de' Medici: An Historical Biography*. London: Hamish Hamilton, 1984.

———. *Siena: A City and Its History*. London: Hamish Hamilton, 1979.

———, and P. Collinson. *The Sack of Rome, 1527*. London: Palgrave Macmillan, 2004.

Kempers, Bram. *Painting, Power, and Patronage: The Rise of the Professional Artist in Renaissance Italy*. London: Penguin, 1987.

Kent, Dale. *The Rise of the Medici: Faction in Florence 1426–1434*. Oxford: Oxford University Press, 1978.

Kirk, Thomas Allison. *Genoa and the Sea: Policy and Power in an Early Modern Maritime Republic, 1559–1684*. The Johns Hopkins University Studies in Historical and Political Science. Baltimore: Johns Hopkins University Press, 2005.

Kirkpatrick, Robin. *The European Renaissance 1400–1600*. New York: Longman, 2002.

Konstan, A., and T. Bryan. *Lepanto, 1571: The Greatest Naval Battle of the Renaissance*. Oxford: Osprey Publishing, 2003.

Lane, Frederic. *Andrea Barbarigo, Merchant of Venice: 1418–1449*. New Haven, CT: Yale University Press, 1976.

Larner, John. *Italy in the Age of Dante and Petrarch: 1216–1380*. A Longman History of Italy. Vol. 2. New York: Longman Group, 1980.

———. *The Lords of Romagna: Romagnol Society and the Origins of the Signorie*. Ithaca, NY: Cornell University Press, 1965.

Looney, Denis, and Deanna Shemek, eds. *Phaethon's Children: The Este Court and Its Culture in Early Modern Ferrara*. Tempe: Arizona Centre for Medieval and Renaissance Studies, 2005.

Lopez, Robert S., and Irving W. Raymond, trans. and intr. *Medieval Trade in the Mediterranean World*. New York: W.W. Norton.

Lubkin, Gregory. *A Renaissance Court: Milan under Galeazzo Maria Sforza*. Berkeley: University of California Press, 1994.

Machiavelli, Niccolo. *The Prince*. Trans. and ed. Robert M. Adams. New York: Norton, 1977.

———. *The Discourses on Livy*. Trans. H. Mansfield and N. Tarcov. Chicago: University of Chicago Press, 1998.

———. *The Florentine Histories*. Trans. H. Mansfield and L. Banfield. Princeton: Princeton University Press, 1990.

———. *The Prince*. Trans. and ed. Robert M. Adams. New York: Norton, 1977.

Mallett, Michael. *The Borgias: The Rise and Fall of a Renaissance Dynasty*. Chicago: Academy Chicago Publishers, 1987.

———, and Shaw, Christine. *The Italian Wars, 1494–1559*. Cambridge: Pearson, 2012.

Marino, John, ed. *The Short Oxford History of Italy: Early Modern Italy*. Oxford: Oxford University Press, 2002.

Martines, Lauro. *April Blood: Florence and the Plot against the Medici*. Oxford: Oxford University Press, 2003.

———. *Power and Imagination: City-States in Renaissance Italy*. New York: Alfred A. Knopf, 1979.

Miller, Keith. *St. Peter's*. London: Profile Books, 2007.

Mollat, Guillaume. *The Popes at Avignon: 1305–1378*. London: Thomas Nelson & Sons, 1963.

Muir, Edward. *Civic Ritual in Renaissance Venice*. Princeton, NJ: Princeton University Press, 1981.

Najemy, John M. *Corporatism and Consensus in Florentine Electoral Politics, 1280–1400*. Chapel Hill: University of North Carolina Press, 1982.

———, ed. *The Short Oxford History of Italy: Italy in the Age of the Renaissance*. Oxford: Oxford University Press, 2004.

Norwich, John Julius. *A History of Venice*. New York: Alfred A. Knopf, 1982.

———, ed. *The Italian World*. London: Thames and Hudson, 1983.

Origo, Iris. *The Merchant of Prato*. Harmondsworth, Middlesex: Penguin Books, 1963.

Parks, Tim. *Medici Money: Banking, Metaphysics, and Art in Fifteenth-Century Florence*. New York: Atlas Books, 2005.

Partner, Peter. *Renaissance Rome: 1500–1559: A Portrait of a Society*. Berkley: University of California Press, 1976.

Partridge, Loren. *The Art of Renaissance Rome: 1400–1600*. New York: Harry N. Abrams, 1996.

Petrarch. *Canzoniere*. Trans. M. Musa. Bloomington: Indiana University Press, 1999.

———. *Invectives*. Trans. D. Marsh. Cambridge, MA: Harvard University Press, 2008.

———. *My Secret Book*. Trans. J.G. Nichols. Foreword by Germaine Greer. London: Hesperus Press, 2002.

Phillips, Mark. *Francesco Guicciardini: The Historian's Craft*. Toronto: University of Toronto Press, 1977.

————. *The Memoirs of Marco Parenti: A Life in Medici Florence*. Princeton, NJ: Princeton University Press, 1987.

Polizzotto, Lorenzo. *The Elect Nation: the Savonarolan Movement in Florence 1494–1545*. Oxford-Warburg Studies. Oxford: Clarendon Press, 1994.

Portoghesi, Paolo. *Rome of the Renaissance*. London: Phaidon, 1972.

Prescott, O. *The Lords of Italy*. New York: Harper and Row, 1972.

Queller, D. *The Fourth Crusade: The Conquest of Constantinople*. Pennsylvania: University of Pennsylvania Press, 1999.

Rabb, Theodore K. *The Last Days of the Renaissance and the March to Modernity*. New York: Basic Books, 2006.

Rabil, Albert, ed. *Renaissance Humanism: Foundations, Forms, and Legacy*. Philadelphia: University of Pennsylvania Press, 1988. 3 vols.

Raffini, C. *Marsilio Ficino, Pietro Bembo, Baldassare Castiglione: Philosophical, Aesthetic, and Political Approaches in Renaissance Platonism*. New York: Peter Lang (Renaissance & Baroque Studies & Texts), 1998.

Ramsey, P., ed. *Rome in the Renaissance: The City and the Myth*. Binghamton: MRTS, 1982.

Riley-Smith, J. *The Oxford Illustrated History of the Crusades*. Oxford: Oxford University Press, 2001.

Robb, Nesca. *Neo-Platonism of the Italian Renaissance*. London: Allen and Unwin, 1969.

Sapori, Armando. *The Italian Merchant in the Middle Ages*. Trans. Patricia Ann Kennen. New York: Norton, 1970.

Schiffman, Zachary S., ed. *Problems in European Civilization: Humanism and the Renaissance*. Boston: Houghton Mifflin, 2002.

Servadio, Gaia. *Renaissance Women*. New York: I.B. Tauris, 2005.

Sider, Sandra. *A Handbook to Life in Renaissance Europe*. New York: Facts on File, 2005.

Simon, Kate. *A Renaissance Tapestry: The Gonzaga of Mantua*. New York: Harper and Row, 1988.

Stephens, J.N. *The Fall of the Florentine Republic: 1512–1530*. Oxford: Clarendon Press, 1983.

Stinger, Charles L. *The Renaissance in Rome*. Bloomington: Indiana University Press, 1998.

Tabacco, Giovanni. *The Struggle for Power in Medieval Italy: Structures of Political Rule*. Cambridge Medieval Textbooks. Cambridge: Cambridge University Press, 1989.

Trease, G. *The Condottieri*. London, 1970.

Tuohy, Thomas. *Herculean Ferrara: Ercole d'Este, 1471–1505, and the Invention of a Ducal Capital*. Cambridge: Cambridge University Press, 1996.

Van Veen, Henk. *Cosimo I de' Medici and his Self-representation in Florentine Art and Culture*. Cambridge: Cambridge University Press, 2006.

Vasari, Giorgio. *Lives of the Artists*. Trans. George Bull. 2 vols. New York: Penguin, 1965.

Vespasiano da Bisticci. *The Vespasiano Memoirs: Lives of Illustrious Men of the XVth Century*. Renaissance Society of America Reprint Texts 7. Trans. William George and Emily Waters. Intr. Myron P. Gilmore. Toronto: University of Toronto Press in association with the Renaissance Society of America, 1997.

Viroli, M. *Niccolo's Smile: A Biography of Machiavelli*. Trans. A. Shugaar. New York: Hill and Wang (Farrar, Straus, Giroux), 2002.

Waley, Daniel. *Siena and the Sienese in the Thirteenth Century*. Cambridge: Cambridge University Press, 1991.

Walker, Paul Robert. *The Feud that Sparked the Renaissance: How Brunelleschi and Ghiberti Changed the Art World*. New York: William Morrow, 2002.

Weinstein, Donald. *Savonarola and Florence: Prophesy and Patriotism in the Renaissance*. Princeton, NJ: Princeton University Press, 1970.

Welch, Evelyn. *Art and Society in Italy 1350–1500*. Oxford: Oxford University Press, 1997.

———. *Shopping in the Renaissance*. New Haven, CT: Yale University Press, 2009.

White, Jonathan. *Italy: The Enduring Culture*. New York: Continuum, 2000.

Wilkins, E.H. *Life of Petrarch*. Chicago: University of Chicago Press, 1961.

———. *Studies in the Life and Works of Petrarch*. Cambridge, MA: Medieval Academy of America, 1977.

Witt, R., and Kohl, B. *The Earthly Republic: Italian Humanists on Government and Society*. Philadelphia: University of Pennsylvania Press, 1978.

Woodward, W.H. *Vittorino da Feltre and Other Humanist Educators*. Toronto: University of Toronto Press, 1997.

SOURCES

FIGURES

2.1 *Coronation of Charlemagne.* Scala/Art Resource, NY.

2.2 *The Divine Comedy of Dante Illuminates Florence.* Scala/Art Resource, NY.

3.1 *Adimari Wedding Cassone.* Erich Lessing/Art Resource, NY.

3.2 *The Birth of John the Baptist.* Scala/Art Resource, NY.

3.3 *The Birthing Tray for Lorenzo de'Medici, 1449.* © The Metropolitan Museum of Art. Image source: Art Resource, NY.

3.4 Palazzo Davanzati Exterior. Bartlett Cultural Connections.

3.5 Palazzo Davanzati Bedroom. Scala/Art Resource, NY.

4.1 *Six Tuscan Poets.* Minneapolis Institute of Arts, The William Hood Dunwoody Fund, 71.24.

5.1 *The Tomb of Leonardo Bruni.* Scala/Art Resource, NY.

5.2 *Portrait of the Artist's Sisters Playing Chess.* Erich Lessing/Art Resource, NY.

5.3 University of Padua, The Great Hall (*Aula Magna*). M. Danesin/Università degli Studi di Padova.

5.4 University of Padua, The Anatomy Theatre. Gianni Degli Orti/The Art Archive at Art Resource, NY.

6.1 The Florentine Florin. Classical Numismatic Group, Inc. Licensed under CC-BY-SA.

6.2 Florence, the Palace of the Wool Guild. Scala/Art Resource, NY.

6.3 San Gimignano. Erich Lessing/Art Resource, NY.

6.4 Florence, Palazzo della Signoria (Palazzo Vecchio). Nicolo Orsi Battaglini/Art Resource, NY.

7.1 *The Return of Pope Gregory XI to Rome.* Scala/Art Resource, NY.

7.2 Rome, Palazzo Venezia. Scala/Art Resource, NY.

7.3 *The School of Athens.* Scala/Art Resource, NY.

7.4 *The Disputation over the Holy Sacrament.* Scala/Art Resource, NY.

7.5 *Paul III and His Grandsons.* Scala/Ministero per i Beni e le Attività culturali/Art Resource, NY.

8.1 Pisa, *Campo dei Miracoli* (Field of Miracles). © DeA Picture Library/Art Resource, NY.

8.2 *After his election, the Doge thanks the Grand Council in the Grand Council Hall of the Doge's Palace in Venice, Italy.* Erich Lessing/Art Resource, NY.

8.3 Venice, Palazzo Ducale. *Bocca del leone.* Bartlett Cultural Connections.

8.4 Venice, Palazzo Ducale. Scala/Art Resource, NY.

8.5 *Procession in the Piazza San Marco.* Erich Lessing/Art Resource, NY.

8.6 Venice, San Giorgio Maggiore. Gianni Degli Orti/The Art Archive at Art Resource, NY.

8.7 Venice, *Fondamenta dei Mori.* Bartlett Cultural Connections.

8.8 *Portrait of the Ottoman sultan, Mohammed, the conqueror of Istanbul.* Gianni Degli Orti/The Art Archive at Art Resource, NY.

8.9 *Battle of Lepanto, 1571.* Erich Lessing/Art Resource, NY.

9.1 Naples, Castello Nuovo. Gianni Degli Orti/The Art Archive at Art Resource, NY.

9.2 Pavia, The Certosa. Scala/Art Resource, NY.

9.3 The Sforza Altarpiece. Erich Lessing/Art Resource, NY.

9.4 *Family of Lodovico Gonzaga.* Scala/Art Resource, NY.

9.5 *Amor and Psyche.* Erich Lessing/Art Resource, NY.

9.6 *April, the sign of Taurus and the Triumph of Venus.* Scala/Art Resource, NY.

9.7 Urbino, the Castle of Federigo da Montefeltro. Scala/Art Resource, NY.

9.8 *Federigo and his son, Guidobaldo.* Erich Lessing/Art Resource, NY.

9.9 *Portrait of Baldassare Castiglione.* Erich Lessing/Art Resource, NY.

10.1 *Primavera (Spring).* Alfredo Dagli Orti / The Art Archive at Art Resource, NY.

10.2 *Lorenzo il magnifico and the Platonic Academy (Célébration néo-platonicienne à la cour de Laurent de Médicis).* Erich Lessing/Art Resource, NY.

10.3 Florence: The Villa at Careggi. Scala/Art Resource, NY.

10.4 *The Platonic Academy, 1485–90.* Scala/Art Resource, NY.

11.1 *Girolamo Savonarola.* Erich Lessing/Art Resource, NY.

11.2 *The Entry of Charles VIII of France and His Army into Florence on 17 November 1494.* Erich Lessing/Art Resource, NY.

11.3 *The Burning of Savonarola, 23 May 1498.* Erich Lessing/Art Resource, NY.

12.1 *The Siege of Florence, 1529–30.* Alinari/Art Resource, NY.

12.2 *Eleonora of Toledo.* Alfredo Dagli Orti/The Art Archive at Art Resource, NY.

12.3 *Palazzo Pitti, with the Boboli Gardens and Belvedere Fortress.* Gianni Dagli Orti /The Art Archive at Art Resource, NY.

14.1 *The Lamentation.* Alinari/Art Resource, NY.

14.2 *Image of Good Government.* Erich Lessing/Art Resource, NY.

14.3 *The Trinity.* Scala/Art Resource, NY.

14.4 *The Montefeltro (or Brera) Altarpiece.* Scala/Art Resource, NY.

14.5 *The Uffizi Adoration of the Magi.* Erich Lessing/Art Resource, NY.

14.6 *Pallas and the Centaur.* Alfredo Dagli Orti / The Art Archive at Art Resource, NY.

14.7 Gattamelata. Alfredo Dagli Orti /The Art Archive at Art Resource, NY.

14.8 Bartolommeo Colleoni. Scala/Art Resource, NY.

14.9 *Miracle of the True Cross.* Cameraphoto Arte, Venice/Art Resource, NY.

14.10 *Sacred and Profane Love.* Scala/Ministero per i Beni e le Attività culturali/Art Resource, NY.

14.11 Notebooks, *Anatomical Drawing.* Scala/Art Resource, NY.

14.12 Rome, Vatican Apostolic Palace. Sistine Chapel. Scala/Art Resource, NY.

14.13 Florence, Church of San Lorenzo, New Sacristy. Alfredo Dagli Orti /The Art Archive at Art Resource, NY.

14.14 Rome, Vatican Apostolic Palace, Room of Heliodorus. Alinari/Art Resource, NY.

14.15 Florence, Church of Santa Croce, The Pazzi Chapel. Alfredo Dagli Orti /The Art Archive at Art Resource, NY.

14.16 Rimini, Tempio Malatestiano. Scala/Art Resource, NY.

14.17 Rome, Forum boarium, Temple of Vesta. Bartlett Cultural Connections.

14.18 Rome, Tempietto, San Pietro in Montorio. Scala/Art Resource, NY.

14.19 Pope Julius II medal. © The Trustees of the British Museum/Art Resource, NY.

14.20 *The Entry into Jerusalem.* Opera di S. Maria del Fiore, Firenze.

14.21 *The Sacrifice of Isaac.* Opera di S. Maria del Fiore, Firenze.

14.22 *Salt Cellar* (*Saliera*). Erich Lessing/Art Resource, NY.

15.1 Donatello, *David*. Scala/Art Resource, NY.

15.2 Verrocchio, *David*. Erich Lessing/Art Resource, NY.

15.3 Michelangelo, *David*. Scala/Art Resource, NY.

15.4 Rome, Pantheon. Scala/Ministero per i Beni e le Attività culturali/Art Resource, NY.

15.5 Vicenza, Villa Rotonda (Capra). Bartlett Cultural Connections.

15.6 Vicenza, Teatro Olimpico. Scala/Art Resource, NY.

15.7 Rome, The Basilica of St Peter. Vanni/Art Resource, NY.

MAPS

2.1 The Geography of Italy. Courtesy of Graphic Maps.

9.3 Emilia-Romagna, including Ferrara. © European Union, 1995–2012.

INDEX

Abati, Bella degli, 28
Abruzzo, 20
academic freedom, 87
accounting, 82
active life. *See* engaged secular life
Acts, 64
Adam and Eve, 77
Adorno family, 141–42
Adrian VI, Pope, 131, 251
Aeneid (Virgil), 32, 83
Aeschylus, 86
Africa (Petrarch), 59
The Age of Constantine the Great (Burckhardt), 7
Age of Reason, 5
Agnadello, 124, 243, 326, 338
Agostino Chigi, villa of, 254
Al-Andalus, 161
Albania, 160
Albert, Prince Consort of Victoria, Queen of Great Britain, 6
Alberti, Leon Battista, 12–13, 19, 187, 213
 De re aedificatoria, 192, 309
 facade of Sant'Andrea, 310
 On the Family, 36, 77
Albizzi, Rinaldo degli, 108
Albizzi oligarchy, 108
Alexander VI, Pope, 22, 50, 118, 121, 171, 175, 195, 202, 218, 230, 237–38, 248, 331
 children, 122–23
 death, 124
 distribution of food in hard times, 122
 mistresses, 122–23, 133
 sold Church offices, 122
 uncanonical personal life, 122
Alexandria, 212
 Alfonso I d'Este, Duke of Ferrara
 excommunication, 195
Alfonso of Aragon, Duke of Bisceglie, 123
Alfonso V, King of Aragon, 21, 172–74, 195
Alighieri, Alighiero, 28
allegory, 213, 221, 290, 298
altarpieces, 298
Amalfi, 137–38, 159
ambassadors, 80. *See also* names of individual ambassadors

Ambrose, Saint, 175, 181
Ammanati, Bartolomeo, 261
amorality, 8, 32
Angelico, Fra, 118, 331
Anguissola, Minerva, 79
Anguissola, Sofonisba, 79–80
anthropocentric conception of the world, 64, 334, 338
antipopes, 117
antiquity. *See* classical antiquity
Apennines, 19
Apostles' Creed, 65
Appiani, Gherardo, 140
Apuleius, *Golden Ass*, 212
Aragonese (Spanish dynasty), 171
archaeology, 4, 65, 285
architecture, 157, 169, 192, 285, 307–11, 338
 animated by classical models and texts, 307, 309
 new architecture of landed magnates, 328
 new humanist style based on Vitruvius, 309
 Venetian Renaissance style, 158
Arena (Scrovegni) Chapel, 90
Arezzo, 236
Argonautica (Flaccus), 65
Ariosto, Lodovico, 191
 Orlando Furioso, 19
Aristotelian learning, 30–31
Aristotelian philosophy, 28, 70, 218
Aristotelian praise of monarchy, 210
Aristotelianism, 61, 212
Aristotle, 11, 84, 198
 Economics, 74
arithmetic, 69, 84
Arrabbiati (the Enraged), 236–38
Arrabiati Signoria, 239
ars dictaminis, 70, 81
art, 157, 213
 became royal and private (not communal), 325
 developing into propaganda for the prince, 316
Art of War (Machiavelli), 260, 272
arte del popolo di dio (guild of the people of God), 106
Arte della Lana (cloth manufacturers), 95
Arthurian knights, 19
arti maggiori, 100–101, 107
arti medie (intermediate guilds), 100–101

arti minori (craft guilds), 101, 106–7
artisan guilds, 94
artisans, 42, 46
artist, changing status, 303
artist as creator, 286, 301
artist as hero, 315
artists as companions of popes and princes, 303
arts, study of, 87
Asconius' commentaries on Cicero, 65
Asti, 176
astronomy, 69, 84
Augustine, Saint, Bishop of Hippo, 60, 86, 212, 217
 moral philosophy, 64
 on neo-Platonism and Christianity, 212
 Petrarch's reading of, 57, 62
 Platonism, 61
Autobiography (Cellini), 315
Avignon, 55, 57, 113, 117, 177
 papacy in Avignon, 113–14, 171 (See also
 Babylonian Captivity; Great Schism
 [1378–1417])
Azzo d'Este, 192

Babylonian Captivity, 20, 113–15, 330
Baldwin of Flanders, 149
Balìa, 248
Balkans, 159, 161
Bands of Hope, 235–36, 238
Bank of St George (Banco di San Giorgio), 142–43
bankers, 80, 100
bankers and industrialists, 97
banking, 20, 27
banks, 94, 105, 109. See also names of individual
 banks
 Venetian trading and banking firms, 328
Barbara of Brandenburg, 187
barbarian invaders, 2, 21, 76, 143, 229
barbarian invasions, 25, 186, 226, 237
barbarians, 5, 11, 57, 251, 254, 257–58, 265–71, 277,
 315, 323
 Machiavelli's use of term, 242
Barbaro, Ermolao, 156
Barbaro, Francesco, On Wifely Duties, 77
Barbarossa (Khayr al-Din), 161
Barcelona, 138
Bardi, Simone de', 28
Bardi (bank), 105
Bargello, chapel of the, 288
barnabotti

Baron, Hans, 9–11, 321
 The Crisis of the Early Italian Renaissance, 9
Baron thesis, 175, 321
Basil, 86
Basilica of Saint Anthony of Padua, 90
Basilica of San Francesco d'Assisi, 288
Basilica of Santa Maria Novella, 309–10
Basilica of St Peter in Rome, 118, 124–25, 307
Bassano, 151
Beatrice d'Este, 184–86, 192
Beatrice of Dante's Paradiso. See Portinari, Beatrice
Beckford, William, 6
Bella, Giano della, 100
Bellini, Gentile, 298
Bellini, Jacopo, 298
Bellini family, 157, 188, 298, 300, 325
Bembo, Pietro, 156, 191, 199
 Prose della vulgar lingua, 159
Benedict VIII, Pope, 137
Benedict XI, Pope, 114
Bergama, 176
Bernard of Clairvaux, Saint, 31, 82
Bernardo Rossellino's (Bernardo Gamberelli) tomb
 of Leonardo Bruni, 295, 298
Berruguete, Pedro, 199
Bessarion, Basilios, Cardinal, 156
bible (commissioned by Borso d'Este), 193
Bible (Vulgate Bible), 63
biblical exegesis, Christian tradition of, 66
Biondo, Flavio, 118, 275
The Birth of Venus (Botticelli), 213, 219, 293
Bisticci, Vespasiano da, 198
Black Death, 58, 94, 290, 313
Blacks, 103
Bò. See University of Padua
Boboli gardens, 261
Boccaccio, Giovanni, 3, 32, 58, 65, 73–74, 85, 235
 Decameron, 27, 213
 Life of Dante, 27–28
 popularized Petrarch's belief in the value of
 ancient culture, 71
Boccanegra, Simon, 141
Boethius, Consolation of Philosophy, 212
Boiardo, Matteo Maria, 195
 Orlando Innamorato, 195
Bologna, 20, 55, 57, 62, 124, 176–78, 181, 195, 242
Bologna, University of, 90
Bonacolsi family, 186
Boniface VIII, Pope, 29, 103, 114

claims of universal dominion, 113

The Book of the Courtier (Castiglione), 188, 198, 202, 205–6, 209, 338

Borgia, Cesare, 13, 32, 118, 122–24, 189, 202, 241, 268, 271
 alliance with Louis XII of France, 123
 French royal bride for, 241
 suggested Florence should take back the Medici, 267

Borgia, Juan, 123

Borgia, Lucrezia, 118, 123, 188, 195

Borgia, Rodrigo, 118, 121

Borgia papacy, 122–24

Borgias, 205

Borso d'Este, 193, 195
 library, 193

Boschetti, Isabella, 189

Bosnia, 159

botanical gardens, 90

Botticelli, Sandro, 213, 217, 219, 221, 238
 associated with Laurentian Florence, 293
 Birth of Venus, 213, 219, 293
 converted to puritanical fundamentalism, 218, 298
 neo-Platonic inspiration, 293
 painter of the Medici, 295
 Pallas and the Centaur, 293
 Primavera, 293
 Uffizi Adoration, 219, 293

Bourbon, Constable of (Charles III, 1490–1527), 251, 279

bourgeois revolt of 1343, 106

Bracciolini, Poggio, 65, 71–72, 117–18, 151, 275, 280, 331
 History of the Florentine People, 73
 humanist in emerging civic mold, 73
 recovery of lost classical texts, 73
 rediscovered Vitruvius' book on architecture, 309

Bramante, Donato, 125, 310–11, 331

Brera Madonna, 293

Brescia, 176, 178, 181

"bride of Christ," 123

Bridget of Sweden, Saint, 115

broglio, 154

bronze casters, 312

bronze doors of the Baptistery of Florence, 312–13

Brunelleschi, Filippo, 1, 108, 117, 213, 261, 312

commissioned to construct cathedral dome, 309, 338

Bruni, Leonardo, 27–28, 71–72, 78, 97, 107, 118, 180, 275, 280, 321, 331, 338
 Cicero Novus, 74
 civic humanism, 73–74
 History of Florence, 230
 History of the Florentine People, 76
 Life of Dante, 74, 81
 tomb of, 295, 298
 translated Platonic dialogues, 212

Bruno, Giordano, 50, 331, 334

Bulgaria, 159

Buontalenti, Bernardo, 261

Burckhardt, Jacob, 8–9, 11, 32, 315
 The Age of Constantine the Great, 7
 canonization, 11
 Cicerone, 7
 Civilization of the Renaissance in Italy, 6–7, 81
 The Civilization of the Renaissance in Italy, 319
 methodology, 6–8, 10–12
 state as work of art, 13

burning of the vanities, 238, 323

Byzantine empire, 21, 117, 144, 159, 266

Byzantine Greeks, 22, 212

Byzantium, 24

Cabot, John, 165

Caesar, Julius, 60, 76, 83, 210

Caffa, 142

Calimala (cloth dealers), 95, 100

Calixtus III, Pope, 118

Calumny of Apelles (painting), 213

Calvin, John, 331

Cambio, Arnolfo di, 103

Cambio (bankers and money-changers), 100

Camera degli sposi, 187

Campaldino, battle, 100

campanilismo, 22

canzoniere, 219

Cape of Good Hope, 164

capella dei principi at San Lorenzo, 325

capital, instruments for the pooling of, 94

capitalist exploitation of industrial manufacturing, 94

Capitoline Museum, 120

Cappello, Bianca, 262

carpets, 27

cartels, 95, 100
Castel Sant'Angelo, 122, 131
Castello Sforzesco, 183, 186
Castiglione, Baldassare, 211
 The Book of the Courtier, 87, 188, 198, 202, 205–6, 209, 338
 as diplomat, 205
 idolization of the virgin duchess, 203
Castle Church of Wittenberg, 130
Catanei, Vanozza dei, 122
catasto of 1427, 107, 323
Catherine of Siena, Saint, 115
Catholic Reformation, 50
Catullus, Gaius Valerius, 213, 238
Cellini, Benvenuto, 131
 attendant on pope during sack of Rome, 314–15
 Autobiography, 315
 bronze portrait bust of Duke Cosimo, 315
 at court of Francis I, 314–15
 Fontainebleau nymph, 314
 Perseus for Cosimo I de' Medici, 315
 saltcellar, 314
 treatise on the arts of the goldsmith and sculpture, 315
Cereta, Laura, 77–78, 177
 education, 77
 Litterae Familiares, 78
Chabod, Federico, 9–10, 319
chain of being, 212
chancellors or chancery offices (Venice), 145, 157, 325
chancellorship of Florence, 71–73, 76, 78, 97, 290
charity, 46, 60
Charlemagne, 24, 76, 210
Charles, Duke of Calabria, 105
Charles, Duke of Durazzo, 171
Charles I, King of Naples, 171
Charles IV, Holy Roman Emperor, 58
Charles V, Holy Roman Emperor, 131, 143, 161, 164, 189, 195, 244, 251, 257
 imperial coronation, 254
 promise to restore Florence to the Medici, 254, 279
Charles VIII, King of France (r. 1483–98), 175, 184, 233–34, 323
 driven from Italy, 236, 240
 invasion of Italy, 174, 230, 266, 271
 triumphal march into Naples, 174

chastity, 119
Chigi, Agostino, 307
childbirth, death during, 37, 42
children born to widowed mothers, 42
Christ, statue of, 238
Christian/Turks struggle for the Mediterranean, 159–61
Christian humility and charity, 60
Christian morality, 82
Christian tradition of biblical exegesis, 66
Christian tradition of the Fall, 211
Christian victories over Turks in Europe, 161, 164
Christianity, 6, 8, 218
 ambiguity about classical antiquity, 63
Chrysoloras, Manuel, 71, 73, 85–86, 180, 212
Church, 12, 21, 25, 47, 49
 endangered, 331
 as heir to the Roman Empire, 22
 hospitals and other social services, 47
 invention of venal offices, nepotism, pluralism, and non-residence, 115
 moral authority, 114–15
 power and wealth, 114
 provided opportunities to contribute to community, 46
 satirized by Pulci, 221
 spiritual welfare, 47
 states of (*See* states of the Church)
Cibò, Innocenzo, Cardinal, 256
Cicero, 5, 11, 28, 55, 63–64, 82–83, 212, 285
 changing attitude to, 74
 civic humanism and, 65
 classical prose, 61–62
 example of rhetorical perfection, 84
 Letters to Atticus, 59, 65, 74
 Litterae Familiares, 72, 74
 lost letters to his friend Atticus and his brother Quintus, 65
 moral philosophy, 64
 participation in state, 74
 Petrarch's letter to, 59, 65, 74
 as politician, 65
Cicero Novus (Bruni), 74
Cicerone (Burckhardt), 7
Cimabue, 288, 316
ciompi, 99, 321
 subject to merchant guilds, 95
 unemployment and low wages, 227

ciompi revolt, 106–7
circle of Lorenzo the Magnificent, 217–22
circumnavigation of the Cape of Good Hope, 164,
 226, 326
citizen army, paradox of, 271
cittadini originari (ordinary citizens), 145–46, 157, 325
city governance, 93–98
 need for notaries, secretaries, or administrators,
 70
 opportunity to contribute to the governing of
 one's native city, 70
city-states, 5, 12, 19, 25
 developed from self-governing communes, 26
 ruling elite, 10
civic humanism, 63, 65, 71–74, 107, 175, 206, 259,
 298, 320–21, 338
 irrelevant to a society ruled by despots, 209–10
 republican ideal, 9, 28, 209–10, 221–22
civic virtue, 32, 60
Civilization of the Renaissance in Italy (Burckhardt),
 6–7, 81, 319
Classe, 144
classical antiquity, 2–4, 9, 12, 32, 59, 212
 European knowledge extended beyond (with
 Portuguese exploration), 164–65
 freedom of women and, 42
 as guide to life and letters, 62, 82, 320
 models of ancient art, 286
 preferring over medieval, 6
 recovery of, 7, 51, 69, 71–72, 118
 return to, 4–5, 8, 11–12
 reverence for, 338
 search for classical manuscripts, 64–65, 73, 86
 sensual attractions feared by Christians, 63
 value to humanity, 63
classical authors, 172, 198. *See also* names of specific
 authors
classical literature, 62, 71, 83, 87
classical tradition in love, 213
Clement of Alexandria, 205
Clement VII, antipope (r. 1378–94), 117
Clement VII, Pope (r. 1523–34), 117, 131, 191, 195,
 248, 274, 278, 281, 314–15, 331
 disastrous miscalculation, 251, 279, 282
 escape to Orvieto, 254
 illegitimate son, 255
 modus vivendi with Charles V, 279
 territories to Habsburgs, 254

clerical celibacy, 119
cloth industry, 226. *See also* wool industry
Coeur, Jacques, 226
coinage, 25, 95
collegio (Venice), 147
Colonna, Giacomo, 55, 57–58
Colonna, Oddone, 117
Colonna, Vittoria, 78
Colonna family, 205, 242
Columbus, Christopher, 121–22, 165
Comedia. See Divine Comedy (Dante)
comic poets, 221
Commentary on Plato's Symposium on Love (Ficino),
 213
commerce and trade, revolution in, 94
commune of Florence, 98, 105
commune of Mantua, 186
communes, 26
Como, 176
comparative stylistics, 65
competitive search for shining excellence, 121, 169,
 196, 301, 309, 312, 337–38
condottiere principalities, 19, 209
condottieri (mercenary captains), 95, 169, 181, 191–92,
 256, 295
 Gonzaga family, 188, 229
 Urbino, 198–99
confraternities, 46–47
Consolation of Philosophy (Boethius), 212
Constance, Council of, 117
Constantine I, Emperor of Rome, 24, 118, 120, 210,
 226
Constantinople, 21, 24, 27, 117, 120
 fall to the Turks, 142, 159, 225–26, 326
 restoration of Greek dynasty in, 141
contado, 237
contemplation, 71–72, 74, 215, 277
continuity or gradual change, principle of, 4, 10–11,
 13, 31
contracts and correspondence, need for, 26, 70
convents and monasteries, 37, 77
 services to the community, 47–48
 surplus children of the propertied classes, 48
Convivio (The Banquet) (Dante), 30
Copernicus, Nicholas, *On the Revolution of the
 Heavenly Bodies*, 90
Córdoba, Gonzalo de, 174–75, 241
Cornaro, Caterina, 161

corporatism, 11

Corsica, 137

Cosimo I, Grand Duke of Tuscany, 256, 260–61
 creation of court, 259
 destroyed republican institutions of Florence,
 257, 259
 Florence recovered some external independence,
 324
 loyalty to, 325
 marriage, 257, 260
 moved against monastery of San Marco, 259
 new form of patronage, 140, 261, 337
 provided security, stability and honor, 260
 public execution of republicans, 257, 324

Cossa, Francesco del, 193

Council of Basel, 118

council of Bologna, 191

Council of Constance (1414–17), 117

Council of Five Hundred, 234, 240, 254, 273

Council of Florence, 117, 212, 217, 221, 234, 237, 273

Council of Pavia (1423), 117

Council of Pisa (1409), 117

Council of Seventy (1480), 110

Council of Siena, 117

Council of Ten (*Consiglio dei Dieci*), 147, 149, 154–55

Council of Trent, 50, 133

Counter-Reformation, 90, 320, 323, 331, 334

country villas, 45

court culture, 42, 205, 222

The Courtier (Castiglione), 87

courtly love, medieval tradition of, 213

courts, 19. *See also* names of specific courts

craft guilds, 101, 106–7

credit and exchange, new methods of, 94

Creed, 82

Cremona, 178, 241

Crete, 21, 161

The Crisis of the Early Italian Renaissance (Baron), 9

Crusades, 25, 27, 94–95, 119–20, 138, 140, 229
 expansion of the cities of Italy, 26
 made Venice a rich European power, 149
 urban development and, 26

cultural history, 6, 10–12

cultural model of ancient Greece and Rome, 5

currencies (stable currencies), 26, 180
 Florentine coinage (florin), 95

cursus honorum of a young Venetian patrician, 145,
 156–57

Curzola, 141

Cyprus, 21, 161, 164

Daddi, Bernardo, 289

daily life (structures of everyday life), 35

Dalmatia, 154, 174

Dalmatian Coast, 21

Dame Philosophy, 30

Dante Alighieri, 2–3, 28–30, 35, 61, 73
 active citizen, 31
 battle of Campaldino, 100
 Convivio, 30
 De monarchia, 30–31, 55, 72
 Divine Comedy, 27–28, 30–32
 enemy of papal party, 29
 exile, 30–31, 103
 Ghibelline creed, 30–31
 The Inferno, 140
 medieval figure, 31–32, 336
 Paradiso, 28, 32
 politically engaged and married, 27–29, 32, 74
 role in Italian cultural development, 27
 service to Florence, 28
 trials, 30
 use of vernacular, 31–32
 Vita Nuova (New Life), 30

Dante's vision of Beatrice, 28, 30–31, 57, 213

David (Donatello), 295

De humani corporis fabrica (Vesalius), 90

De monarchia (Dante), 30–31, 55, 72

De nobilitate legum et medicinae (Salutati), 72

De principatibus (Machiavelli), 269

De re aedificatoria (Alberti), 192, 309

De rerum natura (Lucretius), 65

De Sanctis, Francesco, 276

De seculo et religione (Salutati), 72

De tyranno (Salutati), 72

De vita solitaria (Petrarch), 59

De vulgari eloquentia, or *On the Eloquence of the
 Vernacular Tongue*, 30

Decameron (Boccaccio), 27, 213, 238

Decembrio, Pier Candido, 180

decorative arts, 285, 312–17

decorum, 211

Della Casa, Giovanni
 Il Galateo, 133

della Rovere, Francesco Maria, 202–3

della Rovere, Giuliano, 124–25, 242

della Rovere family, 205
Demosthenes, 85
despotic monarchies, victory of, 320, 338
despotic principalities, 209–10
despotisms, 9, 42, 180
Deuteronomy, 82
Dialogues (Plato), 206
Dias, Bartholomew, 165
Dionysius the Areopagite, 65, 212
Discourses on Livy (Machiavelli), 260, 271–76
Disputation over the Holy Sacrament (Raphael), 125, 254
divieto, 106
Divine Comedy (Dante), 27–28, 30–32
Doctrinale (Alexander de Villa Dei), 83
doges, 141
doges (Genoa), 143
doges (Venice), 144–45, 147, 149, 154, 156
dolce stil nuovo style, 31
Don John of Austria, 164
Donatello (Donato di Niccolò di Betto Bardi), 90, 213, 238, 295, 309, 312, 322
David, 295
Donati, Gemma, 28
Donation of Constantine, 24, 65, 172
Donatus, 83
Doria, Andrea, 143
Doria, Lamba, 141
Doria family, 205
Dovizi da Bibbiena, Barnardo, 130
dowries for orphaned daughters of soldiers, 200
dowry, or bride-price, 36–39, 46, 107, 178, 181, 189.
See also *Monte delle doti*
Duomo (cathedral) of Florence, 117
dyers, new guild of, 106

Economics (Aristotle), 74
education, 12, 47, 51, 82, 222, 315, 321. *See also* humanist education
cittadini originari (ordinary citizens), 145
at court of Alfonso the Magnanimous, 195
medieval education, 81
palace schools, 87
schools of humanist educators, 87, 90
schools of Vittorino and Guarino, 86–87, 90
secular education, 70–71, 73, 80
Venice, 157 (See also *cursus honorum* of a young Venetian patrician)
women and girls, 77–78, 80, 87, 188

Edward, III, King of England, 178
Edward IV, King of England, 200
Egypt, 160
Eleanor of Toledo, 258, 260–61
Eleonora of Aragon, 195
Eleonora of Habsburg, 191
Elizabeth of Valois, 80
eloquence, 63–64. *See also* rhetoric
human conversation has power to elevate, 62
as index to the soul, 62
spoken and written word, 336
Emilia-Romagna, 19
employment, 46
energizing myth, 10, 12, 74, 319, 323, 336
energizing myth of humanism, 323, 337
energizing myth suited to the aristocratic courtier class, 209–10
engaged secular life, 71
England
Hundred Years' War, 226
tax to the pope, 95
Wars of the Roses, 226–27
English Royal College of Physicians, 90
English wool, 95, 226
Erasmo da Narni (Gattamelata), 90, 295
Ercole I d'Este, 188, 195
Ercole II d'Este, 196
Eremitani, church of the, 90
Este family, 192, 197, 210
patronage of culture, 196
warrior princes, 196
Este lands (Ferrara, Reggio, and Modena), 19, 229
estimo (direct tax on wealth), 105
ethics. *See* moral philosophy
Eugenius IV, Pope, 117–18
Euripides, 86
European voyages of discovery, 164–65
exceptionalism of the Florentine republic, 230
excluded communities, 47–50
excommunication, 176, 195, 238
exploration, interest in, 8, 164–65

Fable of Orpheus (Poliziano), 219
Fabriano, Gentile da, 117
Facta et dicta memorabilia (Maximus), 83
factionalism, Machiavelli's analysis, 273
Falier, Marin, 154
fame, 58, 60, 81
family, 35–36, 45, 50, 77

extended kin groups, 35–36, 45
female children, 42
preference for male children, 39
scandal, 37–38
family churches, 45
family strategies of marriage and power, 42
Farnese, Alessandro, 133
Farnese, Giulia, 123, 133
Farnese, Ottavio, 257
Farnese family, 205
Federigo II Gonzaga, Duke of Mantua, 189, 191
Federigo III (r. 1496–1501), 175
Federigo of Aragon. *See* Frederick IV of Naples
Felix V, antipope (r. 1439–49), 118
Feltre, Vittorino da, 78
Ferdinand V, King of Spain, 161, 175, 241–43, 268, 278
treaty with Louis XII of France, 241
Ferrante (r. 1458–94), 174
Ferrara, 19, 117, 191–97, 229, 243, 249
Ferrara despotism, 19
Ferrara family, 186
Ferrarese school, 193
Ferrarese tradition of epic poetry, 195
feudal class of landed magnates. See *magnati*
feudal society, 10, 20, 22
Ficino, Marsilio, 219, 221, 277
Commentary on Plato's Symposium on Love, 213
Platonic Theology, 212, 217
translated the Hermetic Books, 217
translation of Plato into Latin, 216
Filarete, 118
First Crusade, 26, 138
The First Decade (Machiavelli), 265, 268
"First Fruits," 95
The Flagellation, 293
Florence, 5, 9–12, 19–20, 55, 76, 86
architecture (*See* Florentine architecture)
chancellors (*See* chancellorship of Florence)
civic humanism, 72, 74, 76, 209
cloth industry, 94–95, 226–27
cynicism, 323–24
Dante's efforts to maintain harmony, 29
diplomatic and political talent, 229
end of the Renaissance, 320–25
expansion at expense of neighbours, 103, 138, 181, 227
factionalism, 240
failure of will, 323
famine and plague in, 237
feuding nobles, 99
fiscal irresponsibility, 235
French invasions, 323
government and economy, 93–98
Great Council, 117, 212, 217, 221, 234, 273 (*See also* Council of Five Hundred)
houses (or palaces), 43
humanism as energizing myth, 156, 290, 320–21
leading Guelf state, 94
legal position of women, 42
lesser guildsmen had access to elected public office, 46
loss of independence, 324
maritime power, 261
Medici principate, 255–62, 269, 279
merchant guilds, 95
merchant patricians, 70, 93, 103
monarchical despotism in, 247, 260, 271, 323–25 (*See also* Cosimo I, Grand Duke of Tuscany)
new courtly society, 262
papal banking and tax collecting, 98
Peace of Lodi and, 151, 229
Piagnoni mini-coup, 237
place to learn Latin and Greek, 72, 85, 117
recessions, 180, 227, 237
Renaissance neo-Platonic activity, 216
as a republic (*See* Florentine Republic)
state brothels in, 50
storehouse of art, 97
vassal state of France, 242
at war with France, 230
war with Milan, 9, 175
wealth of, 93–94, 98, 100
wool working and the textile trade, 94–95, 226–27
Florence as David, 322
Florence as the new Jerusalem, 230, 235
Florentine architecture, 103, 307, 309–10
Florentine art, 293
Florentine Baptistery, 118, 313, 322, 324
Florentine bourgeois revolution, 99–100
Florentine coinage (florin), 95
Florentine *contado*, 100
Florentine Republic, 70, 93, 98–107, 247, 254, 278, 323
heir of republican Rome, 230, 321

humanism, 312
 perceived as a failed experiment, 324
 republican regime under Savonarola, 266
Florentine state dowry fund. See *Monte delle doti*
Fogliano, Guidoriccio da, portrait, 290
Forlì, Melozzo da, 199
fornication *vs.* chastity, 119
Fornovo, victory at, 236, 240
Fortezza da Basso, 255, 257
fortuna, 225, 230, 237, 324
fortune, 271, 281
Foscarini, Lodovico, 77
Fourth Crusade, 27, 141, 149, 151
France, 227, 242, 267, 269
 army, 230
 dynastic claim on Milan, 241
 dynastic claim on Naples, 227, 229–30
 Hundred Years' War, 226
 mercantile houses, 226
Francesco III Gonzaga, 191
Francis, St, 49, 60
Francis I, King of France, 131, 189, 243–44, 249, 314
 taken prisoner by Emperor Charles V, 251
 war with the Habsburgs, 142–43
Francis of Assisi, Saint, 11
Franciscans, 49, 236–38
Franco, Veronica, 77
Franco-Prussian War (1870–1871), 7
Franks, 143
Fraticelli, 49
Frederick II, Holy Roman Emperor, 24
Frederick III, Holy Roman Emperor, 193
Frederick IV of Naples, 241
free-standing equestrian statues, 90, 295
free-standing male nude figures, 293
free trade, 6
free will, 212
Fregoso family, 141–42, 205
French Angevins, 171–72
French house of Anjou, 142, 172
French population in northern Italy, 17
Frenza, 123
Friuli, 21, 151
Fugger, Jacob, 226

Gaddi, Taddeo, 289
Il Galateo (Della Casa), 133
Galen, 90
Galileo, 90, 140, 191, 276, 331, 334

Gaston de Foix, 243
Gattamelata. *See* Erasmo da Narni (Gattamelata)
genius, role of, 13, 314, 316, 337
Genoa, 137, 141, 151, 159, 236
 after victory at Meloria, 141–43, 149
 alliance with Pisa against Muslims, 137
 appropriated Pisa's markets and trade, 138
 Black Sea outposts, 161
 captured by Habsburg Spaniards, 143
 Crusades and, 26, 138
 economic power, 137, 142
 French influence, 142–43
 internal conflicts, 141–43
 mercantile interests, 137, 142
 as mercantile oligarchy, 143
 Muslim invaders, 137
 strategic importance, 142
 War of Chioggia, 142
 war with Venice, 141–42
 wealth, 138
"Genoese Century," 143
geography, 84
geometry, 69, 84
German mercantile houses, 226
German-speaking lands in Venetian mainland
 territories, 17
Gerusalemme Liberata (Jerusalem Delivered) (Tasso),
 19, 195
Ghent, Justus van, 198–99
Ghetto (in Venice), 49
Ghibellines (supporters of the empire), 24–25,
 30–32, 55, 58, 60, 93, 141–42, 171, 186
Ghiberti, Lorenzo, 118, 312–13, 322, 324
Ghirlandaio workshop, 198
Gibbon, Edward, 5–6
Gilson, Etienne, 11
Giorgione (Giorgio Barbarelli da Castelfranco), 300
Giotteschi, 289
Giotto, 1–2, 90, 288, 312, 316
 bridge between medieval and Renaissance
 worlds, 286
 new artistic world, 289
Giovanni dalle Bande Nere, 256
Giovio, Paolo, 2
Giudici e Notai (judges, lawyers, and notaries), 100
God, 4, 8, 24, 31, 47, 63–64, 212, 286
 absorption of individual soul in, 32
 anger from presence of heretics, 48–49
 knowledge of, 31

moral laws of, 271
Platonism and, 212–13, 215
pure love, 214
Savonarola's angry and vengeful, 230, 232, 238, 323
Savonarola's prophecies and, 236, 239
gold, 122
Golden Ass (Apuleius), 212
Golden Book, 145
goldsmiths, 94, 120, 131, 312
gonfaloniere, 234, 257
gonfaloniere di giustizia, 101
gonfaloniere for life, 240, 247
Gonzaga, Cecila, 78
Gonzaga, Elisabetta, 78, 202, 205
Gonzaga, Ercole, 191
Gonzaga, Francesco (1466–1519), 186, 188, 202
Gonzaga, Gianfrancesco, Marquis of Mantua, 86, 123, 187
Gonzaga, Guglielmo, 191
Gonzaga, Lodovico, 187
Gonzaga, Luigi, 186
Gonzaga, Vincenzo, 191
Gonzaga court in Mantua, 187
Gonzaga family, 19, 186, 196, 229
 condottieri princes, 191
 military tradition, 186, 188
Gonzaga patronage of artists, 19, 186, 188, 191
good letters and good thought connection, 64
Gorgias (Plato), 212
Gothic style, 2–3, 6, 11, 289–90
Goths, 143
Grado/Aquileia, patriarch of, 144
Granada, 161
grand courtesans, 51, 77
grandi (wealthy, ancient, urban families), 98, 100–101, 103
Great Council (Florence), 234, 237, 273
Great Council (Venice), 145, 147, 149, 155–56
Great Hospital (Milan), 183
Great Schism (1378–1417), 20, 22, 49, 117, 171, 178, 330
 healing of, 192
Greek, 71, 77, 81, 85–86, 130, 180, 219
 translations of Greek classics into Latin, 73, 118, 188
 in Venice, 156
Greek and Latin texts, 198
Greek scholars, 117–18, 217, 221

Gregory XI, Pope, 115
Grenada, 227
Grimani family, 159
Guarino, Veronese, 77, 86
Guelf/Ghibelline distinctions, 29, 32, 55, 93, 98–99, 141–42, 186
Guelf/Ghibelline game of double allegiance, 193
Guelfs (papal supporters), 24–25, 94, 103, 138, 171, 192
Guicciardini, Francesco, 83, 276–82, 331, 338
 advised Clement VII to favor French over the Habsburgs, 279, 282
 ambassador to King Ferdinand of Aragon, 278
 Aristotelian, 278
 as commander of papal army, 279
 contribution to Western culture, 280
 cynicism, 280–82
 education, 277
 exiled, 257
 genius at administration, 278–79
 governor of Modena, 278
 History of Italy, 276, 280–81
 marriage, 278
 Ricordi, 277–78, 280, 282
 La Storia florentina, 278
 support of Alessandro de' Medici's regime, 256, 279–80
 use of original documents, 275–76, 278, 281
 withdrawal from political life, 277
guild membership, 26, 29, 46
guild of the people of God, 106
guild republicanism (Florence), 100
guilds, 93–94, 99
guilds based on textiles, 100
guilds of Florence (table), 101
Guiscard, Robert, 22

Habsburg dynasty, 244, 337
Habsburg Empire, 328
Habsburg hegemony, 338
Habsburg lands, 227
Habsburgs, 143, 180, 191, 195, 254
Hagia Sophia, church of, 226
harmony between Platonism and Christianity, 217
harmony in Renaissance neo-Platonic universe, 212–13, 221
Harvey, William, 90
Haskins, C.H., *The Renaissance of the 12th Century*, 11
Hebrew, 49, 130, 188

Hell, 32
Henry the Navigator, Prince (1394–1460), 164
Henry VII, Holy Roman Emperor, 30, 55, 142, 175
Henry VIII, King of England, 243, 249, 331
heresy, 49–50, 218, 266
Hermes Trismegistus, 212, 217
Hermeticism, 49
Herodotus, 85
heterodox thought, 49–50, 276
hierarchical universe, belief in, 212
high Renaissance, 300–306
Historia naturalis (Pliny), 165
historical periodization, 1–2, 320
historical scholarship, 76
historiography, 6, 9, 83, 272, 275, 278
history, 69
 in humanist curriculum, 83–84
 modern discipline of, 4
History of Florence (Bruni), 230
History of Florence (Machiavelli)
 commissioned by the Medici, 272, 274–75
 emphasis on foreign policy, 275
 a landmark of historiography, 272
 pessimism, 276
 and traditions of earlier Florentine histories, 274
History of France (Michelet), 6
History of Italy (Guicciardini), 276, 280–82
History of Rome from its Foundation (Livy), 76
History of the Florentine People (Bracciolini), 73
History of the Florentine People (Bruni), 76
Holy League, 125, 195, 240, 243, 269
Holy Roman Emperors, 60. *See also* names of
 emperors
Holy Roman Empire, 17, 22, 31, 98, 171, 241,
 243–44
 claims on authority, 24
Holy See, 20, 24, 98, 115, 121, 125
Homer, 86, 219
homosexuality, 50
House of Anjou, 230
House of Aragon, 172
House of Aragon (genealogy), 173
House of Este (genealogy), 194
House of Gonzaga (genealogy), 190
House of Sforza (genealogy), 182
House of Visconti (genealogy), 177
houses (of privileged elite), 43–45
human agency on earth, 13
human body (develop along with the mind), 81

human dignity, 7, 80–81
human form, reverence for, 286
human nature, 80, 271
human rationality, 282
humanism, 8–11, 13, 21, 48, 62, 74, 285, 320–22, 336
 active participation in government, 337
 attacks on, 323
 definitions, 69
 ideology of the Renaissance, 61, 69
 role in development of architecture, 309
 secular in nature, 70
 and social and geographical mobility, 336
humanism and women, 76–80
humanist curriculum, 69, 81–86, 133
humanist education, 62–63, 80–82, 192, 210
 development of the individual self, 81
 entrée into a privileged class, 86
 intellectual, physical, and moral, 81
humanist education for women, 77–79
humanist educators, 86–87
humanist fixation on the word and the text, 66
humanist idealism, 97
humanity's place in the universe, 212
hundred theses for debate, 218
Hundred Years' War, 226
Hungary, 151
Huns, 143
hypnotic magnificence, Venetian policy of, 120

Iberia, 161
imbroglio, 154
immortality of the soul, 90, 212
immunity of the clergy, 113–14
Imola, 123
imperial army, 251, 254
imperial coronation, 254
Imperial House of Hohenstaufen, 171
income and wealth tax, 107, 323
Index of Prohibited Books, 133, 135, 331, 338
individual, 321, 323, 337
 active role within the community, 336
 cult of the extraordinary individual, 315 (*See also*
 genius, role of)
individualism, 6, 8, 11, 13, 32, 81, 211, 282
indulgences, 124
infant and child mortality, 38
The Inferno (Dante), 140
Innocent IV, Pope, 58
Innocent VIII, Pope, 121, 218, 230

Institutio oratoria (Quintilian), 62, 65
institutionalized Christianity (Middle Ages), 31
intermarriage, 97
intermediate guilds, 101
internal, spiritual liberty, 211
international trade, 95
Isabella d'Este, consort of Francesco II Gonzaga,
 Marquis of Mantua, 13, 78, 123, 186, 191–92, 202
 education, 188
 library, 188
 patronage of the arts, 188–89
 skilled diplomat and ruler, 189
Isabella of Castile, 161
Islam, 218
Istria, 154
Italia mia (Petrarch), 57
Italian dialects, 31–32
Italian League, 229
Italian particularism, 22
Italian universities, 69, 87, 90
Italian vernacular, 27
Italian vernacular culture of later Renaissance, 202
Italian vernacular lyric, 219
Italy
 barbarian invaders, 21
 cynicism after crisis of sixteenth century, 265
 fragmentation, 21–22, 24–25, 93, 180
 French invasion under King Charles VIII, 174
 Guelfs and Ghibelline conflict, 25
 instability and fractiousness, 13
 natural regions, 17
 new balance of power dependent on France and
 Spain, 226, 242
 before the Renaissance, 17, 27
 revolution in commerce and trade, 94

Jerome, St, 63, 65, 86
Jerusalem, 138
Jesuits, 133, 331
Jewish and Christian intellectual traditions
 (connections), 49
Jews, 47–48, 50
 expulsion of the Jews (1492), 161
 little protection from law, 49
 resented for their success, 48
 restrictions, 48–49
Joachim of Fiore, 230–32
Joanna I, Queen of Naples, 58, 171–72
John Chrysostom, Saint, 86

John the Baptist, 312
John XXIII, antipope, 117
Josquin des Prez, 195
Judaism, 218
Julius II, Pope, 13, 22, 118, 195, 202, 243, 268, 331
 commissioned Bramante to build the new
 basilica of St Peter, 311
 desire to build a centralized papal monarchy, 242
 papa terribile, 125
 patron of the arts, 125
 secret peace with Venice, 243
 sold church offices, 124
 tomb, 254, 303
 warrior pope, 242
Julius III del Monte, Pope, 50
Justinian, 62

Knights of St John of Jerusalem, 160–61
Kossovo Polje, battle of, 159
Kulturgeschichte, 6

labor force, merchant control of, 95. See also *ciompi*
Lactantius, 86
Lana (manufacturers who traded in raw wool), 100
Landino, Cristoforo, 219
Laocoön, 286
Lascaris, Beatrice Balbo, 181
Last Judgment (Michelangelo), 131, 133, 306
Latin, 21, 27, 30, 59, 61, 70, 73, 77, 79, 81, 86, 219
 as an alternate first language, 82–83
 classical style of, 4
 Greek authors translated into, 73, 118, 188, 212,
 216, 219
Latin authors, 71
Latin grammar, 82–83
Latini, Brunetto, 28
Latino, Cardinal, 99
Laurentian age, 108
Laurentian Florence, 248
Laurentian Library in Florence, 73
law, equitable treatment before, 180, 200
law, study of, 55, 62, 72, 87, 90
law governing property of high ecclesiastics, 120
League of Cambrai, 124, 195, 243, 268
lectura criminalium, 90
Legend of the True Cross, 293
leisure, 51
leisured class of learned laymen, 70
Lent, 237–38

Leo X de' Medici, Pope, 131, 203, 234, 243, 278, 281,
 324, 331
 celebration following the election of, 248
 centered his court on luxury, learning, music
 and art, 130
 dream of strong state in central Italy, 249
 recreated the University of Rome, 130
Leonardo da Vinci, 1, 13, 176, 188, 303
Lepanto, 140, 328
Lepanto, battle of, 164, 261
lesser guilds, 101, 107
lesser tradesmen of the wool industry, 99
letter writing, use in secular life, 70
Letters to Atticus (Cicero), 74
Levantine wealth, 137
Leviticus, 82
Liber sine nomine (Petrarch), 60
liberal arts, 69
liberal progressives (among European intellectual
 elites), 6
life as work of art, 211
life expectancies, 42
Life of Castruccio Castracani (Machiavelli), 272
Life of Dante (Boccaccio), 27–28
Life of Dante (Bruni), 74, 81
Linacre, Thomas, 90
Lionel, duke of Clarence, 178
Lionello d'Este, 192–93
Litterae Familiares (Cereta), 78
Litterae Familiares (Cicero), 72, 74
Lives of the Artists (Vasari), 2–3, 288
The Lives of the Painters, Sculptors and Architects
 (Vasari), 315–16
Livy, 83, 280
 History of Rome from its Foundation, 76
Lodi, Piacenza, 176
logic, 86
logotherapy, 65
Lombard, Peter, 70
Lombard law, 42
Lombard Plain, 19, 143
Lombards, 143
Lombardy, 19, 181, 229
long-distance trade, 25–27, 70, 94, 100, 155. See also
 luxury trade with the East
Lopez, Roberto, 11
Lord's Prayer, 82
Lorenzetti, Ambrogio, 290
Lorenzetti brothers, 290

Lorenzetti, Pietro, 290
Lorenzo the Magnificent. See Medici, Lorenzo de'
Lothair II, Holy Roman Emperor, 138
Louis, King of Hungary, 160
Louis IV, emperor (the Bavarian), 140
Louis IX, King of France, 171
Louis XII, King of France (r. 1498–1515), 175, 184,
 189, 195, 242, 268–69
 death, 249
 diplomatic offensive against Milan, 241
 problems with England, 243
Louis XIII, King of France, 277
love, 36
 beginning of ascent toward the divine, 213
 classical tradition in, 213
 in Renaissance neo-Platonic universe, 212, 221
lower-middle-class
 participation in government and community, 46
Lucca, 20, 30, 103, 107–8, 229, 236
Lucian, 83
Lucretius, 64
 De rerum natura, 65
Luther, Martin, 50, 124, 130, 254
Lutheran revolt, 331
luxury goods for aristocratic life, 26–27, 94, 150,
 165, 226
luxury trade with the East, 138, 149–50, 164, 226.
 See also long-distance trade
 Venetian loss of, 328

Machiavelli, Niccolò, 13, 83, 123, 240–42, 269, 276
 as administrator and diplomat, 266–68, 270
 ambassador to Cesare Borgia, 267
 Art of War, 260, 272
 comparison, decline of Roman Republic with
 Florence, 273
 correspondence with Vettoria, 269
 De principatibus, 269
 Discourses on Livy, 260, 271–76
 dispatches sent back to Florence, 267–68
 embassy to King Louis XII of France, 267–68
 family, 266
 favored a ruling elite, 273
 First Decade, 265, 268
 hatred of the great Florentine families, 273
 History of Florence, 272, 274
 hope, 282
 idealist seeking temporary refuge in cynicism,
 271, 273

Life of Castruccio Castracani, 272
Mandragola, 272
marriage, 267
militia and, 268–69
on need for prince to assume authority, 270, 324
The Prince, 57, 174, 265–72, 274, 324
republican ideals, 271, 324
Second Decade, 268
Macrobius, 212
Madonnas (paintings), 298, 300
Magna Graecia, 17
magnati, 21, 97–98, 100–101, 103
Malatesta temple, 310
Malta, siege of, 161
Malta, Turkish assault on, 161
Mandragola (Machiavelli), 272
Mantegna, Andrea, 19, 90, 187–88, 298
Mantua, 12, 19, 86, 186–91, 243
Mantua, Marquis of, 243
Manutius, Aldus, 188
March of Treviso, 150
Margaret of Austria, 255, 257
Maritain, Jacques, 11
maritime states, 137. *See also* names of specific
 maritime states
marriage, 46–47, 98
 age at, 37–38
 annulment, 39
 canon (or Church) law governing, 39
 consent, 39
 continuation of the groom's family line, 39
 designed to bring advantage to bride's male kin, 77
 divorce, 39
 increase of population through, 39
 laws, 39
 marriage alliances, 35–36
 power in, 42
 remarriage, 42
 social mobility through, 78
 transfer of property from one generation to the
 next, 36
Marsuppini, Carlo, 71
 tomb of, 298
Martin V, Pope, 117, 330
Martini, Simone, 290
Mary of Savoy, 181
Mary Tudor, 249
Masaccio, 117, 293
 Trinity, 293

Mass for Duke Hercules of Ferrara, 195
mathematics, 77, 82, 86
Mathilda, Countess of Tuscany, 186
Maximilian, Holy Roman Emperor, 241, 243, 268
Maximus, Valerius, *Facta et dicta memorabilia*, 83
Medici, 11, 13, 49, 97, 108, 120, 140, 229, 234–35, 293
 expulsion from Florence, 140, 240, 266, 338
 Machiavelli's treatment in the *History*, 275
 order and renewed prosperity for Florence, 180
 return to Florence, 131, 240, 269, 279
 rise of, 107–10
 tombs of later Medici princes, 298
Medici, Alessandro de', 254–57, 279–80
Medici, Cardinal Giovani de' (later Pope Leo X)
 welcomed back to Florence, 248
Medici, Catherine de', 250
Medici, Cosimo de', 73, 107, 117, 140, 151, 174, 183,
 247
 Greek scholars and, 217, 221
 patronage and interest in Plato, 216
 role in arranging Peace of Lodi, 229
Medici, Francesco de' (1541–87), 261–62
Medici, Giovanni de' (1475–1521), 247, 324
Medici, Giovanni de', Cardinal, 234. *See also* Leo X
 de' Medici, Pope
Medici, Giuliano de', duke of Nemours (1479–1516),
 248, 298
Medici, Giuliano de', 109, 120, 203, 219, 272
Medici, Giuliano de' (1479–1516), 249
Medici, Giulio de', 117, 131, 250–51, 274
Medici, Ippolito de, 255, 315
Medici, Lodovico de'. *See* Giovanni dalle Bande Nere
Medici, Lorenzino de', 256, 259, 280
Medici, Lorenzo de', 50, 109–10, 120–21, 130, 174,
 180, 198–99, 213, 217, 219, 229, 237, 323
 death, 232
 patron of art and learning, 108, 216, 303
 political skill, 266
 Savonarola and, 230
 tomb, 298
Medici, Lorenzo de', (1492–1519), 249–50, 272
Medici, Lorenzo di Pierfrancesco de', 295
Medici, Piero de', 110, 232, 237, 248, 266, 275
 capitulation to Charles VIII, 266
 deposed, 233–34
Medici bank, 109
Medici (genealogy), 250
Medici hegemony, 108
Medici palace on the Via Larga, 234, 248

Medici popes, 247–55, 278, 281, 331
Medici principate, 255–62
Medici tombs, 225, 398
medicine, 48, 72, 87, 90
Medieval Europe, 5
medieval period. *See* Middle Ages
medieval science, 11
medievalism, 10–11
Mediterranean, Christian/Turkish struggle for, 159–61, 164
Mediterranean trade, 140, 149. *See also* long-distance trade; luxury trade with the East
memorization, 82–83
Meno (Plato), 212
mercantile patriciate, 12, 70, 93, 95, 97, 103, 141–42, 144, 325
mercenaries, 202
 Florence's use of, 229
 Italy's use of, 266
 used by popes of the Babylonian Captivity, 115
 Venice's use of, 151
merchant guilds, 95, 100
merchant nobility. *See* mercantile patriciate
merchants, 80
Metamorphoses (Ovid), 83
Michael VIII, Palaeologus, 141
Michelangelo Buonarroti, 1, 12–13, 73, 78–79, 125, 131, 133, 188, 255, 295, 311, 313, 331, 338
 in circle of Lorenzo de' Medici, 303
 commissioned to carve Julius II's tomb, 303
 commissioned to paint ceiling of the Sistine Chapel, 303
 commissioned to paint the Sistine altar wall, 306
 David (sculpture), 303, 322, 324
 described as *il divino*, 286, 316
 Doni Tondo, 303
 The Last Judgment, 306
 Medici tombs, 298
 neo-Platonic ideas, 306
 Pietà (sculpture), 303
 tomb, 306
 trained in workshop of Domenico Ghirlandaio, 303
 vernacular poet, 306
Michelet, Jules, 9
 History of France, 6
Michelozzi, Michelozzo, 108
Middle Ages, 2–5, 9–11, 28, 31
 as age of darkness, 76

conflict between papacy and empire (Guelfs/Ghibellines), 24
 Romantic movement and, 6
 saintly poverty, 74
 theocentric world, 4
Middle Platonists, 212
Milan, 9, 12, 19, 142, 172, 174–86, 240, 243
 after Peace of Lodi, 229
 armaments, 180
 controlled by artisan guilds, 94
 court, 58, 60, 184
 expansion at expense of neighbours, 227
 French retreat from, 243
 French rule, 184, 186, 241–42, 244, 338
 industry, 176, 180, 183
 patronage of art in, 176
 silkworms, cultivation of, 176
 struggle for the regency, 180–81
 taxation, 175–76, 179–80
 wars with Florence, 175
 woolen manufacturing industry, 176
millenarian theocracy, 235
Modena, 192–93, 197, 229, 249, 254, 279
modern state, 323
modernity, 8, 11
Mohàcs, 160
Mohammed the Conqueror (Mehmed II, r. 1444–46, 1451–81), 159
monarchical states, 169. *See also* names of specific monarchical states
monarchy, 13, 19, 31, 45, 114, 133, 180, 242
 absolutist monarchy of Cosimo I, 323
 Aristotle's view of, 210
 freedom for women and, 78
 Salutati's praise for, 72
monasticism, 72, 213, 218
money markets, 27
Monferrato, marquis of, 142
Montaperti, battle of, 98, 138
monte, 106–7, 323
Monte delle doti, 37, 107, 109, 237, 323. *See also* dowry, or bride-price
Monte di Pietà (bank), 235
Montefeltro, Federigo da, 198–200, 202, 205, 209, 293
Montefeltro, Guidobaldo, 202, 205
Montefeltro Counts and Dukes of Urbino (genealogy), 202
Montefeltro court, 198–99

Montefeltro of Urbino, 196, 198
Montemurlo, 338
Monteverdi, Claudio, *Orfeo*, 191
Moors, 161
moral laws of God, 271
moral philosophy, 64, 69, 82, 84
morality based on ancient texts, 81–82
Morea, 21
Morgante Maggiore (Pulci), 221, 238
Moro, Lodovico il, 176, 199, 202, 240
Moses, Michelangelo's image of, 125
Moses and the Jewish cabala tradition, 49
mundualdus (or legal guardian), 42
Murano glassworks, 146
music, 69, 84, 195, 219
Muslim culture, 17
Muslim states of North Africa, 161, 164
Muslims, 22, 47, 137, 159
mystical tradition, 230–32
mysticism of Hermeticism, 49
mysticism of St. Bernard, 82
myth of Florence, 107, 321
myth of Venice, 151–56

Naples, kingdom of, 20–22, 160, 171–75, 229, 243
 annexed by King Louis XII of France, 241
 Aragonese foothold in, 268
 dynastic feudal monarchy, 169
 Ercole I's connection through marriage, 195
 expansion at expense of neighbours, 227
 fall of, 338
 France's dynastic claim on, 227, 266
 goal of Charles VIII, 240
 left to Ferdinand of Aragon and Sicily, 241
 Sforza's diplomatic connections to, 183
 Spanish rule, 242
Napoleon, 197
Nardi, Jacopo, 256
natural beauty, 8
natural philosophy, 84
naturalism in art, 4, 8, 69, 286, 289–90, 303, 320
Neapolitan Angevins, 171
neo-Platonism, 48, 117, 211–13, 306
 of the courtier, 338
 Florentine context, 221
 Renaissance version of (*See* Renaissance neo-Platonism)
neo-Platonism and Christianity
 compatibility, 49, 212–13

nepotism, 120–21
Nero's Golden House, 130
Niccoli, Niccolo, 72–73
Niccolò III d'Este, Marquis of Ferrara, 192, 195
Nice, 17
Nicholas III, Pope, 99
Nicholas V, Pope (r. 1447–55), 118, 331
nobility of virtue and learning
 preferred over nobility of birth, 87
Nogarola, Isotta, 77–78
Normans, 22
northern Europe (or territorial monarchies), 227, 229, 243
 mercantile houses, 226
 return of stability after Hundred Years' War, 226
 threat to Italy, 240, 337
notaries, 80
Novara, 178
Novello, Guido, 30
nude figure, 286, 293, 295
numismatics, 4, 65

Olgiati, Girolamo, 183
Obizzo d'Este, 192–93
Oltr' Arno, 45
On His Own Ignorance (Petrarch), 61
On the Citizen Orator (Quintilian), 73
On the Family (Alberti), 36, 77
On Wifely Duties (Barbaro), 77
or social continuities, 35–51
oranges, 27
oratory, 84
Order of Saint Stephen (Santo Stefano), 140, 260
Ordinances of Justice, 100, 103, 106
Orfeo (Monteverdi), 191
Orlando Furioso (Ariosto), 19
Orlando Innamorato (Boiardo), 195
ornamental glass, 147
orphanages, 46
Orsanmichele, 322
Orsini family, 205, 242
Orthodox Christianity, 22, 47, 50
Ostrogoths, 143
"other," 50
Otranto, 17, 160
Ottoman Empire, 160
Ottoman Turks, 159, 164
Ovid, 28, 213, 235, 238
 Metamorphoses, 83

Pacioli, Fra Luca, 293
Padua, 58, 85, 151, 181, 326
paganism, 63–64, 72
palace schools, 87
palaces, 97. *See also* names of specific palaces
Palazzo della Signoria, 103, 234, 238, 240, 249,
 260–61, 303, 309
 art developing into propaganda, 316
Palazzo Medici, 108, 249, 260
Palazzo Pitti, 45, 261, 325
palazzo Rucellai in Florence, 309
Palazzo Tè, 188–89
Palazzo Vecchio, 103
Palermo, 171
Palestine, 138
Palladio, Andrea, 1, 157, 328–29
Palladium, 338
Pallas and the Centaur, 293
Palmieri, Matteo, 286
 Treatise on the Civil Life, 3
Panofsky, Erwin, 10
 Renaissance and Renascences in Western Art, 9
papacy, 19, 49, 227, 242
 assigned Pisa and Genoa to expel Muslims, 137
papacy/empire conflict (Guelfs/Ghibellines), 24–25
papal banking and tax collecting, 98
papal dues, 94
papal states. *See* states of the Church
Paradiso (Dante), 28, 32
Paris Commune, 7
Parlamento, 248
Parma, 176, 178, 181, 249, 254, 279
Parte Guelfa (Guelf Party), 98, 103
paternalism, 210
patrilineal family name, 42
patronymics, 35
Paul, Apostle, 20, 64
Paul II, Pope, 120, 193
Paul III, Pope, 123, 133
 new form of patronage, 337
 patron to Rome, 133
Paul IV, Pope, 133, 331
Pavia, 179, 251
pawn shops, 48
Pazzi Chapel, 309
Pazzi Conspiracy (1478), 110, 131, 219, 242
Pazzi (family), 97, 120
Peace of Lodi, 151, 174, 227–29, 242
Pellicciai (traders in fur pelts), 100

Peloponesus, 161
perfectibility, idea of, 316
periodization, 1–2
Persia, 160
perspective, 293, 303, 313
Perugia, 178, 181, 242
Perugino, Pietro, 188, 307
Peruzzi, Baldassare, *Sala delle prospettive*, 131 254
Peruzzi (bank), 105
Peter III, Spanish king of Aragon (d. 1285), 171
Peter the Apostle, Saint, 20, 24, 115
"Peter's Pence," 95
Petrarch, 2, 7, 12, 32, 51, 69, 85, 97, 212, 338
 Africa, 59
 ambivalence about civic virtue, 59–60
 belief in value of ancient culture, 71
 benefices, 57, 60
 bridging pagan and Christian worlds, 63–64
 children, 58, 60
 Christian belief, 59
 De vita solitaria, 59
 devotion to Latin classics and Cicero, 55, 57, 59
 diplomatic missions, 58
 early humanism, 61–66, 74, 336
 fame, 57–60
 family banished, 103
 friendships, 55, 57
 On His Own Ignorance, 61
 idealization of Laura, 57–58, 60, 177, 213
 Italia mia, 57
 letters, 59–60, 65
 Liber sine nomine, 60
 life and career, 55–61
 lifetime corresponded to Babylonian Captivity,
 113
 patrons, 57–58
 psychological regimen, 65
 received by Giovanni Visconti, 176
 search for classical manuscripts, 64, 285
 Secret Book, 60
 Song Book (canzoniere), 59, 177
 stateless wanderer, 59, 62
 transition figure, 59
 Trionfi, 177
 vernacular love sonnets to Laura, 57
Phaedo (Plato), 212
Phaedrus (Plato), 212
Philip II, King of Spain, 80
Philip IV, King of France

dispute with Pope Boniface VIII, 113–14
philological analysis, 71–72
philology, 4, 65
philosopher king, 63
physical education, 84–85, 87
Pia, Emilia, 205
Piacenza, 178, 181, 249
Piagnoni (Savonarolans), 236–37, 248, 259
Piazza della Signoria, 238, 324
Piccolomini, Aeneas Silvius, *The Story of the Two
 Lovers*, 119
Pico della Mirandola, Giovanni, 13, 48–50, 217, 219,
 295
 concept of the unity of truth, 218
 converted to puritanical fundamentalism, 218
 Savonarola's teaching and, 230
Piero della Francesca, 199
 Brera Madonna, 293
 The Flagellation, 293
 Legend of the True Cross, 293
Pietro Serino of Brescia, 77–78
Pisa, 20, 103, 159, 236, 242, 268
 after Meloria, 138, 140–41
 alliance with Genoa against Muslims, 137
 became part of Florence state, 140
 capture of, 107, 140
 Council of, 117
 defeat at Meloria, 138, 149
 economic collapse, 140
 Genoese supremacy over, 141
 Muslim invaders, 137
 new focus on learning, 140
 power and wealth during the Crusades, 138
 rivalries with Genoa, Venice and Amalfi, 137
 servicing the Crusades, 26
 taken by Florence, 181
 warfare with Genoa, 138
 wealth, 137–38
Pisanello, 117, 192
Pisano, Andrea, 312
Pitti, Luca, 261
Pitti Palace, 259
Pius II, Pope, 119–20, 242
Pius III, Pope, 124, 242
Pius V, Pope, 260
plagues, 48, 58. *See also* Black Death
Plato, 205, 211–12, 217
 Dialogues, 206
 Gorgias, 212

Meno, 212
Phaedo, 212
Phaedrus, 212
Republic, 212
Timaeus, 212
Platonic Academy, 213, 216–22, 293, 295
Platonic belief in harmony and love, 221
Platonic love, 213, 219
Platonic relationships, 202–3
Platonic Theology (Ficino), 212, 217
Platonic tradition, 211–13
Platonism, 61, 84, 198, 212
Plautus, 83
Pliny, 286
 Historia naturalis, 84, 165
Plotinus, 205, 212
Plutarch, 83
podestà (chief of police and military commander), 100
poetry, 19, 69
political liberty, 9
political theory, 265
politics and propaganda in art, 290, 316
Poliziano, Angelo, 217, 221
 Fable of Orpheus, 219
 love for the Medici, 219
 Stanze per la giostra di Giuliano de' Medici, 219, 295
 translation of Homer into Latin, 219
Pollaiuolo, 121
Pomponazzi, Pietro, 90, 326, 334
Ponte Sisto, 120
poor, 230, 235
poor people in Italian Renaissance towns
 everyday lives, 46–47
poor relief, 47
poor women working next to men, 42
poorer or less privileged Italians, 35
popolo grasso (rich merchants and entrepreneurs),
 98–99
popular preachers, 47–48, 50
popular suffrage, 141
Por' San' Maria (silk merchants and weavers), 100
Portinari, Beatrice, 28, 30–31
Portinari, Folco, 28
portrait busts based on Roman models, 293
portraits, 298
portraiture, 326
portraiture in sculpture, 295
Portuguese, 326
Portuguese ship design, 165

Portuguese voyages around African continent,
 164–65
postal system, 180
poverty, Franciscan respect for, 97
practical affairs, humanist education for, 80
Prato, 269
prayer for the souls of the dead, 47
Pre-Raphaelites, 6
prejudice, 48, 50
prestanze, 103, 105
Prester John, 164
Primavera (painting by Botticelli), 219, 293
The Prince (Machiavelli), 57, 174, 265–72, 274, 324
princely despotism, 9
princes, 19, 78, 169
 compared to Caesar or the good emperors, 210
Prince's handbook genre, 271
principalities, 19, 78, 84, 169–206
priors, 99, 101, 105–6, 234
 executive power, 100
Priscian, 83
professional civil servants, 107
professional letter writers, secretaries, orators, 70
progress, 6, 9
property-owning elite, 76
Prose della vulgar lingua (Bembo), 159
prostitutes, 50–51
prostitution, 46
Protestantism, 130–31, 133
Provençal dialect, 31
Provençal love lyrics, 55
Psalms, 82, 188
Pseudo-Dionysius, 206, 212
psychological consequences of Agnadello, 326
Ptolemy, 84
public health, regulation of, 178
public works, 178
Pugin, Augustus Welby, 6
Pulci, Luigi, 217
 Morgante Maggiore, 221
Purgatory, 32

Quintilian, 84, 285
 On the Citizen Orator, 73
 Institutio oratoria, 62, 65

Raphael, 1, 125, 130–31, 199, 303, 306, 331
 chief architect of the new basilica of St Peter in
 Rome, 307

commissioned by Pope Julius II to decorate
 private apartment, 307
Disputation over the Holy Sacrament, 254
Galatea, 307
stanza della segnatura (Pope Julius II's library), 307
Raphael, school of, 24
Ravenna, 20, 30, 144, 195, 243, 338
realism, 289
realism in anatomy, 313
rebirth *(rinascita)*, 2
Reformation, 89, 159, 306, 338
Reggio, 192–93, 197, 229, 279
Il Regno. *See* Naples, kingdom of
Renaissance
 defining, 1, 4, 10, 12, 35
 as elite movement, 51
 as historical phenomenon, 1–2
 history of a mentality, 319
 open at both ends, 11
 opposing methodologies, 2
 as retrogression in field of scientific endeavour, 11
 self-definition, 5
 turned Rome into a leading center of culture
 and power, 330
 writers and artists saw themselves as special, 4
Renaissance and Renascences in Western Art (Panofsky), 9
Renaissance art and sculpture, 286–97
Renaissance as a decline from the Middle Ages, 11
Renaissance conceit, 213
The Renaissance in Italy (Symonds), 9
Renaissance Italian house (of privileged elite),
 43–45
Renaissance Mannerist palaces, 259, 261
Renaissance neo-Platonism, 205–6. *See also*
 neo-Platonism
 close association with some ideals of Christian
 humanism, 212
 coincided with Medici hegemony, 221
 freedom was internal and spiritual, 213
 ideology of the later Italian Renaissance, 211
 new ideology or energizing myth, 210
 replacement for civic humanism, 211
The Renaissance of the 12th Century (Haskin), 11
"Renaissance" point of view, 6
Renaissance scholars
 preference for ancient over medieval world, 4–5
René I, King of Naples and Jerusalem, 172
rentiers, 226, 328
Republic (Plato), 212

republican liberty, 9, 76, 78, 320, 324
republicanism, 6, 213
republics, 12–13, 19, 42, 321. *See also* names of
 specific republics
 elite lay citizens (self-government), 26
 foreign relations in, 267
revolt of the *ciompi*, 106
"Revolt of the Medievalists," 11
Revolt of the Sicilian Vespers, 171
Revolution of the Heavenly Bodies (Copernicus), 90
rhetoric, 64, 69–71, 83–84, 86. *See also* eloquence
Rhodes, 160
Riario, Girolamo, 109, 120
Riario, Piero, 120
Richilieu, Cardinal, 277
Ricordi (Guicciardini), 277–78, 280, 282
Risorgimento (movement for Italian unity), 276–77
Robert of Anjou, King of Naples, 85
Robert of Geneva, 116
Robert of Naples, 105
Roberti, Ercole, 193
Romagna, 20, 242
Roman Catholic Church. *See* Church
Roman Civil Law, 62
Roman Empire, 6, 19, 31
 collapse of, 17, 21, 25, 70
 replaced republican world of Roman Republic,
 210
Roman Inquisition, 50, 133–34, 159, 331, 338
Roman law, 90
Roman Republic, 76, 210
 declined as it became wealthy, 273
 grown too weak to sustain self-government, 271
 parallel with Florentine Republic, 321 Romano,
 Giulio, 19, 188–89
Romanticism, 6–7
Rome, 5, 10, 12, 21, 57, 70
 attractive center for humanism and scholars, 331
 of Augustus *vs.* Rome of AD 700, 1–2
 during Babylonian Captivity, 20, 113–15
 banking and cultural centre, 20, 130
 as the *caput mundi*, 20, 115, 331
 destruction and slaughter by imperial army,
 251, 254
 end of Renaissance in, 330–34
 during Great Schism (*See* Great Schism
 [1378–1417])
 Greek scholars, 118
 holiest place in the West, 20

 moral decline, 121
 rebuilding during Renaissance, 118
 Renaissance architecture, 310
 as Renaissance state, 113, 117–21
 return of the papacy, 115
 riot on Alexander's death, 124
 sack of (*See* sack of Rome)
 warring noble families of the city, 114, 122
Room of the Giants, 189
Rubens, Peter Paul, 191
Rucellai (family), 97
Rucellai gardens, 259–60
Ruskin, John, 6, 9

sack of Rome, 191, 195–96, 306, 331, 338
 psychological shock, 331
sacred relics, 187–88
Sacristy of San Lorenzo, 309
Sadoleto, Jacopo, 130
Sala delle prospettive (Peruzzi), 254
Salutati, Coluccio, 73, 78, 97, 180, 290, 321, 338
 circle, 72–76
 civic humanism, 71
 De nobilitate legum et medicinae, 72
 De seculo et religione, 72
 De tyranno, 72
 moved humanism toward sphere of political
 affairs, 72
 politically engaged and married (still
 transitional), 71
 transitional figure (valued contemplative as well
 as the active life), 71–72
 translations of Greek classics into Latin, 73
salvation, 47, 64
Salviati, Maria, 278
Sammicheli, Michele, 157
San Francesco in Arezzo, church of, 293
San Francesco in Assisi, church of, 288
San Lorenzo fuori le Mura (St Lawrence outside the
 Walls), 118
San Lorenzo in Florence, 298, 325
San Marco, monastery of, 230, 236–38
San Niccolo di Casole, monastery of, 160
San Paolo fuori le Mura (St Paul outside the Walls),
 118
Sansovino, Jacopo, 157
Sant'Andrea, church of, 187
Santa Croce chapels, 288
Santa Croce (Church), 295

Santa Maria dell'Anima, 131
Santa Maria Maggiore (St Mary Major), 118, 122
Santa Maria Nuova (hospital), 28
Sanzio, 199
La Sapienza, 130. *See also* University of Rome
Saracen kingdoms, 159
Saracens, 137
Sardinia, 137–38, 172
Sarton, George, 11
Savonarola, Girolamo, 49–50, 110, 140, 218, 234, 275, 295, 323, 338
 allegiance to Charles VIII, 236–37, 240
 anti-Medici propaganda, 232, 266
 assassination attempt, 237
 attacks on Pope Alexander, 232, 237–38
 burned as a heretic, 266
 challenged to an ordeal of fire, 238
 enemies (Franciscans of Santa Croce), 236
 enemies (great patrician families), 235
 excommunication, 238
 execution, 239
 failure in foreign affairs, 236
 God's instrument claim, 230, 238
 moral legislation, 235
 prophecies, 230, 237–39, 266
 reign of moral terror, 238
 rise of, 230–32, 240
Savoy, 17
Scala, Cangrande della, 186
Scamozzi, Vincenzo, 157
La Schifanoia, palace of, 193
schismatic Christians, 47, 49
scholarship, 157
 civic responsibility and, 31, 59–60, 71–72
scholarship, modern concept of, 66
scholastic curriculum of the trivium and quadrivium, 69
scholastic thought, 32, 63–64
scholasticism, 61–62, 70
The School of Athens, 125
schools existed to train the leaders of society, 87
schools of humanist educators, 87, 90
schools of Vittorino and Guarino, 86–87, 90
science, 84, 140
"scientific," 6
scientific endeavour, 11
Scientific Revolution, 5
Scipio Africanus, 60
Scott, Sir Walter, 6

Scotus, John Duns, 69
Scrovegni chapel in Padua, 288
sculpture, 285, 295, 322
Second Decade (Machiavelli), 268
Secret Book (Petrarch), 60
secretaries, 80, 145
secular education, 70, 73, 80
secular learning, 71
secular life of political and scholarly activity, 71
secular wisdom and experience, 97
secularism, 6, 8, 31–32
self, cultivation of, 211
self, modern concept of, 320
self-confidence, 27, 320
self-confidence, loss of, 326, 337
self-definition, 4–5
Selim I (r. 1512–20), 160
Seneca, 11, 59, 63, 82–84, 212
 moral philosophy, 64
Serenissima, 21, 149, 157, 325. *See also* Venice
serfs, liberation of, 100
Serrata (Closing of the Great Council), 145, 149
servants, 45
Settignano Desiderio da, 298
sexual love, 213
Sforza, Battista, 202
Sforza, Francesco, 13, 181, 183, 229
Sforza, Francesco, duke of Milan, 202
Sforza, Galeazzo Maria, 183, 209
Sforza, Giangaleazzo, 183
Sforza, Giovanni, 123
Sforza, Lodovico, Duke of Milan, 186, 243, 303
 diplomat and patron of the arts, 183, 185
 exile and death, 241
 mistresses, 184
Sforza, Massimiliano, 243
Sforza dynasty, 19, 210
Shakespeare, William, *The Taming of the Shrew*, 89
Sicilian Vespers, 171, 174
Sicily, 17, 19, 21, 169, 174, 241
 cosmopolitan character, 22
 Muslim domination, 17
Siena, 20, 103, 107, 181, 229
 incorporated into Florentine dominion, 260
Siena, Council of, 117
signori, 8, 20, 25, 114, 140, 175
 cultural world of, 206
 of Ferrara, 192
 of Mantua, 186

Milanese, 175–76
papal vicars, 123
patronage of the arts, 169
signoria, 71, 103, 105–6, 234, 238, 323
silk industry, 183
silks, 27
silkworms, cultivation of, 176
Silver Book, 146
simony, 115, 121
Sistine Chapel, 120, 125, 131, 133, 303
Sistine Choir, 120
Sixtus IV, della Rovere, Pope (1471–84), 109–10 124, 242, 331
 attempt to annex Ferrara, 195
 contributions to Rome, 120–21
 patron of art, learning, and building, 120
social and economic history, 12
social history, 8
social mobility, 10, 46, 51, 86, 145–46, 213, 321
 Church offered, 331
 humanism and, 336
 Silver Book and, 146
 through marriage, 37
Soderini, Piero, 234, 240, 247, 267–68, 270, 273, 275, 278
Song Book (canzoniere) (Petrarch), 177
Sophocles, 86
Spain, 227, 242, 269
Spain, union under Ferdinand of Aragon and Isabella of Castile, 164, 227
 new Christian power, 161
Spalato (Split), 21
Spanish ship design, 165
Speziali (physicians, apothecaries, spice merchants), 100
spices, 26, 165, 326
sports or "games," 85, 87
St Ambrose, seat of, 19
St Gall, library of, 65
St John Lateral, the cathedral of Rome, 118
Standard Bearer of Justice, *gonfaloniere di giustizia*, 101
stanza della segnatura (Pope Julius II's library), 125, 307
stanze di Raffaelo (fresco for pope's private apartment), 307
Stanze per la Giostra di Giuliano de' Medici (Poliziano), 295
Stanze (Raphael), 125
state archives of Florence, Venice, and Rome, 12

state as a work of art, 7, 13, 97
state as creation of God, 8
state (modern state), 323
states of the Church, 20, 121, 227, 229, 243
stoicism, 63, 84
La Storia fiorentina (Guicciardini)
 critical analysis of original sources in, 278
 in the development of history as a discipline, 278
The Story of the Two Lovers (Piccolomini) Aeneas Silvius, 119
Strozzi family, 97
studia humanitatis, 81
Suleiman the Magnificent, Sultan, 160
Swiss Confederacy, 243
Swiss Confederation, 241
Swiss mercenary army, 244
Sylvester, Pope, 24
Symonds, John Addington, *The Renaissance in Italy*, 9
Syria, 160
 ports in, 138

tailors, new guild, 106
The Taming of the Shrew (Shakespeare), 89
Tasso, Torquato, 191, 195
 Gerusalemme Liberata (Jerusalem Delivered), 19, 195
taxation, 105, 107, 175–76, 179–80, 235, 323
 higher taxation of Jews, 48
Teatro Olimpico, 329
Temple of Vesta, 311
Ten Books on Architecture (Vitruvius), 309
"Tenths," 94
Terence, 83
territorial monarchies. *See* northern Europe (or territorial monarchies)
Tertullian, 63
textual editing, 4, 65, 71
theocentrism, 4, 63–64
theocracy, 230
Theodosius, 210
theology, 69–70, 221
Thirty Years' War, 191
Thomas, Apostle, Saint, 31
Thomas Aquinas, Saint, 70
Thorndike, Lynn, 11
Thucydides, 85
Tibullus, 238
Tiepolo, Bajamonte, 147, 154
Timaeus (Plato), 212

time, modern concept of, 320
Titian, 300–301
Tomeo, Niccolò Leonico, 90
torture, 235
towers attached to fortress-houses, 103
trading houses, 94
Transfiguration (Raphael), 131
Treatise on the Civil Life (Palmieri), 3
Treaty of Blois, 175
Treaty of Lyons, 268
Treviso, 21
Trinity (Masaccio), 293
Trionfi (Petrarch), 177
truth from eloquence, 63–64
truth through the word, 65
Tura, Cosmè, 193
Turkish assault on the Balkans, 159
Turkish conquest of Constantinople, 142, 159
Turkish control in the Mediterranean, 164
Turkish expansion against Christians of Europe,
 160–61
Turkish fleet, 160
Turkish threat to the Mediterranean, 140–41
Turkish wars, 154
Turks, 50, 117, 140, 160
Tuscan academies, 259
Tuscan dialect, 31
Tuscan nobility. See *magnati*
Tuscan states, 138
Tuscany, 19–20, 99, 107, 140, 229
Twenty, council of, 234

Uccello, Paolo, 213, 293
Uffizi Adoration (Botticelli), 219, 293
Uffizi (Offices), 261, 325
Ugolino della Gherardesca, 138, 140
Unam sanctam (1302), 113
unbridled egoism, 7–8, 13, 32, 81, 315
unemployment, 227
unity of truth, concept of, 218, 221
University at Pavia, 180–81
University of Montpellier, 55
University of Padua, 86–90, 157, 325–26
University of Paris, 30, 70
University of Pisa, 140
University of Rome, 120, 122, 130
Urban II, Pope, 26
Urban VI, Pope, 116–17
Urbino, 10, 123, 169, 191, 198–206, 249

Urbino, palace of, 198
Urbino Bible, 198
Urbino court, 205, 242
usury, 82, 93

Valentinois, French duchy of, 241
Valerius Flaccus, *Argonautica*, 65
Valla, Lorenzo, 24, 65, 172, 331, 334
Valois kings of France, 143, 229, 244, 337
Vasari, Giorgio, 261, 324
 attacks on religion, 5
 de facto official artist of Duke Cosimo I, 316
 Lives of the Artists, 2–3
 The Lives of the Painters, Sculptors and Architects,
 315–16
 and modern discipline of art history, 316
Vasco da Gama, 164–65, 326
Vatican Library, 118, 120, 198
Vaucluse, 58–59
Venetian art, 298
Venetian Church, 158–59
Venetian empire, 149–51, 158, 174, 243, 325–26
Venetian justice, 154
Venetian myth of the state, 326
Venetian nobility, 156, 330
 concerned with trade, 157
 patrician merchant oligarchy, 145
 from seafaring to landed property, 226, 328
Venetian prisons (or leads), 154
Venetian Renaissance style of architecture, 158
Venetian style of painting, 298, 300, 325
Venetian trading and banking firms, 328
Venice, 12, 17, 50, 58, 76, 137, 141–45, 158–59, 174,
 181, 242
 accomplice of King Louis in defeating Milan, 241
 after Peace of Lodi, 229
 aristocratic coup *(Serrata)*, 145
 attack by Pope Julius II, 242–43
 bronze casting, 312
 challenge to Este lands, 195
 collapse of the Republic, 330
 conflict with northern perimeter of papal states,
 158
 constitution, 144, 147
 craftsmen, 146–47
 defeat at Agnadello, 124
 defeat in war of the League of Cambrai, 268
 disasters that changed the mentality of the
 ruling class, 326, 328

as dominant economic and naval power in
 Europe, 141
end of the Renaissance in, 325–30
expansion at expense of neighbours, 181, 227
factions, 155
gerontocracy, 155, 157
homogenous state, 144
humanism in, 156–59, 325
intellectually repressed society, 157
learned women or female writers, 77
legal position of women, 42
loss of Cyprus, 164
loss of self-confidence, 326, 328
mainland territories, 149–51
mixture of principality and democracy, 149
non-noble Venetians, 145–47
ornamental glass, 147
Peace of Lodi, 151
policy of territorial expansion, 149–50
portraiture, 326
private patronage to artists, 326
role as buffer state, 243
servicing the Crusades, 26
struggle for maritime supremacy, 149
supported Obizzo d'Este in capturing Ferrara,
 192
terraferma empire, 21, 151, 157–58, 174, 243,
 325–26
trade and commerce, 144, 149–50, 154, 326
truce with Spain and France, 269
War of Chioggia, 142
wealth, 137, 149, 326
Venice in the Renaissance, 145–49, 151, 158
Venice of Palladio, 329–30
Vergerio, Pietro Paolo, 65, 74, 180
vernacular, 4, 27, 30–31, 57, 73, 82, 159
Verona, 30, 86, 150–51, 178, 181, 326
Verona, cathedral library of, 59, 64
Verrazano, 165
Verrocchio, Andrea, 303, 322
Vesalius, Andreas, *De humani corporis fabrica*, 90
Vespucci, 165
Vettori, Francesco, 256, 269
Via Maggio, 45, 261
Vicenza, 151, 326
Vico, 276
Vienna, 160
 clientage and patronage, 155
Villa Dei, Alexander de, *Doctrinale*, 83

Villani, Giovanni, 95
violence, 121
Virgil, 28, 31, 60, 82, 186, 188
 Aeneid, 32, 83
virtù, 81, 225, 281, 324
virtuoso, 8, 13
Visari, Giorgio *Lives of the Artists*, 288
Visconti, Bernabò, 178, 181
Visconti, Bianca, 181, 183
Visconti, Filippo Maria, 181, 229
Visconti, Galeazzo, 177–78
Visconti, Giangaleazzo, Duke of Milan, 9, 71–72,
 107, 140, 175, 192, 209, 230, 320
 attempt to build a united Italian state, 178
 enlightened despotism, 180
 interest in learning, government, and patronage,
 178
 support for scholarship, 180
 wars, 179–80
Visconti, Gianmaria, 180–81
Visconti, Giovanni, 142, 176
Visconti, Violante, 178
Visconti family, 19, 58, 71, 151, 175, 181, 241
Vita Nuova (New Life) (Dante), 30
Vitruvius (Marcus Vitruvius Pollio), 329–30
 Ten Books on Architecture, 309
Vittorino da Feltre, 86
Voltaire, 5, 9, 276
Volterra, 109, 236
vulgare illustre (Dante's vernacular), 31
Vulgate Bible, 65

wages, 46
Walter VI of Brienne, Duke of Athens, 105
War of Chioggia, 141, 149
War of the League of Cambrai, 243, 268, 326
War of the Mantuan Succession, 191
War of the Pazzi Conspiracy, 109, 120, 233
War of Urbino, 130, 249
warrior chieftains, 169. *See also condottiere*
Wars of the Roses, 226–27
weights and measures, 25
Wenceslas, Emperor of Germany, 175
wet nurses, 45
Whites, 103
widowed mothers, 42, 45
William of Ockham, 69
wise princes, 12–13
women, 43, 50–51, 174, 183

artisan women, 42
Bands of Hope and, 235
in *The Book of the Courtier*, 205
control by husbands and fathers, 77
court life required accomplished women, 42
education, 77–78, 188
exclusion from political life, 76
freedom restricted, 42
grand courtesans, 51, 77
humanism and, 76–80
under the law, 42
nuns, 77
oversight of servants, 77
persecuted as witches, 50
property, 42

prostitutes, 50–51
responsibility for education and rearing of
 children, 45, 77
Savonarola's teaching and, 230
women artists, 79–80
women writers, 80
women and children
 contribution to stable lower-middle-class
 quality of life, 46
wool industry, 99, 176, 226

Xenophon, 85

Zara (Zadar), 21